STYLE IN THE ART THEORY OF EARLY MODERN ITALY

When Giorgio Vasari invented the new literary form of art history, he attempted the first definition of style because, he believed, style gave structure to history. Artists signaled, with style, essential information about themselves and their place in history: their character, their political alliances, their ideas about art. However, these signals, being visual and embedded in mimetic forms, were inherently ambiguous and divergently interpreted even by the most visually literate audiences. For Vasari, and for later art writers working in his shadow, style slipped through their verbal nets.

In this study, Philip Sohm explains the verbal strategies for defining style and why they usually met with failure. He explains discussions of style from Vasari to Baldinucci, showing the linguistic dimensions of visual perception and how concepts of language shaped ideas of style.

Philip Sohm is Professor of the History of Art at the University of Toronto. The author of *Pittoresco: Marco Boschini, His Critics, and Their Critiques of Painterly Brushwork in Seventeenth- and Eighteenth-Century Venice*, he has contributed to the *Journal of the Warburg and Courtauld Institutes, RES*, and *The Renaissance Quarterly*, among other publications.

STYLE IN THE ART THEORY OF EARLY MODERN ITALY

PHILIP SOHM

University of Toronto

CAMBRIDGE
UNIVERSITY PRESS

PUBLISHED BY THE PRESS SYNDICATE OF THE UNIVERSITY OF CAMBRIDGE
The Pitt Building, Trumpington Street, Cambridge, United Kingdom

CAMBRIDGE UNIVERSITY PRESS
The Edinburgh Building, Cambridge CB2 2RU, UK
40 West 20th Street, New York, NY 10011-4211, USA
10 Stamford Road, Oakleigh, VIC 3166, Australia
Ruiz de Alarcón 13, 28014 Madrid, Spain
Dock House, The Waterfront, Cape Town 8001, South Africa

http://www.cambridge.org

First published 2001

Printed in the United States of America

Typefaces Bembo 11.5/15 pt. and Centaur *System* DeskTopPro$_{/UX}$ [BV]

A catalog record for this book is available from the British Library.

Library of Congress Cataloging in Publication Data
Sohm, Philip L. (Philip Lindsay), 1951–
Style in the art theory of early modern Italy / Philip Sohm.
p. cm.
Includes bibliographical references and index.
ISBN 0-521-78069-1
1. Art, Italian. 2. Art, Renaissance and Baroque – Italy. 3. Art –
Philosophy. 4. Style (Philosophy) I. Title.
N6914 .S65 2001
750'.1'8 – dc21 00-065141

ISBN 0 521 78069 1 hardback

For Matthew

Contents

ILLUSTRATIONS

ACKNOWLEDGMENTS

I didn't intend to write this book. Much like my previous one, *Pittoresco*, it stuttered into existence accidentally as I tried to map the linguistic world of early modern art critics. The reader of this book can glimpse that imagined book buried in various sections, such as "Misprision by Nomenclature" (in Chapter 5) and "Lexical Fields" (in Chapter 7), where I argue that a writer's concept of style is contained in (and limited by) his or her particular vocabularies. I had intended to show, for example, how a critic who admires depictions of moving figures might supplement the standard artistic lexicon with terms borrowed from treatises on dance, comportment, and horsemanship. Several years ago, however, as I prepared to write just such a book during a research leave at the Institute for Advanced Study, I tried to explain it to my colleagues there. What became distressingly clear was that a book on stylistic terminology could not be written without first broaching the subject of style itself. This proved more difficult and fascinating than I had anticipated and somehow led to this book on the competing concepts of style.

At the Institute for Advanced Study, Nicholas Adams, Noberto Gramaccini, Jack Greenstein, Irving Lavin, Marilyn Lavin, and Alessandro Nova were especially helpful as I turned to the substance of style instead of just its accidental properties. Their tolerance in listening to my inchoate thoughts, as well as their comments on my lectures and writing, proved to be of enduring importance. I have been similarly fortunate at the University of Toronto in having a brilliant group of colleagues working on Renaissance and Baroque art and architecture: McAllister Johnson, Matt Kavaler, Michael Koortbojian, Evonne Levy, Alex Nagel, and Alina Payne. Sometimes without knowing it, by challenging me with their own work, and sometimes by patiently commenting on my own, they encouraged me to question my own certainties.

As this book evolved, various scholars generously took time to read

drafts of individual chapters and to comment upon them critically and substantially. In addition to those already named above, I would like to thank Erin Campbell, Joseph Koerner, Lea Mendelsohn, Mary Pardo, Francesco Pelizzi, Giovanna Perini, François Quiviger, Rebekah Smick, and Paul Taylor. My greatest debt, however, is owed to Elizabeth Cropper, Alex Nagel, and Richard Spear. Not only did they generously agree to read the entire typescript in its penultimate version, but they even read a lengthy third section on Baroque Mannerism that will serve as the basis of a later study. Their sensitive and critical readings helped make this a better book. Two important studies were published too recently to be considered, one on the Renaissance artist's intellectual life (Ames-Lewis, 2000), the other on Sebastiano Resta and the early modern culture of collecting (Warwick, 2000). The Social Sciences and Humanities Research Council of Canada consistently funded all of the research.

My wife, Janet Stanton, selflessly gave me the time and emotional support that made this book possible in the first place. And finally this book is dedicated to my son, Matthew, whose intellectual curiosity, linguistic prowess, and subtle understanding of Italian literature continually inspired me as I was writing.

INTRODUCTION

Flaubert likened style to God: both are present everywhere and visible nowhere. As something inevitable, impalpable, pervasive, and vaguely contradictory, style imposed ragged edges on the tidy overview that I had originally planned to write. Friends warned me that everything is style, or at least one step removed from style, a discouraging sentiment that I now tend to believe. After reading many conflicting theories of style from the sixteenth century onward I am convinced of only one thing: that style is a term of convenience with no stable meaning beyond the one that a writer wants to give it for some strategic purpose. Agostino Mascardi became similarly disenchanted after spending "many wakeful nights" during the 1630s reading disparate and competing explanations of style.[1] He opened a chapter "Digressione intorno allo stile" (Digression on style) by recalling the "academic assemblies and private meetings" where the nature of love was debated without resolution. "I met with the same thing in my work on style," he concluded. The debates lacked closure because discoursing about love was like falling in love. We each find our beloved to be uniquely beautiful, and so too our idea of love is uniquely correct. Paolo Pirani, critiquing Mascardi's *Dell'arte historica* a few years after its publication, noted how the complications of style as a concept affected writers. Mascardi wrote a "digression," Pirani concluded, instead of "an exact investigation," because style is "a difficult affair and almost, I will say, unfit for rules and subject to mutations because it varies not only among regions and countries but among individuals . . . but even more clearly it changes with the times."[2]

Few art historians can avoid addressing style in their work and yet there are relatively few studies devoted entirely to style as a concept.[3] Why is this so? According to George Kubler, "style is a word of which the everyday use has deteriorated in our time to the level of banality. It is now a word to avoid, along with déclassé words, words without nuance, words

gray with fatigue."[4] And according to Martin Kemp, "style history has become unfashionable in the history of art," largely discredited by "its earlier incarnations . . . [as] an internalised, jargon-ridden exercise of the most inward-looking kind."[5] Style has indeed become a portmanteau term as big and gassy as "art." Witness, for example, the decision by Penguin Books editors to call their Pelican art series "Style and Civilization," where "style" serves metonymically as "art" in the common phrase "art and civilization." Svetlana Alpers says that in her writing she tries "to avoid its terminology altogether."[6] She casts style into disrepute because it refuses to remain fixed in any given place: "The study of styles and genres seems to me always in danger of extracting, by naming and singling out, the accomplishment of specific modes that seem by virtue of this nomination to have preeminence. But style is what you make it. . . ."[7]

The "danger" of writing about style ran even deeper than Alpers recognized. Let me illustrate this by looking closely at her language as she introduces her ideas:

> To ask an art historian to speak on the subject of style is to expect something straight from the horse's mouth. Even when the topic is not set, colleagues in the other humanistic disciplines assembled (to take a typical academic situation) for a qualifying examination will turn to the art historian as the acknowledged bearer of, definer of, style. "How would you describe the style of the baroque lyric in France," or "Could you comment on the development of the German baroque drama?" The questions are put to the student, but the professor of French or German looks across at the art historian for confirmation. We know the answers, for it is we who set, who validated, the questions. It is at moments like these that I begin to squirm. And, indeed, I have done a certain amount of squirming in preparing this essay. For the normal invocation of style in art history is a depressing affair indeed. One might prefer, as I have tried in my own writing and teaching, to avoid its terminology altogether.[8]

What makes Alpers "squirm"? Here is a partial list in no particular order: the categorizing mentality that wields style to shape history and that believes in stylistic constancy; the creation of periods labeled by a style, particularly the label "Baroque"; the discussion of style and content instead of "description and narration"; the economic forces in the art market that drive our interests in style; the preconditioning of art-historical methods based on the

aesthetic ideals of Italian Renaissance art that are imposed inappropriately on Flemish and Dutch art. These are reasonable doubts, and now twenty years later many more could be added. But Alpers intends to question the validity of style not just through a process of elimination; her approach is more subtle than that. If "style is what you make it," as she declares in her title, and history shows that it can be made into almost anything, then style loses any meaningful place in art history. She tries to nullify its meaning by making it semantically infinite, thereby succeeding in her goal "to avoid its terminology altogether."

Style's prismatic diffusion compromises its utility as a concept, according to Alpers, but this is true only if we seek some stable or universal meaning. What if, instead, its semantic mutability were considered as receptive ground onto which writers could project their personal views? What if a definition of style (even Alpers's anti-definition) were taken as a stalking horse? There are many ways to uncover stalking horses. Mine is philological. I believe that a writer's personal beliefs about pictorial style are carried in the writer's semantics and literary style. Style as a concept reflects the semantic structures of language best known to the writer (this is a premise explored at some length in Chapter 2), but of equal interest for me is how traces of a writer's biases are embedded in the writer's diction and metaphors. Sometimes a writer's style can tell us more than his or her overt declarations. Consider, for example, how Alpers opens her essay by narrating an academic mise-en-scène where "colleagues in humanistic disciplines" constitute a class of people – art historians – all of whom share common interests and abilities. They are style experts who know how to collect individual works or artists and arrange them into fixed and standardized categories like the "Baroque." Her "colleagues" think of art historians in the same way that she claims art historians think of style as monolithic constancies. She does not thematize her vignette in this way but instead allows its subliminal message to introduce her theme. There is, however, an internal contradiction that shows just how stubborn and resistant style is to analysis. In order to reject art histories that discuss style as a collective form or mental set shared by a diverse group of individuals, she must first create a class of art historians who think this way. To make her point, she lapses into the same collectivizing mentality that she opposes. Her presentation of "art historians" and "colleagues in the humanities" are as much hypostases as the "Baroque." Everyone at some time needs to reduce complex individuality into tidy groups, often to help polemicize some issue, and maybe this too makes her squirm.

Alpers's language is pungently metaphoric when she gives art historians

a "horse's mouth." The idiomatic expression "straight from the horse's mouth" is meant to be read as "from the source itself" but instead of using this more neutral phrasing, she chose one that barely conceals her hostility toward certain forms of art history. The dominant figure of speech, however, involves a queasy visceral feeling that she calls squirming. She "squirms" when her colleagues all turn to look at her on a matter of style; and is "squirming in preparing this essay." This suggests two things to me: (1) Style is something that she feels but cannot articulate; it is "a depressing affair" that she tries to "avoid," but what she actually avoids is any further exploration into the emotional discomfort and latent vulnerability that style induces in her. And (2) style is something best captured by metaphoric language. She did not intend this reading but, at least, this is what style is for me. Alpers's literary style reveals more than she declares about her concepts of pictorial style. And if this conclusion can be extrapolated a bit further, how you write or speak shapes and reflects how you see.

Alpers's combative stance toward style may be, for her, a typically aggressive way of writing about art history, but it also characterizes feelings of hostility that style often engendered during the seventeenth century. One literary critic from the time envisioned the style of contemporary painting as a banquet of body parts that "seemed cut by a butcher into tiny pieces and confusedly arranged into a pile."[9] The cutting edge of style, or what might be termed the stiletto of style, was pointedly described by Paolo Sarpi, the Venetian Republic's official historian. Soon after being excommunicated in 1607, he was assaulted by five men with daggers, victim of an ongoing diplomatic war between Venice and Rome. He told the attending physician that he had been attacked *stylo Romanae curiae*, meaning both by the knife and by the pen (or legal procedure) of the Roman Curia.[10] His joke rests on the etymology of *stylos*, but his intent conveys something deeper than wordplay. In my first chapter, "Fighting with Style," I will suggest how style provoked artists and critics into fights.

The dubious status of style can be traced back at least to Aristotle, who called it the most "vulgar" part of rhetoric, "a mere outward show for pleasing the listener" that "beguiles" or "lures" the audience into judging by sense instead of intellect. He embarked on this lowly topic grudgingly in recognition of a corrupt, malleable, pleasure-seeking audience:

> But no treatise has yet been composed on delivery, since the
> matter of style itself only lately came into notice; and rightly
> considered it is thought vulgar. But since the whole business of
> Rhetoric is to influence opinion, we must pay attention to it,
> not as being right, but necessary. . . . [It] is of great importance
> owing to the corruption of the hearer. However, in every system
> of instruction there is some slight necessity to pay attention to
> style; for it does make a difference, for the purpose of making a
> thing clear, to speak in this or that manner; still, the difference is
> not so very great, but all these things are mere outward show for
> pleasing the hearer.[11]

If style panders to the senses of a corrupt audience, the best style should be
one that masks itself and lets the content shine through clearly. Style gives
expression to the content but should not draw attention to itself. Those who
wanted to taint style in general, or at least a style that was displayed "openly
and avowedly," associated it with sophistry and with unscrupulous and for-
eign practitioners.[12] It was directed toward the gullible, most often identified
as women and foreigners. Saint Gregory the Great, writing within this
tradition, identified style with the colors of painting and the rhetorical
"colors" of figural speech:

> For thus Sacred Scripture consists of words (*verbis*) and meanings
> (*sensibus; res*) as a picture consists of colors and objects; and it is a
> foolish person who loses himself in the colors of a picture to the
> extent that he ignores what is being painted. For the same reason,
> if we seize upon the words which are spoken outwardly and
> ignore the meaning, as if ignorant of the things themselves which
> are depicted, we seize the colors alone.[13]

Art critics also categorized viewers' capabilities by class. The "vulgar" appre-
hend art with their senses and hence look only at the surface and fall for the
eye appeal of color, especially bright, rich, local colors; the "learned" prefer
thinking about *invenzione* and *disegno*.[14] For Giovan Pietro Bellori, people
who "admire vulgarities and styles" at the Farnese Gallery are looking at
"the colors and the gold" with their eyes instead of their intellects.[15] The
vulgarity of style assimilates a broader polemic against color, cosmetics, and
fancy dress as deceits of masking and feminine guile.[16] The feminization of
style as a concept will be discussed in Chapters 4 and 8, but for the moment
I will only note that style was tainted by the oppressed class associated with

it (women) and by a coded social discourse that embedded those prejudices in language.

Echoes of the purist Platonizers reverberate throughout the seventeenth century, but they did not monopolize the discourse. Contrary and compromise views coexisted. Consider, for example, the metaphor of style as seasoning. Purists who advocated the supremacy of content presented seasoning as a disguise that blanketed the nutritional value of food (i.e., content). Metaphorists, on the other hand, who enjoyed linguistic and visual ornaments, thought it enhanced the flavor of a text. During the 1680s, the painter and forger Giambattista Volpato asked, "In what way does one apprehend style, and what is this style?"[17] His answer ties style to visuality and expression: "Style is the perfect expression of the work and that which, giving the final apparent being, is first enjoyed by the eyes and then considered by the intellect, and thus . . . it is the final seasoning that satisfies the common sense." That style is a spice for the senses can be traced back to Plato, but Volpato owed more to the contrarian Marco Boschini, who tells us what paintings taste like (spices, spongy bread, marzipan, and pasta), what they sound like (mostly concerts), and what they feel like when he runs his fingers across the surface. He even tells us about their smell, that most provocative sense: "It seems to me, when I leave this Scuola [di San Rocco], that I was in a druggist's shop and had under my nose those aromatic smells which completely comfort the heart. I am left with that fragrance in my mind and it seems to purge the intellect so that my heart leaps with joy in my breast."[18] Titian's finger painting was a "seasoning" that Boschini particularly enjoyed.[19]

What makes these commentators' view of style as seasoning contrarian is its rejection of Plato's famous analogies of rhetoric as cookery and of philosophy as medicine, where Socrates steers his pupil Polus toward the truth of philosophy and away from Gorgias's sophistic rhetoric.[20] Cooking uses "pleasure as a bait to catch folly and deceives it into believing that she is of supreme worth." Gendered as a woman, cooking takes on traditional feminine attributes: it ingratiates, beautifies, flatters, and sways consumers without regard for a food's (i.e., argument's) inherent merits. It pleases without necessarily nourishing. After reading this passage, Pietro Testa concluded that "things lose beauty as they diverge from purity and simplicity, and in this styles of painting condemn themselves; one demonstrates this with the most sensible things, of good food and good wine, which are spoiled by whoever adulterates them with seasoning."[21] Like other sensual snares, style and spices entice people into mistaking lies for the truth, appearance for

reality, form for substance. For Vincenzio Carducho, possibly repeating a sentiment of his teacher Federico Zuccaro, Caravaggio was just such a spoiler because he served "a new food seasoned with such a rich and succulent sauce that it has made gluttons of some painters, who I fear will suffer apoplexy in the true doctrine."[22] Many Seicento art writers subscribed to the purist belief that, as Sforza Pallavicino rendered it, "truth is so beautiful unadorned that every extraneous cosmetic stains it."[23] Many more, and often the same ones, also knew that the bland food of philosophy and science needs the spices of rhetoric in order to evade boredom.[24] Seasoning should improve, not mute or disguise, the natural flavor; it should provide variety in order to avoid satiety.[25]

The heritage of style's vulgarity is still felt today. William Strunk and E. B. White brought up generations of writers with the seemingly stoic advice that "a careful and honest writer does not need to worry about style," although what they really meant by this was a version of Castiglione's *sprezzatura*: "to achieve style, begin by affecting none."[26] Style may be necessary but it should remain invisible. In Anglo-American middle-brow media culture, style is most often treated as a diverting frivolity. A recent lead article in the "Style and Travel" section of the London *Sunday Times* introduces us to Bubbles Rothermere, "the former starlet who loved nightclubbing and champagne . . . the ultimate Party Girl." Bubbles would no doubt have been a devoted reader of the "Women's Section" of the *Washington Post* before it was renamed "Style" in 1981. The "Styles" section of the Sunday *New York Times* featured in one issue articles on "The Smell of Money" (the Business Section gets money; Style gets its smell), on "The Last Stewardess" (not the pilot but the ornamental Singapore Girls), and on "The Presidential Windbreaker." This last article, which trades on the most ancient tradition of style as clothing, looks at recent presidential politics through its outer wrapping. What in the 1970s had been a water-repellent Air Force windbreaker with a discreet presidential seal became with Ronald Reagan a bizarre showpiece. Reagan, an identity-migrating actor/president, was the first to have his name embroidered over the seal: "The seal with the eagle sends a simple fashion message: 'I'm the President.'" Fans of Roland Barthes, myself included, will object to such a simple reading of fashion and the trivialization of style. Semiotics has done much to help style recover from the condescending views that associated it with effete collectors, rhapsodic curators, and gushy word painters of various sorts. Privileges that had

been claimed for the "higher" intellectual pursuits of iconographic meaning or the social contextualization of art as a commodity could now be redirected to style. How this happened, and what the consequences were for the understanding of style, will be explored in Chapter 1.

Style's demeaned status lingers behind the reluctance of art historians to define it as a concept. It persists in a modernist prejudice that unfairly associates style with effete connoisseurs, totalizing Hegelians, and the florid prose of aesthetes. It reveals a disinclination by art historians, either by ideology or by training, to engage philological methods that would seem to abandon paintings either as objects or images. Mannerism, the period style premised on either a celebration or an excess of style, suffered from a similar fate. The 1960s saw a blitz of Mannerist concept studies, possibly in response to the English translation in 1957 of Walter Friedländer's 1925 article where we find the term "Mannerism" added to the German title: "Die Entstehung des antiklassischen Stiles in der italienischen Malerei um 1520" is rendered as *Mannerism and Anti-Mannerism in Italian Painting*.[27] The C.I.H.A. conference of 1961 gave Mannerism equal billing with Renaissance in its "Studies in Western Art" series, with contributions by John Shearman, Wolfgang Lotz, Craig Hugh Smyth, and others. One year later the Accademia dei Lincei published its conference proceedings devoted to the "terms and concepts" of *Manierismo, Barocco, Rococò*. Craig Hugh Smyth's *Mannerism and Maniera* and John Shearman's *Mannerism* were published in 1962 and 1967, respectively. And in 1965 Sydney Freedberg published in the *Art Bulletin* his reading of *maniera* and Mannerism as "having style" and "stylized style."[28] After 1967, just as these studies were being absorbed into literary and musicological studies, the status of Mannerism sagged.[29] In part this can be credited to the undisputed power of Shearman's "stylish style" that quashed competing views and closed further discussion; in part the revolution of 1968 destabilized totalizing period-style studies, especially any based on such a questionable concept as style. Thereafter, but especially in the mid-1980s after Antonio Pinelli published his effective distillation of earlier literature, the best scholarship on Mannerism either denied its existence or made it a subject of historiographic rather than historical importance.[30] Mannerism also lost its dominance over historicized studies of *maniera* where style was defined as a pretext to define Mannerism.[31] Martin Kemp and David Summers in particular have presented new readings of style in sixteenth-century art literature without once resorting to Mannerism. Style and Mannerism have been so marginalized that Bernard Aikema recently dismissed their study as

"a sterile exercise amongst scholars in which the same sources are reiterated to support positions ever more irreconcilable."[32]

There is, however, another way of considering the reluctance to address the concept of style. Perhaps art historians are too busy practicing stylistic analyses to define their terms. This sounds like an accusation of philosophical laziness, but what I want to suggest is that style is less important as a concept than as a heuristic that enables us to perform certain analytic functions.[33] Connoisseurs attribute and date paintings; they divide and group paintings into schools (Florentine, Jesuit, *caravaggisti,* etc.) and periods (Gothic, Mannerism, Baroque, etc.) The empiricist Carl Friedrich von Rumohr, who rejected the Romantics' conflation of style and ideology and took instead an autopsy approach that paid particular attention to technique, defined style as "a habitual compliance with the requirements of the materials."[34] Formalists detached style from content and from the artist's character in order to enhance it as "a certain mode of representation" and as a "method of composition."[35] They postulated an internal "life of forms" (Henri Focillon) or a "collective psychology" (Heinrich Wölfflin) that tend to distance style from explicit individual realities. Iconographers assumed that meaning is carried primarily by the content and assigned to style the subservient role as a corrective lens that enabled them to choose between possible textual meanings.[36] Biographers used style as an unmediated sign of character though sometimes reconstructing it in a flattened and overdetermined way.

In each of these practices style is a visible form that expresses something invisible. It is a sign of something greater than itself. What I want to show with this episodic and starkly reductive account is merely how wonderfully flexible style is and how adaptive it is to the contingent needs of art historians. Style cannot be defined as one thing or another because it is what we want it to be. We remake style to reflect our needs and our vision of art. It is a tool of subjectivity, judgment, and taste as much for artists as for art historians.

"Failure to recognize what style is persists, I believe, into current theory."[37] This recent statement by Richard Wollheim is certainly true and remains true despite his own worthy efforts to remedy the situation. The perception of failure, and perhaps even the reason why historians and theorists have failed "to recognize what style is," rests partly with style's chameleonic nature. But partly the sense of failure arises

from posing a misleading question. To ask "what style is" presupposes that style "is" something other than a heuristic prism.[38] Is style really a concept? If this doubt seems reasonable, then we might best look at style through its performative aspects. "What is a style?" is a better question than "What is style?"[39] To answer this question requires a review of art history itself, which is beyond my ability and endurance, but if such a review were written, it would become clear that the practice of stylistic analysis by historians working on sixteenth- and seventeenth-century art is much more sophisticated and pluralistic than historical studies of style theories.

To ask what style is turns out to be the wrong question as much in seicento Italy as today, as it presupposes a stable, delimited concept when style then too was more like a fragmented, paradoxical set of competing ideas. My initial reaction to this insight about style's semantic instability was one of disappointment and frustration. I tried to anchor its meaning by examining definitions, assuming that definitions sought stability, consistency, and clarity, only to discover that early modern writers like Mascardi had experienced similar difficulties. As it turned out, there were only four definitions written between 1550 and 1700, by Giorgio Vasari, Nicolas Poussin, Marco Boschini, and Filippo Baldinucci. Their rarity made them seem precious, and so I decided to probe and unravel their semantic constructions with particular care. These definitions helped me appreciate the resistance of style to definition and made me realize that an essential feature of style is its tendency to evaporate under scrutiny. In the conclusion to this book, I study this lability through the vocabularies that early modern critics developed to describe ephemeral, ineluctable forms, or what I call "indeterminate styles."

But why were there so few definitions? It is not as if style were a negligible element in sixteenth- and seventeenth-century art criticism. The word for style that dominated art writing was *maniera*: it was used over thirteen hundred times by Vasari in the Giunta edition, overwhelming the alternative terms *stile* (15), *gusto* (16), and *carattere* (8).[40] *Maniera* pervades the literature as if it were conventionally understood as a measure of quality; as a quality of artistic character and technique; as a characteristic form; and as a means to classify works, artists, schools, and periods. It was the preferred term when painters spoke.[41] The virtual monopoly that *maniera* enjoyed in mid-sixteenth century Florence eroded only slightly over the following decades and even centuries. Poussin tried to depose it in favor of the literary term for style (*stile*) but met with a generally apathetic response; Agostino Mascardi tried out *carattere* only to reject it as an inadequate synonym for style; and Carlo Cesare Malvasia wavered between *maniera, gusto, modo,* and

carattere as he drafted the *Felsina pittrice*, but ended up favoring *maniera*.[42] To gauge just how popular *maniera* was, compare its frequency of usage in Vasari's *Vite* (1,304 times) to his use of such canonical terms as *disegno* (c. 800), *giudizio* (403), *invenzione* (389), *imitazione* (242), and *fantasia* (102).[43] If any word deserved definition, it would seem to have been *maniera*.

If style was given vital social and economic functions in seventeenth-century Italy, and if *maniera* was a particularly favored term in most critics' lexicons, then why should there be such a gap between definition and usage? One reason might be that early modern writers on art inherited Aristotle's and Seneca's low opinion of style as vulgar, sensual, beguiling, and effeminate. But, even if some writers held on to the presumption of style's vulgarity, this alone cannot explain why style was so central to art criticism and yet so rarely defined. Other aspects of painting, such as invention, design, coloring, imagination, *historia*, and chiaroscuro, were readily, and in some cases repeatedly, defined, so it was not a reluctance to commit denotation. More likely, the absence of definitions was a kind of avoidance strategy arising from problems inherent within the unwieldy and elusive concept itself.

Simply put, style resisted definition as much then as it does now. Petrarch, who introduced style as "air" and "shadow," identified it as a form of shoptalk among painters who spoke of it as something that wavers between similarity and dissimilarity.[44] Like insubstantial air and shadow, he thought that writers' styles escape rational, verbal discourse; they are something "elusive" that cannot be "extricated except in silent meditation" and that can be only "felt rather than expressed." Whereas Petrarch was writing about his difficulties in recognizing and describing particular literary styles, Agostino Mascardi was the first writer (that I know of) to draw a related conclusion about the concept itself: "If anyone were to ask me what style is, I would have to say frankly that I don't know."[45] A century later we find an anonymous French art critic stuck at the same point: "Style cannot be defined in the different arts; it is a feeling that an artist has, a predilection for something, more or less, that is impossible to explain without being inside the artist's head."[46]

When Poussin and Baldinucci defined style, they tried to compensate for its indeterminacy by programatizing style. Poussin tried to order and stabilize it by means of rhetorical *genere* and musical modes. Baldinucci submitted it to a systematic philology where style is presented as a relational semantic within a lexical field. Boschini, on the other hand, embraced its disorienting and distorting effects. However, when the literary structures of all four definitions are probed in terms of semantics and intertexuality, other

clues emerge about style's intractability. In Chapters 4 to 7, I will try to show how the definition strategies are marked by paradox, etymological avoidance, and semantic inversion. A numinous sense of dislocation permeates their definitions. Readers (or, at least, this particular reader) expected consistency, clarity, and closure, and found instead that these expectations had indeed been solicited only to be subverted.

Recently a friend of mine, having listened patiently about defining style by deferral and avoidance, asked what style meant to me personally. I answered without hesitation or equivocation: style is your personal identity. This concept reaches back to antiquity and was later given robust expression in artist biographies; and yet, because definitions of style preferred to locate style in aesthetics, technique, rhetoric, and a formalist language, the psychological dimension of style makes only brief appearances in this book: as self-expression (Chapter 1) and as an innate talent (Chapter 2). "As are men's lives, so is their speech."[47] Seneca the Younger, whose version of this Greek proverb I quote, was a keen observer of the ethical and psychological dimensions of style. Like his father, he thought that style was a mirror of a writer's moral character. Besides what Seneca tells us about style and speech being gendered (men talk; women are silent), he solidified a tradition that saw style as personal and self-revealing. Petrarch cited Seneca in likening imitation and style to family resemblance whereby writers "stamp" themselves onto their models so that "in seeing the son's face, we are reminded of the father's."[48] They explained influence and originality by analogy to bloodlines. As the son resembles his father and imposes himself over him, so too is style both one's personal and one's inherited identity. While following Seneca's letter closely, Petrarch added an interesting observation derived from the shoptalk of painters: "While often very different in their individual features, they have a certain shadow our painters call an 'air' (aerem), especially noticeable about the face and eyes, that produces a resemblance; seeing the son's face, we are reminded of the father's." *Aria* in early modern art literature generally signified a characteristic facial expression, but gradually it migrated into the realm of psychological projection, that is, how works resemble their makers and how artists are manifest in their works. *Aria* became, like style, a flexible portmanteau term whereby facial expression could signifiy various kinds of similarity: how figures by a painter look like siblings; how an outer form reveals an inner essence; how a painter as father projects his face onto his progeny. By the fifteenth century, painting as

a self-reflective art had become proverbial: "every painter paints himself."[49] By the sixteenth century, *aria* had become synonymous with *maniera* and *stile*, and remained so into the seventeenth century.[50]

In art-historical parlance, style and the artist are so deeply imbricated that not only does an artist's style stand as a sign of the artist, but inversely the artist can be a metonymy for his or her style. Even linguistically sophisticated historians confuse the creator of a style with the style itself. Take, for example, this passage by Leonard Barkan, a gifted writer and profound scholar of language: "When Vasari describes Raphael as an artist who created himself out of particles from Perugino, Leonardo, Fra Bartolomeo, and Michelangelo, he is rhetorically inventing an artist who is himself a work of art."[51] What Vasari actually wrote, and it is quoted by Barkan in the notes, was this: "He added various methods chosen from the finest works of other painters to form from many different styles a single manner which he made entirely his own."[52] The notion of the artist as a work of art may be embedded in Vasari's *Vite*, but the bald exchange of artist and style, where Raphael "created himself" instead of creating a personal style, expresses Barkan's sense of contiguity.

This autobiographical concept of style carries with it many dubious assumptions – that one's soul or character is natural and not constructed; that it is manifested in some kind of unmediated fashion – but beyond these essential qualifications there remains a grain of truth. Rupert Murdoch once told an interviewer that in business negotiations he pays more attention to gesture, body language, vocal timbre, and changes in enunciation than to what is actually being said. Whether or not this is a theoretically defensible position, it certainly proved to be deeply enriching. Style for me includes this nonverbal dimension that communicates sensually and emotionally without the signification of words or texts or literary meanings. Roland Barthes, Richard Wollheim, and other modern theorists locate style in the body: a physical habit, a visceral feeling or, from a related medical perspective, a residual sense of self.[53] Oliver Sacks believes that " 'style,' neurologically, is the deepest part of one's being, and may be preserved, almost to the last, in a dementia."[54] Seicento critics somatized Mannerism as senility, physiognomy, and physiology. Styles are subcutaneous matters.

If I were to write another book on style, I would probably model it on an unconventional and completely refreshing biography by Richard Spear, *The "Divine" Guido. Religion, Sex, Money and Art in the World of Guido Reni*.[55] This is not a book on style, but by giving us such a vivid portrait of Reni as a vain, suspicious, insecure, misogynist, obsessive, and phobic man,

it opens before us a new window onto Reni's art and style. Reni had a complex array of psychological needs and behavioral solutions, and his art was at once a product of those needs and a coping strategy for life's problems. Spear does not reduce Reni to a tidy cipher – the melancholic loner, the courtly manipulator, the temperamental creator – but allows him a jagged, conflicted character that can be all of these things, at once shy and boastful, craving adulation yet averse to hearing it. If this were simply biography, it would have little practical relevance to a study on style, but Spear shows how Reni's psychological complexity enables us to experience a similar equivocation and contradiction in his art. Before reading *The "Divine" Guido*, I had looked at Reni's *Atalanta and Hippomenes* (Madrid, Prado; Figure 1), the painting chosen for the dust jacket, merely as an example of Reni's stony ideal of classicism, or possibly as an example of his aversion to engage the erotica of Ovid. I would not have noticed so readily how the lovely Atalanta is being cold-shouldered by a virginal Hippomenes, shoving her off the page, over the spine, and onto the back cover. However, after reading it, this frigid erotic encounter suddenly became fraught with complication. Once having learned about Reni's fear of physicality – his high level of hygiene, his virginity, his misogyny, and his embarrassment at obscenities and dirty jokes – it was impossible for me to see *Atalanta and Hippomenes* in the same way. Suddenly Reni started popping up everywhere in his work in unexpected guises – here as Hippomenes, there as the unseen viewer of suicidal Cleopatras – never as a psychological automaton but instead as an elusive presence speaking within the conventions of Baroque culture.

If style carries a psychological intimacy revealing the unspoken secrets of the self (even if those secrets are coded in a particular historical idiom), and if style carries the body's history, then inspecting someone's style is voyeuristic if not intrusive. This may contribute to style's squirm factor. Style is a form of intimacy. It tells us what codes a person has selected to signal political and social allegiance – that is, it tells us how they want us to look at them. And then there is the subversion of the code by the body and psyche. Past experiences, all of our triumphs and humiliations, are somatized and leak out in everyday life. We carry our histories in our bodies – our tone of voice, carriage, and so on – and display them everyday to observant viewers. Social conventions of dressing, talking, and behaving can help us fashion certain public personae but cannot completely suppress our histories.[56] They express the tension between private and public selves, the congruity or incongruity of how we want to appear and how we "really" are. It is both bred in the bone and at home, a biological imperative and a

learned coping strategy. Style is thus unsettling, not just because of its intimacy, where "one reads the heart from the face" as Petrarch put it, but because it presents us with an uncertain interpretive ground. When we look at style do we peer deep into the character and soul, or are we looking only at a constructed public persona contrived, like clothing, to project a certain image? Have we attained an intimate knowledge or are we being manipulated? Is style self-revealing or self-fashioning? The answer is, obviously, yes to both questions. It is, to use Roland Barthes's phrase, "a personal mythology." We choose our style to persuade others to see us in a self-flattering way. Our public style masks our secret motives, and our inner self will always seep through the cracks of our public edifice.

Style as intimacy draws on a venerable history shared by style and love. Both have a wandering quality (*vaghezza*) or make the heart roam (*vagare*); both are ineffable and beyond description (*non so che*); both are located in the characteristic expression (*aria*) of a person; both attract most powerfully when the style or beloved resembles ourselves; or, in other words, they are to some degree narcissistic. The pairing of style and love is not my invention. Agostino Mascardi opens the "Digression on Style" by commenting on the penchant to discuss style in relation to Plato's theory of love that "visible beauty" (style) enraptures souls and makes them love "invisible beauty" (truth).[57] Love is blind and so is style. Both lie just beyond conscious will and rational explanation, "felt rather than expressed," as Petrarch put it. Through style, the artist's mind unthinkingly expresses itself; it is a lifelong characteristic so persistent that it survives changes of subject, medium, intention, and place. Style is what you don't want to know about yourself. Michelangelo thought his art was completely natural. Vasari, who worshipped Michelangelo like a god, barely mentions style in this longest of "Vite," and style is entirely absent from his own "Vita." If style reveals an overall unconscious manner of self-presentation, then it tells us what lies just beyond the artist's self-knowledge. Being peripheral, it is central. It tells us what the artist cannot disclose.

If "every painter paints himself," so too might it be said that every art historian defines style in his or her own self-image of art and history. Style invites solipsism. John Shearman tells his readers on the cover of *Mannerism*, even before he defines the stylish style, about his passion for sailing and Henry James. I do not mention this to explain his theory – a discussion of Georg Weise's seminal studies would do that better – but only to hint that

life and style are sometimes connected, however tangentially, even for art historians. This is my solipsism: I am a writer not a painter and have analyzed style through the language of other writers leading me to define style as language. To call style language, however, only defers explanation. What language? I have resisted imposing modern meanings on earlier art criticism, but reading literary theories, particularly those on indeterminacy by Hans Jauss and Wolfgang Iser, has led me to see certain issues as nascent during this period. My comments on definition strategies that undermine themselves (Chapters 3–7), on style as deviation (Chapter 6), and on indeterminate styles (Chapters 6 and 8) show signs of their influence. Modern (or postmodern) theorists of style tend to maintain a strategic silence about the past or, when mentioned, premodern writers are simplified and flattened out. The quirky corners are unknown, or, if they do not fit preconceived ideas, they are avoided. Antecedents may resemble their historically distant progeny only dimly, but a kernel of resemblance remains. Here is a final solipsism: I am a writer whose personal habits of equivocation and contingency predispose me to untether style from any firm anchors and fixed place.

STYLE AND LANGUAGE

FIGHTING WITH STYLE

Today it is fashionable for painters to do nothing but squabble among themselves about manner, taste, and style, and this arose because the reasoning is not established according to solid principles. Maximus of Tyre said that in his day one painter never contradicted another on the matter of style because each walked unwaveringly along the same path of knowledge, hardened by true and good discipline. Today each painter introduces precepts according to his own inclination, a precept of one painter is negated by that of another, and this is most certain – that it is not well-founded.[1]

In the prefatory "Osservazione" to his *Vite de' pittori, scultori ed architetti che hanno lavorato in Roma, morti dal 1641 fino al 1673*, Giovanni Battista Passeri described the mid-seventeenth century as a querulous age obsessed with style. Why did style provoke such disagreement in the seventeenth century? What were people arguing about? What were the modes of argumentation? Style had an edge, often serrated, that was used to separate insiders and outsiders, good and bad. Prejudice was voiced with style. Readers attuned to the ambiguities of language will find in this chapter's deliberately ambivalent title a set of overlapping meanings. "Fighting with style" can mean that critics were fighting about style, its meanings and practices; that the mode of fighting was stylish with parries of a gilded sword; that critics fight about an artist's character, a nation's identity, or some other matter with style as their weapon; and finally, that today some art historians fight with style as their opponent (fighting *against* style) as, for example, David Summers does by identifying it with the multifarious "idealist-historicist-relativist tenets of modern art history."[2] Art historians who want to discredit style often seem to adopt a combative tone. That style could signal all of these things at once might be a source of discomfort for some readers who want semantic meanings to be clear and unequivocal – the

"squirm factor" that I mentioned in the Introduction – but for me it is style's very ambiguity that makes it important and appealing. In style I see the clouded uncertainties of human personality and the acculturated codes of behavior.

Living in an age of subjectivity and relativism when each painter introduces precepts "according to his own inclination," Passeri asserted a "most certain" argument that trumps all others by appealing nostalgically to the certainties of a simpler age ("simpler" only from a viewpoint of retrospective reductionism). Maximus of Tyre serves as Passeri's authority. In his age, according to Passeri, "a painter never contradicted another on the matter of style" because painters shared a canon of knowledge and art. Actually Maximus never made any such statement. To the contrary, his *Orations* resembled seicento relativists more than Passeri would have us believe. "Human beings are terribly contentious," he tells us, citing as evidence the representations of gods and heroes: "There is no one set of rules governing images, nor one set form, nor one single skill or material for their making."[3] Even Homer's poetry "is not beautiful for all people on all occasions."

The nostalgic reconstruction of antiquity as a time of stylistic certainty, and the need to anchor the insecurities and ambiguities of modern times in a more secure past, also structure Angelo Decembrio's account of an artistic contest between Pisanello and Gentile Bellini. Lionello d'Este had instructed the two painters to portray him with complete accuracy and objectivity, evidently assuming that his face could serve as an authoritative standard against which art could be judged.[4] He was surprised to find, however, that each painter captured his appearance exactly and yet each differed in recognizable ways: "You remember how Pisanello and Bellini, the finest painters of our time, recently differed in various ways in the portrayal of my face. The one added a more emphatic spareness to its handsomeness, while the other represented it as paler, though no more slender; and scarcely were they reconciled by my entreaties." Decembrio, in reporting these results, concluded that this illustrated an essential difference between ancient and modern art: in antiquity artists worked toward a common end, "whereas nowadays, as we know, they are consumed by rivalry with one another."

Passeri rued the fights over style that surrounded him without, however, refraining from combat himself. He reported Duquesnoy's prescient hieratic distinction between "Greek style" and "Latin style" and sanctioned the invention of the "Greek style" as a coherent, stable standard by which to evaluate other, lesser styles: "[Duquesnoy] wished to show himself a

rigorous imitator of the Greek style, which he called the true mistress of perfect procedure in art because it held within itself at one and the same time grandeur, nobility, majesty, and loveliness, all qualities difficult to unite together in a single compound, and this feeling was increased in him by the observations of Poussin, who desired altogether to vilify the Latin style. . . ."[5] Charles Dempsey has given us a fascinating account of this crucial turn in the history of naming and defining classicism,[6] but for the moment I just want to illustrate how Passeri positioned himself above the fray by appealing to a kind of supra-style that transcends individual style. By polemicizing style as a mire of individual expression where artists fashionably feuded, he was actually participating in the squabble that he deplored. He did so by attacking a central tenet of art criticism: that all style is individual and that belief in a stable ideal is a chimera. If only, he seemed to be saying in the prefatory "Osservazione," art could be governed by "discipline" and "principles," then it would become objective, absolute, and presumably impervious to the raging geniuses who only want to paint in their own way. One senses why Passeri was so popular as a lecturer at the Accademia di San Luca. There was also a wider audience and context for his remarks. Ten years later Francesco Fulvio Frugoni, a bellwether critic and author of *Del cane di Diogene* (Venice, 1687–89), described the triumph of style and fashion (*moda*) as a form of extermination of truth and beauty – "it sterilizes every place it is spread" – and envisioned "a kind of warfare, always conducted by means of stratagems and tricks."[7]

One of the fighters was Pietro Testa, a fellow student of Passeri in Domenichino's studio during the 1620s. Like Passeri, he lamented the "corruption" of art as *manieracce* born from a loss of reason and good principles.[8] Elizabeth Cropper has shown how much emotional investment Testa made in the subject and how he responded to this perceived decline with anger: "What unleashed his tongue and drove him to the game of writing was anger, often very heated anger, provoked by the bad teaching he saw everywhere around him. . . . If Testa was angered by such works because they denied the universality of ideal painting, he was also driven to despair by their success."[9] With good cause, Cropper describes Testa's tone as one of sarcasm, mockery, and bitterness, driven as much by antisocial tendencies and social alienation as by theoretical issues.[10] Before Passeri and Testa studied with Domenichino, Giovanni Battista Agucchi had also talked with Domenichino. He polemicized the fragmentation of style into styles most famously as an "infection" and as "artistic heresies":

Then there came about the decline in painting from the peak it had gained. If it did not again fall into the dark shadows of the early barbarians, it was rendered at least in an altered and corrupt manner and mistook the true path and, in fact, almost lost a knowledge of what was good. New and diverse styles came into being, styles far from the real and the lifelike, based more on appearance than on substance. The artists were satisfied to feed the eyes of the people with the loveliness of colors and rich vestments. Using things taken from here and there, painting forms that were gross in outline, rarely well joined together, and straying into other notable errors, they wandered, in short, far from the good path that leads one toward perfection. While the profession of painting was infected, so to speak, in this way with so many artistic heresies it was in real danger of going astray.[11]

Agucchi attributed the problem of "artistic heresies" to Mannerism, when the stylistic canons of antiquity and the Renaissance disintegrated, and held out hope for renewal with the Carracci, but what is important here is how he used style to pathologize painting. Styles are reprehensible because they deviate from "the true path" and "perfection." Art should have style, not styles: "It does not, therefore, follow that there must be as many styles of painting as there were painters, but that one style alone may be deemed that which was followed by many who, in their imitation of the true, the lifelike, or simply the natural, or the most beautiful in nature, follow the same path and have the same intention. . . ."[12] The "one style" that stands "alone" as the standard for all others is that of ancient sculpture (which he takes as a unity instead of many competing styles). His absolutist stance, like that of Passeri's Maximus, subjected art to a test of purity that he construed as being outside of time – or at least as having withstood the test of time.

ꙮ STYLE AS SYMBOLIC FORM

Theodor Adorno argues that normative or "obligatory styles" are a sign of and reflex by a closed and repressive society.[13] When critics insist on the authoritative validity of their particular stylistic norm, they are exercising ethical and political judgments motivated by a need to control social structures and to make individuals conform. Agucchi expressed a doctrinaire certainty with such terms as "heresies" and the "true path." Whether or not his mantle of authority befits his various ecclesiastical offices as secretary to the papal nuncio in Paris, archbishop of Ravenna, and

secretary to Gregory XV, I shall leave to the readers' prejudices. Lorenzo Pasinelli, in upholding antiquity, Raphael and the new Raphaels as absolute and eternal standards, adopted Agucchi's metaphor of heresy to indicate departures from orthodoxy.[14] Some purists like Francesco Milizia so idealized the norm that all style was deemed "defective" for being personal: "the style of a great artist, however beautiful it may be, is always defective because it is never the same as beauty in nature; it always manifests the effects of the artist's personality."[15] What made style defective was that it departed from his constructed ideal of antiquity. Diderot arrived at a similar conclusion in looking at style from the constructed ideal of nature: art should have "no style at all, either in drawing or color, if nature is to be scrupulously imitated."[16] And, writing earlier as a connoisseur, Baldinucci decided that style deviated (and must deviate) from antiquity and nature (see Chapter 7).

Fighting suggests that styles are embedded in ethics, politics, and psychology, and that style could be symbolically invested with extra-artistic values. Passeri, Testa, and Agucchi wrote in response to optimistic modernists whose position was popularized by Secondo Lancellotti in *L'oggidì overo il mondo non peggiore né più calamitoso del passato* (1623) and *L'oggidì overo gl'ingegni non inferiori a' passati* (1636). They took style (that is "good style") to represent ancient certainties. In this section I propose to introduce ways in which style participated in the politics and sociology of gender, and how it could represent national character and power, or an artist's identity and sense of self-worth. If style did not embody these higher philosophical, political, or personal values, it would not be worth fighting over. To fight also requires polarized positions that are intolerant of differences and ambiguity: Boschini's relentless polemic against Vasari demonized the enemy (Florence) and foresook any equivocal or contradictory evidence that might have suggested Vasari found merit in Venetian art.

Stoics and seicento neo-Stoics probed the ethics and psychology of style in ways that made style into a symbolic form of great diagnostic power.[17] The mode of argumentation adopted by Agucchi and Passeri that used style as evidence of social and moral corruption was essentially Stoical, as were most seventeenth- and eighteenth-century criticisms of Mannerist art.[18] Seneca the Younger was particularly influential in associating stylistic excesses with the feminine, artificial, ornamental, and degenerate: "Wherever you find a corrupt style of speech in favor, you may be sure that morals too have deviated from the right path. Luxury in feasting and clothes are signs of an ailing society; so, too, licentious speech . . . shows the degeneracy of the minds from which it proceeds."[19] Seneca the Elder took grooming

habits and other activities marginal to politics and morality and invested them with grave importance. Decadent morality among orators was represented by means of beauty, effeminacy, and other gendered superficialities: "waving the hair, thinning the tone of the voice till it is as caressing as a woman's, competing in bodily softness with women, beautifying themselves with indecent cosmetics."[20] Seneca the Younger found Cicero's speech to be "degenerate" and "deployed too effeminately," as were Maecenas's strange dress and gait.[21] Emasculation "sometimes happens to a man, sometimes to an age." Attention to style, any style other than his own "pure" and "clear" one, indicates a superficial mind "absorbed in petty things" rather than one focused on the subject.[22] His injunction "Seek what to write rather than how to write it" expressed the hope that style would disappear just as Seneca tried to make it seem to disappear in his own writing. Cicero, on the other hand, thought that the Stoics had no feeling for style, which was not true even if it was the impression they wanted to project.[23]

As personal identity, style meant fighting for self-preservation or self-advancement; as national identity, it meant fighting for cultural supremacy. Concepts of national styles are a by-product of collectivist myths and national stereotyping that served political agendas for military, economic, or cultural supremacy. As in politics, regionalism in style meant factionalism and reductive mentalities that were inclined to simplify the complexity of individuals and societies. From the Lombard perspective of Agucchi, Scannelli, Malvasia, and Gherardi, the "Lombard" style of painting was natural and pure whereas the "Roman" and "Tuscan" styles were artificial.[24] From the Roman perspective of Passeri: "Opinions are allotted to sects, and the various schools try to authenticate their opinions. . . . The Accademia of Tuscany wants to uphold its uniqueness in having true and unique mastery of perfect design and condemns the Lombard school as innocent of this good foundation."[25] He cited Michelangelo's dismissal of Titian's *Danaë* and Venetian painting in general – as related by Vasari: "It is a shame that in Venice they never learned to design well from the beginning. . . ."[26] – as a particularly egregious example of contentious parochialism.

How style was politicized can be seen in the case of Venetian colorism. Like the sober senatorial toga, colorism was both the sign and the product of a stable, free republic: "In conclusion, the Venetian pictorial style carries with it the same liberty that everyone enjoys who lives in this city."[27] When

the Venetian critic and art dealer Marco Boschini drew this conclusion in 1660, he contributed to a pseudo-Longinian revival, popularized in the multieditioned *Ragguagli di Parnaso* (Venice, 1612) by Traiano Boccalini, which joined two famous concepts: that an orator's or a poet's eloquence depended on political freedom, and that Venice's mythical liberty produced political stability and economic prosperity.[28] Boschini seems to have been the first to transpose Boccalini's discourse to Venetian art criticism. One strategy to maintain your cultural supremacy was to argue for the inferiority of others. Vasari's charges against Venetian painting of simple naturalism and visual illiteracy (where literacy is construed as knowledge of antiquity) is a well-known example. Art critics and historians responded patriotically in a cultural war initiated by Vasari and reinvigorated in 1647 by a new edition of his *Vite de' pittori, scultori ed architetti*.[29] In defending Venetian painting, Boschini used physically repellent terms ("a stinking vase") and militaristic imagery ("birds bombing with turtles"), as if the Tuscan Vasari were a foreign invader.

This pan-Italian battle underlies the bloodier fights that were endemic between painters, or between painters and critics, about the reputations of individual artists. Painters fought with words, damning with stylistic monickers – such as the gothic Borromini, mannered Bernini, dessicated Raphael, and sloppy Tintoretto – and battled with pictures, as, for example, in the case of Titian's *Monkey Laocoön* (Figure 5). Style could also critique style. Annibale Carracci was famous for his pictorial, nonverbal retorts, as his *Laocoön* sketch showed. At another time, having just seen a painting by Caravaggio, he asked:

> Is there anything so marvelous here? Did it seem to you that this was something new? I tell you that all those fellows with the never-seen-before style that they themselves invented will always have the same reception when they appear and will have no less praise. I know another way to make a big splash, in fact to beat and humiliate that fellow; I would like to counterpose to that bright color one that is totally soft. Does he use a slanting, sharply delimited light? I would like it open and direct. Does he cover up the difficult parts of art in nighttime shadows? I, by the bright light of noon, would like to reveal the most learned and erudite of my studies.[30]

Art criticism dramatized disagreements over style in terms of fights. Annibale plans "to beat and humiliate that fellow." (The words are Malvasia's, but the sentiment could easily have been Annibale's.) He saw style as a means for

revenge: "When Agostino comes [to Parma] . . . let us apply ourselves to learn this beautiful style [of Correggio's], as this will be our trade in order to be able one day to mortify this beret-wearing rabble that attacks us as if we were assassins. . . ."[31]

Style even led to violence, real, imagined, and threatened. Domenico Calvaert subjected his students Guido Reni and Domenichino to physical and verbal abuse for painting in the Carracci style; this style made him "rant" and "rave."[32] Caravaggio threatened to carve a frieze on Reni's forehead if he did not stop stealing his style.[33] Caravaggio had cause for anger. Cesare d'Arpino had arranged, out of spite, for Reni to paint a *Crucifixion of St. Peter* that had been intended for Caravaggio, promising Scipione Borghese that Reni would transform himself into Caravaggio and paint it in his "dark and driven style." The *Crucifixion of St. Peter* (Vatican, Pinacoteca; Figure 2) has been seen as an artistic homage to Caravaggio, as a clever market strategy of Reni, as a case of a weaker artist coming into the orbit of a stronger one. Caravaggio saw it, more than an artistic theft, as a theft of personal identity whereby Reni would "transform himself into Caravaggio" in order to paint in his style. He reacted with characteristic violence, because he valued his self-fashioned identity as art rebel and singular paragon of nature. Reni threatened his unrivaled status and "never-seen-before style," but for the threat to be effective he had to believe, like so many others, that style was power. Caravaggio's interpersonal style was confrontational and bullying; Reni, who was "anxiety-prone, mistrustful, and even paranoid," quickly backed down, assuring Caravaggio, according to Malvasia, that he did not want "to compete with anyone, knowing and admitting that he was inferior to all."[34] For a man with a deep-seated inferiority complex, this must have been a difficult statement to make.

Whether a sign of feudal fealty to the master or a theft of identity, style was worth fighting about or fleeing from in shame. What else, other than the psychologizing of style, made it so vital to the lives of artists that they would feud over it? Style had a market value that represented considerable sums of money. With time, styles proliferated, as did the need to differentiate among them, and collections became ever more diverse. Paintings without attributions, and judging from inventories many were unattributed, need style experts to facilitate their sale. Who painted what became an important question, especially as the old masters started to fetch high prices. To be a collector or dealer, and both were growing groups during the seventeenth century, required a knowledge of style in order to protect investments and reputations. Old masters were a finite resource subject to an increasing

demand. This motivated the production of fakes along with an attendant expertise to identify fakes. Also, as the stock of old masters became depleted, a demand grew for lesser masters, which in turn demanded wider connoisseurial experience to sort them out. Paintings were appraised for sale based on their size, condition, and subject, but by the seventeenth century the variant that determined value more than any other was authorship. Investment of capital in art required and encouraged a growth in reliable experts to attribute or authenticate.[35]

As the art market grew and diversified, connoisseurs and critics developed an ancillary need to refine and expand the language used to describe different styles. (This subject will be taken up in the final section of this chapter.) And, from the artist's point of view, the market value of style heightened competition, as the story of Caravaggio and Guido Reni shows. To earn a reputation as an artist, it was not enough to be a reliable supplier and good courtier; one had to be original, possessor of a recognizable style that no one else could produce. After Vasari's *Vite* were published, artists might also factor style into considerations about their posthumous reputations. Because Vasari ennobled artists through biography and used style as a sign of their identities, his *Vite* must have seeded hopes (and doubts) about the adequacy of their style. Did it represent them well? Did it contribute to the progress of art?

✐ FIGHTING WORDS

"The pen is an evil weapon, the point of which sometimes, though it does not pass through the viscera, transfixes the reputation, more dear than life itself."[36] Malvasia opens an omnibus life of early-sixteenth-century Bolognese painters by cautioning his readers against Vasari's animus toward Bagnacavallo, Amico Aspertini, and others who (according to Vasari) "have their heads filled with pride and smoke." Vincenzo Vittoria turned Malvasia's *sententia* against its author, as Charles Dempsey has adroitly remarked, by hoisting him by his own petard because he had dared to criticize Raphael.[37] Critics and artists fought styles by name calling or pinning an unsavory sobriquet onto an artist. It was a successful attack strategy because it reduced the complexity of an artist's style to a single memorable defect. One flaw, even if it is a flaw conceived in prejudice, stands as synecdoche, crowding out more nuanced, contradictory, or historicized insights into the artist's work. It tamps down a complex of conflicting

artistic values and hence serves as a shorthand for critics. Terms like *diligente* and *ammanierato* became sites for intense logomachies.

Statuino was another fighting word, a battle standard in the good fight against bad taste.[38]

> These new masters in their schools and in their books instruct us that Raphael is dry and hard, that his style is stony (*statuina*), a term introduced in our time. They affirm that he did not have frenzy or spirited daring and that his work was improved by his followers. Others offered different opinions, more noxious and reckless than one can imagine, still less pronounced by one who discourses with reason and intellect. Whence the poet Boschini, speaking in the person of a portraitist, reached a definitive conclusion. When questioned on how he liked Raphael, he responds by twisting his head and singing in his distorted language: "He nods his head ceremoniously and said: Raphael (to tell you the truth, if I may speak freely and honestly) does not please me at all." Carlo Maratta, however, was wont to reprove with agitation this vulgar opinion of our century that one does not have to follow Raphael to have a dry and stony style, responding that rather their brains are made of stones and rocks [i.e., they are "blockheads": *di macigno*].[39]

Giovan Pietro Bellori is quite exceptionally personal about Boschini. He mocked his "distorted language," referring both to his Marinist style of writing and to his use of Venetian dialect, and even mocked his body language, giving Boschini an undignified cranial twisting. In other words, he attacked Boschini's character (if style is identity) and his nationality. Boschini's dubious artistic taste is somatized in an undignified body language ("twisting his head") and form of speech. Art critics did not normally "sing" and, if this unusual form of speech refers to more than dialect poetry, it might even be considered as illicit. In criminal argot, to say that someone "sings" implies he is a thief.[40] I cannot say whether Bellori used "singing" to imply that Boschini had stolen Raphael's honor, but at least this figure of speech might have heightened the negative tone of Bellori's report.

Never before or after was Bellori quite this rude in naming and condemning a fellow critic. He once wrote that Giovanni Baglione's *Vite de' pittori, scultori ed architetti* "was written wretchedly," criticizing the writer's achievement through his literary style just as he did with Boschini, but this comment was discreetly marginalized in his personal copy of the *Vite*.[41] Public discourse was usually cloaked in greater civility, at least when living

writers were concerned. Sometimes accusations of bias and lying were lev-
eled, usually at Vasari. Boschini called him a festering bouquet of flowers, a
mangy dog, and "the stinging nettle in the garden of painting," all bilious
epithets that Boschini deserved more than Vasari.[42] Boschini was unusually
impolite with Vasari, but when he named living writers he was much more
restrained. Typically in seventeenth-century criticism, when strong distaste
was voiced, names were rarely named if the author was still alive.[43] Vincenzo
Vittoria was just as rude as Bellori about Malvasia's *Felsina pittrice*, but he
decided that a decent interval should lapse after Malvasia died before publish-
ing his opinions. He wrote his polemic in 1679 and published it in 1703,
ten years after Malvasia's death.[44]

What provoked Bellori into breaking this code of honor was an attack
on his hero Raphael, the first such attack in print in a major art publication.
Raphael had slipped from favor in certain circles, starting most famously
with Annibale Carracci's writing to his cousin Ludovico, but the criticism
remained behind closed doors, voiced in letters to family or within the
studio: "And that beautiful old man, St. Jerome, has he not more grandeur
and also more tenderness than has the St. Paul of Raphael, which at first
seemed a miracle to me and now seems a completely wooden thing, hard
and sharp?"[45] When Malvasia published Annibale's letter about Raphael's
Ecstasy of St. Cecilia (Bologna, Pinacoteca Nazionale; Figure 3), it was con-
sidered inflammatory, although he more than Annibale received the blame,
and it persists as an irritant to some modern scholars who have tried (unsuc-
cessfully) to suppress its importance by accusing Malvasia of falsifying docu-
ments.[46] In order to help himself articulate what he liked about Correggio's
Madonna and Child with Saints Catherine and Jerome (Parma, Galleria Nazion-
ale; Figure 4), and as we have noted he felt some frustration putting his
thoughts into words, Annibale used Raphael to illustrate what Correggio
had contributed to art. His language has its roots in rhetoric, but it also
resonates as shoptalk in its use of "wooden," a term that Leonardo had used
repeatedly in his technical or studio notes. I call it "shoptalk" not just because
Annibale's letter to Ludovico was a substitute for conversation in the studio
(although it is that too) nor because Leonardo discussed it as technical advice
to other painters, but because the term "wooden" transfers qualities of an
artist's material to the qualities of its styles. The transfer is illegitimate,
according to Leonardo, because it makes figures appear stiff, dry, sharp,
knotty, muscular, and devoid of grace.[47] It illegitimately transfers to painting
qualities inherent to sculpture.

Raphael emerges as wooden through a calculated exercise of historical

hindsight and revisionism. Annibale looked at Raphael through the corrective lens of Correggio, and from this perspective Raphael came to look more like the "hard and affected" Michelangelo, whose critical fortunes were starting to wane at this time and plummeted thereafter.[48] Annibale's language applied to Raphael and Correggio the most venerable of stylistic polarities – soft (*tenero*) and hard (*cosa di legno, duro,* and *tagliente*) – and in so doing problematized the history of art. Wooden, hard, and cutting circumscribe a single style that was thought to be immobile, too emphatically contoured with sharp lighting and unblended colors.[49] Hard styles were often mentioned in conjunction with their opposite: soft, melting colors; *sfumato* light; blurred contours. Boschini thought the soft–hard polarity originated with Aristotle,[50] but most art critics would have been more familiar with it from ancient rhetoric in general. Dionysius of Halicarnassus likened Lysias' orations to archaic paintings with their simple, unblended colors and clear outlines, in contrast to Isaeus's orations, which he thought were like more modern paintings, with nuanced color and an interplay of chiaroscuro: "In order to clarify further the difference between the two men, I shall use a simile from the visual arts. There are some old paintings which are worked in simple colours without any subtle blending of tints but clear in their outlines, and thereby possessing great charm; whereas the later paintings are less well-drawn but contain greater detail and a subtle interplay of light and shade, and are effective because of the many nuances of colour which they contain."[51] Cicero and Quintilian used similar parallels.[52]

Rhetoricians and art critics agreed that both oratory and art evolved from an archaic hard style to a modern soft style. They agreed about this historical trajectory, but they invested the forms with different values. Dionysius, Cicero, and Quintilian intended to praise the older forms as more enduring, less indulgent toward verbal trickery, and more powerful in effect. In contrast, art critics deemed hard styles to be not only outdated but also artistically inferior to the modern soft style. Hard styles were construed as historically distant or, in a further twist, geographically distant, foreign and hence unsophisticated.[53] German and quattrocento painting bore the brunt of these charges. They are dry bones, "as much skeletons as figures being dry and without spirit."

Annibale Carracci must have assumed that Ludovico would bring these common associations to his letter and would recall, in particular, Vasari's preface to part 3 of the *Vite*: "Their figures [i.e., those by quattrocento artists] appeared crude and excoriated, offensive to the eye and harsh in style. ... This artist [Correggio] painted hair, for example, in an altogether new

way, for whereas in the works of previous artists it was depicted in a labored, hard, and dry manner, in his it appears soft and downy. . . ." Annibale refashioned Vasari's history by demoting Raphael from his exalted status to the rank of an outdated quattrocento artist. Raphael becomes Perugino. What Annibale did was reverse the order of history devised by Vasari, where Raphael was Perugino at first but then became Raphael.[54] Boschini also made Raphael retrogressive by transforming him into the Bellini of Rome, and hence into a quattrocento master in Vasarian terms:

> And thus to respond to Vasari who praises Raphael to the skies, I say that Giovanni Bellini's brush was more learned. . . . First there was Giovanni Bellini who rendered each figure in a purified style of good forms and who was certainly one of the most talented artists of those times. Also, even Raphael took on a style of great diligence and learning! . . . In all this one sees painting stupefied by its meticulous diligence. . . . And that was the good road for a certain time, highly esteemed for being the first Style. Later on came an immortal spirit who was our Giorgione.[55]

Boschini used the code of "diligence," often identified as a cause for hard styles, to mark Raphael as a quattrocento painter.

When Annibale used "wooden, hard, and sharp" and "tender" styles to reconfigure the history of style, he initiated a reassessment of Raphael that had a profound impact on artistic taste and practice. As time passed, Annibale's view of the wooden Raphael became widely accepted. Francesco Albani heard "even from painters" that Raphael's style was "hard and cutting," as if this opinion were more common among the public.[56] Salvator Rosa reported that Raphael was not popular among Neapolitan painters because they found his work to be "stony and dry," and he heard similar reservations expressed from a Bolognese perspective by Simone Cantarini.[57] Carlo Maratta and Bellori blamed "new masters" with "fantastical opinions" about a stony Raphael. Malvasia's tag for Raphael – Boccalaio Urbinate (Jugmaker of Urbino) – appeared in only a few copies of the *Felsina pittrice*, but that was enough to help launch Vincenzo Vittoria, writing under the influence of Carlo Maratta, in a booklet diatribe on the subject.[58] When Giovanni Pietro Zanotti decided to defend Malvasia two years later, he dismissed the sobriquet Boccalaio Urbinate as "a slip of the pen," meaning (I assume) a slip in judgment, and quoted Malvasia as saying, "I don't know how such temerity and insolence could have come from my pen."[59] This confession, written suspiciously in the style of Zanotti himself, supplements

the definitive proof of its absence in the original manuscript, which Zanotti then owned. Zanotti failed to note another derisive nickname that Malvasia accepted for publication: Seccarello l'Urbinate (The dry man from Urbino).[60]

The respect accorded to hard styles by Cicero, Quintilian, and Dionysius of Halicarnassus rested on a bedrock of values: appeal of the intellect over the senses; ancestor worship; respect for those who first created a style. Hard styles in art criticism also referenced antiquity, but in a more deeply conflicted way. Ancient sculpture represented the canon for modern artists, and yet everyone also seemed to know that studying, copying, and contemplating statues transformed the softness of living flesh into hard stone.[61] These unwanted side effects were acknowledged even by dedicated boosters of antiquity. Vasari thought that Battista Franco spent too much time imitating statues instead of nature and that as a result his work was "hard and cutting," as one sees, he tells us, in *Tarquin and Lucretia*.[62] These dangers, however, paled in comparison to the benefits, at least in Vasari's mind. The discovery of the Laocoön, the Apollo Belvedere, and other Hellenistic works in the early sixteenth century "caused the disappearance of the dry, hard, harsh style that art had acquired through the excessive study of Piero della Francesca, Lazzaro Vasari, Alesso Baldovinetti, Andrea del Castagno. . . ."[63] When Titian mocked idolaters of the *Laocoön* with his *Monkey Laocoön* (Figure 5), or when Malvasia launched into a philippic about pointless trips to Rome to study statues and recast Vasari's story of Brunelleschi's Roman trip into an opera buffa, they struck at the core of Renaissance art and the academic literature and instruction that accepted ancient sculpture as the undeniable repository of knowledge. In a polemical canard penned in the margins of his copy of Vasari's *Vite*, Annibale called Vasari "ignorant" because "he did not notice that the good ancient masters took things from life, and he wants to believe instead that it would be better to copy secondary things that are ancient rather than things that are alive."[64] In Malvasia's view, the stony style is further evidence that the "Roman style" is artificial and studied, whereas his fellow Bolognese paint naturally and purely, just as they should.[65]

Statuino thus illustrated the dangers of good intentions. Previously, stony styles had referred to hard materials alone: Leonardo's and Annibale Carracci's "wooden" (*legnoso*); Passeri's "stony" (*di pietra*). Clearly related to these is Ludovico Dolce's critique of quattrocento painters and Michelangelo as stony (*di porfireo*), a critique that archaicized Michelangelo precisely on those grounds that he had staked out for himself.[66] In some ways *statuino* is a more effective epithet because it combines the formal qualities of stoniness

with the cultural referencing of the antique, and hence represents a considerable advance for those wanting to attack anticophiles. *Statuino* combines the good intentions of imitating ancient art with the undesired consequence of an art that mirrors the hardness of its models. If in Annibale's construction nature is primary and alive, then antiquity, being secondary, is probably dead – "things that are ancient instead of things that are alive." This does not represent the full extent of his ideas on antiquity, only an overactive response to provocations he found in reading Vasari. Boschini, probably after conversations with Malvasia, also used the Carracci to suggest that ancient statues are dead things, hardened by rigor mortis. Boschini has Agostino Carracci give this advice to his brother Annibale, who was nervous about not yet having visited Rome to study its antiquities: "Fear nothing . . . and come to Rome and do not doubt that, although there are statues in abundance there, really they neither move nor know how to speak."[67]

The "stony" ideal as seen by a sixteenth-century practitioner is found in *The Academy of Baccio Bandinelli in Rome* (Figure 6) where the Academy members hold and draw various statuettes. The Carracci, who opened their academy to natural light and life studies, could have seen Bandinelli's Academy as an ideal in extremis: introverted, denatured, windowless, lit artificially, and surrounded only by artificial objects. Candlelight serves as a heuristic for the study of chiaroscuro and shadow projection, but visually the cast shadows are sharp and cutting; in other words, they represent iconically Raphael's *statuino* style.

Statues thus both introduced the canon and invited its transgression. This duality of coexisting virtue and vice can also be found in the acculturated values assigned to "hard" forms. Hard styles resulted not only from imitating statues but from a too slavish imitation of one model in general.[68] More than Raphael's reputation rested on the charge of stoniness. All of the new Raphaels – Poussin, Domenichino, Reni, and so on – could be condemned by association.[69] In France, some thought that Poussin's passion for antiquity had led him to neglect nature and to transform flesh into stone, so that it "resembled painted stone having more the hardness of marble than the delicacy of flesh."[70] Poussin might have welcomed de Piles's description of his painting as "severe" because severity was a code for ancient simplicity and grandeur within the rhetorical literature that we know he was reading.[71] On the other hand, "severe" could also mean "rigid," according to the Crusca *Vocabolario*, a quality associated by Cicero and Quintilian with archaic statues.[72]

So far I have presented only the antagonisms and social disfunctions of fights over style. There were, however, benefits of such style obsession, in particular a growing sophistication among critics in their perception and description of style. Many years ago I started a lexicon of Italian stylistic terminology, tracking about two hundred adjectives commonly used to modify "style" (*maniera, stile, forma, modo, carattere, gusto*) across two centuries, starting with Vasari's *Vite* of 1550. I filed over two thousand examples, enough to be useful for simple statistical analyses but not enough to constitute completion. A glance at the list of terms in the Appendix will give some idea why I finally agreed with Francis Sparshott that "an anatomy of style terminology would be an endlessly intricate and tiresome affair."[73] Although the results remain provisional, one conclusion can be drawn about megatrends in usage. We know that Vasari's *Vite* defined art history for centuries to come in terms of biographical approach, ekphrastic technique, stylistic periodization, and so forth, but less well known is how the imprint of his language defined a lexical canon that dominated at least two centuries of art writing. Over one-half of the two hundred terms were used by him, although not always with the meanings and values accorded them by later critics. For the half century after the first edition of the *Vite*, the language of style criticism remained more or less stable, but in the seventeenth century stylistic terminology nearly doubled. In contrast to this semantic inventiveness, the eighteenth century (up to 1770) contributed only four new stylistic terms, all critical of the baroque style. According to Lorenzo Valla, "a new subject requires a new vocabulary,"[74] but it is not clear what, in this case, the need was. One might want to argue that artists and art consumers valued individuality and originality more in the seventeenth than in the eighteenth century, when a more conformist, academic mentality set in. As pictorial styles proliferated, so too did the language that described them. I tend to believe that the growing vocabulary can be better explained by linguistic developments during the seicento, particularly a love of neologisms, metaphoric speech, and other forms of catachresis that gave critics greater latitude in their choice of words and emboldened them by competitive example to invent new ways of describing style. If Passeri's view about an obsession with style is correct, then artists and critics would naturally seek to write about it both more precisely and more evocatively. With an expanded metaphoric language available to them, and a willingness to use it,

they had both the will and the ability to expand the linguistic horizons of criticism.

Interest in style also brought with it a greater visual acuity, at least if we can accept verbal descriptions as an indicator of how people looked at paintings. Consider, for example, how Carlo Cesare Malvasia found four different styles – those of Raphael, Correggio, Titian, and Annibale Carracci, each attached to a different figure – in a single fresco by Guido Reni:

> The painting represented, with a certain charm which did not detract from its gravity, St. Benedict coming out of a cave high up in a mountain, and receiving gifts offered him by the rustic inhabitants, who varied in sex, age, coloring, size, attitude, and dress. These included a lovely Raphaelesque girl clothed in veiling, holding a basket of eggs. Behind her is seen the hand and smiling face of an older woman painted in the style of Correggio. Both of them look out at the spectators with such vivacity and spirit that they seem to breathe. A shepherd painted in the style of Titian is playing a flute with hands that seem of living flesh. . . . There is also a woman painted in the manner of Annibale, with a nursing child at her breast. . . . Leaving aside many other figures, the most prominent of all is a great form, completely nude, who pulls a balky donkey with such awesome and vigorous force that the outlines might have been drawn by Michelangelo. It was also softer and more covered with lifelike flesh than the figures of the Lombard School.[75]

Although we know Reni's fresco at San Michele al Bosco only through painted and engraved copies (Figure 7), each imposing its own interpretation of Reni's style onto the original, it is still possible to see in the drapery, figural type, and pose that Malvasia's perception of stylistic quotations is justified, and that Reni, like other seventeenth-century artists, varied his figural style for just this kind of referencing.[76] Cinquecento ekphrases tended to be prosopopoeic.[77] Writers assumed a transparency of representation, so that describing what you saw through a picture frame was much the same as describing a scene through a window frame. Editorial comments about artifice such as a beautiful foreshortening were sometimes appended or unobtrusively inserted into the description itself, but they tended not to rupture the illusion as insistently as Malvasia did when he repeatedly referred us to the styles of other painters. More than most previous writers (with Boschini as a possible exception), Malvasia mediated between a painting's

illusionistic representation and the artistic devices employed by the artist to make the representation. In the case of this particular description, Reni's figures are transformed from actors in a drama to signifiers of style.

Elizabeth Cropper and Charles Dempsey have written that, if "the great discovery of the Renaissance was style, that of the seventeenth century was the critical investigation and manipulation of style."[78] They had artists in mind, but writers developed a similar stylistic self-consciousness, none more than Malvasia. Mimesis in its conventional sense was still praised, but increasingly style became recognized as the object of imitation. Style references style. In describing Annibale Carracci's *Assumption* (Bologna, Pinacoteca Nazionale), Malvasia postpones any mention of expressive poses or lighting effects until after he raises questions of Annibale's technique, intentionality, and sources: ". . . it was made *alla prima* so that it resembled a sketch more than a finished painting, at any rate it is very well preserved. In this painting Annibale had looked at Tintoretto, and further in the more learned and magnificent drapery folds he sought out Veronese."[79] The painted surface and the formal vocabulary of drapery folds are adduced as evidence of Annibale's artistic intentions. Familiarity may dull our appreciation for Malvasia's accomplishment, as it resembles in simplified form what art historians still do today. He invites the viewer to watch Annibale as he looks (*mira*) at Tintoretto and Veronese. We see a sketchy technique that in its freshness and its guileless lack of finish reminds us of the physical act of production. *Alla prima* was used by Malvasia and his contemporaries as evidence of the artist's intentions, spontaneously revealed to the discerning eye.[80] It is a private act whose sole intended audience is the artist. Annibale left this exposed, a common enough act in itself, but exposed in a particular form that enabled Malvasia to see Tintoretto.

Lomazzo's ideal painting of *Adam and Eve*, where Adam is drawn by Michelangelo and colored by Titian, and Eve is drawn by Raphael and colored by Correggio, gave Malvasia his interpretive template for the *St. Benedict Receiving Gifts*.[81] The correspondence between the *Adam and Eve* and *St. Benedict Receiving Gifts* is close but not exact: Lomazzo has two figures painted in four styles, and Malvasia has four figures in four styles; the Lombard Correggio colors Raphael in Lomazzo instead of a Lombard coloring of a Michelangelo figure in Malvasia's reading. Seicento art theorists gave Lomazzo's *Adam and Eve* mixed reviews. Giambattista Volpato accepted it as a fulfillment of Tintoretto's motto, hung on his studio wall, that admonished him to use "the drawing of Michelangelo and the coloring of Titian."[82] Domenichino and Francesco Scannelli, on the other hand, questioned its

practicality, because, they thought, no single artist can paint in four different ways and because these particular styles are incompatible.[83] Michelangelo would draw Adam with excessive artifice, stony surfaces, and bold contours, but then Titian would cover up the artifice with naturalism. Hard outlines would be softened and lost to Titian's style. Scannelli rejected the *Adam and Eve* for reasons similar to why Bernini rejected the venerable story of Zeuxis and the Crotonian women: the different styles (body parts) taken from different artists (women) would make the painting (figure) appear fragmented and hence would violate the cardinal rule of unity.[84] Malvasia, however, was not bothered by the "monstrous" combination of styles, viewing it instead as evidence of Reni's mastery over style.

Lomazzo's *Adam and Eve* can be most clearly situated within the debates on imitation that predicate a canon and the ability of artists to manipulate it. How the Carracci replaced Lomazzo's ideal with a new conception of imitation has been clearly established by Charles Dempsey.[85] My point here, however, is that Malvasia transplanted the dominant theoretical model to explain ideal imitation from the realm of nature to style. Instead of having Zeuxis combine the beautiful parts of nature, Malvasia has Reni gather together the most beautiful styles. Instead of having his readers look at a representation of nature, Malvasia has them look at style.

An oft-told story about Annibale Carracci's early years in Rome shows another way that style usurped the traditional roles of nature in art criticism. In its early version by Giulio Mancini, we learn how Annibale tricked local connoisseurs by switching a painting by Sebastiano del Piombo with one of his own, much as Annibale had been tricked by Passerotti with fake Michelangelo paintings.[86] The story at this point in its life was brief and intended to show Annibale's versatility. In the later accretion by Malvasia we are told something about Annibale's motivations: how, when Annibale Carracci arrived in Rome, local artists treated him as their inferior. The theme of revenge through deception marks it as an early version of the Van Meegeren gambit. Malvasia's source was Boschini, whose elaborate narrative he quoted at length. In Boschini's invention, Annibale and Cardinal Odoardo Farnese conspired to shame the Roman painters with a variation on the illusionist scam where viewers mistake painting for reality, whether it is Zeuxis trying to lift Parrhasius's painted curtain, or Cimabue trying to brush away a painted fly, or Titian climbing a ladder to see whether Peruzzi's stucco decoration at the Palazzo Ghisi (complete with painted dust) was real or not, or Annibale Carracci trying to pick up a book in Bassano's studio only to find it to be painted paper.[87] Cardinal Farnese pretended to be waiting for a shipment of

old-master paintings and made certain that the sniping group of painters and dilettantes heard about his mounting excitement. On the side, he had Annibale produce some bait, which was then packed up and delivered. He assembled the dilettantes and painters in his palace and had Annibale wait unobserved in the wings:

> The crate was brought there in front of them, and everyone waited with curiosity. As it was unnailed and untied, everyone watched and waited with an expression of curiosity. . . . Finally the pictures emerged like rays of resplendent sunlight. The dilettantes and more learned were stunned and took these works as exquisite. One person said, "This is by Parmigianino"; another said, "This is certainly by Correggio"; and another said with certainty: "It is perhaps even better than Correggio. This has definitely surpassed him." Everyone was stunned and spellbound, but His Eminence was laughing inside. . . . In short, when each of those painters had convinced themselves, the Cardinal said: "This time he who has spoken badly has spoken well," and everyone blushed. His Eminence then said: "Hurry, Carracci, come here so that you can see how your inventions have brought you glory. You have conquered Parmigianino and Correggio," and having said this, he turned around and raised a curtain covering the doorway.[88]

Before Malvasia quoted Boschini's story, he prepared the reader for its moral that the punishment fit the crime: the Roman painters had mocked Annibale for wanting to be "the ape of Titian, Correggio and Veronese," and Annibale showed them how completely he had fulfilled that aspiration. Malvasia's idiomatic phrase "the ape of . . ." (*la scimia di*) deliberately recalls its normal usage − naturalists as apes of nature − and hence the analogous (perhaps even higher) deception perpetrated by Annibale by mimicking style. His success rests on the fact that he could imitate old-master styles better than the Roman painters could discern them. A related story with the same moral is told by Giulio Mancini. Annibale painted a Flagellation in the style of Sebastiano del Piombo, framed it in an old frame, and presented it to Odoardo Farnese. Odoardo rhapsodized that no one could paint this way today, and Annibale enjoyed his humiliation in revealing the truth.[89]

As a story of deception, Boschini's version adopted a narrative structure and staging similar to Pliny's story of Zeuxis and Parrhasius (9.310–311):

Parrhasius entered into a competition with Zeuxis, who produced a picture of grapes so successfully represented that birds flew up to the stage buildings; whereupon Parrhasius himself produced such a realistic picture of a curtain that Zeuxis, proud of the verdict of the birds, requested that the curtain should now be drawn and the picture displayed; and when he realized his mistake, with a modesty that did him honor he yielded up the prize, saying that whereas he had deceived birds, Parrhasius had deceived him, an artist.

Zeuxis, like the Roman painters, suffered from pride and was subsequently humiliated. In both stories, a painting serves as bait that whets the viewer's curiosity and the subsequent deception renders judgment about the artist's merit. In both stories, a painting is covered (or appears to be covered) and then is discovered by an expectant audience. In Pliny's story, a curtain "veils" the supposed painting; in Boschini's story, the real artist is revealed from behind a curtain.[90] The important difference between the stories is that Parrhasius's painting signified nature and Annibale's signified style. Zeuxis looked at the painting and found nature; the Roman painters looked at the painting and found the styles of Parmigianino and Correggio.

These deception stories illustrate how artists were believed to be in complete control of their styles to the extent that they could transform their style into someone else's. Seicento painters like Luca Giordano, Pietro della Vecchia, and Paolo De Matteis built their reputations, in part, on their chameleonic ability to paint in many different styles. Sometimes the intention was to deceive for personal gain at crucial stages in an artist's career, often to gain a foothold in the art market, as when Pietro Liberi returned to Venice and introduced himself as Guido Reni or when Annibale Carracci pranked the Roman artists.

Mimicry implies choice. "Do you want to be Giorgione or Tintoretto or Veronese, or do you want to be yourself?"[91] With this question Pietro da Cortona hoped to steer his student Ciro Ferri back to himself, pulling him away from a strengthening consensus in the mid-seventeenth century that style can be learned and you learn it by becoming an old master. You cloak yourself in someone else's style and conceal who you really are. Annibale and Ludovico Carracci enacted Cortona's advice in their academy, as is testified by the diversity of styles emerging from it, but they might also have responded to Cortona's question by noting its false premise: that one must either be oneself or someone else. For the Carracci, one way of being oneself

was by freely choosing different styles: "They did not want to be tied to a single style nor restrained to the imitation of a single artist . . . compulsorily dragging our taste behind someone else's genius."[92]

Artists who cloaked themselves in the styles of others met with varying degrees of success. For every Giordano who was thought to absent himself from his works, there was a Paolo de Matteis who tried and failed: "Giordano does not live in those works by Luca, but in those by Paolo [where he tries to be Raphael, Titian, and Correggio] one always recognizes Matteis."[93] Bernardo de' Dominici easily recognized Matteis in "Correggio," as can we, but did he really think that Giordano's "Correggio" was so indistinguishable from the original? How much could an artist really escape the strictures of personal style and paint entirely in another artist's style?

Consider, for example, a story told by Carlo Ridolfi about one of Tintoretto's many marketing ploys. When Tintoretto heard that Veronese had received the commission for the high altar in the Chiesa dei Crociferi, he convinced the patrons that he could paint it himself, presumably at a lower price, in the style of Veronese.[94] Whether or not Tintoretto succeeded in his intention, and the historical record shows that no one actually believed that it was painted by Veronese,[95] the *Assumption of the Virgin* (now in Venice, Chiesa dei Gesuiti; Figure 8) is nonetheless an honest effort at emulation. Still, however much the cloud patterns and color harmonies might resemble Veronese, Tintoretto's personal style still intrudes. What does this mean? Because we find his highlit folds on the Virgin's clothing and his characteristic physiognomy imposed on her face, does this signify an unconscious lapse into his own style, proving the inevitability of personal style, or did he actually want some of his style to intrude so that the real author of this accomplished emulation could be identified? If you are inclined to side with the first possibility, then you probably prefer to think of style as innate and too deeply ingrained to escape. On the other hand, the second possibility will appeal to readers who believe that style is a controllable reference system. The first favors an epistemology of style as talent (*ingenium*), the second of style as an art (*ars*). The interdependence of these two will be considered in the next chapter (section on "Bipolar semantics").

Success in a project like Tintoretto's depends on a viewer who is either gullible or cunning, again depending on which of the two goals is accepted. Instead of trying to determine the artist's intention, it might be worth asking what responses viewers could have had (or were narrated as having) when looking at paintings that mimic styles. If Tintoretto intended to remain

entirely invisible within his Veronesian style, then the appropriate response would be one of deception. Many such stories are told – like the one involving Annibale Carracci and Odoardo Farnese – but they all involve enough literary artifice to call into question their authenticity as historical documents. Boschini, for example, intertextually implants Pliny into his Carracci-Farnese story. Raffaelle Soprani narrated another deception by style and revelation that resembles Boschini's. When Giulio Cesare Procaccini was told that Ottavio Semini's *Rape of the Sabines* (Genoa, Palazzo Doria) was not by Raphael, "he was mute with shock, and with a gesture of astonishment, almost not believing his own eyes, he continued his walk without saying anything."[96] Looking at the painting today, anyone would easily agree with Carlo Ratti's editorial remarks: "It is not credible that Procaccini took this work as Raphael's, but perhaps he made this claim in order to praise our Ottavio."[97] It is even possible that Soprani, by instilling his story with histrionics and hyperbole, wanted us to doubt its credibility. On the other hand, inventories of art collections reveal serial misattributions that show just how gullible or hopeful collectors could really be.

The second reading of Tintoretto's story – the one that accepts an intentional residue of Tintoretto lingering in "Veronese" – sees the *Assumption of the Virgin* not as a failed emulation but as a cunning rhetoric. Malvasia looking at Reni's *St. Benedict Receiving Gifts* provided an alternative viewing model to the experience of the duped Roman painters. By complimenting Reni's talent for stylistic emulation, Malvasia simultaneously demonstrated his own powers of observation and showed himself to be Reni's equal as an expert on styles. He often pointed out how Ludovico Carracci worked simultaneously in two styles; a Saint Jerome in the *Madonna degli Scalzi* (Bologna, Pinacoteca Nazionale) fulfilled Lomazzo's ideal by seeming to be "drawn by a Michelangelo and colored by a Correggio."[98] For visual references of this kind to be viable as a mode of artistic expression, parallel competencies are required: an artist who can paint in different styles and a learned viewer who can decode the styles. The seventeenth century saw both of these conditions fulfilled as a symbiotic relationship developed between painters and audience, one based on a knowledge of art history and an agreed-upon canon. The ideal viewer should, in some way, be like these mimic painters and become a "compendium of every singular style" or a "great connoisseur of styles."[99] As these epithets of Della Vecchia and Tiepolo suggest, knowledge of style was normally considered the domain of artists. The seventeenth century saw the rise of a new class of connoisseurs –

for example, Giulio Mancini, Filippo Baldinucci, Paolo del Sera, and Sebastiano Resta – who were not trained as painters. The poet Alessandro Allegri (1560–1629), who was not such a connoisseur, nonetheless knew that "modern painters" stopped signing their work in the corner because viewers could recognize them simply from the style.[100]

The Language of Style

Literary structuralists have taught us how to think of language counterintuitively. A rhapsodic epistler tries to describe a holiday alpine scene to a friend but instead sends a coded message that relies as much on their common linguistic world as on any unmediated impression about the Alps. Language refers first to language and only secondly to its ostensible subject. When this insight is applied to style, or more properly to the concept of style, it becomes clear why we cannot write about style without first considering its literary boundaries and preconditions. Because style is explained with language, it absorbs with that explanation characteristics that are peculiarly linguistic. Because style is explained in texts, and because "every text is the absorption and transformation of other texts," it is also bound to reflect the structures of those discourses.[1] Art critics, theorists, and historians observe paintings visually, but what they see and how they explain it are constrained by conceptual and linguistic structures that they have acquired through years of reading.

When I say that the language of style looks at itself as much as the paintings it describes, I do not mean to suggest that this is the proper way to understand style or that the critics were blind to what they were seeing. It just happens that the logocentricities of style are my subject of study. Pictorial style as practiced by painters is primarily a visual and expressive phenomenon; or, as one seventeenth-century painter put it: "Your style will be the perfect expression of the work, and it gives the final visible existence and first gives pleasure to the eye and then is judged by the intellect."[2] Giovanni Battista Volpato, a seicento imitator and forger of Jacopo Bassano, here identified three separate but sequential stages: the painter makes style that expresses; the eye enjoys style; the intellect judges it. Volpato did not use "expression" in its usual senses as "an expression of emotion . . . in the faces, movements and gestures of the figures" or as "a demonstration [and] decla-

ration."[3] Although by "usual," I do not wish to suggest that "expression" was an oft-used term before the mid-seventeenth century; Vasari used it only once, Armenini never. Volpato, however, used it often as a means to designate an emotion or mood achieved by a formal, visual vocabulary of color, light, brushwork, and line, such as the "**Z**-curves" of Tintoretto's drapery, or the curving lines ending with acute angles, or the slanting light that fragments form and elongates shadows.[4] In other words, style is an extralinguistic and non-narrative form of address. In the staged sequence of style, language is given a place only at the end, when the intellect judges.

Unfortunately language can capture style only by distorting the initial experiences of making, seeing, and feeling. Despite an ironic mismatch of tools and goals, textual analysis still seems to be a reasonable, if inherently limited, means to reconstruct the period eye. Michael Baxandall's *Giotto and the Orators* introduced many Renaissance specialists to the verbal dimension of visual perception and how "highly formalized verbal behaviour bears, with little interference, on the most sensitive kind of visual experience."[5] He also warned against the limitations of this approach:

> Any language, not only humanist Latin, is a conspiracy against experience in the sense of being a collective attempt to simplify and arrange experience into manageable parcels. The language has a limited number of categories, grouping phenomena in its own way, and a very limited number of conventions for setting these categories in relation to each other. So as to communicate with other people we keep more or less to the rules; we contract to call this section of the spectrum *orange* and that other section *yellow*, and to use these categories only in certain acceptable relationships, such as nominal and adjectival, to others. In our normal speech we struggle to compromise between the complexity and variety of experience on the one hand, and the relatively limited, regular, and simple system of language on the other.[6]

In *Patterns of Intention* Baxandall pushed his argument about the exigencies of language even further: "In fact, language is not very well equipped to offer a notation of a particular picture. It is a generalizing tool. Again, the repertory of concepts it offers for describing a plane surface bearing an array of subtly differentiated and ordered shapes and colours is rather crude and remote."[7]

Historians of seventeenth-century art have since given evidence that suggests this dire view should be moderated. Elizabeth Cropper has been

particularly effective by showing how literary style shaped pictorial style – both its perception and its practice – and how literary style served as a synecdoche for the beauty of women, the beauty of painting, ethical behavior, and the complexity of character.[8] Her argument that visual perception is socially constructed in language helps correct the views held by such art historians as E. H. Gombrich and David Summers who "attempt to ground all naturalistic representation in natural perception"; it also serves as a powerful model (at least for me) of how to escape from such assumptions by attending more closely to our linguistic heritage.[9] I would like to mention one other seicento specialist, at the risk of offending many more who have contributed so much to the field.[10] A glance at the Bibliography under Giovanna Perini's name will show the expanse of her work in this field; a further glance at my Notes will show how important it has been for my own. In particular, she has shown how art writers molded their literary style to match the pictorial style they described or admired. Giovan Pietro Bellori's ekphrastic style, for example, tends to be *statuino*, thereby matching the *statuino*, pictorial styles of his heroes Raphael and Poussin.[11]

How seventeenth-century writers understood the contingencies of style and language, and how they fashioned the concept of style along linguistic models, is explored here in four sections, more miscellaneous than comprehensive. "A Plain Translator" considers Bellori's self-presentation as a literary illusionist who creates transparent word paintings. "Whose Language?" inquires into the different visual and verbal competencies of painters and humanists, and how they saw this impinging on the translation of visual forms into words. If "A Plain Translator" examines hopes and aspirations, then "Whose Language?" admits the constraints. "Bipolar Semantics" surveys linguistic epistemologies that helped to shape seventeenth- and twentieth-century theories of style. "Metaphor and Metonymy" takes an aptly pithy and allusive look at how concepts of style and vocabularies of stylistic description were modeled on translative figures of speech.

✍ "A PLAIN TRANSLATOR"

Seventeenth-century writers on art worried about the inadequacies of language much less often than do modern linguists, but those who did tended to frame the question around aporia, a rhetorical topos of speechlessness. For example, in 1660 Bellori silenced himself at the end of a lecture to the Accademia di San Luca because, "just as sight is more

effective than words, I therefore have nothing to say and remain silent."[12] Several years later Giovanni Battista Passeri extended the conceit of silence to include aporia and used it as the subject for his lectures to the Accademia, including one called "Il Silenzio." He proposed silence as the best response to good paintings because the confusion and astonishment that they evoke cannot be conveyed in words.[13] Standing at the lectern, he even feigned aporia in order to show his audience what the appropriate response would look like. Words even failed the prolix Boschini – or at least that is what he wanted his readers to believe. Imagining himself on a pulpit rather than at a lectern, he responded to paintings by Gerolamo Forabosco "like that preacher who, climbing up to his pulpit, remains frozen like a green parrot. . . . The more I say the more confounded I become, and always more embroiled."[14]

Art books often included prefatory remarks about the author's personal inadequacies – a tradition spawned by Vitruvius and developed by Ghiberti, Vasari, and others – but rarely do we find comments about the intractability of language itself and the disparity between word and image. Suggestive statements are usually scraps floating in a theoretical vacuum or so freighted with rhetorical cliché as to neuter their meaning. If asked the question whether it is possible to translate an image into words accurately, many writers would have admitted that words are but "shadows" of the image. Gian Giorgio Nicolini thought this to be such a revealing trope that he used it for his title: *Le Ombre del pennello glorioso* (Venice, 1659). Nicolini was a failed painter who, by his own account, took up writing about pictures as a surrogate for painting.[15] His book is devoted mostly to one painting by Pietro Bellotti, the *Fate Lachesis* (Stuttgart, Württembergisches Landesmuseum; Figure 9), a repulsively obsessive representation of aging. Nicolini proved himself to be as obsessively detailed in his description of this painting as Bellotti had been in his rendition of nature. Despite his attempt to match Bellotti's hyperrealism, Nicolini felt that he had failed: "I cannot explain how alive and real would be the being of these hands that they move without movement . . . so too in the distinct muscles, the raised veins, the visible sinews and the real wrinkles in the work of senile nature shown."[16] His words, he tells us, are "written copies" and "disanimated works" that "imperfectly convey" the painting.[17] These expressions of a frustrated writer trying to sublimate his failed ambition to be a painter suggest more than they actually reveal. They never go beyond the notion that language differs from images and that this particular writer's language suffers from serious limita-

tions. In this sense, it is little more than a refinement of the humility trope used by so many other writers in their prefaces.[18]

Nicolini's strategy to compensate for linguistic poverty relied on the honored techniques of *enargeia*, especially amplification, enumeration, and accumulation. Other writers depended more on metaphor, for reasons that will become clear later. Bellori hesitated to adopt the former and emphatically rejected the latter. By questioning the two standard rhetorical techniques of description, he summoned doubts about the genre itself. When Lione Pascoli disavowed "boring descriptions" in his *Vite*, he made it sound as if all descriptions are boring.[19] Perhaps, then, Bellori believed, like Lucian, that "word-painting is but a bald thing."[20] Bellori cited Lucian just before declaring his descriptive method and his putative role as a "plain translator" of images into words:

> Once I had already described the images of Raphael in the Vatican Stanze and had decided to occupy myself by writing the Lives, Nicolas Poussin advised me that I should proceed in the same way, and that besides the universal invention I should comply with the conceit and movement of each and every figure and with the acts that accompany the emotions. In doing that I still hesitated to become detailed by multiplying particulars with the danger of obscurity and irritation, painting having its delight of sight that does not partake, except a little, with that of hearing. And it is a terrible thing to resort to your own talent and add to the figures meanings and feelings that they do not really have, diverting them and interfering with the original [meanings and feelings]. I will therefore be satisfied to play the role of plain translator, and I have used the easiest and purest ways of writing without extending the literal meanings of words and thus representing the inventions and artifice so that one should know what was the talent of each artist. . . . [21]

By insisting on "literal meanings" and on the "easiest and purest" literary style, and by refusing to indulge in the linguistic distortions of figurative speech ("extending the literal meanings of words"), Bellori hoped to convince his readers that he would not do the "terrible thing" of superimposing meaning and expression onto the paintings he described. His status was that of "a plain translator." Just as he refused to "extend" language into a figurative realm, so too would he avoid "interfering" with the expression of paintings. Literary style, verbal explanation, and visual perception are here

woven together by Bellori. Like Vasari, who knew that a new literary genre (art history) needed a new literary style, Bellori wanted to write as Poussin painted: clearly; without ornamental flourishes; truthfully.[22]

By claiming to limit his language to denotational rather than figurative meaning, Bellori rejected the literary style known as Marinism, a style that had been adopted by Marco Boschini and Carlo Cesare Malvasia and that was attacked by Bellori for both its style and its content.[23] In the previous chapter we saw how he had mocked Boschini's Marinism and Venetian dialect by asking his readers to imagine a parodic pantomime: "twisting his head and singing in his distorted language."[24] Followers and detractors of Marinism signaled political and cultural alliances by using or abusing it, and Bellori was no exception.[25] Writing from within the cultural arena of the Accademia Reale sponsored by Queen Christina, he expressed a nostalgic ideology of "purity" and "simplicity."[26] By making Boschini "sing" some anti-Raphael sentiment, Bellori hoped to discredit his artistic taste by ravaging his literary taste. This is a compelling attack strategy, because it takes bad writing as symptomatic of bad artistic taste. Eighteenth-century critics of seicento art were especially inclined to damn art through the literary style of its proponents. Like baroque styles of painting, Malvasia's style was considered to be "overloaded," "bombastic and redundant," and "a disaster of infinite magnitude" that needed "weeding" and "could not be read without nausea."[27] Giovanni Lodovico Bianconi called the *Felsina pittrice* "a rare sorry mixture of Lombard-Bolognese idioms and imbecilities, baroquisms, and vile phrases made entirely without purpose, puerile reflections, interminable praises and inimicable periods of hot air."[28] Bianconi was Giovanni Battista Passeri's eighteenth-century editor who tried to impose his literary taste on the manuscript by correcting its florid and metaphoric style. He found the prefaces, in particular, to be so ornately phrased that the only solution was excision.[29]

Bellori's literary practice and his self-representation as a "plain translator" are not fully compatible. Recent studies have shown that he manipulated his style for expressive purposes and engaged in cornucopian digressions, elaborate poetic conceits, and other literary devices closer to Marinist floridity than to Senecan purity.[30] As early as 1750 his style came under attack as "extremely verbose and diffused . . . according to the style of that time"; it was said to bring "tedium," just that quality that Bellori was hoping to avoid.[31] Although Bellori refrained from metaphoric speech more

than many of his contemporaries, preferring instead an antiquarian mode that valorized a transparency between word and image, it remains clear that we cannot read Bellori in the same way that he thought he could write about paintings. His language, however simple and clear he tried to make it, imposed itself between his readers and the paintings. With his claim to write in a pure, simple, and plain manner, he shows how much his language, like ours, was value-laden. All stylistic values are culturally or historically specific and determined by linguistic codes. Any writer who pretends to be styleless is actually applying social conventions of precision, clarity, and simplicity that signal to readers that this writing is true and real.[32] Bellori might have fulfilled his ambition of pure description for some of his contemporaries, at least for those who shared the same linguistic values, in other words, whose language so resembled his own as to render Bellori's invisible. None of us can have an unmediated relationship to his text, and a purist might argue that none of his contemporaries could either, and hence his language needs reconstruction.

Bellori's "plain translator" is a pose of humility that functions because of the acculturated values of "simplicity" as truthful and objective. Writing simply or purely usually meant writing truthfully.[33] Vasari hoped to write "naturally" and "with that accuracy and with that fidelity that are essential for the truth of history."[34] Annibale Caro advised Vasari to write as he spoke, "that is, your writing should have more of the literal than the metaphoric and foreign," and with this recommendation he wanted to restrain an inexperienced writer by encouraging him to find a style that suited his subject.[35] Historiography, he thought, should be in a simple style. According to Paolo Cortesi, "many people believe that history ought to be written without any stylistic embellishments, which might detract from the truth and fidelity of a subject. . . ."[36] Although he did not ascribe to this view himself, he thought it represented the dominant view on historiographic style during the fifteenth century. It survived into the eighteenth century and beyond. In the 1730s the art collector, critic, and historian Lione Pascoli established his credentials of objectivity by telling his readers about all of the archival and other family documents that he had consulted. His intent was "to write exactly" about artists with "a plain, clean and simple style."[37]

Philosophers and art theorists who claimed to write "plainly" and "without a veil of fiction or . . . beautiful words" wanted to reassure their readers of their own sincerity and honesty.[38] This was a rhetorical ploy. Practitioners of the plain style try to disguise its artificiality in order to convince readers (or listeners) that they are being given the plain truth, but

in reality the plain style is as artfully contrived and "veiled" as any florid style. Bellori wanted to placate his readers by insisting on his "most easy and most pure ways of writing," but in doing so he engaged in artificial, socially coded structures that were anything but pure and simple.

The uneasy frisson between Bellori's self-proclaimed ideal and his real practice suggests that his solution of unmediated writing, untainted by personal values, was not easily attained. Nor was he so naive as to believe that he could attain his ideal. Doubt runs through this passage: "I still hesitated. . . . the danger of obscurity and irritation . . . it is a terrible thing. . . ." Wary of the contingencies of language, he nonetheless showed himself to be a clever manipulator of rhetorical conventions. The modeling of verbal description on visual scanning failed to acknowledge fundamental differences between reading and looking, and it was probably for this reason that Bellori feared turning a purposeful viewing experience into a tedious reading experience: "I still hesitated to become detailed by multiplying particulars with the danger of obscurity and irritation." Despite Poussin's sanction and, in hindsight, despite the enthusiastic reception by an anonymous reviewer in the *Giornale de' litterati* (1673), Bellori suspected that language could not capture the particularities of sight without an irritating multiplication and redundancy. Above all he feared that language would impose itself on the image instead of evoking it, and that by "interfering with the original" he would project himself or his "talent" into the paintings. To avoid this outcome he experimented with new forms of verbal description whose structure and syntax systematically move the reader through a visual grid. Poussin approved of this method because it resembled the visual strategy that he had proposed to Chantelou for "reading" the *Fall of the Manna*.[39]

Bellori tried to circumvent the deficiencies of language in another way. Most of his books included reproductive prints, a publishing format first used for antiquarian studies and only later adopted, albeit infrequently, for art writing in the seventeenth century.[40] In one title, he or his publisher, Giovanni Giacomo de' Rossi, declared that the reproductive engravings "translated" paintings and sculpture.[41] Reproductive prints are paradigmatic translations, because ideally they leave the expression of figures untouched and do not "interfere with the original." In this sense, the phrase "plain translator" is tautological, since every translation aspires to erase itself, "altering the accidents without spoiling the substance of the original feeling," in the words of Marino.[42]

Seventeenth-century writers experienced the liminal status of style as they struggled to fix it with language. Annibale Carracci, after intently studying Correggio's paintings in Parma, expressed his frustration with the limitations of language to his cousin Ludovico: "I like this clarity [in Correggio], I like this purity that is real, not lifelike, is natural, not artificial or forced: everyone interprets it in his own way, I see it this way: I can't express it, but I know what I must do and that's enough."[43] The admission that he could not "express" Correggio's style in words is painfully revealed by his trite critical language. He did not, however, anticipate similar limitations in painting. Artistic practice evidently bypasses linguistic boundaries. Many years later in Rome, Annibale, listening to a learned discussion on the Laocoön, and sensing the futility of capturing visual form in words, put an end to it by making a drawing: "We other painters, explained Annibale laughing, have to speak with our hands."[44] When Malvasia tried to compose verbal solutions to the visual riddles (*enimmi, o divinarelli pittorici*) that Annibale had composed, he too felt that his words were insufficient and resorted to a rare illustration for the *Felsina pittrice* (Figure 10).[45]

I cite these examples, not to insinuate that artists are subliterate or verbally inept, but rather to show that artists, who after all are the most visually literate group, were most painfully aware of the complexity of translating images into words. Even Bernini, who as a successful playwright could claim equal competences in verbal and visual skills, felt the constraint of language in discussing a painting with Chantelou. Standing in front of Veronese's *Children of Zebedee Presented to Our Lord by Their Mother* (Grenoble, Musée des Beaux-Arts; Figure 11), he pantomimed his critique of the figural distortions and anatomical inaccuracies that he saw but could not express in words.[46] Humanist art critics, bound by the limits of language in print, were not as lucky as Annibale and Bernini, who could draw, paint, or pantomime their responses. They faced a dazzling array of different pictorial styles with only a paltry arsenal of terms and clichéd phrases at their command. Describing an artist's style or a style of a painting usually involves little more than "verbal pointers."[47] There were exceptions, increasing in frequency during the seventeenth century, but even in lengthy and detailed descriptions, references to style are marginalized and parenthetical, as if they would interfere with the verbal illusion of a pictorial illusion. A good example of this is Agucchi's description of Annibale Carracci's *Sleeping Venus* (Chantilly, Mu-

seum), what may be the most elaborately plotted reading of a painting prior to Bellori's *Vite* and the "Conférences" at the Académie Royale de Peinture et de Sculpture.[48] Agucchi tried to match the specificity of sight with an itemized verbal inventory of every figure and every prop that, ironically, gives little sense of their appearance.[49] This is perhaps why he conceded that a visual copy would be superior to his written surrogate. Giovanni Pietro Zanotti, a painter writing exclusively for painters, chose to avoid "detailed descriptions" because artists were more interested anyway in design and style, suggesting that even the most "detailed descriptions" cannot convey the visual dimensions of design and style.[50]

Pietro Aretino is often acclaimed as a writer who, more than others, vividly captured verbal analogues of paintings: "Aretino does not portray things any less well in words than does Titian with colors; and I saw his sonnets written for various portraits by Titian, and it is not easy to judge if the sonnets are born from the portraits or the portraits from the sonnets."[51] Art historians today tend to agree with this optimistic conclusion by Sperone Speroni that Aretino's writing reached a near parity with Titian's paintings,[52] and for years I too read his sonnets with this set of expectations before realizing that Aretino was more interested in playing word games that invest light and color with symbolic meaning than in evoking the particularities of sight. A more honest assessment comes from Aretino himself when, in describing a sunset on the Grand Canal, he stumbled over color descriptions ("In some places the colours were green-blue, and in others they appeared blue-green") and appeals to Titian for help: "I cried out three or four times: 'Oh, Titian, where are you?' " He tried looking at the sunset as a painter – "Oh, how beautiful were the strokes with which Nature's brushes pushed the air back at this point, separating it from the palaces in the way that Titian does when painting his landscapes!" – but in the end he had to admit that a painter could depict a sunset better than a writer.[53] A writer describing a sunset painted by Titian, one that "would have reduced people to the same stupor that so confounded me" in looking at the sunset itself, would face exactly the same limitations.

Annibale Carracci's unspoken demonstration that art comments on art more effectively than words provided Charles Dempsey with the perfect opening to the vexed problem of theory and practice.[54] In his now famous solution that Annibale theorized through practice, Dempsey finds within the paintings themselves "a mind given to disciplined ratiocination and synthesis, to the employment of dialectical thought to his art, and . . . the end result, however much it was conceived as a return to nature, was the product of a

highly artificial and abstract scheme for ordering the data of experiential nature. . . ."[55] His conclusion argues for the ability of painters to critique in painting the styles of other painters, and to do so with greater precision and subtlety than they (or anyone) could with words. Clearly words and texts alone remain a sideshow, albeit an essential one as it gives us access to studio and gallery conversations, but the main act rests in painting.

The select audience of visual form is the subject of Pliny's famous story of Apelles' line:

> [Apelles] went at once to [Protogenes'] studio. The artist was not there, but there was a panel of considerable size on the easel prepared for painting, which was in the charge of a single old woman. In answer to his enquiry, she told him that Protogenes was not at home, and asked who it was she should report as having wished to see him. "Say it was this person," said Apelles, and taking up a brush he painted in colour across the panel an extremely fine line; and when Protogenes returned the old woman showed him what had taken place. The story goes that the artist, after looking closely at the finish of this, said that the new arrival was Apelles, as so perfect a piece of work tallied with nobody else; and he himself, using another colour, drew a still finer line exactly on the top of the first one, and leaving the room told the attendant to show it to the visitor if he returned and add that this was the person he was in search of; and so it happened; for Apelles came back, and, ashamed to be beaten, cut the lines with another in a third colour, leaving no room for any further display of minute work. Hereupon Protogenes admitted he was defeated, and flew down to the harbour to look for the visitor; and he decided that the panel should be handed on to posterity as it was, to be admired as a marvel by everybody, but particularly by artists.[56]

This story has a long and complicated history of reception,[57] but behind the various interpretations – are Pliny's *lineas* superimposed or adjacent, monochrome or color, or perhaps even circular? – is the assumption that the marks were nonrepresentational. Denied any mimetic value, they become referents to the artist, not nature, and hence challenged the visual competences of different viewers. Pliny underscored this point by differentiating two classes of viewers: the servant, who finds the line to be an incomprehensible calling-card line, and the artist, who immediately identifies Apelles as its author. The servant is an early example of stupid viewers gendered as women,

particularly old women, who do not know how to read the artifices of art.[58] Not only could Protogenes recognize artistic quality in a single line, he knew exactly who had made the line. After the missed encounters were over, the painting "looked like a blank space" with "almost invisible lines" and yet it was displayed as a masterpiece on the Palatine, "admired as a marvel by everyone, but particularly by artists." Lucian was even more explicit about the distinct skills and interests of professional and lay audiences. Zeuxis, he tells us, packed up and took home a painting that was being widely applauded only for its subject. The public saw nothing of the painter's craft, "the precision of line, accuracy in the blending of colors, taste in application of the paint, correct use of shadow, good perspective, proportion and symmetry," because these aspects are best appreciated by artists and are "not completely discernible to the eye of an amateur," not even one as keen as Lucian himself.[59]

Artists have access to a formal language unavailable to most people, an insider's knowledge born from scrutinizing competitors and comparing one's own strengths and limitations to theirs. Style is intensely visual, and when verbalized it can be best understood as a kind of "shoptalk" that requires technical experience and visual acuity. Vasari told his readers that he wrote "as I speak," using "the language and words typical of our artists."[60] *Statuino* and *legnoso* are two examples of shoptalk that have already been encountered. *Leccato*, which also describes the degree of finish, is another: "This painting is not finished or, as we painters say, licked, but one can say that it is diligently tossed off."[61] These three words suggest how shoptalk could be arcane and somewhat paradoxical, involving transpositions of media (wood into paint and sculpture into pictures) and oxymoronic expressions ("diligently tossed off"). Lorenzo Pasinelli dumbfounded a German who confused diligence and diligence.[62] Simply put, artists had more invested in style than nonprofessional consumers of art.

When all of this evidence is reviewed, a pattern of usage emerges. Debates over style might have adopted their terms of reference from ancient rhetoric but, as Passeri indicated, artists were the ones obsessed with style: "Today it is fashionable among painters to do nothing but squabble among themselves about manner, taste, and style. . . ."[63] The stories of Apelles' line, Annibale Carracci's Laocoön sketch, Bernini's pantomime, and Passeri's aporia also suggest that style formed part of the artist's domain. In the deception played by Annibale Carracci and

Cardinal Farnese, painters were the primary audience for the tricked-up "Parmigianino" and "Correggio." They were the ones whose pride needed adjusting, and they were taught their lesson by means of style. It is also worth looking ahead at who defined style. Of the six definitions of style formulated between 1550 and 1700, four were written by painters (Giorgio Vasari, Nicolas Poussin, Marco Boschini, and Giambattista Volpato) and one by a sculptor (Orfeo Boselli). The only nonpractioner to define style (Filippo Baldinucci) was an art curator with some studio training who published a polemical pamphlet asserting his expertise in style. As Baldinucci understood, the question "Who is qualified to write about style?" is a subset of the contentious question about what credentials writers on art should have in general. The answers to Baldinucci's question fall along predictable lines. Humanists insisted that, because painters imitate nature and because everyone is experienced in observing nature, the public is therefore qualified to judge.[64] The belief in a phenomenological commonality between "the sensible perception of art and the sensible perception of nature" survives today at the highest levels of art theory.[65] Painters, on the other hand, "are accustomed to laugh when they hear various learned gentlemen reason about painting."[66] Straddling these extreme positions were those who thought it possible for lay viewers to look at paintings like painters do by "becoming" painters and exercising their imaginations when looking at paintings.[67]

Conventional wisdom dating back to antiquity assumed that painters were best qualified as connoisseurs, and, acting on this belief, many artists supplemented their income with consulting fees.[68] The claim that style is a specialist's knowledge was made famous by Giorgio Vasari when he tried to explain why someone who is not a historian should write a history of art. As he tells the story of the origins of the *Vite*, one night in 1546 various learned luminaries, none of them artists except Vasari, were gathered at dinner with Cardinal Alessandro Farnese when Paolo Giovio expressed the desire to write a history of art:

> Expanding on this subject, [Giovio] certainly demonstrated great knowledge and judgment in artistic matters; but it is equally true that, since it sufficed for him to make a grand sweep, he did not look with subtlety, and in speaking about those artists he often either confused their names or surnames, birthplaces, [and] works or did not speak about things precisely, but only roughly. When he had finished his speech, the Cardinal turned to me and said: "What do you say about it, Giorgio, won't this be a beautiful work and labor?" "Beautiful," I replied, "if you, most illustrious

monsignore, will be helped by someone in the profession to put things in their proper place and to say how they truly are. I say this because, although his speech was marvellous, he has confused and replaced many things one with others." "Could you then," added the Cardinal upon the urging of Giovio, Caro, Tolomei, and the others, "give a summary and an ordered account of all those artists and their works, according to a historical order? And thus your arts will also have this benefit from you."[69]

After Vasari modestly defers, Paolo Giovio states exactly what Vasari could bring to such a history that he and his fellow diners could not:

"My dear Giorgio, I want you to take on this work in order to record at length everything in that way which I see you will know how to do very well, since I do not have the heart to do so, not knowing the styles nor the many details that you would know, without which, even if I were to write it, I would make it much more like a little treatise such as Pliny's."[70]

This origin story is stuffed with rhetorical topoi and sounds vaguely fictional, but whether or not this conversation ever took place as Vasari claims is less important for us than the truth of Vasari's conviction that he could write a better history of art because he was a painter.[71] According to "Giovio," artists are better prepared to write about style and "details," presumably some kind of insider's knowledge. Vasari seized other opportunities to remind his readers that he wrote as an artist, not as a writer or historian: once in the dedicatory letter to Duke Cosimo de' Medici, again in the concluding letter to his readers in the 1550 edition, and yet again in the concluding letter to his fellow artists.[72] In so doing, he situated himself within a tradition of other self-proclaimed professionals, like Vitruvius, Ghiberti, and Leonardo.

Why did Vasari abrogate the ability of nonprofessionals to write informatively about art? He had many declared goals in writing the *Vite* – to motivate patrons, to create a lasting record of Renaissance art (one that would survive a new dark ages), to instruct artists by identifying models worthy of imitation – and among these was one to which only an artist could aspire: he wanted to write a history of style for the lay audience "in order to help people who cannot find [this] out for themselves."[73] As proof that artists recognize the styles of other artists, he turned to a commonplace from calligraphy used previously by Filarete: "Long practice instructs learned painters to recognize, as we say, the various styles of artists, just as a learned

and practiced court scribe can identify the different and varied scripts of his equals."[74] The phrase "as we say" intimates a platitude circulating widely in art studios. Being knowledgeable about style also assumes an interest in style, and so we find Vasari signaling artists as his audience for discussions on style and artistry. For example, an extended analysis of Raphael's stylistic development was addressed to artists.[75] And in the life of Michelangelo he commented how artists "became astonished and admired seeing the extreme artistry shown to them by Michelangelo."[76]

Recognizing and appreciating different styles is one thing; translating pictorial style into words is quite another. Artists might have been most expert at identifying other painters' work and labeling them for collectors, but were they better equipped to analyze the peculiar stylistic properties using language? Painters had the "eye," and in light of Alexander's famous gift of Campaspe to Apelles because the painter was better equipped to appreciate her beauty, they referred to this fact with particular pride.[77] When Salvator Rosa was shown a mediocre painting made by a boastful dilettante, he responded with an ironically spirited gesture and exclaimed with wonder, "Oh, think what you would say if you could see it with the eyes of Salvator Rosa!"[78] Language was the domain of humanists, which included some artists as a small subset, so the question should be asked: did they write about style differently than artists?

Most humanists, theologians, physicians, and other nonprofessionals writing about art were not as interested in style as artists were. A few important exceptions must be noted immediately – Mancini, Baldinucci, and Malvasia (who claimed painters as his audience) – but, in balance and with these exceptions in mind, I believe that style was less central to their writing than it was to that of artists. My impression can be quantified. When I started research on this book, my original intention had been to study how the critics' lexicons of style changed with time and circumstance. I built up a file of two hundred terms and thousands of sample entries that, even though it remains incomplete, still can be used as a statistical average to confirm that artists wrote about style more often than humanists. About 62 percent of the two thousand (or so) entries were written by painters or sculptors, whereas this group represents only 34 percent of the 248 authors who wrote about style that I have catalogued. Humanists made important contributions, but their interests in art inclined more toward the literary and the theoretical than the visual and technical. Literati looking at a

painting confabulated meanings, as, for example, the academicians did in Anton Francesco Doni's imaginary "Academia pellegrina" when they tried to explain a painting of *Wisdom and Fortuna* by Giuseppe Salviati. Not only did their explanations completely ignore style, but each was so different from the other that it almost seems that the academicians were looking at different paintings: "Fortune is never still; whosoever is continually favored by Fortune possesses a streak of madness; whosoever is ashamed of his fortune deserves every evil; wherever a wise man may travel he will feel a citizen of that *patria*."[79]

These academic word games avoided the tricky problems of pictorial representation and personal (or stylistic) expression. This was the artist's realm, according to Pliny and Lucian. Writing in a similar vein as Lucian's "Zeuxis or Antiochus," Gabriele Paleotti, archbishop of Bologna, concluded that paintings can be understood either through the painting itself or through the person who looks at it. Painters, as a category of viewers, concentrate on their particular areas of expertise, those areas that enable them to make paintings resemble heaven and earth: perspective, artifice, foreshortening, chiaroscuro, contours, coloring, relief, and proportion.[80] "Erudite persons," however, "study the subject: is the site correct for this time and place? are the inhabitants clothed appropriately? etc." Painters, in Paleotti's view, were not often erudite, but he conceded to them the area normally defined and discussed as style in order to retain control over iconography for learned viewers like himself. Carla Caterina Patina did much the same in looking at Titian's *Tobias and the Archangel Raphael* (Venice, Accademia).[81] As did Giovanni Magni, Mantovese ambassador in Rome, when he expressed his bewilderment to Duke Vincenzo I Gonzaga concerning the enthusiastic reception of Caravaggio's *Death of the Virgin*: "This work is greatly admired by men in the profession, but because the inexpert and unknowledgeable desire certain pleasing attractions for their eyes, I must rely more on professional opinion than on my own sense, since I am unable to comprehend certain occult artifices which make this painting so estimable."[82] "Idiots" (meaning the illiterate), Paleotti's third category of viewers, responded to paintings sensually, looking impressionistically, which for a reformer with pastoral duties uppermost in mind, constituted the greatest threat.

Paleotti's hierarchy privileges a logocentric world. Vasari and other artists who insisted on style as visual knowledge risked being relegated to the status of second-class citizens in the world of letters. Vincenzo Borghini, an iconographic and literary advisor to Vasari, persisted more than most during the sixteenth century in denigrating artists' verbal and intellectual abilities.

He argued that artists in the Accademia del Disegno should discuss art with art, not with words: "When you enter into disputes, you leave your own house, where you are in charge, and enter the house of philosophers and rhetors where you do not have much of a part."[83] He proposed a motto of stricture for the Accademia, one that carried a certain weight coming from the Medici *luogotenente* to the academy: "Academy of DOING and not of REASONING!" (*Accademia di FARE e non di RAGIONARE!*).[84] In its majusculed stringency and exclamatory insistence, we can sense some of the resistance faced by artists. He also dismissed the literary pretensions of those artists responsible for Michelangelo's funeral by calling them "baby sparrows," and elsewhere he "marvels" that "good men with an art in their hands" should seek fame in writing.[85] Cosimo I de' Medici said in March 1563, regarding the Academy's mandate, that artists "need to produce works not words."[86] Had Federico Zuccaro known of Cosimo's and Borghini's admonition, he might have wondered if this was why he met only with sporadic success in making artists talk at the Accademia di San Luca.

Artists were complicit in being typecast as visual but not verbal. One sculptor declared that it would be easier to carve two statues than to give a talk at a Zuccaro-led Accademia di San Luca.[87] To avoid giving lectures, his fellow artists adopted passive-aggressive strategies by agreeing to give a lecture and then not appearing. Zuccaro felt no such reluctance to lecture, but he did think it necessary to dumb down the content so that artists could understand.[88] But the most common manifestation of this analphabet syndrome appears in prefaces to books written by artists. Consider this partial list of artists who disclaimed any competence in writing: Vitruvius, Ghiberti, Leonardo, Ascanio Condivi, Vasari, Giampaolo Lomazzo, Francesco Bisagno, Amedeo di Castellamonte, Giambattista Volpato.[89] Their claims to be artists, not writers, can be read as humility tropes so worn-out and overused that they actually prove these artists to be unsteady, or at least unoriginal, writers. They can also be read as expressions of real insecurities produced by cultural assumptions that artists cannot write well. Just as plausibly they might be clever manipulations of those assumptions, a kind of preventive deferral that preempts their critics. Whether compliant or manipulative, complicit or rebellious, they do acknowledge persistent assumptions held by the literate public.

W ere there biases endemic to nonprofessionals writing about style? Did professional writers judge styles differently than painters? According to the Venetian nobleman Vincenzo Da Canal, a diver-

gence of opinion was common in the early eighteenth century: "It is the opinion of art professors of good taste that contemporary painting has arrived at greater perfection than in the preceding period. I do not know if I can admit this to be true. It is my impression that this opinion is an illusion."[90] Da Canal's dire view is typical of a large group of historians, antiquarians, and literary critics writing between 1680 and 1760.[91] By typecasting painters as optimistic but deluded and himself as pessimistic but insightful, he represents a more general division between these self-selected constituencies. For example, the painter Passeri and the antiquarian Bellori, writing their *Vite* during the same years, came to opposing conclusions: that contemporary art was flourishing and withering, respectively. The Florentine painter Sebastiano Mazzoni published a sonnet in 1661, "That our present Age does not merit blame," evidently in response to opposing views such as those expressed at the same time by the antiquarian Carlo Dati ("We live in an age of spoiled taste if not to say corrupted taste").[92]

The "public" was often hypostasized in literature as ignorant gluttons for color and sensuality or as bored seekers of new stimulation. Art writers, however, rarely thematized their own collective identity. An interesting exception comes from Lorenzo Ruspoli, a papal chancellor to the Accademia di San Luca, speaking to artists assembled on the Campidoglio. The occasion was the annual awards ceremony, a time when speakers, often art *amatori* from other academies, particularly the Accademia degli Arcadi, were invited to speak.[93] Like Ruspoli, these *amatori* often had no publication record on artistic matters nor much experience in commissioning or collecting art.[94] Their speeches tended to be blandly uplifting and clichéd – retelling stories about ancient artists, recounting how nobles esteemed art, and so on – as if to confirm the most conventional views of past art and therefore to mirror what contemporary artists should aspire to. In his oration, however, Ruspoli intended to bolster the artists' spirits, evidently flagging from being a constant "target of criticism," by reminding them of the laughable errors committed in the past by Vasari, Bellori, Malvasia, and Algarotti.[95] Two communities are envisioned: astringent critics and creative artists. Critics by their very nature, having "a very exacting and insatiable genius," are rarely satisfied and tend to prefer styles that reflect their own taste. Consequently, any artist who listens to them will paint the way that critics write, that is, in a "too studied style."[96] Such was Ruspoli's antipathy that he blamed critics for the decline of art into its present "miserable condition." Artists, he believed, had had their natural talent corrupted by subjugating

themselves to the unfair censure and oppressive canon of critics.[97] By blaming critics for artistic decline, Ruspoli reversed the impolite remarks often voiced in those years on the Campidoglio by critics who held artists responsible. They cited the deleterious effects of Borromini and Bernini on their followers (Tiberio Soderini in 1766), "the extravagances of the Gothic taste" (Francesco Ruspoli in 1777), and their preference for "mannered sculpting, fanciful painting and completely ornamental" (Alessandro Lante in 1786).[98] Ruspoli responded that one loses one's ability to invent new ideas if one listens to the critics complaining of unbridled imagination, and art's trove of individual styles will consequently wither. Remember, he reminded his audience, the censure that Bernini had to endure in order to produce his "most elegant works."

Ruspoli's oration reminds us that when we read complaints about seicento art, we are being asked to look at it by a narrow, privileged group of literary-bent writers. This is a helpful reminder, but it simplifies a complex situation where painters and critics did not always inhabit separate solitudes, but rather where painters acted as critics or were quoted as authorities by critics to advance their own agendas. The example of Carlo Maratta can be used to illustrate the problem of unraveling artists from critics. Maratta, the chipper public relations man for the Accademia di San Luca, reassured his fellow artists when they were gathered on the Campidoglio that their art "will be the envy of posterity; no one will be able to surpass our century but will be left with the glory of following in our footsteps."[99] This Maratta sounds very different from the "Maratta" presented by Bellori or Pier Jacopo Martello, or the "Maratta" who participated in dialogues written by Vincenzo Vittoria and Giovanni Gaetano Bottari. The fictionalized or historicized Maratta might sometimes promote the Accademia's mandate – "Maratta used to say that a good school could make a good student" – but more often he was portrayed as a harsh critic of contemporary art and academic standards.[100] The problem here is separating Maratta's actual views from those held by writers invoking his name. When, for example, Bellori tells us what Maratta thought about contemporary art, he is really reiterating his own "Idea":

> Young people brought up on these ideas loathe study and work and avoid those goals that they must follow so that painting, instead of assuming its natural form, takes on the appearance of ghosts and fantasies, far in every way from the truth. However,

our century laments in vain that good painters do not exist or issue from our schools and that most of the most conspicuous works are badly done because our painters have abandoned their studies and good principles.[101]

According to Vincenzo Vittoria, one of Maratta's students, Bellori frequented Maratta's house on the Pincio, and in their long conversations together they generally agreed about everything, at least as Vittoria remembered them or chose to record them in his *Academia [sic] de pintura del Senor Carlos Maratti.*[102] I do not mean to suggest that the Marattas assembled by Bellori, Vittoria, Martello, and Bottari were canards, although the authors must slip into their creations in some way, but rather that the critic's and artist's communities were not as separate in values and goals as Ruspoli states. Ideas flowed in both directions. For his part, Maratta discussed poetry and poetics with literary critics including Martello and Scipione Maffei and incorporated their ideas on poetry into his discussions of the arts in his teaching and informal "academy" at home.[103]

✎ BIPOLAR SEMANTICS

When style resisted definition and mutated to suit personal agendas, writers responded with interpretive strategies that tried to fix the ineffable within a bipolar semantic. This was Baldinucci's solution when he defined six antinomial styles immediately after defining *maniera* (see Chapter 7). It almost seems that the ambiguities of style provoked countervailing responses that oversimplify by trying to fit the amorphous into dualities. Binomial systems are effective didactics, as Aristotle noted in listing the Pythagorean contraries,[104] so effective that the formalist histories of style – abstraction/empathy (Worringer), haptic/optic (Riegl), linear/painterly (Wölfflin), being/becoming (Frankl), or classical/anticlassical (Friedländer) – remain topical long after we have stopped believing in such totalities. At various points in its history, style has been identified with one or both of *morphē/eidos, ars/ingenium, res/verba*, matter/form, exterior/interior, convention/innovation, objective/subjective, synchronic/diachronic, extrinsic/intrinsic, and signifier/signified. Beyond structuring our thoughts, polarities give discussions of style a certain electrical charge and narrative thrust. What they mask, however, is how often style is not one or the other but always both. Dichotomy gives language order, tension, and (paradoxi-

cally) an evocative ambiguity. I say this with some trepidation, because for deconstructers polarities are more than just misleading abstractions: they ossify the free play of language and ideas.[105]

Style is often defined by opposition and exclusion: "Style is neither a genetic nor a teleological concept; it is neither set before the artist nor accepted by him as a goal. It is neither a species-concept under which particular phenomena are subsumed nor yet a logical category from which other concepts could be derived."[106] Wölfflin is famous for cordoning style into one area and bifurcating the remainder into various binomial sets. In theory he recognized the "double" or "twofold, root of style" as "general style" (a historical or period style) and "individual style" (as in the "style of Giotto," referring either to Giotto himself or to some follower), and yet in practice he wrote only a history of "general style" without reference to individual style: "a history without names."[107] Later writers disagreed while holding on to the belief that individual and general style should be understood separately. Richard Wollheim, for example, states that he will discuss pictorial style without reference to general style, which he dismisses as "taxonomic" and denies a history, an explanatory value, and a "reality."[108] Only individual style has a "reality" because it is "generated" by psychological, physiological, and rational motives; only it can be explained through a set of causes, either artistic volition or as a manifestation of change to the person. General style has no "explanatory value" and hence merely catalogues a preexisting condition: "If general style dropped out of our thinking, we should lose a tool of classification. If individual style dropped out of our thinking, we should lose a form of explanation – as well as losing sight of a piece of reality."[109] George Kubler successfully broke down many of the barriers between individual and general style by proposing to interpret style as an "exhaustive overlay of different descriptions that incorporate apparently contradictory notions," and yet he too could not do this without alternative totalizing binomials: style is synchronic, not diachronic; taxonomic not evolutionary; spatial not temporal.[110]

Why does binarism inform most definitions of style long after its origins in antiquity have been historicized or discarded? I believe, and will argue below, that it reflects theories of language, notably forms of structuralism, that find meaning in oppositional relations.[111] Our binarisms of style derive from antiquity: *eidos* and *morphē; ars* and *ingenium; res* and *verba*. The Italian *forma*, one of *maniera*'s contingent concepts, includes both "that intrinsic principle by which things realize their being" and "the exterior appearance" (to quote Baldinucci's definition), both the visible forms of *morphē* and

the conceptual forms of *eidos*, both *disegno interno* and *disegno esterno* (to use Federico Zuccaro's application).[112] Because David Summers has written so comprehensively on the history, meanings, and associations of *hylomorphism* and the position of form in the history of art history, I have decided to consider instead how the other polarities – *ars/ingenium* and *res/verba* – have permeated seventeenth- and twentieth-century discussions of style.[113] Of the two sets of polarities, *ars/ingenium* enjoyed a privileged position because it helped writers to advance autobiographical explanations of style. *Res/verba*, whose centrality in literary stylistics remained unchallenged until the nineteenth century, was mentioned only once, by Poussin, in the six definitions of style (see Chapter 5).

Ars (or *technē, disciplinam, doctrina, studium*) encompasses the theories, precepts, or models that can be transmitted and learned by an orator (but also a poet, architect, artist, etc.). It constitutes an articulate code to which large segments of society subscribe. *Ingenium* (or *natura*) is an artist's individual talent, a natural gift that cannot be acquired through study but can be nurtured by study and a moral, healthy life. Cicero internalized this double epistemology of style in *De oratore* where Antonius takes the position for natural talent, denying that oratory, historiography, and other forms of writing require rules, and Crassus holds the opposite position.[114] The introduction of *De oratore* prefigures their disagreements when, on the one hand, Cicero claims that "eloquence is dependent on the trained skill of highly educated men" and his brother Quintus, on the other hand, takes Antonius's position that rhetoric "depends on a sort of natural talent and on practice" more than on "the refinements of learning."[115] These are extreme positions that Cicero was careful to compromise when, for example, Crassus becomes an Antonius and says that "natural talent is the chief contributor to the virtue of oratory."[116] All rhetoricians and poets knew that orating, poetizing, and painting required an exercise of both *ars* and *ingenium*: "Often it is asked whether a praiseworthy poem be due to nature or to art. For my part, I do not see of what avail is either study, when not enriched by nature's vein, or native talent, if untrained."[117] Horace's antithetical parallelism, where art and talent are mutually dependent and equally valuable, is tilted in favor of *ars* by most rhetoricians, as one might expect from those codifying its rules. Quintilian identified it as the means to perfect the "raw material" of natural talent: "The average orator owes most to nature, while the perfect orator owes more to education. . . . To conclude, nature is the raw material for education: the one forms, the other is formed."[118]

Ars implies intentionality. A set of rules or models can only be seen as

effective if you assume that the artist has the will and the means to make a choice in following them. The metaphors of disguise that frequently accompany discussions of rhetorical style – clothing, cosmetics, spice, masks – assume that the dresser and cook have control over their body and food. Orators can speak in any style, adapting it to the *officia oratoris*.[119] Some might be naturally inclined to one style more than another, but it was assumed that every orator could give deliberative, epideictic, and judicial orations, could move, delight, and instruct; could speak in the grand, middle, and plain style: "We are at times solemn, at times simple, at times we steer a middle course. Style follows our thoughts, changing and transforming itself to create every pleasure for the ears."[120] Style *follows* content. French literature of the thirteenth and fourteenth century embedded this rhetorical concept in the expression *faire manière de*, which signified artificial or feigned behavior, not necessarily in a derogatory sense but as a matter of self-control and good manners.[121]

B elief in rhetorical style allows art historians to reconstruct an artist's intentions: if an artist operates intentionally and manipulates a particular style for a particular effect, then the historian should be able to reverse the process and discover why that choice was made. Gombrich's definition of style exemplifies this rhetorical model by postulating a high degree of intentionality. When he claims that style cannot exist unless it is deliberately chosen from a set of alternative styles, he evokes as proof one of the great modern orators in his definition: "It might have saved critics and social scientists a good deal of trouble and confusion if Churchill's distinction had been applied in the usage of the term – that is, if the word 'style' had been confined to cases where there is a choice between ways of performance or procedure."[122] What Gombrich wants for style is a "return to the lessons of ancient rhetoric" where orators chose between "alternative vocabularies provided by social and chronological stratifications." He excludes *ingenium* from style with Churchillian authority by labeling it the "physiognomic fallacy,"[123] a theory, popular through the nineteenth century, that takes style to be an external sign of individual or collective character. Artists do not have control over physiognomy; it is fixed at birth, like *ingenium*.

Some art writers in the seventeenth century subscribed to the rhetorical model of style (see Chapter 5), but generally they preferred the "physiognomic fallacy" lamented by Gombrich. Quartremère de Quincy, for ex-

ample, called style a physiognomics that reveals the character of an individual, a school, a country, or a period.[124] Physiognomics claims to read character from facial features. Trading on the reputations of Aristotle and Polemon, it was once deemed to be scientifically and philosophically legitimate, a pragmatics that held many parallels to painting.[125] Fathers and rulers could diagnose the character of their charges and hence reinforce or correct their strengths and weakness; even national character could be autopsied.[126] Physiognomics interprets the structure of nature – "the faces and order of the whole world" – in order to divine the "invisible world" from the visible.[127] It was, thus, a semiotic system that structurally resembled style analysis: if inner realities of character are projected outwardly – "all animate bodies are material portraits of their souls"[128] – then the process must work in reverse and the inner reality can be adduced by examining external form. According to Camillo Baldi, inventor of graphology and translator of the pseudo-Aristotelian *Physiognomica* (Bologna, 1621), physiognomy and style are closely related.[129] Styles are like faces, he tells us: each is different and yet beautiful; those differences are easier to observe than to describe and explain; both express many things at once.[130]

Gesture was another semiotic system related to style. Giovanni Bonifacio, author of the first-ever gesture manual, *L'Arte de' cenni* (Vicenza, 1616), considered it to be a subset of physiognomics, directed by the same principles and toward the same end.[131] Bonifacio was a lawyer and a judge who used gesture professionally in dealing with clients, witnesses, and rival lawyers. Because he believed that gesture never lies, it could be used to separate what people said from what they really thought, "a window to the heart" that could unmask "our most secret thoughts."[132] Gesture resembled physiognomics as a truth-telling heuristic where outer sign always had a direct correlation to inner secret. However, unlike physiognomics, which predicated an innate fixity and granted individuals only a limited set of behavioral options, gesture was also understood to be a cultural construct that, like language, allowed people to choose freely the mode and content of communication. If a physiognomic view of style assumed that artists had as little control over the forms they painted as they did over the way their faces looked, then a gestural view pointed toward a rhetoric of style. Like style, gesture was a nonverbal, precognitive form of communication, "a form of outward show intended to affect the audience."[133] Most rhetorical systems included delivery as a component of style or, as in the case of Aristotle's *On Rhetoric*, introduced style by way of delivery as an affective property that was intended to convince or move the audience.

Bonifacio poised gesture in between physiognomics and rhetoric, between the innate and the learned, the habitual and the premeditated, the reflexive and the deliberate. Gesture was not just a truth finder for judges but a social code of comportment such as that presented in Castiglione's *Cortegiano*. Courtiers, he believed (and recent studies have proved him right), had to know how to interpret gesture because their profession involved dissimulation.[134] If Castiglione's *Cortegiano* can be read, in part, as a manual for simulation, a social code book for a disciplined ease, then the *L'Arte de' cenni* can be read as a manual to decode the truth that lies behind public performances. It reveals what was intended to be concealed. Bonifacio believed that a residue of true feeling would leak through any attempt by courtiers to control their movements and expressions, and that gestures arise spontaneously from the soul and hence can be only incompletely filtered or censured by the mind.[135]

Cicero wondered why there were so many different styles when there was only one art:

> There is a single art (*ars*) of sculpture, in which eminence was attained by Myron, Polyclitus and Lysippus, all of whom were different from one another, yet without the consequence of our desiring any one of them to be different from what he was. There is a single art and method of painting (*Una est ars ratioque picturae*), and nevertheless there is an extreme dissimilarity between Zeuxis, Aglaophon and Apelles, while at the same time there is not one among them who can be thought to lack any factor in his art.[136]

Why is art (*ars*) singular, when its applications are not? If sculptors faithfully follow the "single art of sculpture," and painters apply the "single art and method of painting," why don't they arrive at a single solution? Cicero's answer was esssentially the same as that given by Francesco Solimena: "The diversity of beauty in paintings comes in large part . . . not from the art, which is always the same, but comes from [the artist's] character."[137] What strikes me as most important about Cicero's line of argument is his perception that painting and sculpture best exemplified individuality of talent, and that the source of style was innate and hence stable, and in this respect he was followed by Castiglione, Malvezzi, Mascardi, and others when they wanted to discuss style as an individual expression.[138]

Renaissance artists who wrote theories and technical manuals had just as much invested in *ars* as rhetoricians, and yet they still tended to skew style toward *ingenium*, holding it in symbiotic imbalance with *ars*:

> Theory, however, will be useless unless one is born a painter. Neither continual work, long studies, an acute intellect, knowledge of literature, theology, geometry, etc. will serve unless one is born to be a painter, born with the grace of art. This grace gives to all parts of painting a marvelous *leggiadria* and that is born with you. Without this, you can only imitate the styles of others without any hope of equaling them. If you are born to be an artist, then you can achieve excellence by following my advice, although each of you will have a different style according to your *genio*.[139]

Rules enabled Armenini, Lomazzo, and other painter-pedagogues to attain mediocrity as artists, but, lacking the talent necessary for artistic success, they learned about the importance of *ingegno* from personal experience. They believed in rules, possibly prescribing them in compensation, but they never succumbed to giving them priority. Lomazzo identified aspects of nature – physiology, physiognomy, and astrology – as sources for style and artistic excellence.[140] Cennino, Leonardo, Vasari, and many others likened style to *aria*, an innate individual expression and family resemblance.[141] Vasari defined style as *ingegno* transcending *ars* (see Chapter 4). And the Carracci encouraged their students to follow the path of their own *ingegno* instead of imposing a standardized model for all.[142] All of them subscribed in some way to the physiognomic fallacy.

These examples, all taken from writing artists, give the impression that artists privileged talent more often than did humanists writing about art. This is probably not entirely true – the physician Francesco Scannelli assigned each artist's style to a human organ (Raphael is the liver, Veronese the genitalia, etc.) and thereby demonstrated how style is a natural function[143] – but a story told by Malvasia would seem to confirm its general validity. When Guido Reni displayed his paintings to the public in his studio, he was often dismayed that "everyone attributed his art to a divine talent, to a special gift from heaven."[144] He responded to this assumption with a defensive hostility: "What character of my own? . . . What divine talent? These gifts are acquired only through constant study and persistent work. . . . What character? Was it ever anything other than a habit built on the strength of repeated observations made in order to choose the best and the most beau-

tiful?"[145] When Reni's admirers assumed that his style was innate, they were speaking both literally and metaphorically within the artist's studio. In other words, they were expressing, or thought they were expressing, a studio sentiment. Reni's denial can be seen as a correction of a general misapprehension or as evidence of his shame and self-loathing. Richard Spear suggests that we are presented with a psychologically revealing form of behavior when Reni eavesdrops from behind a door and subsequently denies any presence of his character in his art.[146] He denies his character because he is "self-conscious of his inadequacies and, with a feeling of shame, sought to cover them up," and because he wants to assert himself in precisely that area where he felt most insecure: his shallow learning. By insisting on *ars* over *ingegno* (or *carattere*), he adopts one of various stratagems of disguise.

Biography became the dominant historiographic genre after Vasari partly because, by rendering an account of character, it gave the most convincing explanation of why painters painted the way they did. The belief that "the temperament of the artist determines what he uncovers in the style of painting" embedded itself in the very syntax of biography: "Stefano Fiorentino . . . was also more unified in the colors and more smoked than the others."[147] This kind of hypallage, where artist and style are telegraphically collapsed, was endemic in art literature. Winckelmann looked at a face painted by Annibale Carracci and found himself also looking at the artist himself.[148] Because "our concepts are formed according to our disposition" and because Annibale was "rude and obstinate," so too were his figures. If style conforms to character, then Caravaggio's murderous rages, dark complexion, and sinister tenebrism become threads of a single fabric. The biographical schema of Vasari's *Lives* continually reinforced the self-reflexivity of style by presenting narrative as artistic parable: Cruel Castagno, who first painted with a knife and ended Domenico Veneziano's life with lead weights, paints fierce and strongly delineated figures. Parri Spinelli, traumatized by muggery, ceases to paint his figures upright and shows them instead as shying away to one side.[149] These seem more like allegories of style than psychologically nuanced explanations for the causes of style, but for the moment they can at least exemplify the priority given to *ingenium* in art writing.

What Gombrich disparagingly called the "physiognomic fallacy" is known today more respectfully as the "signature theory" of style.[150] Nelson Goodman proposes it in favor of other definitions of style somewhat apologetically because it did not overturn conventional wisdom as radically as his other ideas on art: "If this definition does not seem notably novel. . . ."[151] Gombrich condemns physiognomic theories by taking them at face value. If

physiognomy is a bogus science (and it is), so too must be its analogous epistemology for style. Proponents of signature theories, however, looked to a deeper reality and found that style is rooted in the body beyond the artist's control. Style can be used to unwrap the body's history and inner secrets. Whereas Gombrich's rhetorical theory of style assumed that artists can control their style and that their deliberation allows critics to reconstruct their intentions, signature theories introduce a degree of indeterminacy. If style is born from and contained within the artist's history and personality, it must therefore lie just beyond the critic's full comprehension, much as it lies just beyond the artist's control. An artist can try different gestures and accents, as would an actor adopting different disguises, but traces of his or her real identity will remain, born from inescapable reflexive habits. For a historian of theater, "style is, like the body, a zone where the reach of control ends somewhere in its unaccessible middle."[152] Even actors, masters of disguise by profession, are defeated by their bodies and introduce themselves in some way into every character they play, never fully able to escape their expressive habits. According to Wölfflin, the notion that "every painter paints 'with his blood' " has been known and accepted for a long time.[153] The body-style metaphor remains useful today. Barthes says that style "springs from the body" as a kind of "reflex" and biological "substance." Wollheim denies that style must have a "reflective consciousness" and argues instead that it can be "encapsulated in the artist's body" as a pattern of manual control.[154]

As I have presented the rhetorical and signature theories of style, they seem to be alternative or seemingly incompatible epistemologies of style. Occasionally, in order to clarify (or simplify) an argument, they were considered in this way, but most scholars see them in a dialectical relationship or as an intersection of the learned and innate, the collective and individual, the public and private languages. Style integrates us into a common discourse and separates us from it. Culture shapes our style and, in turn, our style shapes culture. James Ackerman expressed this view most clearly.[155] He defines style by asking why art works made at one time and place share "structures" and "relationships" and why those "established patterns" change over time. His explanatory dichotomy is of stability (*ars*) and change (*ingenium*). Stability represents the shared formal, expressive, and conceptual languages of a period or culture; it is a prior restraint that the artist changes, however imperceptibly, with every new art work. Change is not driven by

some "vague [collective] destiny" or "historical forces" but by inventive, curious individuals.

To call style a "language" and a "vocabulary," as Ackerman does, only defers explanation. Cicero, Quintilian, Filarete, Vasari, Malvasia, and many others turned to writing in order to explain pictorial style, but each meant something different (see Chapter 5). Many meant handwriting and thought of it as an identifying signature that was either an exterior form (Filarete and Vasari), an expressive form (Boschini), or a psychological form (Malvasia). Joshua Reynolds thought that "style in painting is the same as in writing, both have the power over materials, whether words or colours, by which conceptions or sentiments are conveyed."[156] Meyer Schapiro engages in a related practice by defining style as a language: "A style is like a language, with an internal order and expressiveness, admitting a varied intensity or delicacy of statement."[157] And Martin Kemp calls style "a language of visual 'qualities' that conveys meaning in a social context."[158] Neither Ackerman nor Schapiro nor Kemp tells us his theory of language or how language operates like style, but it is clear that they are all indebted to a Saussurian distinction between *langue* and *parole*. Of course this debt may only be an application of stucturalist ideas then circulating in art history, but it is plausible to suppose that they had firsthand experience as well.[159] Schapiro, for example, defined style in structuralist terms as a "constant form" that constitutes a "coherent and expressive structure": "For many writers a style, whether of an individual or group, is a pervasive, rigorous unity. Investigation of style is often a search for hidden correspondences explained by an organizing principle which determines both the character of the parts and the patterning of the whole."[160] Style is a Saussurian *langue*, "a common ground against which innovations and the individuality of particular works may be measured."[161] More recently, Helmut Wohl inserted language in a less problematic way: "Throughout the book I shall use the term 'language of art' in a straightforward way. . . . [The] 'language' of a work of art was synonymous with its style, with the formal elements that, in the words of Henri Focillon, 'make up its repertory, its vocabulary, its system of relationships, its syntax.' "[162]

Structuralists, it should be noted, generally associated style with *parole* or the individual enactment of *langue*. Barthes asks us to think of *langue* and *parole* as horizontal and vertical axes.[163] The horizontal axis is *langue*, a global set of rules or a "social horizon" (or, as Hans Robert Jauss would later call it, the "horizon of expectation") that describes the social conventions or

shared practices of language available to all writers and readers at a given time and place. The vertical axis demarcates a writer's departure from the historically constructed horizon. Barthes calls style the "vertical and lonely dimension of thought." All writing must trespass from the horizontal axis; all writing must have style: "Style is almost beyond [literature]: imagery, delivery, vocabulary, spring from the body and the past of the writer and gradually become the very reflexes of his art. Thus, under the name style a self-sufficient language is evolved which has its roots only in the depths of the author's personal and secret mythology."[164]

Style as a necessary deviation from a collective code underlies definitions from Baldinucci to Ackerman and Goodman (see Chapter 7). It is also submerged in stories about style, many revolving around the consequences of making copies. Perino del Vaga, for example, copied Michelangelo's *Last Judgment*, German engravings, and ancient statues (*ritrarle*), and yet he always changed them "reducing them to his native sweet style" so completely that one sees only Perino and no Michelangelo.[165] This typical account of emulation presents a set of authoritative models (Perino's *langue*) that are transformed into a personal idiom (*parole*). Assuming we know the sources, as we would in a canonical age, then style presents itself as a pattern broken; or as Michael Riffaterre explains it:

> The stylistic context is a linguistic pattern suddenly broken by an element which was unpredictable, and the contrast resulting from this interference is the stylistic stimulus. The rupture must not be interpreted as a dissociating principle. The stylistic value of the contrast lies in the relationship it establishes between the two clashing elements; no effect would occur without their association in a sequence. In other words, the stylistic contrasts, like other useful oppositions in language, create a structure.[166]

Style simultaneously manifests itself as both deviation and convention, as "an inseparable binomial, like a metaphor that simultaneously refers to its original and its figurative sense."[167] (Baroque critics thought of style as metaphor and thought of metaphor as a linguistic transgression of the norm; see next section, "Metonymy and Metaphor.")

A few words should be said in conclusion about that other enduring binomial: content and style; *res* and *verba; inventio* and

elocutio. In ancient rhetoric and poetics it was assumed that style was separate from and subservient to content. Style dresses content in suitable clothes that express a proper relation between truth (content) and appearance (style). Clothing and body could stand either in a truthful relation – outer form reveals inner content – or in a sophistic relation where style disguises truth. Agostino Mascardi, the Roman rhetorician and historiographer whom Poussin misprized for his definition of style, noted that "many worthy and learned gentlemen" believed that style either reveals or conceals the content.[168] He proposed instead that style reveals or conceals the writer's character. To show why style does not always refer to content, either expressing or suppressing the truth, Mascardi asks us to consider the act of dressing rather than the articles of clothing. He proposes two actors for his analogy: a valet who represents *ars* and a prince who represents *ingenium*. The valet exercises his judgment and knowledge when he chooses suitable clothing for the prince, whether it be dignified for solemn events or plebian for wandering in disguise among the masses. The prince accepts the clothing offered by the valet as appropriate, but no matter what costume is worn, he remains inviolate with his true identity visible through the clothing. *Ars* may change superficial appearance, but style represents a deeper, more durable identity.

Modern semiotics also elides the dualistic vision of style and content. Barthes, who acknowledged how much semiotics owes to the traditional oppositions of content as the signified and style as the signifier, thought that this traditional relationship needed to be destabilized and inverted.[169] In a classical view of style as clothing, style can be peeled away to reveal the content unmediated by style, but for a semiotician the peeling process only reveals different signifiers. Style and clothing reflect social conventions, either articulate or submerged, that groups subscribed to willingly or instinctively. For some structuralists, a change in linguistic form need not compel a change in meaning: "To put the problem more concretely, the idea of style implies that words on a page might have been different, or differently arranged, without a corresponding difference in substance. Another writer would have said *it* another way."[170] But for most semioticians style is not just the signifier, as classical semantics would have it, but also the signified: "What are termed in ordinary language 'stylistic' variations are differences of meaning, and therefore, 'style' is meaning."[171] Raymond Queneau playfully proved this point when he described in ninety-nine different styles the "same" vignette of a man boarding a bus. Each style brings with it a different view, a different sensation, a different experience, proving that we cannot say the same thing in different ways. Two years after Queneau published his *Exercises de Style*

(Paris, 1947), Nelson Goodman argued against synonymy trying to prove that style must also be content.[172]

✑ Metonymy and Metaphor

That the word "style" originated in metonymy is obvious from its etymologies: pen (*stilus* and *stile*) and hand (*mano*).[173] Both refer "style" back to the act of making (the Crusca *Vocabolario* defined "style" in 1612 as *modo di fare*), but ultimately they refer us to the creator. Style invites us to see the artist at work and in the work. Etymology was a common strategy of definition because, as its own etymology suggests (*etumos* as true or real), words were thought to testify to their origins, and in their origins one found essence and true meaning.[174] The search for truth in origins, and especially in etymologies, made Isidore of Seville's *Etymologiarum sive originum* a Renaissance best-seller, with one late-fifteenth-century Venetian bookseller ordering a staggering eighty copies.[175] In the case of style, however, it was a truth that definers wanted to avoid, because the *mano* of *maniera* could also be construed as a reference to craft and manual production, associations that artists had fought long and hard to overcome.[176]

Another popular application of metonymy to style originated in a figure of speech, first applied to Phidias by Lucian, that later came to be shared by both *disegno* and style: "to reckon the lion from the claw" (*leonem ex unguibus aestimare*).[177] Vasari evoked it in defining *disegno*, a close relative of style:

> [*Disegno* is] nothing other than a visible expression and declaration of our inner conception and of that which others have imagined and given form to in their idea. And from this, by chance, arises the Greek proverb *From the claw, a lion*, where the clever man, seeing carved only the claw of a lion, grasped with his intellect what were the size and form of other parts of the animal, and then the whole animal, as if it were present in front of his eyes.[178]

Because style was thought to suffuse the whole much as the artist's "shadow" or "air" covers every corner, even a fragment or a detail must contain the artist and represent a life's work. When Marino wrote that "from a single stroke or line, you know the excellence of the artist," he defined the

74 ✑ *Style and Language*

integrity of style by recalling Apelles' calling card to Protogenes as well as contemporary connoisseurial practices of autopsy.[179] Connoisseurship was a metonymic process. It assumed that technique and character are stable and will manifest themselves equally everywhere in a painting or drawing so that any detail, but most often hair, drapery folds, brushwork, and earlobes, will identify the maker as reliably as the whole. Bellori found Raphael's style in "every stroke and every line of the brush."[180] And in sending one of twelve (untraced) *Apostles* by Domenichino to his friend Bernardin Regni, Tommaso Stigliani reassured him that he would know all twelve by looking at the one, just as one knows the barrel of wine by tasting a glass of it.[181] Sometimes the metonymy of style led to an inductive hubris, none greater than Adolf Loos's claim (which has a familiar archaeological ring) that "if nothing were left of an extinct race but a single button, I would be able to infer, from the shape of that button, how these people dressed, built their houses, how they lived, what was their religion, their art, and their mentality."[182]

Metaphor is another trope of rhetorical *elocutio*.[183] Seicento art critics explained style and Mannerism metaphorically as a stain, as spice, as clothing, as expression, as pollution, as senility, and as narcissism. Many of these metaphors of style were also metaphors of metaphor – spice, dress, ornament, and jewelry – which opens the possibility that style is metaphor. Much of this book is devoted to explaining how these metaphors functioned, who preferred them and why, and what their choice of metaphor reveals about their taste in art and their ideas on the history of art.

Critics described artists' personal styles by using metaphoric language: stony, sweet, cold, furtive, clean, and so on (see Appendix 1). Most style terms are metaphoric and, at their deepest level, inherently ambiguous, wandering in their associative meaning, teasing evocatively. A style that is described as caressing, stony, pungent, sweet, licked, or jabbed can suggest many things at once. Metaphor is a kind of linguistic economy that extends the boundaries of language in order to meet the challenge of describing or explaining new experiences or new ideas. As the trope that injects new meaning into conventional linguistic practice, metaphor has recently been identified as "one of the appropriate ways, if not the most appropriate way" for art critics to find verbal equivalents for unorthodox pictorial styles.[184] As pictorial styles evolve, so too must the language that describes them. As noted in the previous chapter, Vasari established the literary canon that broadly defined the contours of stylistic description for the following two centuries. The seventeenth century witnessed a significant

expansion of stylistic language, in keeping with that period's love of neologisms, metaphoric speech, and other forms of catachresis (critics of Marino and his followers called it the *stile metaforuto*). In contrast to this semantic inventiveness, eighteenth-century critics shared a suspicion of metaphor and linguistic novelty, and consequently they contributed remarkably few stylistic terms, and most of those were adopted in order to criticize seicento painting.

Why metaphor was so vital for stylistic description is suggested by its ability to evoke things absent. According to Aristotle, metaphor enlivens descriptions because it "sets the scene before our eyes."[185] According to the *Aristotelian Telescope* by the great seicento metaphorist Emanuele Tesauro, metaphor makes visible the invisible: "And what deep discussion using the simple nouns for things could possibly express inexpressible concepts, make us sense insensible things and see the invisible, as metaphor does? Just try to explain these concepts with simple nouns: 'He has a suave manner. His spirit is turbulent. He has a hard character, a black soul, muddy thoughts, precipitous deliberations.' "[186] A language that made absent paintings "visible" to readers held many possibilities for art critics at a time when few art books were illustrated. Metaphor, in some sense, is a surrogate experience of viewing. Reading Malvasia gave Bottari a headache, and yet he admired how his metaphoric style made the words visually vivid.[187] It does not re-create the actual painting in its particulars but evokes the sensations and emotions of seeing the painting. Amedeo di Castellamonte enjoyed the illustrations in his book *Venaria Reale. Palazzo di piacere, e di caccia, ideato dall'Altezza Reale di Carlo Emanuel II Duca di Savoia* for being "exact, accurate and truthful," but for his verbal descriptions he preferred a more figurative and more elevated style.[188] Metonymy was also a trope to evoke presence from absence: the lion exists physically only as a claw, but through an imaginative reconstruction the viewer can see the whole animal "as if it were present in front of his eyes."

Metaphor transforms literal meaning by deviating from normal usage: "Metaphor consists in giving the thing a name that belongs to something else."[189] Metaphor's semantic tension creates a destabilized distance between denotation and association and hence may be said to stand in relation to normal usage much as pictorial style stands in relation to nature.[190] Agostino Mascardi was thinking along these lines when he defined metaphor:

> Metaphor is the daughter of necessity but afterwards is adapted
> to delight; however, it always holds the eye fixed onto the

mother [nature], and with her consent it nurses delight. Everyday speech should not be forgotten to counteract the habit of metaphorical speech. Painting portraying a beautiful landscape or a lovely face gives great pleasure but, in the end, the pleasure is even greater when they are natural instead of simulated things. Metaphor resembles one's native tongue, although it tends to please however strange it may appear at first sight. However, it would be undoubtedly arrogant to want to expel common parlance [from one's speech]. It suffices for the poet to avail himself of ornament not for dressing, of seasoning not for food, of pleasures not for needed sustenance. In conclusion, metaphors and other verbal figures salt speech: used in moderation, they add taste; poured on with prodigal hand, they offend.[191]

Mascardi's definition indirectly suggests how style might be like metaphor. First, and most typically, he invests metaphor with the same metaphors as style (clothing and food). It is an artificial topping to a natural body. It stands in relation to "everyday speech" much as a painting does to the scene or person in nature it represents. Baldinucci defined style as a deviation from nature or from an artistic norm by modeling his concept of style after language and metaphor (see "Deviation," Chapter 7). Also like style, metaphor gives pleasure but does not instruct; it conveys appearance but not substance; it dresses, ornaments, and flavors but does not substantially touch meaning; it is the daughter of nature, not the mother herself. These metaphors of metaphor alert us to its attendant dangers. It was a sign of genius (Aristotle), a source of charm and grandeur (Demetrius and Cicero), a kind of enigma (Aristotle), or a means of brevity (Cicero), but it also invited eccentricity, cloying affectation, obscurity, and fragmentation of thought.[192] Metaphor should be pleasing but restrained within a moral or didactic function; it is artificial, but should never be detached from natural speech or a higher conceptual truth.

When metaphor transgresses conventional meaning, it becomes elusive, irreducible, and unparaphrasable. It gives us "untranslatable information" or, as Tesauro put it, "expresses inexpressible concepts."[193] Its success in doing so is part of its picturing function. By naming the unnameable, metaphor performed an important function in overcoming the indigence of language. According to Gian Battista Vico, anticipating modern discourse on metaphor (as so much else), metaphor is not just an embellishment to language designed to please; it carries meaning that cannot be conveyed by any other means.[194] In conclusion, style resembles metaphor in that both are

born from talent; both are understood as a creative transgression of conventional usage; both are transformative, giving personal inflexion to "natural" speech or natural appearance; and both transcend the literal and find similarity in dissimilar things.

DEFINITIONS OF STYLE

DEFINING DEFINITION

Style demands and defies definition. Why this is so lies partly in the meaning and function of the word "definition."[1] Aristotle defined it as a universal "essence" that is selected from and prioritized by its constituent elements: "Definition is generally held to be of the essence, and essence is always universal and affirmative. . . . In order to establish a definition by division, we must keep three things in mind: (1) to select attributes which describe the essence, (2) to arrange them in order of priority, and (3) to make sure that the selection is complete."[2] By the criteria of essence and division, only four definitions of pictorial style were published between 1550 and 1700: those of Giorgio Vasari (1550), Nicolas Poussin (c. 1650s), Marco Boschini (1660), and Filippo Baldinucci (1681). The two unpublished definitions by the sculptor Orfeo Boselli (c. 1650–57) and the painter Giambattista Volpato (c. 1685) described style's essence without, however, dividing it into parts.[3]

Also in the *Posterior Analytics,* Aristotle defined definition as a search for singularity within variety that, when all variants are subsumed, results in "a single expression":

> We must set about our search by looking out for a group of things which are alike in the sense of being specifically indifferent, and asking what they all have in common; then we must do the same with another group in the same genus and that belong to the same species as one another but to a species different from that of the first group. When we have discovered in the case of this second group what its members have in common, and similarly in the case of all the other groups, we must consider again whether the common features which we have established have any feature which is common to them all, until we reach a single expression. This will be the required definition.[4]

His inductive process of selection moves from the particular to the general and from species to genus, and in this way it closely resembles idealist imitation. It creates an entelechtic form from a set of similar but diverse particulars. In other words, the essentialist definition of "definition" resembles Vasari's definition of "style" as ideal imitation (see Chapter 4). Style is definition.

Aristotle warned against literary techniques that might undermine a definition's clarity. Equivocation and metaphor were the primary culprits.[5] The definitions by Vasari, Poussin, Boschini, and Baldinucci may meet the structural criteria set out by Aristotle, but they failed to be precise and clear. Instead they tended to fragment rather than synthesize, misdirect and equivocate rather than declare meaning directly. Each definition admitted, either openly or implicitly, that style evades standard procedures of definition. Poussin, who was inclined toward definition, came closest to meeting Aristotle's criteria. Boschini, who was more metaphorically inclined, most directly violated Aristotle, especially when he defined by metaphor.

As if to counteract the ineffable nature of style, definitions tried to stabilize its meaning by adhering closely in diction and linguistic structure to famous sources. The only writer who did not present a consensual or retrospective view, Marco Boschini, enjoyed his role as a bounder, disavowing Vasari and other "professors." The structure and terms of Vasari's definition adopted Vitruvius and Agnolo Firenzuola. Poussin plagiarized parts of a treatise on historiography by Mascardi. And Baldinucci lifted parts from the Crusca *Vocabolario*.[6] Obviously the reliance on other texts is not limited to definitions, but the frequency of borrowing is definitely higher for this set of examples than for most other passages. Even more striking is the respect for and adherence to the original terms, structure, and syntax, that is, to the literary fabric of their sources. Because many definitions are intended to be consensual, summary, and conclusive, they reference and absorb earlier definitions. When Pietro da Cortona and Andrea Sacchi came to debate the meaning of *disegno*, they turned to Federico Zuccaro's definition for the terms of engagement, just as Zuccaro had turned to the definitions by Vasari and Armenini for his own.[7] Armenini, in turn, reviewed definitions of *disegno* by Varchi, Pino, Dolce, Lomazzo, and Vasari before selecting parts from each for his own.[8] Not all of these writers agreed about *disegno* – Zuccaro in particular tried to overturn earlier views – but at least all of them wanted to show themselves as engaged in (re)writing tradition. Another controversial definition of *disegno* – Lomazzo's assertion that it is the "matter" of painting and color the "form" – provoked denials by Domenichino and

Carlo Maratta.[9] They were not always certain where the idea originated – "I don't know if it was Lomazzo who wrote that . . ." – but they always maintained the original terms of reference before denying them.

Definitions of style were much less cohesive and structured than the definition debates surrounding *disegno*. Each relied on entirely different theoretical and literary traditions; each drew different conclusions that served the writer's needs. Surveying the field of style definitions, one has the impression not so much of disagreement as of indifference to competing views, as if there were no existing consensus about what style was. There is some truth in this impression, which, I believe, should alert us to the dichotomous and fragmentary nature of the concept itself. However, this impression was as much a calculation on the writer's part as a reality. Vasari, Poussin, and Baldinucci seem to be engaged in a process of definition by deferral, similar in structure to the *disegno* definitions, each using other definitions to frame their own. In their use of sources, they wanted their definitions to seem transparent and neutral by articulating them within the context of earlier writers. Their motive was, in part, to mislead their readers into accepting a tactical definition as an objective one. By "tactical" I mean a polemical mode of appropriating certain meanings and excluding others. It is a mode that subverts competing views without directly acknowledging their existence. C. S. Lewis has shown that "we define our words only because we are in some measure departing from their real current sense."[10] He urges us to be skeptical of those who want to define: they use the appearance of objectivity to forward a personal agenda; they seek closure when none can be attained.

Definitions of style legislate good art. By defining style in terms of their favorite style, Vasari, Poussin, Boschini, and Baldinucci effectively narrowed a broad theoretical category into an expression of personal taste. Style as a concept justified the particular style that each writer practiced in painting (only Baldinucci did not paint) and praised in criticism. The case is equally true with writers. The French naturalist Buffon defined style as a "clear and natural" order of thoughts, just those qualities that he thought all good writing (like his) should have.[11] No one defined pictorial style with the intention of judiciously exploring a semantic landscape and mapping out as many meanings as possible. Their intention was to close, not open, lines of inquiry. Definition for them was a mode of authority: to prescribe, to exclude, to fix. They overtly signaled their biases or silently passed over alternative meanings. Only Baldinucci's has the philological trappings of a true definition, appearing as it does in a dictionary, but even his has a

personal agenda that neither captures the range of meanings available to his contemporaries nor conveys his own usage of style as an art historian.

Definitions are inherently conservative. Leonardo Bruni held that semantic meaning (*significatio*) is a complex interplay of denotation (*vis*) and usage (*usus*), where usage precedes denotation. Definition is more a matter of consolidation than exploration, of describing usage more than thinking abstractly. Many sixteenth-century dictionaries were structured accordingly with a synthetic definition followed by examples of usage. Some of the earliest dictionaries provided only examples of usage. Fierce philological debates erupted as a consequence of dictionaries, as with so many other self-appointed authorities, and the point of contention invariably focused more on usage than on denotation. Whose voice is authoritative? The *Vocabolario degli Accademici della Crusca* (first edition, Florence, 1612) sat at the eye of this storm because of its conspicuous heft and the (self-fulfilling) pretension of pan-Italian validity. Because the illustrative passages quoted after each definition came from Tuscan writers of the "golden age" (Dante, Petrarch, and Boccaccio) and tended to exclude modern writers, the Crusca provoked debates about who constituted proper authority.[12]

Definitions are also inherently limited and limiting. Style definitions omit references to imagination, ornament, and psychology, and not because they were thought to be irrelevant. Hence definitions are less useful as surveys than as landmarks for privileged concepts reflecting a writer's occupation, intellectual preoccupations, or aspirations, his literary taste and political agenda or national orientation. The transformative power of definitions is so great that in some cases the concept of definition bleeds into what is being defined. In other words, definitions can sublimate themselves into the qualities that are being defined. The medium or literary genre shapes the content. Vasari's definition of style as ideal imitation resembles the Aristotelian reading of definition by Emanuele Tesauro, who likened it to Polyclitus' canon that "gathered all of the perfections of an ideal figure."[13]

Style can be understood in many ways other than by definition – by its linguistic or narrative functions, by the formal, psychological, gendered, rhetorical, or philosophical qualities that accrue to its usage as an instrument of description and analysis. What interests me about definitions – and the reason why the following four chapters are devoted to them – is that writers take such care in framing them and pay so much attention to their literary structure and tactical importance in advancing an argument. Definitions invite close examination with promises of closure, and yet the definitions of style examined here fracture at the slightest probing. They simultaneously

offer and withdraw understanding. The literary strategies found in these definitions signal the inherent instability of style: misdirection and paradox (Vasari), metaphor (Boschini and Volpato), misprision and inversion (Poussin), and antinomy (Baldinucci).

Instead of trying to capture an ur-style or defining a conceptual hierarchy for style, I have asked how its antinomous divisions and fragmenting undercurrents can help to illuminate the problem of style. Style is commensurate and ineffable; it is individual and categorical; it is beauty and distortion; it is individual and collective; it surpasses nature and hence is superior to it but also deviates from nature and hence is inferior: by twisting nature, it creates a new nature. Style mutates into its opposite, turning against the artist's best intentions. Vasari sought grace, which was style for him, and wound up with affectation and mannerism; Caravaggio sought nature, but coded it so obviously that it seemed artificial. These reversals were not observed by Vasari or Caravaggio – artists have a blind spot about their own styles – but revealed themselves only to those outside the frame who had different stylistic ideals.[14]

GIORGIO VASARI

AESTHETICIZING AND HISTORICIZING STYLE

It seems almost too convenient that the father of art history should be the first writer to attempt a formal definition of pictorial style. Vasari consulted texts by Cennini, Ghiberti, Filarete, Leonardo, Billi, Gelli, and others and turned to various friends and prominent literary advisors (Paolo Giovio, Annibale Caro, Vincenzo Borghini, etc.) for further advice. The emergence of style as a central topic, one fit for definition and employed as an epistemological tool, coincides with the emergence of art history as a new literary genre distinct from other historiographic forms. There were writers on art history before Vasari, but no one had thought of it as a separate literary genre with its own unique textual and historical demands. However indebted Vasari may have been to them, and often it is impossible to disentangle Vasari from his sources, he differed from his predecessors in many ways when it came to style. In the "Preface to the Whole Work," Vasari told his readers that he wanted to help them recognize artistic quality ("perfection and imperfection") and to help them distinguish between styles (*discernere tra maniera e maniera*).[1] In the "Preface to Part Two," he centered his agenda around style even more explicitly:

> I have endeavored not only to record what artists have done but also to distinguish the better from the good, the best from the better, and to note with some care the methods, expressions,

styles, brushstrokes, and imaginations of the painters and sculptors, studying as diligently as I know how to help people who cannot find out for themselves how to understand the sources and origins of various styles, and the reason for the improvement or decline of the arts at various times and among different people.[2]

In these prefatory remarks, Vasari weaves together two kinds of style: individual and general. The phrase "methods, expressions, styles, brushstrokes, and imaginations" concerns individual styles, those which humanize artists by revealing various personal matters such as their training and histories, their influences, the triumphs and failures of their lives, and the innate cast of their minds and souls.[3] The second kind of style consists of the abstract aggregates of individual styles, either normative (good, better, best) or period (trecento, quattrocento, cinquecento). Normative and period styles are closely related in Vasari's art historiography. He configured the history of art into three stages, with a rising trajectory from trecento to cinquecento art. Their number and staging correspond to absolute standards of quality, described as the good (*buono*), better (*migliore*), and best (*ottimo*).[4] Artists are collected into epochs, he explained, "because of the similarity of their style."[5] Style gives history its shape and order. It marks time and defines periods in history, giving them coherence and individuality. Structurally, the *Vite* are divided along these lines. Individual style is discussed in various *vite*, and general style is covered in the various prefaces: "Here [in the prefaces], I will discuss the matter [of methods, manners, and styles] in general terms, paying more attention to the nature of the times than to the individual artists."

The influence of the *Vite* was immediate and enduring, dominating what writers thought about art history for the next two hundred years. By the end of that time, after hundreds of writers attempted to differentiate new styles from old and articulate new perceptions of old styles, the language in their employ was much the same as Vasari's. Looking at the two hundred or so stylistic terms that I have been cataloguing for a forthcoming lexicon, over one half in general circulation during the eighteenth century had been used by Vasari.

❧ MANIERA AND MANNERISM

Today *maniera* in Vasari's *Vite* is best known through modern studies on Mannerism. The foundational theories of Manner-

ism, notably those by Walter Friedländer and Max Dvořák, barely used Vasari at all and looked instead at Mannerism through the eyes of German Expressionism. When art historians in the 1960s tried to avoid this kind of retrospective reading, they turned to the word *maniera* as a means to interpret Mannerism in sixteenth-century terms. Anthony Blunt signaled this route to a philologically based history of Mannerism as early as 1940: "Vasari often talks of the *maniera*, and it is from this word that the whole school of the late sixteenth century now takes its name. It is therefore a quality of considerable importance, but it is not easy to isolate its meaning."[6] Blunt made several influential assumptions: that Vasari's *maniera* defined Mannerism; that the importance of *maniera* derives from its role in defining a historical period; and that style or *maniera* has a meaning that can be isolated even if "it is not easy to isolate its meaning." Because most later scholars of Mannerism subscribed to these beliefs, they invested *maniera* with considerable epistemological importance. Fortunately for them, style's polysemous semantic enabled them to manipulate it to suit their various agendas. In so doing they distorted the concept of style, simplifying it and making it less intractable so that it would conform to their preconceptions of Mannerist practice.[7]

Debates over Mannerism gravitate toward *maniera* for validation. Craig Hugh Smyth claimed "to examine again the way *maniera* was used and what developments it referred to, so that we may compare our modern concepts of Mannerism."[8] John Shearman took it as "axiomatic, as history entitles us to do, that every mannerist work of art must somehow exemplify the quality of *maniera*."[9] Jeroen Stumpel, on the other hand, disputed that Mannerism was a preexisting independent entity defined by sixteenth-century writers as *maniera*: "So, gradually it had come to be taken for granted that Mannerism really had already existed in some self-conscious sense, before it was created by modern art history."[10] His argument, however, tends to slip unwittingly into a similar fallacy when he identifies *maniera* with a nominal reality known as Mannerism rather than with a historical reality of artistic practices.

I believe that neither Shearman nor Stumpel was strictly right. When scholars translate *di maniera* as Mannerism, they impose anachronistic beliefs onto their sources, because Mannerism did not then exist as a reified artistic movement or period style and would not until the seventeenth century. Mannerism as a discrete period in art's history was neither the creation of the sixteenth nor of the twentieth century; it was neither a historical reality nor a philological misunderstanding; instead, it was, I will argue in a forthcoming study on "Baroque Mannerism," an invention of seicento critics searching for a means to criticize contemporary painting. Much as Dvořák and Fried-

länder looked at Rosso through the prism of Kirchner, the followers of Raphael and Michelangelo helped seicento critics to explain the "plague of modern painting," to use one of their many terms of pathology.

Blunt's hope "to isolate [style's] meaning" suggests that style in the age of Vasari had a single meaning and that it could be isolated from other meanings. Even a casual glance at Vasari's *maniera* offers little foundation for such hope. In his mission statement quoted above, Vasari mapped out the semantic terrain of style by using a string of five related terms: "methods, expressions, styles, brushstrokes, and imaginations." Methods (*modi*) and imaginations (*fantasie*) were considered causes of style, the first technical and the second intellective. Expressions (*arie*) and brushstrokes (*tratti*) were considered to be products of style, the first psychological and the second technical. Style (*maniera*) is the dominant term: it stands at the center of a ring sequence (abcba); and its frequency of usage in the *Vite* far exceeds the others (*modo*, 938; *aria*, 278; *maniera*, 1,304; *tratto*, 35; and *fantasie*, 62).[11]

The semantic field contained by these five terms corresponds to the preferred scholarly explanations of style and Mannerism. Vasari defined *maniera* as a transcendent, aestheticized beauty. This definition will be discussed in the following sections, but for the moment let it be noted that by defining style as beauty, Vasari narrowed its meaning and made it strategically more restricted than his linguistic practice in the *Vite*. It was style in this specific sense that Weise and Shearman used to support their reconstruction of Mannerism. *Modi* and *tratti*, on the other hand, describe a narrower semantic field that involves mostly issues of technique, a practiced hand, and a professional routine.[12] When Miedema and Stumpel restricted *maniera* to a "working method based on routine" in their effort to deprive style of the normative aestheticizing of Shearman's stylish style, they drew upon this narrowly prescribed meaning and reduced the complexity of style far more than Shearman ever did.[13] Whereas *modi* and *tratti* concern technique, procedural routines, and other physical or external manifestations of style, *arie* and *fantasie* cover the intellective, imaginative, or psychological generation of style. Because they have greater explanatory value and are more deeply entwined with philosophy, they have drawn the attention of David Summers and Martin Kemp, who, in a series of brilliant articles, show how an artist's talent (*ingenium*), spirit (*spiritus*), or character (*carattere*) was thought to infuse itself into the work.[14] *Maniera* and *aria* were the visible results of that process of projection. They explain sixteenth-century *maniera* without reference to Mannerism. It is symptomatic of style's precarious status that each of these three exemplary pairs of scholars excluded competing meanings from consid-

eration. Each pair restricted style to just one area of the semantic field listed by Vasari, the one that coincided with his epistemological model for art, and in so doing continued the practice of tactical definition during the sixteenth and seventeenth centuries.

Style degenerates into Mannerism. Smyth turned for proof to Vasari on Mino da Fiesole and Perugino, and to Ludovico Dolce on Michelangelo. These oft-quoted passages deserve further study for at least two reasons: (1) they reveal most clearly the internal tensions and fissures that run through concepts of style; and (2) they contain clues about the subjectivity of vision and the tendency of art to look more artificial to viewers who do not share the same cultural or aesthetic preoccupations as the artists. Artists easily overlook their own formulae, as do their admirers, whereas their detractors notice them more readily. What seemed to be a natural style appears contrived to other viewers who ascribe to different codes of natural representation. The recognition of Mannerism was historically an outsider's experience.

Vasari's usage of *maniera* veered across a complex and often contradictory terrain – a stable principle of ideal beauty, an artist's characteristic voice; a routine technique, or a formal pattern repeated and propagated irrespective of circumstance – that was made to serve, legitimately, competing theories of Mannerism. Modern theories of Mannerism tend to isolate these meanings, accepting certain ones and ignoring others, but underlying their differences is a conception of style as a formula. Whether it is an aesthetic principle of grace or proportionate beauty or a formulaic practice, style cannot avoid repetition. It plants the seeds of its own failure. Integral to style are qualities that subvert its realization as an aesthetic standard. What had once been a fresh and beautiful arrangement – a figure's shy sway or a light's glint – can degenerate into self-caricature. What had been an effective visual shorthand can become a lazy proclivity. In this section I will discuss how Vasari and some of his contemporaries understood style as a formula, and how they exploited its coexistent but incompatible qualities of variety and monotony, beauty and deformity.

Vasari defined style as a constant and ubiquitous feature "introduced in every work and in all the figures." Smyth concluded from this that by style Vasari meant a "single stereotype." Formulae enabled painters to work faster, fill larger wall spaces, and maximize their income. Paintings increased in size during the sixteenth century, in part for the purpose of decorating ever larger

churches and palaces, and this was only possible if painters had certain patterns committed to memory and had a sufficiently broad technique to cover the prescribed space. Miedema countered that Smyth's "interpretation must be incorrect, if only because the use of the same stereotype in every figure is in total contradiction to the repeated stipulation for *varietà*."[15] Condemnations of figural formulae are found earlier in Leonardo and are certainly implicit in the frequent praise of figural variety, but it was not specifically identified as an attribute of style until Gelli, Vasari, and Dolce.

Miedema's contentiously narrow reading of Smyth's thesis should not conceal an underlying truth about the dubious conjunction of style and repetition. To the degree that style is constant, it contravenes the privileged aesthetic principle of variety. Vasari understood figural uniformity as a by-product of technical expertise or unshakable personal expression; however, since artists could better control their training than their character, the dangers of Mannerism's *maniera* as a repetitive form gravitated more to studio practice. Miedema argued that all practice involves some shorthand formulae, and this is undoubtedly true, but the issue for Vasari and other critics of mannered art was an inability to recognize excessive repetition. Leonardo, for example, prescribed the heuristic aid of making reiterative drawing as part of a visual memory exercise but insisted that no trace of figural repetition should be evident in the finished work.[16] Inevitably traces persisted, even in Leonardo's own work, because manual and mental habits are not easily lost once they are imprinted by training and practice. They are also not easily recognized by their practitioners. Vasari saw the monotonous results of Perugino's stereotyped figures, but from a seicento perspective Vasari also fell victim to formulaic excesses when he adopted some of Michelangelo's muscular contortions.

When literary critics discussed repetition, they had access to a respected repertoire of literary techniques: *epanaphora* (repetition of an introductory word or phrase), *antistrophe* (repetition of the last word or phrase), *paromoisis* (similarity of the final syllables of successive clauses), *epanalepsis* (repetition of a participle in the course of a lengthy sentence), *parisosis* (clauses of equal length and syntax). Art critics were less fortunate. Their readers expected repetition to be defective, in part because it was more noticeable in a synchronous medium, in part because discredited medieval art was saturated with repetitions. The prejudices against repetition blinded art critics to its expressive potential at a time when artists were exploring this area.[17] For example, within the chaotic tumult of Perino del Vaga's *Fall of the Giants* (Genoa, Palazzo Doria; Figure 12), two giants have fallen into identical

poses. Assuming that this repetition is intentional on Perino's part and not simply a lapse of attention, we can ascribe various possible meanings, such as an intention to convey a sense of copiousness as recommended by Demetrius (2.61) or to suggest that the rebellious giants were like-minded. As a painter, Vasari also used repetition for iconographic purposes to identify partners in original sin in the *Allegory of the Immaculate Conception* (Oxford, Ashmolean Museum). When P. L. Thomassin engraved this painting, he exercised a formalist prejudice against repetition and cast Adam's arm into shadow so as to modify and loosen the mirrored symmetry with Eve (Figures 13 and 14).

Two popular verbal expressions illustrate the slippery slope of style: "to reduce" (*redurre*) and "of style" (*di maniera*). When Vasari wrote that Mino da Fiesole and other artists imitated art more than nature and that they "reduced to style the things they took from nature," he was playing with contradictory impulses of style.[18] "Reduction" usually involved issues of high finish and perfection, as when Vasari defined sculpture by way of a Platonizing poem by Michelangelo: sculpture is an art that starts with an "idea" and then sheds the superfluous stone in order to "reduce" matter to form.[19] "To reduce," in this sense, is a kind of selective imitation like those of *disegno* and *maniera*.[20] Design "extracts from many single things a general judgment" and transforms the imperfections and accidents of nature into more refined but less varied forms.[21] Standing alongside such idiomatic expressions of *ridurre* was a contrary, literal meaning. Vasari used it to indicate a reduction in size, with reference to Alberti's perspective screen, or a reduction from three dimensions to two dimensions.[22] In this sense, reduction produces something equivalent to, but measurably less than, the original. *Ridurre* also described diminished circumstances brought by external force or personal failing as, for example, being "reduced to poverty," "reduced to slavery" or "reduced to decadence."

Contained within these meanings of "reduction" – both positive and negative; idiomatic and literal – is the sense of transformation from one condition to another. Style reduces nature to art. This is both its triumph and its peril. Perhaps because the expression "to reduce" embraced opposing meanings, it made clear and unequivocal statements about beauty difficult. When Vasari wrote that Verrocchio "polished and finished" *Christ and the Doubting Thomas*, and "reduced the figures to the perfection one sees today,"[23] it sounds like unqualified praise; but when these statements are read in the context of his linguistic usage where the phrase "to reduce to perfection" is reserved for lesser artists (those from foreign lands or distant times), one realizes that Vasari wished to delimit and diminish Verrocchio's achieve-

ment. Foreign sculptors, for example, who by nature lacked the Italians' perfect *disegno*, "reduce things to such a subtlety that they stupefy the world."[24] Paolo Uccello "reduced to perfection the method of drawing perspectives from the plans of houses and the profiles of buildings" by applying "method and rule" instead of working "by chance." Read in isolation this also sounds like praise, and it was, to the extent that Vasari admired the scientific advances that Uccello brought to art, but he also registered some doubt concerning the consequences of Uccello's method: suppressed creativity and a dry style, like most other quattrocento art. Ironically, Uccello's goal and method for attaining a beautiful style sowed the seeds of his failure. He hoped to achieve a visual unity by means of proportion and rule but produced instead a style that fragmented form with a dry, linear, labored, and contoured style (*secco, stento, piena di proffili*). The phrase "reduced to perfection" thus captures the precarious status of artistic intention. Just as Uccello's art turned against him, so too the phrase "reduced to perfection" turns against its first literal meaning as "finished to perfection" and inserts disturbing undertones about whether artists can judge their own successes.

The phrase *di maniera* is even more poignant in its self-contradiction. Vasari believed that artists should imitate ancient art and the modern masters, and thereby attain *maniera*. He also knew that when an artist imitates style instead of nature, the results can be repetitive and unnatural, an unpleasant side effect that was also called *maniera*. This linguistic confusion between two opposing types of *maniera* reveals the problematic status of an art that simultaneously held style and nature as equally important objects of imitation. Giovan Battista Gelli and Vasari tried to avoid this eponymous confusion syntactically by dubbing formulaic style as *di maniera*; Ludovico Dolce was content to use the meanings of *maniera* interchangeably, without the prepositional distinction. Their diction verges on the formulaic: "all the figures . . . made in almost the same way" (Gelli); "he made all the figures with the same expression" (Vasari); and "where all the forms and faces one sees are almost always alike" (Dolce). The formal properties of *di maniera* painting may share resemblances, but the locations varied. Gelli found it in painting before Giotto, Vasari in Perugino, and Dolce in Michelangelo. Apparently artists at nearly any time in history were susceptible to this lapse of style into formulae. It was not a period-specific problem, certainly not as it became with Mannerism, because formulae were inherent to style itself.

Gelli came the closest to identifying *di maniera* as a period style – "the crude and ignorant style of the Greeks," namely, the Byzantines – while at

the same time acknowledging it as a universal problem. He used Giotto as the pivotal artist in a historic break from Byzantine stylization, the first artist since antiquity "to consider the true way of making art well, that is, to copy things from nature."[25] The Byzantines

> made things with that way and with that style which they had developed by habit without considering natural things. . . . [You] will see all the figures of that time to be made in almost the same way either with their feet splayed and affixed to the wall or with their hands open and all resembling each other in the bust, even having almost the same one, which directly contravenes nature as anyone can observe . . . and the same was done again later by all those masters who followed the way of painting *di maniera*, that is, they did not try to extract things from the natural.[26]

Gelli defined *di maniera* by way of habit. Because working by "habit" and working "by style" describe the same function (working without reference to nature) and result in the same repetitive forms, an equivalence is established. An artist who works from "habit" rather than from nature will produce repetitive forms with figures made "in the same way," which ignores and contradicts the variety of nature. Nature is to style as variety is to monotony. Style in its aberrant form (*di maniera*) reduces nature to a schema.

Vasari borrowed copiously from Gelli, including a description of Byzantine figures, but he reserved the formulaic *maniera* for quattrocento artists. He applied the phrase "reduced to style" (*ridotta a maniera*) to describe Perugino's habit of making all of his figures with "the same expression (*aria*)."[27] Perugino's figures are famously repetitive, cloying in their identical, beatific smiles. Twins, triplets, or quadruplets were evidently fetching to his patrons and public, but to a more discriminating audience they could be annoying. According to Vasari, the artist's friends complained to him about the repetition of figures, to which Perugino responded: "You liked them when I first used them, why do you complain now?"[28] Apparently his figures had become more noticeably formulaic in old age. They also marked his work as old-fashioned. Paolo Giovio wrote of Perugino in a similar vein, possibly inspiring Vasari, describing an aging Perugino unable to change the stereotyped images of his youth and frustrated with his impotence because Leonardo, Raphael, and Michelangelo were forging ahead with majestic, varied figures that conveyed the potency of nature.[29] Of course it is unfair and inaccurate to condemn Perugino's formulae solely as a problem of old age. He had been painting this way since the 1480s. What had changed by

1520 was not so much the reality of his style as its perception by viewers whose taste was transformed by Leonardo, Raphael, and others.

Gelli's and Vasari's *di maniera* was a preterite style whose redundant forms were exposed for what they are by a newer, more natural and varied style. Perugino played the role of a Byzantine painter to the new Giottos (Leonardo, Raphael, and Michelangelo). Historical distance made the repeated schemata of style at once more recognizable and more irritating.[30] Styles that viewers take to be beautiful or truthful tend to be invisible to them as styles. When a style no longer abnegates itself and becomes visible, as with the Byzantines and Perugino, then it seems mannered.

Dolce attacked Michelangelo's art with a related strategy: "Whoever sees a single figure by Michelangelo sees them all."[31] The reason for this, he reminds us, is that he paints with "*maniera*, that is to say, with bad practice where the forms and faces are almost always alike."[32] With this bon mot, he captured (and exaggerated) a tendency toward cloning and helped to push Michelangelo's reputation into a downward spiral. By labeling Michelangelo as a *maniera* painter, Dolce hoped to tap into the historical contingency of stylized painting where, now, Titian subjugated Michelangelo to the role assigned by Giovio to Perugino, or by Gelli and Vasari to Byzantine painting. Michelangelo became the new Perugino.

Dolce situated his comments within a dialogue whose literary form and narrative content bear on its meaning. His intention (or, at least, one of them) in writing the *Dialogo della pittura* (Venice, 1557) was to rebut Vasari's partisan promotion of Michelangelo and his concordant demotion of Venetian painters. Dolce's main strategy was to assign a dim-witted Florentine philologist, Giovan Francesco Fabrini, to argue Vasari's position. The plodding Fabrini debates Pietro Aretino, a canny choice by Dolce for his own surrogate. Being a compatriot of Vasari's from Arezzo and a friend of Michelangelo, Aretino is assured literary protection against possible charges of parochial bias.

Fabrini is initially cast as stubborn, monolatrous (whenever the subject of Michelangelo arose), and seriously out of touch with contemporary Venetian painting. When the *Dialogo* opens, Aretino tells Fabrini of an episode that took place two weeks earlier in the church of Santi Giovanni e Paolo where he found Fabrini so absorbed in front of Giovanni Bellini's *Saint Vincent Ferrer* altarpiece that he didn't even notice Aretino and his two friends.[33] Aretino then goes on to explain why he should not have turned his back on Titian's *Martyrdom of St. Peter Martyr* on the opposite side of the nave. Fabrini protests in his opening statement that Michelangelo's is the

only art really worth admiring: "[T]he man who has seen once only the pictures of the divine Michelangelo should not – in a manner of speaking – really trouble any more with opening his eyes to look at the work of any other painter whatever." Aretino recasts Fabrini's figurative language into a silly literal statement that describes Fabrini's opinion as a kind of blindness: "[Y]ou want men to put their eyes out, so as to avoid seeing paintings other than those of Michelangelo." Fabrini's responses continue to be equally obsessive: "For Michelangelo's excellence is so great that, without going beyond the truth, one may suitably compare it to the light of the sun, which far surpasses and dims all other lights." Aretino delicately calls this trite piece of hyperbole "poetic." Because Fabrini's first act is rapt admiration of Bellini, and because his first statements are parodic versions of Vasari's praise for Michelangelo, the reader is invited to consider the two artists as equal exemplars of Fabrini's questionable artistic taste. Because Bellini and Michelangelo are both surpassed by Titian, might not Michelangelo be as antiquated as Bellini in his own way?

Fabrini's monomania as an art lover is presented by Dolce as paradigmatic of Michelangelo's art. Fabrini speaks of Michelangelo with unwavering zealotry and with a reiterative insistence that simply ignores Aretino's arguments: "And I shall always keep on telling you that Michelangelo stands alone." This is a setup for Aretino's response: "It is a child's habit to go on repeating the same thing over and over again." Evidently Michelangelo draws partisans to himself who think and act repetitively and obsessively. One knows the artist through his admirers.

Michelangelo's monotonous *maniera* casts a skeptical light on Vasari's definition of *maniera* as ideal imitation where the goal of style is to reform the diversity of nature into a single idea or ideal form. Dolce did not deny that art must give order, structure, and beauty to nature, but he was more wary than Vasari of the loss of variety that comes with the search for an ideal. The lesson he wished to stress was that style is more than just a means to ideal beauty, it is also an impediment. Style as an ideal form contains the seeds of its own demise.

In Michelangelo's defense, Vincenzo Danti responded to Dolce with a strategy of denial: "Hence one sees that Titian painted figures of women sometimes beautifully and sometimes not, depending on the model he copied, as happens when one works only by way of copying. And Michelangelo always painted and sculpted them in one way, always beautiful, because he worked by way of imitating the intentions of nature."[34] Yes, he admitted, Michelangelo always painted "in one way," but this should be taken as

evidence of successful imitation, where acute judgment discerns the good parts of nature and extracts the best "into the same composition." His "habits" are good ones, born from long study, that enable him to work solely from his imagination instead of from nature. To confirm his argument Danti trots out Titian, who is capable only of copying (*ritrarre*) and hence whose work changes with the accidents of nature. Michelangelo masters nature, and Titian submits to it. For Dolce, variety in painting was evidence of its responsiveness to nature, its expressivity and decorum; for Danti, it was evidence of insufficient judgment and an untrained imagination.

Vasari stands somewhere in between Dolce and Danti. He understood style to have the paradoxical schism polemicized by Dolce and even played word games – *maniera* becomes *di maniera* – to signal their proximity and easily transgressed borders. A mere preposition separates the two. Vasari tended to separate the two styles and avoided the uncomfortable problems of contradiction by assigning them to different historical periods. Repetitive style is discussed in the context of quattrocento art (Mino and Perugino); the ideal style of grace was the achievement of the cinquecento.

Mannerism was a seicento invention, insofar as conceiving and naming it as a period style constitutes its invention, and Dolce's critique of Michelangelo is usually accepted as an important preliminary step toward defining it. A second step was taken by theologian-critics of cinquecento art. Giovanni Andrea Gilio da Fabriano, for example, adopted the phrase *di maniera* for contemporary Roman painters who indulged in style instead of content, artifice instead of nature, elegance instead of expressive decorum. To explain the problems of Michelangelo's *Last Judgment*, he turned to an unattributed painting of *St. John the Baptist*, who daintily holds the cross with his pinkie and twists his leg to vaunt his muscles.[35] Because the pose responds neither to the variety of nature nor to the narrative necessities of the subject, Gilio hints at a formulaic repetition.

☙ STRUCTURE AND SOURCES

Rule (*regola*) in architecture was the means to measure antiques, following the plans of ancient buildings in making modern ones. Order (*ordine*) was the differentiation of one kind from another so that every body should have its characteristic parts, and that the Doric, Ionic, Corinthian, and Tuscan should no longer be intermingled. Proportion (*misura*) in sculpture, as in architecture, was the making of the bodies of figures upright, the members

being properly arranged, and the same in painting. Design (*di-segno*) was the imitation of the most beautiful things of nature in all figures whether painted or carved, and this requires a hand and genius to transfer everything which the eye sees, exactly and correctly, whether it be in drawings on paper, panel, or other surface, as in sculptural relief. Style (*maniera*) then became the most beautiful because it used frequent copying of the most beautiful things, and by combining the most beautiful parts, whether hands, heads, bodies, or legs, to produce a figure with all possible beauties, then used them for every figure in every work; this is what is known as a fine style. . . . [36]

Vasari's definition of style suffers from a rigid enumeration of "things": "Doric, Ionic, Corinthian, and Tuscan . . . paper, panel, or other surface . . . hands, heads, bodies, or legs. . . ." Its syntax is clumsy and banally repetitious, particularly in its superlatives: "the most beautiful things . . . the most beautiful . . . the most beautiful things . . . all the beauties." The effect is baffling and bland, both requiring rereading for comprehension yet offering no inducement to do so, as if Vasari were repeating a school lesson only barely understood. He tried to be precise, but for all of his effort – and perhaps he tried too hard – we are left with a conceptual minestrone. I do not blame Vasari for any of this, nor do I want to detract from his literary gifts. Quite the contrary. In trying to write the first encompassing definition of pictorial and sculptural styles, he appears to have encountered linguistic and conceptual resistance. I say "appears" because the difficulties he confronts are self-created in order to deceive the reader. He presents himself awkwardly as one who wants to control and limit the semantics of style, but actually, I will argue, his failure opens up the truly elusive meaning of style.

The contrived clarity and structure of his five interlocked definitions give an initial impression that style can be separated from the other four parts of painting. It cannot. Style is not independent; it cannot stand alone. The dissective structure of his definitions signifies many things. In this section, I will argue that it reveals Vasari's sources and hence the conceptual contexts of his definition. In the next two sections, some of its theoretical and historiographic functions will be considered: (1) Style is imitation, the process by which artists judiciously select the beautiful parts of nature and discard its imperfections. The dominant metaphor of pictorial imitation – Zeuxis's Helen assembled from the beautiful parts of Crotonian women – thematized the dissection of nature and its reassembly. In this formulation, style is beauty.

(2) Beauty implies timelessness; as an absolute, it is eternal. Opposed to this aestheticized style stands a historicized one. By virtue of its position in the *Vite* opening the third preface, the definition of style mediates between quattrocento and cinquecento art. Theorists had previously subdivided painting into its constituent parts – indeed, it became a literary setpiece – but none set it within a subdivided historical structure with art progressing through ever-better stages. Vasari defined style as specific only to the conditions of making art during the fifteenth century. By historicizing style, he gave us insights that were fresh to Renaissance art literature. Previously, historians had thought that pictorial styles were subject to history, changing uniformly with time and thus a useful tool of historical analysis. Vasari, however, suggested that not only the practice of style but the concept itself were subject to history and the changing contexts of making art.

Vasari was not a theoretically rigorous or consistent writer. This gives his interpreters perilous latitude. Regarding the definitions just quoted, Robert Williams sensibly warns us that they have "proved resistant to coherent explanation: The definition of the five qualities and their relation to each other are unclear and contradictory."[37] I agree, but would go further and argue that they are deliberately unclear. This section concerns the order and structure of Vasari's definition. The concluding section, "Historicizing Style," reveals how Vasari undermined that order.

Vasari divided painting into five "things" (*cose*) that are presented in a thematically linked series. He started with architecture (rule and order), introduced sculpture and painting with the third "thing," and closed by restricting the fourth and fifth "things" (design and style) to sculpture and painting. Conceptually, there is also a sequence that governs his presentation. Rule, order, and proportion concern the systematic dissection of art into measurable parts. The identification, classification, and separation of the parts make rule, order, and proportion related aspects of a single endeavor. By their terms of definition, all three suggest a system (rule), a canon (order), or a mathematically stable way of making art (proportion). With his use of the subjunctive tense, Vasari makes them prescriptive, as if each referred to a stable norm. Measurement presupposes terminal points or discrete and quantifiable units. Order concerns keeping the parts in their proper place so that they are not "intermingled." Whereas rule, order, and proportion cohere around the themes of division and separation where one part is not confused, mixed, or exchanged with another, design and style are

more concerned with establishing a coherency among the parts. These topics were present in rule, order, and proportion as well, but in the final two definitions they are given central importance. Despite these subtle distinctions, what is most noticeable about *ordine, regola, misura, disegno*, and *maniera* is their similarity. In cinquecento usage they appeared in various configurations that suggest either a shared semantic field or synonymity.[38]

Dividing the art of painting into an inclusive set of parts was understood as an essential part of definition for cinquecento art theorists. Giovanni Battista Paggi identified division and definition as synonymous in the title and text of his fly sheet *Diffinizione ossia divisione della pittura* (Genoa, 1607). The divisions tended to involve formal or visual qualities. The three parts for Alberti were circumspection, composition, and reception of light. Alberti's structure remained topical with the Italian translations of *De pictura* by Lodovico Domenichi (Venice, 1547; Florence, 1568) and Cosimo Bartoli (Venice, 1568). Of the few writers who adapted his division, Giovanni Battista Armenini remained closest. He added color and expanded "circumspection" beyond its original formal aspect of an enclosing contour to include aspects of imagination, judgment, and the correspondence of mental and visual images.[39] Leonardo identified two overlapping sets: (1) two "principal parts" (lines and shade; or, alternatively, figure and color) with five dependent "parts" (surface, figure, color, light and shade, nearness and distance); and (2) ten "functions" or "topics" (light, shade, color, volume [*corpo*], form [*figura*], site, distance, nearness, motion, and stasis).[40] He also divided the first "principal part" into point, line, surface, or plane and volume.[41] Lomazzo reduced Leonardo's ten parts to five by compressing "distance and nearness" into "perspective," "motion and stasis" into "pose," and so on.[42] Paolo Pino was the first art writer to broaden the parts to include aspects beyond visible form and technique. His triad of invention, design, and color was adopted by Dolce and infiltrated itself into Vasari's writing and terminology. It became the dominant structure thereafter.[43] Invention included content or literary meanings; design included judgment and talent, and subsumed all parts given to painting by Leonardo and Lomazzo except color.

Even from this brief overview it is clear how much Vasari's division differs from its alternatives. Vasari's definitions restrict painting to issues of form, like Alberti, Piero, and Leonardo, and exclude the more intellective functions and humanistic aspects introduced by Pino. The division of painting was laden with ancient precedents and guiding models. Leonardo and Lomazzo explicitly adopted Aristotle; Alberti and Pino used Cicero. For

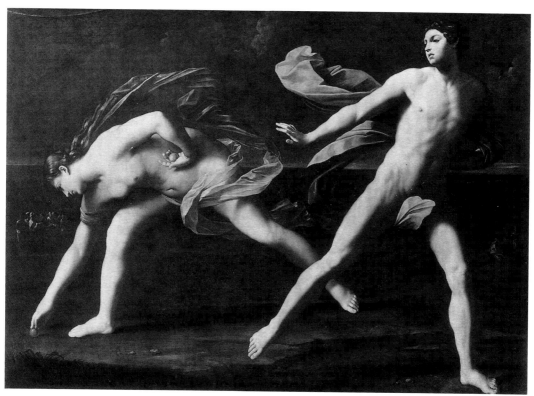

1. Guido Reni, *Atalanta and Hippomenes*, Naples, Museo di Capodimonte. Photo: Alinari/Art Resource.

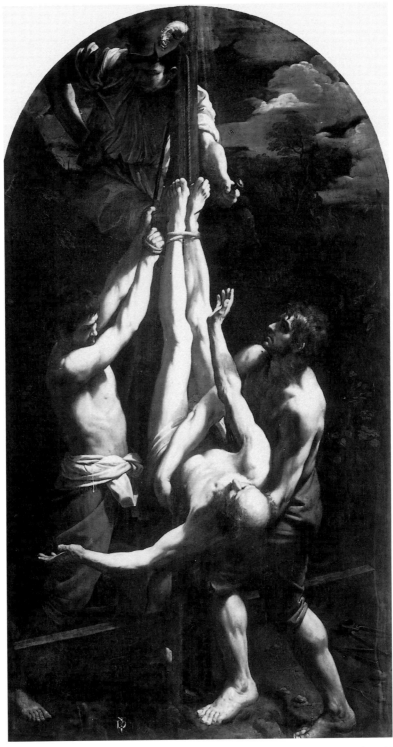

2. Guido Reni, *Crucifixion of St. Peter*, Vatican, Pinacoteca. Photo: Alinari/
Art Resource.

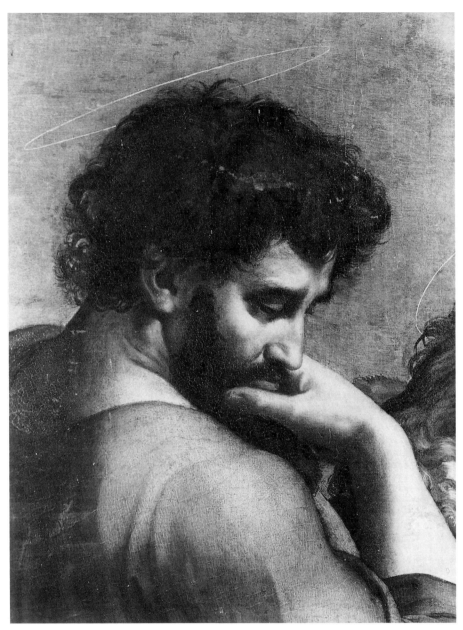

3. Raphael, *Ecstasy of St. Cecilia*, detail, Bologna, Pinacoteca Nazionale. Photo: By permission of the Soprintendenza beni artistici e storici per la provincia di Bologna.

4. Correggio, *Madonna and Child with Saints Catherine and Jerome*, detail, Parma, Galleria Nazionale. Photo: By permission of the Ministero per i Beni e le Attività Culturali.

5. Niccolò Boldrini, *Caricature of the Laocoön Group*, woodcut, Middletown, CT, Davison Art Center, Wesleyan University. Photo: Davison Art Center, Wesleyan University; DAC 1960.14.5.

6. Agostino Veneziano, *The Academy of Baccio Bandinelli*, engraving, Middletown, CT, Davison Art Center, Wesleyan University. Photo: Davison Art Center, Wesleyan University; DAC 1967.24.4.

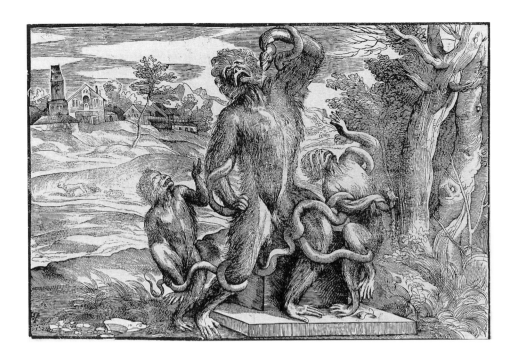

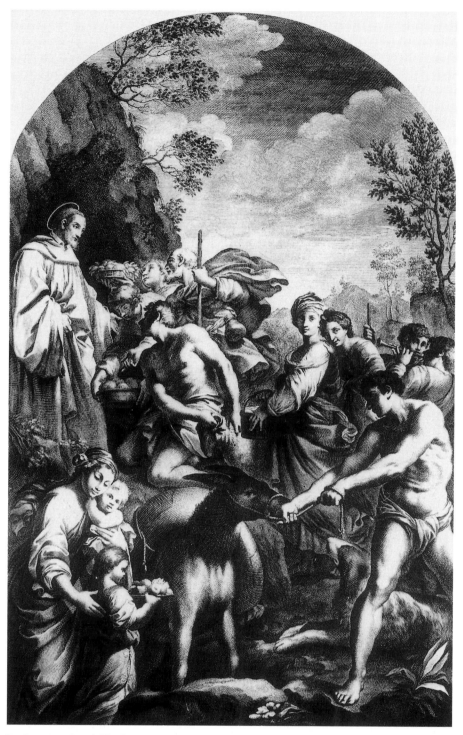

7. Gaetano Gandolfi after Guido Reni, *St. Benedict Receiving Gifts from Farmers*. Engraving in Giampietro Zanotti, *Il Claustro di San Michele in Bosco di Bologna* (Bologna, 1776), n. 5. Photo: Thomas Fisher Rare Book Library, University of Toronto.

8. Jacopo Tintoretto, *Assumption of the Virgin*, Venice, Chiesa dei Gesuiti. Photo: Osvaldo Böhm.

9. Pietro Bellotti, *Fate Lachesis*, Stuttgart, Staatsgalerie. Photo: Staatsgalerie Stuttgart.

no fra eſſi coſì frequenti, e che in poche linee, ò ſegni gran coſa racchiudeuano, e riuelauano, come queſti quattro per eſempio :

Spiegando eſſer il primo vn Muratore dalla parte di là d'vn muro, che riboccando, ò ſtabilendo, ſoprauanza quello con la ſomità della teſta, e della cazzuo-

10. Annibale Carracci, *Visual Riddles*, in C. C. Malvasia, *Felsina pittrice* (Bologna, 1678), 1:468. Photo: Thomas Fisher Rare Book Library, University of Toronto.

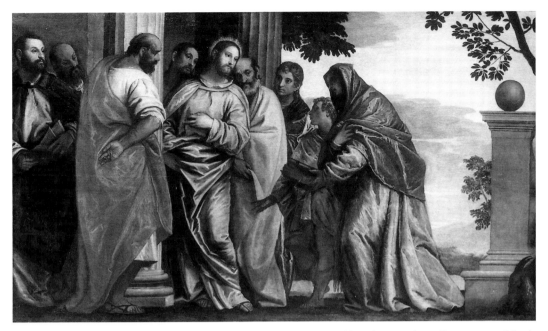

11. Paolo Veronese, *The Children of Zebedee Presented to Our Lord by Their Mother*, oil on canvas, Musée de Grenoble. Photo: Musée de Grenoble.

12. Perino del Vaga, *Fall of the Giants*, Genoa, Palazzo Doria Pamphili. Photo: Art Resource, NY.

13. Giorgio Vasari, *Allegory of the Immaculate Conception*, Oxford, Ashmolean Museum. Photo: Oxford, Ashmolean Museum.

14. P. L. Thomassin after Giorgio Vasari, *Allegory of the Immaculate Conception*, engraving, Oxford, Ashmolean Museum. Photo: Oxford, Ashmolean Museum.

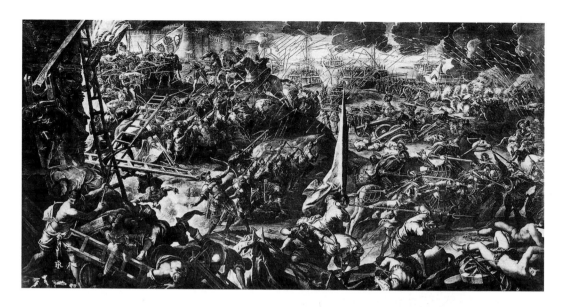

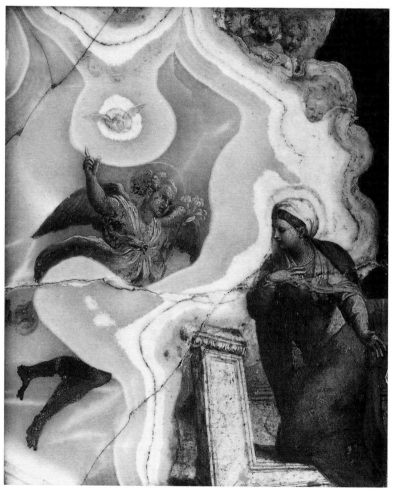

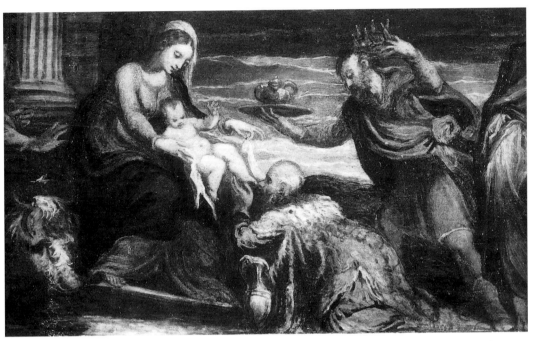

17. Andrea Schiavone, *Adoration of the Magi*, Venice, Santa Maria dei Carmini. Photo: Fondazione Giorgio Cini.

15. Jacopo Tintoretto, *Battle of Zara*, Venice, Palazzo Ducale, Sala dello Scrutinio. Photo: Alinari/Art Resource.

16. Antonio Carracci, *Annunciation*, oil on marble, Naples, Museo di Capodimonte. Photo: Courtesy of the Ministero per i Beni e le Attività Culturali, Soprintendenza per i B.A.S. di Napoli.

18. Francesco Bassano, *Adoration of the Shepherds*, detail, Venice, San Giorgio Maggiore. Photo: Alinari/Art Resource.

19. Andrea Schiavone, *Mystic Marriage of St. Catherine*, woodcut, London, British Museum.
Photo: Copyright British Museum.

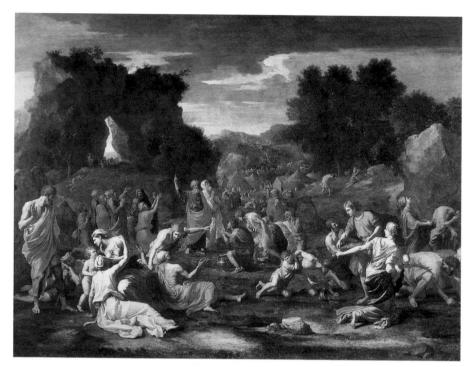

20. Nicolas Poussin, *The Israelites Gathering the Manna in the Desert*, oil on canvas, Paris, Louvre. Photo: Giraudon/Art Resource.

21. Giovanni Lanfranco, *Assumption of the Virgin*, detail, Rome, Sant'Andrea della Valle. Photo: By permission of the Ministero per i Beni Culturali e Ambientali–Istituto Centrale per il Catalogo e la Documentazione.

Vasari it was Vitruvius, albeit echoed distantly. Vitruvius defined six "things" that architecture consisted of: *ordinatio, dispositio, eurythmia, symmetria, decor,* and *distributione*. Vasari referred directly to Vitruvius at least twenty times in the *Vite* and borrowed his modest apologia for writing as an architect (painter). Beyond the obvious utility of Vitruvius and the references to architecture in three of the five definitions by Vasari, there are lexical details as well as similarities of literary structure and syntax that testify to his identification as Vasari's source: "Ordinatio est. . . . Dispositio autem est. . . . Eurythmia est. . . . Item symmetria est. . . . Decor autem est. . . ."[44] Only two of Vitruvius's terms – *ordinatio* and *symmetria* – correspond to Vasari's, and then more by orthography than by content. *Ordinatio* is "the balanced adjustment of the details of the work separately, and, as to the whole, the arrangement of the proportion with a view to a symmetrical result" (1.2.2). The Renaissance translations are only marginally clearer, but it is evident from them that *ordinatione* concerned proportion and composition. The terms of reference (*modo, misura, proporzione, simmetria, disposizione*) are certainly compatible with Vasari's definitions of rule (*il modo del misurare*) and proportion (*misura*). *Ordine*, however, bears no resemblance beyond the accident of orthography. Vasari's use of *ordine* as the classical orders originated with Raphael and did not encroach on the Renaissance translations and commentaries that generally refer to Aristotle's *Metaphysics*.[45] Vasari adapted Vitruvius's *ordinatione* elsewhere in the *Vite*, calling it *ordine* and segregating its meaning from the classical orders, but on the occasion where Vitruvius seems most obviously evoked, he abandoned it. The relation of *symmetria* and *disegno* is even more complicated. On the one hand, they occupy the fourth position in Vitruvius's and Vasari's lists; both were taken to be synonymous by Bernardo Daniello; both produced beauty (*venusta* and *bellezza*, respectively). On the other hand, no reference to imitation, genius, or techniques of copying can be found in Vitruvius's *symmetria*, and it was this aspect of *disegno* that most interested Vasari.

Daniele Barbaro remarked that many Renaissance readers of Vitruvius's definitions thought that "in defining these six things he said the same thing in many ways," a misapprehension he hoped to correct.[46] There is no evidence to suggest that Vasari discovered anything like Barbaro's complex thematic kinships, but at least he grasped the underlying currents of Vitruvius's definitions. When their definitions are considered individually, their content seems very different, but cumulatively the literary structure and flow of ideas is similar. Both sets of definitions addressed related issues: How to structure, organize, reduce, and regulate the parts into a whole; or, in

Vitruvius's words, how to make "an appropriate effect of modules or forms taken from the work itself and from every part of its members . . . a fit assemblage of parts . . . a suitable display of parts in a composition. . . . an emended display of the work composed from the parts."

Source hunting is a risky business, and few have ventured hypotheses in this area, but a small and telling detail in Firenzuola's *Dialogo della bellezza delle donne, intitolato Celso* (1548) suggests that it might be another of Vasari's sources.[47] The evidence is of great philological simplicity. Firenzuola opens the section on grace and charm (*leggiadria*) by first defining its common usage:

> Grace and charm (*leggiadria*) are nothing other than . . . an obser-
> vation of a silent law, as others have said and according to the
> intent of the word itself, given and promulgated by nature to you
> women in your movement, comportment, and use of the body
> as a whole and its particular members, moving with grace, mod-
> esty, nobility, measure, and good manners so that no movement
> and no action would be without rule, mode, measure, or design
> (*regola, modo, misura, disegno*).[48]

The qualities of *leggiadria* that close the sentence (*regola, modo, misura,* and *disegno*) are virtually those terms presented in exactly this order by Vasari to describe the five parts of beauty (*regola, ordine, misura, disegno,* and *maniera*). A few paragraphs later Vasari applied these terms in describing Leonardo's achievement: "good rule (*regola*), a better order (*ordine*), correct proportion (*misura*), perfect design (*disegno*), and inspired grace."[49]

The nearly identical diction and sequence of terms in these two sections suggest that Vasari knew Firenzuola's text and adopted it for some specific purpose. There is one minor adjustment in both passages where Firenzuola's *modo* becomes *ordine*, but this has little semantic significance: Vasari uses *modo* and *ordine* synonymously elsewhere in the *Vite*, as did one of his literary advisors, Giovan Battista Gelli; and the dictionaries by Ambrogio Calepino (published in 1553) and the Accademia della Crusca dictionary of 1612 all defined *modo* by means of *ordine* (and, tautologically, *ordine* by *modo*).[50] The fifth element of Leonardo's work, grace, is contained in Firenzuola's definition by *leggiadria* itself as "the action filled with grace." What was grace (the fifth element) in Leonardo's achievements is style (*maniera*) in the preliminary definitions of quattrocento attainments. (Vasari could substitute grace for style in the Leonardo list because the two were virtually

synonymous.) The significance of Firenzuola for Vasari, especially in terms of a transcendent feminine beauty, will be discussed in the section below, "Historicizing Style."

❧ STYLE AND IMITATION

In Vasari's definition, design and style are virtually synonymous as coexisting kinds of Zeuxian imitation: "Design was the imitation of the most beautiful things in nature. . . . Style then became the most beautiful to have been employed by the frequent copying of the most beautiful things. . . ." Vasari thus attached imitation (*imitare*) to design and copying (*ritrarre*) to style. If he chose his terms with a purposeful intent, then an important distinction may be drawn between the ideal (design) and the natural (style), between selective and uncritical reproduction, between poetry and history, along the lines defined shortly later by Vincenzo Danti.[51] In fact, the distinction is more apparent than real, as both design and style contain aspects of both imitation and copying, with the former taking precedence: style combines (*aggiungerle insieme*) the hands, head, torso, and legs of the most perfect bodies, which is a standard reference to Zeuxis and the Crotonian women; and design transfers or reproduces (*rapporti*) accurately and exactly what the eye sees on the surface. The sequence of presentation in these two sentences thus provides a purposeful symmetry that identifies design with style: imitation/copying and copying/imitation.

Style revolved around imitation long before Vasari wrote his definition and continued to be contained by its orbit long thereafter.[52] Cennini and Leonardo discussed style as the consequence of imitation. Both drew on rhetorical traditions, notably in Aristotle and Cicero, which Cennini absorbed indirectly and Leonardo read firsthand. Because pictorial style often appears as a subcategory of imitation, I may be charged with looking at imitation through the wrong end of the telescope. This is especially true for Vasari, who rarely took style and imitation at parity. Consider, for example, his most complex statement on the subject found in the preface to Mino da Fiesole's life:

> When our artists do not attempt anything in their work other
> than to imitate the style (*maniera*) of their teacher or of another
> master, because their way of working pleases them, whether in
> the poses of figures, or expressions of heads or folds of drapery,

they study these alone. Although with time and study they can achieve similar things, they will never arrive with this alone at that perfection of art since it is readily apparent that one rarely passes the person he walks behind. The imitation of nature is fixed (*ferma*) in the style of that artist whose long practice has become style. Although imitation is the fixed (*ferma*) art of doing precisely that which you must do to understand the most beautiful things of nature, grasping nature directly without the style of your teacher or other artists, who have already themselves reduced to style the things they took from nature. Although it seems that the works of excellent artists are natural or verisimilar, it is not possible ever to use such diligence that one can make the works so similar to nature that they seem to be nature herself; nor can one compose a body so perfectly that art surpasses nature, not even by choosing the best from nature. And if this is true, it follows that the things taken from nature by you make your paintings and sculptures perfect; and that he who strictly studies only the styles of other artists, and not human figures or other natural things, necessarily makes works less well than nature or the works of the artist from whom he has derived his style. When it was seen that many of our artists did not want to study other works than those of their masters, and left aside nature, as it turns out, they did not learn everything possible from or surpass their master, but instead did great injury to the talent they possessed, for had they studied style and natural things together, they would have created more successful works than they have.[53]

This ambitious statement is set against the backdrop of a polemic on literary imitation, best known from a famous exchange of letters between Pietro Bembo and Pico della Mirandola. Vasari sided with Pico when he made imitation dominate style. Whereas imitation examines style, creates and studies it, style submits to imitation and becomes either the object or the product of imitation. Both style and imitation are described as acts: style as a "way of working" and imitation as an "art of making." Although "way of working" and "art of making" both suggest production (*operare* and *fare*) and method (*modo* and *arte*), style is dependent on imitation, clearly not its equal or equivalent. It is either the result of nature imitated or the limitation imposed on the imitation of nature: "Because the imitation of nature is fixed (*ferma*) in the style of that artist whose long practice has become style." This sounds tautological – style determines imitation, and imitation makes style – and even seems to contradict the following sentence about imitation being "the

fixed (*ferma*) art of . . . grasping nature directly without the style of your teacher or other artists."

Vasari used *ferma* twice in successive sentences, perhaps from linguistic fatigue or more deliberatively for reiteration.[54] The repeated *ferma* almost seems to be a sly demonstration of the fixities of style and the kind of repetitive dangers inherent in style discussed above ("*Maniera* and Mannerism"). The first *ferma* suggests an involuntary containment of style as a stable mode of production. The second *ferma* indicates a more selective stance in relation to nature, and hence suggests artistic control. By giving the two *ferma* opposing values, Vasari presents a paradox wherein style limits imitation to itself and imitation proceeds without style. The simple response to the contradictory *ferma* is to note that he merely wanted to differentiate between two objects of imitation – style and nature – and to warn against the dangers of imitating style rather than nature, as Mino did so subserviently with Donatello. A more complicated explanation would refer to the kind of internal contradictions and self-defeating strategies inherent in the making and thinking of style (see "*Maniera* and Mannerism"). The paradoxical *ferma* demonstrates the dangerous similarity of good and bad style, and how easily they are mistaken. Style is the result of imitating nature, which is inevitable, but it can also be the object of imitation, which is dangerous. If an imitator falls short of the thing imitated, then it is better to be a follower of nature than a follower of art. This sentiment, along with its implications for artistic progress, was voiced most strenuously by Leonardo, who envisioned a declining spiral and progressive loss of variety when artists imitate art instead of nature.

ℰℱ HISTORICIZING STYLE

Structurally, Vasari's definition of style serves as a bridge between the collected lives of quattrocento artists in his part two and the prefatory review of cinquecento styles in part three. This liminal positioning typifies most discussions of style throughout the *Vite*. For some reason, Vasari thought that style aptly introduced or concluded ekphrases or descriptions of life events. His three prefaces, where period styles are reviewed, framed the collected lives of artists from each period. The general frames the particular. Because style "reduces" the incidental to the essential, it could serve as a gateway to and from discussions of individual works or

individual artists. Period style is a composite of differing personal styles in much the same way that personal style is a distillation of qualities found throughout an artist's work. Both individual and period styles consist of a repeated, recognizable form; both assume the presence of stable and distinct elements that are found in a large group of works, either the artist's oeuvre or the production of an age.

Just as Vasari used artists' styles to classify individuals into groups and to give history a shape, so too did he use style as a theoretical concept to define essential differences in mentality between two periods. Every reader of Vasari knew that artists' individual styles change with time. What is less obvious, indeed has evaded detection, is that Vasari also knew that concepts of style change with time. In other words, he understood that the theory of style was subject to historical change as much as the practice of style. Because his definition of style limits its meaning to the quattrocento, and because it does not correspond to his usage of style elsewhere, it may not be what scholars believe it to be: a precise statement of the essential nature of style. "Rule *was* . . . Order *was* . . . Proportion *was* . . . Design *was*. . . ." Every English translation and discussion of this passage that I have seen renders the passage into the present tense, possibly with the reasonable expectation that definitions should be written in the present tense. In so doing, these translations (and the interpretations based on them) obscure Vasari's intended meaning.

The past tense of Vasari's definition signaled at least one of two things: either that quattrocento artists had failed to attain their goals of order, rule, proportion, and so on or that the nature of those goals had changed. The first interpretation takes style as an absolute value or qualitative measure; it is a yardstick that can help one judge art from any period. The second takes style as a relative value, redefined to fit changing artistic practices. Patricia Rubin suggests that, while both possibilities may be true, "rule, order, and proportion were important components of Vasari's notion of the 'perfection of art' because to compose a painting, building, or sculpture with due measure was to seek correspondences to the essential forms of nature rather than to copy the accidents of material reality."[55] Vincenzo Danti, on the other hand, accepted only the second explanation.[56] "Rules, orders, and proportions" for him marked the misplaced ambitions of artists before Michelangelo, artists who sought illegitimate first principles. Failure resulted not so much from the artist's inability to apply these principles as from the inappropriate identification of rule, order, and proportion as representational means. Quattrocento artists adhered too literally to rule, order, proportion,

design, and style. In the paragraph that follows his definitions, Vasari systematically undermines the previous set of definitions:

> But although the artists of the second period made great additions to the arts in all these particulars, they still did not attain to the final stages of perfection; for they lacked in their rules (*regola*) a freedom which, while being outside the rules, was regulated by them, and which might be able to exist without causing confusion or spoiling order; which order had need of an invention abundant in every respect, and of a certain beauty maintained in every least detail, so as to reveal all that order (*ordine*) with more adornment. In proportion (*misura*) they lacked good judgment which, without measuring the figures, invests them with a grace beyond measure in the dimensions chosen. In design (*disegno*) there was not the perfection of finish, because, although they made an arm round and a leg straight, the muscles in these were not revealed with that sweet and graceful ease that hovers between the seen and the unseen, as is the case with the flesh of living figures; nay, they were crude and excoriated, which made them displeasing to the eye and gave hardness to the style. The style (*maniera*) was lacking a grace and delicacy that comes from making all figures light and graceful, particularly those of women and children, with the limbs true to nature, as in the case of men, but veiled with a plumpness and fleshiness that should not be awkward, as they are in nature, but refined by design and judgment.[57]

By maintaining the same order of presentation (*regola, ordine, misura, disegno,* and *maniera*), Vasari invites us to judge quattrocento art from the superior perch of cinquecento art. In each part he identified quattrocento deficiencies: "they did not attain . . . , they lacked . . . , they lacked . . . , there was not . . . , the style was lacking. . . ." What they lacked was transcendence: a freedom to break the rules, a grace beyond measure, and a liminal ease. Absence replaces essence. Cinquecento art questioned the constraints of quattrocento rule, order, proportion, design, and style, just as Vasari gives us a set of five definitions in one paragraph only to subvert it in the next. He even embedded this deconstructing of absolutes into the literary structure of his text. Note how he retains the earlier sequence but syntactically varies the sentences so that they lose the clarity and uniformity of the definitions.

Vasari's definition of style is thus revealed to be an interesting case of

indirection. Style *was* design and imitation, but he does not tell us directly what it is now. Rule, order, proportion *were*; now they have gone beyond themselves and artists have transcended them by license. Now they are defined by their paradoxical nature: "being outside the rules, it was regulated by them." Or by their liminality: "between the seen and the unseen." In other words, what we took to be a definition turns out to be only contingent. What was understood to be style, was not exactly style (or was style only for one century, the quattrocento). In this way Vasari sinned against Aristotle's insistence that writers of definitions should "take care not to become involved in equivocation."[58] The displacement of style may contribute to an impression, held by Gombrich, of the "metaphysical fog which settled over the discussions of art in the sixteenth and seventeenth centuries."[59]

What then *is* style? Cropper has gone a long way in answering this question with her analysis of beauty.[60] What Gombrich saw as "a metaphysical fog" arose from tensions within his history and from a tendency to naturalize and idealize beauty as a standard outside of time. Cropper suggests that we should attend to the literary conventions of beauty (and, hence, implicitly Vasari's *maniera*), and most particularly to its affective appeal to the beholder. What was taken as "fog" is actually the means of attraction. Gombrich sought some of the objective, natural, nontemporalized order that Vasari defined as quattrocento style and was not fully prepared to receive the affective stylistics of Vasari's and post-Vasarian theories. Quattrocento art attained commensurate beauty, which was superseded by the ineffable beauty of cinquecento art. When Vasari claimed that quattrocento style relied on rule, order, proportion, and design to define the parts and join them into a whole, he caught a dominant thrust of fifteenth-century art theory that was, according to Martin Kemp, "devoted to the promotion of a set of principles which lay beyond the vagaries of individual style."[61] Alberti distrusted individual talent (*ingegno*) and preferred to quantify beauty by means of perspective and proportion. As Vasari's rule, order, and proportion suggest, the controlling mechanism was articulate and quantified; style, as the expression of beauty, could be arranged by number or proportion. Quattrocento style was, in other words, an *ars*, and for this reason it appealed to Gombrich's rhetorically grounded definition of style.

What modern artists had that quattrocento artists lacked was *licenza*, an ability to question the rules and destabilize traditional orders.[62] Artists

were not bound by rules, yet their work was ordered by rule; they used measure, yet produced works "beyond measure." In design, they produced things "that appeared between the seen and the unseen" (*fra 'l vedi e non vedi*), in contrast to quattrocento design, which "requires a hand and talent to transfer everything which the eye sees" as if fifteenth-century artists were only concerned with the visible. Modern artists go "beyond" rule, order, and measure (Vasari uses *oltre* three times). What strikes me about all of these statements is their elusiveness, as if Vasari did not quite know where to place modern rule, order, and design; or, to be more exact, as if now, in the sixteenth century, they had no particular or constant place. Their defining characteristic seems to be their ineffability. Vasari might have read about transgressing rules in ancient rhetoric and poetics or in Renaissance architectural discussions on license.[63] License has paradoxical applications much like style. For Vasari, it allowed Michelangelo to create a "new nature" and modern artists in general to achieve perfect beauty, and yet at the same time it encouraged artists to adopt "fantastic ornament . . . more of the grotesque than of rule and reason," thereby initiating art along a declining path.

Grace (*grazia*) is another key term here, even taking precedence over license. Vasari mentioned it twelve times in this short preface in relation to cinquecento art, but never in relation to the quattrocento. In fact, he specifically excluded it in referring to fifteenth-century paintings because they "lacked that graceful and sweet ease." Vasari used "grace" in various ways: as an inner quality of the artist, as an outer movement of the body, as an animating quality, and as a unifying quality. In the preface, grace was most consistently juxtaposed to quattrocento study. Verrocchio and Pollaiuolo tried to improve their art "by more study" (*più studiate*); a few sentences later, he tells us that quattrocento artists "could not readily attain [grace] by study," that their work had a dry, crude, and cutting style (*maniera secca e cruda e tagliente*) because of excessive study.

Style and grace were bound together in art literature with theology, etiquette, and social manners, as Richard Spear shows in his elegant history of grace.[64] Raphael or his presumed amanuensis, Castiglione, in their famous letter to Pope Leo X, a letter known and used by Vasari, tied style and grace together as qualities absent from Gothic architecture: *privi d'ogni gratia, senza maniera alcuna*.[65] In modern art historiography, from Weisbach to Weise to Shearman, the concept of artistic *maniera* was thought to signify "courtly grace" and hence be "borrowed from the literature of manners, and had been originally a quality – a desirable quality – of human deportment."[66] Style as grace originated in French literature of the thirteenth and fourteenth

centuries to indicate someone who had grasped and embodied a social code for stylish comportment. It did not enter Italian literature until the mid-fifteenth century and became quickly immersed in the Florentine culture of Vasari's youth: "If you walk, stand or sit, always do so with style."[67] With its adoption by Castiglione, it entered mainstream Italian culture.

Grace was often gendered and associated specifically with female beauty. More than any other scholar, Cropper has shown us how pertinent Firenzuola's and Dolce's definitions of female beauty are to cinquecento ideas of pictorial beauty.[68] My purpose here is a more limited one: to show how Firenzuola's structure of commensurate and incommensurate beauty could have helped Vasari to structure his own ideas on quattrocento and cinque-cento style. Like Vasari, Firenzuola distinguished between conventional ideas of commensurate beauty and his personal view that beauty is a transcendent quality that escapes the determinacy of measure. Ineffable beauty is, in his words, a "silent rule" and "unwritten" that eludes language and reason; it is "neither known by reason nor can it be produced by reason . . . neither can it be taught in books nor known in general practice."[69] He points to a certain Lucrezia, who "has everything necessary for *leggiadria* and therefore she pleases everyone even though her actions perhaps lack some trifling thing according to the measures of those meticulous artists (*disegnatori*). . . ."

Firenzuola defined *grazia* and *vaghezza* by their elusiveness. Grace is "that occult way to make a certain union of various parts of the body which we know not how to describe."[70] Its proportions are hidden and defined in no text. Indeed, the beauty of grace transcends proportion, making it possible for a woman who lacks canonical proportions to have grace anyway: "this splendor [is] born from a hidden proportion and from a measure that cannot be found in our books and which we do not know and cannot even imagine. And so it has, as with things that we cannot explain, an 'I don't know what' (*un non so che*)."[71] The indeterminate quality of grace, when it appears as the related *vaghezza*, makes the mind wander, and desire its beauty. Firenzuola's explanation of *vaghezza*'s etymology – *vagare*: to wander and *desiderare*: to desire – was adopted by Lomazzo to describe beautiful movements and served the Crusca editors for their first edition of the *Vocabolario* of 1612.[72]

The vagabond qualities of *vaghezza*, like Firenzuola's *grazia*, derived from the Aristotelian conventions of women as inconstant, vacillating, and unstable.[73] These survived in many forms, none perhaps as mordantly elaborated as Michelangelo Biondo's protracted analogy of women to amorphous smoke.[74] In the *Metaphysics* Aristotle attributed to the Pythagoreans a table of opposites that located male and female among other hieratically structured

dualities: unity/plurality, right/left, odd/even, stable/mutable, determinate/indeterminate, and good/evil.[75] Inevitably, women were assigned to the sinister, odd, multiple, transitory, and evil side. What Firenzuola did, and he is not unique in this, was to transform a traditional defect into a virtue. What the Aristotelian tradition identified as vague, indeterminate, and unbounded, and hence feminine matter (in contrast to the clear determination or definition of masculine form), Firenzuola adopted to contrary effect. Instead of establishing them as the defects of women, he finds them to be precisely those qualities that make her beauty superior to man's. If beauty (which is grace and style) is incommensurate, and if it escapes reason, measure, and verbal description, then Firenzuola undermines the Aristotelian tradition that man is the embodiment of reason and hence is superior to woman, who has no reason. Instead, woman possessed a beauty beyond reason that eluded man's verbal net.

Firenzuola's play on two notions of beauty (the proportionate and the ethereal) might have appealed to Vasari. Donna Lucrezia "lacks some trifling thing (*cosellina*) according to the measures of those meticulous artists," and yet she has *leggiadria*. Those "meticulous artists" sound very much like Vasari's version of quattrocento artists who "lacked that visual judgment which, disregarding measurement, gives the figures . . . a grace that simply cannot be measured."[76] The limiting and normative *regola, modo, misura*, and *disegno* are important for Vasari as qualities to be superseded before the true beauty of *leggiadria, grazia*, and *vaghezza* can be attained. The transcendence of proportion as the basis of beauty in both Firenzuola and Vasari must be understood in relation to a misrepresented tradition that found them to be coextensive. Pietro Bembo states the conventional view thus: "Beauty is nothing other than a grace born from proportion and decorum, and from a harmony of things . . . since a body is beautiful because its members adhere to a proportion in relation to each other, so too a soul is beautiful to the extent that its virtues harmonize with each other."[77] Firenzuola devoted several pages to the intellectual history of beauty and noted several key authors (Plato, Aristotle, Cicero, Ficino) who allegedly stand behind this position.[78] By historicizing contemporary attitudes on beauty and assigning to the past an allegiance to the idea of proportion, Firenzuola is able to claim originality for his definition of incommensurate beauty. Actually, the rejection of proportion could have been known to Firenzuola from a wide variety of sources, mostly theological, but the most immediate context for his work would have been other treatises on women and love. In Leone Ebreo's *Dialoghi d'amore* (Rome, 1535; written in 1501), a philosophical tradition of

beauty ("many philosophers have defined it in this way") and a more popularizing tradition assigned to an anonymous "many" are hypostasized in order to differentiate commensurate beauty from his more transcendent definition of beauty as spiritual grace: "If well considered, beauty, although found in proportionate and harmonized things, will be found to be beyond its proportion."[79] In the *Libro della beltà e grazia* (written between 1543 and 1553), Benedetto Varchi also places in the past an equation of beauty with proportion: "And these [earlier writers] say for the most part that beauty is nothing other than the correct proportion and correspondence of all the parts."[80] His purpose, like Firenzuola's, was to juxtapose the corporeal, commensurate beauty of "Aristotle and the others" to his own, higher spiritual beauty.

By associating the two levels of beauty with a historical progression in art from the quattrocento to the cinquecento, Vasari stands clearly in the overlapping literary traditions on beauty, love, and women that are here represented by Firenzuola, Ebreo, and Varchi. Literature on art offered little in this area. As Vasari defined them, modern artists questioned precisely that tradition of Alberti, Dürer, Piero della Francesca, Pacioli, and others who wrote on proportion and perspective as the twin pillars of art. The quattrocento penchant for measurement is also well known from transcription devices like Alberti's pointing device or sinopia enlargement grids, or from Brunelleschi's perspective experiments and measuring expeditions to Roman antiquities, or from the *marzocchi* among other mathematical ruminations by the obsessive Uccello. Vasari probably learned to be skeptical of their commensurate ideals from Michelangelo, but with an essential difference: Michelangelo viewed the problem as an artist while Vasari contextualized it as a historian, thus giving a historical structure to an artistic problem.[81]

Vasari's purpose in subverting his own definition is to show how style as a concept as much as a practice is historically contingent. Style as a visible form was well known to be the most reliable indicator of historical change. Vasari realized, however, that if the practice of style changed with time, so too might the concept itself, and that it might change in ways that mirrored the styles of the historical periods to which they were attached. The structure of Vasari's definition is a manifestation of methodical dissection of a whole into its component parts that he took to be characteristic of quattrocento art. In other words, the division of quattrocento achievement into five parts partakes of the quattrocento spirit that is so concerned with the parts and how to unify them. Their success was

compromised by an unrelenting focus on detail and on division more than on unity. Quattrocento style was deemed hard and dry because artists attended too closely to the parts and to the precise measure. In other words, the mode of presentation that Vasari chose for his definition carries both the strengths and weaknesses of the art it describes.

Vasari also borrowed from rhetoric the conventional duo of *ars* and *ingenium* in order to differentiate and historicize quattrocento from cinquecento styles and concepts of style. These alternative sources of making speeches (and making art) are interdependent and represent two concepts of style that Vasari used as his organizing nexus: *ars* and *ingenium*.[82] Quattrocento artists lacked the grace and transgressive license to break the quantifiable norms of rule, order, and proportion that correspond to *ars*. "That certain something" and "resolute boldness . . . and supreme grace" eluded their method of "correct proportions" and "study." Vasari's intention, however, was not simply to demonstrate the superiority of *ingenium* over *ars*, as Lomazzo and Armenini did with their more articulate and universal judgments. Instead *ars* and *ingenium* created a historical dialectic underpinning the mechanism of period shifts from the trecento (*ingenium*) to quattrocento (*ars*) to cinquecento (a fusion of the two, with *ingenium* leading the way). Giotto, father of trecento art, had no *ars* or good models available to him, and so he had to rely on nature both as a visible model to copy and as innate talent. The adherence to rule, order, and measure allowed quattrocento artists to rival nature and attain a degree of commensurate beauty, but there were consequences to and inherent limitations of working by rules. "Study . . . gives dryness to style" in general, and it did in particular with Paolo Uccello, whose talent dried up and made his style labored and hard as a consequence of undue attention to an important aspect of *ars* (perspective): "Whoever follows [the matter of perspective] beyond moderation wastes time, exhausts his natural powers (*natura*), and fills his talent [or mind: *ingegno*] with difficulties . . . and makes his style dry and angular, which comes from wanting to treat things too minutely and in excessive detail."[83] History proceeds from period to period, perface by preface, in a dialectical progression.

What is conspicuous about Vasari's definitions of design and style is the silence about character, talent, imagination, judgment, and other epistemological questions. How does an artist recognize the "most beautiful things of nature," and how are those beautiful parts transformed into "a figure with all the beauties"? His five definitions omit the artist from art. Rule, order, measure, design, and style seem to be immutable principles, commensurate and invariable, that operate independently of who applies them. The absent

artist may be accidental, a consequence of those sources that he chose to follow, but it could also be intentional. Certainly Vitruvius and Firenzuola gave Vasari a convenient, conceptual structure within which to situate style, but the fact that they had little or no need to discuss artistic sensibilities and differences also helped him demonstrate an essential point about quattrocento painting. By absenting the artist, Vasari could draw attention to the strengths of quattrocento painting – its objectivity, stability, and commensurability – as well as to its weakness – a dry allegiance to the literal. With cinquecento painting, Vasari introduced, or in some cases magnified, the spiritual, creative, and animating qualities of making art, qualities that are inherent in an artist's talent and character.

NICOLAS POUSSIN AND THE RHETORIC OF STYLE

Polysemous style provided fertile ground for confusion and ambiguity. Vasari turned to history to resolve one of style's dichotomies: a commensurate *ars* or an ineffable *ingenium*. Grammar provided a second solution: *maniera* is ideal beauty; *di maniera* is a formulaic degradation of that beauty. The preposition *di* both calls attention to their precarious proximity and tries to cordon them off. Poussin solved the problem of polysemy even more directly by labeling different aspects of style with different terms (*stile* and *maniera*).

Vasari defined style as grace and ideal form. Artists exercised relatively little control over the circumstances that might affect their attainment. History and psychology were more powerful determinants than education and self-will. Quattrocento conceptions of style, according to Vasari, misrepresented artists' ability to manipulate beauty by external or rational means. They misunderstood beauty as being limited to the perceptible (nature), the commensurate (proportion), and the articulate (rules), and, believing in control, they ignored the spiritual or transcendent means of grace and genius. Quattrocento artists were thus caught in the paradox of diligence, made famous by the frustrated Protogenes, who worked laboriously and hopelessly to represent exactly the saliva on a horse's mouth. When diligence failed him, he threw a sponge at the picture and the resulting splatter depicted the foamy mouth perfectly. Thus he succeeded only by relinquishing control. Diligence turned out to be a self-defeating strategy as much for quattrocento artists as for Protogenes.

Whereas Vasari relegated the orderly control of style to the past, Poussin embraced its regulated aspects when he defined it in terms that recall Vasari's quattrocento measuring of style: measure (*mesure*) and fixed order

(*ordre*).[1] Poussin returned *maniera* to the realm of *ars* and reinvigorated discussions of style as a servant of content. What is noticeably absent in Vasari's definition and most of his stylistic analyses is how style suits the subject. Dolce's critique of Vasari revolved around questions of decorum, or finding the suitable style or form for the figure or narrative to be represented. Dolce denied that a single beauty exists, applicable to all situations, even if it is as great as Michelangelo's, because the beauty of each form depends on it being a fit expression of the subject. It is this question that concerned Poussin.

Giovan Pietro Bellori published Poussin's definition of the *maniera magnifica* along with other miscellaneous notes (*avertissements*) on painting that Poussin had collected, probably as part of a planned book on painting. By 1651 Poussin had abandoned this project because, by his account, it was like bringing water to the ocean.[2] Despite his protestation, he probably continued writing after 1650.[3] What remains does not constitute a coherent theory but fragmentary thoughts, assembled and edited by Bellori, much like his letters to friends and patrons, or the conversations paraphrased by friends and acquaintances. It might be this episodic literary form as much as the content that led Bellori to describe the notes as written "in the style of Leonardo da Vinci."[4] There are benefits and losses to having his thoughts survive only in note form. On the one hand, notes and letters impose a discontinuity of ideas. Written over many years and untouched by any obvious editorial ordering, the notes lack an internal textual unity and, as his interpreters, we should be wary of creating an artificial consistency to his literary legacy. What we have lost in textuality, however, we gain in intertextuality. In a remarkable piece of textual detection, Anthony Blunt identified many of Poussin's sources, including Quintilian, Torquato Tasso, Lodovico Castelvetro and Paolo Arese, and Agostino Mascardi.[5] In other words, Poussin defined style from within the traditions of rhetoric, poetics, and historiography, not art theory, criticism, and so on. His main source was *Dell'arte historica* by Agostino Mascardi, one of the most popular, if not the most popular, book on historiography of the mid-seventeenth century.[6] Interest in it merited the publication of four editions (Rome, 1636; Venice, 1646; Venice, 1655; Venice, 1674) and a book-length critical review by Paolo Pirani in 1646, *Dodici capi pertinenti all'Arte Historica del Mascardi*.

> Of the various forms of the **grand style (*maniera magnifica*). Of subject matter (*materia*), of conceit (*concetto*), of structure (*struttura*), and of style (*stile*).** The grand style consists of four things (*cose*): the subject or theme (*materia overo argomento*), the

conceit, the structure, the style. The first thing, which is the foundation for all the others, is **that the subject should be great as would be battles, heroic actions, and divine things**; but, the material that the painter is working on, being grand (*grande*), the first piece of advice is that the artist should stay away, as much as possible, from **trivial things (*minuzie*)** so as not to contravene the decorum of the story, passing over quickly the great and magnificent things (*le cose magnifiche e grandi*) only to become lost in the vulgar and frivolous. It is appropriate for the painter not only to have the art (*arte*) to give to the subject and to select from it that which by its nature is most amenable to every ornament and perfection; but those who select base themes (*vili*) do so because of the weakness of their talent (*ingegno*). . . . As for the conceit (*concetto*), this is **purely born from the mind**, which inexhaustibly explores the subject; this was the conceit of Homer and Phidias in which Jupiter moved the universe with a gesture. It is, however, the design (*disegno*) of these subjects that expresses the conceits. The structure or composition (*la struttura o composizione*) of the parts should not be sought studiously, nor entreated, nor labored over, but should be similar to nature. **Style (*stile*) is a particular and diligent manner (*maniera*) of painting and drawing born from the particular genius (*genio*) of each painter in his way of applying and using his ideas; this style, manner or taste (*stile, maniera o gusto*) comes from nature and talent (*ingegno*).**[7] [The passages that Poussin lifted from Agostino Mascardi's *Dell'arte historica* are printed here in bold.[8] They will be discussed in the following section.]

Poussin's interest in the "grand style," however characteristic it may be of his own pictorial ambitions, was also a means to discuss style in general. His strategy of definition resembles the one we will meet with Boschini – both take a favorite kind of style and transform it into style itself – except that Boschini's definition quickly vanished from sight and Poussin's was eventually canonized in the Crusca Vocabolario where, in the 1747 edition, *maniera* is newly defined as *grandiosità*.[9] Structurally there are similarities with Vasari's definition of style. The "grand style" is divided into four "things" (*cose*), each defined separately, with style (*stile*) closing the list: subject matter, conceit, composition, and style. However, what those "things" are, how they relate to each other, and how style is defined are strikingly different. Vasari dealt with visible form, the structure of beauty, and the process of selecting and combining forms. No mention of subjects was made. In Poussin's definition, subject matter serves as the "foundation" for the conceit, composition, and style. In Vasari's definition,

the five "things" overlap in meaning and are presented as an evolving sequence, with style as the culmination and consequence of the preceding qualities. They are a means to an end ("a beautiful style") that the artist can control by rule and proportion. The four "things" in Poussin's definition also follow a progression (albeit a thematically different one from Vasari's) from the internal to the external, the conceptual to the visible. *Materia* is literary, existing only in the artist's mind as words and ideas. *Concetto* is both conceptual, "purely born from the mind," and visible, and hence mediates between the two.[10] *Disegno* "expresses the conceits" and thus draws on its traditional function as a bridge between mind and senses, ideas and forms. *Struttura* involves the composition of parts into a whole and seems to be purely visual or, at least, encompassing the entire area of Vasari's five "things."

The sequence of presentation (*materia, concetto, struttura*) corresponds to the successive stages in Poussin's creative process as described by Sandrart: "When he was planning some work, he read carefully all the available texts and pondered over them. Then he made a couple of sketches of the composition on paper. . . ."[11] *Stile* does not easily fit into this progression since it is presented as a precondition or constant inclination that affects all the other acts. Coming last, one might assume that *stile* should also be purely visual, but in fact it occupies a liminal state comparable to *concetto*: both are "born" from the mind (conceit) or genius (style); both "express" or "apply" the interior ideas, presumably giving them a perceptible form.

Poussin's four "things" resemble in their order and content the standard division of painting into invention (*materia*), design (*concetto* and *struttura*), and coloring (*stile*). The resemblance is closest for "subject matter" as the literary invention. The creational imagery that Poussin attached to "conceit" is reminiscent of Vasari's discussion of *disegno* as preexisting Creation and as the master plan for "the creation of all things when Almighty God [made] the vast expanse of the universe." Poussin likened the creative function of conceit, "born (*parto*) of the mind," to the "gesture" that Jupiter used to "move the universe." Composition is listed as a separate category but was taken to be a part of *disegno* by Vasari. This leaves style occupying the place of coloring, much as in rhetoric *elocutio* and *locuzione* were metaphorized as color.[12]

✒ Misprision by Nomenclature

Poussin's use, and more pertinently his misuse, of Mascardi is both cunning and revealing. What his sources were and how

he read them tell us more about his true interests than his actual words, which, in any case, were not always his own. Art historians have accepted Blunt's discovery of Mascardi as Poussin's source with equanimity and alacrity, as if Poussin's thoughts had been opened simply by identifying a source.[13] I do not mean to suggest that Mascardi's importance for Poussin has been neglected – Genevieve Warwick and Anthony Colantuono have effectively employed his historiography to explain the rhetoric of Poussin's history paintings[14] – only that the relation between Mascardi's "Digression on Style" and Poussin's definition has been viewed more as a passive absorption or an idle reworking than as a thoughtful intervention.

Mascardi defined style through a process of elimination. He stripped it of its rhetorical meanings in order to conclude that style in historiography most resembles style in art: an individual expression of an artist's character and talent, not a standard rhetorical category. Initially his approach is lexical. Etymologies of *stylus* and prevailing views on *locuzione* and *carattere* are reviewed and rejected because they predicate a writer's control over his style. (Mascardi gave no place to women writers.) *Stile*, he tells us, derives from *stylus*, the sharp end of a writing instrument whether pen or chisel, which captures metonymically the essence of writing: creation (the sharp end) and emendation (the blunt end).[15] The *stylus* obeys the writer. A similar fate awaited *locuzione*, because it individuates form only in relation to content, not the writer.

Carattere should have opened the door he sought – "a certain particular quality" uniquely expressive of the writer – and he did briefly consider its etymology as "a spiritual sign impressed on the soul by God."[16] However, this facet of *carattere* was quickly dropped in favor of rhetorical *caratteri* or "genres of style" as defined by Demetrius and Hermogenes, the two most technical and mechanistically prone ancient authorities. With the help of Demetrius's and Hermogenes' more famous exegetes (Paolo Arese, Francesco Panigarola, and Pier Vettori), Mascardi showed how the three *caratteri* may vary in terminology (*maggiore, mezzano, minore; sublime, temperato, tenue*; etc.) and may vary in the attributes assigned to them, but they always derived lexically and functionally from types of subject matter. By narrowing its meaning, he limited its explanatory function. Rhetorical *caratteri* are like the compass points of the four winds: they give clarity and order to meteorological/stylistic discussions, but in reality the wind rarely blows exactly along these cardinal axes, just as in practice style never conforms entirely to rhetorical categories. Thucydides, for example, may have tried to point his stylistic compass along a certain axis, but it always tilted toward the *grande*,

even when a delicate subject demanded that he tone it down. It was this kind of empirical observation of writers that led Mascardi to conclude that *carattere* "addresses art and study" but style "derives from nature and talent."[17] Theory wants *ars* to guide *ingenium*, but in practice, talent dominates art. Style for Mascardi was the deviation of practice from the cardinal axes of theory.

For validation that style is "a particular and individual manner of talking and writing," Mascardi turned first to "everyday" experience in viewing paintings and sculpture where "a certain individual style" distinguishes one master's work from all others, where an expert can attribute a painting having seen only a detail of it.[18] Mascardi then cited a higgledy-piggledy list of exemplary painters whose work can be sorted and classified by a nonspecialist audience: Raphael, Correggio, Parmigianino, Titian, Cavaliere d'Arpino, Reni, Lanfranco, and Pietro da Cortona. Actually this is not the random selection it first appears to be. It proves that great art depends on a broad spectrum of talents. No single style monopolized art; no easy categories like classicism, Mannerism, or baroque can define good or bad taste.[19] Mascardi credited Cicero with the strategy of listing painters as proof of the individuality of style, thus situating himself within and advancing the cause of seicento Ciceronianism.[20] He asks us to consider this phenomenon: how one artist will always impose "delicacy" onto his figures (Mascardi listed no women painters) while another will always make figures with "a resolute and virile style"; how one artist endows young boys with the ferocity of Ippolito, but another transforms all women into amazons. By showing that artists apply gendered styles (delicacy and virility) to figures of the wrong sex, he does not mean to malign the artists – in fact he praised them as excellent – but to identify an inevitability. Artists cannot sublimate themselves to the content because talent and genius will always intervene. To ask a writer "What style do you write in?" presumes a choice when in fact little exists.[21]

This brings us to a curious misprision. Mascardi imported into his rhetoricized historiography a concept of pictorial style in order to redefine literary style. He was then manipulated by a painter (Poussin) to justify a conventional literary concept of style for painting. The strategy of differentiating two types of style – one individual, another categorical – and labeling them with different terms was not Mascardi's invention, but he did reverse the standard nomenclature by adopting an artistic one instead. Poussin did the same in reverse by adopting a literary nomenclature. For Mascardi and his readers, *stile* was the dominant term; for Poussin and other painters,

maniera was the dominant term for artistic style, possibly by virtue of its etymology (*mano–maniera*).[22] Mascardi used painters and sculptors to validate his idea of style; Poussin used historiography, rhetoric, and poetics for his. Poussin suppressed individual style by accepting Mascardi's terminology of *stile* without, however, agreeing with Mascardi's conclusion. Poussin redefined style by co-opting the literary meaning of style as a mode while retaining the artistic terminology of *maniera*. The displaced concept of individual style of talent, nature, etc., is then labeled with a minority term (*stile*).

The question that concerned Mascardi and Poussin was whether style is a product of art or a by-product of the artist's character? Is it rhetorical or psychological? Elizabeth Cropper and Charles Dempsey have shown how cannily Poussin as a painter manipulated style for expressive and ethical purposes.[23] I aspire to a more limited proof of their conclusions by asking how Poussin's theories of style justified his artistic practice. By defining *maniera* as a rhetorical category that depends on the subject for its form, and by defining *stile* as natural talent, Poussin exploited linguistic practice in art literature by reversing their conventional meanings. *Maniera* conventionally signified those qualities individual to the artist, products of talent, genius, or the imagination. Mascardi understood this when he switched to artspeak and used *maniera* consistently instead of *stile* while discussing pictorial style: "One can, I believe, compare the style (*maniera*) of painters to the style (*stile*) of writers."[24] Mascardi accepted *stile* as the legitimate term of reference for discussion of literary style; his goal was to redefine the term. Poussin, on the other hand, accepted the meanings of pictorial and literary style but transposed the terms that normally were used to designate these different meanings. He argued by nomenclature. Literary *stile* became pictorial *maniera* in his hands; and, concurrently, he marginalized the traditional concept of pictorial style as an individual form by assigning to it the marginal term of *stile*.

This is a clever, even devious, strategy, but was it effective? Was Poussin's nomenclature adopted by other critics? Was it even consistent with his own usage? Sadly these questions must be answered with a resounding "no." Bellori was typical in adopting a syntax that identified *stile* as synonymous with *maniera*: "he followed the *stile* of Caravaggio with its strong and shaded *maniera*"; and "the attack of Polyphemus was animated with the most grand and vehement *stile* . . . but, besides the grand *maniera*, Annibale [Carracci] set aside the example of forceful action described by Leonardo."[25] In his life of Poussin, Bellori even reversed Poussin's terminology and used *maniera* as individual style and *stile grande* as the subject genre that he worked

in; and he assigned Poussin's work in the Long Gallery of the Louvre to the stylistic category of the grand style, except that he called it the *stile magnifico*.[26] Bellori also attached *stile* indiscriminately to subject-based pictorial styles that borrowed their names from poetics much as Poussin's *maniera magnifica* came from rhetoric.[27] Although *stile* and *maniera* often appeared together in a single sentence or successive sentences simply as a means to vary diction and avoid repetition, there were instances where they were clearly differentiated.[28] The art dealer Paolo del Sera individuated *stile* and *maniera* as personal and generic style respectively but reversed the terms of reference employed by Poussin.[29] Bellori also distinguished between the meanings as Poussin did, but did so only rarely.[30]

Panofsky claimed that Poussin applied the term *stile* to painting for the first time and that only thereafter was it used to describe individual style.[31] This view was corrected by Dempsey, citing examples by Delminio and Castiglione as evidence, but this has not dissuaded others from maintaining Panofsky's position.[32] However, behind Panofsky's misjudgment was a grain of truth: before Poussin, writers applying *stile* to painting tended to be literary critics or philologists (Pietro Bembo, Baldassare Castiglione, Pietro Aretino, Domenico Fiorentino, and Giulio Camillo Delminio). And it is certainly true that *stile* became significantly more popular in the late seventeenth and early eighteenth centuries.[33] Whereas the literati's use of *stile* might be discounted as a kind of verbal habit, transferring the dominant term in literature to art, by the early eighteenth century it had entered the mainstream of art writing. Poussin's influence and the robust afterlife of Bellori's *Vite* can account for some of this. It might also reflect how style became increasingly rhetoricized in the settecento, or how writers after Poussin felt an ever-greater need to separate style from the pejorative associations that had accrued to *maniera*. Baldinucci's invention of *ammanierato* in 1681, for example, addressed the need to save *maniera* from stylization. *Stile* represented at least a neutral ground for style, or possibly a higher ground validated by literary theory.

✧ THE GRAND STYLE

The "grand style" (*magnifica, grande, eroico, grave, sublime,* or *maestoso*) was an importation from rhetoric, poetics, and historiography.[34] Although art critics rarely acknowledged this fact,[35] and even Poussin disguised the origins of his *maniera magnifica* by not citing his sources,

they did transfer to painting its rhetorical roots. Subjects painted in the "grand style" included, according to art writers, apostles, strongmen, miracles, tragedies, and especially battle scenes, just as Demetrius and Mascardi prescribed and Poussin reiterated.[36] In this respect Poussin's definition theorized contemporary art-critical practice. Ancient and Renaissance rhetoric deemed the grand style to be the most persuasive – overpowering the will of listeners – and also the most difficult to master. Cicero likened it to "the roar of a mighty stream," holding the "power to sway men's minds and move them in every possible way"; for Quintilian it was "like some great torrent that rolls down rocks and 'disdains a bridge' and carves out its own banks for itself; [it] will sweep the judge from his feet, struggle as he may, and force him to go whither it bears him."[37] It was thought to carry the majesty of the Roman people.[38]

In Italian art criticism, the grand style never acquired the resonance it did in France as a political and aesthetic signifier.[39] It did, however, provide one term of reference for a persistent controversy initiated by Vasari over Raphael's putative debt to Michelangelo.[40] Much like the logomachia over Raphael's "stony style," critics fought over the title of the "grand style" as part of their attempt to establish a canon with absolute standards. Because it was granted authoritative status as the style of antiquity, Bellori reserved it for painters like Raphael, Domenichino, Sacchi, and Poussin.[41] Other writers, however, did not think of it so restrictively, finding instead an unpredictable cast of characters that included Raphael, Giorgione, Palma Vecchio, Michelangelo, Bronzino, Veronese, Tintoretto, Annibale Carracci, Domenichino, Pietro da Cortona, Poussin, and Solimena.[42] Clearly any style that contains Raphael and Tintoretto or Poussin and Solimena was not conceived according to modern conceptions of classicism.

Poussin's use of the "grand style" to exemplify and define the relation of style and subject cannot be set aside simply as the consequence of using Mascardi as his source, thus relegating it to the category of historical accidents. Defining style by its highest form, "highest" by the writer's standards, was a strategy not limited to Mascardi. Orfeo Boselli also used the "grand style" to exemplify style in general, and Antonio Franchi used the *gran maniera* to exemplify perfection in painting nude figures.[43] Poussin's *maniera magnifica* was similarly motivated. It was not just one of several possible stylistic genres; it was *the* genre, the greatest, most difficult, and potentially most dangerous of the rhetorical styles.[44] Exemplary, elevated, and noble, it gave the greatest range of stylistic expression, certainly more than the styleless "plain style." As the most elevated form, it best suited Poussin's aspirations

as an artist. Most of his paintings can be classified within the magnificent, by the criterion of either theme or subject. His patrons even thought of it as Poussin's personal style in which he always worked. When he painted in a more florid style, his clients could object. Jacques Stella was unhappy that the *Rinaldo and Armida* he received from Poussin (now lost) seemed too soft (*mol*) and lacked the severity of style of the *Camillus and the Schoolmaster of Falerii* (Paris, Louvre).[45] Evidently he thought Poussin always tended toward the severe rather than the soft. Chantelou was similarly disturbed that the *Baptism* he received was too soft (*trop doux*) in comparison to the other Sacraments.[46] In his defense, Poussin cited Traiano Boccalini's best-seller *Ragguagli di Parnaso*, where no less an authority on the arts than Apollo himself is given the role to defend sweetness (*douceur*) as a "friend of nature."[47]

As Duquesnoy's friend and pupil, Orfeo Boselli could have offered Poussin another explanation, when in about 1657 he defined the grand style as a form of "exquisite taste" that manifests itself in

> sweetness and tenderness, which consists in knowing how to hide the bones, nerves, veins, and muscles; in keeping one's eye to the whole and not the parts – something so difficult that only to the ancients was conceded the great marvel of seeing a figure consummately beautiful, with everything and with nothing being there. . . . The more they remove the grander the style becomes, for by so much the more does a sense of flesh increase as the hollows become less deep; and they substitute for the muscles something that seems a vein. It is an artifice beyond the supreme, and of surpassing difficulty.[48]

Poussin strove toward this exquisite minimalism of the grand style where "the more [sculptors] remove the grander the style becomes," believing in both its aesthetic value and its utility in visually referencing his admiration of ancient art; and yet he still worried that the formal vocabulary of "sweetness and tenderness" would be misinterpreted. His need to justify his "soft" style to Stella and his "sweet" style to Chantelou suggests a certain defensiveness when it came to styles more loving, intimate, sensual, and feminine than the violent, heroic, and masculine "grand style." To paint softly or sweetly brought together conflicting feelings of pride and fear. On the one hand, sweet and soft paintings demonstrated his ability to change style at will; on the other hand, it could lead viewers, even learned ones like Stella and

Chantelou, to believe that this was his usual personal style, an identification he wished to avoid. In other words, the conflict faced by Poussin involved two opposing concepts of style: should he be rhetorical and paint in a style appropriate to the subject? or should he think of style as an extension of himself, expressing his character? He was torn between what he believed intellectually (*maniera*) and what he thought others believed (*stile*).

Softness and sweetness, virtually interchangeable in art criticism, were usually terms of praise and had been applied to Leonardo, Raphael, del Sarto, Giorgione, Rosso, Beccafumi, Parmigianino, Taddeo Zuccaro, Titian, Barocci, Annibale Carracci, Albani, Reni, and Sacchi.[49] Normally soft and sweet styles were taken as signs of artistic progress over harder and coarser styles (*duro, aspro, rozzo, crudo*). And yet by the mid-seventeenth century some critics began to wonder whether the advance toward sweetness had not gone too far.[50] Guido Reni did more than any other artist to brighten seicento palettes with a liberal use of white, a conventional attribute of sweet styles, thus contravening "his master Lodovico Carracci who advised him to think for a whole year before using one brushstroke of white."[51] Malvasia saw the generational change from Ludovico Carracci to Reni, from master to pupil, from *forza* to *dolcezza*, in conflicted terms.[52] On the one hand, he tried to justify it as a conventional sign of progress by likening Reni's position historically to that of Veronese in cinquecento Venice, postulating that a drift from *fierezza* into *delicatezza* was inevitable and that it was being repeated in seicento Venice in the sometimes saccharine art of Pietro Liberi, Pietro Bellotti, and Giuseppe Diamantini.[53] On the other hand, he thought that it was a "decline of style."[54] Reni received the brunt of the critics' ire, but in fact it was perceived as a dubious pan-Italian trend.[55]

Poussin's defensiveness regarding his sweet and soft style could have arisen from some anxiety about being identified with that other "new Raphael," Guido Reni. For an unenthusiastic supporter of contemporary art in general who thought that "in comparison to the ancients, Raphael is an ass," Poussin could be expected to resist current trends, especially if, as Scannelli and Malvasia believed, Pietro da Cortona was one of its practitioners.[56] Sometimes modern art was called "delicate," a term that normally occupied the same semantic space as "soft" and "sweet," in order to indicate a misbegotten taste for excessive artifices like fluttering, iridescent, and undulating drapery, or for an inappropriate effeminacy.[57] *Morbido, dolce*, and *delicato* could designate feminine qualities attributed to feminine subject matter, a laudable decorum of form and subject, but in these terms there also lingered from

ancient rhetoric a sense of gender inferiority and inappropriate effeminacy. Delicacy "transforms men into women."[58] Soft and effeminate harmonies in music corrupt and deprave.[59]

✐ STYLE AND CONTENT

Poussin loved to paint Stoic subjects and shared the Stoics' forensic contempt for flashy, conspicuous styles. Style must serve content. He probably would have agreed with Seneca the Younger's warning to Lucilius not to be too solicitous of style: "You should seek what to write rather than how to write it."[60] Seneca knew that style, like content, could signify the character and ethics of a writer or society, and indeed could signify moral health or turpitude independently of the content. A style untethered from content was seen as a self-indulgence or sensual infatuation with form, and hence as a sign of moral rot. Seneca knew that form shaped content just as content shaped form, but given the choice of whether to let form or content lead the process of writing, the latter always won. For Poussin, art also originated in thinking about the subject, either in narrative or thematic terms, rather than in formal considerations.

Most writers accepted the reciprocity of style and content while believing in them as separate entities that could be analyzed independently of each other. There was some recognition that style and content were at once the same and different, or, as T. S. Eliot put it, "it is always true to say that form and content are the same thing, and always true to say that they are different things."[61] To say that style follows subject does not mean that, in the process of composing invention, style does not reinvent the subject nor that the painter does not fully discover the subject until it is submitted to visual inspection. Still, writers and painters needed a point of departure and a continuing point of reference, and for Poussin it usually was the subject. It was, in his terms, the "foundation" for conceit, composition, and style. Other painters shared his belief.[62]

How Poussin exempted style from the dominion of subject suggests a less hieratic relationship than the one just indicated. Style can replace subject in its expressive functions: if a painter lacks a subject that can "awaken astonishment in the soul," the same result can be attained by "the excellence of the style (*maniera*)."[63] This suggests that the effects, and hence presumably the means, of style and content can differ. That beauty can reside as much in the application of art as in the subject was a theme that Vasari favored in

order to explain the success of ugly images like Leonardo's monsters, Giulio Romano's giants, and Piero di Cosimo's oddities. According to Virgilio Malvezzi, "there can be a terrible beast, or displeasing carcass, or horrible monster, but the picture of it will still be delightful. A man can be deformed in body parts and with an abominable soul, yet an imitation of him is pleasant."[64] Despite the pustulous sores, gangrenous decay, and other "deformed and horrible" aspects of *St. Roch with Plague Victims*, Annibale Carracci managed to give it beauty.[65] Style transcends subject. Instead of looking at the subject, the viewer is captivated by art and style.

When Jacques Stella asked for a painting in a particular style, Poussin agreed without prevarication: "I have painted it in the style you wanted."[66] He also obliged Jean Pointel's request for a painting that thematized female beauty, the *Rebecca and Eliezer at the Well* (Paris, Louvre).[67] Nor did the subject matter straitjacket style. Cassiano dal Pozzo was astonished to see how two paintings of the same subject (*Penitence*) by Poussin could have dispositions so completely different. It is a perception born from attitudes shaped by literary analysis.[68] Poussin was proud enough of this accomplishment to write to Chantelou about it, although deferring the praise to Cassiano for recognizing his success.[69]

Style could even justify a deviation from the Bible. In the French Academy debates on the *Rebecca and Eliezer at the Well*, Charles Lebrun explained the conspicuous absence of camels by reference to aesthetic or stylistic considerations, notably that the physical deformity of the camels contravened standards of beauty and the "mode" in which Poussin chose to paint.[70] Philippe de Champaigne rejected this explanation as frivolous, intimating that the choice may not have been made deliberately for aesthetic reasons but rather from ignorance. Lebrun drew him up short on this point by forcing Champaigne to acknowledge that, "as everyone here knows, Poussin is far too learned and enlightened." Having clarified the question of intentionality – Poussin knew what he was doing and had a reason for omitting the camels – Lebrun returned to explain how aesthetic concerns can determine choices in invention. The ten camels described in the Bible would have contravened the aesthetic principle of "purifying the subject, ridding it of inessentials, and thus concentrating on the principal action without bizarre objects to distract the eye of the spectator and amuse the feeble-minded." His decision was based on "the principle that painting, like music, has diverse modes" and that the invention should be shaped to suit the mode: "Thus, Poussin, having considered the particular characteristics of the subjects that he treated, decided to remove those objects which ran

contrary to the mode." (I will return to the question of modality in the final section of this chapter.)

Rather than thinking of style and subject in a hieratic relation, Poussin's definition of "conceit" suggests a liminal staging between pure content and pure form where a clear demarcation between form and content is blurred. Tommaso Stigliani made this point when he defined literary *stile* as a fusion of content (*sentenza*) and syntax or the structure of words (*locuzione*).[71] Style is neither form nor content but an alloy, much like bronze, to use Stigliani's analogy. This may seem obvious to us, but at a time when metaphors for style favored its separation from content – clothing, ornament, or other kinds of outer casing – it was more insightful than it might at first appear. The relation of style and subject was generally considered as a topic of decorum. It became a primary concern for theologian-art critics who, applying a Catholic Reform agenda to painting, privileged accuracy and clarity of representation.[72] Saturate yourself first in the subject, Gilio advised painters, by investigating, inquiring, and reading so that you have "in mind all of the subject and each of its particularities."[73] Their aesthetic ideal was a nonaesthetic stance where artistic matters like design, drawing, shading, and coloring were kept separate from subject matter. Matters of art or artifice were deemed to be irrelevant to the subject or, worse, a distraction from the subject by calling attention to the artist's talent.[74] Explaining why artists indulged in unnatural distortions of pose, whether of excessive elegance or twisting contortions, Gilio concluded that they paint this way because they could paint this way.[75] As part of the heritage that rejected such Mannerist displays, seicento writers on art are thought to have placed a higher estimation of content over form than cinquecento writers.[76] Poussin's writings would seem to support this claim, although not unequivocally; Boschini's contradicted it.

✑ MASTERY OVER STYLE

Two weeks after Poussin had first defended his *Baptism* against Chantelou's claim that its style was "too sweet," he returned to the subject. He had not yet received another letter from Chantelou, but he evidently wanted to clarify his previous letter where he cited Traiano Boccalini's defense of Guarini's sugary *Pastor fido* as a precedent and justification for painting sweetly. Now Poussin begged Chantelou to see how each painting in the Sacrament series was painted differently.[77] "Vulgar painters"

do not vary their styles in this way, he claimed. They believe that style should change as little as possible, and as a consequence, their work looks like engravings, reduced to a kind of mechanical uniformity. Whether they believed that style lay somewhere beyond their control or that they chose not to exercise that control, Poussin says nothing. He recognized some truth in the perception that one's style is irrevocable and tried to deal with it by relegating personal style to the nominal netherworld of *stile*.

Real style (*maniera*), however, could be mastered. He had two possible motives in hiving off *maniera* from *stile*. First, he wanted to establish that style was not just an autonomous function born from formative habits or temperamental predispositions. Theories of style that were either based in psychology or on historical determinism assumed that style remained mostly beyond conscious control. Rhetoric gave Poussin an alternate etiology. His self-proclaimed ability to manipulate style was taken by others, just as Poussin hoped, as a demonstration of his knowledge of art. Second, he wanted to show that style could (and must) be manipulated to suit the subject. In other words, style was not just a manifestation of *ingenium* and the artist's nature, as Vasari and others believed, but it was a rhetorical *ars*. The irony here is that in Mascardi's rhetoricized account of historiography pictorial style was evoked in order to explain what style really is, and yet, by deliberately misreading and upending Mascardi, Poussin tried to rhetoricize pictorial style.

By "vulgar" Poussin meant not just a coarse and plebian opinion – the *volgare* to the higher learning of Poussin's Latin – but also a common, customary, and familiar one. In this latter sense, he gave an accurate account of what most painters believed style to be most of the time – personal and uncontrollable – a view also subscribed to by collectors, dealers, curators, and others who used style to attribute and classify paintings. When Annibale Caro complained about Taddeo Zuccaro's intransigence, he played to the popular belief that artists are inflexible in their approach: either the invention is adapted to the "disposition" of the painter, Caro writes, or the painter's "disposition" to the invention. As Zuccaro was unwilling to bend to accommodate the invention, he therefore had to be accommodated in order to avoid disorder and confusion.[78] Cases of misdirected style reveal painters who can only paint in one style. Guido Reni painted *Sampson* in his characteristic delicate style when, according to Malvasia, a *maniera forte* like Annibale Carracci's would have been more suitable.[79] In explaining why Reni was not the best artist to depict a Samson, Malvasia concluded that "every man is born with his own talent." The alternative was to choose only those subjects

that conformed to your style. Parmigianino, realizing that nature impelled him to paint gracefully, excluded from his repertoire grave and funereal subjects.[80] Michelangelo's and Tibaldi's "bold and vigorous style" was thought to exclude successful depictions of tender and delicate subjects.[81]

"I am not at all like those who always sing in the same key (*ton*)," Poussin wrote proudly to Chantelou, "I know how to vary the key when I want."[82] André Félibien, Poussin's dutiful interpreter, discussed the control of artists over style in similar terms: "As Poussin told me, singers change their key to suit the piece and so should painters."[83] With the term "key," Poussin anticipated his letter written several months later to Chantelou that referred pictorial style to the musical modes as a justification for why he could paint in different styles at the same time. The question of the musical modes as a stylistic classification system will be discussed shortly, but for the moment I would like to point out that what Poussin claimed he could vary at will was *maniera*, not *stile*. Having measure and a fixed order, the style within his control is described in terms of art rather than talent, much like Vasari's quattrocento style.

By rejecting "those who always sing in the same key," Poussin exempted himself from three traditional aspects of style: mannerism, idealism, and self-expression. First, and most obviously, he wanted to distance himself from "di maniera" painters like Michelangelo who lapsed into formulae and always repeated themselves: "If you've seen one. . . ." Ludovico Dolce's caricature of Michelangelo as a painter of brawny stevedores resonated well into the seventeenth century. Following Roland Fréart de Chambray's reading of Dolce, Bellori considered Michelangelo inferior to Raphael because of his narrow range of style: "Michelangelo was truly great in the grand Herculean and robust style, but . . . this alone is not enough to garner fame as a great artist, it being necessary to possess all of the other forms, tender, polite, svelte, graceful, and delicate [like Raphael]."[84] As I tried to show in the preceding chapter, mannerism and idealism were closely aligned. To "always" paint "in one way" meant for Vincenzo Danti successful imitation – imitation being "a fixed art" – and attaining "a style that flees imperfect things and approaches perfection."[85] Dolce, Poussin, and many others, on the other hand, rejected this paradigm of style as ideal beauty as a form of mannerism.

Another good reason why artists might "always sing in the same key" and change their style only "ever so little" revolves around the inevitable

and innate limitations imposed by character and personal habits. In Mascardi's auditory analogy, style is like an accent: involuntary, ingrained, and habitual, formed early in life, anchored in the body and displayed in public always in the same way.[86] Francesco Algarotti also likened style to "a particular accent of the painter . . . pronouncing different languages in the same way," remaining the same regardless of the content.[87] Poussin in Rome, with his French accent, would have known exactly how cognitive and physical habits can be enduring and intractable.

Poussin's belief that innate style could be conquered is oddly reminiscent of Abraham Bosse – oddly because Bosse has been generally relegated by scholars to a small group of inconsequential eccentrics.[88] In *Sentiments sur la distinction des diverses manières de peinture, dessein & graveure* (Paris, 1649), a book less intriguing than its title, Bosse argued that the presence of style is not inevitable but merely the consequence of defective art. His belief stemmed from a charmingly naive faith in perspective as a scientific method that enables artists to copy nature without any distortions. To illustrate his view, he adopted and overturned one of the oldest topoi for discussing stylistic differences. Angelo Decembrio and Antonio Filarete, it may be recalled, proved the painter's unavoidable imposition of style on nature by discussing how different artists portrayed a single sitter differently, Lionello d'Este and Francesco Sforza respectively.[89] Each artist strived to depict their duke faithfully and yet each rendered him in dissimilar ways. Bosse held, in contradiction, that with a correct application of perspective many painters could "copy the same head after nature, commonly called portraiture, all from the same position and distance, and they would arrive at exactly the same appearance so that one could not say which style is whose."[90] However, because of "the ignorance that reigns in these times," artists work by imagination rather than rule, and hence styles "multiply infinitely."[91] Reality evidently did not dampen his idealist fantasy that style could be escaped.

Poussin's conviction that he could manipulate style led him to ascribe similar abilities to a few well-qualified painters. This, in turn, opened up new interpretative paradigms for art critics. Bellori, for example, concluded an encomium of the *Battle of Constantine* by Giulio Romano by noting that "the coloring was too tinted with black and the contours were too harsh (*aspra*)," tendencies that were imputed to Giulio's work in general.[92] The critique of *Constantine* as an example of Giulio's propensity to color too darkly originated with Vasari and was available to

Bellori in a variety of sources: "And if this scene [*Constantine*] were not too much darkened and loaded with blacks, which Giulio always delighted to use in coloring, it would be altogether perfect; but this takes away much of its grace and beauty."[93] Bellori thus accepted from the critical fortunes of Giulio Romano both the attributes of excess and the belief that style remained unchanged regardless of possible variables like subject, medium, or time. We know that Poussin also believed that Giulio's "manner is piu Cruda," to use Richard Symonds's pidgin quotation of Poussin.[94] However, in the *Descrizione delle imagini dipinte da Rafaelle d'Urbino nelle Camere del Palazzo Apostolico Vaticano*, Bellori attributed to Poussin a different view.[95] "Poussin" found harshness (*asprezza*) in the *Battle of Constantine*, as everyone else did, but identified it as a decorous expression "of the violence of a big battle and of the vehemence and fury of the combatants" and not as an attribute of personal style. By repeating the terms *aspro* and *asprezza*, "Poussin" shows that he found the same stylistic quality as Bellori even if they disagreed on its source and on the artist's intentions. By assuming style to be constant, Bellori represented the conventional attitude toward style in much the same way that Poussin did when he ascribed it to "vulgar painters": it is deemed to be a stable language and should be judged against predetermined aesthetic standards. Critics before Poussin sometimes read style in relation to subject, and Bellori did so frequently;[96] thus what he wanted to show with "Poussin's" correction of his criticism was an ideal of subject-based style criticism. In so doing Bellori misrepresented himself in order to point out how criticism was changing and how Poussin played a pivotal role in that change.

As for his own style as a painter, Poussin managed to remain virtually invisible to his three principal Italian biographers, Bellori, Passeri, and Baldinucci. They depersonalized it in ways that would have pleased the artist, referencing style only to subject, the antique, and Raphael, and cordoning off style from character and talent. Their imperception of personal style is a powerful testimonial to Poussin's success in transforming style from *ingenium* to *ars*. No stable formal vocabulary or psychological stylistic attributes are identified. Félibien also made all of his references to Poussin's style contingent on the subject, nature, or antiquity, with one telling exception when he denied charges of a certain hardness that resulted from pondering sculpture too often.[97] What marked Poussin's style for Félibien was its transparency stripped of any superfluous ornamentation; it is "completely distinctive" and yet "unattached to any particular style."[98] In Bellori's life of Poussin, the paragraph that opens "Concerning the style of this artist . . ." gives us no

sense of what Poussin's paintings look like or what visual qualities individuate his work.[99] We are told something about his compositional method using staged wax models but nothing about how the results differ from, say, Tintoretto or Federico Barocci, who used similar methods. We are told how he read and annotated Greek and Latin stories before composing, that he was "well instructed and learned in art," and that he dispensed harsh criticism liberally.[100] In other words, Bellori saw Poussin's style just as Poussin understood the concept of style: as a product of *ars*, not *ingenium;* as an expressive instrument cannily controlled by the artist; as an expression of text, not self.[101]

Cinquecento and early seicento writers preferred different etiologies of stylistic change. These could be psychological, biological, or even ontogenic, each assuming a passive role for the artist or art that was swept along by the passage of time and by an evolutionary process of growth and/or decay. Explanations of stylistic change were also constructed around stories of artistic influence, such as Andrea del Sarto's trip to Rome, Raphael's viewing of the Sistine Chapel ceiling, and the discovery of the Laocoön and other Hellenistic statues in the late fifteenth and early sixteenth centuries. These gave the artist a more active role than the former, but they are still more reactive than proactive. Regardless of the degree of volition, both etiologies assumed that style at any given time will always be the same, even if from time to time it changes. From visual evidence, art critics knew that artists worked simultaneously in different styles, and did so deliberately even if their motives sometimes remained obscure. Pontormo painted the ceiling in the Capponi Chapel in "his early style," but "thinking of new things," he forged ahead with a new style for the altarpiece of the *Deposition*.[102] On the other hand, critics could also present two styles as a taxonomical fact unattached to any particular rhetorical or artistic function, as did Giulio Mancini in commenting on Cristoforo Roncalli's two different styles for two adjacent chapels in Santa Maria d'Aracoeli, one "vigorous and reinforced" and the other "completely pleasing and sweet."[103]

The articulation of motives assigned to artists for willfully manipulating their styles also became more specific in the seventeenth century, as did the range of perceived motives. As noted in the first chapter, style could be used as a form of criticism, as Reni did (or, by another account, Annibale Carracci) when he decided to comment on Caravaggio's *Crucifixion of St. Peter* by painting another "in a contrary" style.[104] Examples abound of artists changing styles to suit the tastes or pocketbooks of patrons or to secure an artist's reputation or to increase market share.[105] Ribera and Mattia Preti were

thought to have brightened their colors and made their style more charming (*vago*) in response to criticism by Massimo Stanzoni and "various Neapolitan gentlemen."[106] In so doing they turned against their "natural tendency" to paint in a Caravaggesque style "con maniera gagliarda" and "alla maniera forte, anzi terribile." Similarly, Guercino modified his tenebrism by adopting a "delicate and sweet style" in order to comply with public taste, a serious miscalculation because (according to Passeri) it initiated a downward spiral into a languid, enervated style.[107] And yet, just when Guercino had sunk most deeply into a faux Reni style, he agreed to paint for Antonio Ruffo a pendant to his Rembrandt. This would require the sixty-nine-year-old artist to paint "in my early robust style" in order to make it stylistically compatible with Rembrandt's work, a proposition that Denis Mahon dismissed as an "inherent improbability."[108] Rembrandt's painting was described as a murky "half figure, clothed, and lit only by a spot of light on the tip of the nose," a style that evidently explains why "the great painters . . . do not want to associate themselves with a bagatelle like this." This, however, did not bother Guercino or Giacinto Brandi, who thought he had inherited the commission after his master's death.[109]

✐ THE MODES OF STYLE

If you find that the painting of the Finding of Moses which belongs to M. Pointel attracts you (*vous a donné dans l'amour*), is this a reason for thinking that I did it with greater love (*fait avec plus d'amour*) than I put into your paintings? Cannot you see that it is the nature of the subject which produced this result and your state of mind, and the subjects that I am depicting for you require a different treatment? Forgive my liberty if I say that you have shown yourself precipitate in your judgment of my works. To judge well is very difficult unless one has great knowledge of both the theory and practice of this art. We must not judge by our senses alone but by reason. . . .

Those fine old Greeks, who invented everything that is beautiful, found several Modes by means of which they produced marvelous effects. This word 'mode' means, properly, the ratio or the measure and form that we employ to do anything, . . . a certain manner or determined and fixed order in the process by which a thing preserves its being.

As the Modes of the ancients were composed of several

things put together, the variety produced certain differences of Mode whereby one could understand that each of them retained in itself a subtle distinction, particularly when all the things that pertained to the composition were put together in proportions that had the power to arouse the soul of the spectator to diverse emotions. Observing these effects, the wise ancients attributed to each [Mode] a special character and they called Dorian the Mode that was firm, grave, and severe, and they applied it to matters that were grave, severe, and full of wisdom.

And passing on from this to pleasant and joyous things they used the Phrygian Mode because its modulations were more subtle than those of any other Mode and because its effect was sharper. These two manners and no others were praised and approved by Plato and Aristotle, who deemed the others useless; they held in high esteem this vehement, furious, and highly severe Mode that strikes the spectator with awe. . . . Furthermore they considered that the Lydian Mode was the most proper for mournful subjects because it has neither the simplicity of the Dorian nor the severity of the Phrygian.

The Hypolidian Mode contains within itself a certain suavity and sweetness which fills the soul of the beholders with joy. It lends itself to divine matters, glory, and Paradise.

The ancients invented the Ionic which they employed to represent dances, bacchanals, and feasts because of its cheerful character.[110]

Poussin sounds annoyed as he explains to Chantelou the formal and expressive differences between the *Ordination* and the *Finding of Moses*: "Cannot you see . . . ? you have shown yourself precipitate. . . ." And how could Chantelou himself not be a little annoyed to discover that Poussin had enrolled him in a class of stupid viewers: "We [i.e., you] must not judge by our senses alone but by reason"? Poussin took it upon himself to supply the necessary cognitive adjustment. He wanted Chantelou to understand that different subjects demand different styles, that no painter should be limited to a single style, and that style should be expressive, engendering a feeling in the viewer without necessarily signaling the painter's feelings. These ideas on style are familiar from Poussin's other letters and from his definition of style. He even employed the same proof-by-plagiarism found in the definition of style, here with Poussin's words and ideas originating in Zarlino's *Istituzioni harmoniche* (Venice, 1553).[111] One reason *Dell'arte historica* piqued Poussin's interest was Mascardi's use of paint-

ers to resolve the question of style. In the case of the *Istituzioni harmoniche*, what might have attracted Poussin was a language familiar to him from reading art literature, a language that could be transferred to painting with a minimum of emendation. The semantic cluster of *mode, manière, ordre* (in Zarlino: *modo, maniera, ordine*) resembles Vasari's quattrocento definition of style and other cinquecento linguistic practices. As a "determined and fixed order," *mode* suggests the proportionality and stability that Vasari's predecessors mistakenly sought, believing that style could be submitted primarily to an *ars* instead of an artist's *ingenium*. Poussin's *mode*, in other words, resembled his definition of *maniera* as an *ars* in distinction from the individual talent of *stile*.

The suspicion of plagiarism once freighted this letter with a precarious status of suspected inauthenticity. Those who regarded it as a careless transcription, stitching together different sections with serious consequences for the original meaning, tend to interpret the act of copying as either a sign of disinterest or as evidence of a warmed-over opinion on stylistic decorum.[112] Mahon, in particular, wanted to diminish the "theory of the modes" (he always used distancing quotation marks) because it conflicted with his conception of style as a connoisseur's heuristic for dating, his project being to reconstruct an alternative and more precise chronology after visiting the 1962 Poussin blockbuster at the Louvre. Others, more recently, were intrigued by the novelty of explaining pictorial style by means of musical modes. Cropper showed just how purposeful Poussin's alterations to Zarlino were, thus enabling scholars to broaden their reading of Poussin's letter beyond the question of style-and-content that preoccupied scholars during the 1960s.[113] Discussions of Poussin's theory of the modes now include pictorial narrative, the nature of judgment, formal expression, the unity of visual forms, and the function of precognitive, preverbal impressions.[114] Above all, scholars have recently shown how the modes provide a visually expressive language of emotional effects (*effets*), whether, in Poussin's words, they are "firm, grave, and severe" or "pleasant and joyous" or "vehement, furious, and highly severe" or have "suavity and sweetness." The modes "fill the soul of the beholders" and "arouse the soul of the spectator to diverse emotions," although exactly which elements of a painting were thought to achieve these psychosomatic effects remains unclear.[115] Poussin understood stylistic expression to be pantropic, "scattered about in all parts so that one can recognize everywhere joy or sadness, anger or sweetness according to the nature of the story."[116]

Despite these impressive achievements, little attention has been given

to the rhetorical dimensions of the modes and, in particular, to the classifi-
cation of styles into a limited set of global types. The modes are music's
version of the rhetorical *genere* (Cicero), *idèai* (Hermogenes), or *charactèr*
(pseudo-Demetrius). These are identified by Cicero as the grand (*grande,
robustum, sublime, grave*), median (*mediocre, floridum*), and plain (*subtile, tenue,
extenuatum*); by Hermogenes as clarity (*saphèneia*), grandeur (*mègethos*), beauty
(*kàlos*), rapidity (*gorgòtes*), character (*éthos*), sincerity (*alètheia*), and force (*dein-
òtes*); and by the pseudo-Demetrius as the grand (*megaloprepès*), ornate (*gla-
phyròs*), humble (*ischnòs*), and forceful (*deinòs*).[117] As stylistic categories, the
modes divide the musical terrain into a totalizing array of all possible styles,
each one as a coherent form of expression. For Poussin, the modes were
both a map of stylistic genres and a lexical maneuver to signal how artists
can control their styles (where *mode* is coextensive with *maniera* and avoids
any hint of *stile*). Above all, the modes allowed him to insert the artist's
choice of visual expression into a broader menu of choices.

Unlike rhetoric, poetry, music, and architecture, no comprehensive
system of stylistic types became widely accepted for the figural arts. Rhetoric
shaped art criticism in many ways – how painting was defined and divided
into parts, how composition and expression were discussed, or in parallels
drawn between painters, orators, and poets – and enriched the vocabulary of
art writers (*grave, disciolto, schietto, severo, sublime*, etc.); and yet, even with the
rhetorical and poetic styles buried everywhere in the language of art criti-
cism, writers on art could not agree on how to divide style into an inclusive
canon of styles. No Italian critic before Francesco Milizia gave a complete
Ciceronian classification of style such as the one used by Melanchthon
(where Dürer exemplifies the "Grand style," Grünewald the "Middle style,"
and Cranach the "Simple style").[118] Niccolo Simonelli crowned Salvator
Rosa as "the Demosthenes of Painting," but he did not name other painters
as examples of the other rhetorical styles.[119] Francesco Albani was variously
described as "the Horace of painting," his genre as "Lyric," and his style
"heroic" because it matched in painting what Torquato Tasso achieved in
poetry,[120] but again we are not told who might be "Epic" or "plain."

Despite many such opportunities to translate the *genera dicendi* into
genera pingendi, art writers were typically reluctant to declare overtly what a
complete set of pictorial styles might be. Only architects, starting with
Vitruvius, and arguably because of Vitruvius, adapted the decorous and
expressive functions of oratorical styles to the architectural orders.[121] Poussin's
exegetes in the Académie came closest to doing the same for painting. Henri
Testelin even tried to anchor the modes to the more stable tradition of the

architectural orders whereby the Doric order serves as the source for the Dorian mode of painting, and the Ionic order for the Ionian; he even inserted a new *mode Corinthien* to complete the structure.[122] The similarity between modes and orders was more than a lexical coincidence: both were intended "to establish unity throughout the treatment of the building/painting, and both had an expressive function."[123]

Why, then, despite Testelin's explicit analogy, did pictorial styles not cohere around a stable canon like the architectural orders? Why were they not codified for painting and sculpture as they were for music? Artists, collectors, and theorists essayed various schemes of impressive ingenuity, but, as the following pages will document, their solutions shared little in common, and hence none attained the authoritative position of the orders or modes. Why pictorial style resisted an agreed-upon classification can be partially explained by asking why architects and composers were so rarely assigned individual styles. Why, when style in painting invited psychological insight into the artist's life and work, were buildings and compositions not seen as extensions of the architect's or composer's character or seen as a form of self-expression, inadvertent or intended? These are complex questions that invite many answers, and I venture the following tentative thoughts at the risk of sounding conclusive.

One fruitful approach would be to consider the status of ideation and execution in architecture and music in comparison to painting and sculpture. Architects can transmit their plans to craftsmen by means of a tightly pre-scribed set of notations (ground plans, elevations, the orders, etc.) and can record for posterity the essence of their buildings by similar means. Architects need not be masters of any particular craft skill or have an aptitude for manual coordination in order to be excellent at their profession (which is not to say that they do not need to know how the various trades operate). The art of architecture, in other words, rests more at the ideational than the execution phase. The art of painting holds the two in balance. Painters' drawings and sketches can serve similar functions as an architect's design, usually when large studios or specialist crafts are involved (Raphael's tapestry designs, for example), but even a notational sketch or a fully elaborated *modello* carries vital visual information to the studio, and this information rests on the artist physically manipulating pigment. Composers, like archi-tects, rely on others (entirely) to give their work a sensory reality. They employ self-referential languages based on proportion and geometry that tend more toward abstraction than does painting, which references the infi-nite variety of nature.

Pictorial style, in contrast, has an essentially performative dimension: it is rooted in the body as an accent or as a manual habit (the hand or *mano* of style). *Maniera*, as the Crusca academicians decided, involves "working," unlike *stile* that did not necessarily suggest handiwork. Without saying so explicitly, Castiglione gave performance a central role for style. In his discussions of music, no reference is made to styles of composers; musicians, on the other hand, have styles. Bidon's style of singing is "quick, vehement, impassioned"; Cara's style is more "serene and full of plaintive sweetness."[124] From Bidon and Cara, Castiglione turned immediately to Leonardo, Mantegna, Raphael, Michelangelo, and Giorgione as proof that "we recognize each to be perfect in his own style." The common thread seems to be that music and painting are performed arts. Castiglione was typical of early modern Italian writers in not attributing individual style to composers or to their compositions. Only when a musician uses his or her body to give the disembodied set of notes an auditory reality can Castiglione differentiate styles. Painting, however, unlike music, could not exist as abstracted notes but (in early modern Italy) always carried traces of the artist's physical act. The act of painting requires the artist's body to intervene between materials and ideas, and just as the body and its gestures are uniquely and observably individual, so too will style be. And to the degree that style is individual, it will resist classification.

Because the impulse in Italian art writing was toward individuation, not standardization, even the few categories of pictorial style that did exist tended to be eccentric and unacceptable to everyone except its author. Individuation also encouraged the invention of style systems grounded in epistemologies that best explained individual differences: psychology, physiology, and physiognomy. Lomazzo, most notably, devised a humoral-astrological classification of style into seven genres, each with an epitomizing "governor" (Michelangelo, Gaudenzio, Poliodoro, Leonardo, Raphael, and Titian).[125] The physician Scannelli invented a microcosmic metaphor of the "body of art" in order to justify an artistic canon where each organ was assigned to a different artist and style.[126] Raphael was the liver, Veronese the genitals, Michelangelo the skeletal structure, Titian the heart, and so on. Other systems proved equally unconvincing to contemporary writers. No one found Boschini's "boat of painting" to be useful, where Bellini was the hull, Giorgione the rudder, Bassano the windows, Veronese the lantern, and so on.[127] Nor did anyone adopt Sebastiano Resta's divisions based on the Muses, where Urania inspires Raphael and his followers, Euterpe inspires Correggio and his followers, Thalia the Venetians, and Terpsichore the better

Mannerists.[128] These totalizing schemes submitted style to a priori templates derived from outside the practice of painting. Other schemes worked more inductively from techniques of style or from lexical categories. Francesco Lana divided painting into three styles of technique: *unendo* (blending colors smoothly), *tratteggiando* (modeling with lines), and *a botte* (painterly or sketchy painting).[129] The painter, forger, and theorist Giambattista Volpato, writing shortly thereafter, tried to excavate and make explicit the hidden structures of style that were buried in language. He divided style and language into four fundamental "types" (*sorti*), identified as *vago, diligente, forte, franco*, whose syntactical combinations (when applied to all parts of painting) would capture the individuality of an artist's style. Tintoretto was *franco* and *forte*; Veronese was *franco* and *vago*; Giorgione was *forte* and *diligente*; Bellini was *vago* and *diligente*.[130]

The inventors of these eccentric schemes relied on canons of great painters to validate their elaborate allegories. Canons existed, however, without such conceptual superstructures. Giulio Mancini, for example, simply divided modern painting into four "orders, classes, or, as we say, schools": (1) Caravaggio and his naturalist followers; (2) the Carracci and their followers who mix the styles of Raphael and "Lombardy"; (3) Cesare d'Arpino who follows nature less exactly; and then (4) everyone else.[131] All critics compare art to a set of artists who exemplify good art. Sometimes the set is enunciated, as Alberti did with his dedicatees or as Vasari did by locating the stars in each of his prefaces. However, by "canon" I mean something more specific: it must be an inclusive, explicit, and deliberate set that represents all good styles. Lomazzo invented two famous canons: the seven "governors of painting" based in number and type on Hermogenes' seven styles; and the ideal *Adam and Eve*, where Adam is designed by Michelangelo and painted by Titian, and Eve is designed by Raphael and painted by Correggio. Boschini identified five painters (Titian, Tintoretto, Giorgione, Bassano, and Veronese) as the five "vowels" of painting.[132] Francesco Albani likened Titian, Correggio, Raphael, and Michelangelo to the four rivers running from the four corners of the world into the sea of painting.[133] Mascardi listed four cinquecento painters (Raphael, Correggio, Parmigianino, Titian) who are matched stylistically by four seicento painters (Reni, Lanfranco, Cesare d'Arpino, Cortona). Sometimes painters painted canons.[134] By the eighteenth century, various canons became embedded in language itself when artists' names were adjectivized: Correggesco, Tizianesco, Carraccesco, Pussinesca, and so on.[135]

Even though no consensus emerged from these ingenious and some-

times quirky systems of classifying style, their number suggests an unarticu-
lated need for a *genera pingendi*, a need that gained some urgency in the late
sixteenth and seventeenth centuries as painters added new styles at a rate of
proliferation that Agucchi found alarming. Most seicento canons, and explic-
itly those of Mascardi, Albani, Scannelli, and Boschini, tried to situate con-
temporary painting within an established grid of old masters and thereby
direct future developments. They were instruments of understanding and
control designed to answer the question of what a good style is and how an
artist can attain it. As the inventory of art grew, dealers, collectors, and
connoisseurs were faced with their own practical exigencies that begged for
some kind of reductive framework.

Poussin's venture into the modes may seem to be a timely step in this
direction, and in a general sense it was, but his intentions were fundamentally
different. Unlike Volpato's "types" or Resta's "Muses" that tried to categorize
existing paintings, Poussin's "modes" explained why a painter painted in a
particular way. In looking to artists making art, they more closely resembled
Lomazzo's "governors" or Boschini's "vowels." However, unlike these and
other systematicians, Poussin presumed a wider latitude of stylistic control by
an artist. How this is so can be seen by considering the modes in relation to
other geographic classifications of style. Vasari initiated the concept of com-
peting regional styles, pitting Florentines against Venetians in a way designed
to provoke polemical discussion.[136] He succeeded. However, it was not until
early in the seventeenth century with Agucchi that a fixed canon was defined
and given an explicit historiographic context.[137] Agucchi identified four
"schools or styles," the same in number (as he noted) although not in
characteristics as ancient painting: the Romans excel in the "grand style" by
following the "artifice" of antiquity and the beauty of statues; the Venetians
are natural and sensual; the Lombards follow nature "in a tender, easy, and
noble way"; the Tuscans are diligent, detailed, and expose the artifice of
art.[138] Like the four schools of antiquity that he borrowed from Pliny (Asi-
atic, Attic, Sicyonian, and Roman), the Italian schools reflect the native
culture of each region. At the same time as Agucchi, Giulio Cesare Gigli
proposed a competing canon of thirteen artistic *patrie* (Venice, Vicenza,
Verona, Mantua, Cremona, Brescia, Bergamo, Milan, Genoa, Bologna, Si-
ena, Florence, Rome), but, unlike Agucchi's canon, Gigli's did not survive
in art literature. The simplicity of Agucchi's scheme, along with the impor-
tance of his readers (Gigli's little book slipped quickly into obscurity), guar-
anteed its survival as the dominant geographic division of painting.[139] An-
other advantage of Agucchi's canon was that it sprang from habits of national

stereotyping and the belief in collectivist myths, whereas Gigli's *patrie* read more like an abridged atlas. Regional styles had been politicized by Vasari, and Florence paid dearly for his *campanilismo* – note, for example, how Agucchi assigns to Tuscany a lowly status – but, besides categorizing style around a cultural-political nexus, regional schools were also diagnosed medically as a product of climate, physiology, and psychology, starting aptly with the physician-connoisseur Giulio Mancini.[140]

In his letter to Chantelou, Poussin did not make explicit the applicability of the modes to geographic divisions of style. Félibien, however, attributed to him the intention of inserting the modes into the schools of Italian painting.[141] In his commentary, he first rehearsed the effects and functions of the modes in ways that closely resemble Poussin's letter – the Dorian is grand and majestic and should be used to praise; the Phyrgian is full of fury and movement and should be used to inspire courage; the Lydian is sweet and harmonious and should be used to beget love and excite joy – and then proposed that, because their character derived from their place of origin in Greece, they could also be applied to regional styles in Italian painting. Thus Roman painting is Doric; Florentine painting is Phyrgian; Lombard painting is Lydian. Although this explanation is more detailed than that offered by Poussin to Chantelou, the frame of reference in terms of the formal and expressive qualities is basically the same. Agucchi and Malvasia, among others, labeled the Roman school as "grand"; and before them, in literary criticism, ancient Latin was deemed as inherently heroic, "full of grandeur and Roman majesty."[142]

By categorizing style along immutable principles – biology, astrology, geography, and history – these systems submit style to the dictates of nature. Artists thus become subservient to a higher natural or supernatural domain. How you painted depended on when and where you were born or what temperament or astrological sign came with your birth. Poussin's "modes" of painting departed from these categories of style in that they empowered artists to choose and manipulate their own styles. Because he believed that style should be voluntary, Zarlino's modes advanced his case by showing how the choice and application of style operated within a global context. Seicento canons presupposed that artists could "gather together the perfection of many artists," much as Lutio Faberio saw in Ludovico Carracci a combination of Michelangelo, Titian, Raphael, Correggio, and others.[143] Boschini's painters-as-vowels metaphor similarly presumed that every artist could (and must) deploy all five for eloquent speech, "that without the style of each master, one certainly cannot make a worthy painting." What re-

mained unquestioned, however, was the belief that a Florentine could not paint like a Venetian on one day and like a Lombard on the next; instead, the goal of artists was to assimilate different regional styles into a single, stable, personal style.

When the modal division of style is considered in relation to Poussin's definition of the *maniera magnifica*, he can be seen as promoting Roman values and the autonomy of artists to choose their styles instead of being born to them. However, the assumption of geographic pictorial styles, unlike the musical modes, is that a painter will normally paint in a style characteristic of his or her city or country. Before recalling Agucchi's four "schools" to help him situate the styles of Domenichino and Reni, and by way of excusing Domenichino's artistic limitations, Malvasia noted that "everyone cannot be all things."[144] Poussin's genius, however, at least according to Félibien, was that he *could* be all things, and in this respect he was "singular and incomparable." Equally talented in all three modes, Poussin became a supranational artist who transcended the limitations of local idioms. He was, in this respect, much as Bellori imagined himself to be, writing an art historiography that specifically eschewed the regional approach preferred by his contemporaries.[145] In one sense, Poussin's multidextrous style resembles the eclectic ideal popularized by Lomazzo's imaginary *Adam and Eve*, practiced by Lutio Faberio at Agostino Carracci's funeral, or applied to Poussin by Charles Le Brun in his Academy lecture of 1667.[146] But in another sense, Félibien claimed much more for Poussin: not only could Poussin synthesize Roman, Florentine, and Venetian styles into one, he could adopt each one separately. He conquered all the major stylistic territories of Italy.

MARCO BOSCHINI

THE TECHNIQUES
AND ARTIFICE OF
STYLE

Marco Boschini, the Marinist poet and Venetian propagandist, earned his living as an art dealer, jeweler, writer, engraver, and occasional painter. He disliked the cult of Raphael that Poussin fostered, and, as we saw in "Fighting with Style," he spurred Bellori into an uncharacteristically rude response. Boschini challenged Bellori's and Poussin's beliefs in ancient statues as a source for good style and, according to Bellori, did so in a verbal and body language as twisted as his artistic taste. Raphael looked "stony" to Boschini, at least when judged by the standard of his own pictorial practice. As a painter trying to emulate Tintoretto in practice and glorify him in writing, it was easy for Boschini to typecast Raphael as a hard painter, diligent and accurate in the rendition of anatomy, but lifeless. What Poussin thought of Boschini's hero, Tintoretto, can only be guessed, but it is unlikely to have been kinder than what Boschini said of Raphael. Richard Symonds, when he spoke with Poussin between 1649 and 1651, possibly during one of their evening conversations in the Piazza di Spagna, noted that Poussin disliked masses of foreshortened figures on ceilings, especially those by Pietro da Cortona in the Palazzo Barberini. He called them "licentious and improper because we are not accustomed to seeing people in the air."[1] Boschini loved the Barberini ceiling for its *maniera pelegrina* and devoted more lines to it than to any other non-Venetian paint-

ing because he thought that Cortona had painted it under Venetian influence.[2] He called Cortona "a great friend of our Venetian style," and being a personal friend as well, he quoted or cited him as an authority more often than any other non-Venetian artist.[3] We normally think of Cortona for his debt to Veronese, and Boschini was not entirely negligent of this debt, but the point that he insisted on repeatedly was how Cortona "held Tintoretto close to his heart" and especially loved the "monstrous art" of his ceilings.[4] His flying squadrons of strangely foreshortened figures were taken as a mark of his genius. This is why Boschini mocked artists like Poussin who revered ancient statues: "You cannot make statues fly, but our learned Venetian painters make human figures fly." Tintoretto's *Capture of Zara* (Venice, Palazzo Ducale, Sala dello Scrutinio; Figure 15) achieves "spiritous movements that give the finger to statues and terror to men"; they are made "without definite rules and precise measurements. . . . For the sculptor can easily make use of measurements, whereas the painter uses form without form, even with form deformed. . . ."[5]

These comments appear in a libelous ad hominem attack directed against Vasari's Tuscan and anticophile biases, the *Carta del navegar pitoresco*.[6] Ironically, despite all the bilious names he called Vasari (a festering bouquet of flowers, a mangy dog, etc.), Boschini inherited more of Vasari's aesthetic values than he cared to admit, and even borrowed from Vasari his mandate in writing: to evaluate art first by absolute standards ("the good and the bad," or "the good, better, and best") and then by the relative standards of individual style.[7] They both loved figural complications, either the distortions of sharp foreshortening or the writhing masses of entwined, multifigural compositions; they both wrote in praise of artifice; they both polemicized "naturalists" as scapegoats for artistic failure. Both defined style as normative, an absolute standard against which individual artists could be judged; and, although they disagreed about what constituted that standard, they shared a belief in its existence.

In 1674 Boschini wrote a primer for foreigners decoding the mysteries of Venetian painting that he had expounded fourteen years earlier in *La Carta del navegar pitoresco*, a 700-page dialect poem. The primer, introducing the second edition of his art guidebook to Venice, served as "Brief instructions" ("Le Breve instruzione") before one visits *The Rich Mines of Venetian Painting* (*Le Ricche minere della pittura veneziana*). It opens with a short history of painting, starting with the Bellini and ending with the "seven styles" of contemporary Venetian art, and is followed by three sections on design,

coloring, and invention. In the section on coloring he defined its various parts (*membri, . . . circostanze e particolarità*) in this way:

> Sometimes color is used in a thick mixture (*impasto*), and this is the foundation; sometimes it is used for sketchy brushwork (*macchia*), and this is style (*maniera*); for the blending (*unione*) of colors, and this is delicacy; for tinting and shading (*ammaccare*), and this is the distinction of the parts; for raising and lowering the hues, and this is rounding out (*tondeggiare*); for the scornful touch (*colpo sprezzante*), and this is boldness of coloring; for the veiling, or, as they say, caresses (*sfregazzare*), and these are retouches to give greater unity.[8]

Syntactically these linked sentences readily declare themselves as definitions. Each sentence tells the reader what something "is"; and, by means of a series of semicolons, we are invited to read each as part of a whole. Style is situated within a semantic grid of painting techniques. Although Boschini's intention was not to define style but to use style to define *macchia*, the grammatical structure suggests that the reverse may also be true: if *macchia* is style, then so too style may be *macchia*. That style and *macchia* are synonymous was an idea that originated in the *Carta* of 1660: "Sketchy brushwork (*machia*) is thus born from style (*maniera*), the touch of learned artifice."[9] As parsed in the *Carta, macchia* and *maniera* may not be identical, but they are intimately related "by birth" with priority given to style. Structurally *maniera* and *macchia* were also identified when he wrote of the Roman ex-patriot Giuseppe Salviati: "He has followed the Venetian style / He has practiced the artificial sketchy brushwork" (Ha seguì la maniera generosa, / Ha esercità la machia artificiosa . . .).[10]

Defining *macchia* as style is a good example of a tactical definition — that is, an appropriation of a potent word and the denial of its actual usage. Just as Vasari wanted to claim for style those aspects of painting he most valued (design, ideal imitation, and grace), so too did Boschini want to restrict style to his preferred species: painterly brushwork. Hence style was identified with other terms for sketchiness: "But to arrive at the style (*maniera*) and the sketchy brushwork (*trato*) of, for example, Veronese, Bassano, Tintoretto, and Titian, that is something, for God's sake, to make you crazy."[11] *Macchia* has the same effect: "Venetian *macchia* is so important that it drives foreigners crazy."[12] The disorienting, destabilizing effects of style and *macchia* will be discussed in the next section of this chapter, but for the

moment I just want to illustrate how style and painterly brushwork were frequently twinned, and of the terms for sketchiness none was evoked in relation to style as frequently or as explicitly as *macchia*.

Also tactical was Boschini's use of the expression *di maniera*. Venetian painters are "Masters of style" (*Mistri de maniera*) who enliven paintings with thrusts (*colpi*) of the brush and with "a single brushstroke loaded with color."[13] By co-opting the expression *di maniera* that had been used by Dolce, Vasari, and Gelli to designate stylistic formulae, Boschini transformed it from blame to praise. Venetian painters are acclaimed as *Pitori de maniera*, or *Mistri de maniera* or as having *depenta de maniera*.[14] He also used this semantic strategy of antiphrasis to cleanse *macchia* (stain or sketch) and *artificioso* (artificial), two terms synonymous with style, of their pejorative associations.

To impose upon Boschini's writing a rigid interpretive frame that expects clarity, consistency, and an orderly progression of ideas would fail to recognize his mode of thought and writing. However, unlike the *Carta*, an art-critical barcarole that espoused a sensual, associative approach to art rather than a logical and theoretical one, the prosaic "Breve instruzione" differed in audience and function. Intended to guide visitors around Venice in a clear and structured fashion, and to introduce them "concisely" to the history and principles of Venetian art, the mode of writing was adapted accordingly. It certainly informs the definition of seven techniques: *impasto, macchia, unione, ammaccare, rillevare ed abbassare, colpo sprezzante, velare o . . . sfregazzare*. In writing for foreigners in an approximate Tuscan, Boschini reduced the range and nuance of language he had adopted for a local audience that read dialect. The terms for brushwork that he listed here would have been familiar to any reader of Italian art books. Set aside are those parochial words for brushwork like *bota, bulega, ciera, spegazzone*, and *tresco*.[15] Spellings of Italian words were normalized: *machia* in the *Carta* becomes *macchia* in the "Breve instruzione." Boschini presents a representative spectrum of pictorial techniques ranging from a smooth, concealing surface (*unione; velare, o . . . sfregazzare*) to an open, active, even agitated surface (*impasto; macchia; colpo sprezzante*). His terms include aspects of illusion: how one object is separated from another by means of color and light (*ammaccare*); how an object is given the appearance of relief (*rillevare*). The sequence of presentation also suggests some intentionality: it opens with *impasto* as the "foundation," which involves "sketching in the figures with underpainting"; the terms of illusion follow each other; and twice, terms for smooth finish alternate with terms for sketchy finish (*macchia, unione; colpo sprezzante, velare, o . . . sfregazzare*).[16]

As an art term signifying a sketch or sketchy painting, *macchia* never entirely shed its primary denotation as a stain: "Sign that liquids leave and the mess on the surface that they touch."[17] In his *Vocabolario toscano del arte del disegno* (1681), Filippo Baldinucci repeated this definition from the *Vocabolario degli Accademici della Crusca* as the first meaning of artistic *macchia*, thereby retaining its associations with a messy, superficial form.[18] In 1623 the Accademici della Crusca emended their original definition of 1612 by introducing the idea of *macchia* as an accidental form: "Sign or coloring that rests on the surface of objects, different from their own color, by whatever accident."[19] In literary usage *macchia* most often designated a blemished visual form: an aberration of an otherwise clean surface, such as the spot on soiled clothing or pustulant sores on the flesh of plague victims.[20] Metaphorically it could mean stained virtue or a soiled reputation.[21] Whether as a physical, moral, or spiritual disfiguration, *macchia* suggested degradation and pathology. It was "filth." The intersection of the literal, artistic, and ethical meanings of *macchia* are recorded in Baldinucci's art dictionary:

> Sign that liquids, colors, and dirt leave on the surface of things that they touch on top of which they fall. Latin *Macula*. Painters use this word to explain the quality of various drawings, and sometimes also paintings, made with extraordinary facility . . . so that it almost appears to be made by itself and not by the hand of the artist. . . . In stones of various colors, one says *macchia* of that color which appears on top more than underneath. . . . And similar to these, one calls *macchie* those different types of color with which sheets of paper are artificially colored, known as marbled paper. And *macchia* signifies a dense and frightfully dark forest. . . . And from here, in whatever way brutes and thieves hide in the shadows (*macchie*) to engage in their malfeasance furtively, one says, to make whatever it may be *alla macchia* is to make it in hiding, secretly and furtively; thus of printers, counterfeiters, and forgers who print and make money without any authorization, one says to print or mint *alla macchia*. Also among painters one uses this term for representations that are made without having the object in front of them, saying to represent *alla macchia*, or this representation is made *alla macchia*.[22]

Baldinucci followed the wording of the 1612 edition of the Crusca *Vocabolario* for the first sentence of his definition, not because that was his standard

practice in writing his own definitions (it wasn't), but because by retaining its original meaning he rendered *macchia* more pluralistic, contradictory, and subversive. For its part, the Accademia della Crusca ignored frequent usages of *macchia* as a sketch, and it was partly this kind of exclusion of trade language that motivated Baldinucci to write his corrective *Vocabolario*.[23] Baldinucci complicated the Crusca definition by making *macchia* into a semantically slippery term that combined its denotation as an unsightly, randomly formed stain, its artistic meanings as a sketch and as tenebrism, and its moral dimension as dishonest behavior.

Macchia is a term defined by contrasts and inversions: it is a form made by chance in nature (a stain) and a form that appears to be made by chance in art (a quick sketch); it is a natural form that mimics artistic production (patterns in marble) and an artistic form that mimics nature (marbled paper). Antonio Carracci's *Annunciation* (Naples, Museo di Capodimonte; Figure 16) is a good example of *macchia* painting. Painted on a thin alabaster slab, whose reverse side depicts the *Madonna and Child with St. Francis*, its surface is left exposed in order to represent clouds. It is "painted" both by nature and the artist. *Macchia* stands in relation to nature in two opposing ways: it is a form copied directly from nature without emendation (marbled paper) and a form "made without having the object in front of them." Antonio's clouds not only "appear to be made by [themselves]," they are naturally produced forms that are embedded in the marble and untouched "by the hand of the artist."

The early history of *macchia* as an art term reveals an inherently ambivalent semantic. According to Vasari, "we [artists] call sketches (*schizzi*) . . . a preliminary kind of drawing that are made to determine poses and the preliminary composition of the work; they are made in the form of a stain (*macchia*)."[24] A *macchia* is not itself a kind of sketch, as it would become later, but expresses provisionality and improvisation.[25] It is still a "stain" in the sense used by Leonardo to describe the "spotted walls with various stains" that artists might use to stimulate a flagging imagination.[26] Stained walls helped Piero di Cosimo to discover battles, fantastic cities, and landscapes, much as clouds did for "Apollonius," who found, according to Philostratus, figures in the "shapeless and haphazard" forms.[27] Anton Francesco Doni saw figures both in clouds and in *una macchia d'un paese*, that is, equally in art as in nature.[28] Stains and clouds were useful to imaginative viewers because they were vague and indeterminate, opening instead of closing possible readings.

Macchie in Vasari's time were intended for private use to help artists explore forms, and not for public display. When a *macchia* transgressed this boundary between the private and public realms, when a stain jumped from

the page onto the canvas, then critics before Boschini identified it as a sign of artistic failure. Whereas a disordered *macchia* was appropriate for the studio because of its stimulating confusion, the public could not be expected to respond in the same way in looking at a "stained" painting. Vasari criticized Schiavone's paintings in the Carmine (Figure 17) as "*macchie* or sketches without being finished at all" and Titian's late work as "executed with broad and bold strokes and stains (*macchie*)." Other cinquecento writers assumed that *macchie* would be "grossly done" or "vile" or "disordered" or "confused" or "obscure" or "unfinished" and hence in need of being "brought to perfection."[29] Armenini singled out as a peculiar modern failure the affrontery "to display in esteemed public places works with some parts sketched (*abozzate*), some parts half finished, some things well made but many scarcely dabbed (*macchiate*)."[30]

Boschini came to the opposite conclusion. He praised Pietro Liberi for using finish (*finitezza*) in private cabinet painting and a bolder style for public works.[31] Critics who failed to look with the eyes of a painter could not "read" Tintoretto's *macchie*. His *macchie* are "Latin letters that are incomprehensible to the unlearned and hence attacked by the dolts."[32] Andrea Schiavone "imprinted those Latin letters with *macchie* that drive the baboons crazy for not understanding that which matters most."[33] Vasari, who had attacked Schiavone's *macchie*, was the very baboon Boschini had in mind.

Boschini did not try to conceal the pejorative meanings of *macchia* but, like Baldinucci, embraced both its virtues and its vices: "O stains (*machie*) without a blemish (*machia*), even splendors that brighten as if they were light."[34] Or: "Whoever shrinks from *machia* will soil his colors and stain (*machia*) them. . . ."[35] Playing with such antiphrases and ironies was a favorite activity for Boschini, who deliberately contradicted himself (or at least appeared to do so) in order to challenge and puzzle his readers with mirrored inversions. Venetian painting is a "form without form, or rather form deformed"; it finds its "true formation in fluid form."[36] Boschini was thinking of radical foreshortenings — it is "through imperfection that perfection will appear" — but the paradox of a metamorphic form describes *macchia* just as well. Like the representation of Venetian painting as "form without form," *macchia* is an antinomy, a kind of subversive twin that undermines and contradicts the conventional idea that contains it.

In this brief semantic history, I have tried to show that a congruity exists between understanding the visual and verbal languages of

macchia. Verbally, *macchia* is an antinomous concept that disorients the reader. Visually, a painted *macchia* casts necromantic spells, confuses, terrorizes, and terrifies viewers; it even drives them insane.[37] *Macchia* provided fertile ground for misunderstanding: "If they [those dumb foreigners again] were to know the value of sketchy brushwork (*machia*), they would apply all their talent to it and study that great foundation [of art], nor would they call it a blemish (*machia*) but splendor."[38] Another dim-witted foreigner invented by Boschini asserted that "he who does not apply pigment evenly makes his figures completely blemished (*tute machiae*)," to which Boschini responded, "O *machie*, which are like so many pure stars."[39] These examples elide semantic contradictions and act like the indeterminate form of an ink blot. What looked like a stain becomes a figure when viewed by a painter or by a viewer who looks with the eyes of a painter. What one took to mean "stain" or "sketch" or an inappropriately sketchy painting turns out to be an aesthetic ideal. An image seemingly made by chance, which "almost appears to be made by itself and not by the hand of the artist" to use Baldinucci's phrase, is revealed as the highest form of learning "that comes from great study and learning."[40]

The Crusca definition of *macchia* as a dark forest, a forgery, and a deep, cloaking shadow opens another area of transgressive meaning. As "a dense and frightfully dark forest," it is a place of malfeasance, presumably the place where counterfeiters mint their coins in secret. The shadows of the forest both protect the illicit activity from public view and emblematize its violation of laws and social norms. In art criticism, painters like Caravaggio and Guercino who were thought to hide their ignorance of anatomy and *disegno* in shadows, were labeled "furtive" or "clandestine" *macchia* painters.[41] Co-existing with the clandestine art of *macchia* painters was another kind of *macchia* that simultaneously composed and fragmented pictures by means of large masses of shadows. Occasionally in the late seventeenth century, and then with greater frequency in the mid-eighteenth century, the meaning of *macchia* as an obscuring shadow was transferred to the realm of painting. Boschini did not discuss *macchia* as a dark tonal mass or shadow, but the painter Luigi Scaramuccia put those words into the mouth of "Boschini" in his artistic peregrination *Le Finezze dei pennelli italiani*, where "Boschini" chaperones the "Spirit of Raphael" and a Perugian painter around Venice. When they arrive in front of Titian's *Martyrdom of St. Peter Martyr* (formerly in Venice, Santi Giovanni e Paolo), "Boschini" says: ". . . being further away, one makes out a beautiful *macchia* or, as we want to say, a mass produced by large areas of light and shadow placed in the right tempo."[42]

Boschini had alternative choices when selecting a term for sketchy brushwork that would be identified with style. *Macchia* belongs to a semantic family that describes open brushwork, whether a rubbing and caressing (*sfregazzo; strisso*) or jabs, punches, and thrusts of the sword (*bota; colpi de scrimia; sfodra*).[43] Why, then, did he choose *macchia* instead of other available terms? Why did it best define style? Here are four possible answers:

1. Boschini wanted an Italian (Tuscan) term for the "Breve instruzione" instead of one in dialect like *macchia*'s Venetian cousin *spegazzone* (blot, smudge, or stain). This answer is valid only when carefully circumscribed. It explains why *spegazzone* and the other dialect terms listed above were not chosen, but it fails to explain the exclusion of *colpo* or *tocco*, terms of wider usage than *macchia* in Italian art criticism.

2. Boschini thought that as "a sign that liquids . . . leave on the surface of things" *macchia* would evoke the quintessentially aqueous Venetian ambient. Both in its literal meaning as a stain, which suggests a liquid infusion, and in its figurative extensions into art criticism, *macchia* vividly captures the shifting, fluid reflections of Venice in its canals. It is presented by Boschini as anamorphic and metamorphic much like Venice's watery foundation that fragments and distorts the tectonic grid. Venice and *macchie* were considered magical and enchanting; both were visually unstable. The *Carta* and the *Ricche minere* are intensely patriotic books that adopted style, particularly *macchia* style, as a means to convey national identity. The freedom (*libertà*) of the Venetian brush and imagination became in Boschini's hands an expression of the myth of Venice as a republic free from foreign domination and having constitutional guarantees of individual freedom.[44]

3. *Macchia* as an indeterminant, antinomous, and transgressive concept and form captured aspects of style as a concept that originated with Vasari and became well rooted in seicento art criticism. In Baldinucci's words, "with style [esteemed masters] establish in their own way an ineffable distance from the agreed upon imitation of the true and natural. . . ." The implications of style as an "I don't know what" (*non so che*) will be discussed in Chapter 8.

4. Terms for edgy painterly forms like *bota, colpo, sfodra, sfregazzo, strisso,* and *tocco* refer specifically to a manual act and might be construed as mere technique or as a restriction of art to craft. Although Baldinucci noted that a *macchia* "appears to be made by itself and not by the hand of the artist," *macchia* did not entirely avoid the implications of manual production. Boschini called it a "blow" (*colpo cusì fiero*) and "mortal strokes" (*colpi mortali*).[45] "Those strokes, those *machie*, those jabs (*bote*)" in Bassano's *Martyrdom*

of St. Lucy (Bassano, Museo Civico) enticed him to rub his hands over its surface.[46] Unlike *colpo* or *tocco*, which refer primarily to the painter's hand, *macchia* mediates between the physical and the "higher" issues like imitation and creativity. The next section will suggest reasons why definitions of style avoided references to *maniera*'s etymology of *mano* (hand).

✍ THE HAND

No definition of pictorial style explicitly recalls its etymology until the mid-eighteenth century.[47] We have no text like Agostino Mascardi's *Dell'Arte historica* that explores possible semantic derivations of *stile* from the writing instrument "stylus."[48] Stylus, the sharp end of a writing instrument whether pen or chisel, captures metonymically the essence of writing: creation (the sharp end) and emendation (the blunt end). Mascardi acknowledged this to be philologically accurate but denied it any explanatory value because, he thought, it assumes the writer to have complete control over what is written. The stylus transcribes the words in the writer's mind without any kind of intervention. Like the hand that holds it, the stylus is a compliant instrument. Style's stylus thus proposes a mechanistic model of literary production at odds with Mascardi's belief that style is an innate, inner voice beyond the reach of authorial intention. In his view, and it is one that I concur with, the writer's hand betrays the mind.

Not only is the derivation of *maniera* from *mano* (hand) absent from every definition, but manual aspects of painting such as technique and brushwork are either suppressed or only discreetly acknowledged. This was not a product of ignorance or oversight so much as a deliberate avoidance of the uncomfortable truth that painting is a physical act. The *mano* of *maniera* was discussed outside of definition, but there was something about a definition that engendered a protective response. We find hints of *maniera*'s etymology in Filarete, when he notes how figures by one painter share a style (*maniera*) because they came from one hand (*mano*), and in Vasari, who included *tratti* among a list of style-related terms: "methods, expressions, styles, brushstrokes and imaginations of the painters and sculptors."[49] Given that the knowledge was there to be used, its absence from definitions appears to be deliberate.

One possible reason for overlooking *maniera*'s etymology is that the hand, as the instrument of production, evoked physical labor and recalled the struggle during the fifteenth century to redefine painting as a liberal art

instead of as a craft.[50] Angelo Decembrio, writing mid-century, has "Leonello d'Este" declare that poets are superior to painters because their work "depends more on the intellect, [and] surpasses by far the work of painters, which is executed through the talent of the hand."[51] Prejudices against craft such as these survived well into the sixteenth century. In 1591 the Genovese nobleman and painter Giovanni Battista Paggi defended the status of painting as a liberal art as if the matter were still in doubt. He was particularly worried by what his peers might think of his practice of painting and anticipated charges that he was engaged in an *arte manovale*: "And, to start with the staining of your hands, I say that it is not necessary to touch the paints with your hands, but that when they come to be touched it is more by disgrace than from need and greatly prejudices the nobility of the art."[52] He tried to calm his discomfort with touching paints by reminding readers that other noble arts like music, fencing, and equestrianism involve manual dexterity. Paggi's paintings show this aversion to messing with paints: not wanting to soil his person, he barely dared to play with pigments on the canvas, which makes his works look as if they were "painted more with the breath than with the brush."[53] Titian, for one, thought otherwise and used his fingers as brushes,

> by rubbing his fingers and blending the highlights into the middle tones thus unifying one color with another; at other times, with a smear of his fingers, he placed a stroke of shadow in some corner to reinforce it next to some smear of bright red, almost a drop of blood. . . . And Palma [Giovane] testified this to me as the truth, that in finishing a work Titian painted more with his fingers than with his brushes.[54]

Artists' hands are the repositories of gestural habits and in this sense may be said to embody their histories. As artists train their hands to represent visual forms, a mimetic shorthand develops that becomes, over time, an efficient means of production. The artist's hand (and sometimes, as in the case of Jackson Pollack, the whole body) seems to act spontaneously and balletically, controlled as much by a corporeal knowledge as consciously willed in each precise movement. Gradually habits develop that, even if they avoid the formulaic, at least share a common morphology and syntax in the ways that the brush dapples sunlight on foliage or shimmers light over satin. If Oliver Sacks is to be believed, the manual routines of artists become so somatically embedded that they can even survive traumas to the rational

mind: "neurologically, [style] is the deepest part of one's being, and may be preserved, almost to the last, in a dementia."[55]

Early modern writers heroized artists as masters of their hands, rational and always in control as they mediated between ideas and materials, imagined and visual form. According to Michelangelo, artists "paint with the head not with the hands" and express their ideas "only by the hand that obeys the intellect."[56] Great art would otherwise be impossible. These idealistic assertions mask an underlying anxiety felt by the hypochondriacal Michelangelo that his hands might disobey his intellect and imagination, that his body was an inadequate vessel for his mind. By positing the dominion of mind over hand, he revealed a concern about noncompliance. Setting aside artistic incompetence and such medical disorders as tremors or failing eyesight, are there other more universal conditions under which hands resist the artist's conceptions? A consideration of style partially affirms the obvious in this matter: artists do not consciously will all the movements of the brush. Style was thought to be an inimitable, personal, and stable (or slowly evolving) mode of working, a kind of involuntary reflex or habit that manifests itself in a stable gestural repertory. Style was more than this, of course, but the style experts known as connoisseurs practiced their trade on the premise, at least from the sixteenth century onward, that painters employ a consistent, and indeed inescapable, set of forms and brushstrokes.

In early modern art literature, the hand became an important site for perceived tensions between manual habit and intellective deliberation, practice, and theory, making and thinking.[57] Hands appeared most often as laudatory metonymies: as agents of an artist's creativity, originality, and individuality. The theology of the hand as God's instrument of creation appealed to artists and their supporters because it elevated art above the exigencies of a painter's materials and manual production. Dürer centered his Christlike *Self-Portrait* (1500) on his *divinae manus*; and Poussin depicted Christ as *Deus Pictor* in *The Healing of the Blind* (1650), where his healing touch cures the blind just as Poussin's touch opens our eyes to divine acts.[58] Other ennobling meanings accrued to hands as perceptual tools. Descartes likened seeing to touching – the rays of light serve the eye much as the sticks of the blind serve the touch[59] – and touching was sometimes understood even as a superior form of sight. Ghiberti, after looking at an ancient statue of Hermaphrodite, discovered artistic subtleties that had remained invisible to the eye only by running his hands over the marble surface.[60] Sculpture is inherently tactile – a fact deployed against sculptors by painters in persistent *paragone* debates[61] – but viewers of paintings also resorted to touching, most

often to dispel optical deceptions. Matteo Colaccio, like other spectators of naturalist paintings, sought reassurance from his hands after looking at the *intarsie* in Sant'Antonio in Padua: "Everything seems real to me, I cannot believe it is feigned. I come closer, and run my hands over them all, stepping back, I look at everything carefully."[62] Marco Boschini engaged in another sort of discernment when he rubbed his hands across the surface of Jacopo Bassano's *Martyrdom of St. Lucy* and *St. Valentin Baptizing St. Lucy*, hoping to discover the truth about "those strokes, those stains (*machie*), those jabs (*bote*)."[63] As if identifying with Saint Lucy, whose blindness brought insight, Boschini acted like a blind man by feeling the painted surface. It is through touch that he corrected the "confusion" of sight and came closest to Bassano's manual gestures that left their impressions in the jagged pigment. He could literally feel the movement of the artist's brush.

These divine and truthful hands coexisted with corporeal and deceptive hands. This alternate tradition assigned a servile status to the hand, one that rested on religious and metaphysical beliefs in the mind/body hierarchy where, in Marsilio Ficino's words, "nature has placed no sense farther from intelligence than touch."[64] It was hence applied to lower social classes: women, whose craft and understanding were often rendered as manual and tactile, and artists whose work was necessarily handmade and, to some degree, crafted. Various hierarchies of the senses and intellect circulated, but it was generally accepted that the relation was one of "service" with touch and sight "serving" common sense and the intellect.[65] Normally the hand "obeys" the intellect, and if it does not, at least according to Benedetto Varchi's reading of Michelangelo's sonnet quoted above, there are two possible causes: either the hand has not received sufficient training and practice, or it has experienced some physical handicap or accident.[66] This instrumental view of the hand assumes its compliance. It is a responsive servant that does not interject itself between the mind and the painting; in theory, its masters are the mind and the imagination. From the artist's practical experience, the hand may not submit so readily.

Michelangelo's famous struggles with stone originated, in Varchi's mind, from the fact that his hand worked "in opposition to the desired effect."[67] Because many Renaissance and baroque artists and theorists felt ambivalent about the supposedly menial tasks of manual production and about the reality of disobedient hands, they tried to move art away from *techne* toward *metatechne*, out of the painter's studio and into the humanist's study.[68]

Various kinds of evidence can be advanced to explain how artists and

writers dealt with their ambivalence about the craft of art. I propose to use language as my point of entry and, in particular, to focus on definitions as the most privileged literary mode of authority. Vasari and Poussin preferred to locate style in judgment and the intellect rather than in the body and senses; Baldinucci located it in taste and talent. Their avoidance of the hand may reflect a predisposition against the physical that can be traced back to earlier debates regarding the status of art. Artists and art writers who fought so long and hard to define art as a liberal art and not just a craft were evidently disinclined to recall the origins of this ignominious prejudice and absorb it into a concept so central to art. Prejudices survived well into the sixteenth century. In the section "Whose Language?" (Chapter 2), I introduced Vincenzo Borghini as an example of how artists could still suffer from narrow typecasting even under the most enlightened circumstances. Whatever Borghini's motives, and I suspect some involved a resistance to artists encroaching on his literary domain and thereby undermining his status, he slagged artists because they make things instead of thinking about them, their art is "in their hands" rather than in words. Paolo Giovio applied an edgy sarcasm when he praised Vasari as "fattivo, expedito, manesco et resoluto pittore" (in a letter to Cardinal Alessandro Farnese). He is an energetic maker of things (fattivo) and a handy painter (manesco) who, like many artists he implies, is unmanageable and truculent (also manesco).

In order to compensate for the ignoble necessity of manual production, artists and their supporters insisted that the excellence of art rested more in the conception than in the execution. Federico Zuccaro, for example, unabashedly acknowledged in court that his assistants painted the Porta virtutis but that nonetheless he considered it to be his painting, because, "truly, the invention, the conception, and the idea were mine, and it is quite true that I had it executed by that apprentice, having other things to do myself."[69] Authorship resided in invention, not in manual production. By isolating style from the hand, writers also protected it from the damaging physiological effects of old age. When Poussin defined style, his shaky hand had just started to show itself in his paintings. He had other motives for guarding style from technique, but mixed among them must have been personal anxiety about the artistic consequences of his tremors. By rendering style literary and rhetorical, he could postpone the admission that "with age his hand weakened, which he found to be an impediment in painting."[70]

The explanations proposed here for the absence or suppression of maniera's etymology are valid only to the extent that the hand was identified primarily with practice rather than theory, with technique rather than con-

ception and expression. The hand was more polyvalent than this. Its status as the "servant" of the mind, to use Baldinucci's metaphor,[71] was not always demeaned in such self-serving and polemical ways. Of the writers who defined style, Boschini came closest to bringing *mano* into *maniera*, not directly but by its technical and visual associations. By defining *macchia* as *maniera*, he situated style squarely within technique, notably brushwork. *Macchia* was associated with the hand as the handling of the pen (*il modo di . . . portar la penna*) or the artist's "touches" (*tocchi*) imprinted into the pigment.[72] Because brushwork is that part of painting where the manual gesture is most visible, and because *macchia* was the most sketchy (and hence most visible) of brushstrokes, it was a perfect place to locate style's handiwork.[73] Boschini was one of a handful of writers who challenged these values. Consistently contrary and adversarial to the Tuscan/Roman tradition that Vasari represented, he imbued brushwork with theory and made it carry more ideas and emotions than previous art writers had imagined to be possible.[74] In this respect Boschini theorized tendencies then current.

Richard Spear has given us a wonderful cultural history of the hand and its fluid, pluralistic semantics, embracing technique, legal documents, connoisseurship, art pricing, and a range of theoretical issues such as originality, talent, "divine" creativity, and style.[75] Despite the range of symbolic territory covered by the hand, when references to the hand are separated from corollary metonyms like the brush, the evidence clusters around issues of technique, originality, and individuality. Because originality and individuality anchored many discussions of style, any assertion that the hand posed problematic issues had to be restricted or, possibly, disqualified. Although the "hand" was tinged by persistent reminders of painting as a craft, this was mitigated by its other associations. In art-critical practice, *mano* could be used synonymously with style without any evident discomfort.[76]

Whatever aversion writers had toward manual production when theorizing style, connoisseurs who wanted to identify the style, and hence the authorship, of a painting looked first at technique. The craft of style might have been problematic for definitions or theories of style, but as a diagnostic tool for attribution, technique was unrivaled. Boschini, whose income depended largely on his activities as an art dealer, certainly knew the kind of trade secrets first systematically recorded by Giulio Mancini, personal physician to Urban VIII and unpublished author of *Alcune considerationi appartenenti alla pittura come di diletto di un gentilhuomo nobile* and *Alcune considerationi intorno a quello che hanno scritto alcuni autori in materia della pittura* (completed in 1621 but with later emendations).[77] As a collector writing for fellow collectors, he

gave considerable thought to the kinds of evidence needed for attribution. As a physician, he must have been predisposed to diagnosing surface or sensory phenomena as symptoms of a disease's (an artist's) identity. When written records such as contracts, letters, guidebooks, and biographies lay silent, he directed the connoisseur to visible evidence such as types of pigment, varnish, and craquelure. Highlights and sketchy brushwork, especially on drapery folds, hair, and eyes, were deemed particularly revealing as the identifying signature or handwriting of an artist.[78]

With his definition of style as *macchia*, Boschini took a symptom of style and made it into style itself. He defined by metonymy. Although he was the only writer to define style in this way, it must have permeated seicento beliefs sufficiently for Roger de Piles to open his definition of style by trying to displace its centrality: "One calls style (*manière*) the habit that painters have formed, not only in handling (*maneggiare*) the brush, but also in the three principal parts of painting which are invention, design, and coloring."[79] By telling us that style is *not* just the "character of the hand," he in fact tells us what most people actually thought. What he hoped to transform style into is not what style was thought to be. In a later definition, de Piles solved this problem by adopting a strategy similar to Poussin's and defined style by nomenclature, naming it *esprit*. *Manière* remained as a formal language originating in "the character of the master's hand" and "the movement of the brush." *Manière* is mutable, "changing this way and that," but true style, which he renames as lofty *esprit*, is a product of the intellect and character, and hence is deemed to be stable and transcendent.[80]

❧ ARTIFICIAL STYLE

"Artificial style" was a pleonasm that the wordy Boschini sometimes slipped into as a matter of emphasis. Venetian painters represented nature "with stains (*machie*) of color and beautiful hues! Oh what an artificial style!"[81] Style, sketchy brushwork, and artifice formed a tight semantic nexus in Boschini's writing. The adopted Venetian Giuseppe Salviati "has followed the Venetian style / He has practiced the artificial sketchy brushwork" (*la machia artificiosa*). . . . [82] *Macchia* "is born from style, the touch of learned artifice."[83] The "Venetian style" of "blots" (*spegazzon*) is called "an artificial style."[84] Titian's late style is called *una machia artificiosa*. Painterly styles, like Boschini's other favored artifices such as radical foreshortenings and squadrons of flying figures, did not originate with a natural

model: "The first oil sketches and rough outlines derive from the concepts in their mind without reference to nature or even to statues."[85] The sarcastic phrase, "even to statues," was one of many comments about Vasari's mistaken adulation of ancient statues. Viewers who look at Tintoretto's foreshortened figures in *St. Roch in Prison* (Venice, San Rocco) "as if they were natural," in other words with the expectation only of illusion, will not appreciate his "artificial style."[86]

Most writers would have agreed with Aristotle that style was artifice.[87] Where they would have disagreed with Boschini was in his celebration of conspicuously artificial art. Visual distortions that openly acknowledged painting's artificiality were, he believed, more truthful and more compelling than either natural appearance or appearances made deceptively natural by *sprezzatura*. His view of language was similar. As a Marinist poet, he reveled in sensuous metaphors and linguistic liberties that called attention to the act of writing. Whereas Bellori mocked Boschini's writing as "twisting his head and singing in his distorted language," Boschini was proud that his writing reeked with "incense," that it abounded with such "style, artifice, explanations, and conceits" that it defied description.[88]

Artificio and *artificioso* were two of Boschini's favorite words. He used them more frequently than any writer I have ever encountered, even surpassing Vasari, another fan of artifice. Whereas Vasari used *artificio, artificioso*, and other cognates eighty times in the Giuntina edition, in the *Carta*, a mere one-fifth the size of the *Vite*, they appear nearly a hundred times.[89] This may be dismissed as a verbal habit or quirk without much meaning beyond "of the artist" or "art." By definition, albeit a tautological one, all art is artificial. Because artifice is a precondition of making art, the central issue was not whether it was necessary, but whether it should be visible. Artifice "transforms" nature into art or the hardness of statues into the delicacy of painting, to use the terms of Vincenzo Danti and Francesco Scannelli,[90] but should the viewer be aware of the transformation? Should artifice be recognized by the viewer? On these questions there was near unanimity: artifice must be disguised. To reveal artifice was a failure, a rupture of illusion, like exposing the backstage mechanics of theatrical scenery. For a painting to be "artificial" could mean that its artifice had been unmasked.

Artifice was discussed most often in terms of illusion, with foreshortening as the most conspicuous form. A figure is distorted as an optical correction so that it can appear to the viewer as a figure moving naturally in or out of space. According to Armenini, because the "artifice of foreshortening" is a distortion, lazy painters think that any stretched figure will do.[91]

These painters were deceived, because a successfully foreshortened figure appears natural and conceals the method, hard work, and long study of models that preceded its production. The concave surface of a dome complicates the making of foreshortened figures because it imposes a distortion of its own that must be compensated for by an "extreme artifice" with figures painted "*di sotto in sù*."[92] For Scannelli, a successful artist will make figures in a dome appear real and not what they really are – "artificial in a convex space" – whereas an unsuccessful artist will produce "that affected artifice" that breaks the illusion by calling attention to itself.[93] For Bellori, the painted stucco figures and frames in the Farnese Gallery make it "the most artificial effect among modern examples of perspective," because the eye is deceived even knowing that it is fiction.[94]

The other common artifice that produced natural effects involved detail and finish: the subtly portrayed veins and hair on statues, the smallest details in all of nature painted by God-the-miniaturist (*alluminatore*) or "every tiny wrinkle, every curl of hair."[95] These "tiny things" withstand the closest scrutiny. They are rendered "so artificially" and "with wonderful artifice" that their artifice is cloaked from even the most persistent eye.[96] Only the hand can testify as to whether it is real or painted. Paradoxically, the effort to make artifice undetectable behind a detailed natural appearance could, for some viewers, produce the opposite effect of exposing artifice. Artists who "retouch their work too assiduously," like the obsessive-compulsive Protogenes, were thought to be in particular danger.[97] For Boschini, however, the "artificial style" of Venetian *spegazzoni* "tosses diligence in the corner" and creates a vivid illusion by fragmenting and blurring the painted surface, messing up its clarity and transparency.

Foreshortening, hairsplitting, and other forms of artifice aimed for naturalism but often produced its opposite. From this dilemma of unintended artifice arose critical topoi for the self-masking of artifice, best known in the ancient aphorism *ars est celare artem*, and famously renewed by Castiglione for a Renaissance audience under the neologism *sprezzatura*.[98] His paradoxical statement – "That art is true art which does not seem to be art" – acquired canonical status among art critics. It rendered art antinomous as a self-contradicting law, and in this respect it is similar to Vasari's contingent definition of style, to Boschini's style as *macchia*, and to Baldinucci's definition of style as a form of mannerism. It intimates that art (like style) is something that eludes direct definition.

The critical reception of Michelangelo's art shows how the boundary between art and artifice is porous and fraught with subjectivities. Michelan-

gelo himself was dazzlingly self-deluded about where his style lay along that boundary, believing that his figures were made with such art (*arte*) that "they appeared natural not artificial."[99] This misconception illustrates how artists could recognize their own styles only with great difficulty. Vasari agreed with Michelangelo because, as his facile emulator, he held Michelangelo to be timeless, transparent, and hence styleless. Ludovico Dolce, on the other hand, looked at Michelangelo with Venetian eyes and came to the opposite conclusion. He could be blunt in rendering judgment – a formulaic painter of stevedores – but when it came to the issue of Michelangelo's reputed *sprezzatura* he was aptly circumambient. Michelangelo's followers, he tells us, had so imbibed their idol's artifices that it blinded them to Raphael's *sprezzatura*. Habituated to excessive displays of art, they thought that "Raphael's delicate and restrained style showed too much ease and consequently did not have as much artifice to it."[100] They forgot the golden rule: "Art is the hiding of art's presence." Eventually the artifice in Michelangelo's art became more generally recognizable. For Lomazzo and Scannelli, Michelangelo lacked "the artifice to hide art" and showed why "nothing is worse in art than to show the art of art."[101] Michelangelo even came to be proverbialized as a synonym for artifice. Bartolomeo Carducci, a luckless follower of Federico Zuccaro, found the paintings by Gregorio Pagani to be "too artificial" and gave him this painful bit of advice: "If you were to Michelangelize somewhat less, then you would be envied here in the highest degree."[102] This brief history of Michelangelo's art suggests that artifice was only a temporary social or artistic code and not an immutable standard. The fetishistic display of muscles was an artifice that remained invisible to Michelangelo himself and his devotees, and could be seen for what it was only by artists with different interests.

Caravaggio, the rebel "anti-Michelangelo," to use Vincenzio Carducho's clever turn, tried to obliterate *sprezzatura* altogether. Bellori has Caravaggio claim that, "repudiating all other rules, he considered the highest artifice not to be bound to art."[103] This casts Caravaggio into the dubious category of naive viewers who mistake paintings for reality, only here it is nearly delusional, as the artist himself is denying authorship: "He claimed that . . . he never made a single brushstroke that he called his own, but said rather that it was nature's." Art that abandoned art was rarer and far more dangerous than the civil dissimulation of *sprezzatura* that only seemed not to be art. Emanuele Tesauro, the great baroque connoisseur of metaphor, author of *Il Cannocchiale aristotelico* (The Aristotelian telescope) and a writer who appreciated such contradictory challenges more than Bellori, took the aban-

donment of art as the highest form of artifice: "Just as with the fancies of painters, nothing is more artificial than sinning against art, and nothing more sane than losing one's sanity."[104]

Let us now return to how Boschini broke the conventions of illusionism. *Sprezzatura* was thought to be the highest artifice because it *appears* to be natural, not because it *is* natural. The confusion between appearance and reality marks many discussions of *sprezzatura*. According to Vasari, Titian's late paintings appear so deceptively easy, "made without effort" and "concealing the labor," that "many people" mistook appearance for reality and made "clumsy paintings" in imitation.[105] Boschini also turned to *sprezzatura* to justify painterly brushwork,[106] but where he differed from Vasari is on the point of whether the *colpi, macchie,* and other broad strokes should actually be visible to and appreciated by the viewer. Vasari insisted that in these late works "nothing can be seen from nearby" and that they need distance to blur or elide the messy surface.[107] Similarly, Mary of Hungary thought that a late Titian portrait "does not bear looking at too closely"; and the Milanese painter Aurelio Luini, looking closely at a landscape by Titian, found only "a smeared thing" (*una cosa empiastrata*), only to discover a sunlit winding road when he stepped farther away. Distance corrects the deformations of painterly brushwork, transforming them into illusion. In contrast, Boschini wanted viewers of Venetian paintings to look at them closely, if only to be dazzled and confused. The viewer becomes an active participant in creating a dialectic between deformation and illusion, transforming *macchie* from stains to works made by nature.

Boschini likened the experience of seeing apparently chaotic brushwork (*un Caos*) to spiritual revelation. The light emanating from the infant Jesus in Francesco Bassano's *Adoration of the Shepherds* (Venice, San Giorgio Maggiore; Figure 18) is "fiercely confusing" and "a chaos" when seen from nearby, but when one steps back the blinding light resolves itself into the Christ Child.[108] By stepping back, the viewer is spiritually reoriented. Confusion, chaos, and the aporia of *macchia* ("language cannot describe it") must precede revelation. Boschini agreed with the traditional view that distance brings illusion to sketchy brushwork, but he disagreed with the view that "from nearby they lose their reputation."[109] The artifice of painterly brushwork should be on open display. He wanted the viewer to appreciate the *machia artificiosa* for what it was and not just what it appeared to be, for the artifice as much as the illusion.

Macchia artificiosa recalls the Crusca definition of it as forgery and hence as an unnatural form. This was the only pictorial meaning assigned to it in

the 1612 edition of the Crusca *Vocabolario*: "To make whatever it might be by *macchia* means to make it secretly, furtively, as in 'to mint coins.' Painters say 'to portray by *macchia*' when they portray something without having it in front of them."[110] The unnatural *macchia* was artful but illicit.[111] In adapting this definition, Baldinucci combined it with the second definition in the Crusca dictionary: "For a dense and frightfully dark forest. . . . And from this *macchia* we say *immacchiare* and *ammacchiare*, which is to conceal by *macchia*."[112] In Baldinucci's view, Andrea Boscoli and Cesare Dandini were unnatural painters as a consequence of their painterly brushwork. Boscoli's "vigorous *macchie*" and "charged and disconnected style of handling" made his work "somewhat mannered" and "somewhat removed from the natural."[113] And Dandini, grieving after his father's death, abandoned the natural world in favor of artificial distortions, painting "in that way we call *alla macchia*."[114]

FILIPPO BALDINUCCI

CATALOGUING STYLE
AND LANGUAGE

Baldinucci's definition of style, published in the first-ever art dictionary, the *Vocabolario toscano dell'arte del disegno* of 1681, is divided into two parts: one on style in general, which is presented here; and the other on different kinds of styles, to be quoted and discussed below in the section titled "Lexical Fields":

Maniera. Way, manner, form of working (*operare*) of painters, sculptors, and architects. One means by mode that it regularly restrains any artist in his work (*operar*); whence it becomes very difficult to find a work (*opra*) by one master completely different from another work by the same master, which does not show any sign in the style of being by his hand and not by another's. It follows by necessity, even with esteemed masters, that with style they establish in their own way an ineffable distance from the agreed-upon imitation of the true and natural, no less of one than the other. From the root *maniera* comes mannered, which one says of those works where the artist, distancing himself a lot from the true, draws entirely upon his own style as much in making human figures as animals, plants, draperies, and other things; these things could well appear to be made with ease and boldness, but they will never be good, nor will they have much variety. And this vice is so universal that it embraces, more or less, most artists.[1]

This does not seem to be as overtly tactical or self-contradictory as the previous definitions. Its presentation in a dictionary lends it an air of objectivity and authority, only partly warranted as we shall see shortly. Neutrality is apparently guaranteed by opening the definition – "a way of working" – just as the authoritative *Vocabolario degli Accademici della Crusca* did.[2] The phrase *modo d'operare* or *modo di fare* was the most conventional and uninflected meaning for style, being used more often than any other to explain *maniera*, and hence adopted by the Accademia della Crusca for its definition.[3] Baldinucci elaborated on the phrase by locating style, not only in the artist's "working" (*operar*) but also in the "work" (*opra*) itself, where "work" and "working" intermingle and penetrate each other in a way that suggests causality. *Operar* can be read either as the verb "working" or in its substantive sense of "work" while still retaining the sense of action or deed. The definition of style concerns primarily the producer and the act of production; the following definitions of stylistic types concern the visible results of that production.

Baldinucci's linguistic agenda for style can be introduced through an examination of his motives in writing the *Vocabolario*. By his own account in the preface, one morning soon after returning to Florence from Vico Pisano, he met Senator Giulio Pucci, and as they strolled from the Duomo to the Piazza "del Granduca," Pucci suggested that Baldinucci write an art dictionary. What Pucci extemporaneously named a "Vocabolario toscano dell'arte del disegno" would define the terms and expressions commonly used by artists and dilettantes.[4] The specific details of their meeting lends the story an air of authenticity, but how likely is it that on this chance encounter Pucci came up with the exact title that Baldinucci would use? And is it mere coincidence that Baldinucci, who at the time wanted to advance his career with the Medici, just happened to be walking toward the Piazza "del Granduca"? This story sounds even more fictional when the trope of convenient dissemblance is recognized, where modest authors claim to be writing only at the behest of another. Vasari adopted just this strategy in explaining the origin of the *Vite*, where Cardinal Farnese, Paolo Giovio, and others urged him to write a history of art,[5] and since Baldinucci aspired to be the new Vasari, the story must have had a special appeal.

The purpose of Baldinucci's origin story was to deflect any suspicion that he had written the *Vocabolario* for selfish motives. Actually he had one or two pressing on his mind. Uppermost was his desire to gain entry into the prestigious watchdog of language, the Accademia della Crusca, and to consolidate his position with Leopoldo de' Medici, who was an ardent

supporter of and participant in the academy's lexicographic activities. His strategy was successful in this respect. One year after publication of the *Vocabolario*, he was elected as member of the Accademia, and during the following years Baldinucci remained happily employed as Medici art curator.[6]

Beyond the political motives for writing the *Vocabolario*, Baldinucci planned it as a linguistic preparation for writing his biographical history of art, the multivolumed *Notizie dei professori del disegno dal Cimabue in qua*, started in 1681 and completed posthumously by his son Francesco Saverio in 1728. With the *Notizie*, Baldinucci hoped to advance his career and position in history by becoming the new Vasari, renewing the *Vite* and expanding its purview to Europe in general without losing its Tuscan bias. The *Vocabolario* espoused Tuscan linguistic supremacy and hence used language as a political instrument, as the title's conspicuous *Toscano* suggests and as he proudly declared when he wrote "in our language and in no other." To venture forth as a supporter of the much beleaguered Vasari was for Baldinucci an expression of civic pride calculated for its political effect with the Medici. Maligned by many writers for propounding Florentine superiority,[7] and favored by Medici munificence, Vasari represented for Baldinucci the status of cultural commissar that he sought for himself. He envisioned the Medici drawing collection in similar terms as did Vasari's *Libro de' disegni* – as a visual history matching in scope and structure the written history of art. Although not a practicing artist himself, Baldinucci studied drawing with Carlo Dolci, engraving with Jacopo Maria Foggini, and painting with Matteo Rosselli, although "merely as a pastime and for recreation."[8] His true devotion was "less to painting and drawing than to acquainting myself with the paintings and drawings of the masters, particularly those of the past." To this end Leopoldo de' Medici sponsored an artistic tour of Lombardy in 1665 so that Baldinucci could "master the styles and taste of the great painters of that land" and thus advance his expertise as drawings curator for the Medici collection.[9]

In writing the *Vocabolario* to prepare for the *Notizie*, Baldinucci seemed to acknowledge that historiography was defined by and even limited to language, except in art historiography where drawings could also tell the story. Thus, before embarking on the *Notizie*, he wanted to systematize, expand, and inflect the terminology of art historiography. The need to do so, he claimed, arose from the intentional neglect by the Accademia della Crusca in compiling the *Vocabolario degli Accademici della Crusca* (Florence, 1612), the most comprehensive and most consulted Italian dictionary. Even

though one of his primary audiences were the Crusca academicians, and despite the fact that his dictionary was intended to correct certain deficiencies and oversights of the Crusca dictionary, Baldinucci departed from the philological standards set by the Accademia della Crusca. First, he omitted Latin etymologies because, he said, he did not know them, and second, he omitted the usual citations and quotations from literature as examples of linguistic usage. Giovanni Cinelli Calvoli questioned his linguistic competence – Baldinucci almost invited such criticism – but then he misunderstood Baldinucci's intention, which was to define how artists used these words as a kind of studio vocabulary and to define his own usage in the *Notizie*.[10] He envisioned his dictionary as a challenge to the terms of reference of the Crusca *Vocabolario*, terms that specifically excluded trade or specialty terminology, and, judging by the third edition of 1691 that included many of Baldinucci's emendations, it was a successful challenge.[11]

✐ Individuality and Subjectivity

All definitions have an agenda, even those staged with philological clarity and convention, and Baldinucci's is no exception. He ignored the epistemology of style, whether it be psychological, astrological, ethical, or otherwise, in favor of a taxonomic approach. The taxonomic unit that interested him was individual style and not regional, national, period, or school styles. This can be seen too in the *Notizie*, where periods (Vasari's centuries or Baglione's pontificates) are rendered meaningless as an arbitrary template of decades. Instead his definition privileges the uniqueness of each artist's style where every artist's work shares "a sign" with all other works by that artist. This restriction reveals his definition as strategic, born of his experience as a curator of drawings. Despite the pretext of inclusion and objectivity assumed for a dictionary, his entry is thus somewhat lopsided and unrepresentative. Just as Poussin consigned individual style to the linguistic netherworld of *stile* in favor of rhetorical *maniera*, so too does Baldinucci limit style to curatorial experience and consequently omits any reference to rhetorical style or to the realities of contemporary studio production.

To define style as a stable mode that "regularly restrains any artist in his work" was hardly new to Baldinucci. It was explicit in usages by Filarete, Vasari, Dolce, Gelli, and many others and was central to Roger de Piles's definition of *manière* as a manual and mental habit.[12] The knowledge that

style is individual and marks all work by an artist saturates art literature in the early modern period, as the fundamental studies by Warnke and Kemp have shown.[13] It even shaped exam procedure at the Accademia di Belle Arti in Venice, where professors verified that students had actually done their submitted competition drawings by having them make an "improvised" sketch in their presence.[14] The competition drawing, often a copy of a masterwork, might have taken weeks and the sketch just minutes, but the professors knew that the style would be the same in both. Style as certification was also well known in calligraphic practice and literature, where handwriting would confirm a document's legitimacy.[15] Connoisseurship was the pictorial application of the signature theory of style. In this section I want to show how, in his role as curator, Baldinucci's dependence on style as a heuristic helped shape his definition and discussion of style in general. In defining style, individuality, not artistic identity, concerned him.[16]

What is unexpected about Baldinucci's definition is how it restricts the artist's ability to manipulate style. When he wrote that style "regularly restrains any artist in his work," he predicated a certain loss of artistic control and autonomy. The ubiquity and stability of style in all works by an artist imply a degree of inevitability. An artist cannot escape his or her style and cannot become completely cloaked in that of another. In this sense, Baldinucci's definition is oddly anachronistic, in denying possibilities of stylistic control that Poussin had explored in his definition and that had been acccepted by most art critics by mid-century. He made no reference to artists imitating or mimicking the styles of other artists but referred instead only to self-imitation where an artist "draws entirely upon his own style." This belief in style's indelibility was nurtured by his experience as curator and by an attendant belief system that had to predicate style as fixed in order to facilitate his connoisseurial activities. If artists could freely manipulate their styles, as Poussin believed, to fit the subject or their changing artistic goals, then as a connoisseur Baldinucci would have had less stable ground to practice his trade.

Neither ignorance nor neglect motivated Baldinucci's silence on the rhetorical dimensions of style. Nor can the exigencies of space and the need for concision explain his silence. In a lengthy letter to Vincenzo Capponi, published as a pamphlet two weeks after Cosimo III's censor approved the *Vocabolario*, Baldinucci quoted and contextualized his definition.[17] Yet, despite the opportunity to elaborate, he retained the strictures of style as an individual and constant form. His motives for doing so and his real interest in style are made clear in this letter. Capponi was the grand duke's *luogotenente*

at the Accademia del Disegno, and so Baldinucci might have had some reasonable hope that he could convince Cosimo III of his qualifications to serve as art curator. He posed four pertinent questions to that end: (1) can a dilettante judge art just as well as a professional painter? (2) what rules can help decide whether a painting is an original or a copy? (3) what rules can help in attributing a painting to one master or another? and (4) what esteem should be given to copies?[18]

Baldinucci's equivocal answers reveal his solipsistic agenda for style. To the first question, he conceded to painters greater expertise in judging art but, not unexpectedly, tried to carve out for himself a new professional niche as "expert dilettante." Conventional wisdom and practice assumed that painters were best qualified to attribute paintings, and Baldinucci wanted to prove otherwise.[19] In answer to the second and third questions, he was evasive, as if to show that sometimes the difference between copy and original or master and follower is virtually imperceptible. He cited two instances that illustrate how the evidence of style is not always what it seems to be. First there is Giulio Romano's famous mistake when he identified Andrea del Sarto's copy (Naples, Museo di Capodimonte) of Raphael's *Leo X* (Florence, Palazzo Pitti) as the original.[20] If there are no rules, and if even the most expert viewer is deceived (Giulio helped Raphael paint *Leo X*), then what hope is there? Although some clues for attribution are given, such as looking at the patina and at the stroke of the pen, he concluded that "for these above-noted reasons it seems to me to be absolutely impossible in our times always to give a secure judgment whether a painting might be by the hand of a certain master, or not."[21] Despite the impression of certainty, this conclusion is actually a red herring. Baldinucci misrepresented popular opinion, particularly within the artistic community, in order to promote himself as a uniquely talented connoisseur. Artists may have abandoned hope for a secure science of attribution, but he had not.[22]

Structurally his argument pivots on style. As the first step in his proof, he quoted his own definition of style, thus giving it a strategic importance.[23] If style "regularly restrains any artist," giving all work a resemblance that is uniquely distinct from the work of other artists, then the "sign in the style" can be diagnosed. If style is unique, then it must also be inevitable even when artists try to transcribe faithfully what a particular object or person looks like. The portraits of Leonello d'Este and Francesco Sforza (discussed in Chapter 5) are good examples of how painters involuntarily impose their style on their subjects. Passeri theorized the subjectivity of style with the dictum: one hundred eyes looking at a single scene will see it and represent

it in one hundred different ways, and Baldinucci adopted a similar figure of speech in writing to Capponi: "[It] will happen that, should ten painters make at one time a portrait of a young man, each one will portray the same hair and the same drapery with a different softness or hardness from that of every other painter, that is, in all respects according to his own style."[24]

The subjectivity of taste and style became an increasingly popular topic in the late seventeenth century, driven probably by the emergence of aesthetics as a topic in rhetoric and philosophy, starting with Ettorri's Francophile *Il buon gusto ne' componimenti rettorici* and consolidated by Muratori's influential *Delle riflessioni sopra il buon gusto nelle scienze e nell'arti*.[25] An "Accademia del buon gusto" was established in Palermo in 1718. According to an anonymous writer of the early eighteenth century "an object can be equally considered from many viewpoints, and when presented to different minds and to different eyes an object will appear to them different and varied against all reasonable expectation. I cite in evidence painters who all see the same things yet never paint them all in the same way. . . ."[26] A century later Ludwig Richter recounted an artistic experiment that he and three friends devised in Tivoli. They agreed to paint the same landscape, framed in the same way, and each "firmly resolved not to deviate from nature by a hair's breadth: and although the subject was the same, and each quite credibly reproduced what his eyes had seen, the result was four totally different pictures, as different from each other as the personalities of the four painters."[27] You cannot escape your style.

What constituted the "sign" that Baldinucci mentioned would change over time.[28] According to the poet Alessandro Allegri, quattrocento artists placed "a sign (*cifera*) in the corner of the picture" to state authorship, whereas "modern painters" were known to connoisseurs by their style (*maniera*).[29] Whether or not Allegri was correct in suggesting that style during the sixteenth century replaced more literal codes (initials or signatures) as a means of identification, it is certainly true that style required *intendenti* to interpret the new sign. The task of attribution is difficult, as Baldinucci acknowledged, and requires great learning based on repeated study of many paintings by a single master. However, once those paintings are "impressed in the mind," their individual character can be extracted as easily as a *cifera*. Baldinucci insisted, and Giovanni Gaetano Bottari agreed in his editorial comments of 1754, that the question of expertise had been incorrectly framed.[30] Judgment of style depends not so much on a professional's knowledge of how paintings in general are made but on a knowledge of particular paintings. Artifact trumps process.

Passeri and Baldinucci introduced the subjectivity of sight as a precondition of artistic representation. Baldinucci, however, transferred the subjective eye from the artist to the connoisseur. Differences in style may be inevitable, just as some residue or "sign" is inescapable, but these are sometimes hard for viewers to detect because, as Baldinucci noted, many styles differ only "by certain minutiae of a most particular taste." Production and reception clashed in this respect. The history of connoisseurship from its infancy in the seventeenth century to the present day is fraught with disagreement, indecision, comical error, and vacillation, all consequences of the similarity of styles and the subjectivity of the viewer.[31] Jonathan Richardson's vivid analogy of differentiating styles and trees was based on his real-life frustrations as a connoisseur:

> To be able to distinguish betwixt two things of a Different Species (especially if those are very much unlike) is what the most Stupid Creature is capable of, as to say This is an Oak, and That a Willow; but to come into a Forrest of a thousand Oaks, and to know how to distinguish any One leaf of all those Trees from any other whatsoever, and to form so clear an Idea of that one, and to retain it so clean as (if occasion be) to know it so long as its Characteristiks remain requires better Faculties than every one is Master of.[32]

Style tantalizes with a theory of stable individuality promising a decipherable sign, but in practice it withholds easy recognition.

Baldinucci wanted to suppress this equivocal experience of connoisseurial practice by insisting that every sign can actually be securely identified. This was as much a career move as an honest conceptual stance, one that he hoped would secure his position as curator in an increasingly competitive art market. The need for a specialized knowledge arose from the burgeoning of artistic styles. Oddly, as art production increased and styles diversified during the seventeenth century, there was a corresponding loss of acuity regarding older styles. Baldinucci drew these two phenomena together when he compared quattrocento and seicento painting. Quattrocento painters, to his eye, tended to work with barely distinguishable styles, whereas the seventeenth century celebrated differences and individuality.[33] The history of style is filled with similar histories of prejudice. Giorgio Vasari thought all Byzantine painting looked alike with its tip-toed figures. As time passed, even quattrocento painting began to shrink into an undifferentiated mass. Vasari had little trouble identifying individual characteristics, but a century later Baldinucci

and Boschini had to admit that they looked very much alike. Perceptually attuned to the grandiloquence of seicento painting, they never developed the quieter visual skills of appreciating quattrocento nuance.

Baldinucci welcomed the new seicento styles as a market response by artists to satisfy the demands of collectors who had refined and narrowed their tastes. He located the driving force for artistic change in the market-place, in other words, with collectors like himself and Lorenzo Gualtieri (the recipient of his letter where these comments are made).[34] Some collectors wanted pictures with dark backgrounds, others with light backgrounds, others with immoderate caricature, others with bright colors, others with a beautiful touch of the brush. Different styles suited different tastes, and artists developed styles to satisfy those tastes. Baldinucci was agnostic regarding the quality of different styles. One was not necessarily superior to another, but rather a product of different temperaments and educations that were "infinite" in combination. Just as no two artists painted in the same way, no two viewers responded to paintings in the same way. Painters were "regularly restrained" by their styles, just as collectors gave "no regard to anything else" but styles that conformed to their personal taste; they were "blind" to other possibilities.

These discussions about the intractability of style as a tool for attribution, about the qualifications of those who judge style, and about the explosion of styles were a means to an end: to justify Baldinucci's aspirations to expand curatorial control over the growing Medici collection of drawings, and to convince Vincenzo Capponi to help him realize those ambitions. Lorenzo Gualtieri could be useful in the same way but presumably had already been persuaded of Baldinucci's skills as a connoisseur, having administered to him a test that involved the attribution of two hundred drawings.[35] Baldinucci passed with distinction.

✐ DEVIATION

In his definition, Baldinucci gauged individual style against two stable norms: "the true and the natural." Style is thus a kind of deviation in much the same way that for Vasari the modern style of *grazia* went beyond the stable, rule-bound imitation of the fifteenth century. Even Baldinucci's terminology of "an ineffable distance" (*un non so qual lontananza*) to describe the divergence of style from the true and natural recalls Vasari's indeterminate location of style "between the seen and the unseen." Each,

however, assigned a different historical function to deviation. Vasari considered the licence of style as a mark of progress, present during certain periods but not during others. Baldinucci found the certain "distance" to be a precondition of making all art; it is not always present to the same degree and in itself is not desirable. It is even potentially dangerous as the first easy step to mannered art (*ammanierato*), which he defined in the next sentence as the consequence of style. By defining style as an individual and indeterminate distance "from the true and natural," he brought together two Renaissance commonplaces that were normally kept apart: style as the ideal (the combining of the most perfect parts) and style as a distortion of nature and beautiful art (what Mino did to Desiderio). For Vasari, style could be one or the other but not both at once. Style was a means to imitate ideal beauty; simultaneously and conversely, it was an impediment to attaining that goal. Baldinucci's definition differs from Vasari's by excluding the possibility of individual style ever attaining the ideal. For Vasari, Michelangelo reached the empyrean heights of perfection. For Baldinucci, such perfection could not exist: "It seems impossible to me that one could recognize in a single artist such a perfection in his art that one could qualify it absolutely as superior to every other."[36]

In contrasting Vasari and Baldinucci, I do not mean to suggest that the "style as deviation" thesis originated with Baldinucci. Abraham Bosse thought the mere existence of style signified an artistic deficiency, rendering all style as a mannerism. If artists painted correctly, by using the scientific rules of perspective, there would be no style. (I cannot tell if Bosse actually believed this naive claim, but that is what he said.) And Bellori discussed Rubens's style as a superimposition of the artist on his source.[37] For an artist with a strong style, to make a copy in a style other than his own was impossible. Despite his best efforts, Rubens could never follow the lines or contours of ancient statues when drawing them and instead altered the lines with his own style. (Bellori assumed here that Rubens actually wanted to make an uninflected copy.) And, most famously, Agucchi interpreted the proliferation of new modern styles as a symptom of a general artistic decline, calling them "heresies."[38] Heresy suggests a departure from dogma and absolute truths that pertain for everyone at all times. Where Baldinucci differed from Agucchi, Bosse, and Bellori, however, was in his belief that the deviation of style was inevitable and natural, not an individual or cultural failure. Instead of lamenting the loss of purity and the departure from a restrictive canon, as did Agucchi, other late seicento writers conceded the diversity of styles and the subjectivity of artistic taste as simply a fact of nature.[39]

Baldinucci's definition of style is a kind of antiphrasis that contains within itself irreconcilable and contradictory aspects. In order to maintain the purity and, hence, the utility of *maniera* as a term, he inserted into his definition a caricatural meaning, *ammanierato*. This strategy of defining a stylistic quality by means of its most exaggerated, distorted form was well known from Cicero and Quintilian.[40] Bellori, in drawing on this tradition, commented how quests for beauty unintentionally transmute beauty into deformity because "beauty resides nearby to ugliness just as vices touch virtue."[41] Bellori believed, as did Cicero and Quintilian, that beauty and ugliness inhabited separate, albeit contiguous, domains. In his view, artists occupy one domain or the other. For Baldinucci, however, artists could occupy both realms of style and stylization. His view that *maniera* and *ammanierato* are intimately and inextricably linked, even causally dependent, was rejected by Honoré Lacombe de Prezel, who borrowed the structure of Baldinucci's definition but emphasized that style and mannerism are "two expressions . . . that designate two very different things."[42] Baldinucci, however, thought that, just as all artists and their works must have style, so "most artists" lapse into mannered styles.[43]

Mannerism is style magnified. All style is a distortion, "an ineffable distance from the agreed-upon imitation of the true and natural," and the contiguous boundary with the mannered is blurred and easily transgressed. The difference between style and mannerism is only a matter of degree. Style moves only "an ineffable distance" away from ideal and natural beauty, while an artist becomes mannered by "distancing himself a lot" from those norms. These ideas were present in the cinquecento expression *di maniera*, which signaled by nomenclature the small step from style to mannerism, the two being separated by a tiny preposition. After the publication of the *Vocabolario*, Baldinucci's solution took root. *Maniera* and *di maniera* survived as alternatives,[44] but clearly there was a need among art writers for the kind of linguistic distinction that Baldinucci made.

Maniera was not the only definition in the *Vocabolario* to undermine itself. Baldinucci defined composition (*composizione*) as "a combination and mix of things."[45] For a term so central to art as composition, and so precisely applied in a long post–Albertian tradition, it seems odd that he chose such a vague and uninflected definition. It is atypically brief and gives no indication of its applicability to art. An easy explanation would be simply to note that Baldinucci repeated the definition in the *Vocabolario degli Accademici della Crusca*, but, considering his philological intentions to correct the Crusca bias against trade terms, we should assume that he exercised a choice in accepting

their definition.[46] Something in the seeming banality of "composition" must have struck him as suitable, and what that might have been can be glimpsed within the lexical nexus of his *Vocabolario*. *Mescolanza* and *accozzamento*, the mixing and combining of his definition, have a semantic undertow that endows composition with elements of confusion and disorder. For the definition of *mescolare*, he appends a neutral description ("to place different things together") to a more allusive and provocative synonym, *confondere* ("to mix up").[47] The polysemous *confondere* is more explicit about its chaotic nature and the notional state that mixing produces: "To mix different materials together, without distinction and without order, to dissipate, liquify, and melt. To convince others with reasons [but] make it remain confusing."[48] In other words, *confondere*, like our expression "mixed up," can be value-free (as in "the paints are mixed") or narrowly judgmental (as in "confusing"). What seems unavoidable from these definitions is that there is something disorienting and chaotic about combining different things.[49]

✑ LEXICAL FIELDS

Following his definition of *maniera*, Baldinucci defined fourteen different kinds of style:

Maniera cruda: Crude style. One says this of those painters who, not knowing how to make use of middle tones, pass from dark shadows to bright lights without any transition; and in this way pictures are made with almost no imitation of the true and without relief. One also says this of those with little experience in unifying colors; passing from one color to another, they do not observe the required proportion, as if someone threw the blackest ink onto the whitest paper. . . .

Maniera dilavata: Washed-out style. It is made by whoever colors without force or relief, whose pictures, because of the weakness of the hues, gain more by chiaroscuro than by natural coloring.

Maniera forte, o gagliarda: Strong or robust style. It is [applied] to that painter who makes his figures stand out from the picture plane and gives them great relief by means of the strength of deep shadows and bright lights.

Maniera gretta: Stingy style. Term that one opposes to that which we call *manierona* ("grand and bold style"). It is [applied] to that

artist who works meagerly or coldly, that is, without magnificence, without boldness, with little artifice and invention, without ornaments or any other of the parts that make a work admirable and invite attention.

Maniera ideale: Ideal style. Term used by Luigi Scaramuccia, painter from Perugia, in his book titled *Le finezze de' pennelli italiani*, to explain the style of that artist who does not stay very close to natural appearance in his work so that he completely forgets to observe the most beautiful in nature and in the works of the most sublime masters.

Maniera languida: Languid style. Contrary to the vigorous style.

Maniera legnosa: Wooden style. [Applied] to that painter who, although having good coloring, invention, and other beautiful qualities, nevertheless has a certain affliction of taste that prevents him from making his figures svelte and giving them movement and animation; with a certain finished coloring he makes his figures appear hard, as if he were portraying a painted wooden statue instead of a living person. One recognizes this vice more from the whole than the parts, which can often appear on their own as well drawn, well colored and adorned. In any case, many who were burdened with this ugliness during the last century wanted to imitate the divine Michelangelo in making muscles and draping their figures. . . .

Maniera Lombarda: Lombard style. One says this of those artists who are able to imitate the beautiful and natural way of coloring of the most celebrated Lombard painters.

Maniera risentita: Vigorous style. Contrary to the languid style. [Applied] to that artist who, in defining muscles of figures, works with great ardor and vigor. In the expression of the heads, in the foreshortenings, in the movements, and in the expression of emotions, the artist always chooses that which is most lively and which one rarely sees in nature in the same subject. . . .

Maniera secca: Dry style. [Applied] to that artist who works in such a way that one sees more of the artist than of nature. . . . or to that artist who outlines his works dryly, that is, without any softness, and to that artist who, for want of understanding, does not give relief, adornment, or truth to the chiaroscuro, design, and invention.

Maniera svelta: Svelte style. Contrary to the stumpy, squat, or stocky style. One says of this style of painting, sculpture, and

architecture that, as much in the parts as in the whole, one sees the thin and long more than the heavy and short. . . .

Maniera tagliente: Cutting style. See Cutting (s.v. *Tagliente*: One says this of a vice that soils paintings; and it happens when the artist does not observe in the coloring the proper gradation, diminution, or subtle brightening of chiaroscuro so much so that one moves from the brightest lights to the deepest shadows without any middle tones, which one also calls the crude style).

Maniera tozza e atticciata: Stumpy and squat style. See *Maniera svelta*.

Maniera trita: Chopped style. See *Trito* and *Tritume* (s.v. *Trito*: Minced. Detailed, whence minced style, that which gives tiny details. And s.v. *Tritume*: Defect of every invention or composition of painting or sculpture but more properly of architecture; and it occurs when the parts or members are excessively varied, in excessive quantity, and too detailed).[50]

Unlike Vasari's style as graceful beauty, or Poussin's usurpation of style within the grand style, or Boschini's style as painterly brushwork, Baldinucci deflected any normative standard by dispersing style into styles. Similarly, in his letter to Capponi he illustrated the definition of *maniera*, quoted from his own *Vocabolario*, by discussing immediately afterward the styles of twelve different painters. Giambattista Volpato answered the question "In what way does one apprehend style and what is this style?" by defining four stylistic qualities (*accidenti*) and applying them to a group of Venetian painters.[51] He argued that any individual style can be characterized by some combination of *franco, forte, diligente*, and *vago*: Titian's style is *franco* and *forte*; Veronese's is *franco* and *vago*; Giorgione's is *forte* and *diligente*; Bellini's is *vago* and *diligente*. The fourteen styles defined by Baldinucci are not intended to be inclusive like Volpato's canon of four, instead they are exemplary. They demonstrate that style is individual, contextual, and hence best known by its attendant attributes. Benedetto Varchi distinguished two modes of explaining meaning by way of Aristotle: definition, which identifies the "essence" of a person, concept, or thing; and description, which presents "accidentals" or contingent qualities.[52] Baldinucci's definition proceeds from similar principles. He understood that style is grasped as much through its perceptible attributes as through the abstract concept itself. Vasari, Poussin, and Boschini located style somewhere in the "true and natural," but Baldinucci's style is "an ineffable distance" from that immutable realm. It is contextual, relational, and metaphorical.

Style here resembles language, in the sense that meaning depends on predicative relations and interdependent qualities whereby one style (or word) evokes the presence of others. That Baldinucci thought of style as language arose naturally from his activity as lexicographer. The Crusca academicians defined words mostly through synonyms and by illustrative quotations. Synonyms defer definition, dislocating meaning into other words that, in turn, reference yet some other word. Following the Crusca definitions leads you through an endlessly circuitous path of semiosis. What results, if one holds the various synonyms in mind, is a semantic web that I will call a "lexical field."[53] By envisioning style as a lexical field and, simultaneously, as existing in a lexical field, Baldinucci revealed a truth about the perception of style as a cognitive function. Not only do we tend to describe a style in relation to other styles (the relation may be explicit or implicit), but we see it within a similarly structured visual frame of reference.

If style is an individual sign located some indeterminate distance from the "agreed-upon" poles of natural and ideal beauty, then critics who wanted to capture that individuality and distinguish it from other styles were faced with a linguistic challenge of considerable magnitude. If their language were as infinitely flexible and inventive as the styles they hoped to describe, then it would be a fair match. Instead, what most critics had was a standard set of terms that could be combined in different clusters, even modulated into meaningful sequences. There are far more shades of color than words to describe them. Of course this is as much a problem of perception as of language. Color fields and lexical fields lack clear-cut boundaries; meanings of words bleed into each other as much as colors do. If we showed people colors in minute grades of variety, we would find that somewhere between, say, *yellow* and *green* there would be a border zone where the naming wavered. Rhetoric and poetics helped to map out types of styles into lexical fields, but in art criticism no articulate system emerged. Instead, the lexical fields usually remained unarticulated and submerged within the language of stylistic criticism.

How, then, is Baldinucci's stylistic/lexical field structured? In the *Notizie*, he used about eighty different terms to differentiate styles, so the fourteen listed here must be seen as representative rather than comprehensive. (Of course, they might be completely arbitrary, but considering his ambition to impress the Crusca academicians and his interest in cataloguing styles, this seems unlikely.) Nor are these simply fourteen of the most commonly used terms. With the exception of *maniera secca*, he did not use these terms in practice as often as he did many others, like *amoroso, brioso, bizzarro,*

diligente, delicato, duro, fiero, finito, franco, presto, pastoso, pulito, replicato, strapaz-zato, velato, and *vago.* I do not want to suggest that his chosen terms are obscure, only that if the basis of inclusion were frequency of usage, then one would expect to find fewer terms like *gretta, tozzo,* and *trito,* which are not often found in art criticism.

Every writer contours the lexical field differently, depending on artistic taste, literary training and ability, or lexical availability. Those areas of a lexical field which are most developed held the greatest interest for the writer and probably correspond to the writer's visual interests and acuity. Just as the Inuit have a more extensive vocabulary to describe "white" and "snow" than Italians, so too did Boschini have a wider lexicon to describe coloring and brushwork. Language adapts to need. Not only does a lexical field signal areas of interest for the critic, it also bounds and limits a critic's attention to those areas which language has made available. Thus to understand *what* style is, we must also consider *where* style was invested.

In Chapter 5 various stylistic classification systems were reviewed, each containing overlapping lexical fields based on national identity, rhetoric, music, or psychology. Gender is another culturally encoded meaning latent in stylistic terms.[54] None of these conceptual divisions, however, illuminate Baldinucci's choice of styles. His style terms refer instead to the traditional triad of invention, design, and coloring. Unlike Poussin, who drew style closely into the orbit of invention – an inclination that eighteenth-century critics adopted with relish – Baldinucci better reflects his Italian contemporaries, who generally located style more often in design and coloring than in invention.[55] When an accounting is made of his fourteen terms, the proportional distribution looks like this: seven describe coloring (*cruda, dilavata, forte, legnosa, Lombarda, secca, tagliente*); six apply to design (*legnosa, languida, risentita, secca, svelta, tozza*). If, however, Baldinucci's division of painting into four parts is used (invention, design, coloring, and *accordamento*), the distribution pattern changes significantly. *Accordamento,* the fourth part added by Baldinucci, is defined as a harmonious fitting together of the parts: "When all the things painted on a canvas or panel will be placed in such a way that from the whole (*tutte insieme*) results a harmonious concordance and union."[56] Nine of his fourteen stylistic qualities concern aspects of *accordamento: cruda, dilavata, forte, languida, legnosa, risentita, secca, tagliente, trita.* The prominence of *accordamento* in this list stems from the concept of style as a means to attain formal unity.[57]

Baldinucci's stylistic terms are predominantly formal and visual. Only two are normative, describing not particular forms but aesthetic virtues or

vices (*gretta, ideale*). And only one term (*maniera Lombarda*) is based on pronominal usage that refers to a broader classification system. He completely excludes any terms that suggest psychological attributes (*amabile, furbesco, libero,* etc.). None are rhetorical in nomenclature (*attico, magnifico, ornato, severo, sublime,* etc.). None are spiritual (*grazia, maestoso, spiritoso, splendido,* etc.). Style seems to exist without reference to content, as if Bernini's opinion about antique sculptural fragments were true: they may be robbed of content, being just figural parts, but they have style.[58] Style as a historical marker emerges only once, where the *maniera legnosa* signals the failure of Michelangelo's followers. Baldinucci tilted style toward form and suppressed all other dimensions because his real interest in style was that of a connoisseur. As he told Vincenzo Capponi, style is a tool for attribution and classification.

To the extent that Baldinucci's definitions venture into the absolutes of aesthetics, we find him obsessed with bad art: of the fourteen terms, ten are reserved for bad art. The reason for this is suggested by the definition of style and its proximity to mannered art. There is something inherently deforming about style; it is, by definition, a distortion. Others also found danger lurking everywhere in style. Armenini mentioned style most often to warn artists against some hidden threat. Standard models of imitation are fraught with stylistic snares: "engravings give a harsh style, painted works retard style, statues harden it . . . and objects of nature, if not excessively beautiful, which is rare, promote a stunted and feeble style."[59] Failure was integral to other definitions or dissections of style. Orfeo Boselli's definition of style is brief and canonical – "the way of working by imitating one thing more than another" – but its substance lies in noting how artists can err, either by their innate talent (*Genio*) or by their education.[60] Artists may have "troubled and corrupt humors" or a "bad complexion," or they may study "bad masters, thus acquiring false precepts from the start and forming a habit that once worn is difficult to change." Giampietro Zanotti did not define style, but his extended index for *Maniera* in *Storia dell'Accademia Clementina* (Bologna, 1739) lists the important topics of style, about half of which involve either equivocations, such as Cignani's style being beautiful but labored, or warnings of excess: Tibaldi's style needs to be moderated and studied only in moderation; too much knowledge of Guercino is unnecessary.[61]

All terms in Baldinucci's list, except for the anomalous *Lombarda*, are stitched together into a semantic grid of synonyms and antonyms. Six of the fourteen terms are formally introduced as antonyms (*languida* vs. *risentita; gretta* vs. *manierona; tozza* vs. *svelta*); two more are assumed to be antonyms

(*dilavata* is defined as lacking force and hence is the contrary of *forte*). The five remaining terms, again excluding *Lombarda*, are virtually synonymous and involve transgressions of *accordamento*. Lights of the "crude style" *(maniera cruda)* jump from dark to light without transition; its coloring is similarly disjointed, detaching lips from the face. The "chopped style" (*maniera trita*) renders a painting "into the smallest particles." This dissective effect is central to the sharp lights of the "cutting style" (*maniera tagliente*) that lack any "gradation, diminution, or subtle brightening of the lights and shadows." Its firelight flickers; its moonlight blanches. Like the "crude style," which he cites as a synonym, the "cutting style" and the "dry style" (*maniera secca*) lack relief. Both slice form with too heavy lines, bluntly dividing one form from another.[62] Each of these styles is defined by an absence of connective tissue and a breach of *accordamento*.

Like most other art historians and critics, Baldinucci thought of the crude, cutting, dry, wooden, and chopped styles as proximate vices.[63] They are defined by absences. The crude style is "without middle tones" and "without relief"; the cutting style is "without middle tones" and "without . . . softness"; the dry style is "without any softness." As antonymous styles, they are also defined by a bipolar semantic that hints at style's dichotomous nature. If, however, these defective styles are considered as mannered,[64] then the structure is not simply one of incompatible polarities but one of a downward gradient. *Ammanierato* is separated from *maniera* by degrees along a continuum: style is "an ineffable distance from the agreed–upon imitation of the true and natural," whereas the mannered artist "distanc[es] himself a lot from the true."

Freezing stylistic qualities into polar dualities implies a certain rigidity of thinking. One can believe that Guercino's style is "the opposite of and contrary to the style of Guido Reni" only if their styles are reduced to a few, simple stylistic tags: Reni had charm (*vaghezza*), Guercino had boldness (*fierezza*); Reni had open (*aperto*) light, Guercino's was shuttered (*serrato*) like Caravaggio's.[65] And how can Raphael's style be "completely the opposite" of Caravaggio, as Federico Borromeo and De' Dominici would have it?[66] Poussin and Boschini also defined style by situating particular styles within a lexical field of aligned or opposing styles. For Poussin, the *maniera magnifica* implies the other rhetorical styles. For Boschini, *macchia* as *maniera* appears within a nexus of opposing techniques of coloring: *impasto, unione, ammaccare, colpo sprezzante,* and *velare*.

Underlying these attempts at classification is the belief that style, like

linguistic meaning, is relational: "For almost all the types of style can best be described by looking at them in relation to other types."[67] Rhetorical *comparatio* employed bipolar semantics to attribute and analyze orations or texts. Cicero's stylistics involved oppositions within a single style opening out to oppositions of different styles:

> The orators of the grandiloquent style, if I may use an old word, showed splendid power of thought and majesty of diction; they were forceful, versatile, copious, and grave, trained and equipped to arouse and sway the emotions; some attained their effect by a rough, severe, harsh style, without regular construction or rounded periods; others used a smooth, ordered sentence structure with a periodic cadence. At the other extreme were the orators who were plain, to the point, explaining everything and making every point clear rather than impressive, using a refined, concise style stripped of ornament. Within this class some were adroit but unpolished and intentionally resembled untrained and unskillful speakers; others had the same dryness of style, but were neater, elegant, even brilliant and to a slight degree ornate.[68]

Art critics were usually silent about their inheritance from rhetoric. Its grid of contraries — hard/soft; strong/weak; clear/vague; rough/smooth; continuity/division; composition/decomposition — was so steeped in their classical education and in the language of criticism itself that they might have been blinded by its obviousness. One writer who stated the obvious was Francesco Algarotti, who observed that the description of styles as contraries derived from poetics.[69] He contrasted the "minute, half-toned, finished" style of Bellini, Holbein, and Leonardo to the "resolute, bold, sketchy" style of Tintoretto, Bassano, and Rubens, and then compared those extremes to analogous ones in poetry, with Homer replacing Bellini and Virgil replacing Tintoretto. In between, there are "infinite gradations." This sounds (and is) far-fetched, but Algarotti saved himself by concluding that this bipolar scale is not fixed and absolute but fluid and relative. Homer is poetry's Bellini when compared to Virgil, but when he is compared to Pulci, he becomes poetry's Tintoretto.

Relational semantics recognizes a certain porous blurring of meaning. A style term does not have a fixed and absolute meaning but is understood through the artist it describes and through contingent stylistic qualities. This was an adaptation strategy to compensate for having a relatively meager

lexicon of style terms. Consider, for example, how broadly a term like *delicato* was stretched to cover over thirty painters working in very different styles.[70] Having imprecise semantic boundaries shifts the burden from the writer to the reader, who is assigned the responsibility for a close textual reading.

A Conclusion on Indeterminate Styles

Style has a way of evaporating under scrutiny, being "extremely fragile and evasive."[1] Dorothea Franck recently called it "a shy animal" that can only be caught by metaphor: "It appears to belong to the category of things which change as soon as you take a sharp look at them, like quarks or the expression on a face. As a kind of shadow, attached to every human action or its products, style functions unproblematically as long as it stays in peripheral perception."[2] Of her three metaphors for style – quarks, facial expression, and a shadow – two were used by Petrarch. The fact that Franck was unaware of this makes her invention even more credible. Art critics following Petrarch connected style to expression (*aria*) and shadow, and hence conveyed its mode of signification: associative, unstable, insubstantial, and inchoate. Like style, *aria* was a signifier of an interior psychological condition, just as shadow evokes a more palpable physical presence, something absent or ontologically indistinct.

Indeterminate style sounds like a precariously modern idea, but still I think that enough examples have emerged in the preceding chapters to justify a closer look: for example, Vasari's liminal modern style as something "between the seen and the unseen" and "beyond measure"; Firenzuola's wandering *vaghezza*; Boschini's anamorphic *macchia*; Boselli's *maniera magnifica* where "everything" and "nothing" are seen simultaneously; and Baldinucci's *non so qual* distance from the true and natural. I have tried to explain how a writer's agenda imposed meaning on style. In one sense, my stated intention is misleading because it presupposes that style has a meaning that exists outside of any given text, a kind of ur-style that writers knew about and chose to alter. What I actually wanted to show with these definitions was how chameleonic style is, how readily adaptable to the critic's needs. It may

be true that most art-theoretical concepts are utilitarian in this sense, but my impression is that style offered greater interpretative latitude. The subjectivities of style as a visual phenomenon seem to have accrued to the concept. Just as every painter has an individual style, so too every writer understands style differently. Just as "every painter paints himself" and every style reflects its maker, so too every writer reshapes the concept of style in his or her own image. It is this phenomenon of self-reflective style that makes it seem to wander as a concept. If style is inherently indeterminate, fluid, and easily malleable, then it can be readily defined to fit a writer's needs.

Conceptualizing style can provoke aporia. Style can be named more easily than defined, experienced more than understood; or, as Charles Altieri put it: "Clearly style's resistance to description makes it impossible to offer firm definitions."[3] One often finds modern theorists of style defining it by contradiction and denial: "Style is not coherence; nor is it deviation; nor a tracing made of this or that social stratum."[4] Unbeknownst to Altieri, Todorov, and other modern theorists, Agostino Mascardi had arrived at a similar conclusion in 1636 after undertaking the most comprehensive review of the literature to date. In the final section of the "Fourth Treatise" he tempts us with closure by entitling it "What Style Is" only to withdraw it. His strategy of discovering style through earlier usages proved to be a failure, he admitted, because every conventional reading of style was inadequate for a definition of it. As for his own conclusion, he wrote ruefully, "If anyone were to ask me what style is, I would have to say frankly that I don't know."[5] He knew that differences between individual styles could be easily recognized, that one style could be distinguished from another as any connoisseur knew, but he could not articulate what exactly those differences were, just as he could not define style unequivocally.[6] Instead of resisting the fact that style escapes definition, he embraced it as an essential part of what style is.

Mascardi tried to convey style's elusiveness in various ways. He used ancient authority, for example, the *Symposium* where, he thought, Plato defined style with an enigma.[7] Style is not something that can be stated directly or unequivocally; its meaning exists in contradiction and concealment. Style is not a stable truth. Even more interesting than his (mis)use of Plato is the title Mascardi gave to the "Fourth Treatise" on style: "Digression on Style" (DIGRESSIONE INTORNO ALLO STILE). Here he intimated that his discussion of style would stray. This is not a usual digression either in length or in importance. "Digression" suggests that an analysis of style must wander and that style lacked the secure place of his other treatise topics (what is history; who should write history; the truth of history; and the structure of

history). Each of the other "treatises" are broken down into *capitoli* (chapters), but the "treatise" on style is divided into *particelle* (paragraphs or some other small portions). True to their label, the *digressione* and *particelle* are more episodic than the other treatises. He had to change the literary form to accommodate the concept. As if to compensate for its vagrant exposition, Mascardi virtually shouted his title, the only one to be given such majuscular emphasis.

Mascardi likened style to a foreign air, a hint of strangeness and the extraordinary that one hears when a foreigner speaks your language: "an I don't know what of the foreign" (*un non so che di pellegrino*).[8] In 1666, Sforza Pallavicino concluded that style always had "much of the foreign in it" (*tanto di pellegrino*).[9] *Pellegrino* can signify many things, but among their intended meanings, Mascardi and Pallavicino probably meant to include its most common and literal meaning: wanderer, pilgrim, or foreigner. What the *pellegrino* in style evokes, then, is a sense of strangeness and the unusual that can excite pleasure in the way Aristotle noted: "We should give our language a 'foreign air'; for men admire what is remote, and that which excites admiration is pleasant."[10] Modern literary theories define style as "a linguistic pattern suddenly broken."[11] If every style is individual, as Mascardi stated, then every style (like every accent) will seem "foreign" because of its differences from one's own. It exists, as Baldinucci wrote, at "some distance from the agreed-upon imitation of the true and natural."

Of the two parts of his (un)defining of style – that it is indeterminate (*non so che*) and foreign – being foreign is subsidiary to being indeterminate. It is the quality of foreignness that makes style seem to be not just from a different place but out-of-place and not fitting into readers' or viewers' expectations. This "I don't know what" signals an area of visual and semantic slippage where an artist's particular idiosyncrasies diverge from the conventions of ideal and natural beauty. For Baldinucci it was the slight differences between similar styles that made attribution so difficult (*una non so qual lontananza*), what Luigi Lanzi called *insensibili*.[12] Lacombe in his art dictionary of 1758 liked the idea of style as conceptually and visually elusive: "Style is a fashion or form in making, a touch, a taste, a choice, in short an 'I don't know what' [*non so che*] that characterizes the works of a painter and lets us understand them. It is a breath of a whole school."[13] In 1775 Giovanni Battista Verci used the Italian translation of Lacombe's definition for his own.[14] Because style was generally understood as a stable set of forms that exist in all paintings by a single master or even a whole school or period, it may be said to exist in-between paintings or to infuse the forms of any

particular painting. It is everywhere but nowhere in particular. In Lacombe's words, it is "a breath of a whole school." For Cennino, Leonardo, Francisco de Hollanda, Gelli, Vasari, and others, style resembled "air" (*aria*).[15] Petrarch, who initiated "air" into art theory and criticism, identified it as a form of shoptalk among painters who spoke of "air" as a "certain shadow" that wavers between similarity and dissimilarity. Because "air" and "shadow" are insubstantial, their recognition and description escape rational, verbal discourse; style is, in Petrarch's words, something "elusive and unable to be extricated except in silent meditation, for the resemblance is to be felt rather than expressed."

One symptom of style's aporia is its semantic meandering. Mascardi forewarns us that the treatise on style will differ from the other four, more conclusive treatises because in it he will "digress." When one looks back on the other definitions it becomes clear that Vasari's and Boschini's also revolved around unstable centers and fluid semantic boundaries. Vasari defined by misdirection in order to conclude that modern style is "beyond measure" and "appears between the seen and the unseen." It is something that has no particular or constant place. It wanders (*vagare*) and, according to Vasari, it has a charm (*vaghezza*) that escapes verbal description. Boschini defined style as a stain and sketch, thus evoking an amorphous liquidity suited to the city of Venice itself and to his chosen form of literary expression, a barcarole. Semantically liminal, *macchia* is neither premeditated nor chaotic but "almost thrown down by chance";[16] neither natural or unnatural, it is a provisional form that leaves the viewer more interpretative latitude than finished styles.

Macchia is one of several indeterminate forms that provoke conflicting responses because it lacks closure. *Ammaccatura*, literally a "bruise," entered art vocabulary through sculpture and was later transferred to painting, where it describes how drapery flows "most softly" with slight indentations and undulations.[17] Baldinucci defined *ammaccature* by means of exclusion and contradiction: they are "certain drapery folds" yet they are not folds, "neither deep furrows, nor folds, nor compressed wrinkles." He cannot define the term because sculptors and painters "cannot name it." Scannelli described *ammaccature* by means of *leggiero*, which can mean something light, thin, or delicate, but equally, according to the Accademia della Crusca, something unstable and inconstant.[18] *Leggierezze* recalled for Federico Borromeo paintings of silk with *colori cangiante* fluttering in the wind, for him an image of unredeemable frivolity and instability.[19] When applied to drapery folds, *ammaccature* are diaphanous, evanescent, insubstantial, and barely perceptible.

Both *ammaccatura* and *macchia* originated as terms that describe blem-

ishes, respectively a bruise and a stain, and, to the extent that their denotations adhered to their adaptations, they may be considered to be semantically dislocated and unstable. Indeterminate forms recruit conflicting perceptions depending on the expectations and experiences of the viewer. Vasari saw Tintoretto's paintings as unfamiliar and hence unorganized: "executed by him in a fashion of his own and contrary to the use of other painters. Indeed he has surpassed even the limits of extravagance with the new and fanciful inventions and the strange vagaries of his intellect, working at haphazard and without design . . . done more by chance and vehemence than with judgment and design."[20] Vasari lacked the perceptual experience to find structure in this particular chaos. Giorgione's frescoes on the Fondaco de' Tedeschi also confused him. He thought they were personal inventions made "according to his own fancy in order to display his art." They seemed not to refer to any known person or subject: "I, for my part, have never understood them, nor have I found, for all the inquiries that I have made, anyone who understands them. . . ." All depends on the viewer's perceptual and intellectual expectations. Similar charges were leveled against Vasari and his contemporaries by Gilio da Fabriano and Paleotti. Gilio, arguing against a modern penchant for complexity and distortion, cited Vasari's Sala dei Cento Giorni as paradigmatic of an art that can be easily misconstrued: "If ten people gaze on such frescoes, they will make ten comments and not one will correspond with the next."[21] Gilio took these subjective responses as a sign of Vasari's artistic failure.

Another symptom of style's indeterminacy is the difficulty that art historians and critics had in agreeing on how to classify it. Only the realities of time and place brought a consensus, possibly because these were wedded to the economic needs of collecting and to the requirements of historiography. The totalizing systems proposed by Lomazzo, Scannelli, and Boschini were rejected by everyone. In classifying nature, early modern scientists accepted a certain fluidity where objects from one category are transposed into another: "Renaissance natural history fabricated categories that purposefully demonstrated the permeability of the boundaries among kingdoms, challenging the ability of the naturalists to taxonomize their world."[22] Paula Findlen explains this by reference to the "jokes of nature," which transform one substance into another, one species into another, horses into wasps or dirt and menstrual blood into red toads, to use examples from Giovan Battista Della Porta's *Magia naturalis*. Coral is the best-known transmorphic artifact, "hardening at the touch of air, that which was a plant when under water becomes rock when brought above the surface."[23] The displacement

of one category into another was not seen as scientific errors of taxonomy but as evidence of nature's fecundity and playfulness. In art criticism it proved how an artist's procreative nature was uniquely individual.

☙ THAT CERTAIN SOMETHING

Mascardi mentioned the slight differences between related styles as an aid in defining what style itself is: "an I don't know what" or "a certain something" (*un non so che*).[24] Baldinucci, drawing on his curatorial experience, also defined style as that "*non so qual* distance from the . . . true and natural." Every painter, no matter how great, has a *non so che* of his teacher.[25] Mascardi's *non so che di pellegrino* and Baldinucci's *non so qual lontananza* suggest that style is not fixed, determinate, or normative, as Vasari's rejected quattrocento concept of style confirms, but is unique, subjective, and relative. Sperone Speroni described the resemblance and differences between a person and his portrait as "a certain *non so che*."[26] Filarete also grappled with this issue in describing portraits of Francesco Sforza as always alike and always different.[27] As one might expect from the expression itself, *non so che* describes the ineffable by means of absences or lacunae, either visual or verbal. It is known best by what it is not and by what it transcends: "For beyond invention, beyond design, beyond variety and beyond the fact that his works are all supremely moving, one finds in them that element which, according to Pliny, the figures of Apelles possessed, charm, that is, that indefinable something (*quel non so che*) which customarily proves so attractive with painters no less than with poets. . . ."[28] *Non so che* identifies a liminal space or trespass of conventional boundaries. Titian gave his Adonis an androgynous expression (*aria*): "I mean that in a woman it would embody a certain something (*non so che*) of manhood, and in a man something of beautiful womanhood: a difficult mixture. . . ."[29] Sperone Speroni, like his friend Ludovico Dolce, turned to *non so che* to describe hermaphroditic love: "That love is perfect whose knot binds and conjoins two lovers completely, such that, having lost their proper appearance, the two become some indescribable third thing (*un non so che terzo*), not otherwise than is said in fables of Hermaphroditus."[30]

Writers evoked *non so che* when language failed them. The idiom implies that if "I don't know" then perhaps it is something that cannot be known. Ludovico Antonio Muratori answered the question "What is grace?" by turning to "an occult quality or even that famous '*non so che*,' wonderful

name, which serves a writer to name everything that he does not know how to explain."[31] Good taste or style, according to the Veronese painter Giambattista Cignaroli, evades explanation: "Certain hesitations and resolutions make the coloring true and real by scattering over the whole *un non so che* of good taste [that] can be seen but is impossible to explain."[32] *Non so che* results from contradictory and incompatible techniques (*indecisioni* and *rissoluzioni*) or from the presence of opposing styles. Phidias' statues were thought to be replete with *non so che*, having "the grand and exquisite together."[33] As a verbal mode, *non so che* insinuates rather than declares. When Annibale Carracci wanted to damn Pomarancio's style with slight praise, he said that "non era niente inferiore" to the earlier stylistic experiments. Giulio Mancini explained Annibale's intention in stringing these three negatives together as "wanting . . . to insinuate a *non so che* of something more" than he actually says.[34] Vasari's strategy of defining by misdirection adopted *non so che* as a rhetorical device, as did Mascardi's choice of a "digression" to analyze style. Hence, as a verbal mode, *non so che* provides the reader with areas of ambiguity that need to be filled in to complete the meaning, much as viewers of *non so che* must read figures, buildings, or landscapes in deep shadows, clouds, and ruins.

Being indeterminate, at least by verbal and conceptual standards, *non so che* identifies an area of enchantment and irrational attraction. Simone Cantarini concluded, after studying Guercino's *Investiture of San Gugliemo* (Bologna, Pinacoteca Nazionale); "ugly and deformed feet, hands, and head, and yet I must like it." *Non so che* is a quality that insinuates itself and pleases despite culpable dominant qualities, forcing Cantarini to like ugly bodies or G. P. Zanotti to like the *non so che* of artificiality and the counterfeit in Domenico Viani's *Jupiter and Ceres*.[35] Baruffaldi explained Cantarini's conflicted response, one where "the intellect is spellbound more than satisfied," by referring to the painting's *non so che*.[36] The same contradictory effect was observed in poetry. Apostolo Zeno quarantined Marino among poets obsessed with external beauty, excessive ornament, puerile themes, and other seicento failings, and yet he had to admit that his poetry had "a peculiar *non so che* that even pleases men of sound judgments."[37]

If *non so che* is beyond verbal description and rational discourse, how then does one recognize it and convey its presence? It is best known by its effects on the viewer, emotional, spiritual, and even magical. It "moves," "pulls," "inspires," "enraptures," and "enamors," verbs that suggest a loss of control and absorption of the viewer by the art.[38] It is a spell that attracts despite (or maybe because) neither the source nor the effect can be articu-

lated or it possesses, in Francesco Algarotti's words, "that invincible charm which is as certain to win as it is impossible to define."[39] In a lecture at the Accademia di San Luca, the painter Giovanni Maria Morandi used *non so che* as a critical virtue in order to find fault with Félibien's *Conférences*, a copy of which had just been received in 1681. Morandi thought Félibien's art criticism was too intellectualized and laboriously verbal, consequently missing the emotive appeal of grace in art: "And since the heart does not have fixed norms as does the intellect, grace cannot be learned or explained, but instead one feels it and draws it out from nature. Grace is a *non so che* that pleases, bewitches, and seduces, and predisposes the soul to sublime happiness."[40] The effects that Morandi desired were broached in Boschini's affective criticism where, for example, the *non so che* of Veronese's *Wedding at Cana* (Paris, Louvre) "magnetizes" his ideas, "wounds" his heart, and deprives him of speech.[41]

One would expect such an indeterminate quality, felt more than understood, not to have a particular identifiable look. And yet, actually, *non so che* had a precise and stable pictorial repertory. As an expression or expressive effect, it could range from geniality to terror, yet most often it was located in beatific or soporific expressions that speak of an otherworldly or liminal state.[42] A common form of *non so che* involves shadows whose blurring, murky, and masking effects produce a loss of clarity, both visual and verbal. The inky shadows of "liquid color" in Mastelleta's landscapes gave his paintings, according to Malvasia, "an I don't know what of antiquity and style" (*un non so che di antico e di maniera*).[43] Sebastiano Filippi painted with a *non so quale oscuro contorno* that made his paintings appear to be draped in a gossamer veil.[44] Clouds are a perfect *non so che*, unstructured and unstable, whose dissolving light and shifting forms defy description.[45] So too are ruins "consumed by time."[46] It was also adopted by critics to explain how the "most subtle" layers of underpaint peek through the painted surface to show the warmth of skin, or how a mixing of pigment can disguise the materials into a flowing, undifferentiated (*pastoso*) whole, or how the variegated patches of color in Schiavone's woodcuts mysteriously cohere (Figure 19).[47] Just as *non so che* describes a visual fusion or blurring, so it also signaled a temporal seepage where a residue from the first phases of artistic creation survives the later stages of reasoned and deliberated finish, or where an artist's youthful spirit survives in the later work.[48]

When the usage of *non so che* is considered diachronically, one finds two periods of interest and exploration, one in the mid-sixteenth century and the other in the late seventeenth and early eighteenth centuries. The

first blooming of *non so che* happened just when treatises on love and women enjoyed a surge of popularity. Elizabeth Cropper has written most persuasively on the affective properties of *non so che*, locating it as a specifically gendered and linguistically constructed quality that was attributed by men to women in order to describe emotions of attraction. By the affects that I have described above, it is easy to understand why the indeterminacy of *non so che* could be gendered as feminine. *Non so che* had been a central part of the language of love ever since Petrarch described, or more precisely failed to describe, a "certain something" that made him fall in love with Laura. Ludovico Dolce wrote that a *non so che* in paintings by Raphael, Titian, and Parmigianino attracted him, and in order to illustrate how Raphael's art attracts, he quoted Petrarch: "And in her eyes an indefinable something (*un non so che*) to lighten night in a thrice and darken day."[49]

From the point of view of a man writing about a woman, falling in love meant succumbing to mysterious charms and powers. It transferred to the object of love (the woman) the experience of the lover: rational men became irrational and emotionally fogged just as women were conventionally thought to be.[50] Agnolo Firenzuola consolidated and propagated the related concept of *vaghezza* by transferring the ineffable attraction of the beloved to the concept of beauty. *Vaghezza* embodied *non so che*, or indeterminate beauty, in the first place because of its etymology. *Vaghezza* makes the mind wander (*vagare*) and frees it to desire sensible beauty (*desiderare*). The unstable qualities of *vaghezza* derived from traditional notions of women as inconstant and vacillating. As I tried to show in Chapter 4, Firenzuola and Dolce employed a strategy of inversion that transformed a traditional defect into a virtue. What the Aristotelian tradition identified as vague, indeterminate, and unbounded, they adopted as evidence of women's transcendent beauty. Firenzuola defined feminine beauty as "something we cannot know or even imagine. And so it has, like other things we cannot explain an 'I don't know what.' "

In its second phase of popularity starting in the late seventeenth century, the semantic range of *non so che* broadened and in the process became less specifically gendered. Baldinucci's definition of style is symptomatic of this trend. New critical editions and translations of *On the Sublime* by the Pseudo-Longinus, and Dominique Bouhours's controversial *Le Manière de bien penser dans les ouvrages d'esprit, dialogues* (Paris, 1687) may stand behind the renewed interest. *Le Manière de bien penser* went through a staggering twenty editions in about ten years and struck a nerve in Italy. In 1703 Giovan Gioseffo Orsi made a translation of it as a prelude to an exhaustive

attack. As the title of the Italian edition indicates, Orsi's main purpose was polemical and patriotic: "Seven dialogues that stir up various rhetorical and poetical questions and that defend the progress of Italian writers condemned by the French author."[51] A much expanded two-volume version was published in 1735 with essays by literary and art critics including Zanotti, Baruffaldi, and Salvini. One of Orsi's pet peeves was Bouhours's pivotal thesis that *je ne sais quoi* constituted a new stylistic category, one that superseded Hermogenes' canon of eight stylistic qualities: "Is this the ninth quality that eluded the great man?" asks Orsi.[52] It was indeed Bouhours's intention to suggest a separate stylistic category that transcended and sublimated all others, that operated not with mathematical certainty or philosophical precision but instead with nuance and ambiguity.[53] Analogously, interpreters of art succeeded when they abandoned ratiocination and clarity in favor of intuition and the *aperçu*. Bouhours valorized impression over explanation, sensation and feeling over analysis. *Je ne sais quoi* is an emotional response to art: it provokes love and hate and desire; it surprises, dazzles, and enchants us. He also discussed *je ne sais quoi* in relation to grace:

> [W]hat else is it [grace], I ask, but a supernatural *je ne sais quoi* that can neither be explained nor understood. The Church Fathers tried to define it and called it a profound and secret vocation, an impression of the spirit of God, a divine unction, an all-powerful sweetness, a victorious pleasure, a bold concupiscence, a covetous desire for the true Good: in other words, a *je ne sais quoi* which can readily be felt but which cannot be expressed in words and about which we would do well to say nothing.[54]

Despite Orsi's objections, Zanotti accepted *je ne sais quoi*, or as he called it *non so che*, as an umbrella term and made it synonymous with modern painting: "it is what the modern style is called," as if this were a matter of consensus.[55]

ᴠᴀɢʀᴀɴᴛ Sᴛʏʟᴇs

Vaghezza has a semantic *non so che* that wavers in between concepts of beauty, desire, femininity, ornament, and cosmetic prettiness.[56] The term itself contains ambivalent attitudes toward feminine beauty and sensory attraction.[57] In Chapter 4 I tried to show how it

helped Firenzuola to write about a subject – feminine beauty – that can be "neither known nor produced by reason, . . . neither can it be taught in books nor known in general practice." Whereas *non so che* avows its own uncertainty and displacement, *vaghezza* flirts with indeterminacy etymologically. Two etymologies were generally available: *vagare* (to wander) and *vagheggiare* (to gaze fondly). Baldinucci preferred the latter and developed it with three corollaries that identified *vaghezza* as either a property inherent to an object or a person, or as an emotional response in the viewer to that property, or both at once: 1) an "attractive beauty that induces the desire to contemplate it"; (2) "desirable" or "desirous"; and (3) "delight."[58] It is an oddly restrictive definition. No mention is made of *vagare* or wandering, not even in the Latin etymologies (*cupiditas, voluntas, voluptas*). He omitted any reference to an aestheticized *vaghezza* (grace and elegance) that was so popular in art criticism,[59] focusing instead on the enamoring charm of *vaghezza*.

No one would guess from Baldinucci's definition that *vaghezza* was one of the most malleable and vague terms in the art critic's lexicon. In his definition of *vaghezza*, Lacombe noted that "this word has a broad meaning in painting" even though he restricted its meaning to the first etymology. As one might expect from a term that refers etymologically to wandering, *vaghezza* is a semantic vagrant prone to confusions. Lodovico Domenichi, in translating Alberti's *De pictura* in 1547, used it for *venustas, amenitate, illecebris,* and *lepore*.[60] The fact that Alberti never used *vaghezza* in his own translation of *De pictura*, using instead *venustà, piacevolezza, diletto*, and *dolcezza*, indicates its growing importance in art-critical literature of the mid-sixteenth century. Cristoforo Landino's 1476 translation of Pliny's term *amoenissimam* as *giocundissima* (in reference to some landscape paintings) became *vaghissima* in Ludovico Domenichi's translation of 1561 and Carlo Dati's later one of 1667.[61] By the mid-sixteenth century, *vaghezza* was ubiquitous.

As a wandering beauty, *vaghezza* produced ambiguous or unstable forms and a sense of disorientation and displacement similar to *non so che*. Its affective properties, keenly felt but dimly understood, clouded the intellect and rendered the viewer powerless to cogitate, discriminate, or analyze. It either dazzled and disoriented or enamored and attracted; sometimes it did both. The word "charm" captures its talismanic power, captivating by seduction. In art-critical language, it "tempts," "seduces," "stupefies," and "ravishes";[62] it produces a mental wandering that was likened to searchings of the imagination.[63] Illicit pleasure and poor judgment are suggested by these responses. It stupefied but also made viewers stupid. Many mistook it

for beauty (*bellezza*) because of "plain stupidity" or "general ignorance."[64] To condemn an idea or a style by tainting it with an appreciative lower social or intellectual class was a common strategy, and, as in the case of Carlo Maratta's verdict, it is typically biased.[65] Vasari thought every bungler and cobbler (*ogni ciavattino*) was capable of enjoying the charming coloring of German landscapes.[66]

Vaghezza was a quality that invited problematizing. As a word and concept, it disoriented readers and writers as much as its visual effects disoriented viewers. Critics struggled to separate its true and wayward forms by labeling them *vera vaghezza* and *vana vaghezza*.[67] Its two etymologies – *vagare* and *vagheggiare* – might seem a convenient border, and to some degree this division withstands testing, but still, in practice critics could find virtue or vice in either. Some submitted to its attraction; others, feeling its pull or observing it in others, rejected it precisely because of its attraction. Bellori used it to signify a sensory or sensual appeal of bright and pretty colors.[68]

Unlike *non so che*, wandering *vaghezza* carried negative associations. As a personal quality, it could signify an unrooted vagabond, irresponsible and untrustworthy; a shiftless, unstable character without a sound ethical grounding; a migrant forced from home by bad fortune; an ambling, loquacious bore whose stories had endless digressions. Stoics harped on wandering as evidence of the morally feckless who lacked the intellectual fortitude to resist the lures of sensory distractions: "Do things from outside break in to distract you? Give yourself a time of quiet to learn some new good thing and cease to wander out of your course. But, when you have done that, be on your guard against a second kind of wandering. For those who are sick to death in life, with no mark on which they direct every impulse or in general every imagination, are triflers, not in words only but also in their deeds."[69] In rhetoric, the meandering style (*fluens*) was legitimate for some subjects and occasions but was rated lower than most other styles. In literature, the picaresque novel best represented the fusion of an episodic narrative structure with its roguish drifters. Homeric odysseys, medieval chivalric expeditions, and Dantesque spiritual quests also move from place to place, but unlike in picaresque novels the action is not aimless and morally shifty. Peripatetic art historiography, complete with characters, dialogues, and dramas, was adopted by Marco Boschini and Luigi Scaramuccia (who included "Boschini" as one of his characters). Wandering as a dramatic device, however, did not mean that a wandering literary style was good. Characters might roam, but the reader's attention should never stray.

Looking at paintings requires a roving eye. Ekphrases, as they were

defined in the *progymnasmata*, involved "leading [someone] around," a kind of tour through the scene.[70] If we read most descriptions of paintings as a record of looking or, at least, as a representation of a common pattern of looking, what is most striking is how randomly writers move us around within the painting. Most people are more likely to look at paintings in a fidgety way, at least during the first minutes of orientation, than according to how French academicians prescribed as the ideal or correct way. In their view, based on close readings of Poussin, a properly composed painting will lead the viewer's eye through the episodes. Charles Le Brun, looking at Poussin's *Fall of the Manna* (Paris, Louvre; Figure 20), described an organized viewing response with structural cues or hierarchies that controlled the eye.[71] In particular, "the eye must be able to move about," but it must never simply "wander." Figural pose, gesture, and expression guide the viewer from episode to episode as a pictorial *peripeteia*: "One notices that these groups made up of different figures performing various actions are much like episodes serving the function of what is called a 'peripeteia.' That is, they provide the means of conveying the shift that occurred in the plight of the Israelites, who went from a state of extreme hardship to happier times."[72]

In Italian art history, Bellori exemplifies the method that "describes the paintings figure by figure and part by part," to use the words of his first reviewer.[73] Adopting an ekphrastic technique he learned from Agucchi, Bellori moved the viewer through paintings in various ways, but mostly he described figures individually following a spatial logic, either moving across the plane, usually from left to right and top to bottom as if it were a book, or organized pictorially using framing devices and axiality.[74] Consequently, he preferred those paintings (and gave them the most extensive descriptions) that were composed with clearly legible figures spread across the front plane or in some manner that allows a sequential reading based on physical proximity.[75] The syntax of Bellori's descriptions, often with spatial prepositions opening each sentence, reveals this cast of mind: "E dietro. . . . Sotto le ruote del carro . . . e dietro il caro. . . . Vien tirato il carro. . . . Sopra di uno cavalca . . . e sopra l'altro. . . . Tiene avanti il freno. . . ."[76] When he faced the tumult of Lanfranco's *Assumption of the Virgin* (Rome, Sant'Andrea della Valle), his technique of individuation and sequential reading failed him. And so, partly in compensation, partly as a matter of convenience, he decided to plagiarize Ferrante Carli, who employed a more metaphoric language that could evoke expressive forms and cumulative visual effects more successfully than Bellori's literalist style.[77]

Lanfranco's *Assumption* (Figure 21) embodies one aspect of the *vaghezza*

effect, the one that recruits unresolved and transitory impressions, a blurring similar to the experience of looking at clouds and vapor: "It denotes at any time certain brilliant and luminous tones, broad brushstrokes, great taste in design, blurred light and shade, and finally vapors that seem to envelop all the objects in the painting."[78] Lacombe classified it as a "fugitive or fleeting beauty":

> some breath or so-called fugitive brushstrokes which are not substantially joined to their subject [i.e., the object represented] that grasp in an instant that which is presented by nature. . . . Painters also call "fleeting beauty" such vivid lighting effects produced by an informal heap of clouds, by those heavenly fireworks, by such extraordinary lightening, by infinite spices of variety that the eyes of attentive viewers are wont to see in nature.[79]

Looking at Lanfranco's *Assumption*, where the overall impact registers more powerfully than any particular part, would be closer to the *vaghezza* effect than looking at Poussin's *Fall of Manna*, which invites dissection and analysis part-by-part.[80] Lorenzo Magalotti, friend and patron of Ciro Ferri and an admirer of the Venetian old masters, described clouds, fog, and sparks as having wandering colors (*vaganti colori*).[81] For Milizia, "one calls *vaghezza* the harmony of colors that requires a mix of clouds, hues, lights, reflexions, shadows where connections cannot be discerned. The sky is the most *vago*."[82] Like a flash of lightning, a meteorological effect that Lacombe emphasizes by repetition, *vaghezza* produces its effect "in an instant." Lacombe probably meant this as praise, but it recalled one of the oldest forms of blame, the initial or superficial impression. Naturally this mode of viewing became a convenient means to condemn charming styles. Lomazzo noted that paintings made *all'improviso* or *alla prattica* may have an inspirited quality and seem "at first glance" to have a "non so che di vaghezza," but on closer inspection with "the eyes of reason" they will be judged "unbridled and in fact deprived of everything that would have need of reason."[83] For Scannelli, *vaghezza* "dazzles" the eyes of ignorant modern viewers who are content with first acquaintances.[84] Mastellata's dark shadows "strike the eyes at first sight and please the taste with an extreme *vaghezza*."[85]

The technique of Lacombe's atmospheric and gossamer effects involved two opposing kinds of brushwork, either broad and sketchy (*larghi*) or melting and elusive (*fuggitivi*). The former is a kind of *macchia*, which is a

both visually and semantically indeterminate form (a stain, a sketch, a fake, a deep shadow) and, according to Baldinucci, a "furtive" form.[86] As a seemingly random form, it confirmed the prejudice against *vaghezza* as "chaos" lacking in design and order.[87] The shifting sheen of silky shot colors (*colori cangianti*), where different hues are unexpectedly interspersed into the object color, were the most common type of vagrant *vaghezza*. The visual effect is a certain "flicker" or "sparkle" of color.[88] Lomazzo thought draperies of this kind should be worn by nymphs in gardens near flowing water or by angels whose iridescence resembles the rainbow.[89] Cesare Ripa draped *Irresolutione* in them.[90] The rainbow is a perfect *vago* form, not only because of its shimmering colors and transitory effect but because of its conceptual contrariness, being both heavenly and illusory.

Wandering *vaghezza* was most often found in landscapes where the viewer was invited to roam as if in a pastoral.[91] The attractive *vaghezza*, on the other hand, was most often found in the female body. Dolce tells us that he cannot describe its exact qualities, but he knows the effects (attraction and falling in love) and he knows the location of these effects (the depicted figure). *Vaghezza* need not always be located in the depicted figure, however. Contemporary artists fell in love with the *vaghezza* of colors. Like Giorgione, who "fell so deeply in love with the beauties of nature that he would represent in his works only what he copied directly from life," the artist is assumed to be male and the object of his love is represented as female (*natura*; *vaghezza*).[92] Paolo Giovio claimed that Leonardo would not let his apprentices use brush and color before the age of twenty, so that "the talented but impatient youth was not seduced by the attraction of brushes and by the charm (*vaghezza*) of color before he could achieve the right understanding of the proportions of figures through long and profitable study."[93] Two hundred years later, Francesco Solimena complained that Luca Giordano's students learned painting by becoming lovesick over his charming colors, instead of learning by precept as his own students did.[94] When misguided artists fell in love with the charm of color, fulfilling the fear expressed by Testa's "Giulio Romano," it was perceived as a failure of rationality and intellectual insight.[95] This was an *artist's* response. Sixteenth-century viewers who were not artists, like Dolce, were more often enamored of the depicted figures, almost as a kind of fetishism. In the seventeenth century, the language of charm and seduction persisted as a metaphor of an unreasoned response to painting and could still be attached to the painted figure as the object of desire, but increasingly it became possible to focus on color itself. Caravaggio's color enraptures (*il rapir*) the eye with its *vaghezza*.[96] Paris Bordone,

"loving painter" (*amoroso pitor*), charms the eye (*invaghir*) with sweet colors.[97] These two typical examples written by connoisseurs (Mancini and Boschini) illustrate how seventeenth-century viewers had expanded their field of visual literacy by making color the object of love, and thus accelerated the formation of aestheticism that had begun in the mid–sixteenth century.

Vaghezza, like love, is fickle and seduces by sensory attraction. Its amorphous semantic field perfectly captured love's uncertainty, its ineluctible and fleeting charm. Much like style itself or its alter ego *di maniera*, depending on the critic's bias, it leaned toward appearance rather than substance, external display instead of inner truth. For writers wary of style as individual expression and of seductive optics, it was a false beauty, *belletto* in Bellori's terms; like style in its degraded sense, it was an ornament, a disguise and deceit, a cosmetic mask that concealed defects of design and invention.[98] With its "luxuriant brush," it made people look like parrots.[99] In other words, a lower function that appealed to the senses was used, by choice or by necessity, to compensate for a lack of knowledge. Like style, *vaghezza* was a distortion of the "true and natural." As a flashy, facile technique, it coincided with "mannered" (*ammanierato*) art.[100] The critics who applied *vaghezza* in these ways often did so as part of a broader polemic against the ills of the modern style that had been seduced away from true beauty as represented by a stable canon (antiquity or Raphael) or by an articulate set of rules. In contrast, critics who thought the state of modern art to be healthy and who liked being surprised and consumed by dazzling visual effects tended to read ornamental *vaghezza* more positively.[101] What should be clear, even from this brief summary, is how *vaghezza* evoked conflicting responses. It invited writers to stumble into contradiction just as Giulio da Fabriano did in using it to signify both an artificial, dishonest art and a natural, truthful appearance.[102]

APPENDIX: LIST OF STYLISTIC TERMS USED IN ITALIAN ART CRITICISM, 1550–1750

Note: Whenever possible the terms have been given in adjectival form in order to indicate their function as qualifiers. Types of terms that are excluded:

1 Styles named after an artist (e.g., *tintoresco; caravagesca; giottesco; raffaellizzare*).
2 Geographic styles (e.g., Oltramontano; Veneziano; Romano).
3 General terms of praise (e.g., *bello; impareggiabile*).
4 Terms that relate primarily to invention (e.g., *decoroso; convenevole; benespresso*).
5 Terms that relate primarily to talent (e.g., *ingegnoso; immaginativo; fantastico; peregrino*).

abbacinato
abbagliato
abbozzato; bozzato; sbozzato
abbreviato
accordato; accordo
accurato
acuto
addobbio
addolcire
affettato; affettazione
aggiustura
agile
alla prima
allegro

amabile
ameno
ammaccatura
ammanierato; manierato
amorevole; con amore; amoroso
aperto
appannato
ardito; arditezza
arido
arioso
armonia
asciutto
aspro; asperità
astratto

attico
audace

bagnato
bizzarro; bizzarria
botteggiato; di botte
bravura
breve; brevità
brillo; brillante
brioso; brio
bronzino

cacciato
cadente
caldo
cangiante
caricato
carnoso
a caso
celare
classico
colpato; di colpo
componimento (as finito)
concertato
concordo
confuso
consonanza
contornato
copioso; copio
corrente
corretto
crudo

debole
delicato; delicatezza
destro; destrezza
diafano
difficile
diforme

dilatato
dilavato
dilettevole; diletto
diligente; diligenza
discordo
disinvolto; disinvoltura
disordine
disprezzato; disprezzo
dolce; dolcezza
duro; durezza

elegante; eleganza
eroico
erudito
esatto; esattezza
esquisito; esquisitezza

facile; facilità
fatica; faticoso
felice; felicità
ferace
fiacco
fiero; fierezza
fine; finezza
finito; finimento; finitezza
fiorito
forte; forza
franco; franchezza
freddo
fresco; freschezza
furbesco
furioso; furia

gagliardo; garliardezza
galante
garbato; garbo
ghiotto
giocondo; giocoso
gradevole; gradito

gradioso

grande; grandezza

granito

grasso

grave; gravità

grazioso; grazia

gretto

grottescamente; aggrottesco

guizzante

ideale

impastato; impasto

impiastrato

improvvisato; improvviso

indistinto

languido; languente

largo

leccato

leggiadro; leggiadria

leggiero

legnoso; di legno

libero; libertà

licenzoso; licenza

limato; limatura

limpido

liquido

lisciato; liscio

lucido

luminoso

lusinghevole

lustro

macchiato; di macchia

maestoso; maestà

maestrevole; maestria

magnifico

manierato (*see* ammanierato)

manieroso

miniato

minuto; minutezza

minuzie

morbido; morbidezza

naturale; naturalezza

negligente

netto; nettezza

nonfinito

nonsochè

ondeggiante

ornato; ornamento

pallido

pastoso; pastosità

piacevole; piacente

piazzoso; piazzato

pittoresco

piumoso; piumosità

polito; politezza

pomposo; pomposità

presto; prestezza

pronto; prontezza

pulito; pulizìa

punteggiato

puntuale; puntualità

puro; purità

raffinato

reale

regolato

ricco

ricercato

rilevato

risalto

risentito

risoluto; risolutione

robusto; robustezza

rozzo
ruvido

saporito
sbrigato
schietto; schiettezza
scintillante
sciolto; scioltezza
secco; secchezza; seccagine
semplice; semplicità
serpentinata; serpeggiamento
serrato
severo; severità
sfacciato
sfarzoso
sfogato
sfreggato; sfregazzato
sfumato; sfumante; sfumazione
soave; soavità
sodo; sodezza
sottile
spedito
spegazzo; spegazzone
spiccato
spiritoso
sprezzante; sprezzato
sprezzatura
statuino; statuario
stento; stentato
storpiato
strabocchevole
strappazzato; strapazzone
stravagante

strepitoso
stringatezza
studioso
sublime
svelato; svelatura
svelto; sveltezza

tagliente
temperato
tenero; tenerezza
terribile; terribilità
terso
toccato; di tocco
trascurato
tratteggiato; di tratto
tremendo
trinciato; trincio
tritato; trito
tutt'insieme

unione
unito

vago; vaghezza
velame
velenoso
veloce
venusta
vezzoso
vigoroso
vistoso
vivace; vivacità
vivezza

NOTES

INTRODUCTION

1 Mascardi, 1636, 234–35. For discussions of Mascardi, see Chapters 5 and 8.

2 Pirani, 1646, 27: "E' negozio difficile, e quasi, dirò incapace di regole quello del favellare soggetto à mutationi, se diverso frà gl'huomini, non che frà i paesi, e fra le nationi, variabile con le materie, mà più evidentemente con l'alternativa de tempi."

3 Here is a selection of definitions by art historians who discuss style as their primary subject of analysis rather than as an issue contingent to some other topic, and those who discuss style outside of any particular historical period: Schapiro, 1953, 287–312; Ackerman, 1963, 164–65; Gombrich, 1968, 352–61; Kubler, 1987, 163–73; Alpers, 1987, 137–62; Sauerländer, 1983, 253–70; Ginzburg, 1998, 27–54. For definitions of style in sixteenth- and seventeenth-century art literature, see Treves, 1941; Ivanoff, 1957; Pinelli, 1981; Wohl, 1999. The work by Treves and Ivanoff tend toward the descriptive and oversimplified. Wohl's important recent book, despite its title and that of its first chapter ("Style," 1999, 15–53), avoids style as a concept in favor of style as a means of classification and formal analysis. His few comments about Renaissance concepts of style are unduly restrictive; as, for example: "When Renaissance writers on art dealt with questions of what we call 'style' and they usually referred to as 'maniera,' they did so in terms of decorum – the relationship of the subject to its apt and appropriate means of expression" (16). For *maniera* and Mannerism, see the Introduction and Chapter 4 (first section).

4 Kubler, 1987, 163.

5 M. Kemp, 1991, 139.

6 Alpers, 1987, 137. For an earlier attempt to move the furniture of style around (or out of the room), see S. Alpers and P. Alpers, 1972, 437–58.

7 Alpers, 1987, 158.

8 Ibid., 137.

9 Stigliani, 1627, 29–30: "E testificalo similmente la pittura, la quale, se ben pare, ch'oggidì abbia pur qualche valente artefice: hà però perduta affatto ancor'ella la sua scienza, ed essene rimasta colla sola prattica, essendole mancati, così in Fiandra, come in Italia, gli Alberti, i Bonarroti, e i Raffaelli. Il tutto aggregato è poi quello, che componendosi di parti indistinte, ed indeterminate, può essere, e scemato, ed accresciuto, e mutato senza riguardo alcuno, che sempre rimane quel, ch'era, cioè una mole imperfetta . . . il quale era un tutto integrale, se sarà dal beccaio tagliato in minuti pezzi ed ammassato confusamente in un mucchio sù la sua panca, diverrà un tutto aggregato." For a discussion of this passage and related ones that discuss seicento painting in terms of chopping and piling, see Sohm, 2000b.

10 C. Ginzburg, 1998, 27.

11 Aristotle, *Rhetoric* 3.1.5–6 (1403b–1404a). Annibale Caro (1570, 189) translated it in this way: "Possono [ornamenti ed artifizio; i.e., the elements of elocution and style] nondimeno assai, come s'è detto per la corruzion che regna ne gli auditori. L'ornamento dunque del parlare, per un certo che, si richiede necessariamente in ogni sorte di disciplina. Essendo pur qualche differenza a voler bene esprimere il suo concetto dal dire in un modo, al dire in un'altro . . . Ma tutte queste cose [style, delivery, and acting] hanno loco nella fantasia de gli

uomini, e servono solamente per adescar gli auditori." Most Renaissance translators rendered style as *locutione* (Piccolomini, 1572, 215) or as *elocutione* (Barbaro, 1544, 152v; Maioragij, 1591, 205v; Caro, 1570, 187). For another important source, see Plato, *Phaedrus*, 260 (1961, 505). For a brilliant discussion of early modern prejudices against rhetoric, see Ong, 1958; also Mooney, 1984, 71–77.

12 Cicero, *Orator* 11.38. Sforza Pallavicino called style "the less noble part" of writing (less than content) because it addressed the senses and had "much of the foreign in it." S. Pallavicino, letter of 1666; quoted in Rucellai, 1826, 75. There are two things in writing: *cose* and *stile*. "Lo stile, ch'è la parte men nobile, ma non forse la men difficile, è senza fallo la più sensibile in questi lavori; ha tanto di pellegrino, quanto vaglia a cagionare il piacere; tanto dell'ordinario, quanto non tolga la chiarezza, e l'efficacia dell'insegnare." For a recent discussion of Pallavicino, see Bellini, 1994. For the analogous effects of sophistry, see Cicero, *Orator* 19.65: "Their [the Sophists] object is not to arouse the audience but to soothe it, not so much to persuade as to delight. . . ."

13 *Sancti Gregorii Magni super Cantica Canticorum Expositio, Prooem.* 4 (Migne, PL 79.473–74); quoted and discussed by Trimpi, 1973, 25–26. For the association of words, figural speech, and other designators of style with colors, see Plato *Cratylus* 424D–425A and 431C (1961, 459 and 465); Cicero, *De oratore* 3.25. 96; Cicero, *Orator* 19.65; Barbaro, 1557, 2:37.

14 Pino, 1548, 1:108 and 118; Benvenuto Cellini, letter to Benedetto Varchi (in *Trattati*, ed. Barocchi, 1:80); Ludovico Dolce, letter to Gasparo Ballini; in Roskill, 1968, 207–9; Sorte, 1580, 1:295–96; Armenini, 1587, 36–37 and 62; Scannelli, 1657, 110–11; Francesco Albani in a letter of 29 July 1637 published in Malvasia, 1678, 2:171; see also Malvasia, 1678, 2:119; V. Vittoria, 1703, 2:12; G. G. Bottari, preface to Borghini, 1730, x–xv; and Pascoli, 1736, 2: 317–18.

15 Bellori, 1672, 56: "Ma avanti di passare più oltre dall'immagini di questa camera all'altre della Galeria, dobbiamo avvertire che la loro forma richiede spettatore attento ed ingegnoso, il cui giudicio non risieda nella vista ma nell'intelletto. Questi al certo non resterà sodisfatto di comprendere in una occhiata tutto quello che vede, anzi dimorerà nell'intendere

la muta eloquenza de' colori, essendo la pittura di tal forza che non si arresta ne gli occhi come in suoi confini, ma si diffonde nella mente alla contemplazione. . . . Il che deriva, o dal fidarsi della loro apprensione e di quella prima vista, e molto più dalla ruvidezza del loro intelletto, che non è atto alle cose belle, ammirando le vulgari e quelle maniere che si sono proposte."

16 This complex topic – along with countervailing models – is best explained in two excellent books: Lichtenstein, 1993, and Jacobs, 1997. See also Sohm, 1995a, 759–808. For a gendered reading of *disegno*'s near twin "form," see Summers, 1994, 384–411.

17 Volpato, in Bordignon Favero, 1994, 407–8; in Chapter 5, note 3.

18 Boschini, *Carta*, 47, 191, 204, 206, 221, and 576; for the druggist passage, see *Carta*, 150: "Me par, quando me parto da sta Scuola, / D'esser stà in la botega d'un Droghier,/ E soto el naso quei odori aver / De aromati, che 'l cuor tuto consola. // Resto con tal fragranza in la mia mente, / Me sento sì prugà de l'inteleto, / Che 'l cuor me salta d'alegrezza in peto; / L'anima tuta a giubilar se sente."

19 Boschini, "Breve instruzione," in *Carta*, 712: "Ma il condimento de gli ultimi ritocchi era andar di quando in quando unendo con sfregazzi delle dita negli estremi de' chiari, avicinandosi alle meze tinte, ed unendo una tinta con l'altra; altre volte, con un striscio delle dita pure poneva un colpo d'oscuro in qualche angolo, per rinforzarlo. . . ."

20 Plato, *Gorgias* 464b–466b (1961, 246–47).

21 Quoted in Cropper, *Ideal of Painting*, 235: "Le cose, come si partono dalla sua purità e semplicit[à], perdono la bellezza, e qui si dannano le maniere nella pittura + < + e ciò si prova dalla maniera delle statue antic[h]e e moderne>; si prova con cosa sensibilissima, dei cibi buoni e del buon vino, che chi li altera con condimenti li guasta. Vedi Platone nella *Retorica*." Cropper identifies Xenophon's *Memorabilia* (3.14.5–7) as Testa's source. For an excellent discussion of Testa's use of the *Gorgias*, see *Ideal of Painting*, 235–36.

22 Carducho, 1633; translated by Longhi, 1951, 50–51; and Cinotti, 1973, 121.

23 Pallavicino, *Trattato*, 1646; edition cited: 1662, 38; Reggio Emilia, 1824, 26: "Poichè il dire, che la verità è tanto bella per se medesima, che ogni estraneo liscio le imbratta, e non le adorna le guancie, che alla sua onestà disdicono tutti i

belletti, e mille similglianti dettati, è un voler appunto imbellettar con metafore la bugia, perchè apparisca verità a gl'ingegni di poca vista."

24 Pallavicino, 1646, 41–42.

25 Pallavicino, 1646; edition cited: 1662, 38–39; 1824, 27: "Riprovo parimente un dolce, per cui si tolga il natio sapore della dottrina, facendo mestieri, che l'intelletto sia sicuro d'ogni fraude, ne stia in rischio d'esser talora gabbato in abbeverarsi d'un vino con la concia, dilettevole al gusto, ma nocivo allo stomaco. Per la qual ragione, e con la qual simiglianza ci ammonisce Aristotile che una troppo condita favella non è altresì acconcia per l'Oratore, come sospetta agli Uditori. . . . Voglio che sia un dolce, qual è quella del zuchero nelle vivande, che migliora, ma non muta gli altri sapori." Pallavicino might also have had in mind Cicero's *De inventione* (1.25) and *De oratore* (3.97f) where spice is "added" to "plain food" (i.e., during a forensic oration in the plain style) so that jurors do not become bored. For a discussion of these passages in Cicero, see Fantham, 1988, 282–83.

26 Strunk and White, 1979, 70. Modern studies of ancient and Renaissance rhetoric have privileged *inventio* and *dispositio* over *elocutio*, which is either granted a "grudging status" or left aside for the more philosophical *inventio*: B. Vickers, 1981, 105–32. For a contrary view, see Barilli, 1989, chap. 7.

27 Friedländer, 1925, 49–86. The 1960s saw other publications of earlier works: Pevsner, 1968; Frey, 1964. Mirollo (1984, 33–37) surveys the status of Mannerism in the 1950s and concludes that scholars arrived at an impasse and that art historians were "in mannerism's favorite state of crisis."

28 S. Freedberg, 1965, 187–97.

29 I do not want to suggest that there was no interest, only that later publications never attained the general attention of scholars or secured a canonical position in the field to the same degree as the 1960s publications. Consider, for example, the monumental two-volumed affair by Esther Nyholm (1977) that is virtually lost in obscurity.

30 Pinelli, 1981, 84–184. For denials of Mannerism, Miedema, 1978–79, 19–45; and Stumpel, 1988, 247–64. For historiographic studies, see Mirollo, 1984, 20–71; Cropper, 1992c, 12–21; L. Cheney ed., 1997.

31 Weise, Smyth, and Shearman define style as a preamble to their studies. Pinelli (1981, 84–189) states that he plans to explain what *maniera* is; however, the only textual analyses are brief (Vasari, 124–38, and Dolce, 179–80), and most of his essay is devoted to Mannerist painting as if the meaning of style is contained in its practice. This strategy of defining style through one's idea of practice can also be observed in Nysolm, 1977.

32 Aikema, 1995, 167.

33 Schapiro (1953, 287–88) opens his definition of style by separating meaning according to function. He assigns different meanings for the archaeologist, the art historian, the historian of culture, and the art critic. For Alpers (1987, 137–62), see n. 7. Style as a heuristic forms the basis of Wohl's thorough account of quattrocento styles (1999).

34 Von Rumohr, 1920, 60. For a discussion of von Rumohr, see Waetzoldt, 1965, 298–318; and Podro, 1982, 27–30.

35 Wölfflin, 1912, 572–73. He acknowledges that style shapes content, that the same content cannot be represented in the same manner at different times, and explains the change with reference to issues of perception. For further discussion, see Wiesing, 1995, 116–18.

36 My phrase "corrective lens" refers to Erwin Panofsky's description of the history of style as a "corrective principle" (1955, 61). For a discussion of style in Panofsky's historiography, see Dittmann, 1967, and Holly, 1984. Moxey (1994, 67) sees in Panofsky a "continuing adherence to a notion of the history of art as the history of style, a view popularized by his contemporary Heinrich Wölfflin."

37 Wollheim, 1987b, 25, and 1995, 40–49. Berel Lang (1987, 13–17) arrived at a similar conclusion after trying to discover a systematic foundation within the various literary methods of the eleven essays he edited on the concept of style.

38 For similar conclusions, see Ackerman, 1962, 164–65; and Goodman, 1968, 99–111; and, argued most convincingly, Alpers, 1987, 137–62.

39 For this formulation and a discussion of its implications, see Beardsley, 1987, 205–29. Wohl's recent book, subtitled *A Reconsideration of Style* (1999), is a good example of an extended study of styles that avoids defining style.

40 Barocchi et al., eds., 1994, vol. 1 (arranged alphabetically).

41 De' Domenici, 1742, 3:542 (quoting Matteis): "Quanto al suo naturale stile (da noi detto: Maniera) si accostò sempre a Pietro da Cortona." By *noi*, he meant "us painters." For the question of authenticity concerning Matteis's manuscript that was published by de' Domenici, see T. Willette, 1986, 255–73, and 1994, 201–7.

42 Poussin and Mascardi will be discussed in Chapter 5; for Malvasia's emendations from draft to published text, see, for example, *Scritti*, n.d., 190.

43 I have had to approximate the frequency of *disegno*, because many of its 1,025 usages refer to a drawing as physical artifact rather than drawing or design as a concept.

44 For Petrarch's *aerem*, see note 48. For further discussion of style as an elusive phenomenon, see Chapter 8.

45 Mascardi, 1636, 400; 1859, 283: "Ma io che la mia debolezza, non meno apertamente confesso, di quel che indubitatamente conosco; prego chiunque leggerà, per favorirmi, le mie scritture, à non richieder da me una perfetta diffinitione di ciò che meglio per ventura, nell'intelletto mi cape, che non mi cade sotto la penna: perchè porterò anzi concetti nella mia mente mal digeriti, che una dottrina, che non riceva contrasto. Chiese una volta Bruto da M. Tullio, 'quis est iste tandem urbanitatis color?' ed ebbe per risposta da lui, 'nescio, tantum esse quemdam scio': e pur haveva fin alhora Cicerone l'orationi d'alcuni forastieri riprese, i quali, tutto che grandi fossero, e nominati; tuttavia per esser nati ed educati fuori di Roma, nella lor dicitura un non so che di pellegrino facean sentire, che l'orecchio schiettamente Romano offendeva, e non era 'eorum urbanitate quadam quasi colorata oratio.' S'alcun da me ricerca, che cosa è stile, io di non saperlo francamente dirò, 'tantum esse quemdam scio': è però vero, che mi studierò di far palese il mio senso, nel miglior modo, che mi sarà conceduto dalla fiacchezza del mio povero ingegno."

46 *Résponse aux critiques des tableaux*, 17; in *Expositions publiques de tableaux, sculptures et estampes gravées, faites par l'Académie royale depuis 1673* (Collection Deloynes, Cabinet des Estampes, Bibliothèque nationale) 13:849; quoted without discussion by Becq, 1984, 2:784: "Le style ne peut dans les différents arts se définir; c'est un sentiment dont un artiste est plus ou moins affecté; qui est dans sa tête sans qu'il soit possible de l'expliquer."

47 Seneca the Younger, *Epistulae*, 363. For other citations of the proverb, see Plato, *Republic* 3.400B; Cicero, *Brutus*, 117; Cicero, *Tusculan Disputations*, 5.47; and Quintilian, *Institutio oratoria* 11.1.30.

48 Petrarch (1985, 301–2; 23. 19) refers Boccaccio to Seneca the Younger's *Epistulae* (84.8–9), who wrote: "Even if there shall appear in you a likeness to him who, by reason of your admiration, has left a deep impress upon you, I would have you resemble him as a child resembles his father. . . . For a true copy stamps its own form upon all the features which it has drawn from what we may call the original. . . ." The following discussion is based on the definitive work by Summers, 1989b and 1981, 56–59.

49 M. Kemp, 1976.

50 For *aria* used as the equivalent of *maniera* rather than as a mood or expression conveyed by a figure, Summers (1989b) cites only Vasari and Francisco de Hollanda. To these can be added: (1) Angelo Galli's poem of 1442 listing the qualities of Pisanello's work (Baxandall, 1971, 11–12): "Arte, mesura, aere ed desegne / Manera, prospectiva et naturale"; (2) Gelli's exegesis of Petrarch (1549, 14); and (3) the Marchese di Ayamonte (Ferrarino, 1975, n. 123 [letter to Guzmán de Silva of 24 February 1575], Spanish ambassador to Venice, who assumes *maniera* and *aria* to be understood as closely related, although he attempts to make distinctions when he reassures his correspondent that Titian's old age (about eighty-six) might make his hand tremble, but has not brought a corresponding loss in his "air and spirit" (*el aire y espiritu*). For the seventeenth century, see Mascardi (1636, 286–87), who uses *aria* to help define *stile*, and Pallavicino (1662, 99–100), who approves of Mascardi's view in his discussion of "l'arie, e lo stile" of writers. For the dominant meaning of *aria* as a characteristic facial expression, see Baldinucci (1686, 13, s.v. *aria*), whose two meanings make no reference to style.

51 Barkan, 2000, 107. The following comments do not address Barkan's important analysis regarding the transformation of the Zeuxian legend.

52 Barkan uses Bull's translation (1987, 1:318). The original reads: "[E], mescolando col detto

modo alcuni altri scelti delle cose migliori d'altri maestri, fece di molte maniere una sola che fu poi sempre tenuta sua propria. . . ."

53 See, for example, Barthes, 1971, 3–15; and Wollheim, 1994, 40–9.

54 O. Sacks, 1995.

55 This paragraph is based on my review of *The "Divine" Guido* in *Art Bulletin* 82 (2000): 358–61.

56 The construction of individual identity as "self-fashioning" was popularized by Stephen Greenblatt (1980) and now has an expansive literature building on his work. For a recent review of Greenblatt's legacy in Renaissance studies, see Martin, 1997, 1309–42.

57 Mascardi, 1636, 234–35. For a discussion of Mascardi on style and Poussin's (mis)use of his ideas, see Chapter 5. Mascardi does not comment directly on the validity of this view, although the fact that he assigns it to students and young academicians suggests a degree of skepticism; he seems only to want to show its current popularity and hence the importance of the topic of style.

Chapter 1. Fighting with Style

1 Passeri, c. 1673–79, 11: "A nostri giorni, non si costuma tra Professori di questa, che garire tra di loro della maniera, del gusto, e dello stile, e questo nasce perche non sono bene stabilite le ragioni con suoi saldi principij. Dice Massimo Tirio, che a suoi tempi un Pittore non contradiceva mai l'altro in questo particolare, perche ciascheduno caminava con gl'istessi erudimenti senza variazione, e questi erano assodati nella vera, e buona disciplina. Ciascheduno introduce insegnamenti a suo genio, e ciaschedun precetto è negato da uno nell'altro, e questo è argomento certissimo, che non vi è il suo sostanziale stabilimento."

2 Summers, 1991, 183.

3 Maximus of Tyre, 1997, 18–19 (Oration 2.3) and 33 (Oration 4.1). For the quotation in the following sentence, see 155 (Oration 17). Compare Passeri's use of Maximus of Tyre to Franciscus Junius (1638, 1:175–76), who turns to him after discussing how ancient and modern artists differ: "These Arts were in times past studied with much respect; but now, after that wee have made the greatest point of Art our first entrance into the Art, all goe to it without

any reason or modestie; wholesome counsell is generally rejected; we doe not suffer our selves to be led orderly into the Art, but we doe rush in, having once broke the barres of shame and reverence; you can hardly meet with any one that aspireth to the consummation of this most magnificent Art by tracing the beaten path of necessary precepts held by the ancients. . . ."

4 Baxandall, 1963, 314.

5 Passeri, c. 1673–79, 112; translation by Dempsey, 1988, xl.

6 Dempsey, 1988, xxxvii–lxv. This article is the most sophisticated discussion yet written about naming, valuing, and periodizing ancient art in relation to seicento theory and practice.

7 Frugoni, 1687–89, 1:34 (in margins summarizing the argument for this section): "Moda è una spetie di guerra, tutta fatta a forza di stratagemi."

8 Cropper, 1984, 248–50.

9 Ibid., 103 and 105. As Cropper explains (103–9), Testa objected at least as much to the subjects chosen (by the Bamboccianti) as the styles, although the two are closely entwined. She also notes a similar tone of disgust and condemnation in the attacks by Salvator Rosa, Andrea Sacchi, and Francesco Albani on low-life genre. For a discussion of Albani on the Bamboccianti, see Puglisi, 1999, 51–53.

10 For Passeri's difficult and unhappy character, see Cropper, 1984, 11–64; and Cropper, 1988, xi–xix.

11 Mahon, 1947, 247; trans. Enggass and Brown, 1970, 29: "Avvenne poi alla Pittura di declinare in modo da quel colmo, ov'era pervenuta, che se non sarebbe caduta di nuovo nelle tenebre oscure della barbarie di prima, si rendeva almeno in modo alterata, e corrotta, e smarrita la vera via, che si perdeva quasi affatto il conoscimento del buono: e sorgevano nuove, e diverse maniere lontane dal vero, e dal verisimile, e più appoggiate all'apparenza, che alla sostanza, contentandosi gli artefici di pascer gli occhi del popolo con la vaghezza de' colori, e con gli addobbi delle vestimenta, e valendosi di cose di là e di qua levate con povertà di contorni, e di rado bene insieme congionte, e chi per altri notabili errori vagando, si allontanavano in somma largamente dalla buona strada, che all'ottimo ne conduce."

12 Mahon, 1947, 243–44; trans. Enggass and Brown, 1970, 27: "Non perciò si deono costituire tante maniere di dipingere, quanti sono

stati gli Operarij: ma che una sol maniera si possa reputare quella, che da molti vien seguitata; i quali nell'imitare il vero, il verisimile, o'l sol naturale, o'l più bello della natura, caminano per un'istessa strada, & hanno una medesima intentione, ancorche ciascuno habbia le sue particolari & individuali differenze."

13 Adorno, 1984, 295: "What has been irrevocably exposed is that the authoritative validity of styles was a reflex of the repressive quality of society from which mankind has sought to emancipate itself, so far without permanent success; without the objective structure of a closed and therefore repressive society, an obligatory style is unthinkable." For a discussion, see Hohendahl, 1995, 200–201.

14 When Lorenzo Pasinelli identified the two Michelangelos (Buonarroti and Caravaggio) as examples of "new heresies" – one is too muscular, the other too shadowed – he used as his norm an artistic lineage of Raphaels (as reported by Zanotti, 1703, 98): "Diceva, che l'Arte di dipingere non in altro consiste, che nella imitazione della Natura trattata con vari Caratteri sì, secondo la varietà de' Pittori, mà sempre tendendo all'unico fine, ch'è d'imitare il vero. Soleva però più di tutti gl'altri Maestri encomiare Raffaello, Guido, e il Pesarese [Simone Cantarini], perché secondo il suo intendimento, grandi, e perfetti imitatori di un perfettissimo naturale, chiamando quelle maniere, che, o per lo risalto de' muscoli eccedenti il possibile, o per la forza del chiaro scuro troppo di gran lunga alterate, nuove eresie insorte nella Pittura. . . ."

15 Milizia, 1797, 2:57.

16 Diderot, 1965, 673.

17 Among the best recent discussions of seventeenth-century neo-Stoicism are those by Fumaroli, 1980, 57–70, 152–61, 171–73, 214–19; Morford, 1991; Bulletta, 1995, 51–75, 102–9, 121–27.

18 I am working on a study provisionally titled "Baroque Mannerism."

19 Seneca the Younger's letter to Lucilius (*Epistulae*, letter 114) is the best source for his ethical stylistics. For a discussion of this letter, see Leeman, 1963, 1:264–83.

20 Seneca the Elder, *Controversiae* 1.8–10.

21 Seneca the Younger, *Epistulae* 100.5, 369.

22 Ibid., 115.1–2.

23 Cicero, *De oratore* 2.159–61; Cicero, *Brutus* 117–19.

24 Agucchi (in Mahon, 1947, 246); quoted in Chapter 5, note 138, and discussed in section "The Modes." Sylvia Ginzburg (1996, 278–80) demonstrates how late-sixteenth-century debates about literary regional styles motivated and informed Agucchi's discussion. Scannelli, 1657, 90, 209 and 268–69. See also Malvasia, 1678, 2:207; reiterated by another Emilian critic: Gherardi, 1744, 194: "La maniera Lombarda colla Romana. Se quest'ultima più alle statue, la prima più al naturale s'appoggia; se la Romana più dall'artifizio, dello studio e del disegno si pregia, la Lombarda più della purità, della verità e del colorito fa pompa; entrar l'una nell'altra non si conceda e a ciascuna nella propria indole solo prevalere sia dato."

25 Passeri, 1673–79, 8: "Sono distribuiti in fazioni i pareri, e le scuole diverse procurano d'autenticare le loro openioni, e con pregiudizio della gioventù inesperta, si pone in disputa la verità. L'Accademia della Toscana vuol sostenere la singolarità nell'esser la vera, et unica maestra del perfetta disegno, e condanna quella della Lombardia come innocente di questo buon fondamento. . . ."

26 Vasari, 1568, 7:447.

27 Boschini, 1660, 98: "In suma la Maniera Veneziana / Porta con sì l'istessa libertà, / Che porta ognun che vive in sta Città, / Patria, che tien l'obligacion lontana. // Dei Veneziani sta la porta averta: / Se puol quando se vuol liberamente / Andar dove i depenze, e darghe a mente; / Nissun dise: no'l gh'è; questa xe certa." Shortly after the publication of Boschini's *Carta del navegar pitoresco*, the Perugine painter Luigi Scaramuccia (1673, 91) fictionalized Boschini in order to introduce artistic freedom as a peculiarly Venetian quality, as a central characteristic to Venetian identity. Scaramuccia's *Finezze* tells the story of an art tour of Italy led by "Raphael's Genius." Raphael was the sole and trustworthy guide for the art of Rome, Florence, Siena, and every other location in Italy except Venice, where new issues required a new voice, "Boschini's," which could address the epistemologies of art and liberty. Nearly one century later, Boschini's conclusion about Venetian art and liberty was still considered to be relevant when Francesco Algarotti (1763, 22), writing for a foreign audience, insisted that "genio libero, nutrito forse dalla libertà medesima che regna nel paese."

28 Boccalini (1612, ragguaglio I, n. 28) attributed

Venice's vibrant culture, unfettered by academic rules, to republican freedoms and contrasted this with Spain's culture, stagnating under an absolutist monarchy. For the relation of artistic and political freedom in the pseudo-Longinus's *Sublime*, see Segal, 1959, 121–46. For the reception of the *Sublime* in the seventeenth century, see Costa, 1968, 502–28. For liberty as the cornerstone of the myth of Venice, see: Gaeta, 1961, 58–71; Pullan, 1964, 95–148; and Bouwsma, 1968. Winckelmann (1972, 130) wrote at length about political freedom in ancient Greece as the principal reason for the country's excellence of art: "In Absicht der Verfassung und Regierung von Griechenland ist die Freiheit die vornehmste Ursache des Vorzugs der Kunst." For a discussion of this passage, see Haskell, 1985, 73–88. Boschini deliberately misconstrued the political concepts of Venetian liberty. Whereas Venetian political liberty was known to originate in a respect for law and tradition, Boschini's artistic liberty was transgressive: "Presta è la fantasia seguramente, / Né se trova chi ariva al so camin; / Che int'un ponto la passa ogni confin, / E va de là dal Ciel velocemente" (Boschini, 1660, 298). For further discussion of perceived causalities and symbolic equivalences of style and politics, see Boschloo (1988, 468), who proposes that Malvasia's reading of Ludovico Carracci as an eclectic ideal was based on a civic mentality typically Bolognese. For a more convincing reading of the Carracci studio as a cooperative venture, where all members worked as equals, see the important articles by Feigenbaum, 1990, 145–65, and 1993, 59–76.

29 Hochmann, 1988; Perini, 1988, 278; see also Perini, 1989c. Charles Dempsey (1986, 57–70) has given a detailed account of Malvasia's polemic with Vasari and Baldinucci. Malvasia most resembled Boschini in his combative stance toward Vasari: see Perini, 1981, 216–22 and 232–33. For further information about the deprecating stance of seicento writers toward Vasari's *campanilismo*, see Barocchi, 1979, 5–82; Barocchi, 1984, 75–82; and S. Ginzburg, 1996, 278 and 283. For Boschini's response, see Sohm, 1991, 98–109; and for the Neapolitan polemic, see Pinto, 1997, 24 and 82–84. For additional sources for the reception of Vasari not cited in these excellent studies, see F. Zuccaro, undated letter to Antonio Chigi in Bottari and Ticozzi, eds., 1822–25, 7:510–13; and

David, n.d., parts iii, x–xii, and xxi. Gigli (1615, n.p. [preface]) wrote *La Pittura trionfante* to insert into art history those painters whom Vasari ignored.

30 Malvasia, 1678, 2:9; trans. Enggass and Brown, 1970, 43: "[C]he tante maraviglie, disse Annibale ivi presente? parvi egli questo un nuovo effetto della novità? Io vi dico, che tutti quei che con non più veduta, e da essi loro inventata maniera usciran fuore, incontreranno sempre la stessa sorte, e non minore la loda. Saprei ben io, soggiuns'egli, un altro modo per far gran colpo, anzi da vincere e mortificare costui: a quel colorito fiero vorrei contrapporne uno affatto tenero: prende egli un lume serrato e cadente? e io lo vorrei aperto, e in faccia: cuopre quegli le difficoltà dell'arte fra l'ombre della notte? ed io a un chiaro lume di mezzo giorno vorrei scoprire i più dotti ed eruditi ricerchi." Antonio Francesco Ghiselli (1685–1724) retold this story, with Guido Reni in place of Annibale Carracci: Perini, 1990, 150.

31 Perini, ed., 1990, 152 (letter from Annibale to Ludovico Carracci, 28 April 1580); trans. de Grazia, 1979, 510: "Quando Agostino venirà, sarà il ben venuto, e staremo in pace, e attenderemo a studiare queste belle cose, ma per l'amor di Dio, senza contrasti fra noi e senza tante sottigliezze e discorsi, attendiamo ad impossessarci bene di questo bel modo, che questo ha da essere il nostro negotio, per potere un giorno mortificare tutta questa canaglia berettina, che tutta ci è adosso, come se havessimo assassinato. . . ."

32 Malvasia, 1678, 2:6–7.

33 Ibid., 12–13 and 222.

34 Ibid., 13. For Reni's character I quote and rely on Spear (1997, 19–37).

35 For further discussion on collecting, connoisseurship, fakes, and the art marketplace, see Ferretti, 1981, 115–95; Aikema, 1990, 32–56; Spear, 1997, 215–52; Reinhardt, 1998.

36 Malvasia, 1678, 1:109; trans. Dempsey, 1986, 66: "Una mal arma è la penna, la di cui punta tal volta, se non trapassa le viscere, trafigge la riputazione della stessa vita più cara."

37 Dempsey, 1986, 66. For Vittoria, see Rudolph, 1988–89, 223–66.

38 Perini (1980, 1:227–32) first introduced the relevant passages by Malvasia and Boschini that discuss *statuino;* see also her later articles, especially 1989, 203–19. A key passage is in Malvasia (1678, 1:264): "Certo che Lodovico mai

vide Roma, se non quanto poco vi si fermò in età vicina alla vecchiaia e già gran maestro, come sotto dirassi; e quel fare statuino non era tutto il suo genio, come altresì tutto non lo si era quella inerudita semplicità lombarda; ma cercava un misto che nè l'uno nè l'altro fosse, e dell'uno e dell'altro partecipasse."

39 Bellori, 1672, 627–28: "Questi ['nuovi maestri' who express 'd'opinione fantasticamente'] nelle loro scuole e ne' loro libri insegnano che Rafaelle è secco e duro, che la sua maniera è statuina, vocabolo introdotto all'età nostra. Affermano ch'egli non ebbe furia o fierezza di spirito e che le sue opere da' suoi discepoli venivano migliorate. Altri proferiscono altre sentenze le più nocive e sregolate, che possano immaginarsi, non che pronunciarsi da chi discorre con ragione ed intelletto. Onde il poeta Boschino parlando in persona d'un pittore di ritratti formò una definitiva conclusione, perché interrogato come gli piacesse Rafaelle così rispose distorcendo la testa e cantando in suo linguaggio distorto: 'Lu storse el cao cirimoniosamente / e disse: Rafael (a dirve el vero, / piasendome esser libero e sinciero) / stago per dir, che nol me piase niente.' Suole però Carlo [Maratta] riprovare con senso concitato l'opinione vulgata del nostro secolo, che non si debba seguitar Rafaelle per esser di maniera secca e statuina, rispondendo che più tosto il loro cervello è formato di sasso e di macigno. . . ." Dempsey translates *statuino* as "statuette" instead of "stony," as I have; a better translation would combine the two. For later uses of *statuino* that depend on Bellori's text, see Martello, 1710, 141; Gabburri, n.d., 3: c.1786r/v (quoted in Perini, 1994, 102–3); and F. S. Baldinucci, 1981, 308.

40 Aquilecchia, 1976, 153–69.

41 Baglione, *Vite*; facsimile edition with Bellori's comments, edited by V. Mariani (Rome, 1935): "Ottavio Tronsarelli poeta distese le vite con cognitioni et sensi del Baglione, il qual Tronsarelli non s'intendeva di pittura come ne anche il Baglioni et però sono scritte con tanta infelicità. Gio. Pietro Bellori."

42 Boschini, 1660, 22 and 224. For further discussion of Boschini's views on Vasari, see Sohm, 1991, 98–109.

43 For the polemic against Vasari, see above, note 29.

44 Vittoria, 1703. For a discussion, see Sohm,

1991, 169–74. For an excellent biography of Vittoria, see Rudolph, 1988–89.

45 Annibale Carracci, letter to Lodovico Carracci, 18 April 1580; in Malvasia, 1678, 1:269, and Perini, ed., 1990, 150–51: "[Q]uel bel vecchione di quel San Girolamo [in Correggio, *Madonna and Child with SS. Jerome and Catherine*] non è più grande e tenero insieme che quel che importa di quel San Paulo [in Raphael, *St. Cecilia Altarpiece*], il quale prima mi pareva uno miracolo, e adesso mi pare una cosa di legno tanto dura e tagliente?" Perini has given us the best discussion of the Carraccis' art criticism: "Nota critica," in Perini, ed., 1990, 33–99. For the critical reception of Raphael's paintings, see Golzio, 1971; Rubin, 1995, 357–401; Bell, 1995, 91–111 (including a recent bibliography). Bell (1995, 100) notes that Matteo Zaccolini described Raphael's light as "natural" and hence the opposite of "unnatural darkness" made with "una maniera cruda, tagliente."

46 For Bellori blaming Malvasia instead of Annibale for this view, see 1672, 633: "[O]nde non senza concitamento esagera alle volte contro quello scrittore [Malvasia], quale scrive che i quadri del sovrano Antonio da Correggio che si vedeano appresso la regina di Svezia con ammirazione di ciascuno paiono di mano d'una pittrice e d'una donna e quale chiama maniera statuina la sapienza delle statue antiche, secco Rafaelle e di umile idea d'un vasaio urbinate." Two recent and very important critical reviews of the history of the charges along with cogent rebuttals are essential to understanding this problem: Dempsey, 1990, 14–31; and Perini, ed., 1990, 69–78. See also Dempsey (1986, 57–70) for a general review but within the more specific context of Raphael's reception in the seicento. For further evidence on the accuracy of Malvasia's documents, see Cropper and Dempsey, 1987, 498–502; Perini, 1988, 284; Spear, 1997, 14.

47 Leonardo (1959, 1:132, n. 236): "When you represent in your work shadows which you can only discern with difficulty, and of which you cannot distinguish the edges so that you apprehend them confusedly (*con confuso*), you must not make them sharp or definite (*finite overo terminate*) lest your work should have a wooden effect (*di legnosa resultatione*)." For discussions of this passage, see Gombrich, 1962, 170–79;

Kaufmann, 1975, 271. See also Leonardo (1959, 1:190, n. 363): "O pictore anatomista guarda che la troppa notitia delli ossi, corde e muscoli non si'a causa di farti un pictore legnioso, col volere che li tua igniudi mostrino tutti li sentimenti loro. . . ." And 1:245, n. 488: ". . . come molti fanno, che per parere gran disegniatore fanno i loro ignudi legnosi e sanza gratia che pare a vederli un sacco di noci più presto che superfice umana o vero un fascio di ravanelli più presto che muscolosi nudi." And 1:294, n. 589: "In nella eletione delle figure sia più tosto gientile che secco o legnioso." And 1:295, nn. 592 and 591: "Del serpeggiare e bilico delle figure e altri animali. Qualunque figura tu fai, o animale gientile, ricordati di fugire il legnioso, cioè ch'elle vadino contrapesando ossia bilanciando in modo non paia uno pezzo di legno; Quelli che vuoi figurare forti, non li fare così, salvo il girare della testa."

48 For the critical fortunes of Michelangelo, see Thuillier, 1957; Barocchi, 1984, 4; Perini, 1996, 301–3. For the survival of his reputation in seventeenth-century Rome, see S. Ginzburg, 1996, 286–88. For Michelangelo having "une certaine dureté affectée dans sa manière de desseigner, muscleuse et cochée dans les contours des figures, et par les extravagantes contorsions," see Fréart de Chambray, 1662, 65–66.

49 Vasari, 1568, 4:425–26: "Per ragionar, dunque, primieramente di Giovanni [da Udine], costui imitò sempre la maniera del Bellini, la quale era crudetta, tagliente e secca tanto che non poté mai addolcirla né far morbida, per pulito e diligente che fusse. E ciò poté avvenire, perché andava dietro a certi riflessi, barlumi et ombre, che, dividendo in sul mezzo de' rilievi, venivano a terminare l'ombre coi lumi a un tratto in modo, che il colorito di tutte l'opere sue fu sempre crudo e spiacevole, se bene si affaticò per imitar con lo studio e con l'arte la natura." Vasari (1568, 5:461) paired *duro* and *tagliente* (discussed below and in notes 61–63), as did Richard Symonds writing "shoptalk" in Canini's studio (Beal, 1984, 297): "The manner of Cavalier Giuseppe had generally was this, a hard cutting contorno, Panni duri & taglienti." See also Armenini, 1587, 162; and G. Galilei, *Considerazioni al Tasso* (finished by 1590); in Panofsky, 1964, 17–18: ". . . essendo le tarsie un accozzamento di legnetti di diversi

colori, con i quali non possono già mai accoppiarsi e unirsi così dolcemente che non restino i lor confini taglienti e dalla diversità de' colori crudamente distinti, rendono per necessità le lor figure secche, crude, senza tondezza e rilievo." Scannelli (1657, 68–70) noted that Michelangelo's diligence and detailed attention to anatomy led him to overemphasize contours, giving his paintings a certain hardness (*durezza*). F. del Migliore (1684, 437) presented two opposed pairs of coloring styles to indicate the range available to painters: "colori carichi, o dolci, taglienti, o sfumati." Malvasia (1678, 2:196) used virtually the same terms in opposition to discuss G. B. Mola: ". . . se non lo giunse nella tenerezza delle figure, che in lui parve ritenessero sempre un po' di duro, e tagliente." Malvasia (1678, 2:224) thought that Domenichino's *Last Communion of St. Jerome* suffered from being "così tagliente per tutto, così dura e forzata." Averoldo (1700, 110) describes a *Christ* by Moretto as "così rigorosamente finita, e pure tanto morbida, e delicata, e con tutto vi si vegga la scrutinio anatomico, ed ogni modo non si scopre durezza veruna, ne contorno tagliente. . . ."

50 Speaking as a fictional painter-philosopher "Amigo," Marco Boschini mangled the Aristotelian tradition of secondary qualities (hot and cold as active qualities and wet and dry as passive ones) and situated soft with the former and hard with the latter (Boschini, 1660, 325): "Circa le qualità donca s'estende / (Seguì l'Amigo) el colorir le tele;/ Circa tute no zà, ma circa quele,/ Tra le segonde, che la vista intende. / Perché le prime ative, caldo e fredo, / E le passive, umido, seco, e quanto/ Nasse de qua, duro, aspro, unido, spanto,/ O morbido che 'l sia, toco, e nol vedo." For Boschini's low opinion of philosophical critics – "those severe critics who sit in their rigid chairs" and write "piles of nothing" – see Sohm, 1991, 118–21.

51 Dionysius of Halicarnassus, *Isaeus* 3–4 (177–81).

52 Cicero, *Brutus* 10 and 70; Quintilian, *Institutione oratoria* 12.10.7. For a discussion of these and other passages, see Pollitt, 1974, 263–64. For Vasari's use of Cicero as a model of artistic progress, see Gombrich, 1960b, 309–11.

53 Here are just a few examples. For "hard" terms associated with quattrocento painting, see Va-

sari, 1568, 3:3–19 and 123–24; 4:5–7; 6:155–56: "E perchè in quel tempo Gian Bellino e gli altri pittori di quel paese, per non avere studio di cose antiche, usavano molto, anzi non altro che il ritrarre qualunque cosa facevano dal vivo, ma con maniera secca, cruda e stentata, imparò anco Tiziano per allora quel modo. Ma venuto poi, l'anno circa 1507, Giorgione da Castelfranco, non gli piacendo in tutto il detto modo di fare, cominciò a dare alle sue opere più morbidezza e maggiore rilievo con bella maniera; usando nondimeno di cacciarsi avanti le cose vive e naturali, e di contrafarle quanto sapeva il meglio con i colori, e macchiarle con le tinte crude e dolci, secondo che il vivo mostrava, senza far disegno." For many other usages by Vasari of hard terms applied to quattrocento painting (*secco, crudo, tagliente, tagliato, minuto, stentato, aspro, arido, tritato, legnoso*, etc.), see the index to volume 3 (Testo) by Barocchi and Bertelà (1997). Celano, 1681, 2:232–33: "Cimabue fiorentino fece ripatriare in Italia la dipintura; ma per essere alla maniera Greca faceva comparire tanti scheletri, quante figure, perché secche, e senza spirito; è stata temerità di Leonardo da Vinci, del Buona Rota, di Rafaello, di Titiano, del Correggio, del Sarto, del Vaga, e di tanti altri maestri maravigliosi, l'avere ridotta la dipintura nella nobilità, e maestosa maniera, nella quale si vede, in modo, che al paragone della moderna comparisce una bambocciata." Scannelli, 1657, 123: "Ed opere di tal sorte [referring to Melozzo da Forlì's cupola], quando non fossero contaminate, ed infette dal vitio dell'esecranda seccaggine, solito di quei tempi. . . ." Richard Symonds, in Beal, 1984, 296: "Sta in Cervello di non fare budella ni taglie, ni trippi, some to avoid the Cuttings of Albert Durer run into the Budella of Pietro Cortona. Hard & heavy like Capuccins Cotes." Malvasia, 1678, 2:136: Mantegna's style is "così intero e duro" from having studied statues too much. Sebastiano Resta, in a letter to Giuseppe Magnavacca (Correggio, Biblioteca Comunale, C. 116, vol. 3, n. 17; October 1708) described a "Baccanale Mantegnesco" that was drawn in "qllo stile di riflessar tagliente di qlla scuola." For applications to foreign painting, see Vasari (1568, 5:447–48) regarding Giovanni da Udine learning to paint fruit and flowers from a Flemish painter and finding the Flemings' work to be "di maniera un poco secca e stentata"; 6:158 (Bellini's *Feast*

of the Gods has "un certo che di tagliente, secondo la maniera tedesca"); Armenini, 1587, 140 (quattrocento paintings "riuscivano crude, secche e tagliente" and for this reason cinquecento painters have left this way of working to the "oltramontani." Scannelli, 1657, 142 (regarding Dürer: "contaminate dalla vitiosa seccaggine").

54 Vasari (1568, 4:9) traced a similar development for Correggio, painting hair in a "maniera fine" which was "difficile, tagliente e secca," but then, later, the style of his hair had "una piumosità morbida." Boschini, Malvasia, and others did not tamper with Correggio's position (in terms of its being archaic more than modern) but kept intact his development from a dry to a softer, sweeter, mellow style. In analyzing the changes made by Correggio in *St. John the Baptist* using Raphael's *Deisis with Saints Catherine and Paul* as his source, Sebastiano Resta discerned Correggio deliberately softening the sharp contours by means of diffused light, thereby avoiding a certain *crudezza* (Resta, 1958, 30–31): "Per far isfuggire la schiena portò insensibilmente un poco più in veduta nostra la spalla sinistra onde si vede il muscolo del Toie non solamente di chiaro oscuro più dilatato, ma anco di contorno, benche non spicchi tanto il contorno tagliato fuori delli muscoli infraspinati attesa la tenerezza di quel divino soavissimo pennello incapace di crudezze."

55 Boschini, 1660, 46: "E però per responder al Vasari, / Che porta in sete Cieli Rafael, / Dirò che doto più fusse el penel / De Zambelin. . . ." And 1660, 71–72: "Primo fu Zambelin, che la redusse / In maniera purgada a boni segni, / E ben el giera un dei più bravi inzegni, / Che a quei tempi certissimo ghe fusse. // Un stil tegne pur anca Rafael / De soma diligenza e gran dotrina! . . . In suma qua se viste in diligenza / In la Pitura del stupor l'ecceso: / Onge e peli guardar giera permesso, / Fati con molto amore, con gran pacienza. // Per certo tempo quela fu la strada / Bona, vera e real, de molta stima; / Per esser (come ho dito) dela prima / Maniera, che sarà sempre laudada. // Ma vegne fuora un spirito imortal, / Che fu el nostro Zorzon da Castel Franco." There are hints of this view in earlier published literature: see Scannelli, 1657, 304–6. For a wider study of diligence, see Muller, 1985.

56 Passeri, c. 1673–79, 274.

57 Ibid., 397 (quoting Rosa): "con Rafaele non haveva molta domestichezza perché la scuola Napolitana lo chiama tosto, di pietra, e secco, e non vogliono amicizia sua." For Cantarini criticizing Raphael's *St. Cecilia Altarpiece* in a vein similar to Annibale's, see Zanotti (1703, 95–97), who is reporting somewhat apologetically what his teacher's teacher said: "Mà passiamo con brevità ad un'altra osservazione fatta con mè tante volte dal Pasinelli, al quale, geloso dell'onore del suo Maestro, molto dispiaceva il vedere affermato, che 'il Pesarese allo stesso Raffaello perdesse tal volta il dovuto rispetto,' e che in presenza di Salvator Rosa giunto à vedere la veramente 'non mai a'bastanza lodata Santa Cecilia di Raffaello, con qualche soghigno sprezzante uscissero da quell'ardita bocca simil concetti.' . . . E se mai avesse detto qualche piccola cosa sopra la sudetta bellissima Santa Cecilia, credo, con fondamento, che avrebbe detto assai meno di quello, ne scrisse Annibale à Lodovico. Compatite, ve ne prego, ò Lettori, in queste poche righe un piccolo sfogo del mio buon genio verso del Pesarese, che sarebbe, ve ne assicuro, ben confermato dal nostro Lorenzo, se ancor vivesse, e per on abusarmi più della vostra pazienza, ritornando al primo filo, seguirò à dire. . . ."

58 Malvasia, 1678, 1:337–38, n. 1. For Vittoria's comments on Annibale's letter, see (Appendix), 2:8 and 39–44. For Vittoria's adulation of Maratta and absorption of his ideas, see his *Academia*, n.d., and Rudolph, 1988–89. For the defense of Raphael in the later seventeenth century, see Popescu, 1990; Rosenberg, 1995; and Bell, 1995 and forthcoming.

59 Zanotti, 1705, 39–44. And, for Zanotti quoting Malvasia, see his letter to G. G. Bottari, 10 March 1758, in Bottari and Ticozzi, eds., 1822–25, 3:545–49. Additional manuscript material by Zanotti on Vittoria can be found in the Biblioteca Comunale (Bologna); cited by Perini, 1990, 66. For Zanotti's reply to Vittoria, see Rudolph, 1988–89, 247–53.

60 Malvasia, 1678, 2:345 (discussing how styles of paintings evolve as painters always search for new styles): "Il Buonarroti con la terribilità, tanto lontana dalle passate angustie; con la giustezza il Sanzio, staccato affatto dal perugino Maestro; con la pastosità Tiziano, motteggiante di Seccarello l'Urbinate." For a variation of this

in Malvasia's draft, see Malvasia, n.d. (*Scritti originali*), 200.

61 Leonardo (1959, 1:282, n. 561; 1977, 1:338). V. Borghini, in *Scritti*, ed. Barocchi, 624: "Ma quanto poi alla perfezzione e finimento, non lo voglion d'altri che dal vivo, anzi dicon più là: che chiunque ritrarrà sempre dalle statue e dalle sculture, non sarà mai perfetto e vedrassi sempre nelle sua figure una certa ruvidezza e crudità, perché quel morbido e pastoso lo dà la figura viva e non il sasso etc." Armenini, 1587, 14: "Conciosiacosaché si sa bene che i disegni delle stampe danno la maniera cruda, l'opere dipinte ritardano, le statue l'induriscono. . . ." Vasari thought that Soggi developed a *maniera dura* from working too much from clay and wax models; see also Vasari on Battista Franco in the following note. Boschini, 1660, 126: "Le statue al fin son statue, e la durezza / Par che nel disegnarle ancor s'apprenda." See also Volpato, n.d., fol. 159; Favero, 1994, 412; and Malvasia, 1678, 2:136: "Fu [Alessandro Tiarini] nemico altrettanto de' rilievi e delle statue che induriscono, diceva egli (adducendone fra gli altri esempi quello del Mantegna, così intero e duro, per avere lo Squarcione suo padre adottivo non mai fattogli disegnare che su quelle, e sui rilievi) quanto amico del naturale, scelto però e corretto, che delle statue stesse fu l'esemplar sempre e'l maestro." And see Baldinucci, 1681–1721, 3:516: ". . . quando bene riusciva l'aver imitato le parti, o'l tutto di qualche bella statua di sua [Michelangelo] mano, o antica; onde gran fatto non è, che abbiano per lo più le pitture loro, benchè disegnate a maraviglia, un non so che del duro, e del legnoso." Scaramuccia, 1673, 15: After Girupeno declares his eagerness to study and draw ancient statues, Genio di Raffaelle responds: "Solo d'una cosa giovami avvertirti ed è che tù non t'invaghisca a pieno di quei panni, i quali in se rattengono negl'andamenti delle pieghe alquanto di durezza, e sappi che molti studiando, e riportando sù le Carte queste Sculture, si sono insecchiti, e senza accorgersene dati in dura, e poco lodata maniera." See also Scaramuccia, 1673, 41: Pietro da Cortona's draperies became "alquanto duretti" from studying ancient statues too much.

62 Vasari, 1568, 5:461: "avessono [le opere] del duro e del tagliente."

63 Ibid., 4:7: "Le quali [these statues, i.e., Laocoön, etc.] nella lor dolcezza e nelle lor as-

prezze, con termini carnosi e cavati dalle maggior' bellezze del vivo, con certi atti che non in tutto si storcono ma si vanno in certe parti movendo, si mostrano con una graziosissima grazia, e furono cagione di levar via una certa maniera secca e cruda e tagliente, che per lo soverchio studio avevano lasciata in quest'arte Pietro della Francesca, Lazaro Vasari, Alesso Baldovinetti, Andrea del Castagno. . . ."

64 Perini, ed., 1990, 161 (in life of Titian): "[L']ignorante Vasari [n]on s'accorge che gl'[a]ntichi buoni maestri [h]anno cavate le cose [l]oro dal vivo, et vuol [p]iù tosto che sia buono [r]itrar dalle seconde cose [c]he son l'antiche, che [d]a le prime e princi[p]alissime che sono le vive, le quali si debbono [s]empre immitare. [M]a costui non intese [q]uest'arte."

65 Malvasia, 1678, 2:207. For the polemicization of ancient sculpture as part of an anti-Roman rhetoric, see Perini, 1989, 203–19 (and for the retelling of Brunelleschi's visit, see 217–18). Artifice and nature are also the organizing polarities used by Malvasia to differentiate the Florentine and Roman "schools," on the one hand, and the Lombard and Bolognese schools, on the other (1678, 2:219): "Onde non senza qualche ragione pare poi, che la Scuola Fiorentina e la Romana, più della finitezza e della diligenza amatrici, alla Lombarda e alla Bolognese, più della tenerezza, ed animosità seguaci, fra i due gran concorrenti contrasti a favor del Zampieri quel primato, che al Reni comunemente vien dato." Gabburri (n.d., 3:c. 1786r/v; published in Perini, 1994, 102–3) noted without approval that "various ardent Bolognese painters" used the term *statuino* to raise Ludovico Carracci above Annibale and show that one can become a great painter without studying ancient statues.

66 Dolce, 1557, 183: "Ma bisogna aver sempre l'occhio intento alle tinte principalmente delle carni, et alla morbidezza; percioché molti ve ne fanno alcune che paiono di porfido, sì nel colore, come in durezza, e le ombre sono troppo fiere e le più volte finiscono in puro negro; molti le fanno troppo bianche, molti troppo rosse. Io, per me, bramerei un colore anzi bruno che sconvenevolmente bianco e sbandirei dalle mie pitture comunemente quelle guancie vermiglie con le labbra di corallo, perché così fatti volti paion mascara." The coral lips and faces like masks could refer to Bronzino or other Florentine Mannerists. For

Dolce's criticism of Bellini as hard and too polished, see 1564, 393r; and 1557, 51–53: "Ma Tiziano . . . non poteva sofferir di seguitar quella via secca e stentata di Gentile, ma disegnava gagliardamente e con molta prestezza. . . . Con tutto ciò i pittori goffi e lo sciocco volgo, che insino alora non avevano veduto altro che le cose morte e fredde di Giovanni Bellino, di Gentile e del Vivarino."

67 Boschini, 1660, 168: "Agustin, che de cuor xe generoso, / Esorta so fradel no temer niente: / Anzi che pur el vegna aliegramente / Con sto conceto, che xe curioso. // E vien a Roma, e non te dubitar, / Che, se ben ghe xe statue in quantità, / Te zuro da fradelo, in verità, / No le se muove, e non le sa parlar."

68 Vasari (1568, 4:206) noted that the followers of Michelangelo who study only his work will succeed only in producing "una maniera molto dura." It is unclear whether their hard style would be caused by imitating one model too closely or by similar qualities hidden in Michelangelo's own work – possibly it was both – but in the tradition of connoisseurship from Giulio Mancini to Abraham Bosse to Jonathan Richardson, copies were always thought to be harder or stiffer than the originals. Livio Meus, letter to Ciro Ferri, 24 April 1672; in Bottari and Ticozzi, eds., 1822–25, 2:61: some people identify copies by "qualche durezza che si scorge in alcune teste, ed altre cose." Richardson, 1719, 186–87: "If he attempts to follow his Original Servilely, and Exactly, That cannot but have a Stiffness which will easily distinguish what is So done from what is perform'd Naturally, Easily, and without Restraint."

69 Passeri, 1673–79, 50: "Alcuni accusarono il Domenichino nel panneggiamento, e l'hanno chiamato scarso nella copia, e duro nell'intreccio delle pieghe: et in questo non saprei che dire; ma osservandosi bene in lui il rigore dell'intelligenza, forse haveranno poco da censurare, parlando con la ragione: perche altro è buttare un panno alla disdossa, altro il vestire adattamente, con fare sotto di quello caminare il nudo. In quelli Tondini à me pare che habbia panneggiato con grande esquisitezza, e con uno stile degno d'imitatione." Malvasia (1678, 2:224) thought that Domenichino's *Last Communion of St. Jerome* was "così tagliente per tutto, così dura e forzata." For Domenichino as "tagliente e cruda," see Malvasia, 1678, 2:227. Passeri (1673–79, 82) con-

sidered those who regarded Reni's paintings as "fredde, insipide, e dure" as contaminated by a taste that could only value "quella furia sregolata." Algarotti, 1756, 15: "Se non studiando troppo le statue si potrebbe correr pericolo di dare nello statuino e nel secco, come avvene al Pussino. E per non dissimigliante ragione Michelangelo che tanto studiò su' cadaveri, ha rappresentato molte volte i corpi quasi scorticati."

70 Piles, 1699, 477. De Brosse, letter to Bouhier, 28 November 1739; in 1931, 1:472–73. "L'hyperbole du Poussin est excessive, lorsqu'il dit que, si Raphael, comparé aux autres modernes, est un ange pour le dessin, il est un âne comparé aux anciens. Peut-être que le Poussin, trop accoutumé à la sévérité du dessin des statues antiques qu'il copiait sans cesse, et dont la roideur se fait un peu sentir dans ses ouvrages, n'avait pas l'esprit tout à fait propre à goûter les grâces divines de Raphael. Il est vrai néanmoins qu'il n'y a peut-être, dans aucun tableau de ce maître des maîtres, aucune figure qui égale, pour la beauté du dessin, celle de la mariée dans le tableau de la noce."

71 Piles, 1699, 481: "Son Génie le portoit dans un caractere noble, mâle & severe plûtot que gracieux, & c'est précisément dans les Ouvrages de ce Peintre où l'on s'aperçoit que la grace n'est pas toujours où se trouve la beauté." Agostino Mascardi (1636, 392–94), whom Poussin copied for his definition of style, identified severity as one of several means to attain grandeur. This appears in his discussion of Hermogenes and his translators, and is based on Hermogenes' seven "forms" or "styles" of writing and speaking. The *strumenti* that achieve grandeur are *severità, vehemenza, asprezza, splendore, vigore,* and *parlar raggirato.* Dionysius of Halicarnassus, in differentiating the qualities of grace and beauty, identified grandeur as one of three qualities of beauty in Sylburgium's Latin translation of 1615; but when Poloni modernized it nearly a century later, he amplified it by adding severity. Sylburgium, 1615, 2:18: "gratiam: conformationem, dulcedinem, persuasionem; formositatem and pulchritudine: magnificentiam, gravitatem, dignitatem." Poloni, 1702, 71: "Sub voluptate venustatem pono, gratiam, stylum uberem, suavitatem, facultatemque persuadendi, & caetera istiusmodi; sub pulcritudine, magnificum illud dicendi genus, grave, & severum, digni-

tate ac suadela plenum & quae his similia." Poussin described the style of *Camillus and the School Master of Falerii* as painted in "une manière plus sévère" (more than a rendition of *Rinaldo and Armida*) because the subject is *héroique:* Poussin, letter to Jacques Stella, c. 1637; in 1989, 37. And according to Poussin, the Phrygian mode, to be used to depict battles, has *sévérité*: letter to Chantelou, 24 November 1647; in 1989, 136. Battles and other heroic subjects were considered by Poussin to be suited to the grand style (see Chapter 5). For severity as an austere beauty of a distant past, see Dionysius of Halicarnassus, 1615, 51–52: "Haec esse fortia robusta, dignitatem & rigiditatem plutimam habentia, quaeq; fine molestia exasperent, aures moderatè irritent, inclinentur temporibus, gradintur amplis harmoniis non theatricam aut floridam pulchritudinem prae se ferant, sed illam vetustam & horridam: omnes nunc testes adfuturos existimo, quicunque vel mediocrem sensum elocutionis habuerint."

72 *Vocabolario,* 1612, 792. Cicero, *Brutus* 70; used by Bembo (*Controversies,* pt. 2, p. 9): why look at "the rigid Calamis or even the more rigid Canachus" when there is Lysippus to follow. Quintilian, *Institutione* 12.10.7; 1584, 661: "Perche Calone, & Egesia le fecero più dure [*duriora*], & vicine alle Toscane; men dure [*rigida*] Calami, piu molli [*molliora*] di tutti i sopratocchi Mirone le fece."

73 Sparshott, 1982, 228.

74 Valla, 1962, 1:504: "nova res novum vocabulum flagitat."

75 Malvasia, 1678, 2:12; trans. Enggass, 1980, 48: "Ma fra tutte le più insigni fu la storia di S. Benedetto fatta, ancorchè a olio, con non minor freschezza, nel famoso cortile di S. Michele in Bosco, nel quale Lodovico e suoi seguaci (come si disse) avean fatto l'ultimo sforzo per mostrare in simile concorrenza il loro valore: poichè finita che l'ebbe fece stupire lo stesso Lodovico, che prima di scoprirsi, la vide, pregatone da Guido, perchè vi dicesse sopra qualche cosa e ne lo avvertisse: atterrì quegli altri che si conobbero di gran lunga superati, e fece dire a tutti, che passato egli avesse anche il maestro in certa morbidezza, venustà e grandezza, alla quale nè anche fossero mai giunti gli stessi Carracci. Finse che dalla parte sopra di un monte uscito da un antro il Santo, con certa piacevolezza che punto non pregiudica alla

gravità, riceva varii doni offertigli da que' rusticani abitatori, varii di sesso, di età, di carnagione; diversi di proporzione, d'attitudini e di vestiri. Sul gusto di Rafaelle una graziosa giovane ricinta di sottilissimi veli, con canestrello d'uova, sovra la cui spalla una compagna più vecchia, sul gusto del Correggio, posta la mano e la testa ridente, guardano ambedue gli spettatori, con tanta vivacità e spirito, che par che spirino. Sul gusto di Tiziano un pastorello che sonando un flauto con certe mani di viva e tenera carne, viene attentamente da un altro di non minor bellezza ascoltato. Sul gusto di Annibale una donna con un bambino lattante in collo ed un altro adulto, che con la destra ella spinge ad offerir una canestrella di pomi, da' quali non sa il golosello staccar gli occhi; e lasciandone tanti altri, sul principio un gran nudo intero, così terribile e risentito nel tirare per forza un'asinello restio, che pareva che Michelangelo l'avesse in tal forma contornato, perchè più tenero poi, e più ricoperto di vera carne ei venisse dalla Scuola di Lombardia." For a discussion of this passage, along with the later comments that Malvasia interpolated into this text in his *Il Claustro di S. Michele in Bosco di Bologna* (Bologna, 1694, 5–7), see Dempsey, 1977, 63–65 and 101–2. These frescoes were also taken as a showcase of stylistic prowess by Francesco Algarotti: letter to Gaspero Patriarchi, 7 April 1761 (1791, 8:157). For a related but more common kind of stylistic dissection, see Volpato (n.d., 323; and Bordignon Favero, 1994, 212), who analyzed Pietro Marescalchi's *St. Peter Liberated from Prison* (formerly in San Pietro in Vincoli, Feltre; now in San Giorgio, Villabruna) in this way: "lo stile del panneggiare quanto al disegno è come quello del Golzio, la forza de' lumi ed ombre, come il Tintoretto, ma la macchia così vaga e nobile e franca e morbida che né Paolo, né altri Eccellenti hanno fatto tanto. . . ."

76 For the discussion accompanying the engraved copy by Gandolfi, illustrated here as Figure 7, see Zanotti, 1776, 25–28. For the engraved copy by G. Giovanni, see Pepper, 1984, 214–15. For a discussion of the fresco as evidence of Reni's gender identity, see Spear, 1997, 54–57.

77 See especially Perini, 1989b; Barkan, 1995, 334–35; and Hansmann, forthcoming.

78 Cropper and Dempsey, 1987, 506.

79 Malvasia, 1678, 1:283: "Lo stesso avvien della

seconda, ch'è l'Assunzione di Maria Vergine posta in S. Francesco nell'Altare de' signori Bonasoni, che ancorchè sia fatta alla prima, onde sembri più tosto una bozza che un quadro compito, ad ogni modo si conserva assai bene. Ebbe in questa la mira Annibale al Tintoretto, ancorchè ne' panneggiamenti più erudito e più magnifico cercasse Paolo."

80 Malvasia (1678, 2:240) relates how Marco Sanmarchi, "pittor Veneziano" in style rather than by birth or training, looked at paintings made *alla prima* in terms of successive emendations as the artist sought the desired solution: "si vedevano le mani mutate sei ed otto volte, con incredibile pentimento, e lo stesso delle pieghe dei panni tirate alla prima giù lisce, poi ricercate, e finalmente cancellate. . . ." For intentionality revealed in *alla prima* painting, see also Baldinucci, 1686, 64 (s.v. fresco): "il che avviene, quando il Pittore nel volere imitare perfettamente un color naturale, s'è apposto, come si suol dire, alla prima, senza che abbia avuto necessità di replicarvi sopra un'altra tinta per giugnere all'intento suo." For *alla prima* as the spontaneous exploration of a painter's ideas and hence most revealing of his or her intentions, see Resta, undated letter in Bottari and Ticozzi, 1822–25, 3:482–87.

81 Lomazzo, 1590, cap. xvii, 294. Dempsey (1977, 63) notes a source (maybe *the* source) for Lomazzo in Lucian's description of "the statue of a woman, which not only would have been carved by diverse sculptors, but also painted by different painters, Euphranor giving her the hair he gave his Juno, Polygnotus the delicately tinted brows and cheeks of his Cassandra, Aetion the lips of his Roxana, and Apelles painting the body as he had painted Campaspe." For a discussion of this "painting" in the context of Lomazzo's ideas on painting, see Kemp, 1987, 1–26.

82 Volpato, n.d., 370; Bordignon Favero, 1994, 129. Volpato's judgment is based on a stylistics where artists are seen to combine two of four possible foundational styles (*franco, forte, diligente*, and *vago*); see Chapter 7.

83 For Domenichino's rejection of the eclectic *Adam and Eve*, see Dempsey, 1977, 64–65; and Spear, 1982, 29–30 and 33. For Scannelli (1657, 68–69), see the passage after his quotation from Lomazzo: "Pensa ciò a mio credere solo in riguardo dell'inventione laudabile, mà in effetto di poca riuscita, quando però dalla

Divina potentia non venisse prodotto soggetto, il quale eminentemente contenesse da sè solo simili, come divine qualità, che sono riconosciute nelli quattro citati Maestri, che in un tal caso verisimilmente Artefice così prodigioso potria dissegnare, e colorire ogni sorte d'operatione, ed esprimere ogni più fina bellezza, & anco superare di vantaggio le maggiori difficoltà; mà considerandosi ciò in ordine all'atto prattico, sendo che per essere vissuti questi straordinarj soggetti ad una stessa età, e facilmente ad un medesimo tempo, e però data come possibile l'occasione di un tal congresso per fabbricare di concerto l'opera adequatissima, conoscerassi in un simil caso non poter sortire verisimilmente, che varie, e repugnanti difficoltà per l'unione di queste incompatibili materie in ordine alla lega, e forma di perfettione; non havendo in fatti frà di loro la debita simboleità." The following two pages detail why the combination is impractical. A few years before the *Idea* was published, Armenini (1988, 82–83) described as "crazy" those painters who painted in this way, in particular covering Michelangelo's muscular and anatomically precise figures with a soft, melting coloring: "Ma questi [painters learning their art] debbono essere tali nell'immitatione, che essi abbino similtudine con gli essempi non in una o in due parti, ma in tutte, di modo che, mentre cercano d'assomigliarsi in una, non discordino nell'altra, ma egualmente le considerino e l'imparino, sí che nel porle in atto poi le stiano di maniera, che le siano simile come il padre al figliuolo e l'un fratello all'altro, et in speciale a quelli che la strada tentano et imitano di Michelangelo Buonaroti. Conciosiacosaché nel cercar questa di solennissimi goffi ci riescono, imperò che, essendo difficilissima, come si sa e si vede, pochi ci sono che la vogliono imitar apieno, attesoché, a chi di una parte si cura solo e chi un'altra pigliando et altri quella di lui tramutando et intricandola con l'altre, cosí diverse e strane maniere si veggono rimanere in costoro, perché del loro male non è il maggiore, quanto è il voler traporvi le parti altrui, le quali, quantunque siano bellissime nel suo genere, quivi però a mischiarle si vede che rimangono disunite. Né essi si accorgono in quanti modi questa maniera sia difficile e diversa da tutte l'altre. . . . [E]ssendo chiaro che non si può né lineare né accompagnar giamai una cosí grave maniera, qual'è la sua, con una

che sia o leggiadra o piacevole o pur scordevole per altre vie. . . . E per certo ch'io non so qual sia maggior pazzia che di questi tali, i quali si veggono essere cosí ciechi alle volte, che pongono per le loro opere delli ignudi che sono ridiculosi, a i quali li fanno i lor capi leggiadri, dipoi le braccia morbide et il corpo e le rene ripiene di muscoli et il rimanente, poi, si vede essere con dolcissimi contorni lasciati e con ombre leggieri." In 1476 a complaint was lodged in Pavia about a painting that became "deformed" (*disforma*) because three painters had worked on it: M. Kemp, 1987, 6.

84 Baldinucci, 1681–1728, 5:661. See also Bisagno, 1642, no. 43: "Fuggasi dunque cosí sciocca opinione che si hanno fitto nel capo molti e credasi che se Zeuxi, oltre la tanta diligenza ch'egli usò, non avesse posseduto da sé singolare maniera non avrebbe mai accordato insieme le belle membra divise che lui tolse da tante Vergini, né meno avrebbe condotto a quella perfettione. . . ." The contradictions and ambiguities of the Zeuxis story that Bernini brought to the surface existed in earlier versions, as Barkan (2000) has shown in a brilliant article; see also Lecercle, 1987.

85 Dempsey, 1977, 60–74.

86 Mancini (1956, 1:135) has Annibale paint a Sebastiano del Piombo. For Agucchi reporting Annibale's ideas on copies and imitating the old masters, see Mahon, 1947, 250–51. Neither presents the elaborate narrative and staging found in Boschini and Malvasia. I am indebted to Richard Spear for the reference of Annibale being tricked by antiqued fakes; in Malvasia, 1678, 1:191.

87 For this latter story and its precedents, see Fanti, 1991; Gilbert, 1993, 413–19.

88 Malvasia, 1678, 1:340–41; quoting Boschini, 1660, 517–19: "Non appunto da questa dissimile parmi quella, con che il graziosissimo mio sig. Boschini racconta, ad istigazione di Annibale, aver il Cardinal Farnese mortificato i pittori di Roma, che volevano abbassar questo grand'uomo, dicendone tutti i mali; in particolare, ch'ei volesse fare la scimia di Tiziano, del Correggio, di Paolo Veronese, ma non vi avesse che fare: così dunque egli scrisse nella Carta del suo Navigar Pittoresco: 'Quando i Carazzi fu introdotti a Roma / Dal Cardinal Farnese (co' savemo) / El li stimava, come si medemo, / E i regalava d'ogni onor in soma. / / Questi con ogni industria el so giudicio /

Aplicava a formar pitture degne: / I pitori de Roma anch'essi vegne / A riverirli e a far cortese offico. // Quando i s'acorse che quella maniera / Che podeva portar scorno e vergogna, / A l'ora con mal arte e con menzogna / De l'invidia i butè la prima piera. // E pieni d'aroganza e de perfidia, /Disse che i non intende el bon dessegno, / Nè in colorito i mostra aver inzegno: / O Dio che denti de cagnina invidia! // Questo co i deletanti produseva / (I quai non è del tutto inteligenti) / Una tal controversia e sentimenti / Che de i Carazzi il merito opprimeva. // El Gardenal pativa de st'azion, / Nè podeva un tal scorno compatir; / E un so pensier resolve d'eseguir, / Che remove ogni dubbio, ogni question. // El finse alcuni quadri d'aspettar, / Che per so conto giera sta comprai; / E che de breve i ghe saria inviai / Dove sta fama el fece divulgar. // In tanto quei Carazzi valorosi // Depenzeva con spirito e con arte / Pitture, che viveva in ogni parte. / Come pitori esperti e valorosi. / quando fa a segno tutta la facenda, / Se finse una cassetta forestiera / Zonzer a Roma, con bella maniera/ Perchè ognun tal la creda e la comprenda. // Credeva ognun quel che fu za mentido: / E a quei tuti amorevoli Signori, / No solo deletanti, ma pitori, / Presto fu fatto un general invido. // Con dir che so Eminenza aveva gusto, / A la presenza de quei virtuosi, / Levar de cassa i quadri curiosi: / Dove che ognun concorse al tempo giusto. // Si che se fece nobile corona / Di Prelati, pittori e deletanti: / Vien portà la cassetta là davanti, / E attende curiosa ogni persona. // Mentre la se descioda e se desliga, / Ognun con desiderio virtuoso / Osserva e attende in atto curioso; / E in agiutar nissun stima fadiga. // Che che no è sortisse le piture, / Copme razi del Sol ben resplendenti. / Stupisse i deletanti e più intendenti; / E per squisite tien quelle fature. // Chi dise: questo xè del Parmesan: / Chi dise: certo questo è del Coregio: / Chi dise con sodezza: e forsi megio, / La supera seguro quella man. // Ognun stupiva e restava incantà / Ma so Eminenza rideva in l'interno / Con dir confondo le fure d'Averno: / Non so in la chiusa come la sarà. // In suma quando ognun de quel pittori / Fu reo convinto, disse el Gardenal: / Sta volta dise ben, chi ha dito mal, / E quei se scambia de mile colori. // Replica So Eminenza, e dise: presto / Carazzi vegnè qua, che a vostra gloria / Xè fatta l'invenzion;

vu avè vittoria / Parmesani e Coregi; e dito questo, // Volta le spalle, e s'alza la portiera; / Ognuno resta là senza parlar: / I pitori confusi no' sa dar / Cope ne spade, e xe smaridi in ciera.' " For a discussion of how Boschini represented the Carracci compared to how Malvasia used Boschini to represent the Carracci, see Barocchi, 1979, 56–59.

89 Mancini, 1956, 1:134–35.

90 For a discussion of the theatrical devices and setting used by Pliny in his story, see Bann, 1989.

91 Magalotti, 1769, 2:58–62 (letter to Carlo Rinuccini, undated but after 1690):

"Mi raccontava Ciro Ferri, che quando giovanotto fu per andare a Venezia a studiare, e formare il gusto fu quelle gran maniere della scuola di Lombardia, Pietro da Cortona suo maestro, che gli voleva bene, e che conoscendo il suo forte, e il suo debole, sapeva quel ch'egli era capace di fare, e non fare, gli disse. Eh sai? fa' ch'e' non ti venga voglia di diventare o Giorgione, o il Tintoretto, o Paolo. Piglia solamente quello che si può adattare alla tua maniera presente, benchè tanto inferiore a quella di quei valentuomini: da Paolo quelle belle acconciature di teste, da Giorgione quella gran verità d'espressione, e così di mano in mano; ma sta' in cervello a non pretender di diventar Paolo affatto col metterti a vestir le figure come lui, con quei bei veli, con quei bei rasi, che ti riuscirà benissimo il non esser più Ciro senza arrivar mai a esser Paolo." For an example of the correspondence with Ciro Ferri to which Magalotti refers, see Ferri's letter to Magalotti of 26 April 1670, in Bottari and Ticozzi, 1821, 2:60–61.

92 Malvasia, quoted and discussed in Ivanoff, 1957, 113–14. "Non ci vollero essi legati ad un preciso modo, né astretti ad imitare un solo ... a forza tirando nell'altrui genio il nostro gusto; ma lasciando ad ogn'uno la sua libertà, non altra maniera consigliandogli, che quella stessa che portò seco dalla Natura, né altro Maestro ponendogli avanti, che un buono e bel naturale a tutti comune; ond'è che di tanti valentuomini dalla loro scuola usciti, tanto diverso anche in ciascuno si osservi il carattere, ancorché in tutti sì bello. . . ."

93 De' Domenici, 1742, 3:540.

94 Ridolfi, 1648, 2:38: "Ne' Padri Crociferi, nella maggior Cappella, fece la tavola con lo ascendere di Nostra Signora al Cielo; & tutto che

que' Padri havessero terminato, che Paolo Ve-
ronese facesse quella Pittura, seppe il Tintoretto
tanto dire, promettendogli, che l'haverebbe
fatta su lo stile medesimo di Paolo, si che
ogn'uno l'haverebbe creduta di sua mano, che
ne ottenne lo impiego."

95 Pallucchini, 1981, 1:168.

96 Soprani, 1674, 62. Baruffaldi (1846, 2:86),
 writing in the early eighteenth century, tells us
 of Ipolitto Scarsellino, who copied Jacopo Bas-
 sano so successfully that the *professori* were in
 disarray trying to determine whether or not
 the works were original. Only Leandro Bas-
 sano could resolve the dispute.

97 Ratti, 1768, 1:68.

98 Malvasia, 1678, 1:281: "Dall'altra parte un S.
 Girolamo così risentito di muscoli, ma insiem
 così tenero, che lo direste disegnato da un Mi-
 chelangelo e colorito da un Correggio." For a
 discussion of this painting, see Feigenbaum,
 1993, 64. See also Malvasia (1678, 1:279)
 commenting on how Ludovico worked in two
 antithetical styles in San Domenico: "L'accorto
 Lodovico intanto, riflettendo a i duoi estremi,
 ne' quali potesse necessariamente dare questo
 forestiere; o in un terribile, facile, risoluto, che
 in pochi segni e minori tinte mostrasse gran
 cose e piacesse agli intendenti; o in un gentile,
 finito amoroso, ch'anche i men capaci fer-
 masse, dell'uno e dell'altro modo si valse e
 cercò, fosse per esser l'opra di quel maestro o
 fiera o graziosa, con un eccesso di fierezza e di
 grazia quelle battere e superare." This example
 and others serve as proof that Ludovico's ex-
 cellence lay in his ability to work in and com-
 bine different styles (1678, 1:345–46): "E cosa
 mirabile, che di tante e tante tavole, che in
 Bologna si trovano di Lodovico, mai si veda
 un volto, mai una fisonomia, che ad un'altra
 punto tiri e si assomigli, ancorchè lo stesso sog-
 getto non solo, ma i medesimi personaggi en-
 tro quelle a rappresentarci abbia tolto; osserva-
 zione non saputasi talora praticar da qualcuno
 de' primi maestri del nostro secolo non solo,
 come un Rubens, un Berettini, un Domeni-
 chino, un Albani, ma dagli stessi duo' gran capi
 della scuola Lombarda, il Parmigiano, e il Cor-
 reggio, le teste di tutti i quali, massime de'
 puttini, fratellizzano, e sono le stesse. . . . Di
 qual maestro si è posto in testa di contrafar la
 maniera, mirabilmente l'ha fatto ed in guisa,
 che in lui solo vedendosene tante, si dispera
 talvolta di potersi ben riconoscere la sua ed

assicurarsene. Il considerarsi nel S. Giorgio
nella Chiesa di S. Gregorio tre maniere tanto
diverse, nel Santo, nella Donzella e negli An-
geli nella parte superiore, e che ben si accor-
dano insieme, è cosa che fa impazzire."

99 Boschini (1660, 537) referred to Pietro della
 Vecchia as "Compendio d'ogni singolar man-
 iera"; for further discussion, see Aikema,
 1990, 37–56. Francesco Algarotti (1791, 8:
 157; letter of 7 April 1761 to Gaspero Patriar-
 chi) called Tiepolo the viewer, as distinct
 from Tiepolo the painter, "così gran conoscit-
 or di maniere." For Giordano, see Bellori,
 1728, 351; and de' Domenici, 1742, 3:421–
 22. See Orlandi (1733, 355) for De Matteis as
 a follower of Giordano who learned to paint
 "in an artificial way" and was able to "trans-
 form his brush into a Raphael, a Titian, a
 Correggio, a Carracci, a Reni, a Preti and
 others."

100 Antonio Allegri (1754, 1), in a letter of 23
 January 1592 to Francesco Nori: "Quan-
 tunque gl'intendenti dell'arte alla maniera
 conoscan di chi l'opere sono, non restan per
 tanto i moderni dipintori di porre in un can-
 ton delle tavole una cifera la qual il proprio
 lor nome dimostri o 'l sopranome, e poi con
 grato accorgimento, quando è le fanno a
 posta, vi metton in prospettiva il ritratto,
 l'arme, o la 'mpresa di chi fù cagion principal,
 ch'è le facessero."

✍

CHAPTER 2. THE LANGUAGE OF STYLE

1 Kristeva, 1969, 146.

2 Volpato, n.d., fol. 66; Bordignon Favero,
 1994, 407: "detta [sua] maniera è il perfetto
 dell'espressione del opera, et è quella, che
 dando l'ultimo essere apparente e prima go-
 duta dal occhio, e poi dal intelletto considera-
 ta. . . ." For a discussion of *espressione* as an
 aesthetic concept that can be opposed to *affetti*
 as "a rationalist Italian theory," see Cropper
 and Dempsey, 1996, 47–48. Their proposal
 that expression derives from Le Brun, De
 Piles, and other Academy members corre-
 sponds to Volpato's enormous debt to De
 Piles; see Bordignon Favero, 1994, 76–80.

3 Baldinucci, 1681, 58.

4 See, for example, Volpato, n.d., 68, 70, 204,
 214, and 256; in Favero, 1994, 408–9, 414–
 15, and 420.

5 Baxandall, 1971, 7.

6 Baxandall, 1976, 44.

7 Baxandall, 1985, 3. His most recent and complete statement on this problem can be found in 1991, 67–75.

8 Cropper, 1976, 374–94; Cropper, 1984; Cropper, 1986, 175–90; Cropper, 1992, 101–26; Cropper, 1995, 159–205.

9 Cropper, 1995, 173 (but must be read in context: 159–205).

10 Here are a few recent books with important discussions of language-painting issues in seicento Italy, albeit with a different approach from mine: Lichtenstein, 1993; Bonfait, ed., 1994a and 1994b; Fumaroli, 1994, especially 149–81; Bolzoni, 1995; Colantuono, 1997; Jacobs, 1997; Spear, 1997. For the many articles, the reader should consult the Bibliography. For a fascinating study *On Pictures and the Words That Fail Them*, albeit one that barely touches seicento material, see Elkins, 1998.

11 For important observations on the matching of literary and pictorial styles, see Perini, 1989, 175–206. Her sensitive studies of dialect and phatic language, especially as it pertains to social or political relations, have yet to be matched (especially 1980, 221–53, and 1981, 107–29). She also has shown how art writers criticize the methods or artistic taste of other historians by attacking their literary style (1989, 203–10). For an idea of the extent of her work, see the Bibliography.

12 Bellori, 1672, 25 (at the end of "L'Idea" delivered in 1660); see Cropper, 1984, 170. For painting as *muta eloquentia*, see Fumaroli, 1994.

13 Passeri, *La Mensogna verdica*, n.d., fol. 86r–87v. For a general discussion of Passeri's lecture, see Turner, 1973, 231–47. Passeri opened his lecture with a feint of aporia, probably strengthened by some pantomime, in order to exemplify how paintings should affect the viewer: "Soccoretemi, favoritemi, consigliatemi, son tradito, son deluso, son ingannato. . . . Io non cieco, io non deliro, e pur quello che veggio non è reale, e quel ch'intendo è fantastico. Una magia larva . . . [che] disordina la mia mente, che vuole renderla capace di quella lusinga, che non puo intendere. Ardire, o mia avedutezza smarrita; coraggio o mia accortezza perduta, che gl'occhi, fatti perspicari ti insegnaranno queste chiare dottrine; è l'intelletto divenuto erudito ti farà scusata di questi precetti. Non sia stupore se una muta ascesa sovra le catrede

[sic] del silentio è la maestra parlante di questo Liceo, che havrà colori cosi vivaci d'eloquente espressiva, che non farà andar errato nella cognitione del vero. . . . Se quello, ch'io miro è uno spiraglio di luce; quello ch'intendo un ombra d'intelligenza; concorrà che rimanga offuscato nelle pupille, e nulla mente ottenebrato. Io miro disciollo l'intrigato nodo di Gordiano, ma nello scioglimento di quello, comprendo piu inviluppato il mio pensiero, è la spada del gran Macedone, che ha saputo recidere quel ingroppato ravolgimento, intriga in piu indissolubili legami la capacita mia." Passeri also gave a lecture in 1670 to the Accademia di San Luca entitled *Il Silenzio. Discorso sopra la Pittura* (Rome, Biblioteca Corsiniana, MSS 29 A 21, n. 1), including a five-page feint of confusion, silence, and deference (fol. 5–10). In *La Fantasia* (1673, fol. 1), Passeri opened his lecture with another feint of confusion ("Sento à me stesso rapirmi, e la mia mente sconvolta, si và raggirando negli spaziosi campi dell'aria, nelle confuse ampiezze della terra, e nelle profonde voraggini dell'abisso. Sono agitato à strane comozioni. . . ."), and in the dedicatory preface (n.p.) he suggested that the best remedy to "le confusioni di tante incertezze irresolute" would be to fix one's eyes on the "benigna fronte di V.E. [Cardinal Giacomo Rospigliosi], la quale con un cortese silenzio, e con una pacifica tolleranza, si degnò d'ascoltarle, e di compartirle. . . ."

14 Boschini, 1660, 542: "Ma in fati no so come scomenzar, / E no so come meterme a l'impresa / Del dir la finitezza, ben intesa, / Del so [Forabosco's] penelo; me voria sotrar. // E fazzo come fa quel Orator, / Che quando el monta in pulpito el se perde, / E resta aponto un Papagà bel verde. / Cusì fazzo anca mi; perdo el mio cuor." And 1660, 544–45: "No saverave mai de sto sugeto / Come concluder: perché, più che digo, / Più me confondo, e sempre più m'intrigo. . . ." For further discussion of aporia and disorientation in Boschini's writing, see Chapter 6.

15 Nicolini, 1659, 23 (in a letter to Giovanni Francesco Loredano). For the reception of Nicolini's *Ombre*, see Aikema, 1990, 76.

16 Nicolini, 1659, 89–90: "Posso ben'ombreggiare, non ispiegare quanto vivo, quanto vero sia l'essere di quelle mani, che si movono anco senza moto . . . così ne' muscoli distinti, nelle vene sollevate, nelli nervi apparenti, nelle

crespe veraci, rappresentanti l'opera d'una se-
nile Natura."

17 Nicolini, 1659, 5–7.

18 For the humility trope in antiquity, see Janson,
1964, 125–27; for its application in art criti-
cism, see below, note 38.

19 Pascoli, 1730, 1:n.p. (last page of preface);
1992 ed., 45; cited, but not discussed, by Fran-
genberg, 1994, 192.

20 Lucian, "The Hall," 1913, 199, sec. 21; cited
by Cropper, 1984, 170. For discussions of Bel-
lori's descriptive techniques that prove they
need not be a "bald thing," see Perini, 1989b;
Rosenberg, 1995; Hochman, 1994; Bätsch-
mann, 1995; Hansmann, forthcoming.

21 Bellori, 1672, 8–9: "Poiché avendo già des-
critto l'immagini di Rafaelle nelle camere Va-
ticane, nell'impiegarmi dopo a scriver le vite,
fu consiglio di Nicolò Pussino che io prose-
guissi nel modo istesso, e che oltre l'invenzione
universale, io sodisfacessi al concetto e moto di
ciascheduna particolar figura ed all'azzioni che
accompagnano gli affetti. Nel che fare ho sem-
pre dubitato di riuscir minuto nella moltiplicità
de' particolari, con pericolo di oscurità e di
fastidio, avendo la pittura il suo diletto nella
vista che non partecipa se non poco all'udito.
Et è pessima cosa il ricorrere all'aiuto del pro-
prio ingegno, l'aggiungere alle figure quei sensi
e quelle passioni, che in esse non sono, con
divertirle e disturbarle da gli originali. Mi sono
però contenuto nelle parti di semplice tradut-
tore, ed ho usato li modi più facili e più puri,
senza l'aggiungere alle parole più di quello che
concedono le proprie forme, rappresentando
l'invenzioni e l'artificio, acciò che si sappia
quale fosse l'ingegno di ciascuno. . . ." Bellori's
concept of language and literary style is usually
discussed in the context of his ekphrases; see,
for example, Previtali, 1976, xv–xvi and li–lx;
Perini, 1989, 175–206; Cropper, 1991, 145–
73; Bätschamnn, 1995, 279–313; Hansmann,
forthcoming. Perini (1996, 297) quotes this
passage as evidence of Bellori's literary bias,
using *favole* or *poesie* to mean "paintings."

22 For Vasari's literary self-fashioning, see Sohm,
2000a. For Bellori and Poussin, see note 11
and Chapter 5.

23 For his critique of Boschini's literary style, in-
cluding the full passage quoted in the following
sentence, see Chapter 1. For Bellori's views on
Malvasia, see Perini, 1989a and 1989b. Bellori's
attack on metaphoric art historiography was

preceded by Nicolini, 1659, 40–44: "Ciò serve
per la Historia, che, versando sù la semplice
narrativa de i fatti, non ammette gli abiglia-
menti dell'Eloquenza, nè gli ornamenti
dell'Oratore. Mà, come può sofferirsi il solo, e
ignudo racconto di quello, c'habbia operato
alcuno, per coronarlo d'applausi, se, affato se
n'escludono quei pretiosi colori, che la bellis-
sima Arte del dire insegna; e frà questi la Com-
paratione, che dà lo Spirito alla lode?
Un'historia digressione rigetta la diversità de'
colorati, perch'ella è un marmo scolpito, che
s'hà da vagheggiare nella pura sostanza, in che
l'hà animato un perito scalpello: mà un pane-
girico [such as the one he is writing] non può
risplendere, che frà le differenze delle minia-
ture, come una tela dipinta; poiche, se le Meta-
fore, le Iperboli, i Tropi non gli diano la forma,
sarà una pittura informe, abortita, che invitata
al deriso, non alla stima; e, quando se ne tac-
ciano i parallei, con aggiunta de gli eccessi,
che sono appunto l'ombre, onde più vaghe
spiccano le dipinte fatture, sarà un abbozzo, un
parto dell'Orsa, c'havrà l'imperfettione per la
sua più nobile essenza. . . . Dove l'opere per se
stesse parlano, gli ornamenti retorici non
hanno luoco." Malvasia apologized to Angel-
ico Aprosio for his "low" (*basso*) style in com-
parison to Bellori's "completely elevated and
heroic style" (*lo stile affatto sollevato et eroico*);
letter published by Perini, 1984, 225–26, doc.
8. This might simply be an example of the
humility pose, but considering the jealousy that
Malvasia felt toward Bellori, it could just as
easily be a commentary on Bellori's failure to
serve as a "simple translator." In particular, the
description of Bellori's style as "completely"
elevated suggests a lack of moderation or sen-
sitivity to subject and audience, unlike Malva-
sia who, he says of himself, wrote "per con-
farmi alla materia et alla capacità di quelli a'
quali scrivo, che sono i pittori, etc. . . ."

24 See Chapter 1, section titled "Fighting
Words."

25 For the politics of Marinist poetry in Barberini
circles and for Marinism as an official style of
Urban VIII, see Fumaroli, 1980, 202–27; Co-
lantuono, 1997, 105–10 (with many further
references).

26 For the ideology of the Accademia Reale, see
Stephan, 1966, 365–71. For the origins of the
Accademia dell'Arcadia in the Accademia Re-
ale, see Quondam, 1973, 389–438.

27 Zanotti, letter to G. G. Bottari, 10 March 1758; in Bottari and Ticozzi, eds., 1822, 3: 548–49: "Era bensì nelle sue espressioni talora non poco caricato e scabro, e, più che pulite e gastigate dalla lima, spesse fiate paiono levate dalla incudine dopo alcune poche martellate del fabbro." And in another letter to Bottari of 25 August 1758 (4:202): "Troppi sono i cattivi modi introdotti; e il peggio è, che a' mali conoscitori (e infiniti sono) piacciono e sono da essi blanditi, e premiati. Bisognerebbe, prima di ogni altra cosa, che si estirpassero queste zizzanie. . . ." G. G. Bottari, letter to L. Crespi, 2 October 1756; in Bottari and Ticozzi, eds., 1822, 3:471 ("con quel suo stile fa venire il dolor di testa"). In a letter to Zanotti of 14 April 1759 (Bottari and Ticozzi, eds., 1822, 3: 563–64), he characterized Malvasia's prose as "suo stile artagotico." G. Mitelli, *Vite ed opere di A. Mitelli* (Bologna, Biblioteca Comunale, MSS. B 3375, c. 71v); quoted in Malvasia, 1961, vii, and Malvasia, 1980, 14: "una immensità e catastrofe di quantità infinita di robbe." Costa, 1752, 138 (letter of 27 November 1741 from Gabburri to Costa): "E come si può mai leggere il Malvasia senza nausea, e senza mostrar di esser vivo, quando a 47 della Par. III chiama Rafaello, il Boccalajo Urbinate?" These highly prejudicial statements must be read in light of Perini's astute analysis of Malvasia's literary style.

28 Bianconi, 1802, 4:6–7 (letter of 1776): "Nella Felsina Pittrice incanta quel raro miscuglio d'idiotismi Lombardo-Bolognesi, seicentismi, frasi plebee, fatti interamente inutili, riflessioni puerili, lodi sterminate, periodi nemici del pulmone."

29 Passeri, 1772, x (preface): "Tutti questi Prologhi, sono stati risecati perche non erano suscettibili di ritocco. . . . [Ho] amputate quasi tutte le frasi seicentistiche, i giuochi di spirito le replice fastidiose di parole che erano presso che infinite. . . ." Another settecento reader of seicento art writing, Giacomo Carrara, found Antonio Lupis's letters on art to be written "with that emphatic and hyperbolic style" (con que' modi enfatici ed iperbolici di dire): Bottari and Ticozzi, eds., 1822, 5:363, note 1. For Bianconi's and Carrara's activities as connoisseurs, see Perini, 1991 and 1993.

30 Cropper, 1984, 170–72; Perini, 1989b, 175–206; Cropper, 1991, 168–73; Colantuono,

forthcoming and Marchesano, forthcoming. Perini (forthcoming) notes that the verbal alterations that Bellori made to images might constitute "a hermeneutic hypothesis, a theory or an idea rather than any real work of art."

31 Taja, 1750, 24. The following was written by the publishers Niccolò and Marco Pagliarini in explaining why Taja's *Descrizione* was needed so soon after Bellori's *Descrizzione* (written before 1673 but published only in 1695): "Ma anche questa descrizione [by Bellori] essendo verbosissima, e diffusa al maggior segno in parole, secondo lo stile di quel tempo, in cui visse quel per altro grand'uomo, ed eccellente antiquario, avrebbe al presente recata gran noja. Inoltre quest'opuscolo del Bellori, che piuttosto si può chiamare un elogio, che una descrizione."

32 I have found useful in this matter Barthes, 1970, and Davey, 1995, 177–200.

33 For art historiography, see Ascanio Condivi, who, in the preface to *Vite di Michel Angelo Buonarroti* (Rome, 1553), wrote that he wanted to narrate Michelangelo's life with honesty (*onestà*) and with diligence (*diligenza*), where "diligence" is a code for simplicity. Vasari's literary advisor Vincenzo Borghini thought that critical prose should have truth as its goal and should try to express that truth in a sober, clear, and plain style without "clausule ample e di parole ampullose e magnifiche, o di qualunque altro lenocinio o ornamento estrinseco" (quoted and discussed by M. Pozzi, 1975, 254–56). Borghini advised Vasari to write with diligence so that every detail would be right: "Et pero insistete in questo piu che potete et usateci diligentia; et ogni minutia ci sta bene" (letter to Vasari, 14 August 1564; Frey II, cdlix, 102). Borghini preferred for himself a historiographic style that involved a "minute and detailed treatment" (minuta, e particolare trattazione) of its subject: Borghini, *Discorsi*, 1:11; cited by Rubin, 1995, 195. He intended to examine his subjects diligently (diligentemente) in order to assure the truth; for further discussion on Borghini's historiography, see Williams, 1988, 85–110. Clarity and simplicity were qualities of the plain style used for didactic purposes, hence the Ambrosian Accademia del Disegno specified that professors should lecture with "clear words": Jones, 1989, 50; and see now Jones, 1993. Paolo Beni thought that,

because historians must give a true account of the past, their language must be clear (*perspicua*), correct, and pure (*pura*), natural (*naturalis*) and free of metaphor; see Diffley, 1988, 215. F. Strada (*Prolusiones Academicae*, Rome, 1617) and other anti-Tacitists argued in favor of a simple, truthful style of historiography. For the opposing Tacitist view, see Spini, 1970, 91–133. For other considerations of the style of historiography, see Cotroneo, 1971.

34 Vasari, 1568, 1:3. For Vasari's style of art historiography, see Sohm, 2000a.

35 Caro, letter to Vasari, 15 December 1547; in Bottari and Ticozzi, eds., 1822, 3:205–6; and Vasari, 1930, 1:210, cv: : "In una opera simile vorrei la scrittura appunto come il parlare, cioè ch'avesse piuttosto del proprio, che del metaforico o del pellegrino; e del corrente, più che dell'affettato."

36 Cortesi, 1977, 137; discussed by Black, 1987, 144–45.

37 Pascoli, 1730, 1:45 (preface): "Sarà ogni vita distesa con istile piano, pulito, e facile; e quantunque nerboruto, e storico, privo però del più vago, del più vivo, e del più dilettoso, che porta seco l'istoria nei precetti dell'arte, che quì non ponno aver tutto il luogo. Mi conterrò nella semplice, e nuda narrativa, senza vestirla d'erudizioni vane, d'allegagioni inutili, di descrizioni nojose, d'autorità superflue."

38 These are Lomazzo's words to his readers in the preface of the *Idea* (1590, 1:245–46): "Ma percioché io sono di natura non men libero in dimostrar la sincerità del animo mio, che desideroso di esplicarlo, dirò schiettamente quale sia l'intenzione mia in questo trattato, senza velame di fizioni e senza alcun disegno di voler, con ornamento di belle parole, persuadere che io sia quello che nel vero io non sono, ma con un solo scopo di voler trattare con chiarezza quanto sono per discorrere intorno a quest'arte." For a similar strategy in the style of scientific writings, see Pallavicino, 1662, 167–86.

39 Jouanny, 1911, 21.

40 The work by Perini on Bellori's descriptive modes has been particularly useful: 1989b, esp. 192–94, and 1996, esp. 297–300. Hansmann's important forthcoming article will be the first devoted to the subject. For the illustrated editions, see Bellori, 1657, 1677, 1679, 1680, 1680, 1685, 1691, 1693, 1695 (written by 1670) and 1697. For a discussion of his use of reproductive prints, see Pomponi, 1992; Borea, 1996; and Herklotz, forthcoming.

41 G. P. Bellori, *Sigismundi Augusti Mantuam adeuntis profectio ac triumphus . . . anno MCCCCXXXII, opus ex archetypo Julii Romani a Francisco Primaticcio Mantuae in Ducali Palatio quod del T noncupatur, platica atque anaglyphica sculptura mire elaboratum . . . cum notis Jo: Petri Bellori a Petro Sancti Bartoli ex veteri exemplari traductum aerique incisum* (Rome, 1680).

42 Marino, 1966, 245 (letter to Claudio Achillini, January 1620).

43 Annibale Carracci, letter to Ludovico, 28 April 1580; in Perini, ed., 1990, 152–53; trans. de Grazia, 1979, 510: ". . . mi piace questa schietezza a me, questa purità che è vera, non verisimile, e naturale, non artifitiata né sforzata: ogn'uno la intende a suo modo, io la intendo a così. Io non la so dire, ma so come ho a fare, e tanto basta."

44 Agucchi, in Mahon, 1947, 254. For discussions, see Strinati, 1972, 80–81; and Dempsey, 1977, 1–3.

45 Malvasia, 1678, 1:334–36.

46 Fréart de Chantelou, 1985, 107 (9 August 1665).

47 Baxandall, 1991, 67–75.

48 Malvasia (1678, 1:360–67) quoted Agucchi's lengthy description as evidence of Annibale's artistic worthiness for such elaborate treatment and as evidence of linguistic virtuosity. For discussions of Agucchi's descriptions, see Perini, 1989b, 184; Rosenberg, 1995; and Hansmann, forthcoming. Hansmann argues convincingly that Agucchi was particularly interested in the aesthetic, even synesthetic, transcription of pictorial form. For an interesting example of Agucchi's conceding that visual and verbal languages differ fundamentally, see his correspondence with Bartolomeo Dolcini (1602–3) regarding a painting of *Erminia and the Shepherds* (San Ildefonso, Real Palacio de la Granja) by Lodovico Carracci: Whitfield, 1973, and Vannugli, 1987. Agucchi adjusted his verbal program after realizing that the sight of a distant burning city did not match his expectations: "Quanto alla favola a me è parso, che sia espressa al vivo; nella mia imaginazione, è riuscita punto diversa, nel più delle cose, e massime nella Donna, nel vecchio, e nel fanciullo." He imagined details that atmospheric perspective

did not allow; he thought emblematically instead of visually.

49 For the practice of fragmenting paintings into details for the sake of discussion, see Hochman, 1994, 43–76; and Sawday, 1995, 188–212.

50 Zanotti, 1703, 29: "Nel darvi ragguaglio de' Quadri, non starò à dilungarmi nella minuta descrizione di essi, perche sò, che ciò poco importa à Pittori (à quali solo io scrivo) che fanno stima, e con raggione, del esatto disegno, e della bella maniera di dipingere, più che degli eruditi ritrovati, che tal volta poi non sono del Pittore, mà di qualche Letterato suo Amico."

51 Speroni, 1978, 1:548: "Lo Aretino non ritragge le cose men bene in parole che Tiziano in colori; e ho veduto de' suoi sonetti fatti da lui d'alcuni ritratti di Tiziano, e non è facile il giudicare se li sonetti son nati dalli ritratti o li ritratti da loro."

52 Land, 1986 and 1994. Snyder (1989, 117–29) shows that Speroni did not always believe in the equivalence of speaking and painting. For a discussion of Speroni, Aretino, and other cinquecento Venetian writers considering the problems of description, see M. Pozzi, 1980, 161–79.

53 Aretino, 1957, 2:17 (May 1544).

54 Dempsey, 1977.

55 Ibid., 36. As Dempsey's later work on the "Devout Style" and the "Greek Style" shows (1987 and 1988), the question of style is best solved by pragmatics guided by semantics.

56 Pliny, *Natural History* 35.81–83.

57 H. van de Waal, 1967, 5–32; Elkins, 1998, 22–46.

58 Sohm, 1995a. Spear (1997, 27–29) suggests that Pino's story of an old woman who mistook a depicted shadow for a brown stain served as a source for G. B. Agucchi and G. A. Massani (Mosini) regarding the frescoes in San Gregorio Magno (Rome) by Reni and Domenichino. Spear follows the story through its many seicento readings by Algardi, Malvasia, Passeri, Bellori, Vittoria, Zanotti, and Pascoli.

59 Lucian, "Zeuxis or Antiochus," 1959, 161, sec. 5.

60 Vasari, 1568, 1:3 and 29.

61 Zanotti, 1703, 69 (writing about the *Adoration of the Magi* painted by his teacher, Lorenzo Pasinelli, for Pietro Fortuzzi): "Non è però ne anche questo Quadro finito, ò (come dicono i Pittori) leccato, mà è si può dire diligentemente sprezzato." Zanotti (1703, 29) had al-

ready described himself as a painter writing for painters, but he evidently felt it helpful to reiterate this with the phrase "as we painters say." For *statuino* and *leccato*, see Chapter 1, "Fighting Words."

62 Zanotti (1703, 102–3) explained how easy it is to confuse good and bad finish by having a foolish German point out to Pasinelli that a certain face had not been finished. Pasinelli responded that, actually it was too finished, or rather that it needed to be finished "con quella diligenza da me chiamata poco scrupoloso." The German fell into a confused silence. For Boschini's use of the paradox of true diligence tossing diligence away, also using a German as the victim of confusion, see Chapter 6. For the different meanings of "diligence" in seventeenth-century criticism, see Muller, 1985.

63 Passeri, 1673–79, 11 (as quoted and discussed at the beginning of Chapter 1).

64 Dolce (1557, 154–55), and Baldinucci (discussed in Chapter 7), and Leonardo Bruni (discussed by Baxandall, 1971, 124). Vincenzo Borghini (*Selva di notizie*; published in Barocchi, ed., 1970, 1:628–29) believed that lay viewers could judge the more important parts of painting (invention, expression, and verisimilitude) and granted artists only limited expertise over "those details of art, of certain subtleties, of certain diligences and difficulties." Mancini (1956, 1:291–93) rejected the argument that "if you don't have the art to make it, you won't have the art to judge it" on the basis that art imitates those things in the world with which all people are familiar. Because nature is the object of imitation and all people know nature, therefore they have a standard by which to judge painting.

65 I rely on Cropper's discussion of Summers's work (1995, 171–74).

66 Dolce (1557, 154–55), who proceeded to debunk this view. For the artist's case, see Celio, 1638, 8–9: "Non entro à discorrere del più ò meno, circa l'eccellenza, per evitare la prodigalità di chi troppo ardisce, non essendo della professione del disegno, quali si danno à credere, che solo il veder lume basi à poter bene giudicare delle facultà sudette. . . . Non saprà la pianella, Il Cieco non giudica delli colori: di dove si sente chiaro, che deve sapere operare chi vuol giudicare, dalla prima, e dalla seconda, che non parli alcuno dell'arte, che non è sua, e dalla terza, che sono come ciechi quelli, che

parlano senza essere eruditi in esse Facultà." Passeri (1670, 3–4), also writing as a painter, stated his case early in the introduction. Volpato (n.d., fol. 235), another painter, wrote that only painters can judge painting, especially in those areas of *disegno, colorito*, and *chiaroscuro*. His title foreshadows this argument, where the author unveils pictorial truths to dilettantes: *La Verità pittorica svelata à dilettanti*. For a summary of this debate in antiquity, see Dalla Valle in Dati, 1823, 2:50–54.

67 Borghini, 1584, 444. On pp. 52–53 he also divides painting into parts that do not "pertain to the artist" (*invenzione*) and parts that are "inherent to the artist" (*dispositione, attitudini, membri, colori*). Junius, 1638, 73–77. For discussions of these passages, see Cropper, 1984, 166–67; Frangenberg, 1990, 78–80; and Sohm, 1991, 40–43, 130–31, and 146–49.

68 Dionysius of Halicarnassus, *Demosthenes*, 50: "Sculptors and painters without long experience in training the eye by studying the works of old masters would not be able to identify them readily, and would not be able to say with confidence that this piece of sculpture is by Polyclitus, this by Phidias, this by Alcamenes; and that this painting is by. . . ." The collector Marco Bevilacqua called the painter Orlando Flacco "ecc.mo giudice nel saper discernere tutte le maniere de' principali pittori che sono già stati in Italia": Luzio, 1913, 107 (letter to Vincenzo Gonzaga, 1593). For Pietro da Cortona as consultant on matters of authenticity, see Geisenheimer, 1909, 21 and 37. For Livio Meus, see Bottari and Ticozi, eds., 1822, 2:61–64. For Justus Sustermans, Baldassare Franceschini, and Giovanni Battista Natali as painter-advisors to Leopoldo de' Medici on matters of connoisseurship, see Goldberg, 1988, 60. For Natali's letters to Leopoldo, see Bandera, 1979. Cardinal Luigi d'Este thought that Denijs Calvaert was an expert of styles ("seppe Dionisio conoscerne tutti gli authori"): Malvasia, 1678, 1:197. According to Celano (1681, 2:25), Luca Giordano, "most excellent painter in imitating all the styles ancient and modern," produced works that "deceived the knowledge and judgment of the most expert painters." Although connoisseurship was first discussed at length by a nonprofessional (Giulio Mancini), it was not until later in the century that dedicated lay connoisseurs emerged, including Baldinucci, Sebastiano Resta, and

Francesco Algarotti. Perini (1991, 176–87) shows how the conviction that the technical expertise of a painter is needed for connoisseurship was being eroded in the eighteenth century. For an interesting exchange between a professional curator who was not a painter and a painter who was a practicing connoisseur, see the letters by Algarotti and Luigi Crespi (Bottari and Ticozzi, eds., 1822, 3:419–33).

69 Vasari, 1568, 6:389: "Dintorno a che allargandosi, mostrò certo aver gran cognizione e giudizio nelle cose delle nostre arti; ma è ben vero che bastandogli fare gran fascio, non la guardava così in sottile, e spesso, favellando di detti artefici, o scambiava i nomi, i cognomi, le patrie, l'opere, o non dicea le cose come stavano apunto, ma cosí alla grossa. Finito che ebbe il Giovio quel suo discorso, voltatosi a me, disse il cardinale: 'Che ne dite voi, Giorgio, non sarà questa una bell'opera e fatica?' 'Bella' – rispos'io – 'monsignor illustrissimo, se il Giovio sarà aiutato da chi che sia dell'arte a mettere le cose a' luoghi loro et a dirle come stanno veramente. Parlo così, percio che, se bene è stato questo suo discorso maraviglioso, ha scambiato e detto molte cose una per un'altra.' 'Potrete dunque,' soggiunse il cardinale, 'pregato dal Giovio, dal Caro, dal Tolomei e dagl'altri, dargli un sunto voi, et una ordinata notizia di tutti i detti artefici, dell'opere loro secondo l'ordine de' tempi; e cosí aranno anco da voi questo benefizio le vostre arti.' "

70 Vasari, 1568, 6:389: " 'Giorgio mio, voglio che prendiate voi questa fatica di distendere il tutto in quel modo che ottimamente veggio saprete fare, perciò che a me non dà il cuore, non conoscendo le maniere, né sapendo molti particolari che potrete sapere voi: sanzache quando pure io facessi, farei il più un trattatetto simile a quello di Plinio.' "

71 For further discussion of Vasari's dinner piece, see Sohm, 2000a. Giulio Cesare Gigli (1616, n.p.[preface]) commented on Vasari's rejection of Pliny and Giovio; see S. Ginzburg, 1996, 283–84.

72 Vasari, 1568, 1:3 and 29; 6:410. For Vasari's claims not to be a writer, see Bettarini, 1974, 485–92; and for a wide-ranging discussion of Vasari writing as a painter, see Rubin, 1995, 231–86. For Vasari's technical vocabulary as a painter, see Barocchi, 1981, 5–27; and Panichi, 1991, 13–26.

73 Vasari, 1568, 3:4.

74 Campbell (1996, 278–90) quotes Filarete and gives us an excellent contextualization of calligraphy and painting. He shows how they can have individuality without necessarily having personal identity, i.e., carrying attributes of the scribe's or painter's *ingenium*. For a different view of Vasari's passage (1568, 6:411), see Rubin, 1995, 248–49.

75 Vasari, 1568, 4:204.

76 Ibid., 1568, 6:24–25.

77 Matteo Bandello (1952, 647–50, Novella 58) first retold Pliny's story with Fra Filippo Lippi as Apelles, Cosimo de' Medici as Alexander, and Marca d'Ancona as Campaspe. Bandello's story was later adopted by Vasari with further variations.

78 Baldinucci, 1681–1728, 6:466.

79 A. F. Doni, *La Zucca*, Venice, 1565, 209v; quoted and discussed by Quiviger, 1995, 106–7. For further study on how the literati talked about art within academic confines, see the other essays in this exemplary volume as well as Bryce, 1995, 77–103. Quiviger's short but illuminating essay is a particularly important contribution to the literature on how artists and literati perceived works of art differently.

80 Paleotti, 1582, 171–72, 311, 440–41 and 498–500. For an example of a nobleman making mistaken judgments about the style of a statue, only to be corrected by a sculptor, see R. Borghini, 1584, 159. In this dialogue the Florentine nobleman Girolamo Michelozzo criticizes the fold over the right leg of Jacopo Sansovino's *St. James* (Florence, Duomo) as having insufficient grace, but the sculptor Ridolfo Sirigatti corrects him by pointing out that there were technical problems that made it appear this way. Michelozzo thinks the head should have "more style," whereas Sirigatti believes that "a good master is not always obliged to display style in his works." For a discussion of this passage, see Frangenberg, 1995, 122.

81 Patina, 1691, 23: ". . . ella può essere d'ugual diletto e agli studiosi della pittura e agli amanti delle sagre lettere. Ma lasciando à primi di fermarsi con l'occhio a contemplar l'artifizio delle figure, io mi fò in grazia de i segondi a spiegarne il significato."

82 Published in Cinotti, 1971, 160 (F 79).

83 V. Borghini, 1912, 10–13. This statement and the motto quoted below are discussed by W. Kemp, 1974, 236; Summers, 1981, 532, n. 27;

Waźbński, 1987, 1:162–64 and 301; Farago, 1992, 126 (who notes the context of Borghini as Michelangelo's response to Varchi's request); Scorza, 1995, 137–63; and Frangenberg, 1995. For an important discussion of the "very marginal position" held by artists in cinquecento Italian academies and the implications for the state of literacy in the artistic community, see Quiviger, 1995, 105–12.

84 V. Borghini, 1912, n. viii, 12, and 14: "voi uscite di casa vostra, dove voi siate patroni et entrate in casa di filosofi et Retori, dove voi havete non troppo gran parte . . . è Academia di FARE et non di RAGIONARE." For Borghini and the Accademia del Disegno, see the thorough article (with current bibliography) by Scorza, 1995, 136–64. For other examples of "the superior attitude of the elite, educated literato with respect to the artist," see Rossi, 1998, 60–62.

85 For a discussion of these statements, see Lucas, 1989, 80–82.

86 W. Kemp, 1974, 236: "S. Ecc. dice che bisogna far con l'opere, non con le parole."

87 Mahon, 1947, 167–70.

88 Alberti, 1599, 16; in Zuccaro, 1961, 28. For related topics regarding the Accademia di San Luca, see Strinati, 1972, 67–82.

89 Vitruvius, 1. 1. 17; Ghiberti, 1998, 45–46 (1.1.1); Leonardo, 1970, 1:116: "So bene che per non essere io literato, che alcuno prosuntuoso gli parà ragionevolmente potermi biasimare coll'allegare jo essere homo sanza lettere. . . ." Condivi (1553, preface) confessed that, being trained as a painter and not a writer, his style of writing was not very good. Lomazzo, 1590, 244 (in dedicatory letter): "Benché questo non è soggetto da ragionarne in breve lettera dettata da roza et inesperta lingua, ma degno solo di poemi chiarissimi e d'istorie." Bisagno, 1642, n.p. (preface): "Tratto della Pittura, ma senza Rettorici colori, perche non è mio pensiero tesser panegirici di quest'arte, nè meno prescriver à gli altri, come si hà da scrivere, ma come si hà da dipingere. . . . Aggiungo la mia naturale inchinatione [*sic*] à questa virtù, l'haverne preso con trattar i colori qualche tintura, l'haver visto per curiosità di questa professione molti paesi, l'haver conferito con molti eccellenti Pittori: questi, & altri motivi mi spinsero à metter in carta così rozzamente quello, che i professori di quest'arte hanno con tanta gratia, e leggiadria dipinto nelle tele."

Amedeo di Castellamonte (1674, n.p. [preface]): he begged his patron's pardon for the "rozzezza" of his writing talent because he was more accustomed to building than describing buildings. Volpato, n.d., fol. 239; in Bordignon Favero, 1994, 103. For the origin of the humility trope in ancient and medieval literature, see Curtius, 1953, 93–95, and Janson, 1964, 125–27.

90 Da Canal, 1804, 16 (written c. 1732–35); Zanetti, 1733, 58.

91 These include Giovanni Pietro Bellori, Agostino Taja, Francesco Niccolò Maria Gabburri, Pier Jacopo Martello, Scipione Maffei, Giovanni Pietro Zanotti, Francesco Algarotti, and Giovanni Niccolo D'Azara. I will discuss their critiques of seicento art in a forthcoming study on "Baroque Mannerism."

92 Mazzoni, 1661, 35: "Che l'Età presente non merita biasimo." Dati, 1825, 125 (undated letter probably written between 1669 and 1672): "Siamo in un secolo di gusto un poco alterato, per non dir corrotto. I costumi depravati non ammettono così facilmente i componimenti regolatissimi, e gli orecchi della moltitudine vogliono esser lusingati dal semplice diletto."

93 For a history of the Accademia's competitions and awards, see Missirini, 1823; Cipriani, ed., 1989; Cipriani and Valeriani, 1989, 3 vols.

94 For the Arcadians' participation in the awards ceremonies, see for example the many appearances of Giovanni Maria Crescimbeni, cofounder of the Arcadians: "In Lode della pittura. Sonetto," in *Pompe,* 1702, n.p.; "Alla Città d'Urbino," and "Al Signor Carlo Maratti propagatore dell'incomparabile scuola di Raffaello dà Urbino," in *Le Buone Arti,* 1704, 54 and 71; "Per la ristorazione del famoso Panteon," in *L'Utile,* 1707, 61; "Che per mezzo delle Opere della Pittura meglio comprendiamo le cose intellettuali," in *Le Scienze illustrate,* 1708, 65; "S'invitano i Sig. Accademici del Disegno ad alzare una Mola onorifica alla memoria del Sig. Magg. Francesco Riviera," in *Il Merito delle belle arti* (Rome, 1709), 64; "Al Signor Giuseppe Ghezzi per il nobilissimo quadro della Venuta dello Spirito Santo da lui fatto e collocato nella Cappella Maggiore della Chiesa della Nazione Napolitana di Roma," in *Roma tutrice,* 1710, 62; "Per la Guglea alzata in mezzo alla fontana della Rotonda, ristorata ed abbellita," in *Le Belle Arti,* 1711, 49; "Per la Santità di Nostro Signore Papa Clemente XI. Viva Immagine de' quattro novelli Santi," in *Il Trionfo della Fede,* 1713, 43. In the 1739 record of speeches and poems, the following Arcadians had works published: Francesco Lelli, G. B. Monaldini, G. B. Bassi, G. Cenacchi, G. B. Rizzardi, Giancinto Speranza, Filippo d'Azon, Filippo Bellieri, Domenico Rolli, Antonio di Gennaro, Carlo Mondelli, Prospero Petroni, and Stefano Pallavicini: *Delle Lodi delle belle arti,* 1739. Unlike most of these Arcadians, Crescimbeni had considerable knowledge of contemporary art: see De Marchi, 1987, iv–xxxiii.

95 L. Ruspoli, 1779, xxv: "Io compatisco, anzi deploro, la misera condizione delle Arti vostre fatte oggidò il bersaglio della critica di chi ancor meno ne sappia, e non mai perciò accade, che senza riso, ò a meglio dir senza sdegno, ricordare io mi sentissi dal Vasari, dal Bellori, dal Malvasia, dall'Algarotti, le mal pensate critiche, fatte da persone ancor di alto rango, alle divine opere di un Buonarruoti, di un Tiziano, di un Domenichino, di un Albani, di un Tintoretto."

96 L. Ruspoli, 1779, xxvii: "Cioè, potere alcune volte il solo giudizio del Pubblico, qualch'egli siasi, formarne una più retta critica delle opere vostre di quello, che far non ne potrebbe un' artefice stesso più consumato, e fino il voto più inappellabile di una intera Accademia, si perchè quello suole esser sgombro nell'animo da ogni vil pregiudizio, che la ragione prevenga, sì perchè, per quanto ben vaggano più addentro i consumati Professori delle Arti, sono essi alle volte di un sì difficile genio, ed incontentabile, che mai per essi non si dà cosa ben fatta, e dove non finisce una piega, dove non apaga uno scorcio, dove non risalta un contrasto, e qui più morbidezza vorrebbesi, e la più espressione, nè mai dal tormentar rifinano un marmo sventurato, ed una tela infelice, finchè, per troppo amore di perfezione, spinta non l'abbiano all'altro estremo di troppa studiata maniera, che togliendo a' lavori quel naturale e libero andamento, onde più all'ottimo esemplare assomigliansi, qual'è la natura, gli rende così, perchè di troppo studiati all'avido spettatore men belli."

97 L. Ruspoli, 1779, xxvii–iii and xxxii: "[F]arò io però sempre persuaso, che questa servile soggezione alle altrui ingiuste censure, che ed avvilisce, e corrompe il natural gusto dell'ottimo, infuso anche a' di nostri della Natura in cert'ingegni nati solo a gran cose, si è

quella, che rende forse presente men famosa l'Italia nel pregio delle tre Arti, che celebriamo, di quello, che già ella ne fu ne' lustri trascorsi. Per la qual cosa a non ricovere dalla viziosa critica un comecchè piccolo danno, usar dovete, Giovani valorosi, un generoso dispregio, per cui l'inutile gracchiar di questi Corvi loquaci punto non alteri la placida tranquillità delle vostre applicazioni agl'intrapresi esercizj."

98 Soderini, 1766, 25–28. F. Ruspoli, 1777, 29: "Non andò essa anche immune dalla barbarie ed irruzione de' Popoli, e nelle diverse Epoche ora soggiacque alle stravaganze del gusto Gotico, dal quale alterate furono tutte le proporzioni; ora cadde in una illimitata profusione di ornati. . . ." Lante, 1786, xxxi: "Che se così grandi, e nobili esempj non valessero a commover l'animo d'alcun Artefice moderno, il quale dimentico della pura, ed amabile semplctà più diletto prendesse dello scolpir manierato, e del dipinger fantastico, e del tutto ornamentale, o dell'architettar capriccioso, e stravagante si dichiarasse partigiano, ho ben io con che atterrire quest'ingegno volgare."

99 Maratta, 1696, 23–24: "Ed ancor'Io, Eminentissimi Signori, e virtuosissima Assemblea, vi publico da questo istesso luogo il Centesimo della nostra Accademia del Disegno: Centismo, che nessun di Voi hà veduto, e nessuno sarà per vedere più splendidamente adornato, poi che da questa Accademia è uscito in un Secolo, quanto di bello hà saputo spiegar l'Architettura, distinguer la Scultura, & idear la Pittura, e sarà d'Invidia a' Posteri, non poter superare il nostro Secolo, e solo loro resterà la Gloria di seguirne l'orme. Secolo felice, che fù auspicato, non sotto i Decemviri Padri di scandalosa licenza, ma sotto un Sisto il grande, che non si sà, se fusse Emolo, ò Vincitore delle grandezze di Roma."

100 Bellori, 1672, 626–27: "Egli è solito dire che una buona scuola può fare un buon discepolo. . . ." For his opinion on contemporary painting, see above, note 99.

101 Bellori, 1672, 628: ". . . i giovani allettati da tali dottrine volentieri abborriscono gli studi e le fatiche, e s'allontanano da quel fine che più dovrebbero seguitare; onde la pittura in vece della sua forma naturale prende apparenza di larva e di fantasma, lontana in tutto

dalla verità che ci obbliga ad una buona e perfetta imitazione. Invano però si querela il nostro secolo che non vi siano o sgorghino dalle scuole buoni pittori, e che si veggano sí mal condotte le maggiori e più cospicue opere, restando affatto in abbandono i buoni studii ed i buoni principii." Compare Maratta's "onde la pittura in vece della sua forma naturale prende apparenza di larva e di fantasma, lontana in tutto dalla verita. . . ." to Bellori's Idea: "Laonde quelli che senza conoscere la verità il tutto muovono con la pratica, fingono larve in vece di figure. . . . Rassomiglia Platone quelli primi pittori alli Sofisti, che non si fondano nella verità, ma nelli falsi fantasmi dell'opinione" (1672, 21). This statement is preceded by formal quotations and is followed by paraphrases ("Carlo cautions . . . Carlo abhors . . .") so Bellori's intention is clearly to report Maratta, not to provide personal commentary.

102 Vittoria, n.d., fol. 1, 227–28, 389–90 and 445–48. For a thorough biography of Vittoria, see Rudolph, 1988–89. Vittoria's Academia is a dialogue divided into seven "nights" (noches) between Maratta, Bellori, and a dicipulo, presumably Vittoria. Prandi (1941) has dated it between 1686 (because it is not mentioned in Baldinucci's Notizie) and 1690 when a collection of poems by Giovanni Prati (Il Genio Divertito) mentions it. Rudolph (1988–89, 262) notes that, according to Crescimbeni (1731, 91), the life of Carlo Maratta published in 1731 was "pienamente incominciata da Giovanni Pietro Bellori, e continuata dal Canonico Don Vincenzo Vittoria, la quale è in podere di Faustina Maratti sua figlia, nostra Arcade."

103 For Maffei, see his poem "Sopra il quadro del Signor Cavalier Maratta ch'è in S. Pietro, rappresentante il Battesimo del Salvatore," in Roma tutrice, 1710, 66. Balestra studied in Maratta's studio and was enrolled in the Accademia di San Luca as "Accademico di merito" while Maratta was president; see Gli Eccelsi, 1733, 106. For the inclusion of poetry among the main topics of discussion in Maratta's house on the Pincio, see Vittoria, n.d., fol. 1. Antonio Balestra, who criticized contemporary painting for being "mannered," studied with Maratta; the autobiography that he supplied to P. A. Orlandi is presented by Battisti, 1954, 27.

104 Aristotle, *Metaphysics* 986 a 31–986b: odd/even, unity/plurality, right/left, male/female, at rest/in motion, straight/curved, light/dark, good/evil, square/oblong. For a discussion of these and other polarities in antiquity, see Lloyd, 1971. For a brilliant discussion of their retention in Renaissance art theory and philosophy, see Summers, 1994, 384–411.

105 I do not mean to suggest, however, that deconstruction has shed dichotomies. Paul De Man's essay "Semiology of Rhetoric" (1979) is riddled with them; for further discussion, see Culler, 1988, 107–35. My ideas on the function of structuralist binaries depend on Culler, 1975, 10–16 and 55–74. Roman Jakobson has been particularly influential on discussions of binary distinctive features: Holenstein, 1976; and Jameson, 1972; Riffaterre, 1966, 200–242.

106 Hauser, 1958, 209.

107 Wölfflin, 1915, 1–13.

108 Wollheim, 1987a, 184. Wollheim argues that Wölfflin's school style (Taddeo Gaddi paints in the style of Giotto) is not a form of individual style, even though it may be practiced by an individual, but a form of general style. Wollheim elaborates on his ideas in 1995, 37–49. For a review of nineteenth- and twentieth-century art historiography regarding the position that Wollheim is objecting to, see C. Ginzburg, 1998, 27–54.

109 Wollheim, 1987, 27.

110 Kubler, 1987.

111 Kubler might have absorbed structuralist theories directly through linguistics or through their applications in anthropology. For a review of binary opposition in structuralism, see Culler, 1975, 10–16.

112 Baldinucci, 1681, 62: "Forma. f. Termine Filosofico, ed è quel principio intrinseco, dal quale le cose ricevono l'esser loro. Lat. *Forma*. La forma è una delle due parti essenziali del corpo fisico o naturale, e l'altra parte è la materia." The second definition reads: "Forma. E' la fazione esteriore di che che sia. E per ciò significa bene spesso, imagine, faccia, figura, sembianza, aspetto." For two important discussions of form, see Summers, 1987, and Williams, 1997, 135–50.

113 Summers, 1981, 299–300; Summers, 1987; Summers, 1989, 372–406; and Summers, 1994, 384–411. See also Sharples, 1985, 117–28; Gill, 1989.

114 Cicero, *De oratore* 2.12. 49–2.15.64, and 2.27.30.

115 Ibid., 1.2.5.

116 Ibid., 1.25.113.

117 Horace, *Ars poetica*, 408–10. For a discussion of this passage, see Brink, 1971, 2:173. Vitruvius (1.6–9) adopted Horace to architecture: "He [the architect] must have both a natural gift (*ingeniosum*) and also readiness to learn (*disciplinam*). For neither talent (*ingenium*) without instruction (*disciplina*) nor instruction without talent can produce a perfect artist (*artificem*)." Granger translated *artificem* as "craftsman" instead of "artist;" Vitruvius' meaning lies somewhere in between.

118 Quintilian, *Institutio oratoria* 2.19.2. As the author of a precept book, he had much invested in claiming the superiority of study over nature, which is not to suggest that he remained oblivious to infatuations with study and technique: see 2.20.1–5. He advised teachers to foster the natural gifts (*propria naturae bona*) of their pupils, but for adults he valued *ars* and *exercitatio* as more important (2.8.3; and 8. Pr. 15–16). Fantham (1995, 129) notes how Quintilian used two analogies from agriculture and sculpture to show the greater importance of *ars*. She also discusses Quintilian's views on an orator's character (*mores*) and how the orator should not choose a style that is unsuited to his nature (1978, 106–7). For *ars* as a compensation for modest talent, see also Hermogenes, 1986, 1 (214: Introduction).

119 Cicero, *De oratore* 2.29.128–29; 2.53.214. In summing up his oratorical career, Cicero (*Orator* 21.69) noted that he composed *Pro Rabirio* in the grand style, *Pro lege Manilia* in the middle style, and *Pro Caecina* in the plain style. Each oration, because of its content and function, required a different style to perform one of the three *officia oratoris*, adopting the grand style to move (*movere*), the middle style to please (*delectare*), and the plain style to instruct (*docere*). See also Quintilian 12.10.58–59.

120 Cicero, *De oratore* 3.176–77.

121 Weise, 1952, 181.

122 Gombrich, 1968, 353. He is not nearly as dogmatic in *Art and Illusion*, where he discusses style in relation to perceptual theory and the psychology of representation (1960a, 9–30). For other arguments in favor of intentionality as a precondition for style, see Hasan,

1971, 299–326; Chatman, 1987, 230–44; Meyer, 1987, 21–71; and most recently Altieri, 1995, 201–19: "Personal style is a dimension of purposiveness that we attribute to what I shall describe as dynamic intentionality. Attributions of dynamic intentionality need not presuppose self-consciousness on the part of the agent, but the concept of style has its greatest resonance when we come to appreciate the rendering of intentionality as a deliberate communicative act."

123 Gombrich's concerns about the physiognomic theory of style are long-standing. He first wrote about it in the 1937 volume of *Kritische Berichte zur Kunstgeschichtlichen Literatur;* twenty years later he gave it an important reiteration in his inaugural lecture as Durning-Lawrence Professor at University College, London. See C. Ginzburg, 1998, 45–48.

124 Quartremère de Quincy, 1788–1825, 3:411: "Style . . . devient synonyme de caractère, ou de la manière propre de la physionomie distinctive qui appartient à chaque ouvrage, à chaque auteur, à chaque genre, à chaque école, à chaque pays, à chaque siècle." The idea can be traced back to Dionysius of Halicarnassus (*De compositione verborum*, xxi), who wrote that styles cannot be reduced to classes because they are as individual as our "physiognomies"; however, unlike Quartremère de Quincy, Dionysius seems not to have applied his insight to stylistic analyses of oratory and writing.

125 Caroli, 1995; Bolzoni, 1995, 164–79. For the semiotics of physiognomics, see Eco, 1993.

126 Ingegneri, 1607; published in G. B. Della Porta, 1644, 349–50. For a consideration of physiognomics in antiquity, see Evans, 1969. Aristotle's (actually pseudo-Aristotle's) physiognomics was translated and edited by Baldi, 1621. Polemon's physiognomics was translated into Latin by Carlo Montecuccoli, and thence into Italian by his son Francesco and published in Della Porta, 1644, 399–422. For medieval physiognomics, see Getrevi, 1991. For discussions of Della Porta's physiognomics in a Renaissance context, see Scapini, 1970; Torrini, ed., 1990; and Bolzoni, 1995, 164–74. The literature on physiognomics is a vast resource rarely explored systematically by art historians, but see Caroli, 1995. For a rejection of the premises and practices of physiognomy, see Bartoli, 1646, pt. II, cap. i.

127 Ingegneri, 1607, 350; Ghiradelli, 1630, n.p. (Introduction). Ghiradelli's treatise is particularly interesting for art historians because he includes nearly one hundred engravings of heads, each illustrating a different physiognomic aspect discussed in the text.

128 Ingegneri, 1607, 350.

129 Baldi, 1622. For a discussion of Baldi, see the preface by Armando Petrucci to his edition of Baldi's *Lettera* (Pordenone, 1992); and for a discussion of Baldi in relation to Giulio Mancini, see Sohm, 1991, 76–77. Writers before Baldi had the insight that the style of writing reflects the character of the writer, but none set about applying it to handwriting; see, for example, Vettori, 1594, 201: "qui illam [epistolam] legit eodem tempore quasi apertum aspiciat pectus illius qui scripsit, et intimos suos sensus omnes notos habeat."

130 Baldi, 1622, cap. xii, 44–46: "Siccome non c'è cosa che più dimostri e nella quale più rilucano le qualità dello scrittore ed i suoi costumi, quanto fà lo stile, così altra [cosa] non è tanto difficile da conoscersi, quanto esso [stile] e particolarmente, la sua difficoltà consiste nel saper assegnare le cause della diversità tra questo e quello, nè mi pare, che esempio alcuno più dimostri l'essere suo di quello della faccia umana. Hanno, per esempio, tutte le belle giovani donne la faccia bella, ma molta differenza è fra l'uno e l'altro volto e quantunque si conosca che vi è differenza, però non così facilmente si sa dire quale sia questa differenza. . . . E' chiaro dunque come lo stile è atto a mostrare molte cose dello scrittore come fà il volto. Nelle sue differenze sono difficili e, per conoscere come nascano queste varietà degli stili, si può avvertire che non solo diverse lettere cagionano diverse sillabe, ma similmente le varia il variare la sede delle medesime. . . . Se lo stile dunque sarà uguale, grave e chiaro, si può concludere che lo scrittore sia persona ragionevole, giudiziosa, letterata, di buona creanza, piena d'affetto, verdica, e, probabilmente, si potrà ancor dire piuttosto parca, che liberale, considerata, onorata e modesta, ed è credibile che non sia giovane, nè donna, ma uomo quieto, grave e severo."

131 Bonifacio, 1616, 516. He lays out his thesis in the full title of his work: *L'Arte de' cenni con la quale formandosi favella visibile, si tratta della muta eloquenza, che non e' altro che un facondo*

silentio. *Divisa in due parti. Nella prima si tratta de i cenni, che da noi con le membra del nostro corpo sono fatti, scoprendo la loro significatione, e quella con l'autorità di famosi Autori confirmando. Nella seconda si dimostra come di questa cognitione tutte l'arti liberali, e mecaniche si prevagliano.* For discussions of Bonifacio's treatise, see Costanzo, 1983, 47–54; Casella, 1993, 331–407. For an interesting and rare application of Bonifacio to the interpretion of paintings, see Spear, 1997, 176–78.

132 Bonifacio, 1616, n.p. [preface, ii]: "E chi haverà di quest'arte perfetta cognitione – leggiamo – non haverà bisogno di desiderare nel petto degli huomini quella *fenestra Socratica per veder loro il cuore;* poiché con l'intelligenza di questi cenni i piú secreti pensieri et i piú celati affetti de gli animi de' mortali si manifestano." For the truthfulness of gesture unlocking hidden secrets, see also Quintilian, 11.3. 66; Savonarola, 1498, 30; Leonardo, 1890, 43: "Voi, speculatori, non vi fidate delli autori che hanno sol co' l'imaginazione voluto farsi interpreti fra la natura e l'omo, ma sol di quelli che, non coi cenni della natura, ma co' gli effetti delle sue esperienze hanno esercitati." And Tesauro (1654, 24), quoted by Casella (1993, 335): "E chi haverà di quest'arte perfetta cognitione non haverà bisogno di desiderare nel petto degli huomini quella fenestra Socratica per veder loro il cuore; poiché con l'intelligenza di questi cenni i più secreti pensieri et i più celati affetti de gli animi de' mortali si manifestano."

133 Aristotle, *Rhetoric* 3.6.

134 Bonifacio, 1616, 581–83. As proof of the courtier's ability to dissimulate, see Cardano (1643, cap. v) who claimed to "simulate" feelings frequently, although he disclaimed this as "dissimulation," because they are feelings he had experienced sometime in the past: "Mi sono abituato a dare sempre al mio volto una espressione che non corrisponde al mio sentimento: però posso simulare, non dissimulare; il che però mi riesce facile quando si tratta di dissimulare disperazione perché a questo ho dedicato i miei sforzi interrottamente per quindici anni e ci sono riuscito. Così a volte vado in giro malvestito, a volte tutto elegante; sono ora taciturno, ora loquace, ora lieto, ora triste perché, come ho detto, posso assumere tanto un atteggiamento, quanto quello opposto." See also Accetto,

1984. For the artistic contexts of mimetic and gender dissimulation, see Jacobs, 2000. For a broader consideration of aulic dissimulation, see Villari, 1987, and Zagorin, 1990.

135 Bonifacio, 1616, 7–8. He quoted in evidence Cicero, *Epistolae* 1.9.

136 Cicero, *De oratore*, 3.7.26.

137 De' Domenici, 1742, 3:631: "Che la diversità della bellezza de' quadri viene dal buon partito, che si dice uscita, a cui si appiglia il Pittore, non già dall'arte, la quale è sempre la medesima: e questo avviene secondo si sta d'umore." For a discussion of individual style in the cinquecento, see M. Kemp, 1987.

138 Castiglione, 1528, lib. I, cap. xxxvii, 77–78; Mascardi, 1636, 268 and 287; for Malvezzi's *Discorsi sopra Cornelio Tacito* (1622), see Raimondi, 1961, 206.

139 Lomazzo, 1590, 1:277. For Lomazzo's use of Horace and Vitruvius in relation to *ars* and *ingenium*, see 1590, 1:272. For a related statement giving priority to *ingenium*, see Armenini, 1587, 75; and on Armenini, see Williams, 1995, 518–36; and Williams, 1997, 84–99. Sauerländer (1983, 255–56) argues, without much evidence, that in art writing the normative, rhetorical sense of style "predominated up to the middle of the eighteenth century."

140 Kemp, 1976.

141 Summers, 1989, 15–32.

142 Dempsey, 1977, 63–67; Feigenbaum, 1990, 145–65; and Feigenbaum, 1993, 59–76.

143 Scannelli, 1657.

144 Malvasia, 1678, 2:22; trans. Enggass, 1980, 68: "Solo dolevasi che tutto si attribuise ad una virtù infusa, ad un dono particolare del cielo."

145 Malvasia, 1678, 2:22: "Che carattere proprio? diceva egli – Che virtù infusa? Con incessante studio, e con ostinata fatica si acquitano questi doni, non si trovano già a sorte, né si ereditano dormendo. Che carattere? Saria mai altro egli che un abito fattosi a forza di replicate osservazioni sulla scelta del più buono e del più bello?"

146 Spear, 1997, 15 and 20–22.

147 Vasari, 1568, 3:137–38: "Comunche sia, tornando a Stefano, se gli può attribuire che dopo Giotto ponesse la pittura in grandissimo miglioramento, perché, oltre all'essere stato più vario nell'invenzioni, fu ancora più unito nei colori e più sfumato che tutti gl'altri, e

sopra tutto non ebbe paragone in essere diligente."

148 J. J. Winckelmann, *Beschribung der vorzüglichsten Gemälde der Dresdner Gallerie*, undated but c. 1748–50; quoted in Heres, 1989, 61.

149 Barolsky (1990 and 1991) exhaustively explores Vasari's narratives (fictional in Barolsky's view, and hence more revealing) as forms of art criticism. Narrative and biography became standard forms of stylistic criticism in the seventeenth century, but have not yet been as thoroughly studied.

150 Philosophers accept signature theories more often than do literary theorists: Goodman, 1978, 799–811; Danto, 1981, all of last chapter, with useful comments on Goodman; Robinson, 1984, 227–47; Wollheim (1987a and 1987b) and Altieri (1989, 59–84; and 1995, 201–19) present more moderate views. Among literary critics signature theories are accepted less frequently, especially in recent years; but see Spitzer (1962, 19–22) who moved away from a psychological approach in his later work; and Ullmann, 1964, 121–25.

151 Goodman, 1975, 808. Goodman in *Ways of Worldmaking* (1978, 34), summarizes his style as signature theory in this way: "A property – whether of statement made, structure displayed, or feeling conveyed – counts as stylistic only when it associates a work with one rather than another artist, period, region, school, etc. A style is a complex characteristic that serves somewhat as an individual or group signature." For a friendly discussion and modification of Goodman's signature theory, see Altieri, 1987, 178–91.

152 Franck (1995, 220–41) gives a compelling interpretation of style as body.

153 Wölfflin, 1950, 1.

154 Wollheim, 1995, 40–49. In addition to separating individual and general style, Wollheim finds three constitutive parts of "style-process." The first two fall within *ars*: (1) schema or universal are "available to, or even availed of by, all artists"; and (2) rule or instruction control the application of process of any given schemata. The third part – acquired disposition – is a form of *ingenium*: it is "not just psychological but psychophysical." For further discussion, see the Introduction.

155 Ackerman, 1963, 164–86.

156 Reynolds, 1992, 96 (in Discourse II).

157 Schapiro, 1953, 287 and 291. Schapiro's structuralism may be more closely related to Peirce than Saussure, judging from his language and citation of models in Schapiro, 1969, 223–42.

158 Kemp, 1991, 139.

159 For the influence of structuralism on art history, see Nodelman, 1970, 79–93; Dittmann, 1967; and Bal and Bryson, 1991, 174–95. When Argan (1980, 15–24) says that "Panofsky, not Wölfflin, was the Saussure of art history," he assumes that most art historians believe the contrary. For similarities between Riegl and Saussure, see Iversen, 1979, 62–71; and Iversen, 1993, 55–56. For Panofsky and Saussure, see Holly, 1984, 43–45. Preziosi (1989, 87–90, 111–21, 148–52) discusses the influence of structuralism in art history and presents reasons why "the student of theories of signification in art history should not begin with Saussure" but with Hippolyte Taine instead. Ackerman's reading of style as "structure" and its epistemology located in the needs, goals, and activities of individual artists strongly resembles Hauser, 1958; also published in translation in New York in the same year (1984, 207–29). Hauser defines style as "the result of many conscious and purposive achievements" by individual artists. The explanatory value given to "boredom" to explain changes in style appears to derive from Hauser's "fatigue." Ackerman does not cite his sources, so this cannot be confirmed. Gombrich's psychology of representation as "a linguistics of the visual image" (1961, 9) may also derive from structuralism; see Bryson, 1983; Preziosi, 1989, 117–19.

160 Schapiro, 1953, 292.

161 Ibid., 287.

162 Wohl, 1999, 10. Wohl suggests (41) that "the problem of style" can be best resolved for Renaissance art "in concrete, formal terms, as Offner, Pope and Wölfflin did." (He dedicated his book to Offner.) Wohl also proposed (16) "to examine the role of style as a system of formal relations mediated between what the artist 'has imagined,' especially as this was informed and inspired by literary descriptions and ekphrases in classical and vernacular texts, and the representation of that image in the language of art." Although he attends carefully to the language of stylistic description in quattrocento Italy, with particular attention

given to *ornato* and *rilievo*, "language" for him is most often either a metaphor of visual structure or the basis of content that inspires the artist.

163 Barthes, 1970. Barthes (1971, 3–15) revisits his ideas and finds them largely acceptable.

164 Barthes, 1970, 10. He separates style from *écriture*, which is a mode of writing that an author consciously adopts as a personalized set of conventions.

165 Armenini, 1587, 81–82.

166 Riffaterre, 1959, 171. Fish (1976, 465–85) reevaluates this article in order to show that "we might as well abandon the word [stylistic fact] since it carries with it so many binary hostages (style *and* –)." See also Spitzer, 1962; Guiraud, 1954; Riffaterre, 1960, 207–18; Enkvist, 1964; Levin, 1965, 225–37; Wellek, 1969; and Todorov, 1971, 29–41.

167 Conte, 1986, 81–82.

168 Mascardi, 1636, 270. For further discussion, see Chapter 5.

169 Barthes, 1971 (presented as a lecture at the Villa Bellagio in 1969).

170 Ohmann, 1969, 137. For a rebuttal of this position and a forceful argument against synonymy, see Hirsch, 1975, 559–69.

171 Ellis, 1974, 168–69 (but see his chapter 6 in general). If style is content, then style represents a false theory based on an outmoded "dualistic model" of language.

172 Goodman, 1972, 231–38. For rebuttals, see Hirsch, 1975, 559–79; and Altieri, 1987, 177–91.

173 Sauerländer (1983, 253–70) gives the most complete etymological reading of the historical semantics of style. However, he overlooks some interesting sources, including John Flaxman's lecture "On Style": "But, in the process of time, as the poet wrote with his style or pen, and the designer sketched with his style or pencil, the name of the instrument was familiarly used to express the genius and the productions of the writer and the artist." For Flaxman on style, see Irwin, 1979, 204–15. At about the same time Quartremère de Quincy (1788–1825, 3:410) problematized style as metonymy; in order to introduce his discussion of style (3:411), he brought in handwriting, which he identified as a metonymic process wherein a mechanical activity is identified with and stands in place of a mental activity, i.e., "the art of expressing one's ideas in the signs of writing": "On appliqua par métonymie à l'opération de l'esprit, dans l'art d'exprimer ses pensées avec les signes de l'écriture, l'idée de l'opération mécanique de la main, ou de l'instrument qui trace ces signes."

174 For etymology in the Renaissance, see Rothstein, 1990, 332–47.

175 Taylor, 1942, 200. For origins, see Quint, 1983.

176 See Chapter 6; and Sohm, 1999.

177 Lucian, 1968, 360–61.

178 Vasari, 1568, 1:111: "[Si] può conchiudere che esso disegno altro non sia che una apparente espressione e dichiarazione del concetto che si ha nell'animo, e di quello che altri si è nella mente imaginato e fabricato nell'idea. E da questo per avventura nacque il proverbio de' Greci: *dell'ugna un leone*, quando quel valente uomo, vedendo sculpita in un masso l'ugna sola d'un leone, comprese con l'intelletto da quella misura e forma le parti di tutto l'animale e dopo il tutto insieme, come se l'avesse avuto presente e dinanzi agl'occhi." For a discussion of the aphorism in relation to Vasari, see Williams, 1997, 42. Williams limits his discussion to the time of Vasari, so it might be useful to note how the aphorism was applied early in the seventeenth century to the emergent science of graphology by Camillo Baldi (1622, 3), who uses it to establish a sign system where "from a single letter an astute reader can know the thoughts, habits and character of its writer."

179 G. B. Marino, *Lettere e dedicatorie*, 60–61 (letter of 1 November 1608): "Il dipintore, prima che con terminati profili le sue figure colorisca, in rozzo dissegno o con carbone o con gesso oscuramente l'abbozza. Ed il poeta, avendo intenzione di tessere assai più lunga tela de' fatti del serenissimo don Carlo Emanuello, prima che in più diffuso trattato si distenda, ha voluto quasi per un cenno fabricarne questo picciolo poemetto. Ma non altrimenti che da un tratto di linea fu conosciuta l'eccellenza del pennello e dal solo piede fu argomentata la proporzione di tutta la statua, da queste stanze, benché poche, si potrà giudicare s'egli nel poema eroico sia atto a sostenere infra i due estremi quella mezzanità temperata. . . ." See also Bartoli, 1646; edition in Raimondi, ed., 1960, 338. Mascardi (1636, 287) wrote that experts can attribute a paint-

180 Bellori, 1695, 12: "Riescono veramente queste due figure nel maggiore stile di contorni, di disegno, e di colore, sublimando egli ad ogni tratto, e ad ogni linea il suo pennello, ed essendo maraviglia come dalla gloria di sopra quì sotto si fosse Rafaëlle tanto ingrandito, ed avanzato in sì breve spazio, sopra ciò appresso faremo riflessione."

181 Stigliani, 1664, 55–57 (letter of 17 March 1641).

182 *Adolf Loos: Das Werk des Architekten*, ed. H. Kulka (Vienna, 1931), 25; quoted by Gombrich, 1968, 358.

183 For a review of metaphor in rhetoric, see Vickers, 1988, 320–22. Metaphor and metonymy have been made famous by Roman Jakobson and (thence) semiologists; for a review, see Silverman, 1983.

184 The work of Carl Hausman (1989; and 1991, 101–28) is particularly important for this question.

185 Aristotle, *Rhetoric* 1410b33. For the following quotes see 1412a17ff. For Quintilian, metaphor moves the listener and presents events "vividly before the eye" (8.6.19;9.2.40).

186 Tesauro, in Raimondi, ed., 1960, 75: "Ma qual faconda diceria di voci propie [*sic*] potrebbe esprimere gli inesprimibili concetti, farci sentir le cose insensibili e veder le invisibili, quanto la metafora? Come se tu dicessi: 'Colui ha costumi *dolci*. Costui ha uno spirito *bollente*. Quegli ha un ingegno *duro*, anima *nera*, pensieri *turbidi, precipitose* deliberazioni.' Va ora tu, e spiega questi concetti con più significanti parole proprie." In Torquato Tasso's retelling of Aristotle, metaphor is the orator's means "to make us see the things he describes" and "to make us . . . see the invisible" (Tasso, 1982, 36–37; this passage is discussed by Snyder, 1989, 169–78). The picturing function of metaphor is an important topic for modern theories: Harries, 1978, 71–88; Ricoeur, 1978, 141–57; and Ricoeur, 1981, 173–215. Ankersmit (1995, 141–56) argues for "the essentially metaphorical character of historical representation," because history is absent and metaphors are a strategy of dealing with absence.

187 G. G. Bottari, letter to L. Crespi, 2 October 1756; in Bottari and Ticozzi, eds., 1822, 3: 471–72: "Ella, oltra la naturalezza, ha nel suo stile un'espressiva, che fa vedere con gli occhi le cose che ella racconta essere avvenute."

188 Castellamonte, 1674, n.p. (preface): "Come pure per far vedere di Luogo in Luogo li più curiosi disegni di quelli Edifici, m'habbi necessitato à valermi del metodo di discorrere in dialogo, dal quale è poi venuta la relatione più essatta, più verdica, e più puntuale." He found this to be most like "lo stile Istorico, e Famigliare, che d'altro più elevato dalle figure del bel dire per introdurmi a descrivere non solo gli Edifici, le Architetture, e le Delizie, mà a scrivere anco delle Caccie, e di tutte le altre contingenze della Venaria Reale."

189 Aristotle, *Poetics* 21 (1457b6–7).

190 Beardsley, 1962, 293–307.

191 Mascardi, 1630, 109 (in "Per l'Esequie del Signor D. Virginio Cesarini"): "La metafora è figliuola della necessità, ma poscia adottata dal diletto; ritien, però sempre l'occhio fisso alla madre, e di consentimento di lei accarezza il diletto. Non è da dimenticarsi la favella comune, per contrar l'habito nel parlar metaforico. Gran piacer si ritrahe della pittura d'una bella campagna, d'un saval generoso, od'un volto leggiadro; ma finalmente gusto maggior si prova, dal godimento di queste cose, quando sono naturali e non finte. La metafora è somiglianza dell'idioma natio, e benché come straniera, sù la prima vista rechi piacere, quando però volesse scacciare il parlar cittadino, sarebbe senza dubbio arrogante. Basti al Poeta valersene per ornamento, non per vestito: per condimento, non per cibo: per delitia, non per necessaria sostanza. In somma le metafore, e le altre figure di parole, fanno l'effetto del sale nelle scritture: adoprate con la regola della mediocrità, dan sapore; versate con man prodiga offendono."

192 Aristotle, *Rhetoric*, 3.2.9–3.4; Aristotle, *Poetics* 22.9; Demetrius, 67 and 78–80; *Ad Herennium* 4.15.22; Cicero, *De oratore* 3.158–69; Quintilian 8.6. 14; 9.2. 73; and 9.4.27.

193 For a discussion of metaphor as "untranslatable information," see Ricoeur, 1978; for Tesauro, see above, n. 186.

194 Mooney, 1984, 78–79. He cites Vico's *Institutiones oratoriae* and compares it to Aristotle's *On Sophistical Refutations* (165a11–12) and Cicero's *De oratore* (3.38.155). Black (1954–55, 273–94) argued most famously for the cognitive status of metaphor; for a review of the question, see Cohen, 1978, 1–10.

Chapter 3. Defining Definition

1 Discussions on definition that I found useful include Kessler, 1976; Bolinger, 1985, 69–73; Watson and Olson, 1987, 329–53; Benardete, 1993, 265–82.

2 Aristotle, *Posterior Analytics* 2.3 (91b4–6) and × (93b29–32).

3 Boselli, 1978, Lib. I, cap. xii, 98v–99r; Boselli, 1994, 89: "Si dice *maniera* il modo de l'operare più ad imitazione di una cosa fatta che di una altra. In far questa si può errare o per Genio o per educatione: per Genio piacendo più una cosa men bella che la più bella, il Color nero e non bianco, più l'Agresta, che l'uva; il che può procedere da cattiva complessione o da un composto di humori torbidi e corrotti. Per educatione studiando cose di cattivi Maestri, apprendendo precetti falsi da principio, dalli quali si forma un Habito che una volta vestito è difficile a mutarsi." Volpato, n.d., fol. 66; partially published in Bordignon Favero, 1994, 407–8: "La maniera in qual modo si apprende e che cosa è questa maniera? Il Pittor dopo fatta l'esperienza soprascrita e fatto longo studio sopra il colorito delle cose naturali et artificiali all'hora è necessario, che secondo la propria inclinatione si stabilisca una maniera di colorire da per se, e tale è considerato quel colorito come parte del Pittore, che può anco dirsi una maniera che ha il Pittore d'esprimere cose sue e detta maniera è il perfetto dell'espressione del opera, et è quella, che dando l'ultimo essere apparente e prima goduta dal occhio, e poi dal intelletto considerata e appresso l'altre perfetioni quest'è l'ultimo condimento, che sodisfa il senso comune così de dotti come degli ignoranti. . . ." Bordignon Favero does not include the opening question in her transcription. The definitions by Vasari, Poussin, Boschini and Baldinucci will be quoted and discussed in the following four chapters.

4 Aristotle, *Posterior Analytics* 2.13 (97b8–14).

5 Ibid., 13 (97b28–40): "It is easier to define the particular [i.e., species vs. genus; the individual cannot be defined] than the universal; and therefore we should proceed from particulars to universals. Ambiguities, too, are harder to detect in universals than in *infimae species*. Just as demonstration demands a completed inference, so definition demands clarity; and this will be achieved if we can, by means of the common features which we have established, define our concept separately in each class of objects (e.g., define similarity not in general but in respect of colours or shapes, and define sharpness in respect of sound), and so advance to the general definition, taking care not to become involved in equivocation. If we are to avoid defining in metaphors and defining metaphorical terms; otherwise we are bound to argue in metaphors."

6 Baldinucci, 1681, 88: "Modo, guisa, forma d'operare de' Pittori, Scultori, o Architetti." This opening of his definition takes three synonyms intact and in sequence from the Crusca *Vocabolario*, 1612 ("Modo, guisa, forma") and fuses it with a variation on the third Crusca meaning ("Per una certa qualità, modo di procedere").

7 Missirini, 1823, 112. *Disegno* was the second of four topics discussed: "Similmente cogli insegnamenti del medesimo Zuccari, dell'Accademia secondo Institutore, si raccomandò alli Giovani il disegno, con quel Maestro sottilizando sull'Argomento, ed escludendo le definizioni del Vasari, e dell'Armellino si confermò la conclusione, che il Disegno non sia che l'ordine della nostra mente recato nelle opere, e che perciò alto mirassero quelli, che filosofando dissero l'uomo essere da Dio formato a sua similitudine ed immagine: Imperciocchè siccome Dio è puro spirito, ed ha l'intelligenza perfetta di tutte le cose, e si forma un vivo universale e maraviglioso disegno, o verbo, o concetto nel quale rilucono tutte le cose fatte, e fattibili, così l'anima ha virtù di formare in se stessa un vivo disegno di tutte le cose apprese: ed il disegno esterno è poi l'effetto, il prodotto di quell'interno dell'Anima." Compare this to Zuccaro, 1607, 52–53. Williams (1997, 29–72) has given us the most thorough and subtle reading of Vasari's *disegno* as Platonic idea and Aristotelian universal judgment. See also Summers, 1981, 250–61; and Barzman, 1992, 37–48.

8 Armenini, 1587, 52–53. See Gorreri's notes for the comparative texts.

9 Lomazzo, 1590, 19–28 (chap. 1: "De la definizione de la pittura"); and Lomazzo, 1584, 30–31. Lomazzo contradicted conventional beliefs and presented his own as if they were indisputable: for *disegno* as form, see B. Daniello, *Poetica* (Venice, 1536), 41 (cited by Barocchi, ed., 1960, 1:171); Dolce, 1557, 171; Vasari, 1568,

1, 111; for Testa, see Cropper, 1984, 226–27. For Domenichino's letter to Francesco Angeloni, see Bellori, 1672, 371–72: "Non so se sia il Lomazzo che scriva che il disegno è la materia ed il colore la forma della pittura; a me pare tutto il contrario, mentre il disegno dà l'essere, e non vi è niente che abbia forma fuori de' suoi termini precisi; né intendo del disegno in quanto è semplice termine e misura della quantità; ed in fine il colore senza il disegno non ha sussistenza alcuna. Mi pare ancora che dica il Lomazzo che un uomo disegnato al naturale non sarebbe conosciuto per il solo disegno, ma bensí con l'aggiunta del colore simile, e questo è ancor falso." For a discussion of this letter and Domenichino's views, see Spear, 1982, 29–30. For Maratta's critique of Lomazzo, see Bellori (1672, 632), who identified Lomazzo simply as "un altro."

10 Lewis, 1990, 18.

11 Buffon, 1967 (lecture given 1753), 21–34. Milic, 1971, 77–88.

12 For seicento debates about the Crusca dictionary regarding "good usage," see Vitali, 1966, 124–53.

13 Tesauro, 1654, 636: "Indi adunatele, ne hò fabricata la DIFFINITIONE della Perfettissima Impresa; la qual ti pongo davanti agli occhi, come Policléto la sua Statua, in cui ricolse tutte le Perfettioni di un Corpo Ideale."

14 I will return to the idea of blind spots later in various contexts. I have been helped in this matter by reading Lang, 1995, 18–36; and, in the same fascinating volume, the essays by Davey, 1995, 177–200; and Franck, 1995, 201–41.

CHAPTER 4. GIORGIO VASARI: AESTHETICIZING AND HISTORICIZING STYLE

1 Vasari, 1568, 1:29 (in "Proemio di tutta l'opera"): "Perché, oltra che nella Introduzzione rivedranno i modi dello operare e nelle Vite di essi artefici impareranno dove siano l'opere loro et a conoscere agevolmente la perfezzione o imperfezzione di quelle e discernere tra maniera e maniera." I am assuming, as others have, that the prefaces were indeed written by Vasari, pace Hope (1995).

2 Vasari, 1568, 3:4 ("Proemio della seconda parte"): "E mi sono ingegnato non solo di dire quel che hanno fatto, ma di scegliere ancora discorrendo il meglio dal buono e l'ottimo dal migliore, e notare un poco diligentemente i modi, le arie, le maniere, i tratti e le fantasie de' pittori e degli scultori; investigando, quanto più diligentemente ho saputo, di far conoscere a quegli che questo per se stessi non sanno fare, le cause e le radici delle maniere e del miglioramento e peggioramento delle arti accaduto in diversi tempi et in diverse persone." The most broad-ranging discussion of Vasari is a brilliant book by Rubin, 1995; the relative weakness of her discussion of theory (relative to the tremendous strengths of her work in every other way) is corrected by Williams, 1997, 29–72.

3 For further discussion of this list, see my "Introduction." For two fundamental studies of the concept of individual style in the fifteenth and sixteenth centuries, see Warnke, 1982, 54ff.; and M. Kemp, 1987, 1–26.

4 Vasari, 1568, 4:4–5. In the following two paragraphs Vasari praised trecento art for its "good qualities" (qualcosa di buono), quattrocento art for having "a better style" (con miglior maniera), and cinquecento art as having "achieved everything possible."

5 Vasari, 1568, 3:13 ("Proemio della seconda parte").

6 Blunt, 1973 (but first published in 1940), 154.

7 This is especially true of the studies by Pinelli, 1981, and Mirollo, 1984, 29–71.

8 Smyth, 1962, 1.

9 Shearman, 1963, 2:202; see also Shearman, 1967, 16.

10 Stumpel, 1988, 247. For an earlier, more subtle critique of Shearman from a related viewpoint, see Zerner, 1972, 105–21.

11 These figures refer only to the 1568 edition. For the frequency of usage, see Barocchi, ed., 1994.

12 Vasari (1568, 1:29) introduced his Introduzzione to the techniques of painting, sculpture, and architecture with the phrase i modi dello operare. The Crusca Vocabolario (1612) gives as its first definition of maniera, un modo d'operare.

13 Miedema, 1978–79, 19–45; Stumpel, 1988, 247–64. Campbell (1996, 267–95) has published a fascinating study on Cosmè Tura's virtuostic display of line that, although it concerns quattrocento art, promises a route to reconciling Shearman's and Miedema's theories of style and Mannerism.

14 Summers, 1981, 56–59 and 103–43 (for aria

and *fantasia*); and Summers, 1989, 15–32; Kemp, 1976, 311–23; Kemp, 1977, 347–98; Kemp, 1987, 1–26. For further discussion of *aria*, see the Introduction.

15 Smyth, 1962, 4–6; Miedema, 1978–79, 32.

16 Leonardo, 1956, 384; Leonardo, 1977, 1:287.

17 In a fascinating analysis of Raphael's use of rhetoric in composition, Rubin (1994, 174–75) discusses how Raphael used repetition in terms of *amplificatio* in *Leo III Swearing an Oath before Charlemagne*.

18 For the full quotation and further discussion of the Mino preface, see the section below on "Style and Imitation."

19 Vasari, 1568, 1:82: "La scultura è una arte che levando il superfluo dalla materia suggetta, la riduce a quella forma di corpo che nella idea dello artefice è disegnata." Michelangelo: "Non ha l'ottimo artista alcun concetto, / C'un marmo solo in sé non circonscriva / Col suo superchio e solo a quello arriva / La man che ubbidisce all'intelletto. . . ." See Mendelsohn, 1980, 91–92; Summers, 1981, 203–33. For related examples of reduction without Platonic overtones necessarily, see Leonardo (1959, 254, n. 508), who wrote that an artist who looks at stains on walls or in stones will see "infinite cose, le quali potrai ridurre in integra e bona forma." Benvenuto Cellini (1958, 573) expressed the ambition to "reduce" a lifetime's oeuvre into a single "pure piece." This usage of *ridurre* was not limited to art literature. Vasari's friend P. F. Giambullari (1551, 135) used the expression "reduce all things to a single circle" to indicate philosophers' quest for being or essence (*ente*). Girolamo Ruscelli (1581, 543) noted that the Italian (i.e., Tuscan) language "reduced to a single form" the various Italian dialects.

20 Style was identified by Vasari as the product of "reducing" (Milanesi, 4:198): Fra Bartolomeo "reduced to style" an altarpiece for Piero Soderini. "To reduce" also meant "to finish," "to bring to perfection," or "to give order:" Cennini, 1971, cap. 1, 4–5: "Il quale Giotto rimutò l'arte del dipingere di greco in latino e ridusse al moderno; ed ebbe l'arte più compiuta che avessi mai più nessuno." Albertini, 1510, n.p.: Lorenzo de' Medici wanted to "riducerla [the facade of Santa Maria de' Fiore] a perfectione," which seemed a reasonable wish to Albertini because it was then "senza ordine o misura." Vasari, 1568, 2:4: sculptors and painters, by

adding and removing parts of the modelli "riducono le imperfette bozze a quel fine e perfezzione che vogliono." Vasari, 1568, 3:194–95: "poiché ogni sua [Brunelleschi] cosa con tanto giudizio, discrezione, ingegno et arte aveva ridotta a perfezzione." Vasari (vita Uccello): Uccello "ridusse a perfezzione il modo di tirare le prospettive dalle piante de' casamenti e da' profili degli edifizi." See also Vasari, 1568, 6:406 ("ridurre a miglior forma e più bellezza").

21 Vasari, 1568, 1:110. This recalls in diction and syntax Vincenzo Danti's advice to artists "to extract from the many imperfect parts a perfect composition."

22 Vasari, 1568, 1:22, and 3:268.

23 Vasari, 1568, 3:536–37. For related usages, see Cesare Caporali (1531–1601), in 1916, 2:40: "Nel mezzo un simulacro rutto / di marmo si vedea, già dal vicino / scarpel di Fidia a perfezion ridutto."

24 Vasari, 1568, 1:110.

25 Gelli, in Mancini, 1896, 40–41: "E questo si è perchè lasciando [Giotto] la rozza e poco dotta maniera de' Greci. . . ."

26 Gelli, in Mancini, 1896, 40: "Imperòche allora quando que' maestri di que' tempi volevono dipingere o figure o animali o altro, le facevono con quel modo e con quella maniera ne la quale eglino avevono fatto l'abito senza considerare le naturali. E però, se bene voi avvertite, voi vedrete tutte le fighure di que' tempi essere quasi un modo medeximo o co' piedi appiccati per lo lungo al muro, o le mani aperte e tutte simigliarsi nel busto, anzj aver quasi quel medeximo, la qual cosa è drittamente contra la natura, come più bene osservare ciascheduon. [E] il simile ancora dipoi fecion tutti que' maestri che seguitorno il dipignere di maniera, cioè non cercorno di cavare le cose dal naturale."

27 Vasari, 1568, 3:608: "Aveva Pietro tanto lavorato, e tanto gli abondava sempre da lavorare, che e'metteva in opera bene spesso le medesime cose; ed era talmente la dottrina dell'arte sua ridotta a maniera, ch'e'faceva a tutte le figure un'aria medesima." Vasari (1568, 2:150–51) described the ancient Greek style as "artificiosa" because it had "un'aria medesima." For the associations of style and artifice, see Chapter 6, section "Artificial Style." Gelli's notes quoted above remained in manuscript until the nineteenth century, but Vasari certainly read a

copy and borrowed liberally from it. A published version in 1549, condensed and much altered, can be found in an exegesis by Gelli on two of Petrarch's sonnets (Gelli, 1549, 13–14) where he describes "that style . . . called Greek" as having repeated figures and repeated expressions (*aria*): "[C]onciosia che tutte quelle figure che facevono quegli che seguirono questo modo del fare, o, almanco le piu somigliono, o habbino aria piu tosto di molte altre cose che di huomini." "Modo del fare" can be interpreted as *maniera*, since Gelli identified them as synonyms: "con quel modo e con quella maniera" (where *modo* refers back to *modo di fare*). The Crusca dictionary gives "modo di fare" as the first definition of *maniera*.

28 Vasari, 1568, 3:609–10.

29 First published in Tiraboschi, 1712, 6:116; quoted by Pedretti, 1977, 1:10. As early as 1532, Vasari described Giovio as one of his "protettori": Pagano, 1989, 211–17.

30 The recognizability of the unfamiliar lies behind a strategy of structuralists – Lévi-Strauss in Brazil, Piaget with schoolchildren, Riegl with late antique art or post-Renaissance Italian art – who took the marginalized and unfamiliar in order to achieve a critical distance and nonparticipatory relationship; discussed by Nodelman, 1970, 79–93; and Alpers, 1987, 137–62. For the concept that style succeeds in its self-abnegation, see Adorno, 1984, 191ff.

31 Dolce, 1557, 1:173. See also 1:179: "Ma dico che, essendo l'ufficio del pittore d'imitar la natura, non bisogna che la varietà appaia studiosamente ricercata, ma fatta a caso." And 1:181: "Et una sola figura che convenevolmente scorti basta a dimostrare che'l pittor, volendo, le saprebbe fare iscortar tutte." For a biography of Dolce with up-to-date bibliography, see Terpening, 1997. For a discussion of Dolce's literary and artistic conventions of beauty, see Cropper, 1995, 174–90. For other discussions of repetition, see also Pino, 1548, 1:115. Malvasia (1678, 2:177) and Roger de Piles applied the saying to Francesco Albani: "having admired one work by Albani, one would be able to say one had seen them all." For a discussion of what they had in mind regarding Albani's production of easily manufactured and hence profitable cabinet paintings, see Spear, 1997, 225–52; Puglisi, 1999, 62.

32 Dolce, 1557, 1:196: ". . . in tutte le sue [Raphael] opere egli usò una varietà tanto mirabile,

che non è figura, che ne d'aria ne di movimento si somigli, tal che in cio non appare ombra di quello, che da Pittori hoggi in mala parte è chiamata maniera, cioè cattiva pratica; ove si veggono forme e volti quasi sempre simili."

33 The following discussion is based on Dolce, 1557, 1:145–47; the translations are based on Roskill, 1968, 85–89.

34 Vincenzo Danti, in Egnazio Danti, *Le scienze matematiche ridotte in tavole* (Bologna, 1577), tav. xxxxiiii; reprinted in M. Daly Davis, 1982, 65. This is the outline for the fourteen planned books to follow *Il primo libro del trattato delle perfette proporzioni di tutte le cose che imitare e ritrarre si possano con l'arte del disegno* (Florence, 1567). "Laonde si vede che Titiano ha dipinto alle molte figure di femine bellissime, & alle volte non cosi belle, secondo, che ha favti corpi belli da ritrarre, come quello, che procedeva solo per la via del ritrarre. Et il Buonaruoti, l'ha dipinte sempre, & sculpite tutte belle à un modo, perche procedeva per via della imitatione della intentione della Natura."

35 Gilio, 1564, 2:48.

36 Vasari, 1568, 4:7–9: "Fu adunque la regola nella architettura, il modo del misurare delle anticaglie, osservando le piante degli edificj antichi nelle opere moderne. L'ordine fu il dividere l'un genere dall'altro, sì che toccasse ad ogni corpo le membra sue, e non si cambiasse più tra loro il dorico, lo ionico, il corintio ed il toscano: e la misura fu universale sì nella architettura come nella scultura, fare i corpi delle figure retti, dritti, e con le membra organizzati parimente; ed il simile nella pittura. Il disegno fu lo imitare il più bello della natura in tutte le figure così scolpite come dipinte; la qual parte viene dallo aver la mano e l'ingegno, che rapporti tutto quello che vede l'occhio in sul piano, o disegni o in su fogli o tavola o altro piano, giustissimo ed a punto; e così di rilievo nella scultura. La maniera venne poi la più bella dall'avere messo in uso il frequente ritrarre le cose più belle, e da quel più bello o mani o teste o corpi o gambe aggiugnerle insieme, e fare una figura di tutte quelle bellezze che più si poteva, e metterla in uso in ogni opera per tutte le figure; che per questo si dice esser bella maniera. . . ."

37 Williams, 1997, 43. I am in basic agreement with his direction of thinking that "these passages are pointedly paradoxical," but whereas

he passes over this briefly, I have given it more attention. Williams tends to read Vasari's style as a subset of ideas contained by *disegno*; this is true, but it is also true that Vasari found ways to break the unifying order of *disegno* and to locate style outside of it. As a matter of record, I first made this argument in 1995, too late for Williams to take the material into account in his work.

38 See below, notes 44, 47, 50, and 56 re Gelli and Danti; Gilio, 1564, 2:3 ("regola, modo, ordine, maniera"). Raphael used *maniera* to describe the classical orders, which he called *ordine* for the first time. They seem to be interchangeable for Raphael, but Onians (1988, 248) argues for an overlapping but differently inflected meanings. For an earlier cluster, used by Angelo Galli, secretary to Federigo da Montefeltro, to describe Pisanello's paintings ("Arte, mesura, aere ed desegne / Manera, prospectiva et naturale"), see Baxandall, 1971, 11–13. Baxandall locates the coherence of *mesura, aere,* and *manera* in dance treatises.

39 Armenini, 1587, 57–60 (chap. 5: "Dell'origine della pittura e della distinzione di essa in parti, con una breve diffinizione di ciascheduna"). The parts were identified as *dissegno, lumi, ombre, colorito,* and *componimento.* In addition to the divisions cited below, see Giulio Camillo Delminio (*Della imitazione,* c. 1530; published in Weinberg, ed., 1970, 1:179–81), where painting is divided into seven "gradi": (1) composition with particular reference to the site; (2) differences of figures by gender; (3) differences by age; (4) difference by station in life; (5) anatomy, color, chiaroscuro, drapery; (6) proportion, pose, and movement of figures; (7) judgment with regard to decorum.

40 Leonardo, in Barocchi, ed., 1971, 1:734–35 for the five *parti* ("superfizie, figura, colore, ombra e lume, propinquità e remozione") and the ten *ofizi* or *discorsi* ("tenebre, luce, corpo e colore, figura e sito, remozione, propinquità, moto, e quiete"). For a discussion, see Farago, 1992.

41 Leonardo, in Barocchi, ed., 1971, 1:731–32. For the parts as point, line, and plane, see Piero della Francesca, 1942, 65–66.

42 Lomazzo, 1584, vol. 1, cap.1 and 2: proportion, pose of figures, color, light, and perspective.

43 R. Borghini, 1584, 52. Because of the importance that *disegno* took on after Vasari, Borghini

replaced it with three separate categories ("dispositioni, attitudini, membri") that include all but its interior aspects. Barocchi (1971, 1:936) suggests that Borghini's five parts are a combination of Pino and Dolce with Counter-Reformation concerns for poses and expression. The first three of five "principall points" of painting listed by Franciscus Junius (1638, book 3) are invention, design, and color followed by "motion" (which included emotion and character) and "disposition" or composition.

44 Gombrich (1966, 76) was the first, to my knowledge, to indicate (very briefly) that these definitions are "rather carelessly adapted from architectural contexts." His comment has not been examined further, as one can see from Rubin's discussion of the definitions (1994, 236–41) where, regarding their background, she states simply that they are "ultimately Aristotelian." I am indebted to Mary Pardo for urging me to consider Vitruvius as a fruitful line of inquiry. Vasari called the topics *cose,* as did Vitruvius's Renaissance translators. Elsewhere in the *Vite,* Vasari used *ordine, misura,* and *disegno* in various combinations in order to discuss architecture. In his own life, he noted that before his time buildings were made "senza ordine, con mal modo, con triste disegno, con stranissimo invenzioni, con disgraziatissimo grazia, e con peggior ornamento"; see Vasari, 1930, 2:328. In the preface to part two, he wrote: "Perchè nelle colonne non osservarono quella misura e proporzione che richiedeva l'arte, ne distinsero ordine che fusse più Dorico, che Corinthio o Ionico o Toscano, ma e la mescolata con una loro regola senza regola. . . ." For the Renaissance reception of Vitruvius's terms, see Payne, 1999.

45 For *ordine* as classical orders, see Onians, 1988, 247. For Aristotelian *ordine,* see Giambullari, 1551, 146–47: "Perche altro non è l'ordine, che una congrua e convenevole proporzione di alcune cose secondo il prima e il poi. Et ogni ordinazione come nello viii dela Fisica dice Aristotele, é una proporzione." See also Barbaro, 1556, 27–28; Danti, 1567, 215–16; Summers, 1981, 297–98; and Rowland, 1994, 81–104 for further discussion.

46 Barbaro, 1556, 26.

47 First proposed by Sohm, 1995a. For the availability and relevance of Firenzuola for Vasari, see this article. Cropper (1976, 374–90) dis-

cusses the importance of Firenzuola to Renaissance art theory and practice. Barocchi (1960, 1:311) and Blunt (1973, 97) proposed Castiglione's definition of *sprezzatura* as a primary influence on Vasari's preface. However, Vasari could have learned about this higher form of grace and *leggiadria* from other sources, especially Benedetto Varchi (Blunt, 1973, 93, n. 4) and Leone Ebreo (Barocchi, 1971, 1:310, 386–91). Furthermore, Vasari never used the influential neologism of *sprezzatura* itself. Cheney (1998, 187) states without explanation that in these definitions "obviously Vasari is following Marsilio Ficino," referring to his formal properties of beauty (*ordo, modus, species*).

48 Firenzuola, 1548, 753: "La leggiadria non è altro . . . che una osservanza d'una tacita legge, data e promulgata dalla natura e voi donne, nel muovere, portare e adoperare così tutta la persona insieme, come le membra particolari, con grazia, con modestia, con gentilezza, con misura, con garbo, in guisa che nessun movimento, nessuna azione sia senza regola, senza modo, senza misura, o senza disegno."

49 Vasari, 1568, 4:11.

50 Calepino, 1553; *Vocabolario*, 1612; Gelli, 1551, 490: "E la forma è quel modo e quell'ordine col quale son conteste e tessute insieme l'una parola con l'altra, che si chiama ordinariamente la costruzione." "Bartoli's" question that precedes this section is "E con qual ordine? o in che maniera?" On p. 492, "Bartoli" says, "Questo è appunto l'ordine stesso e il modo che il nostro Giambullari tenne in quelle sue regole. . . ." See also Machiavelli, 1961, 68.

51 E. Danti, 1577, tav. 44; publishing an outline of a lost manuscript by his brother that he planned as a sequel to *Il primo libro del trattato delle perfette proporzioni di tutte le cose che imitare e ritrarre si possano con l'arte del disegno* (Florence, 1567; reprinted and discussed by M. Daly Davis, 1982, 65–68). For discussions of *imitare* and *ritrarre* tracing them back to Aristotle's *Poetics* (1451b), see Barocchi, ed., 1960, 1:252; and Summers, 1981, 279–82.

52 Issues of literary imitation are reviewed in McLauglin, 1995. The canonical literary studies remain: Cave, 1979; Pigman, 1980, 1–32; Greene, 1982. For a few important studies of imitation in Renaissance art theory, see Battisti, 1956, 86–104 and 249–62; Gombrich, 1966, 122–28; Quednau, 1984, 349–67; Summers, 1981, 193–95, 279–82, 300–301 449–50;

Shearman, 1992, 227–61; and Rubin, 1994, 239–49; Didi-Hubermann, 1993, 493–502; Freedberg, 1993, 483–92; Gilbert, 1993, 413–22; Wolf, 1993, 437–52; Williams, 1997, 43–45, 75–85, 106–7 and 155–61.

53 Vasari, 1568, 4:405–6.

54 In addition to the explanation provided below, it should also be noted that Vasari's use of *ferma* recalls the Aristotelian definition of art as "a stable and firm habit." The use of *fermare* to identify the process of transforming nature into art can also be found in Cennini (1971, cap. 1, 3–4): "[E] quest'è un'arte che si chiama dipingere, che conviene avere fantasia e operazione di mano, di trovare cose non vedute, cacciandosi sotto ombra di naturali, e fermarle con la mano, dando a dimostrare quello che non è, sia." In Vasari *maniera* is "fixed"; in Cennini it is style's root, *mano*, that does the fixing.

55 Rubin, 1995, 239. Read in context (238–51) it is clear that Rubin finds *disegno* as imitation as the dominant of the five "parts." Her view of style as imitation is most often true in Vasari. My intention is to note how Vasari sometimes wanted style to transcend imitation.

56 Danti (1567, 3:237) stated that up to the present no one had been able to reduce the representation of the human body to "rules, orders, and measures" (*regole, ordini e misure*). Measure can never be perfect in the human body because bodies are always in motion and hence have no inherent proportion. Danti used some of Vasari's terms in the same sequence (*regole, ordini, misure*) when he wanted to indicate what artists in the past were unable to apply in the representation of figures. For a discussion of this passage, however, without reference to Vasari, see Summers, 1981, 380–83; and Rossi, 1980, 127. Danti was not the only writer to adapt Vasari's terms in an altered sequence; see Gilio, 1564, 2:3 ("regola, modo, ordine, maniera").

57 Vasari, 1568, 4:4–5: "Ma sebbene i secondi [artists of the second period, the quattrocento] argomentarono grandemente a queste arti tutte le cose dette di sopra, elle non erano però tanto perfette, che elle finissino di aggiungere all'interno della perfezione, mancandoci ancora nella regola una licenzia che, non essendo di regola, fosse ordinata nella regola, e potesse stare senza fare confusione o guastare l'ordine. . . . Nella misura mancava uno retto giudizio, che senza che le figure fussino misurate, aves-

sero in quelle grandezze ch'elle eran fatte una grazia che eccedesse la misura. Nel disegno non v'erano gli estremi del fine suo, perché, se bene e' facevano un braccio tondo et una gamba diritta, non era ricerca con muscoli con quella facilità graziosa e dolce che apparisce fra 'l vedi e non vedi, come fanno la carne e le cose vive; ma elle erano crude e scorticate, che faceva difficolta agli occhi e durezza nella maniera, alla quale mancava una leggiadria di fare svelte e graziose tutte le figure, e massimamente le femmine et i putti con le membra naturali come agli uomini, ma ricoperte di quelle grassezze e carnosità che non siano goffe come li naturali, ma arteficiate dal disegno e dal giudizio."

58 Aristotle, *Posterior Analytics* 2.13 (97b38–40).

59 Gombrich, 1966, 155; quoted and discussed by Cropper, 1995, 169.

60 Cropper, 1995, 159–205.

61 Kemp, 1987, 2.

62 For a brilliant discussion of license in Renaissance architectural theory, see Payne, 1999, 13–33, 56–60 and 76–80. Rubin (1995, 236) notes correctly that "in Vasari's third era craftsmanlike artistry is superseded by creative artifice" through an "imaginative privilege of license."

63 Payne, 1999, 13–33. For Vasari on license, see 1568, 4:4–5, and 6:54–55.

64 Spear, 1997, 102–27; see also La Molle, 1988, 28–38 and 88–97; Emison, 1991; Rubin, 1995, 270–72; and Jacobs, 2000.

65 For the publication of the letter in its various versions, see Di Teodoro, 1994, 118. For the best discussions, see Rowland, 1994, 81–104, and 1998, 226–38. For Vasari's knowledge of the letter, see 11 (note), 181 and 186.

66 Shearman, 1967, 17–18 and 64. For the tradition from which his Mannerism springs, see Weisbach, 1919, 161–76; Weise, 1952, 181–85; for an expanded and updated version of this important work, see Weise, 1971, 172–81.

67 Lorenzo de' Medici, 1914, 2:301 ("Canzone a ballo" that begins with the lines "io vi vo' donne, insegnare . . ."): "Se tu vai, stai, o siedi / fa d'aver sempre maniera." Quoted by Weise, 1952, 182–83. Baxandall (1971, 11–12) and Woods-Marsden (1987, 134) provide evidence that *maniera* in the quattrocentro signified courtly demeanor and grace.

68 Cropper, 1976, 1986, and 1995.

69 Firenzuola, 1548, 753–54 (quoted and discussed in Sohm, 1995a). Cropper (1976, 379–

80) draws attention to Firenzuola's interest in the elusiveness of beauty. The following two pages are based on my article of 1995.

70 Firenzuola, 1548, 755: ". . . la grazia non sia altro che uno splendor, il quale si ecciti per occulta via da una certa particolare unione di alcuni membri che noi non sappiam dir." Algarotti called grace *indicibile*: 1781, 8:33 (with reference to Tiepolo's *Banquet of Cleopatra*, now in Melbourne, National Gallery): "una franchezza e leggiadria indicibile") and 1791, 8:264 ("indicibile è la grazia della Santina" by Reni); 1756, 130 (with reference to Raphael: "quella indicibile grazia"); and 1763, 10 (with reference to Correggio: "quella indicibile sua grazia"). On *indicibile* grace, see also Gherardi, 1749, 63–64; and B. de' Domenici, 1741 3: 302.

71 Firenzuola, 1548, 755: ". . . questo splendor nasca da uno occulta proporzione e da una misura che non è nè nostri libri, la quale noi non conosciamo, anzi non pure imaginiamo, ed è, come si dice delle cose che noi non sappiamo esprimere, *un non so che*."

72 Lomazzo, 1584, 129: "La vaghezza, ch'altro non è che un desiderio et una brama di cosa che diletta, fa gl'atti ammirativi, stupidi e contemplanti le cose che si veggono, come d'un vano che stia pavoneggiando se stesso con mille balzi, inchini, movimenti e grilli." *Vocabolario*, 1612, 915–16, s.v. *vago*: "Che vagheggia, amante, lo innamorato. Lat. *amasius*.

Add. Che vaga, errante. Lat. *vagus*.

Per bramoso, disideroso, cupido. Lat. *cupidius*.

Per quello, che si compiace, si diletta.

Per grazioso, leggiadro. Lat. *venustus, elegans*." The quote from Firenzuola closes the definition.

73 For surveys of ancient views on women, with useful bibliographies, see Pomeroy, 1975. For Renaissance examples on the instability of woman, see Certaldo, 1945, 105 and 239; Biondo, 1546, 77 ("does not have any stability"); Dolce, 1545, n.p. ("their thoughts are flighty, less steady"; quoted in Jordan, 1990, 69). Capra (1525, 109) and Sigonio (1978, 189–92) argued that woman may be mutable as alleged, but this is not necessarily blameworthy; as evidence for and against, they cited Virgil, *Aenied* 4.569–70 ("Varium et mutabile semper / femina"); Tibullo, *Elegy* 3 ("sed flecti poterit, mens est mutabilis illis"); Califurno,

Eclogue 3 ("mobilior ventis o femina") and Petrarch, *Canzoniere* (33, 12).

74 Biondo, 1546, 75–87.

75 Lloyd, 1966, 15–170.

76 Firenzuola's statement that a woman may "lack some trifling thing according to the measures of those meticulous artists" but still have grace can be compared to Pico's definition of grace that supersedes measure: "E così per l'opposto si vedrà qualche volta in un corpo, il quale e nella figura e ne' colori potrebbe essere assai meglio proporzionato, apparir nondimeno mirabil grazia" (Pico, 113).

77 Bembo, 1505, 129.

78 Firenzuola, 1548, 728–32. For other passages that identify beauty with proportion, see Romei, 1586, 6.

79 Ebreo; text and passage are quoted by Barocchi, ed., 1960, 1:389: "Se bene consideri, troverai che, quantunque ne le cose proporzionate e concordati si trova bellezza, la bellezza è oltre la loro proporzione. . . . Non la proporzione è essa bellezza, ché di quelli che non sono né proporzionati né improporzionati, perché non sono composti, si truovano bellissimi."

80 Varchi, quoted in Barocchi, ed., 1960, 1:86 and 89: "E questi [earlier writers] per la maggior parte dicono che la bellezza non è altro che la debita proporzione e corrispondenza di tutte le membra <tra> loro; e così vogliono che la bellezza consista e risulti nella debita quantità e della convenevole qualità delle parti, aggiuntovi la dolcezza o soavità de' colori."

81 Summers (1981, 368–96) discusses the opposition between "intuitive and numerical proportion" for Michelangelo, Pino, Danti, and others.

82 For further discussion of *ars* and *ingenium*, see Chapter 2, section "Bipolar Semantics." Submerged in Vasari's definition, *ars* and *ingenium* appear together as an explicit organizing and dividing structure in Poussin's and Boselli's definitions of the *maniera grande*. For Poussin, see Chapter 5; for Orfeo Boselli, who as pupil of Duquesnoy undoubtedly knew Poussin and might even have read his definition of style, see also Chapter 3, note 3. Somewhat later, Lacombe divided his definition of *goût*, which "is used with the same meaning as style (*manière*)," into three parts: natural, artificial, and national (Lacombe, 1758, 183). Natural taste "is the idea and talents that a painter acquires by consulting nature alone without observing

works of the great masters." Artificial taste "is formed from the observation of other paintings and, in general, from that which is learned."

83 Vasari, 1568, 3:61–62: "[C]hi le [le cose di prospettiva] segue troppo fuor di misura, getta il tempo dietro al tempo, affatica la natura, e l'ingegno empie di difficultà, e bene spesso di fertile e facile lo fa tornar sterile e difficile, e se ne cava – da chi più attende a lei che alle figure – la maniera secca e piena di proffili: il che genera il voler troppo minutamente tritar le cose."

CHAPTER 5. NICOLAS POUSSIN AND THE RHETORIC OF STYLE

1 For *maniera* and *modo*, see Crusca *Vocabolario*, 1612. For Poussin's letter to Chantelou, 24 November 1647, see note 11.

2 Poussin (1989, 159–60; Jouanny, n. 184), letter to Chantelou, 29 August 1650. Bellori (1672, 456 and 472–73) described the notes as "varie materie e ricordi" and as "degne osservazioni e ricordi sopra la pittura." The possibility that the definition of style was written before 1650, or at least before 1657, is suggested by the similarity it bears to a discussion of the "Grand style" written between c. 1650 and 1657 by the sculptor Orfeo Boselli. Boselli, as a pupil of Duquesnoy and acquaintance of Poussin, could have known Poussin's definition, just as Poussin could have known Boselli's. I would assume that Boselli borrowed from Poussin, rather than the other way around, because we know Poussin's sources to be Mascardi and Tasso. For Boselli, see P. Dent Weil's preface to her edition of Boselli, 1978, and Torresi's preface to his edition of Boselli, 1994; see also Fagiolo dell'Arco, 1994. For a history of Poussin's planned treatise on "lights and shadows, colors and measures," see Bell, 1988 and 1993; and Cropper and Dempsey, 1996, [145–75]. However, there is no reason to assume that his definition of *maniera magnifica* was written for this project.

3 Bellori (1672, 456) records, in the context of conversations he witnessed between Poussin and Cardinal Camillo Massimi, that Poussin planned to annotate and order the notes "when, because of age, he would not be able to work with the brush." According to Bellori, the manuscript remained with the cardinal al-

though, as Bonfait notes (1996, 48), no reference to it can be found in an inventory of his library drawn up in 1677.

4 Bellori, 1672, 473.

5 Blunt, 1937–38, 344–51.

6 Still the most complete biography of Mascardi is by Manucci, 1908. For discussions of Mascardi's historiography in general, see Spini, 1970, 91–133; Raimondi, 1966, 32; Cropper, 1984, 118–20, 142–43, 158–61, 165–66; Fumaroli, 1980, 223–25; Cropper, 1991, 152–54; Warwick, 1996, 333–48. Poussin and Mascardi shared at least one common friend, Virgilio Cesarini. Mascardi (1630, pt. 2, 55–66) wrote an homage, "Per l'Esequie del Signor D. Virginio Cesarini"; for Poussin and Cesarini, see Fumaroli (1994, 76–77 and 108–12).

7 Bellori, 1672, 479–80; the translation is loosely based on Blunt (1967, 1:363): "Di alcune forme della maniera magnifica. Della materia, del concetto, della struttura e dello stile. La maniera magnifica in quattro cose consiste: nella materia overo argomento, nel concetto, nella struttura, nello stile. La prima cosa che come fondamento di tutte l'altre si richiede è che la materia ed il soggetto sia grande, come sarebbono le battaglie, le azzioni eroiche e le cose divine; ma, essendo grande la materia intorno a cui si va affaticando il pittore, il primo avvertimento sia che dalle minuzie a tutto suo potere si allontani, per non contravenire al decoro dell'istoria trascorrendo con frettoloso pennello le cose magnifiche e grandi per trascurarsi nelle vulgari e leggiere. Onde al pittore si conviene non solo aver l'arte nel formare la materia, ma giudizio ancora nel conoscerla, e deve eleggerla tale che sia per natura capace di ogni ornamento e di perfezzione; ma quelli che allegano argomenti vili, vi rifuggono per infermità dell'ingegno loro. E' adunque da sprezzarsi la viltà e la bassezza de' soggetti lontani da ogni artificio che vi possa essere usato. Quanto al concetto, questo è mero parto della mente, che si va affaticando intorno le cose, quale fu il concetto di Omero e di Fidia nel Giove Olimpio, che col cenno commuova l'universo; tale sia però il disegno delle cose quali si esprimono li concetti delle medesime cose. La struttura o composizione delle parti sia non ricercata studiosamente, non sollecitata, non faticosa, ma simigliante al naturale. Lo stile è una maniera particolare ed industria di dipingere e disegnare nata dal particolar genio di ciascuno nell'applicazione e nell'uso dell'idee, il quale stile, maniera o gusto si tiene dalla parte della natura e dell'ingegno."

8 Blunt (1937–38, 344–51) first identified Mascardi as Poussin's source.

9 Crusca Vocabolario, 1747, 3:90.

10 For a fascinating application of this definition of *concetto* to Poussin's *Exposing of Moses* (Oxford, Ashmolean Museum), see Colantuono, 1996, 2:647–65.

11 J. von Sandrart, 1675, 258; trans. in Blunt, 1967, 242.

12 Aristotle, *Rhetoric* 3.1.5 (1403b–1404a); quoted above in the Introduction. See also L. Salviati, 1827, 13 (representing the Crusca Academicians); discussed by Diffley, 1988, 133. Poussin (in Bellori, 1672, 481: [Topic heading:] "Delle lusinghe del colore." [Text:] "Li colori nella pittura sono quasi lusinghe per persuadere gli occhi, come la venustà de' versi nella poesia." Borea discovered that Poussin adapted a passage from Torquato Tasso, *Discorsi del poema eroico*. For a discussion of Tasso's ideas on art and how he used them to advance his arguments about literary style, see Williams, 1997, 150–62. Read in context, Tasso's use of color as a metaphor of *locuzione* sounds more like Mascardi's discussion of elocution. Mascardi, 1636, 350–61; discussed by Cropper, 1984, 142.

13 Cropper (1984, 118–19) rightly notes that "the extent of Poussin's dependence on Mascardi has not been fully appreciated." She has done us a great service in setting Mascardi in his Roman context, especially in relation to Testa: see 142–43 and 158–61. A recent article by Warwick (1996, 333–48) has helped to correct this situation with regard to Poussin in general, but she does not discuss the definition of *maniera magnifica* in particular.

14 The results have been very interesting; see, for example, Bonfait, 1994b, 170–71; and Colantuono, 1996, 2:647–65; and for the most comprehensive discussion, see Warwick, 1996, 333–48.

15 Mascardi, 1636, 237–46.

16 Ibid., 257–82.

17 Ibid., 288.

18 Ibid., 268 and 287. For style being contained even in the details, see Chapter 2 ("Metaphor and Metonymy").

19 Cropper (1984, 160) makes this point very effectively and puts it in a broad historiographic

context with her compelling discussion of Panofsky's *Idea*.

20 Spini (1970) presented Mascardi as an advocate of Ciceronian historiography, taking the side of Tacists against such anti-Tacists as Famiano Strada (*Prolusiones Academicae* [Rome, 1617]). For further discussion of Mascardi's Ciceronianism, see Fumaroli, 1980, 33; Cropper, 1984, 160; Bellini, 1991, 65–136; and Warwick, 1996. For Cicero's use of artists to exemplify the individuality of style, see *De oratore* 3.7.26. See also Cicero's *Orator* (36) where taste in painting is used to demonstrate how taste in general is personal. Castiglione (1528, lib. I, cap. xxxvii, 77–78) also listed contemporary painters – Leonardo, Mantegna, Raphael, Michelangelo, and Giorgione – and used *maniera* as an ideal beauty to which he juxtaposed individual *stile*.

21 Mascardi, 1636, 288.

22 For *stile* as literary style and *maniera* as artistic style, see Mirollo, 1984, 4–7. It is interesting to note that calligraphers in the early modern period labeled style as *maniera* despite the fact that their writing instrument was a stylus. Calligraphy literature briefly discusses types of quills and how nibs affect the script, but overwhelmingly the experts concentrated on the action of the hand and the forms that it produced.

23 Cropper and Dempsey, 1996.

24 Mascardi, 1636, 287.

25 Bellori, 1672, 235–36: "Valentino nativo di Briè . . . seguitò lo stile del Caravaggio con maniera vigorosa e tinta." And 71: "L'impeto di Polifemo viene animato con lo stile il piú grande e 'l piú veemente, e se ne forma l'atto terribile; ma oltre la gran maniera Annibale ci lasciò l'essempio del moto della forza descritto da Leonardo da Vinci. . . ."

26 Bellori, 1672, 452–53.

27 For example, the *stile eroico* is discussed by Bellori (1672, 536; and 1680, 5). For further discussion of the importation of stylistic terms from poetics and rhetoric, see the preceding section. This calls into question Sauerländer's argument (1983, 258) that Bellori consistently used *maniera* and *stile* in different ways.

28 Ridolfi, 1648, 2:121, 384, and 284: "[S]i dilettò non meno di seguir la via di Titiano, onde fece un misto dell'uno e dell'altro stile [Titian's and Palma Vecchio's] formandone una soave maniera. . . ." Passeri (1673–79, 183,

345, and 355): Guercino "fù Pittore unico nel suo stile, proprio settario della sua maniera"; Boschini (1673, 736): ". . . fu diverso della vaghezza del di lui stile e della dilettevole sua maniera." Vangelri, letter to his uncle Suttermans, 22 June 1675; published in Campori, 1855, 479: "but being inclined toward a different *stile* he went to study under a certain Van Balen who worked with Brueghel . . . and from the two of them (Van Balen and Brueghel) he took his *stile* and combined the *maniera* of the one with the other." Volpato, n.d., fol. 392; in Bordignon Favero, 1994, 88; Bellori, 1695, 33; Orlandi, 1733, 466–67; B. de' Domenici, 1742, 3:66–67 and 111; Ratti, 1768, 2:211–2.

29 Paolo del Sera, letter to Leopoldo de' Medici dated 22 August 1665 (Fileti Mazza and Gaeta Bertelà, eds., 1987, 1:259): ". . . quel disegno, il quale in vero ha più della maniera del Bandinelli che del Passerotto, ma il colorito et il modo del dipingere poi è su lo stile lombardo."

30 Bellori, 1690, 13 (re Raphael, *Mass at Bolsena*): "Fù certamente questa la prima istoria, che nella sua venuta à Roma, Rafaelle dipinse, ancorche lo stile non dimostri ugualmente ancora la gran maniera, alla quale da se stesso si ando avanzando. . . ."

31 Panofsky (1960, p. 115, n. 224; trans. 1968, 240, n. 5): "Here [in Poussin's definition] the expression "style" is used apparently for the first time to designate the individual ways of pictorial representation that so far had been designated by the term *maniera*." Sauerländer (1983, 258) and Mirollo (1984, 26–27) concur with Panofsky.

32 Dempsey, 1977, 102–3. For the acceptance of Panofsky, see Sauerländer and Mirollo (in preceding note); and, most recently, van Eck (1995, 91): "The term [*stile*] was applied to painting and sculpture from the time of Poussin onwards." For Wohl (1999, 16), Castiglione gives us "the only instance" in the Renaissance where *stile* is used as pictorial style. In addition to the examples of *stile* cited by Dempsey, there are also the following: (1) Pietro Bembo, letter of 1 January 1505 to Isabella d'Este (Gaye, 1840, 2:71): "La invention, che mi scrive V.S. che io truovi al disegno, bisognerà che l'accomodi alla fantasia di lui che l'ha a fare, il quale ha piacere che molto signati termini non si diano al suo stile, uso, come dice, di sempre vagare a sua voglia nelle pitture." (2) Pietro

Aretino, in Gandini, ed., 1977, 62 (letter of 11 February 1538 to Nicolò Franco); and see also a letter by Domenico Fiorentino to Pietro Aretino dated 20 May 1541; in *Lettere*, 1552, 2: 193: ". . . si come la figura di San Pier martire in San Giovan & Paulo dal gran Tutiano [Titian] fatta, non si stracca mai farlo grande, cosi l'opere da V.S. con tanta argutia, con tanta facondia, con si mirabil & nuovo stile. . . ."

33 In addition to the texts already cited in this section where *stile* identifies an individual style, see Ottonelli and Berretini, 1652, 26; Malvasia, n.d., 201; Bellori, 1672, 71, 90–91, 381, and 394; Resta, 1707, 5, 24, 26–27; Resta (Codice del Padre S. Resta), 281–83; Giovannelli, c. 1730–40, in Paoli, 1990, 343; Orlandi, 1733, 355; B. de' Domenici, 1742, 3:542 (quoting Paolo de Matteis); Pozzo, 1749, 3:199; Moücke, 1752, 1:225 and 2:2, 20–21; Ratti, 1768, 2:82 and 211–12. For examples of *stile* applied to a regional style, usually identified as *maniera*, see Meli Bassi, 1975, 61 (letter by Pietro Ligari, 7 April 1749, regarding "lo stile veneziano").

34 In his translation and commentary on Demetrius, Panigarola (III, 5, pt. xxv) lists the following synonyms: *magnifica, grande, alta, splendida, maestoso*. For *grave*, see Caro, 1558, 36v; and Minturno, 1564, who is unique among Demetrius's translators in rendering *gravitas* or *gravitate* as *magnifico*, see Patterson, 45. For *eroico* and *sublime*, see Annibale Caro's translation and comments on Aristotle's *Rhetoric* (3.6.205); and Segni translation's (1551, 200). See also Tasso, 1564, 392: "Tre sono le forme de' stili: magnifica o sublime, mediocre ed umile, delle quali la prima è convenevole al poema eroico." For a twinning of *magnifico* and *eroico* in art criticism, see Scaramuccia, 1673, 11; for *maniera grande ed eroico* used twice in one paragraph, see de' Domenici (1742, 3:83; and 3:384), who writes that Mattia Preti "hà in sè tutto l'Eroico che si può desiderare in una Pittura grandiosa, e magnifica, e massimamente ne' soggetti tragici, che furon con particolar genio da lui dipinti, ed ove veramente consiste il carattere eroico di un componimento." See, in addition, de' Domenici, 1742, 3:347 (who discusses Mattia Preti's *gran maniera* with *forme magnifiche* and *gran pieghe de' panni*, where folds and forms are either conventional symptoms or synonyms for style). See also Malvasia, n.d., 124 ("Ebbe egli [G. A. Donducci] un certo modo di orna-

mentare grande e maestoso, non duro e machinoso." For the grand style in poetics in general and Tasso in particular, see Grosser, 1992, 159–73 and 292–300. Poussin was also preceded by Lomazzo in his use of Demetrius to justify appropriate subject matter for the "grand style": Lomazzo, 1584, Lib. VI, chaps. 29–30; cited by Panigarola, 1603, 3:178, pt. xxxxiii.

35 For two exceptions, see Francesco Albani's letter of 29 July 1637 (Malvasia, 1678, 2:170; for text, see note 42), where he immediately followed his praise of Michelangelo and Palma Vecchio for the "grandeur of the heroic style" with an explanatory reference to a prolonged battle of literary critics. And see Roger de Piles (1699, 284–85), who was less direct in his association: "Il semble qu'il [Giulio Romano] n'ait été occupé que de la grandeur de ses pensées Poetiques. . . ."

36 See note 41; for an example of *magnifico* qualifying a battle scene, see Scaramuccia, 1673, 11; for an *opera eroico* of the *Massacre of the Innocents*, see de' Domenici, 1742, 3:193. Franchi (1739, 132) cited "Atleti, Sansoni, Polifemi, e anche uomini faticanti" as appropriate subjects for "il far Nudi di gran maniera."

37 Cicero, *Orator* 28.99; Quintilian, 12.10.61; quoted and discussed by Vickers, 1988, 80–82.

38 Cicero, *Orator*, 72.

39 Becq, 1984, 2:515–87.

40 Vasari, 1568, 4:175: After seeing the Sistine Chapel ceiling, Raphael gave his figures "una certa grandezza e maestà" and "migliorò ed ingrandì fuor di modo la maniera e diedele più maestà." The Medici Chapel had the same effect on Andrea del Sarto ("aveva ringrandito la maniera"): Vasari, 1568, 4:383. According to Francesco Albani (in Baldinucci, 1681–1728, 4:58), Michelangelo "aveva scoperta la grandezza dello stile, in cui era stato superiore ai tre nominati [Raphael, Correggio, and Palma Vecchio], ed assomigliavalo agli antichi." Bellori (1695, 91–92) rejected Vasari's positioning of Raphael as a follower by claiming that the progression toward a grand style ("s'ingrandisce lo stile") was incremental and part of a natural development of his own style. Not only did Raphael not follow, he equaled Michelangelo in the "grand style": *the Mass at Bolsena* was formed "di maniera così grande nelle parti ignude, che può contrastare, e contendere con ogni figura di Michel Angelo." Following this is the section titled "Se Rafaelle ingrandí e

megliorò la maniera per aver veduto l'opere di Michel'Angelo" (Bellori, 1695, 93–104). That Raphael was already on this trajectory even before arriving in Rome is suggested by Scaramuccia, 1673, 83. The standard passage on Michelangelo's Sistine ceiling as exemplar of the grand style is in Vasari (1568, 1:74–75). The Sistine ceiling became such a standard example of elevated subjects painted in a "stile magnifica" that one finds it outside art discourse: Panigarola, 3:178, pt. xxxxiii. For Michelangelo as "illustratore del gran stile e forma," see the letter by Francesco Albani published by Malvasia, 1678, 2:167; see also Baldinucci, 1681–1728, 3:232–33.

41 Bellori, 1680, 5 ("stile heroico de gli Antichi Greci"); Bellori, 1672, 536 ("lo stile eroico"). Franchi (1739, 132) wrote of the Pitti Hercules, the Apollo Belvedere, and the Farnese Torso as exemplifying "il far Nudi di gran maniera." For Raphael and the "stile heroico," see Bellori, 1680, 5, and 1695, 91–92. For Sacchi's "gran maniera," see Bellori, 1672, 552. For Domenichino's *Evangelists* (Rome, Sant' Andrea della Valle) as being "in forma di colossi," because of the size and "sublimity" of the space, and consequently painted in a "sublime e magnifico . . . stile," see Bellori, 1672, 338. For Poussin's "gran galeria del palazzo regio in Parigi" painted in the "stile magnifico," see Bellori, 1672, 453.

42 For Michelangelo and Raphael, see notes 40 and 41. For Raphael and Annibale Carracci as exemplifying a "sì bello e eroico stile" to the young Antonio Balestra, see his retrospective view in a letter of 1703 published by Frati, 1907, 66–67. For Giorgione, see Scannelli, 1657, 49–50. For Bronzino's *Martyrdom of St. Lawrence* (Florence, San Lorenzo), painted "di felice maniera & grande," see Bocchi, 1591, 250–51. For Annibale Carracci, see, in addition to the above, Franchi, 1739, 132. Scaramuccia (1673, 35) wrote that Domenichino made these paintings with "l'eroico dissegno." For Pietro da Cortona, "superiore ad ogni altro alla maniera che si desidera eroica," see a letter by G. B. Muzzarelli to the duke of Modena, 9 November 1661, published by Geisenheimer, 1909, 37. For the "magnifico Paolo," see Roberti, 1758, xix; and similarly for his "eroica maniera," see de' Domenici, 1742, 3:319. For Tintoretto, see Averoldo, 1700, 156. For Solimena, see de' Domenici, 1742, 3:592. For

other references, see Shearman, 1992, 209. For Palma Vecchio, see a letter of 29 July 1637 by Francesco Albani (Malvasia, 1678, 2:170): ". . . ed anco sino poco dopo da Leonardo da Vinci, e dal Palma vecchio, che appunto a simiglianza del Buonarroti pare da me (mi rimetto) occupasse la grandezza del stile eroico, che sempre sta a un segno, senza mai abbassarsi, che fu il gran Torquato Tassi; io non m'intesi dell'invenzioni, ma della grandezza dello stile eroico, che prima di esso Tasso, parlo de' poeti al tempo dell'Ariosto, che fuorono molti, e non li occuparono." Baldinucci, in reading this letter, concluded that the reference was to Palma and not to Leonardo and Michelangelo as well (1681–1728, 4:57–58); it was accepted as the correct reading by Gherardi, 1744, 51.

43 For Boselli's brief definition of style as "il modo dell'operare," see Chapter 3. For a discussion of Boselli's *maniera magnifica* and its utility in defining the "Greek Style," see Cropper and Dempsey, 1996, 40–44. For Franchi (1739, 132–34), see his chapter 12, on "Regole per far Nudi di maniera ingrandita, e caricata."

44 Cicero, *Orator*, 98.

45 Poussin (1989, 37; Jouanny, n. 2), letter of c. 1637 referring to lost *Rinaldo and Armida* (engraved copy in Wildenstein, 1957, n. 164): "Je l'ai peint de la manière que vous verrez, d'autant que le sujet est de soi mol, à la différence de celui de M. De la Vrillière [i.e., Camillus and the school master of Falerii, Louvre] qui est d'une manière plus sévère, comme il est raisonnable, considérant le sujet qui est héroique."

46 Poussin (1989, 128; Jouanny, n. 146) in a letter to Chantelou, 24 March 1647. Chantelou was not consistent in his expectations. After seeing Pointel's *Finding of Moses*, he decided that it had been painted with more "love" (*amour*) than his own *Ordination*. A painting with "love" would have the qualities of softness, sweetness, and smooth finish that bothered Stella and Chantelou. Toward the end of the letter, when Poussin described as "speaking of love" in order to illustrate what a painting of love would have, he wrote that the poet chooses "certain words that are sweet (*douce*), pleasing, and very graceful to the ear."

47 Zeitler, 1965, 32 and 35: Boccalini, 1612; translated into French: *Les cent première nouvelles et advis de Parnasse par Traian Buccalin* (Paris, 1615), pp. 162–63.

48 Boselli, 1978, fol. 11r; translated and discussed by Cropper and Dempsey, 1996, 44.

49 For *dolce* and *morbido* as synonyms, see Vasari, 1568, 4:346; Armenini, 1587, 144; Galileo, in Panofsky, 1964, 17–18; Bocchi, in Williams, 1989, 123; Marino, 1911–12, 1:282 (letter of 1620); Bisagno, 1642, 134; Manolessi, ed., in Vasari, 1647, 3:n.p. (Index, s.v. Stefano pittor fiorentino); Marcello Malpighi, letter to Antonio Ruffo, 18 January 1670, in Ruffo, 1916, pt. 2, 123; Soprani, 1674, 276; Baldinucci, 1681, 49; Gherardi, 1744, 179 and 181. For their application to Leonardo, see Lomazzo, 1584, 174 and 200. For Raphael, see Vasari, 1568, 4:168 and 204–5; Lomazzo, 1584, 174; Resta, in 1958, 19; Titi, 1751, 68–69. For Sarto, see Vasari, 1568, 4:9, 346 and 394; Lomazzo, 1584, 174; Bocchi, in Williams, 1989, 122–23. For Giorgione, see Vasari, 1568, 4:8 and 574, 5:87–88, and 6:156–57; Boschini, 1673, 709; Malvasia, n.d., 389. For Rosso, see Vasari, 1568, 4:476–77. For Beccafumi, see Soprani, 1674, 276. For Parmigianino, see Vasari, 1568, 4:531–32. For Taddeo Zuccaro, see Vasari, 1568, 6:569; and Scannelli, 1656, 177. For Titian, see Vasari, 6:156–57. Faberio, 1603, 40; Scannelli, 1657, 7; Scaramuccia, 1674, 112–13. Titi, 1751, 68–69. For Barocci, see Baglione, 1642, 134. For Carracci, see Agucchi in Masini, 1646, lix; and Scaramuccia, 1674, 63. For Albani, see Passeri, 1673–79, 274. For Sacchi, see Bellori, 1672, 547 and 553; Passeri, 1673–79, 299. For Reni, see Malvasia, 1980, 34–35; Malvasia, 1961, 53–54; Malvasia, 1678, 2:59; M. Malpighi, letter to A. Ruffo, 18 January 1676 (in Ruffo, 1916, pt. 2, 123); Antonio Francesco Ghiselli 1685–1724, "Annales Memorie antiache manuscritte di Bologna raccolte et accresciute sino ai tempi presenti," Biblioteca Universitaria, Bologna, MS 770, vol. xxxviii, fol. 780; quoted by Perini, 1990, 150.

50 As signs of progress, see Vasari, 1568, 4:8–10 and 574, 6:156–57; Gualdo, 1650, 8–9; Boschini, 1673, 706; Resta, 1955, 19; Baruffaldi, 1844–46, 1:64; Gherardi, 1744, 181; Titi, 1751, 68–69; Algarotti, 1791, 8:79 (letter to A. M. Zanetti q. Girolamo, 20 February 1759).

51 For the use of white to create sweetness, as described in the technical literature, see Leonardo, 1959, 1:258, n. 516, and 259, n. 520; Lomazzo, 1584, 120 and 177; Testa, in Cropper, 1984, 238–40. For Ludovico Carracci's advice, see Malvasia, 1678, 2:59. For a complete and compelling history of Reni's slide into excessive light, delicacy, and sketchiness, see Spear, 1997, 275–320.

52 For the comparison of "la forza de' Carrazzi e la dolcezza di Guido," see Malvasia, 1961, 53–54.

53 Malvasia, 1980, 34–35.

54 For the "decline of style," see Malvasia, 1678, 2:32–33.

55 Scannelli (1657, 114) lists the "second manners" of Reni, Rubens, Guercino, Albani, and Cortona as examples of the shift to brightness. For a discussion of this passage, see Stone, 1989, 130–50. Malvasia (1980, 34; 1678, 2:60) saw Reni's bright palette as not limited to his circle of followers but including "other cities and even contrary schools, such as Andrea Sacchi, Cortona himself, Maratti, and everyone else, exaggerating white lead greatly."

56 For Poussin's judgment on Raphael, see De Piles, 1699; edition cited: Paris, 1768, 106–7. De Piles's Rubeniste agenda made him a sometimes unreliable source for Poussin matters, and this might be an instance where he exaggerated in order to discredit. For the identification by Scannelli and Malvasia of Cortona as one of the creaters of a new lighter, sweeter style, see above note 55.

57 For *delicatezza* as a failing of modern art, see Borromeo, 1624, 26–27 and 35; Ridolfi, 1648, 2:33. For *delicatezza* as a synonym for *dolcezza* or *morbidezza*, see Dolce, 1557, 177 ("La qual delicatezza da' pittori è chiama dolcezza"); Vasari, 1568, 4:332; and Fabrini, in his commentary on Horace's verse "Aemilium circa ludum faber Imus, & ungueis / Exprimet, & molleis imitabitur aere capillos" (1573, 362): "Esprimerà, farà che paranno naturali [& ungueis] e l'unghie [& imitabitur] & imiterà [aere] in una statua [capillos molleis] i capelli morbidi, e delicati. cioè, farà i capelli, e l'unghie in una statua di bronzo, che parranno naturali [summa] la somma, il restante, tutto il corpo [operis] de la statua. . . ." See also Armenini, 1587, 109 and 144; Faberio, 1603, 40. For examples of *delicatezza* as a term of praise, see Ghiberti, 3.2.3, 10v; Billi, 57; Anonimo Gaddiano, in Fabriczy, 1893, 68; Borghini, 1584, 159; Girolamo Borsieri, letter to Scipione Toso, May 1621 (in Caramel, 1966, 173–75).

58 Demetrius, 1603, p. 79, n. 192. For the gender of *dolce* and *delicato* as stylistic attributes, see Armenini, 1587, 163 (a soft coloring represents

virgins); Malvasia, 1980, 34–35 (the "delicate modern style" of Veronese is applied to female deities and "Venezia"); and Patina, 1691, 187 (Veronese's *Judgment of Paris* shows him as a painter with "la somma delicatezza del colorito." For other examples, see Sohm, 1995a. For a gendered hierarchy, see Armenini (1587, 109), who wrote that Zeuxis would have needed many more than three models if he were to depict an ideal male body, because its representation demands mastery (*magistero*) whereas the representation of the female body with its delicate softness (*piene di delicate morbidezze*) is more easily mastered.

59 Cicero, *Leg.* 2.38: "... mores lapsi ad mollitiam mollitis pariter sunt inmutati cum cantibus, aut hac dulcedine corruptelaque depravati." For other examples in Cicero, see Mamoojee, 1981, 220–36.

60 Seneca the Younger, *Epistles* 115. 1–2.

61 Quoted by Wellek, 1958, 5. The ambivalence and confusion expressed by Eliot regarding style's position in relation to content remains at the center of modern literary criticism. Even semioticians, who have gone further than most to break down the naive equation of meaning with content, have been charged with maintaining style as a "binary hostage" to content. This is Stanley Fish's phrase in critique of Michael Riffaterre (1966, 200–242). Whereas Riffaterre still believed that, however entwined and mutually dependent, style and content could still be discussed separately, Fish was aggressively expansionist: "For me, a stylistic fact is a fact of response, and since my category of response includes everything, from the smallest and least spectacular to the largest and most disrupting of linguistic experiences, everything is a stylistic fact, and we might as well abandon the word since it carries with it so many binary hostages (style *and*–)."

62 For Domenichino, see Spear, 1982, 1:30–31; for Testa, see Cropper, 1984, chap. 3; for Albani, see Malvasia, 1678, 2:168, and Puglisi, 1999, 48–50; and for Passeri, 1673–79, 274.

63 Poussin, in Bellori, 1672, 481.

64 Malvezzi, 1648, 54–59.

65 Scannelli, 1657, 339; cited and accepted as valid by Gherardi, 1744, 109.

66 Poussin (1989, 37; Jouanny, 4, n. 2) in an undated letter, c. 1637; quoted in note 45.

67 This, at least, was Félibien's presentation of Pointel's intentions (1725, 100). For Félibien's

analysis of the painting, see pp. 111–14. Still the best discussion of this painting is the article by Cropper, 1976.

68 Delminio (*Della imitazione*, c. 1530; Weinberg, ed., 1970, 1:179–83) also applied to painting the literary principle that a single subject and theme can be given an infinite number of different forms.

69 Poussin (1989, 105; Jouanny, 268, n. 108) in a letter of 14 May 1644.

70 Jouin, ed., 1883 (7 January 1668).

71 Stigliani, 1627, 70–71.

72 For a recent and very useful discussion of decorum in mid- and late-cinquecento art literature, see Williams, 1997, 85–100 (also to be consulted for style-content issues discussed below). See also Dempsey, 1982, 65–66; Scavizzi, 1992.

73 Gilio, 1564, 49.

74 Paleotti, 1582, 311 and 379. Gilio (1564, 39–40) used Sebastiano del Piombo's *Flagellation* as an example to explain how a painter may show a perfect knowledge of anatomy and may have the means to imitate the delicacy, beauty, and grace of figures and yet fail by misplacing it in the wrong subject.

75 Gilio, 1564, 48. One may recognize "l'ingegno, la perizia e l'eccellenza de l'artefice" and yet violate nature and the subject.

76 Salerno (1951, 27) believes that Giulio Mancini can be taken as an "index of the turn in the seicento criticism toward a higher estimation of content over form." See also Arikha, 1989, 219–21.

77 Poussin, letter to Chantelou, 7 April 1647 (Jouanny, 353–54): "Je passerai donc à vous dire que, lorsque je me mis en la pensée de peindre le susdit tableau [*Baptism*] de la manière qu'il est, en même temps je devinai le jugement que l'on en ferait. Il y a ici de bons témoins qui vous l'assureront de vive voix. Je n'ignore pas que le vulgaire des peintres ne disent que l'on change de manière si tant sois peu l'on sort (de son) ordinaire car la pauvre peinture est réduite à l'estampe. . . . Je vous prierei seulement de recepuoir de bon oeil comme s'est votre costume, les tableaux que je vous enverrai bien que tous soeint différemment peints et coloriés vous assurant que je ferei tous mes efforts pour satisfaire à l'art à vous et à moi."

78 Caro, 1961, 3:237; also in Bottari and Ticozzi ed., 1822, 3:249.

79 Malvasia, 1961, 78. Besides the examples cited in the text below, see Gherardi, 1744, 109; De' Dominici, 1742, 3:365 and 384–85; Mengs, 1787, 2:275. Discontinuities of style and subject appear in art literature prior to the mid-sixteenth century, but they were not presented with censure or warning. In a typical example, Vasari observes that Taddeo Zuccaro's subject matter was *fiero* and his style *dolce* and *pastoso*, but he did not directly connect the two as inappropriate (1568, 5:569).

80 Bottari, in Vasari, 1759–60, 2:335.

81 Zanotti, 1756, 32–34.

82 Poussin (1989, 128; Jouanny, 370–77, n. 146) in a letter to Chantelou, 24 March 1647: "S'il ne sont contents de la répartie [referring to his defense via Boccalini], je les prie de croire que je ne suis point de ceux qui en chantant prennent toujours la même ton, et que je sais varier quand je veux." Félibien (1725, 116) discussed this statement in relation to Poussin's *Rebecca and Eliezer at the Well* and *Moses Trampling on the Pharaoh's Crown;* see Warwick, 1996, 344.

83 Félibien, 1725, 116.

84 Bellori, 1695, 112: "Qui in risposta avvertiamo solo che Michel'Angelo fu veramente grande nella gran maniera Erculaea, e robusta, ma aggiungiamo ancora che questa sola non basta per acquistar nome di gran disegnatore, essendo necessario possedere tutte le altre forme tenere, gentili, svelte, graziose, e delicate." For a similar condemnation of Michelangelo, see Fréart de Chambray, 1662, n.p. (preface). For Chambray's influence on Bellori, see Previtali, 1976, xxiv–v. For Bellori on Raphael in general, see Bell, forthcoming.

85 Danti, in Barocchi, ed., 1960, 1:241: "un modo di operare il quale fugga le cose imperfette e s'accosti, operando, alle perfezzioni." The Crusca *Vocabolario* defined *maniera* as "Modo d'operare."

86 Mascardi, 1636, 234–35; for further discussion, see Chapter 8. According to Gombrich (1960, 364), "an accent, we suspect, has many similarities to those all-pervading qualities we call 'style.'"

87 Algarotti, 1756, 110: Style is "quasi un particolare accento del pittore, a cui egli è riconosciuto di leggieri, venendo a pronunziare allo stesso modo le varie lingue che gli conviene parlare."

88 Perhaps the best measure for Bosse's isolation from contemporary and later art theory and criticism can be found in the total silence of Becq (1984) regarding Bosse in her exhaustive, 900-page discussion of French theories of art from 1680 to 1814. Carl Goldstein (1994, 76–77) uses Bosse as a foil for mainstream interests in the Académie royale. A useful discussion of his ideas on connoisseurship is Gibson-Wood, 1988, 44–58.

89 For documentation and further discussion, see Chapter 6.

90 Bosse, 1649, 39–40: "Le Naturel estant ainsi bien Copié, il n'y auroit point tant de diverses manières, car ainsi faisant plusieurs qui Copieroient d'apres Nature une mesme teste communement nommée Pourtrait, & d'une mesme position distance, il arriveroit que tous ces divers Pourtraits seroiet entierement semblables, & qu'on ne pourroit pas dire celuy-là est de la manière d'un tel, ou d'un tel, ainsi le mesme des autres Corps visibles de la Nature. . . ."

91 Bosse, 1649, 40: "Mais à cause que l'ignorance a regné en des temps parmy les Pratitiens de cet Art, il est en suitte arrivé que plusieurs se sont sur les Ouvrages des uns & des autres ainsi faits ou formez des diverses maniere à leur fantasie; & comme cela ces choses ont multiplié infiniment."

92 Bellori, 1695, 141: ". . . egli l'abbia colorito troppo tinta di nera, ed alquanto aspra ne' dintorni, e come il troppo uso del nero alle sue opere viene imputato." The *Descrizione* was published posthumously in 1695 but written prior to 1672.

93 Vasari, 1568, 5:60. See also De Piles, in his edition of Dufresnoy's *De arte graphica* (1684, 261–62).

94 Beal, 1984, 44.

95 Bellori, 1695, 141.

96 In addition to the examples cited in the preceding section, see the following. In a letter dated 23 November 1532, Tommaso Lancillotto (in Venturi, 1922, 27–28) explained the unfinished appearance of a completed altarpiece of the Coronation of the Virgin by Dosso Dossi by referring to the doctrine of the Immaculate Conception that it was thought to illustrate: "non sono finite [i.e., the figures] perchè la questione delle Conceptione non è finita, e cossì lui [Dosso] l'ha fatta non finita." Vasari (1568, 4:26) also gave a theological reading to the unfinished appearance of Leonardo's Christ in the *Last Supper*. According to Lomazzo (1590, 289), Gaudenzio Ferrari painted

in different styles (*maniere*) at Varallo, sometimes "delicato e mirabile," but for scenes involving figures of the lower classes ("mori, pastori, ragazzi") he adopted "una maniera capricciosa e vaga." Bellori (1672, 8) acknowledged Poussin's advice in writing about expressive content, but probably also knew about the French Academy discussions of Poussin's paintings.

97 Félibien, 1725, 94–95: "& peut-on rendre les Antiques si recommendables, sans donner envie de les imiter? Il faut, dit-on, en sçavoir ôtre la dureté la secheresse. Qui doute de cela, & qu'il ne faille même prendre garde aux effets des lumieres qui se répandent sur les marbres & sur les choses dures, d'une maniere bien differente que sur les corps naturels, sur de veritables étoffes? Mais où voit-on que le Poussin ait fait des hommes & des femmes de bronze ou de marbre, au lieu de les representer de chair? Il a connu que pour former les corps les plus parfaits, il ne pouvoit trouver de plus beaux modéles que les statuës & les bas-reliefs, qui sont les chef-d'oeuvres des plus excellens hommes de l'Antiquité." Pace (1981, 164) identifies Charles Perrault's *Les Hommes illustres qui ont paru en France pendant ce siècle* (Paris, 1696) as one such complainant: "On lui reprocha que dans plusieurs de ses Tableaux, il y avoit quelque chose de dur, de sec, & d'immobile, deffault qu'on prétendoit venir de ce qu'ils estoit trop appliqué à estudier et à copier les Bas-reliefs antiques. . . ."

98 Félibien, 1725, 157 ("une adresse toute particuliere . . . bien ornée, mais sans sard") and 162: "Il faut avoüer que ce Peintre, sans s'attacher à aucune maniere, s'est fait le maître de soi-même, & l'auteur de toutes les belles inventions qui remplissent ses tableaux."

99 For this paragraph ("Circa la maniera di questo artefice . . ."), see Bellori, 1672, 452–53. Elsewhere in the "life" Bellori used generalized and normative descriptions of Poussin's style: that he has "un buon modo di disegnare" (423), that his lost *Assumption of the Virgin* (Paris, Notre Dame) is "di buon componimento e ben condotta" (425), that he acquired "una bella maniera" for making putti (426), that he made "nobilissimi componimenti" (434). He also noted that Poussin imitated Raphael "con tanto ardore ed essattissima diligenza" (423), but this suggests a neutral reproduction and an absence of style rather than

"diligence" as a visual attribute of finished surfaces, clear contours, etc.

100 Bellori, 1672, 453; and Mancini, 1956, 1:261.

101 The only personal style that Bellori mentioned was Poussin's exemplary *stile magnifico*, and then only to deny charges directed against his Grand Galerie decorations in the Louvre (1672, 453): "La qual credenza confermarono nella gran galeria del palazzo regio in Parigi, volendo che egli non fosse sufficiente né corrispondesse all'ordinanza e nello stile magnifico."

102 Vasari, 1568, 5:323. More often Vasari wrote about the difficulty of changing styles. Piero di Cosimo sought to imitate Leonardo's paintings but remained distant ("cercava imitarlo quantunque egli fusse poi molto lontano da Lionardo"; 1568, 4:62). Most famous is Raphael's difficult, nearly divine, achievement of abandoning Perugino's dry style in favor of Michelangelo's grand one.

103 Mancini, 1956, 1:236–37: "Hebbe varietà di Maniera, come si vede nelle due cappelle d'Araceli, una a man sinistra più fiera e resentita, l'altra a man destra, di casa Mattei, tutta piacevole e suave." See also Lomazzo (1590, 289) on the different styles of Gaudenzio Ferrari at Varallo.

104 Antonio Francesco Ghiselli (1685–1724), quoted by Perini (1990, 150). Reni was also thought to have painted a *St. Joseph* "in a highly charged style with an awesome boldness . . . in order to purge his reputation" of the taint of painting too delicately. Lorenzo Magalotti (1769, 2:116–18) in a letter to Maria Selvaggia Borghini, 17 May 1701: "Mi sovviene d'un famoso quadro di Guido Reni, che tacciato di dipingere troppo delicatamente, e di non sapere uscire di certe morbidezze, si mise, per purgar la sua fama, a dipingere un S. Giuseppe di una maniera sommamente risentita, con una terribile fierezza di colpi, e di tinte; e in braccio gli fece sopra un pannicello un Bambino Gesù con una pesca tra le mani, nel quale versò tutte le più ricercate delicatezze del suo pennello."

105 Spear (1997, 10 and 210–24) gives examples of Titian, Schiavone, Amico Aspertini, and Luca Giordano adjusting their styles to fit the pocketbooks of their patrons in order to contextualize a fascinating study of Reni playing the market. In addition to the examples men-

tioned below of a painter changing style to suit a patron or critic, see Cozzando, 1694, 122; and Orlandi, 1704, 268 (on Mombello painting for nuns).

106 B. de' Domenici, 1742, 3:10–11 and 365. Ratti (1768, 2:82) explained how G. B. Gaulli "at one moment" would paint in "a harmonious style, charming and strong in color" and then at another moment paint in a "less robust" style. Moücke (1754, 2:20) noted that after Veronese declared the paintings by Antonio Aliense to be simply copies of drawings made in his studio, Aliense resolved "to abandon Veronese's style and turned to follow the style of Tintoretto."

107 Passeri, 1673–79, 354. "Havendo mutato parere, nella morte di Guido, di stanziare in patria, mutò anche maniera di dipingere, et havendo lasciata quella forza, et ardimento di scuri fin a quel tempo maneggiata, diedesi ad uno stile delicato, e suave parendogli così di secondare più il gusto dell'universale. S'ingannò con questa novità, perche diede in una debolezza poco gradita (così dicevano li buoni Professori), et in una maniera languida, e di poco vigore, e così interviene a chi vuole innovare le cose già praticate con la comune sodisfazione."

108 Ruffo, 1916, pt. 2, 101 (letter by Guercino of 13 June 1660): "In quanto poi alla mezza figura che ella desiderava da me per accompagnamento di quella del Reimbrant, ma della mia prima maniera gagliarda, io sono prontissimo per corrispondere et eseguire li di lei ordini. . . . Se poi ancora con l'occasione d'inviarmi la misura V.S. Ill.ma volese onorarmi di un poco di schizzo del Quadro del Reimbrant fatto per mano di qualche Pittore acciò potessi vedere la dispositione della mezza figura, il favore mi sarebbe singolarissimo e potrei governarmi meglio per l'accompagnamento, sì come per pigliare il lume al suo luogo." For Mahon's comments, 1949, 105.

109 Ruffo, 1916, pt. 3, 186 (letter of 24 January 1670 by Abraham Breugel): "Per la favorita de V.S. Ill.ma del 29 caduto vedo che V.S. Ill.ma ha fatto faijre parecchie mezze figure dalli meglio pictori d'Italia et che neciuna arive a quella del Rymbrant, è vero io pour sono d'acordo, ma bisogna considerare, che li pictori grandi, conforme quelli che V.S. Ill.ma

à fatto faijre le mezze figure, non vogliono sì assucittare ad una bagatela d'una mezza figura vestita e de che sola vene un lumino soudra il poijuto del naso, e che non si sa da che parte se ne vene perchè tout il reste è oscure." Brandi thought he was painting a pendant to Rembrandt when in fact it was to a painting by Salvator Rosa (Ruffo, 1916, pt. 5, p. 115; letter of 24 January 1671). He was upset to receive this news because he had painted it "di maniera gagliarda," as had been Guercino's intention, but would have used lighter coloring if he had known it was to accompany a Rosa.

110 Jouanny, 1911, n. 156; Blunt, 1989, 133–37; based on the translation in Blunt, 1967, 367–70 (letter of 24 November 1647):

Si le tableau de Moïse trouvé dans les Eaux du Nil, que possède M. Pointel, vous a donné dans l'amour, est-ce un témoignage pour cela que je l'aie fait avec plus d'amour que les vostres? Voyez vous pas bien que c'est la nature du sujet qui est cause de cet effet, et vostre disposition, et que les sujets que je vous traite doivent estre représentés par une autre manière. C'est en cela que consiste tout l'artifice de la peinture. Pardonnez à ma liberté si je dis que vous vous este montré précipiteux dans le jugement que vous avez fait de mes ouvrages. Le bien juger est très difficile si l'on n'a en cet art grande théorie et pratique jointes ensemble. Nos appétits n'en doivent point juger seulement, mais la raison. . . . Nos braves anciens Grecs inventeurs de toutes les belles choses, trouvèrent plusieurs modes par le moyen desquels il ont produit de merveillieux effets.

Cette parole 'mode' signifie proprement la raison ou la mesure et forme de laquelle nous nous servons à faire quelque chose . . . une certaine manière ou ordre déterminé, et ferme dedans le procédé par lequel la chose se conserve en son estre.

Étans les modes des anciens une composition de plusieurs choses mises ensemble de leur variété naissait une certeine différence de mode par laquelle l'on pouvoit comprendre que chacun d'eux retenait en soi je ne sais quoi de varié principalement quand toutes les choses qui entraient au composé étaient mises ensem-

ble proportionnément, d'où procédait une puissance de induire l'âme des regardants à diverses passions. De là vint que les sages anciens atribuèrent à chacun sa propriété des effets qu'ils voyaient naistre d'eux. Pour cette cause il appelèrent le mode dorique stable, grave et sévères, et lui appliquaient matières graves, sévères et plaine de sapiense.

Et, passant de là aux choses plaisantes et joyeuses, ils usaient le mode phrygien pour avoir ses modulations plus menues qu'aucun autre mode, et son aspect plus aigu. Ces deux manières, et nulle autre, furent louées et approuvées de Platon et Aristote, estimant les autres inutiles, ils estimèrent ce mode véhément, furieux, très sévère, et qui rend les personnes estonnés. . . . Il voulurent encore que le mode lydien s'accommodast aux choses lamentables parce qu'il n'a pas la modestie du dorien ni la sévérité du phrigien.

L'hypolidien contient en soi une certaine suavité et douceur, qui remplit l'âme des regardants de joie. Il s'accommode aux matières divines, glorie et paradis. Les Acsiens inventèrent le ionique avec lequel ils représentaient danses, bacchanales et festes, pour estre de nature joconde.

111 Alfassa, 1933, 125–43.

112 Mahon, 1962, 121–26; Badt, 1969, 306–10; Bialostocki, 1961; Zeitler, 1965; and Messerer, 1972.

113 Cropper, 1984, 140–44. See Hammond (1996, 76–78) for another careful reading of changes Poussin made to Zarlino's text.

114 Cropper, 1984, 140–44; Puttfarken, 1985, 29–31; Fumaroli, 1989, 75–79; Bätschmann, 1990, 39–42; Montagu, 1992; Montagu, 1994, 11–15; Mérot, 1994; Puttfarken, 1999, 63–66 and 70–71. Mérot and Fumaroli use Félibien's preface to the Académie conferences (1668, 5:323) to elaborate on the nonverbal/nonfigurative expressivity of color in his reading of Poussin's theories. For a thoughtful separation of Poussin and his academic hagiographers, especially Félibien, see Montagu, 1992. Puttfarken (1999, 65–66) renewed Mahon's warning (1962, 125) to avoid Félibien's "posthumous systematization" of Poussin's ideas and to avoid extrapolating or rigidifying Poussin's intuitive practice.

115 Puttfarken, 1999, 63–66. For the mode "as an expression of the *passion* of the whole," see Bätschmann, 1990, 40.

116 Félibien, ed., 1668, 56. Following Félibien's lead, Henri Testelin (1675, 317) noted that "everything is gay and laughing, pleasing and agreeable" in Poussin's *Rebecca and Eliezer at the Well*. In Félibien's reading of Poussin, a painting's "particular character or style" will be present everywhere, and according to Charles Le Brun, Poussin practiced modal painting in such a way as to give "a general expression" (Montagu, 1992, 237–38).

117 For a review of the complex and overlapping classification systems of style in ancient rhetoric and poetics, and especially for a thorough history of their reception in the Renaissance, see Grosser, 1992.

118 For Melanchthon, see Parshall, 1978, 18–19. For Milizia's rhetorical classification of style as *grande, mezzano*, and *piccolo*, see 1781, 54–55. Borghini's and Gilio's genres (*maniere*) refer only to subjects, not to style. Borghini (1584, 53–54) accepted Gilio's subject-based genres but did not develop a stylistics from this: "E se bene mi ritorna à memoria, egli [Gilio] divide il pittore in tre maniere: in pittor poetico, in historico, & in pittor misto, laqual divisione non mi dispiace." De Piles adapted "styles of thought" from poetics (*élevé* or *heroique, familier* and *pastoral* or *champêtre*) but used a conventional pictorial vocabulary to describe the "styles of execution" (1708, 52–53, 201–3, and 258).

119 Simonelli's tag for Rosa appeared in a poem written in praise of *Titus Devoured by the Vulture* upon its exhibition at the Pantheon on the Festa di San Giuseppe, 1638, and was repeated by Passeri, Baldinucci, and de' Dominici (Grassi, 1984, 2:620–29). The implications of Rosa as Demosthenes are fascinating and not yet adequately explored.

120 Passeri, 1673–79, 274; quoted and discussed by Colantuono, 1997, 9–10. For Albani as Tasso, see Baldinucci, 1681–1728, 4:57–58; for Albani's interest in Tasso, see Puglisi, 1999, 26–28 and 51–52. A. F. Peruzzini also tried to legitimize his landscapes by reference to heroic poetry. Magalotti (Gregori, 1964, 28) reported his conversations with Peruzzini to Della Seta: "Mi era sovvenuto di dirle che in genere di pittura io considero questa maniera, come considero un Poema eroico. . . ."

121 Onians, 1988, 38–40; Rowland, 1998, 230–

33. For the best discussions of *maniera* in Renaissance architecture literature, see Rowland, 1998, 228–30; Payne, 1999, 56–60, 65–67, 138–42.

122 Testelin, 1696; published in Montagu, 1992, 242. Gherardo Spini (1569, 81) had already drawn parallels between the architectural orders and the musical modes, specifically between the *ordine dorico* and the *modo diatonico*, the *ordine ionico* and the *modo cromatico*, and the *ordine corinzio* and the *modo armonico*. For discussions of Spini's ideas, see Waźbiński, 1987, 1:215–34; and Payne, 1999, 114–69.

123 Montagu, 1992, 242.

124 Castiglione, 1528, lib. I, cap. xxxvii, 77–78.

125 For the best discussions of Lomazzo's stylistics, see Klein, 1959, 277–87; M. Kemp, 1987, 1–26; Williams, 1997, 123–35.

126 Scannelli, 1657, 11–25. In the introduction to the first edition of Giovanni della Casa's poems, Severino uses a body metaphor to analyze Casa's poetry. Like Scannelli, Severino was trained as a physician.

127 For discussion of Boschini's "boat of painting," see Sohm, 1991, 97–98.

128 Resta, 1707b, 49–50, 58–59, 62–63, 74.

129 Lana, 1670, 160–61. For a summary and discussion of this passage, see Chapter 6.

130 Bordignon Favero, 1994, 407–8. How individual style can be defined by reconfiguring the lexical fields that describe it will be a subject covered in greater detail in Chapter 7.

131 Mancini, 1956, 1:108–10 (*ordini, classe o ver vogliam dire schole*).

132 Boschini, 1660, 378: "Savemo che le letere vocal / Xe cinque; cusì gh'è cinque Pitori, / Che senza la maniera d'un de lori / Certo non se puol far quadro che val."

133 Malvasia, 1678 ed., 2:167.

134 For Veronese's depiction of Titian, Tintoretto, Bassano, and himself as the string quartet of Venetian painting in the *Feast of Cana* (Louvre), see Boschini, 1660, 204–7. For Ottavio Vannini's *Lorenzo de' Medici among the Artists* (Palazzo Pitti, Sala degli Argenti), see McGrath, 1994, 202–3. For Niccodemo Ferrucci's *The Works of Michelangelo Studied by Painters, Sculptors and Architects* and Francesco Curradi's *Fame Elevates Michelangelo above All Other Artists* (both in Florence, Casa Buonarroti), see Vliegenthart, 1976, 158–65.

135 Orlandi, 1704, 108 (Cignani's style as "un perfettissimo estratto Correggesco, Tizi-

anesco, e Carraccesco") and 312; Orlandi, 1733, 146 (Torcelli colored flesh in "la maniera Baroccesca") and 398 (Bourdon sometimes worked in the Lombard style, sometimes in "la maniera Pussinesca"); Zagata, 1749, 199 ("lo stile Giorgionesca"), 213 ("si pellegrina maniera che assai tiene alla Baroccesca") and 218 ("sodo impasto che Tizianeggia"); and Panni, 1762, 44 ("un non sò che di Tizianesco e Raffaelesco").

136 Bologna (1982, 74–77) notes that the idea of a geographic "school" appeared as early as 1524 in a letter from Pietro Summonte to Marcantonio Michel; however, his "scuola veneta" is not polemicized in juxtaposition with another school as Vasari did, nor is it presented as one of a comprehensive and closed set of schools. For an excellent discussion of geographic classifications, see Perini, 1989a and 1989c.

137 Lanzi (1789) was the first to recognize that Agucchi "fu de' primi a compartire la pittura italiana in lombarda, veneta, toscana, romana." Cited in a thorough account of Agucchi's geographic schools by S. Ginzburg (1996, 274, 278–80, and 283–87), who draws important conclusions regarding the battle for linguistic superiority as the basis for discussions of pictorial schools.

138 Mahon, 1947, 246; this passage was quoted by Masini (1646, xlviii) and Bellori (1672, 330–31): "Appresso li Greci furono prima due le sorti della pittura; l'ellanica, overo greca, e l'asiatica. Da poi la greca si divise in due sorti, attica e sicionia, per l'autorità di Eupompo che fu sicionio; e crebbero tre sorti di pittura, attica, sicionia ed asiatica. Li Romani imitarono i Greci, ma ebbero anch'essi la loro maniera, e perciò quattro furono le maniere de gli antichi. . . . E per dividere la pittura de' tempi nostri in quella guisa che fecero li sopranominati antichi, si può affermare che la scuola romana, della quale sono stati li primi Rafaelle e Michel Angelo, ha seguitato la bellezza delle statue e si è avvicinata all'artificio de gli antichi. Ma li pittori veneziani e della Marca Trivigiana, il cui capo è Tiziano, hanno più tosto imitato la bellezza della natura che si ha avanti gli occhi. Antonio da Correggio, il primo de' lombardi, è stato imitatore della natura quasi maggiore, perché l'ha seguitata in un modo tenero, facile ed ugualmente nobile, e si è fatta la sua maniera

da per sé. Li toscani sono stati autori di una maniera diversa dalle già dette, perché ha del minuto alquanto e del diligente, discopre l'artificio: fra essi eccellentissimi sono Leonardo da Vinci ed Andrea del Sarto fiorentino. . . ."

139 Gigli, 1615, 60–64. For an excellent discussion of Gigli's "schools" especially in relation to Agucchi and to his self-proclaimed debt to Pliny, Giovio, Plutarch, and Suetonius, see S. Ginzburg, 1996, 283–84. For the afterlife of Agucchi's schools, see Mancini (1956, 1:327), who identified the geographic styles as Lombard, Tuscan, Venetian, Roman, and *oltramontana*. Domenichino noted in a letter to Francesco Angeloni that he had Agucchi's "*discorso*" at hand and was reflecting on the "maestri e maniere di Roma, di Venezia, di Lombardia, ed a quelli ancora della Toscana": published by Bellori, 1672, 371. Malvasia (1678, 2:219) analyzed the styles of Domenichino and Reni by reference to this canon. Scannelli discussed four schools (Tuscan-Roman, Venetian, Lombard, and German) (1657, 209–10, 232–34, 268–70). De Piles ("Goût des Nations," 1699, 538–44) identified them as Roman, Venetian, Lombard, German, Flemish, and French.

140 Mancini (1956, 1:128–29) took the psychology of the individual as evidenced in physiology and physiognomy and applied it to societies to explain the origin of regional styles. G. B. Passeri (1768, 121–24), not to be confused with the seicento Passeri, gave an even more complete (and completely wacky) account. Artists in the circle of Duquesnoy, Testa, and Poussin combined geography and historical periodization – another popular way to categorize style – as a means to identify the best ancient models; see Dempsey, 1988, xxxvii–lxv.

141 For the vexed issue of mistaking Poussin's interpreters for Poussin himself, see the brilliant work by Montagu (1992; and 1994, 11–15). Poussin's modes were adopted only in France, an almost too tidy tautology considering the French passion for standardization and hieratic structures. In addition to the considerable evidence assembled by Montagu (1992), see Roger de Piles (1708, 52–53), who divided painting styles into *stile élevé, stile familier*, and *stile pastoral*. Lacombe (1758, 222) divided Renaissance painting into four styles: the vig-

orous and bold; the weak and effeminate; the delicate and graceful; and the sweet and natural.

142 For an important discussion of Agucchi and Tasso's heroic poetics in relation to Poussin and Reni, see Colantuono, 1997, 174. See also Malvasia, n.d., 200; and Giraldi Cinzio, 1982, 147.

143 Faberio, 1603, 40.

144 Malvasia, 1678, 2:219 (preface to the life of Domenichino).

145 Bellori, letter to Carlo Dati, 16 March 1668; Previtali, 1976, xxxii, n. 4: "Le Vite de' Pittori che io vado scrivendo, non sono queste né di Romani, né d'altra particolar Regione, ma ne ho scelti alcuni pochi secondo il mio debile giudicio. Dubito nondimeno nel poco numero di essermi troppo accordato (?) per la scarsità (?) de' nostri tempi; e la mediocrità cosí nella pittura, come nella poesia non deve essere in istima." For a fascinating discussion of Bellori's supranational art history that, in fact, validates the centrality of Rome and antiquity, see Cropper, 1991, 155–73.

146 Le Brun, as reported by Félibien, ed., 1668, 100: "Que Raphael a donné [to Poussin] matière de discourir sur la grandeur des contours, sur la manière correct de les desseiner; sur l'expression naturelle des passions, & sur la façon noble de vestir ses figures. Que dans le Titien on a remarqué la belle entente des couleurs, & le vray moyen d'en trouver l'union et l'harmonie. Que Paul Véronèse a fourny de-quoy s'entretenir sur la facilité & la maîtrise du pinceau, & sur la grandeur de ses ordonnances de ses compositions."

✌

CHAPTER 6. MARCO BOSCHINI: THE TECHNIQUES AND ARTIFICE OF STYLE

1 Beal, 1984, 296: "'tis likely theyle be too licentious & improp. perche non siamo avezzati vedere persone in Aria as Monsr Poussin sd. . . ." The critique of Pietro da Cortona follows immediately; it may be assumed that this preamble applies as well. For Poussin's strolls with foreigners and friends, see Bellori, 1672, 451.

2 Boschini, 1660, 521–23. For the *maniera pelegrina* as a "wandering style," see Chapters 6 and 8. Boschini claimed that Cortona painted the Barberini ceiling immediately after re-

turning from his study of Venetian painting, particularly Tintoretto's ceilings. Most scholars do not take this view seriously, in part because Boschini muddled the chronology (transposing the visits of 1637 and 1644), but Vitzhum thought there was "some grain of truth": review of G. Briganti, *Pietro da Cortona* (Florence, 1962) in the *Burlington Magazine* 105 (1963): 216.

3 Boschini, 1660, 128 ("conceto de Piero Cortona amigo de' Veneziani"), 279 ("è molto amigo / Dela nostra maniera Veneziana"), and 588 ("E xe dei Veneziani un vero amigo"). See the following note for other references to Cortona.

4 Boschini, 1660, 578: "Pietro Cortona, / Ai nostri zorni celebre Pitor, / Quelo che ha'l Tentoreto in mezo al cuor." Boschini, having discussed "l'arte mostruose" of Tintoretto's *Moses fa scaturir l'acqua* (Venice, Scuola di San Rocco) and the stupefying style and artifice of Tintoretto's *Last Judgment* (Venice, Santa Maria dell'Orto), turned to Cortona for a validating view: 1660, 128 and 243. For Cortona's drawings of the sharply foreshortened nude in Tintoretto's *Discovery of St. Mark's Body* (Milan, Brera) as "a perfect intelligence," see 1660, 279. And for Cortona's admiration of Tintoretto's "dessegno" in general, see 1660, 315–16. For Cortona's appreciation of Veronese's "toco, e brilo del penelo," see 1660, 588.

5 Boschini, 1673, 750: "Et a questo proposito basta il vedere nello Scortinio, vicino al Gran Consiglio, la presa di Zara, rappresentata dal Robusto Tintoretto, ove le figure si vedono così fiere e con tant'arte colorite, che pare impossibile che non escano dalla tela. Oh, questi sì che sono movimenti spiritosi, che fanno le fiche alle Statue e terrore a gl'Uomini! e tanto basta. Ma questo artificioso Dissegno né qui pure si ferma, poiché in esso si contengono pur anco gli scorci, una delle più difficili parti del Dissegno, mentre più non serve la misura o la forma; anzi, pure con la difformità, deve l'occhio rimaner ingannato e deve la perfezione con l'imperfezione apparire. . . . E questo è un capo che distingue con carattere di superiorità il Pittore dallo Statuario; poiché lo Statuario può a suo bell'agio valersi delle misure, ed il Pittore forma senza forma, anzi con forma difforme, la vera formalità in apparenza; ricercando così l'Arte Pittorica."

6 For the *Carta* in the contexts of Venetian cul-

ture and Italian art criticism, see Pallucchini, 1966; Sohm, 1991; Merling, 1992.

7 For Boschini's epithets, see 1660, 22 and 224. For further discussion of Boschini's views on Vasari, see Sohm, 1991, 98–109; and Merling, 1992, 227–31. For further bibliography on the reception of Vasari, see above in Chapter 1, note 29. For their mandates, see Vasari, 1568, 3:4 (preface to part 2) and Boschini, 1673, 703.

8 Boschini, 1673, 752: "Dirò adunque che, sì come il Dissegno ha molti membri, così anco il Colorito si dilata in varie circostanze e particolarità; poiché questo alle volte si riceve per l'impasto, ed è fondamento; per la macchia, ed è Maniera; per l'unione de' colori, e questo è tenerezza; per il tinere, o ammaccare, e questo è distinzione delle parti; per il rillevare ed abbassare delle tinte, e questo è tondeggiare; per il colpo sprezzante, e questa è franchezza di colorie; per il velare, o come dicono sfregazzare, e questi sono ritocchi per unire maggiormente."

9 Boschini, 1660, 332.

10 Ibid., 351.

11 Ibid., 328: "Ma l'arivar ala maniera, al trato / (Verbi grazia) de Paulo, del Bassan, / Del vechio Tentoreto e de Tician, / Per Dio, l'è cosa da deventar mato."

12 Ibid., 361: "La machia veneziana è sì importante, / Che la fa zavariar i Forestieri."

13 Ibid., 374: "Talvolta int'una sola penelada / Con el color massizzo, sodo e duro, / I fa la meza tenta, el chiaro e'l scuro, / Che la par carne viva, verzelada. // Questi è colpi de Mistri de maniera, / Fati ala veneziana, e documenti / Dei nostri gran Pitori inteligenti, / Strada perfeta, singular e vera." See also 1660, 469: "E l'è stimà sì doto e cusì franco, / Per i colpi esquisiti de maniera, / Dintornà, destacà con furia vera, / Come del Tentoreto, e niente manco." And 68: "Là ghe xe manierosa maestria: / Ché'l colpizar xe l'Arte del saver." And 328: "Ma l'arivar ala maniera, al trato / (Verbi grazia) de Paulo, del Bassan, / Del vechio Tentoreto e de Tician, / Per Dio, l'è cosa da deventar mato."

14 Ibid., 120, 134, and 374.

15 For discussion of these terms, see Sohm, 1991, 149–53.

16 A possible reading of Boschini's techniques may have been found by Francesco Lana Terzi (1670, 160–61), a pupil of padre Kircher and a provincial polymath from Brescia, who classi-

fied brushwork into three categories: (1) *Unendo*, which is the uniting of wet pigments with a clean brush, as did Correggio, Raphael, and Leonardo; (2) *Tratteggiando*, which separates forms with lines or shades with crosshatching drawn with the tip of the brush, as did Michelangelo, Perino del Vaga, and Guido Reni; and (3) *A botte*, where the brush does not move evenly across the surface but jabs the canvas with quick, sharp strokes, as did Titian, Veronese and Tintoretto.

17 *Vocabolario degli Accademici della Crusca* (Florence, 1612), 496. The first of four meanings of *macchia* is: "Segno, che lasciano i liquori, e le sporcizie nella superficie di quelle cose, ch'elle toccano, o sopra le quali caggiono." The other three meanings are: "Per bosco folto, e orrido. Lat. *vepretum*. . . . E da questa macchia diciamo, immacchiare, e ammacchiare, che è nascondere della macchia.

"Diaciam Cavarne la macchia, che è il cavare di che che sia il più, che si può, facendo bene il fatto suo.

"Far che che sia alla macchia, è farlo nascostamente, furtivamente, come. Batter monete alla macchia. Ritrarre alla macchia, dicono i pittori, quando ritraggono, senza avere avanti l'oggetto."

18 Baldinucci, 1681, 86; quoted below in note 22.

19 *Vocabolario*, 1623, 485: "Segno, o tintura, che resta nella superficie de' corpi, diverso dal lor proprio colore, per qual si voglia accidente. Lat. *macula*."

20 For stained clothing, see Boccaccio, 1956, 133; V. Borghini, 1855, 303; Galilei, 1890, 8:493; Zuccaro, 1605, n.p. (127–28). For plague sores, see Boccaccio, 1956, 45; the physician–art critic Antonio Cocchi (1695–1758), 1791, 1:28'; and Muratori, 1721, 228.

21 See, for example, Vincenti, 1665, 373–74.

22 Baldinucci, 1681, 86:

MACCHIA f. Segno che lasciano i liquori, i colori, e le sporcizie, nella superficie di quelle cose, ch'elle toccano, o sopra le quali cadano. Lat. *Macula*.

I Pittori usano questa voce per esprimere la qualità d'alcuni disegni, ed alcuna volta anche pitture, fatte con istraordinaria facilità, e con un tale accordamento, e freschezza, senza molta matita o colore, e in tal modo che quasi pare, che ella non da mano d'Artefice, ma da per sè stessa sia apparita

sul foglio o su la tela, e dicono; questa e una bella macchia.

Macchia nelle pietre di vari colori, dicesi quel colore, che pare di sopra più a quello del fondo; e di qui chiamansi le stesse pietre macchiate, ed è una bella qualità di esse pietre, con la quale si rendono più vaghe.

A simiglianza di queste chiamansi macchie quelle diverse sorte di colore con le quali artificiosamente son macchiati i fogli, che si dicono marezzati.

E macchia significa bosco folto & orrido, e tal'ora semplice siepe. Lat. *Vepretum*.

E di quà, come che in tali macchie si nascondano, e fiere e ladroni a fare furtivamente loro malefizi, dicesi, fare che che [*sic*] sia alla macchia, per farlo nascosamente, furtivamente; così delli Stampatori, Monetieri, o Falsatori di monete, che senza alcuna autorità del pubblico stampano o lavorano, dicesi stampare, o batter monete alla macchia. Anche appresso i Pittori usasi questo termine ne' ritratti ch'essi fanno, senza avere avanti l'oggetto, dicendo ritrarre alla macchia, ovvero questo ritratto è fatto alla macchia.

23 It was only in the 1691 edition that the Crusca dictionary added to *macchia* its primary artistic meaning (*Vocabolario*, 1691, 3:977): "Abbozzo colorito de' pittori. Bembo, 3. Parendo la macchia, e l'ombra aver veduta, di belle, e convenevoli dipinture." The truncation of Bembo's sentence distorts his meaning, but for a particular end: it gives to *macchia* associations of appearance and possibly deception; by connecting it to "shadow" without telling us whether the shadow is one depicted in paintings or a technique of shading, it evokes ambiguity, a shadowy meaning. Because Baldinucci's associations with obscuring shadows and hence tenebrism did not surface in art-critical practice until shortly before he wrote the definition, the cautious Crusca academicians included this aspect only in their 1747 edition: *Vocabolario*, 1747, 3:67: "Macchia, si dice anche la Maniera dell'ombreggiare, o colorire de' pittori."

24 Vasari, 1568, 1:117: "Gli schizzi, de' quali si è favellata di sopra, chiamiamo noi [artists] una prima sorte di disegni che si fanno per trovare il modo delle attitudini et il primo componimento dell'opra; e sono fatti in forma di una macchia, ed accennati solamente da noi in una sola bozza del tutto."

25 Vasari used *macchia* in both its literal sense as "stain" and its figurative sense as "sketch." Despite Baldinucci's definition, by the seventeenth century *macchia* had largely lost its original meaning as stain; an exception is Andrea Pozzo's warning (1693–1702, sec. 10) to painters that in retouching their frescoes they can sometimes "make a stain of your work."

26 Sohm, 1991, 38. Onians (1998, 16) identifies Alberti as the seminal source that introduces "a natural tendency to see shapes when they were only vaguely suggested." He interprets it as a neuropsychological trait that is rewarded by natural selection and tries to explain progress in art by this means.

27 Sohm, 1991, 38–41.

28 Doni, 1549, 22: "Quando tu ritrai in pittura una macchia d'un paese, non vi vedi tu dentro spesse volte animali, uomini, teste, e altre fantasticherie. Anzi più nelle nuvole, ho già veduto animalacci fantastichi e castelli." See Sohm (1991, 35–41) for Dolce's and Lomazzo's discussion of *una macchia d'un paese*.

29 Sohm, 1991, 38–39.

30 Ibid., 42.

31 Boschini, 1660, 532–33.

32 Sohm, 1991, 43.

33 Boschini, 1660, 344–45: "Andrea Schiaon, vien qua con la to forza, / Vien qua con la bravura to infinita, / Con quel impasto che ha calor e vita; / Vien qua, te prego, e 'l mio parlar rinforza; // Ti, che con quele machie de virtù / Ti ha impresso quei carateri latini / Che fa zavariar dei Babuini, / Per non intender quel che importa più."

34 Ibid., 138. Tintoretto's *Baptism* (Venice, Scuola di San Rocco) shows how original sin (*machia original*) was washed away (137). And he called the old masters of the sixteenth century "jewels without blemish (*machia*) and without taint (*tara*)" (162).

35 Ibid., 375: "E che chi de imbratar colori teme / Imbrata e machia si medemi, e insieme / Resta l'opera al fin quasi che niente." A related contradiction appears several lines later: "Quasi che no i se fida dela scorta, / Che a so muodo de lori ghe fa strada; / I ha sempre qualche dubio, che machiada / Resta l'opera soa, palida e smorta."

36 Boschini, 1673, 750: quoted above in note 5. For further discussion of this passage, see Sohm, 1991, 155–57. One antecedent not mentioned comes from Ottonelli and Berret-

tini (1652, 245) where they discuss *pitture ridicole* that are artificial (*artificiose*), well designed, and show "la deformità non deformamente secondo l'avviso dell'Orator Romano. 'Regio ridiculi deformitate quadam continetur, quae designat turpitudinem non turpiter.' 2 de. Or[atore]." For a sociological reading of deformity in seicento art, see the important article by McTighe, 1993, 75–91. For perspective as deformity, see Massey, 1997, 1148–89. For a discussion of the phrase "beautiful deformity," used by Virgilio Malvezzi to describe Guido Reni's *Abduction of Helen*, see Colantuono (1997, 159–60), who rightly traces it back to G. B. Agucchi and G. A. Masani.

37 Boschini, 1660, 166, 302, 309, and 361.

38 Ibid., 373: "Se dela machia i savesse el valor, / I aplicarave tuto el so talento, / E studierave quel gran fondamento, / Né i ghe dirave machia, ma splendor."

39 Ibid.: "[C]hi no carga ugual, / Resta tute machiae quele figure. / Oh machie, che xe tante stele pure, / E forma el colorito natural!"

40 For the latter phrase, see Boschini (1660, 373) in the stanza following that quoted above in note 38: "Quel toco, quei bei colpi de penelo, / Quel botizar, quei strissi e descricion, / Che vien dal studio grando e cognicion, / Xe l'unico depenzer tanto belo."

41 For further discussion, see Sohm, 2000b. Boschini rarely made reference to the concealing function of *macchia*, and then only to hiding labor with the seemingly casual forms: "La [machia] dà de l'Arte i fondamenti veri, / Soto la qual sta ascose industrie tante" (1660, 361).

42 Scaramuccia, 1674, 95.

43 Sohm, 1991, 140–57.

44 Boschini, 1660, 98. For the text and a related discussion, see Chapter 1.

45 Boschini, 1660, 309.

46 Ibid., 302.

47 Zanetti, 1733, 10: "Il modo di adoperare il pennello che maneggio, o maniera si chiama." Gherardi, 1749, 105: ". . . nel maneggio del pennello, o sia nella maniera." A somewhat looser association of *maniera* with *maneggiare* or handling of colors can be found in Vasari's preface to the life of Domenico Puglio (1568, 4: 247) where he warned against indolent painters who rely on "[il] continuo esercitare e maneggiare i colori, per instinto di natura, o per un uso di buona maniera presa senza disegno alcuno o fondamento."

48 Mascardi, 1636, 237–46. He considered the stylus an "allegorical" object, for example, relating its sharp point to "a stinging and pungent composition" that can cut as effectively as a sword. By a progression of displacements (instrument – act of writing – form of letters – composition), he tried to connect stylus and style, but concluded that this was a barren route.

49 Filarete, 1972, 1:28: "Che se uno tutte le fabbricasse, come colui che scrive o uno che dipigne fa che le sue lettere si conoscono, e così colui che dipigne la sua maniera delle figure si cognosce, e così d'ogni facultà si cognosce lo stile di ciascheduno; ma questa è altra pratica, nonostante che ognuno pure divaria o tanto o quanto, benché si conosca essere fatta per una mano." Vasari, 1568, 4:4 (quoted in Chapter 4, note 2). For a discussion of the hand as a sign of individual style in fifteenth-century writing, see Warnke, 1982, 54–56; Kemp, 1987, 12–14.

50 For a recent, compelling study of the problematic status of the hand in the fifteenth-century struggle against prejudices of art as a craft, see Campbell, 1996, 267–95. For a conclusion based on a broader study of the hand, see Spear, 1997, 253–74: "In its simplest, old-fashioned pictorial meaning, it [the artist's hand] implied professional skill (*techne, ars*) and mimetic aptitude, that is, the acquired technical ability to draw and paint well."

51 Published and discussed by Baxandall, 1963, 320–21.

52 Paggi, in a letter to his brother Girolamo (Bottari and Ticozzi, eds., 1825, 6:74): "E, cominciando dall'imbrattarsi le mani, dico che non è necessario toccare i colori con le mani, ma che quando vengano tocchi, più per disgrazia che per bisogno, pregiudica tanto alla nobilità dell'arte, come l'inchiostro alla nobilità delle leggi, se, mentre un dottore scrivegli vien tocco, o sia per caso, o per volontà; come pregiudica alla nobilità del cavaliere, se il cavallo, nel maneggiarsi, o con ispuma o con sudore, o con far saltare il fango addosso al padrone, in qualche modo lo imbratti." In his letters Paggi used the terms *meccanica* and *servile* interchangeably with *manovale*. For discussions on Paggi as a painter and the unfortunate events that led to the "Disputa," see Renzi Pesenti, 1986, 9–22; Lukehart, 1993, 37–57.

For the most complete and sophisticated consideration, see Lukehart, 1987.

53 This is Federico Zuccaro's description of Lombard painting in general, but it applies particularly well to Paggi's work; in an undated letter to Antonio Chigi (in Bottari and Ticozzi, eds., 1825, 7:511): ". . . il tutto fatto con tanta facilità, che si crederebbe piuttosto fatto col fiato che col pennello."

54 Boschini, 1673, 712: "Ma il condimento de gli ultimi ritocchi era andar di quando in quando unendo con sfregazzi delle dita negli estremi de' chiari, avicinandosi alle meze tinte, ed unendo una tinta con l'altra; altre volte, con un striscio delle dita pure poneva un colpo d'oscuro in qualche angolo, per rinforzarlo, oltre qualche striscio di rossetto, quasi gocciola di sangue, che invigoriva alcun sentimento superficiale; e così andava a riducendo a perfezione le sue animate figure. Ed il Palma mi attestava, per verità, che nei finimenti dipingeva più con le dita che co' pennelli."

55 Sacks, 1990, 20. By style, Sacks means "artistic skill," "aesthetic and artistic feeling," and "personal (and artistic) identity." Robert Storr (1995, 50–53) cited Sacks in order to argue that Willem de Kooning's late works still maintained a psychic and artistic integrity despite the progressive neurological disorder that afflicted the artist at the time.

56 The first quote appears in a letter of 24 October 1542 to an unnamed prelate: Buonarroti, 1965, 4:150. The second quote comes from the opening stanza of the sonnet: "Non ha l'ottimo artista alcuna concetto." This sonnet has a long history of interpretation, starting most famously with Benedetto Varchi's lecture read to the Accademia Fiorentina in 1547: *Due Lezzioni . . . nella prima delle quale si dichiara un sonetto di M. Michelangelo Buonarroti. Nella seconda si disputa quale sia piu nobile arte la scultura, o la pittura* (Florence, 1549). The most complete discussion of its meanings can be found in Summers, 1981, 203–33.

57 For two fascinating surveys of the hand in art criticism, see Warnke, 1987, 55–61; and Spear, 1997, 259–65 (chapter: "Di sua mano"). For a richly documented but conceptually sloppy history of the dichotomies of touch in early modern religious and philosophical literature, see M. O'Rourke Boyle, 1998. For further discussion of the hand and style, see Sohm,

1999 (from which much of this section derives).

58 For Dürer's *Self-Portrait* and Joachim Camerarius's discussion of Dürer's *divinae manus*, see M. Kemp, 1989, 41–42; but especially Koerner, 1993, 149–52. For Poussin's *Healing of the Blind*, see Fumaroli, 1994, 176.

59 Descartes, *La Dioptrique*, Discourse VI, "De la Vision." This passage is discussed in relation to Poussin's *Healing of the Blind* by Cropper and Dempsey, 1996, 211–12.

60 See the fascinating articles by Pardo, (1993, 62) and Jacobs (2000).

61 For the identification of touch and sculpture, see Cropper and Dempsey, 1996, 213–15.

62 Colaccio, 1486, n.p. (letter to Canozzi da Lendinara, makers of the Santo intarsie). Seventeenth-century viewers responded to Carlo Dolci's miniaturist style in much the same way: Baldinucci, 1681–1728, 5:335–37. Dolci's depictions of "every single wrinkle, every turn of the hair and the most tiny ligature" required confirmation by the hand that it was painted and not real ("che la mano stessa del riguardante debba all'occhio servire per testimonio verdico che elle sieno dipinte e non vere").

63 Boschini, 1660, 302–3: "Quando per questo mi son stà a Bassan, / Procurete d'aver bona licencia / D'inzegnochiarme con gran reverencia / Su quel Altar, per tocar con le man // Quei colpi, quele machie e quele bote, / Che stimo preciose piere fine, / Perle, rubini, smeraldi e turchine, / Diamanti, che resplende fin la note. . . . // Ma queste serve più per confusion / A chi le guarda, e che le vede apresso, / Perché ognun dise alora: mi confesso, / Che qua no ghe comprendo distincion."

64 Ficino, 1989, 125 (*De vita*, 1.7).

65 Danti, 1567, 1:225, but see also 228–29: "Tutte le membra, dico delle quali é composto il corpo umano, sono fatte al servizio dei sensi esteriori e interiori; et i sensi esteriori al servizio degl'interiori; e gl'interiori al servizio dell'intendere." For a discussion of the hierarchy of the senses, see Summers, 1987.

66 Varchi, 1549, 2:618–19: "In due modi e per due cagioni non obbedisce la mano all'intelletto, o perché non è esercitata e non ha pratica, e questo è difetto del maestro; o perché è impedita da qualche accidente . . . E questo è difetto della fortuna o d'altri che del

maestro; ma in qual si voglia di questi duoi modi, non si possono esercitare in modo che ben vada l'arti manuali, perché la mano è lo strumento delle arti." See also Varchi, 1549, 1: 28 and 31–32. For a discussion of Varchi's metonymic use of the hand to signify artistic practice or execution, see Mendelsohn, 1982, 100–102.

67 Quoted by Mendelsohn, 1980, 102. Varchi excluded Michelangelo from this human limitation.

68 Williams, 1997.

69 Quoted by Klein and Zerner, 1989, 171; and Spear, 1997, 267.

70 Bellori, 1672, 454: "Ma perché nella nostra umana vita non si trova intiera felicità, questi beni venivano interrotti dalle indisposizioni del corpo che spesso lo travagliavano: aveva egli un tremore e battimento de' polsi che gl'impediva il disegnare, e per questo alcuni suoi disegni non hanno li tratti molto sicuri e paiono fatti da mano tremante. Con l'età s'indebolì poi maggiormente la mano, che al dipingere trovava impedimento."

71 Baldinucci, 1681–1728, 6:46; see also Migliore (1684, 437), who noted that artists must have "obedient" hands. For the hand as "servant of the mind" in gestural communication, see Du Fresnoy, 1684, p. 127, n. 165.

72 Baldinucci, 1681–1728, 6:471 (letter to Vincenzo Capponi).

73 Boschini, 1673, 704. In the introduction of the "Breve instruzione" called "Various Ways to Understand the Styles of Venetian Authors [i.e., artists]," he listed the various parts of painting that need understanding. With the exception of emotions (*affetti*), all are formal. *Macchia* appears on the list framed by *impasto* and *tocco* (touch), by material globs of paint and by the physical act of applying paint.

74 Sohm, 1991.

75 Spear, 1997, 253–74.

76 For example, Tintoretto assured the fathers of the Gesuiti in Venice that he could paint in Veronese's style (*stile*) so successfully that they would imagine it to be done "by his hand" (*di -sua mano*): Ridolfi, 1648, 2:38; cited along with other examples by Spear, 1997, 259, 269, and 273.

77 For Mancini, see Mahon, 1947, 32–38 and 279–331; Salerno, 1951, 26–39; Salerno, 1956, 9–17 (as well as Salerno's introduction to Man-

cini, 1956); Hess, 1968, 103–20; and C. Ginzburg, 1983.

78 Mancini, 1956, 1:134. For histories of connoisseurship as an inspection of brushwork and handwriting, see C. Ginzburg, 1983; Montagu, 1989, 99–103; Sohm, 1991, 63–87; Spear, 1997, 254–55. For style and drapery, see Boselli (1978, fol. 11; and 1994, 89), who located the *maniera grande* in three places: anatomy (bones, muscles, and veins), drapery folds, and hair; Baldinucci (1681–1728, 6:478; letter to Vincenzo Capponi), who found individuality of style in the *aria* of heads and in drapery folds and hair, "perché queste qualità di cose dependono da certe minutezze di particularissimo gusto"; and Zanotti (1756, 15), who discussed the style of Nicolo dell'Abbate in relation to figural poses, drapery folds, and hair. For further discussion of the location of style, see Chapter 7.

79 In the "Termes de peinture," 1667, an unsigned work and de Piles's first, appended to Du Fresnoy's *De arte graphica* (Paris, 1667); edition cited: 1684, n.p.: "*Manière*. Nous appellons Manière l'habitude que les Peintres ont prise, non seulement dans le maniement du pinceau; mais encore dans les trois principales parties de la Peinture, Invention, Dessin & coloris." Lacombe (1758, 222) adopted de Piles's definition for his own dictionary: "La *Maniera*, ed abitudine del Pittore fassi conoscere non solo nel maneggiar del pennello, ma eziandio nelle principali parti della Pittura, come l'Invenzione, il Disegno, il Colorito."

80 De Piles, 1699, 96: "En effet, il y a des Tableaux faits par des Disciples, qui ont suivi leur Maîtres de fort près, & dans le savoir, & dans la manière. On a vû plusieurs Peintres qui ont suivi le Goût d'un autre Pais même, ont passé d'une maniére à une autre, en changeant ainsi & en cherchant une maniére particuliére, ils ont fait plusieurs Tableaux fort équivoques, & dont il est difficile de déterminer l'Auteur. Néamoins, cet inconvénient ne manque pas de remède pour ceux, qui, non contens de s'attacher au charactére de la main du Maître, ont assez de pénétration pour découvrir celui de son Esprit; un habile homme peut facilement communiquer la manière dont il exécute ses Desseins: mais non pas la finesse de ses pensées. Ce n'est donc pas assez pour découvrir l'Auteur d'un Tableau, de connoître le mouvement du Pinceau, si l'on ne pénétre dans celui de l'Esprit: & bien que ce soit beaucoup d'avoir une idée juste du Goût que le Peintre a dans son Dessein, il faut encore entrer dans le caractére de son Génie. . . ."

81 Boschini, 1660, 330–31: "Oh strada mile volte gloriosa, / Che rapresenta superficialmente / Con machie de colori e vaghe tente / La Natura! oh maniera artificiosa!" The painter Francesco Paglia (1713, 1:181–82), pupil of Guercino and reader of Boschini, wrote of forming *macchie* with the artificial brush: "Et dall'osservation di si belle maniere, et modi industriosi di botteggiare con sprezzatura di machie formate d'artificioso pennello, che non regolate forme di Disegno et di colorito, dimostrano naturalezza, e proportion."

82 Ibid., 351: "Quel degno Salviata Isepo Porta / Ha seguì la maniera generosa / Ha esercutà la machia artificiosa, / Tramontana del 'Arte vera scorta."

83 Ibid., 332: "La machia adonca nasse de maniera, / El trato d'artificio de dotrina."

84 Ibid., 74: "E questa xe fondà sui spegazzoni / (A dir co' dise quel tal bel inzegno); / Ma quei gran spegazzoni e quel dessegno / Chi non intende, è gofi e babioni. // Quela xe una maniera artificiosa, / Che trà la diligenza int'un canton; / Quela xe quela che dà perfezion, / E la Pitura fa miracolosa. // Perché chi non intende l'artificio, / E che da presso vede quei spegazzi, /I resta come torsi, i meschinazzi."

85 Boschini, 1673, 753: "E questi primi abbozzi e lineamenti li scaturivano dal loro ideale intendimento, senza valersi del Naturale, né tampoco delle Statue, né da Rillievi, ed in ciò la cura loro maggiore era il concertare il dentro ed il fuori."

86 Boschini, 1660, 109: "Quel altro, che la testa porze avanti, / Butà per tera con la panza in zoso, / L'è un scurzo sì bizaro e artificioso, / Che quasi l'è el più bel de tuti quanti. // . . . E per questo chi studia ste figure, / E che le vede come el natural, / No capisse quel muodo artificial; / Né intende quei dintorni e positure." G. B. Volpato (n.d., fol. 259; Bordignon Favero, 1994, 421), following Boschini's lead in this as he did with so much else, praised "la maniera artificiale" of Tintoretto and his hero, Jacopo Bassano. For contrasts of artifice and nature, see also Volpato, n.d., 363 and 259; Bordignon Favero, 1994, 218 and 421.

87 Aristotle, *Rhetoric*, 3.1.7. Of course, by style

Aristotle meant something more restrictive than most of the art writers cited here. In addition to the examples discussed below, see Marino, *Lettere*, 61 (where *artificio* is identified syntactically with *maniera* and *stile*). Ridolfi, 1648, 2:18: "Quindi è, che il Tintoretto è degno di molta lode, perche seppe valersi delle cose studiate e ridurle nella via sua, formando una maniera artificiosa e ripiena di molte bellezze, onde viene ammirato e riverito da' Professori." Scannelli, 1657, 298 ("artificio di maniera"). Algarotti, 1756, 84–85: "Uno artefice che per lungo tempo avesse fatto suoi studi sopra un così fatto modello, già non prenderebbe a violare con l'artifizio della maniera le bellezze della natura, non darebbe in quella vaghezza e floridità di tinte che tanto è oggigiorno alla moda, non di rose nutrirebbe le sue figure, come argutamente esprimevasi quel Greco, ma di carne bovina." Paleotti (1582, 311) argued for the supremacy of the subject over those matters that please artists: "per la nobiltà dello artificio, per la eccellenza del disegno e maniera meravigliosa." The syntax of this sentence, with its repeated prepositional phrases (for . . . for . . .) suggests that Paleotti thought that *artefcio, maniera*, and *disegno* were closely aligned, if not interchangeable. Sforza Pallavicino (1662 [not 1994 ed.], 21) discusses "l'artificio dello stile" as a subject separate from style's expressive functions.

88 Bellori, 1672, 627–28. For quotation and discussion of this passage, see Chapter 2. Boschini, 1660, 10–11 (quoting a letter to him by Giovanni Francesco Loredano, 23 May 1660): "La carta di navigar di V.S. Molto Illustre m'ha condotto in un Mare di grazie. Averei creduto di patir naufragio tra tanti Venti, se la sua Virtù non m'avesse servito di Bossolo e di Calamita. . . . La prego a compatirmi, se non lodo lo stile, l'Artificio, la spiegatura e i Concetti; perché mi mancano l'espresioni per maniere così delicate. Non v'è cosa più facile della lode: è un Incenso, che non occorre navigare l'Arabia per guadagnarne abbondanza."

89 Barocchi, ed., 1994, 44. Vasari and his contemporaries praised visible and prominent artifices, mostly concerning complicated or expressive figural poses or movement. Summers's discussion of this is still fundamental and unsurpassed; see especially 1981, 41–96, 164–85, 234–41.

90 Danti as quoted Rossi, 1980, 126. Scannelli, 1657, 12: Raphael is the liver of painting be-

cause he extracts the impurities of nature and transforms it into art. Raphael handles sculpture in a similar way: "Rafaello cava a proportione dalla durezza de' sassi, e bronzi nelle statue il sottile, e delicato dell'artificio, tracangiato nella propria delicatezza di buona Pittura. Il fegato, quindi formato, e riformato, che hà se stesso. . . ."

91 Armenini, 1587, 110 and 178. Gilio da Fabriano (1564, 46–48) criticized Michelangelo's foreshortenings as a form of excessive artifice. For the artifice of foreshortenings, see also Landino, 1974, 1:124; paraphrased by Antonio Billi, 1991, 86.

92 Armenini, 1587, 175–77. Superbi (1620, 121–22) described the foreshortened figures in the dome of Santa Maria del Monte (Galasso's *Assumption of the Virgin*) as "molto artificiose." Bellori (1673, 338) praised Domenichino for overcoming this problem. I would like to thank Richard Spear for bringing this reference to my attention.

93 Scannelli, 1657, 89, 122–23 and 222.

94 Bellori, 1672, 59 (the perspective effects of the Farnese Gallery make it an *opera artificiosa*), 72 and 448 ("con sommo artificio di prospettiva").

95 G. B. Adriani, "Lettera," in Vasari, 1568, 1: 209: "Questi [statues by Iolpo in Syracuse] il primo [un zoppo] molto più artificiosamente e con maggior sottiglezza ritrasse ne' corpi le vene et i nervi et i capegli, e ne fu molto commendato." Marino, 1615, 98: "Volete dilicatura maggiore? e come potevano con più esquisito artificio o con più accurata sottilità esser dal suo diligente pennello organizate?" For a discussion of this passage, see Besomi, 1969, 137–40. Baldinucci (1681–1728, 5:335–37) tried to explain Carlo Dolci's unfashionable attention to detail (wrinkles and curls) by reference to artifice.

96 Baldinucci, 1681–1728, 5:335–37.

97 The quote is from Marino (1615, 90): "Nella parte finalmente che pertiene alla diligenza o applicatione, dee l'accorto pittore ogni studio impiegare nell'opere sue e con ogni accuratezza limarle. Non già ch'elleno abbiano con sì fatta industria a leccarsi che ne riescano ricercate, imperoché non vogliono esser polite con istento, ma agevolate con franchezza, o quando pure stento vi sia, non ha egli da apparire, anzi sotto una artificiosa negligenza da nascondersi." Marino was reciting a critical topos:

Pliny, *Natural History* 35.36.80; Cicero, *Orator* 22.73; Castiglione, 1528, lib. I, cap.xxviii, 64; Dati, 1667, 124–25. For a study of diligence in seventeenth-century criticism, see Muller, 1985.

98 Aristotle, *Rhetoric* 3. 2. 4–5 and 3. 7.10; Seneca, *Controversiae* 10.14; Quintilian, *Institutio oratoria* 4. 1. 57; 4. 2. 127; 12. 9. 5; Dionysius of Halicarnassus, *De Isaeus* 16 and *De Lysias* 8; Cicero, *Orator* 77–78. For a discussion of the Renaissance usage of the concept, see D'Angelo, 1986. For Castiglione's *sprezzatura*, see Sacccone, 1979, 34–54.

99 Cosimo Bartoli, *Ragionamento sulla lingua*; quoted in Corti et al., 1981, 191: "Per questo soleva già dire il nostro Michelagnolo Buonarroti, quelle sole figure esser buone, de le quali era cavata la fatica; cioè condotte con si grande arte, che elle parevano cose naturali, e non di artifizio." Michelangelo did not identify his own art as that which is "good," but this may be assumed. Summers (1981, 507, n. 8), following Steinmann (1930, 74), who assigned the quote to Doni (*La libraria*) and to Gelli (*Ragionamenti sopra la difficultà*). Gelli (1551, 481) claimed that Michelangelo used to say that the best single figures are those that have labor removed, that is, are made with such great art that they appear to be works of nature, not artifice ("quelle sole figure esser buone delle quali era cavata la fatica; cioè condotte con sì grande arte che elle parevano cose naturali, e non di artifizio").

100 Dolce, 1557, 149.

101 Lomazzo, 1590, chaps. 37 and 38. See especially the paragraph titled "Arte non dee esser mostrata nell'arte" (1590, 355), which includes the following observation: ". . . perché non v'è cosa peggiore nell'arte che mostrare l'arte nell'arte, la quale tutto al contrario vuol mostrare che in lei non è l'arte, ma l'istessa natura, sí come con ogni studio cercava di far fra gli antichi Apelle." Of the moderns who "follow this part of hiding art," he lists Raphael but not Michelangelo, who demonstrates knowledge of anatomy. See also Lomazzo, 1590, 308 ("L'artificio di asconder l'arte"). Scannelli (1657, 16–17) quoted from Lomazzo's *Idea* to authorize his view that Raphael hid more art than Michelangelo and hence had the superior "artifice" of *sprezzatura*.

102 As reported by Baldinucci, 1681–1728, 3:46: "Questo [a drawing by Pagani of Aurora and Cephalus] piacque all'amico [Carducci], ma parvegli troppo artifizioso, onde con prime lettere gli ebbe a dire: Gregorio se voi michelagnoleggiassi alquanto manco, voi sareste qua invidiato all'ultimo segno."

103 Bellori, 1672, 229–30: "Professavasi egli [Caravaggio] inoltre tanto ubbidiente al modello che non si faceva propria né meno una pennellata, la quale diceva non essere sua ma della natura; e sdegnando ogn'altro precetto, riputava sommo artificio il non essere obligato all'arte." For the phrase "anti-Michelangelo," see Carducho, 1633; in Longhi, 1951, 50–51.

104 Tesauro, 1654, 93 and 95: "L'ultimo Furore è quel de' MATTI; iquali meglio che i sani (chi lo crederebbe?) sono conditionati à fabricar nella lor fantasia metafore facete, & simboli arguti: anzi la *Pazzia* altro non è che Metafora, laqual prende una cosa per altra. Quinci ordinariamente succede che i Matti son di bellissimo ingegno. . . . Queste erano adunque Argutie spaventevoli, & metafore filebilmente ridicole: imitate dapoi da' moderni poeti nella *Pazzia di Orlando*, & di *Armida*: dove tu odi tanti spropositi à proposito; che sicome avviene de' *Grilli* de' Pittori; nulla è più artifitioso che peccar contra l'arte: nulla più sensata che perdere il senno." See also Tesauro, 1654, 466: "Nondimeno (come si avvisò il nostro Autore [Aristotle]) quando sia fallo voluntario; que' vitij grammaticali divengono virtù; & le sciocchezze, artificij: nel modo che il Pittore, non pecca contra l'arte, se à data opera pecca contra l'Arte; alterando le proportioni per bel capriccio, peroche quella non è ignoranza, ma imitatione dell'ignoranza." For the most comprehensive recent work on Tesauro, see Frare, 1991, 33–63. For similar paradoxes regarding artifice and the imagination in Berrettini's and Ottonelli's *Trattato della pittura e scultura* and in Sforza Pallavicino, see Casale, 1997, 115–16.

105 Vasari, 1568, 6:166 (for a quotation and discussion of this passage, see Sohm, 1991, 51–53).

106 Sohm, 1991, 139 and 143–44.

107 Ibid., 43–53 (on the corrective functions of viewing distance) and 141 (for references to the following paragraph).

108 Boschini, 1673, 725–26: "Questo gran Classico [Bassano] dunque è stato di così fiero colpo di pennello, che certo in simile maneggio non ha avuto pari e, a differenza

d'ogn'altro, sprezzando la diligenze e la finitezza, con un Caos (per così dire) de colori indistinti e miscugli di confusione, che da vicino e sotto l'occhio rassembrano più tosto un sconcerto, che un perfetto artificio . . . ma scostandosi in debita distanza, l'occhio e l'orecchio dell'Intelletto restano paghi, e godono la più soave armonia che render possa un ben accordato instrumento. . . . E di questo ne fa chiara fede la Tavola dell'Altare in San Giorgio Maggiore, ove si vede questa Istoria rappresentata in modo che lingua umana non la può descrivere: nulla di meno imperfettamente dirò, che chiunque capita a vedere detta maraviglia resta abbagliato da quei lucidissimi splendori che scintillano dal Bambino Giesù, i quali lumeggiano tutto quel pastorale concerto. . . . Ma chi poi va da vicino a quel Pargoletto Redentore resta così fieramente confuso, sparendogli dall'occhio quello che in distanza formava quel Bambino, vedendolo tutto abbagliato ed incomprensibile, non discernendo più né sostanza, di modo che, quasi temendo d'aversi inavertentemente troppo avicinato a quella rappresentante Divinità, scostandosi alquanto, ritorna allora a vedere la perfezione che di già aveva veduta, non potendosi acquetare di far stupori e meraviglie."

109 This is Michelangelo's view of Donatello's *Cantoria*, as reported by Condivi, but it can stand in for traditional critical views of Tintoretto and the late works by Titian (for which, see Sohm, 1991, 46–52.)

110 Crusca *Vocabolario*, 1612, 496 (quoted in note 17).

111 Paleotti (1582, 311) observed that one does not tolerate forged money simply because it is well minted and made with artifice.

112 Crusca *Vocabolario*, 1612, 496 (quoted in note 17).

113 Baldinucci, 1681–1728, 3:76–77: "Hanno [drawings by Andrea Boscoli] anche [in addition to 'una franchezza e bravura di tocco'] in sè una certa vaghezza cagionata da alcune risentite macchie e attitudinati con disinvolutura e scioglimento di parti, che dà altrui nell'occhio assai, questo però cagiona in loro il difetto di potersi dire alquanto ammanierati. . . . [Se] il Boscoli non si fosse tanto invaghito di quella sua maniera di toccare risentita e sciolta che fece sì che nell'opere grandi discostandosi alquanto dal naturale e dal modo

di colorire degli altri pittori, riuscisse alquanto crudo, sarebbero l'opere sue tenute in maggior pregio."

114 Baldinucci, 1681–1728, 4:552–53: "Fece egli nondimeno in questo tempo [1619, at the time of his father's death, which produced in him a 'disordine'] alcune pitture, nelle quali non mai abbandonò una certa sua maniera diligente, nè tampoco il naturale. . . . Trattennesi anche in tal tempo, con qualche utile, a fare piccolissimi ritratti di femmine sopra rame, in quel modo, che noi dichiamo *alla macchia*, e talvolta dal naturale, come anche fare si costuma in questi nostri tempi da alcuni, per compiacere a certa sorta di persone, le quali, coll'opporsi poi a guisa di specchia concavo al raggio delle proprie pupille quel debole ed offuscato metallo. . . ."

CHAPTER 7. FILIPPO BALDINUCCI: CATALOGING STYLE AND LANGUAGE

1 Baldinucci, 1681, 88: "Maniera f. Modo, guisa, forma d'operare de' Pittori, Scultori, o Architetti. Intendesi per quel modo, che regolarmente tiene in particolare qualsivoglia Artefice nell'operar suo; onde rendesi assai difficile il trovare un'opra d'un maestro, tutto che diversa da altra dello stesso, che non dia alcun segno, nella maniera, di esser di sua mano, e non d'altri: Il che porta per necessità ancora ne' maestri singularissimi una non so qual lontananza dall'intesa imitazione del vero, e naturale, che e tanta, quanto è quello, che essi con la maniera vi pongono del proprio. Da questa radical parola, maniera, ne viene ammanierato, che dicesi di quell'opre, nelle quali l'Artefice discostandosi molto dal vero, tutto tira al proprio modo di fare, tanto nelle figure umane, quanto negli animali, nelle painte, ne' panni, e altre cose, le quali in tal caso potranno bene apparir facilmente; e francamente fatte; ma non saranno mai buone pitture, sculture, o architetture, nè avranno fra di loro intera varietà; ed è vizio questo tanto universale, che abbraccia, ove più ove meno, la maggior parte di tutti gli Artefici."

2 The opening of his definition ("Modo, guisa, forma d'operare de' Pittori, Scultori, o Architetti") takes three synonyms intact and in sequence from the Crusca *Vocabolario* ("Modo,

guisa, forma") and fuses them it with a variation on the third Crusca meaning ("Per una certa qualità, modo di procedere"): *Vocabolario*, 1612, 507, s.v. *maniera*: "Modo, guisa, forma. Lat. *modus, pactum, ratio*.

"Per ispezie, sorta. Lat. *species, genus*.

"Per una certa qualità, modo di procedere. Lat. *institutum, natura*.

"Per usanza costume." The Latin etymology cited for *modo* is *modus*. Among its many meanings, *modus* could signify a manner of speaking or performing: Cicero, *De oratore* 3.117; Cicero, *Topica* 54; Tacitus, *Dialogus* 26.2. It could also indicate the part of speech in rhetoric that deals with manner: Cicero, *De inventione* 1.41; Quintilian, *Institutio oratorio* 5.10.52. Underlying the performative aspect of *modus* and *modo di procedere* may be Aristotle's identification of style with delivery: *Rhetoric* 3.1.5. By eliminating the Latin etymologies, Baldinucci reduced the complexity of *maniera* and rendered any distinction between *moda, guisa,* and *forma* more difficult to decipher. After the publication of the Crusca *Vocabolario*, the phrase "modo d'operare" became a popular tag for style. Its use by authors ranging widely in taste and artistic outlook (Giulio Mancini, Carlo Ridolfi, Francesco Scannelli, Paolo del Sera, Orfello Boselli, Marco Boschini, Giambattista Passeri, G. P. Bellori, Sebastiano Resta, and G. P. Zanotti) is testimony to the influence and canonical status of the Crusca *Vocabolario*. Its use also suggests that the meaning of style had shifted toward technique (style as execution; style as practice) and somewhat away from its earlier connections with talent, character, and imitation. This semantic shift is epitomized by Baldinucci's omission of the Latin roots of *institutum* and *natura*.

3 The Crusca *Vocabolario* cites *modus* as the Latin etymology for *modo*. G. B. Gelli (1549, 13–14), in discussing how "quella maniera . . . chiamata Greca" involves a repetition of figures and expression, says that the artists "seguirono questo modo del fare." Vasari (1568, 4:249) noted that Domenico Puligo "tenne sempre il medesimo modo di fare e la medesima maniera che lo fece essere in pregio." Ridolfi (1648, 1: 384) opened his life of Jacopo Bassano: "Non sono, che veramente degni di lode coloro, che oltre le numerose maniere ritrovate da gli eccellenti Pittori, han saputo inventar nuovi modi di ben dipingere. . . ." Boselli (1978,

98v–99r; 1994, 89) wrote: "Si dice maniera il modo dell'operare. . . ." Bellori (1672, 217) wrote of Caravaggio: "E s'inoltrò egli tanto in questo suo modo di operare, che non faceva mai uscire all'aperto del sole alcuna delle sue figure, ma trovò una maniera di campirle entro l'aria bruna d'una camera rinchiusa. . . ." For similar examples, see also Scannelli, 1657, 12 and 115; Passeri, 1673–79, 12–13; Bellori, 1672, 529; Sera, in Fileti Mazza and Gaeta Bertelà, 1987, 338 (letter of 13 June 1665 to Leopoldo de' Medici); Boschini, 1673, 703; Malvasia, 1678, 2:67; Scaramuccia, 1674, 65; Zanetti, 1733, 10; Zanotti, 1739, 2:297–98. Mengs, in a letter to A. Pons (*Opere*, 2:40–41), acknowledged style as making (*atto pratico* and *esecuzione*) to be its dominant meaning but sided with the alternative presented by Baldinucci and located style in the works themselves: "il modo di essere delle Opere di Pitture." Like Baldinucci, Mengs then proceeded to define style by its attendant qualities, which, however, are predominantly aesthetic in nature: *sublime, bello, grazioso, significante, naturale*. Miedema (1978–79) largely restricted his references to Vasari and did not mention those writers cited here. For style as "modo di dire" in poetics, see Lombardelli, 1598, 141. For style as "forma di dire," see Barbaro, 1557, 2: 381 and 449; Lombardelli, 1598, 133–35; Bartoli, 1646, 389–90.

4 Baldinucci, 1681, ix.

5 Sohm, 2000a.

6 For Baldinucci's admission to the Accademia della Crusca under the name of "Il Lustro," see Parodi, n.d., ii–x. For a thorough biography of Baldinucci that is especially attentive to his curatorial activities, see Goldberg, 1988.

7 See in Chapter 1, "Style as Symbolic Form" and note 29.

8 Baldinucci, 1681–1728, 1:9–10 and 5:342; Goldberg, 1988, 52–53 and 103–4.

9 F. S. Baldinucci, 1981, 2:12. For Baldinucci's collecting and curating for Leopoldo, see Barocchi, 1976, 14–25; Goldberg, 1988, 57–59.

10 G. Cinelli Cavoli, 1716, 60–61: "Questo Dialogo [*La Veglia*] stampato sotto nome di Sincero Veri, è di Filippo Baldinucci; al quale, per essere aggregato alla Celebre Accademia della Crusca, direi, che molto mal si serve delle regole della toscana favella; mentre doveva dire, a mio credere, VEGGIA, e non *Veglia*." For Cinelli's *Biblioteca volante*, see Ricuperati, 1982,

926. For Cinelli and Baldinucci, see Previtali, 1964, 59–61; Goldberg, 1988, 133–53.

11 F. Baldinucci, "L'Autore a chi legge," in 1681, n.p.; Parodi, n.d., pp. i–xxxiii; Goldberg, 1988, 110–13.

12 De Piles, in Charles Du Fresnoy, *De arte graphica*, Paris, 1673. For the simultaneous presentation of form and style, treating them as synonymous, see also Marino, 1911–12, 259 ("Per quel che concerne i particolari, non nego d'avere imitato alle volte, anzi sempre in quello istesso modo, se non erro, che hanno fatto i migliori antichi e i piú famosi moderni, dando nuova forma alle cose vecchie o vestendo di vecchia maniera le cose nuove."); Ridolfi, 1648, 2:384 ("Non sono, che veramente degni di lode coloro, che oltre le numerose maniere ritrovate da gli eccellenti Pittori, han saputo inventar nuovi modi di ben dipingere, essendo facile ad ogn'uno, benche di mediocre ingegno, il seguir le orme dagli altrui piedi calcate, come lo inventar novelle forme fù sempre da grandi e pellegrini intelletti."); Boschini, 1660, 105 ("oh che forme, oh che maniera").

13 Warnke, 1982, 54ff.; Kemp, 1987, 5–13.

14 Bassi, 1946, 150 (quoting the founding academy's statutes).

15 Lanzi, 1789, 1:14: "La natura per sicurezza della società civile dà a ciascuno nello scrivere un girar di penna, che difficilmente può contraffarsi o confondersi del tutto con altro scritto. Una mano avvezza a moversi in una data maniera tien sempre quella: scrivendo in vecchiaia divien più lenta, più trascurata, più pesante; ma non cangia affatto carattere. Così è il dipingere." For further discussion, see Seymour, 1968, 1:93–105; Montagu, 1989, 99–103; Spear, 1997, 254–55.

16 In a recent study on quattrocento painting and calligraphy, Campbell (1996, 281–83) drew a similar distinction between identity and individuality.

17 Baldinucci, "Lettera . . . nella quale risponde ad alcuni quesiti in materia di pittura. 28 aprile 1681. All'illustrissimo e clarissimo Senatore e Marchese Vincenzio Capponi Luogotenente per lo Serenissimo Granduca di Toscana nell'Accademia del Disegno"; published as *Lettera al Marchese Capponi* . . . (Rome, 1681 and Florence, 1687); reprinted in *Raccolta di vari opuscoli sopra varia materia di pittura, scultura e architettura* (Florence, 1765), 1–24; and in Barocchi's appendix to the *Notizie* (1681–1728, 6:

461–85). The date of the censor's report by Antonio de Ricci is 13 April 1681 (*Vocabolario*, xvi). Baldinucci's introduction to the Crusca academicians is dated 20 July 1681 (*Vocabolario*, vii).

18 Baldinucci, "Lettera . . . all'illustrissimo . . . Capponi," in 1681–1728, 6:462–63.

19 For sources and discussion, see Chapter 2, note 68.

20 Baldinucci, 1681–1728, 6:469.

21 Ibid., 471 and 475. Art literature is littered with examples of connoisseurial errors. In addition to the examples cited by Ferretti (1981) and Spear (1997, 265–74), see Malvasia (1678, 1:351), who cites with relish the fact that Salvator Rosa, Francesco Scannelli, and Marco Boschini were unable to differentiate between the styles of Lodovico and Annibale Carracci. Mancini (1956, 1:135) noted that the most clever forger can always defeat "the most intelligent connoisseur."

22 For the connoisseur's tradition that differences will always exist between the master and the most faithful student, or between an original and a copy, see Ferretti, 1981, 118–97; Perini, 1991, 169–94; and Spear, 1997, 265–74. In addition to their well-documented and insightful syntheses, see F. L. del Migliore, n.d., fol. 11: "Sempre dal Maestro al dicepolo posserà qualche diferenza notabile e questa diferenza puodarsi in anche immitare la maniera altrui. . . ." A clear statement of the connoisseur's hubris can be found in Bosse, 1649, 7 and 66–67: "[Il] est comme impossible qu'un Coppiste tant bon soit-il, puisse faire passer aux clairsvoyants, sa Coppie pour l'Original, principalement lors que ledit Original luy est opposé ou present. . . . Ainsi par ce moyan il est aucunement facile à ceux qui ont la disposition & imagination pour se ressouvenir de la forme & maniere de ces choses, de les distinguer ou discerner à l'occasion." For a discussion of Bosse's ideas on attribution, see Gibson-Wood, 1988, 50–55. Lanzi (1789, 1:14–16) described the differences between Michelangelo and his followers as "cose minute o poco men che insensibili," but insisted that even a counterfeiter will be betrayed by brushwork or the depiction of hair.

23 Baldinucci, 1681–1728, 6:476.

24 Passeri, 1673–79, 344: "Benche di ciasc[h]eduno di loro sia guida e maestra la Natura; tuttavia, per essere ella abondante e

copiosa nelle sue diversità, e perche il temperamento del genio, e dell'intelletto di ciascheduno è diferente ne nasce quel portentoso accidente della diversità della maniera ancorche tutte dirette ad un'istesso fine da una medesima scorta. Se un solo oggetto è mirato (per così dire) da cento pupille, ciascheduna di loro lo riguarda diversamente. . . ." Baldinucci, 1681–1728, 6:478 (Capponi letter): "[P]erché queste qualità di cose [i.e., coloring, *aria*, drapery folds, and hair] dependono da certe minutezze di particularissimo gusto; onde accaderà che dieci pittori facciano talvolta un ritratto d'un giovane, e che ciascheduno, ritraendo i medesimi capelli e i medesimi panni, gli faccia con diversa morbidezza o durezza da quella d'ogn'altro, cioè in tutto e per tutto secondo la propria maniera."

25 The affinity of style and taste is also clear from Baldinucci's definition of *gusto* (1681, 72): "One also says 'that painting is made in the taste of Raphael or of Titian etc.' of that painting in which the artist is constrained to imitate the way of working (*modo d'operare*) of that master." For taste as individual instead of normative, see also Bellori (1672, 202, 358, and 400); Poussin, in Bellori, 1672, 480; Sebastiano Resta (1707a, 45; and in Bottari and Ticozzi, eds., 1822, 3:482).

26 Anon., "Lettera," in Orsi, 1735, 2:24: "Ma io non parlo di costoro: dico bensì, che un'oggetto può egualmente bene considerarsi a più vedute; e che presentato a varie menti, o ad occhj varj, potrà dentro tutta la ragione apparir loro diverso, e vario. Testimonio i Pittori, i quali tutto che veggano le medesime cose, pure non le coloriscono tutti a un modo, i lor diversi coloriti essendo la riprova, e nell'istesso tempo la scala delle varie tinte, sotto le quali si offeriscono agli occhj loro i medesimi oggetti."

27 Wölfflin, 1950, 1.

28 For a brilliant discussion of "sign" in Alberti, see Greenstein, 1997, 669–98. For Carlo Bianconi writing a connoisseur's guide to prints, "Instruzione per formare un'idea giusta del pregio delle stampe" of c. 1772–74 (published by Perini, 1995, 232–35), *segni* were the lines, dots, burrs, etc. of a print.

29 Allegri, 1605, 1; in a letter of 23 January 1592 to Francesco Nori; quoted in Chapter 1, note 100.

30 For Bottari's comments, see Bottari and Ticozzi, eds., 1822, 2:520–21.

31 For a thorough and perceptive discussion, see Spear, 1997, 253–74.

32 Richardson, 1719, 201.

33 The examples of quattrocento and early cinquecento artists that Baldinucci cited in support are borrowed from Boschini. He used the same series of Venetian painters as Boschini who wanted to prove the same point. Baldinucci, 1681–1728, 6:475. "nel secolo dei Bellini di quei sette pittori, Marco Basaiti, Benedetto Diana, Giovanni Buonconsigli, Lazzero Silvestrini, Cristofano Parmese, Vittore Belliniano, Girolamo Santacroce, ed altri ancora. . . ."; Boschini, 1660, 707: "Vi furono poi Marco Basaiti, Benedetto Diana, Giovanni Buonconsigli, Lazaro Silvestrini, Cristoforo Parmense, Vittore Belliniano, Girolamo Santa Croce e li Vivarini da Murano." For Baldinucci's use of sources in general (but without reference to this example), see Barocchi, 1975, 6:19–67. See also Algarotti (1791, 8:296), who admits that the differences between Dürer and Mantegna are so slight as to be indiscernible.

34 Baldinucci, 1681–1728, 6:463–64. The linking of artists' styles and collectors' tastes can also be found in Lomazzo (1590, 292), who summed up his argument in an indexical marginalia: "Different styles of painting. Because all of them please differently." Just as different painters will be drawn to different "governors" (one of seven paradigmatic painters) upon which to base their styles, so too different viewers will be drawn to and pleased by different painters, each in conformity to their nature. This suggests a certain reciprocity of making and viewing. See also Paglia (1713, 1:263–64) and Titi (1751, xvii–xviii), who wrote that not all "dilettanti" have the same taste (*gusto*) "perché ad altri piacerà una maniera di dipingere, che ad un altro dispiacerà, con tutto che anche quella abbia il suo merito, et ad altri talvolta piacerà di vedere una Scultura alquanto disegnata, senza importargli, che abbia in se quella morbidezza, che rassembra, e somiglia la verità, purché sappia essere antica."

35 F. S. Baldinucci, "Notizie," 1980, 2:14–15. For further information about Gualtieri, see Goldberg, 1988, 59–60.

36 Baldinucci, 1681–1728, 6:422: "[C]osì impossibile pare a me che sia il poter conoscere in un solo artefice una tale quale perfezione nell'arte sua, che basti qualificarlo assolutamente per superiore ad ogni altro."

37 Bellori, 1672, 267–68.

38 Mahon, 1947, 247–48: "[A]vvenne poi alla Pittura di declinare in modo da quel colmo, ov'era pervenuta, che se non sarebbe caduta di nuovo nelle tenebre oscure delle barbarie di prima, si rendeva almeno in modo alterata, e corrotta, e smarrita la vera via, che si perdeva quasi affatto il conoscimento del buono: e sorgevano nuove, e diverse maniere lontane dal vero, e dal verisimile. . . . Ma mentre in tal modo s'infettava (per dir così) di tante heresie dell'arte questa bella professione, e stava in pericolo di smarrirsi affatto; si videro nella Città di Bologna sorgere tre soggetti. . . . Furono quegli, Ludovico, Agostino, & Annibale Carracci. . . ." For "heresy" in art criticism, see Chapter 1.

39 Scilla, 1688, fol. 110r: "Ridete della vana schiocheria dell'osservanza del costume, e dell'espressione dell'aria, e fisonomia delle teste che secondo i soggetti che rappresentar si devono vogliono costoro che si esprimano proprij e decentemente perche ognuno considera il bello con la propria idea e perche un ingegno libero non puo, anzi non deve soggettarsi all'altrui gusti e precetti. Non vi attrissino gl'obliglii, e le regole infinite che molti maestri anno stimato necessarij alla composizione delle storie. Fate pure à nostro cappriccio, percioche qualunque sconcerto di figure mal poste insiemme sarà stimata bizzaria. Credetemi per appunto così avverrà." See also Passeri, 1673–79, 344 (quoted above in note 24). Students in the Accademia degl'Incamminati were not directed to imitate the Carracci but urged to explore nature through their particular talents, resulting in a multiplicity of styles emerging from the academy. This was taken by Malvasia as proof of its success: "Non ci vollero essi legati ad un preciso modo, né astretti ad imitare un solo . . . a forza tirando nell'altrui genio il nostro gusto; ma lasciando ad ogn'uno la sua libertà, non altra maniera consigliandogli, che quella stessa che portò seco dalla Natura, né altro Maestro ponendogli avanti, che un buono e bel naturale a tutti comune; ond'è che di tanti valentuomini dalla loro scuola usciti, tanto diverso anche in ciascuno si osservi il carattere, ancorché in tutti sì bello. . . ." Still the best discussion of the pluralistic styles within the Carracci studio is Dempsey, 1977. For an important addition to this discussion that compares the feudal and authoritarian studio prac-tices of Calvaert to the collaborative practices of the Carracci academy, see Feigenbaum, 1990, 145–65, and 1993, 59–76. In Florence, Ferdinando Leopoldo del Migliore (n.d., fol. 11) concluded in reading Vasari that even when an artist intends to imitate another, there will always be a difference: "Sempre dal Maestro al dicepolo posserà qualche diferenza notabile e questa diferenza puodarsi in anche immitare la maniera altrui. . . ."

40 For examples of proximate vices (*proxima virtutibus vitia*), see Quintilian 10. 2.13–14; *Rhetorica ad Herrenium* 4.10.15; Demetrius, Segni trans., 1603, pp. 78–79, n.190–92. For an example in Renaissance poetics, see G. B. Giraldi Cinzio, 1554, 92–93: ". . . si dee schivare la soverchia diligenza, acciocché quello che vogliam far virtù non divenga vizio, e il troppo volere abbellire non rechi fastidio."

41 BelLori, 1672, 23. See also Pietro Testa's statement that in trying to escape one extreme one often lapses into the other: Cropper, 1984, 238–40.

42 Lacombe (1758, 222) concludes his definition of style (*maniera*) thus: "Bisogna guardarsi dal confondere queste due guise di parlare, *avere una maniera*, ed *essere manierato*, che sono due cose assai diverse. La maniera d'un Pittore è, come dicemmo, il *fare*, e come il suo *stile*; ma *esser manierato* vale uscir del naturale, e del vero, e posseder soltanto una vigorosa pratica."

43 This should be contrasted to the definition of style by Lacombe (1758, 222, s.v. *Maniera*), who followed the structure of Baldinucci's definition but separated *maniera* and *manierato* as "two very different things."

44 For the retention of *maniera* as mannered, even within Baldinucci's own writing, see *Lezione all'Accademia della Crusca intorno alli pittori greci e latini* (Florence, 1692), 14: "Ed in ogni altro scuopresi talora alquanto di quel difetto, che dicesi maniera, o ammanierato, che è quanto dire debolezza d'intelligenza, e più della mano nell'obbedire al vero." For the survival of *di maniera*, see Monaldini, 1755, 62. In translating the criticism of Pietro da Cortona by Argens that his forms were "a little too uniform," Monaldini added for clarification that he painted "di maniera." Later in the passage he translated Argens's *maniéré*, in reference to Cortona's drapery, as *manierato*. My forthcoming study, "Baroque Mannerism," will follow the critical fortunes of Baldinucci's *ammanierato*.

45 Baldinucci, 1681, p. 38: "Composizione. f. Accozzamento, e mescolanza di cose." *Accozzamento* can refer to figures or colors or both; see, for example, Galileo, 1953, 468: "Il pittore da i semplici colori diversi, separatamente posti sopra la tavolozza, va, con l'accozzare un poco di questo con un poco di quello e di qull'altro, figurando umoni, piante, fabbriche, uccelli, pesci."

46 Crusca *Vocabolario*, 1612, 202.

47 Baldinucci used the Crusca definition: *Vocabolario*, 1612, 525.

48 Baldinucci, 1681, 38; using the Crusca definition in *Vocabolario*, 1612, 209: "Mescolare insieme varie materie, senza distinzione, e senz'ordine, per istruggere, liquefare, e fondere. Per convincere altrui con ragioni, far rimaner confuso."

49 As confirmation, Baldinucci's entry for confusion (*confuso*) should also be noted, since it refers back to mixing and confounding, with the first creating the second. Baldinucci, 1681, 38: "Confuso. da confondere, mescolato in maniera, che più non si riconosca." Baldinucci did not define *accozzamento*, but its application by Savonarola and Galileo as a muddled heap and unwholesome combination of different things is consistent with one of its meanings. Savonarola, 1962, 69: "Quello altro filosofo diceva che erano nel mondo di molti capi e gambe, mani e braccia, e accozzavonsi insieme e facevano gli animali, e tutti si generovono a caso secondo la figura di quelli membri, e però alcuni erano monstri, alcuni in una figura, alcuni in un'altra." Galileo, as quoted in Panofsky, 1964, 18: "[P]erché, essendo le tarsie un accozzamento di legnetti di diversi colori, con i quali non possono già mai accoppiarsi e unirsi così dolcemente che non restino i lor confini taglienti e dalla diversità de' colori crudamente distinti, rendono per necessità le lor figure secche, crude, senza tondezza e rilievo."

50 Baldinucci,1681, 88–89:

Maniera cruda. Dicesi quella di quei Pittori; che non sapendo valersi delle mezze tinte, trapassano senza termine di mezzo, quasi da profondi scuri agli ultimi chiari; e così fanno le loro pitture con quasi niuna imitazione del vero, e senza rilievo. Dicesi ancora di coloro, che poco pratichi dell'accordamento delle tinte, nel passare da un colore ad un'altro, non osservano la dovuta proporzione; a guisa di chi sopra bian-

chissima carta, getta nerissimo inchiostro. . . .

Maniera dilavata, è quella di chi colorisce, senza forza o rilievo; le cui pitture, per la debolezza della tinta, tengono più del chiaroscuro, che del colorito del naturale.

Maniera forte, o gagliarda; è di quel Pittore, che a forza di profondi scuri, e vivi chiari, con mezze tinte appropriate, fa spiccare, e molto rilevare le sue figure sopra il piano della tavola.

Maniera gretta. Termine, che si oppone a quello, che noi diciamo manierona: ed è di quell'Artefice, che opera poveramente, e freddamente; cioè senza magnificenza, senza franchezza, con poco artifizio e invenzione, senza abbigliamenti, o alcuna altra di quelle parti, che rendono l'opera ammirabile, e curiosa.

Maniera ideale. Termine usato da Luigi Scaramuccia Pittor Perugino, nel suo Libro intitolato, le finezze de' pennelli Italiani, per esprimere la maniera di quell'Artefice, che nell'operar suo non istà tanto avviticchiato al naturale, che si scordi del tutto, di ciò à osservato nel più bello della natura, e nell'opere de' più sublimi Maestri.

Maniera languida: Contrario di maniera risentita.

Maniera legnosa; di quel Pittore, che quantunque abbia buon colorito, invenzione, e altre belle qualità; contuttociò, per una certa infelicità del gusto suo nel fare sveltire, le parti delle figure, e dare ad esse moto, e prontezza, con un certo colorir terminato, le fa apparir dure, quasi che fossero ritratte, non da persona viva, ma da una statua di legno dipinta. Questo vizio si riconosce più dal tutto, che dalle parti, le quali bene spesso possono apparire, ciascheduna da sè ben disegnate, ben colorite, e abbigliate; e contuttociò esser cariche di questa bruttura, la quale si scorge in molti di coloro principalmente, che nel Secolo passato vollero imitare il divino Michelagnolo nel muscoleggiare, e abbigliare le figure. . . .

Maniera Lombarda. Dicesi di quegli Artefici, che anno procurato d'immitare il bello

e natural modo di colorire de' più celebri Pittori Lombardi.

Maniera risentita. Contrario della Maniera languida. Di quell'Artefice, che nel ritrovar de' muscoli delle figure procede con molto ardire, e gagliardia; e nell'arie delle teste, negli scorci, ne' moti, e nell'espressione degli affetti, elegge sempre ciò che è più vivace, apparente, e che nel naturale rare volte si vede in uno stesso soggetto. . . .

Maniera secca. Di quell'Artefice, che nell'opera sua procede in tal modo, che fa vedere piu di quello, che la natura nel naturale, da esso rappresentato, è solita di far vedere: ovvero di colui che dintorna seccamente, cioe senza alcuna morbidezza, l'opere sue: & anche di colui, che per poca intelligenza, di chiari, e scuri, di disegno, e d'invenzione, non dà loro, nè rilievo, nè abbigliamento, nè verità.

Maniera svelta, Contrario di maniera tozza, atticciata, o maccianghera: e si dice a quel modo di fare in pittura, scultura, e architettura, che tanto nel tutto, quanto nelle parti, con bel garbo e senza vizio, fa apparire anzi sottigliezza e lunghezza, che grossezza e cortezza, qualità della maniera tozza, atticciata, e maccianghera.

Maniera tagliente. V. Tagliente. (s.v. Tagliente. add. Che taglia. Si dice ad un vizio, che forte imbratta le pitture; ed è quando l'Artefice, nel colorire non osserva la dovuta degradazione, diminuzione, o insensibile accrescimento di lumi, e d'ombre, talmente che si passi dal sommo chiaro allo scuro profondo, senza le mezze tinte; che si dice ancora maniera cruda, propria de' Pittori, che non intendono il rilievo. . . .)

Maniera tozza, e atticciata. V. Maniera svelta.

Maniera trita. V. Trito, e Tritume. (s.v. Trito. add. Minuto: onde maniera trita, quella che dà in tritume. S.v. Tritume. m. Difetto d'ogni invenzione o componimento di Pittura o Scultura, ma più propriamente d'Architettura; & è quando le parti o membra saranno soverchiamente variate, in troppa quantità, e assai minute.)

51 Volpato, in Bordignon Favero, 1994, 407–8: "La maniera in qual modo si apprende e che

cosa è questa maniera? . . . E questa universalmente considerata è di quatro sorti, cioè franca, forte, diligente e vaga; la franca e forte insieme è come quella di Titiano, Bassan Vecchio, Tintoretto, Palma et altri simili, la franca e vaga è come quella di Paulo e simili, la forte e diligente come quella di Giorgione e Palma Vecchio; la vaga, e diligente come quella del Bassano vecchio nella prima sua maniera Gio. Bellino e simili e tali differenze vano sempre congionte a doi a doi; ma sapiate ancora che la vagezza può essere anco misto con la forte maniera; . . . Se parliamo delle maniere in quanto al colorito quella sarà la migliore che con magiore arteficio più imitta la natura, quanto all accidenti del esser franca diligente vaga e forte." For the passage following the opening question (here omitted), see Chapter 3, note 3.

52 Varchi, 1546, 29. For further discussion, see Mendelsohn, 1980, 111–13.

53 For a history of relational semantics in the Renaissance, of which lexical fields are but one component, see Waswo, 1987.

54 Fermor, 1993; Sohm, 1995a; Jacobs, 1997, 85–97 and 123–44.

55 For examples where color and design are presented as carriers of style while excluding invention, see Armenini, 1587, 64; Bellori, 1672, 12 and 394. For examples that include chiaroscuro along with color and design, see Lomazzo; De' Domenici, 1742, 3:27; Zagata, 1749, 215–16; Moücke, 1762, 4:119. For locating style in design, see Delminio, 1544, 179–81. Delminio believed that an artist can display his style (*stile*) in the proportion, pose, and movement of figures. Not surprisingly, considering his definition of style, Vasari located style in design in his critical practice: Vasari, 1568, 2:151; 3:405–6. For other examples of style in design only, see Filarete, 1972, 28; Armenini, 1587, 149, and 216 (who is not consistent in this respect; see below and preceding note); Boselli, 1978, fol. 11; Zanotti, 1756, 15. For style in color, see Armenini, 1587, 64; Agucchi, in Mahon, 1947, 247 (who thought that both style and color were sensual snares); Boschini (see Chapter 6); and Lanzi (1789, 1:14–16), who thought that style was most evident in color because color is more personal and less learned. For exceptions, where invention is included with the other parts as containing style, see Passeri, 1673–79,

368; Gherardi, 1749, 78; Gherardi, 1744, 69–70.

56 For Baldinucci's division of painting into four parts, see 1681–1728, 6:423–24. For the definition of *accordamento*, see Baldinucci, 1681, 3.

57 See, for example, Armenini, 1587, 109: "Fuggasi adunque cosí sciocca opinione, che si hanno imaginata nel capo molti e credasi che se Geusi, oltre la tanta diligenza ch'egli usò, non avesse posseduto da sé singolar maniera, non avrebbe mai accordate insieme le belle membra divise, ch'egli tolse da tante vergini né saria men stata a quella perfezzione, che di prima egli si era imaginato." This passage is paraphrased in Bisagno, 1642. See also Paleotti (1582, 169–70), who described one of the requirements of successfully making images as "il dare grazia e dolcezza ad un sasso, e svolgere in maniera la figura che non paia di molti pezzi." See also Mascardi, 1636 ed., 360 and 533.

58 Baldinucci, 1682

59 Armenini, 1587, 9–18 ("A Gli Studiosi della Pittura. Proemio").

60 Boselli, 1994, 89: "Si dice *maniera* il modo de l'operare più ad imitazione di una cosa fatta che di una altra. In far questa si può errare o per Genio o per educatione: per Genio piacendo più una cosa men bella che la più bella, il Color nero e non bianco, più l'Agresta, che l'uva; il che può procedere da cattiva complessione o da un composto di humori torbidi e corrotti. Per educatione studiando cose di cattivi Maestri, apprendendo precetti falsi da principio, dalli quali si forma un Habito che una volta vestito è difficile a mutarsi."

61 Zanotti, 1739, 2:346.

62 See also Baldinucci, 1681–1728, 3:429: Ventura Salimbeni during his later years rendered forms "alquanto secche, troppo dintornate, particolarmente ne' panneggiamenti, e molto ammanierate...."

63 Leonardo, 1977, 1:294, n. 589 ("più tosto gientile che secco o legnioso"). Vasari, 1568, 1:83 ("non siano [i panni] tanto triti ch'abbino del secco"); 3:315 ("la maniera secca e crudetta"); 4:7 ("una certa maniera secca e cruda e tagliente"); 4:9 ("tagliente e secca"); 4:425 ("crudetta, tagliente e secca"); 7:426–27 ("secco, crudo e stentato"). Armenini, 1587, 140 ("crude, secche e tagliente") and 148–49 ("tagliente e secca"). Annibale Carracci, letter to Lodovico Carracci, 18 April 1580; in Mal-

vasia, 1678, 1:269, and Perini, ed., 1990, 150 ("una cosa di legno tanto dura e tagliente"); Annibale Carracci, marginal note in his copy of Vasari's *Vite*, in Perini, ed., 1990, 160 (refers to Vasari's frescoes in San Michele in Bosco as "goffissime et molto affettata, c[rude e] secche . . ."). Boschini, 1673, 748 ("cosi secche, dure e tagliente"). Malvasia, n.d., 42 ("Fu secco ne' panni . . . [con] certe pieghe dure, crude, +carni+ che parevano di legno"). Malvasia, 1678, 2:232 ("troppo cruda e tagliente") and 2:367 ("secco e tagliente"). For the continuation of this tradition, see Orlandi, 1704, 94–95; Resta, 1958, 30–31; Baruffaldi, 1844, 1:64 and 310–11; De' Domenici, 1742, 3:10–11, 108 and 179–81; Algarotti, 1791, 8:183 (letter to Mariette, 10 June 1761).

64 Baldinucci, 1681–1728, 3:429 (quoted above in note 64); and Bianconi, 1802, 48–49 (letter of 28 August 1776): "A chi accoppieremo noi que seccatori del Zuccheri, disse Batoni e del Vasari? Ad Annibale Caro, riposi io, egualmente seccatore, e manierato del primo, e a Benedetto Varchi il secondo, non meno di lui insecchito, e gretto, per parlare alla Fiorentina."

65 Malvasia, 1678, 2:255–56. For a technical analysis of open and shuttered light, see Volpato (n.d., 214; Bordignon Favero, 1994, 415), who defined three kinds of light: aperto, serrato, e composto.

66 Borromeo, 1624, 97; De' Dominici, 1742, 3:2–3: Giuseppe Ribera went to Rome to study Raphael's paintings, "ma trovò in quell'opere grandissima difficoltà per la maniera dolce, gentile, e corretta, tutta opposta a quella del Caravaggio, che fiera, ruvida, e confusa con l'ombre. . . ."

67 Hermogenes, 1986, 12 (231).

68 Cicero, *Orator* 6.20.

69 Algarotti, 1791, 8:441.

70 Francesco Albani (Cospi, 1659, in Gualandi, 1845, 2:218–19; Orsi, 1709, 1:196); Cristofano Allori (Cinelli, 1677, 259); Federico Barocci (Cardi, 1628, 16; Bellori, 1672, 206; Pascoli, 1732, 162); Fra Bartolomeo (Bottari, 1767, 56–57); Jacopo Bassano (Ridolfi, 1648, 1:400); Giovanni Bellini (Ridolfi, 1648, 1:77; Orlandi, 1733, 192); G. B. Bertusio (Orlandi, 1704, 207); Giovanni Maria Bodino (Lancellotti, 1627 ed., 242); Francesco Cairo (Moücke, 1754, 3:21–22); Correggio (Scannelli, 1657, 305 and 349); Carlo Dolci (Cinelli, 1677, 169;

Moücke, 1754, 3:134); G. B. Gaulli (Ratti, 1768, 2:82); Luigi Gentili (Passeri, 1673–79, 242); Giorgione (Verdizotti, 1622, n.p.); Antiveduto Grammatica (Mancini, 1956, 1:305); Leonardo (Terzago, 1666, 256); Bernardino Luini (Vasari, 1566, 4:585); Carlo Maratta (Bellori, 1695, 268); Palma Vecchio (Ridolfi, 1648, 1:139; Zanetti, 1733, 29); Domenico Panetti (Baruffaldi, 1844–46, 1:185); Lorenzo Pasinelli (Zanotti, 1703, 102–3); Santo Peranda (Ridolfi, 1648, 2:271–73); Paolo Girolamo Piola (Ratti, 1769, 2:33 and 190–93); Raphael (Scannelli, 1657, 309; Monaldini, n.d., 34); Guido Reni (Scannelli, 1657, 349; Passeri, 1673–79, 354; Malvasia, n.d. [1980], 33–35; Malvasia, 1678, 2:20, 58–59, 241; Orlandi, 1704, 207; Zanotti, 1705, 1:273; Moücke, 1754, 2:241); Nicolo Renieri (Paglia, 1713, 1: 121); G. B. Revello (Ratti, 1769, 2:242–43); Carlo Antonio Tavella (Ratti, 1769, 2:202); Tintoretto (Ciapetti, 1678, 24); Titian (Ridolfi, 1648, 1:156, 163, and 177); Alessandro Varotari (Boschini, 1673, 718); Marco Venusti (Scannelli, 1657, 72).

CHAPTER 8. CONCLUSION ON INDETERMINATE STYLES

1 Lang, 1987, 14; and Anceschi, 1989, 201.
2 Franck, 1995, 222. M. Schapiro (1953, 292) defines style as a "constant form" that has "the air of a family of forms."
3 Alteri, 1995, 210–19.
4 Todorov, 1971, 32.
5 Mascardi, 1636, 283–84 (quoted in Introduction, n. 45).
6 Camillo Baldi (1622, 44–45) made a related point regarding the style of handwriting.
7 Mascardi, 1636, 238: "De summo planus, sed non ego planus in imo; / Versus utrimque manu diverso munere fungor; / Altera pars revocat quicquid pars altera fecit."
8 Mascardi, 1636, 283 (quoted above in n. 5). For *non so che* as foreign, see G. C. Becelli, 1732, 301.
9 S. Pallavicino, letter of 1666; quoted in Rucellai, 1826, 75. There are two things in writing (*cose* and *stile*): "Lo stile, ch'è la parte men nobile, ma non forse la men difficile, è senza fallo la più sensibile in questi lavori; ha tanto di pellegrino, quanto vaglia a cagionar il piacere; tanto dell'ordinario, quanto non tolga la chiarezza, e l'efficacia dell'insegnare." For a recent discussion of Pallavicino, see Bellini, 1994.
10 Aristotle, *Rhetoric* 3.2.1 (1404b), 351. Tesauro (1654, 249–50) discussed this passage under the category of *parole pellegrine*.
11 Riffaterre, 1959, 154–74. For a rebuttal, see Fish, 1980, 70–100. For "style as deviation" theories, see the work of Leo Spitzer and Pierre Guiraud. For a review and rebuttal, see Todorov, 1971, 29–41.
12 Lanzi, 1789, 1:14–16 (describing the differences between one Michelangelo imitator and another as "cose minute o poco men che insensibili").
13 Lacombe, 1758, 222, s.v. *maniera*: "Ella si è una foggia di fare, un tocco, un gusto, una Scelta, in somma un non so che, che caratterizza, e fa conoscer le opere d'un Pittore, ed alcuna fiata ancora d'un'intiera Scuola."
14 Verci, 1775, 47–48: "quel tocco, quel gusto, quella scelta, in somma quel non so che."
15 See Introduction and Summers (1989b, 15–32).
16 The phrase is taken from Baldinucci (1681–1728, 6:471 [letter to Capponi]) where he discussed the best formal signs used by connoisseurs to attribute drawings and paintings: "il modo di macchiare" and "certi colpi che noi diremmo diprezzati e quasi gettati a caso." See Chapter 6, section on "*Macchia*," for further discussion.
17 Baldinucci, 1681, 9, s.v. *Ammaccare*. "Termine usato dalli Scultori, e tal ora da' Pittori, per esplicare certe pieghe di panni, e anche delle stesse carni, dolcissimamente piegate in superficie, che non posson dirsi, nè solchi, nè pieghe, nè grinze."
18 Scannelli, 1657, 65: "[R]icoprirà l'ignudo con pieghe diverse convenevoli alla propria attione, facili, e naturali, le quali nella sommità mancando vengano più tosto a dimostrare leggieri ammaccature, e nel discendere al basso nell'incontro di giunture, ò piegamento delle parti non appaiono nella propria attione in modo profondate che non lascino al conoscimento il sodo del vivo, e che restino con vaga dolcezza adorne le membra. . . ." The definition of *leggiero* as "Inconstante: Volubile. Lat. *levis, inconstans, mobilis*" was added to the 1691 edition (3:947), but was used in this way since the trecento. Cavalcanti used it in conjunction

with *vagabondo* to describe vacillating behavior, "all the day going now here, now there." Machiavelli included it in his list of unstable attributes a prince should not have: *vario, leggiero, effeminato, pusillanime, irresoluto.*

19 Borromeo, 1624, 27.

20 Vasari, 1568, 5:468 (referring to Tintoretto): ". . . fatte [le cose della pittura] da lui diversamente e fuori dell'uso degli altri pittori: anzi ha superata la stravaganza con le nuove e capricciose invenzioni e strani ghiribizzi del suo intelletto, che ha lavorato a caso e senza disegno, quasi mostrando che quest'arte è un baia."

21 Gilio, 1564, 98.

22 Findlen, 1990, 307.

23 Ibid., 303 (quoting Ovid).

24 For studies that situate *non so che* in poetry and manner books, see Natali, 1951, 45–49; and Jankelevitch, 1980. Cropper (1976, 1986, and 1995) has written most extensively and persuasively on the feminine attractions of *non so che*, to which my work is indebted.

25 Baldinucci, 1681–1728, 3:648.

26 Garin (1954, 134), quoting Speroni, who is speaking in the guise of Antonio Brocardo, in *Dialoghi del Sig. Speron Speroni, nobile padovano, di nuovo ricorretti; a' quali sono aggiunti molti altri non più stampati e di più l'apologia dei primi* (Venice, 1596), 101–62; first published in 1542.

27 Filarete, 1972, 1:28 (quoted in Chapter 6, note 49).

28 Dolce, 1557, 195: "Perciochè, oltre la invenzione, oltre al disegno, oltre alla varietà, oltre che le sue cose tutte movono sommamente, si trova in loro quella parte che avevano, come scrive Plinio, le figure di Apelle: e questa è la venustà, che è quel non so che, che tanto suole aggradire, così ne' pittori come ne' poeti. . . ."

29 Dolce, letter to Alessandro Contarini, in Roskill, 1968, 213: "E vedesi che nell'aria del viso questo unico Maestro ha ricercato di esprimere certa gratiosa bellezza, che participando della femina, non si discostasse però dal virile: vuo dire, che in Donna terrebbe non so che di huomo, & in huomo di vaga Donna: mistura difficile. . . ."

30 Speroni, *Dialogo d'amore* (completed in 1537); quoted and discussed by Cropper, 1986, 181–82; see also Pardo, 1993. For a compelling account of hermaphroditism, *grazia*, and *non-soche*, see Jacobs, 2000.

31 Muratori, 1735, 363: "Ma che è mai questa grazia? E ella forse una qualità occulta, o pure quel famoso 'non so che,' mirabil nome, di cui si serviva uno scrittore per battezzare tutto ciò che non sapeva spiegare?" Richard Spear (1997, 102–27) has shown how sacred and secular ineffability coexisted in the concept of grace, that quality introduced to style by Vasari to explain the transcendent beauty of modern painting. Fra Bartolomeo's paintings were thought to be full of "un non so che di celeste" and Christ in Santi di Tito's *Resurrection* had for Raffaelle Borghini a *non so che* that originates in grace. Vasari (1568, 4:94) described Saint Bernard in Fra Bartolomeo's *Virgin Appearing to St. Bernard* (Florence, Accademia di Belle Arti) as having "un non so che di celeste." Paleotti (1582, 167) applied the phrase "un non so che di celeste" to Fra Bartolomeo's paintings in general. Borghini, 1584, 188: ". . . quell'attitudine di Cristo, che pende tanto in su la banda manca, ha un non so che, che gli toglie parte di gratia, & il colorito potrebbe esser piu vivo, e piu vago." Raphael's saints have a *non so che* of sanctity and divinity: Dolce, 1557, 1:190. For other examples of spiritual *non so che*, see Boschini, 1660, 211 ("Un certo no so che, brilante e vivo; / Un'anima, che fa l'azione spirante."); Zanetti, 1733, 35 ("un non so che di grazia"); Zagata, 1749, 196 ("un non so che di sublime"); Algarotti, 1756, 131 (grace gives "quel non so che alle cose"); B. de' Domenici, 1742, 3:302 ("una grazia indicibile").

32 Cignaroli, 1761, 59: "Certe indecisioni poi e certe rissoluzioni rendono il colorito vero e reale, spargendo per tutta la massa un non so che di sapore, che veder si puole, ma spiegarlo è impossibile." Despite the perceptual and conceptual problems posed by *non so che*, it was nearly always used as a compliment. A few exceptions should be noted. Vasari (1568, 3:62) criticized Paolo Uccello's paintings as having "un non so che di stento, di secco, di difficile e di cattiva maniera." Here *non so che* refers to Vasari's inability to describe it more precisely or to the fact that there is only a whiff of effort and dessication. Baldinucci, however, gave *non so che* and hardness parallel meanings, with the former being caused by the latter (*Notizie*, life of Ottavio Vanni; quoted by Orlandi, 1733, 468): "E forse la soverchia diligenza lo portò [Ottavio Vanni] a tornar di nuovo su lavori: sicchè l'opere sue patiscono

alquanto del duro, e d'un non so che, che potè nascere da quel difetto." According to Baldinucci (1681–1728, 3:516), followers of Michelangelo can produce "un non so che del duro, e del legnoso." See also Paglia, 1713, 1:177–78.

33 Panigarola, 1609, part 15(2:96): "Overamente sono i parlari antichi, e distesi, come erano le statue ancora de gli antichi, rozzi, semplici, cose in somma deboli, & abbozzate; là dove il ben parlare ritorto alle statue di Fidia s'assomiglia, pieno di non sò che, che hà del grande, & esquisito insieme."

34 Mancini (1956, 1:236–37), reporting what Annibale Carracci said about Pomarancio's *Baptism of Constantine* (Rome, San Giovanni in Laterno) in comparison to his earlier work in Santa Maria de' Aracoeli: "non era niente inferior ad alcun di quegl'altri, volendone in quel modo di dir insinuar un non so che di più." That Mancini possibly kept an exact or proximate locution to what Annibale actually said (Perini, ed., 1990, 166) is suggested by a similar construction in a letter to Ludovico expressing ambivalence about Reni: "Non . . . niego poi che egli non sia valentuomo. . . ."

35 Zanotti, 1739, 358: "un non so chè d'artificioso sì, e d'alterato, ma degno di esser piaciuto."

36 Baruffaldi, 1844, 2:444: "In fatti, avivi si verifica quell'incantare più che appagar l'intelletto, che già si disse di sopra, essendo veramente in essa opera un non so che di grandioso, e di eccessivo che non s'intende, onde soleva dire il famoso pesarese Simon Cantarini, quel gran disegnatore, contemplando quella meravigliosa tavola: 'piedacci, manaccie, e testaccia, e pur bisogna che mi piaccia.' "

37 A. Zeno, book review of G. M. Crescimbeni, *Dialoghi della bellezza della volgar poesia* (Rome, 1712; rev. ed.), published in *Giornale de' Letterati d'Italia*, 6:(1715): 192.

38 For the emotional ties generated by the *non so che* of love, see below. For spiritual *non so che*, see note 31; and Baruffaldi (1844, 2:331), who described a Saint John the Baptist by Giacomo Parolini as "così bene piantata, e di sì vivace colore, che un non so che di maestà ispira, e di venerazione al vederla. . . ." G. P. Zanotti (1760, 4v) wrote that sweetly harmonious coloring has a *non so che* that "enraptures the heart:" "Che i colori concordino tutti dolcemente insieme, non v'ha chi non lo estimi necessario,

e veramente una bella concordanza di essi produce un certo non so che sommamente dilettevole all'occhio, e che il core rapisce, come in una ben composta musica la vicendevol distribuzion delle voci." See also 11r, where he described Reni's *Assumption of the Virgin* (Castelfranco Emilia, parish church) as having "un carattere, e una maestà, e un non so che di celeste, che innamora, e veramente serve alla grandezza, e divinità del divino argomento." And see Baldinucci, 1681–1728, 3:407: ". . . le sue pitture [by Federico Barocci], oltre all'aver conseguito l'applauso e l'ammirazione di tutti i migliori maestri del suo tempo e dell'Europa tutta, ove elle furono e sono state poi tramandate nelle gallerie de' grandi, hanno in sé un non so quale particolare spirito atto a muovere la devozione, la compunzione e simili affetti devoti."

39 Algarotti, 1756, 131: "Esse [the three Graces] danno quel non so che alle cose, quell'attrattiva che è così sicura di vincer sempre, come di non esser mai ben diffinita." For the origin of *non so che* in grace, see Chapter 8, "That Certain Something."

40 G. M. Morandi; in Missirini, 1823, 145: "E dacchè il core non ha norme fisse come l'intelletto, quindi la grazia non s'impara, ma si sente, e traesi dalla natura: che elle è un non so che, che piace, incanta, e seduce, e l'anima a celeste giocondità dispone."

41 Boschini, 1660, 210–11: "El visibile (a dirla) el stimo el manco; / Stimo la calamita dela idea, / Quel spirito divino che me recrea, / E me ferisse el cuor de ponto in bianco. // Un certo no so che, brilante e vivo; / Un'anima, che fa l'azion spirante; / Vorave dir qualcosa de galante, / Ma de forme retoriche son privo."

42 Baglione, 1642, 311: one sees in the *Transfiguration* (Rome, San Salvatore del Lauro) by Giovanni Serodine a "non so che di vivacità e alcune teste tocche molto bene, ritratte dal vivo. . . ." Zagata, 1749, 213: "un non so che di sorriso." Algarotti, 1791, 8:273–74 (describes the magical quality of Veronese's paintings as "quel non so che di geniale"). F. S. Baldinucci, 1981, 225: in a battle scene by Pandolfo Reschi there is "un non so che di terrore."

43 Malvasia, n.d., 119: "Adoprò il nero assai e il verderame che in breve tempo gli fece smontare i quadri e li fece neri tanto più che, subito imprimito, si poneva a dipingere onde

l'imprimatura di poco tempo asciuttava e si beveva tutto il colore onde che non si copriva bene due e tre volte, ma lavorava alla prima non di corpo ma di colore liquido. Questo oscurità però cagionava un non so che di antico e di maniera ne' suoi paesi. . . ." See also Ratti, 1768, 2:70 (referring to Giovanni Raffaello Badaracco's *Nativity* in Genova, Santa Maria della Pace; still there?): "V'ha dentro una luce cosi brillante, e un non so che di bizzarria nelle ombre d'un pastore sonante il piffero e d'altre rusticane cose." Baruffaldi, 1735, 291–92: "E questa tal oscurità (secondo il parer di Torquato Tasso, commento alle Can. del Pigna MS.) giugne un non so che di maesta allo stile, come le tenebre rendono venerabili i luoghi sacri, e inducono maggior divozione." Historical distance often gave paintings a *non so che*. An anonymous letter describing the courtyard of the Palazzo Manin in Venice (printed in *Galleria di Minerva*, 1708, VI/4, 84: anonymous letter dated 18 February 1708): "Vi s'entra per varie logge, che cingono un Cortile, in cui spira non sò che dell'antica venustà, e dell'aria veramente Romana." And another anonymous letter (in Orsi, 1735, 2:9) warned writers against deliberate archaizing that gave their work "a too chaste simplicity," which for "fussy palates" will seem to have "a *non so che* of roughness." The outrageously pseudonymous Glottocrisio discussed this passage in Orsi, 1735, 2:437–38. Maffei (1955, 259) discussed the frontispiece illustration of an Etruscan vase in a letter of 1730 to Beccelli: "Vernice nera forma il campo, e le figure sono di giallo, com'è il solito di cosi fatti vasi; ma un non so che di più antico degli altri par si ravvisi in questo, il quale ancora singolar si rende sopra tutti i monumenti di tal genere per ciò che rappresenta."

44 Baruffaldi, 1844, 1:446. See also Zagata, 1749, 214: "un non sò che di tingue tinta, che direi che quasi fumanti, e al tutto pastose le rende."

45 Agnelli, 1734, 93 (referring to a painting of three figures in a cloud by Francesco Albani): "Quando il lucido Alban pigner solea, / Un non so che di luminoso, e raro / Sopra le Tele sue sempre ponea, / Che il suo pennel fa glorioso, e caro." For a similar siting in clouds of "Un non so che, brilante e vivo," see Boschini, 1660, 211. Algarotti (1791, 8:269) criticized Giambettino Cignaroli's *Assumption* (Forlì, Chiesa de' Filippini) for having clouds too

evenly divided and rigidly organized, thus lacking "quel non so che di leggieri e di aereo che domanda un soggetto, come è quello dell'Assunta."

46 Zanotti, 1739, 2:298.

47 Armenini, 1587, 143 ("un non so che di fiammegiante"). Cignaroli (1761, 59–60) described Correggio's coloring in similar terms as "un non so che di florido e di verginea." For "un non so che di pastoso," see Panni, 1762, 180–81; Zagata, 1749, 197. Zanetti, 1733, 35 ("un non so che di grazie, di prontezza, e di macchia").

48 Lomazzo, 1584, 2:98–99 ("un non so che di furia"). Malvasia, 1686, 151: "Transito di S. Giuseppe, nel quale barluma pur'anche un non sò che dello spirito giovanille, e vigoroso del troppo vecchio Tiarini." Pascoli, 1730, 1:258: "Fu [Melchiorre Caffà] d'ottimo naturale, e costume, . . . e superava colla gentilezza dell'animo un non so che d'innata rozzezza. . . ."

49 Dolce, 1557, 196: "E un non so che negli occhi, che in un punto / Pò far chiara la notte, oscuro il die, / E 'l mele amaro, et addolcir l'ascenzio." In a later passage, Dolce commented that the paintings of Parmigianino have a certain charm (*vaghezza*) that "makes whoever looks at them fall in love." See also Dolce, 1557, 199: "Diede costui certa vaghezza alle cose sue, che fanno inamorar chiunque le rigurarda." Cropper (1995) gives the most convincing reading of Dolce's Petrarchan analysis of pictorial style. See below for the proximity of *vaghezza* and *non so che*. Zanotti fell in love with the work of Raphael, Correggio, and Parmigianino. Citing these painters as examples, he wrote (1760, 4r): "Certe fisonomie, per certo incognito non so che, vi sforzano ad amarle in guisa, che non ve ne potete difendere; e queste fisonomie, che non derivano sempre dalla perfetta castigatura delle parti, che le compongono, ma, come dissi, da un non so che inesplicabile, che v'incanta, e vi lega, sono da studiarsi non poco col copiarle, e ricopiarle ove si trovano."

50 For further discussion on the topos of irrational women, see Sohm, 1995a. Galen (5:413 and 5:23) presented love as an irrational form of desire for a person or beautiful object that disables the lover to judge the object of their love reasonably. Quintilian (6.2.6) claimed that "lovers are incapable of forming a reasoned

judgment on the beauty of the object of their affections." Cicero (12.42, 51) presented carnal pleasure as blindfolding the eyes of the intellect. Capra (1525, 98) identified the effects of feminine beauty as *non so che*: "La quale vista, il qual amore, il qual desiderio non si può muovere se non da un non so che piacere che agli occhi nostri corre ogni volta che si giudizia alcuna cosa esser bella." Capra (1525, 96–97) also defined the corporeal beauty of woman by its effects on man and claims that it is more pleasing than the spiritual qualities of *dignità* and *maiestà*. He did not use the term *vaghezza*, but its qualities are identical: "una venustà, una attrazione piena di desiderio, piena d'amore e questa e propria e peculiare de le donne."

51 G. G. Orsi, *Considerazioni sopra un famoso libro franzese intitolato La manière de bien penser dans les ouvrages d'esprit: cioè La maniera di ben pensare ne' componimenti: divise in sette dialoghi, ne'quali s'agitano alcune quistioni rettoriche, e poetiche, e si difendono molti passi di poeti e di prosatori italiani condannati dall'autor franzese* (Bologna, 1703).

52 Orsi, 1735, 1:58.

53 For excellent discussions of Bouhour and the *je ne sais quoi* in a broader context, see Köhler, 1966; Becq, 1984, 1:97–114. For the use of *je ne sais quoi* in French courtier manuals as the pleasing aspect of grace, see Dens, 1981, 166–70; and Lichtenstein, 1993, 7–21.

54 Bouhours, 1671, 255: "[C]ette grâce, dis je, qu'est-ce autre chose qu'un je ne sais quoi surnaturel qu'on ne peut ni explique ni comprendre? Les Pères de l'Eglise ont tâché de la définir et ils l'ont appelée *une vocation profonde et secrète, une impression de l'esprit de Dieu, une onction divine, une douceur toute puissante, un plaisir victorieux, une sainte concupiscence, une convoitise du vrai bien; c'est-à-dire que c'est un je ne sais quoi qui se fait bien sentir, mais qui ne se peut exprimer et dont on ferait bine se taire.*" Quoted and discussed by Donna Stanton, 1980, 208–11 (whose translation I use here); Becq, 1:1984, 1:105–6; and Spear, 1997, 113–14.

55 Zanotti, 1739, 1:82.

56 For a semantic history of *vaghezza*, not including the art-critical applications discussed here, see Castellano, 1963, 126–69; and Zamarra, 1985, 71–118.

57 The assumed femininity of *vaghezza*, when applied to painting, can be documented by a variety of examples. In addition to those cited elsewhere in this chapter, see Alberti, 1547, 36r (where Domenichi described the color harmonies of an imagined Diana and nymphs as having *vaghezza*); Vasari, 1568, 3:258 (to describe the heads of "femmine vaghissime" painted by Ghirlandaio); Vasari, 1568, 4:114 (to describe the coloring of Correggio's *Madonna della Scala*); Borghini, 1584, 645 (to describe the coloring of Francesco Poppi's *Purification of the Virgin*, Pistoia, San Francesco); Ridolfi, 1648, 2:93 (to describe the atmosphere surrounding an Aurora by Pozzoserato); Scannelli, 1657, 353 (to describe the women surrounding Apollo in Reni's *Aurora*); Anon., 1664, 21 (to describe the miniatures painted by Madalena Covini); Frugoni, 1666, 167 (*vaghezza* as a highly finished painted style suited to vain women); Malvasia, 1678, 2:228 (to describe young virgins); and Panni, 1762, 10, 100, and 102 (to describe the depicted faces of women). The conventional usage that Firenzuola consciously reformed held it to be a superficial quality, often represented as clothing or color, that either was devoid of inner meaning or actively concealed meaning; for a possible usage, see Gelli, 1556, 683. Vasari (1568, 6: 156) wrote that knowledge of *disegno* allows the artist to avoid hiding his ignorance *under the charm of coloring* ("ad avere a nascere sotto la vaghezza de' colori lo stennto del non sapere disegnare"). Boschini, 1660, 182: Giuseppe Salviati "non ha formà / Né Pagi, né livree, né Servitori, Con pompa de vaghezze e de colori; / Ma la simplice e pura verità." Passeri (1673–79, 16) identified the failure of modern painting with professionals "charmed by a charming style" ("invaghiti li Proffesori [*sic*] d'una vaga maniera") that values "simple appearance" over rules, doctrine, and art. According to Lomazzo (1584, 173–74), *vaghezza* is a too visible artifice that corrupts painting by overlaying and suppressing the objects it supposedly represents, thus favoring artifice over illusion. As appearance, it appealed to the senses, and hence to women and the vulgar masses. According to Armenini (1587, 84–85), the masses judge paintings by "the exterior eye" and so are easily dazzled by the *vaghezza* of colors. Lomazzo (1590, 300) discussed the "vaghezza esteriore di colore" that appeals to those who judge by sense. See also Paleotti, 1582, 498–500; Lomazzo, 1590, 304–5 and 323; Agucchi, xlviii; Scannelli, 1657, 110–11;

Zanotti, 1705, 32–33; De' Domenici, 1742, 3: 10–11 and 365.

58 Baldinucci, 1681, 173: "Vaghezza f. Beltà attrattiva, che induce desiderio di contemplarla. Lat. *Cupiditas*.

"Per desiderio, voglia. Lat. *Voluntas*.

"Per diletto. Lat. *Voluptas, delectatio*." The delight of *vaghezza* was a standard topic in art literature before Baldinucci: Alberti, 1547, 28r and 36r; Borghini, 1586, 564; Mancini, 1956, 1:109; Passeri, 1673–79, 274; and Boschini, 1673, 733–34. I will cite Raimondi (1677, 676) as an example of typical usage: "La Pittura è una cosa in se stessa reggia, & gratiosa affatto: perche ella diletta gli occhi con la vaghezza; aguzza l'intelletto con la sottiglezza delle cose dipinte."

59 Tassoni (1627, 634) claimed that Correggio surpassed Apelles "in colorire leggiadramente, e in dar grazia e vaghezza alle pitture." For Boschini (1673, 735), the paintings of Benedetto Caliari nearly attained the "graziosi e vaghi" of his brother's. For Passeri (1673–79, 84), the choir of angels by Guido Reni (San Gregorio nel Monte Celio) were dressed "con un vago panneggiamento . . . assai leggiadramente dipinti."

60 Alberti, 1973, 3:64–69, 76–78 and 86–87; Domenichi, trans., 1547, 27r, 28r, 32v, and 36r.

61 Pliny, 35.37.116; Landino, trans., 1476, n.p.; Domenichi, trans., 1561, 1105; Dati, 1667, 115. *Dolcezza* became *vaghezza* because its Latin root pointed to the main function of *vaghezza*, to please, and sweetness conventionally pleases. Paglia (1713, 2:575) substituted *dolcezza* for *vaghezza* in his manuscript without any further adjustments, as if they were synonymous. See also Vasari, 1568, 6:266–67; Borghini, 1584, 140 and 645; Malvasia, n.d., 389; Malvasia, 1678, 2:115; and Orlandi, 1733, 258. Both *dolcezza* and *vaghezza* signaled smoothly blended colors, often tending toward the pastel; both were susceptible to extremes. For *vaghezza* as color harmony and tonal unity, see Domenichi's translation of Alberti, 36r; Lomazzo, 1584, 266–67 and 307; Scannelli, 1657, 108, 110–11, and 117; Scaramuccia, 1674, 8; Orlandi, 1704, 145 and 198.

62 Giovio, 1956, 1:11; Dolce, 1557, 1:199; Lomazzo, 1584, 2:129 ("fa gl'atti ammirativi, stupidi e contemplanti"); Mancini, 1956, 1:109 and 303 (*rapisce; il rapir*); Calvi, 1655, 86 (*imprigionar*); Boschini, 1660, 178 (*inamora*); Scar-

amuccia, 1674, 8 (*rapisce*); Passeri, 1673–79, 16 (*invogliare*); Malvasia, 1678, 2:14 and 255–56 (*invogliavasi* and *rapire*).

63 Bembo, letter to Isabella d'Este (1 January 1505); in Gaye, 1840, 2:71 (the subject must conform to Giovanni Bellini's *fantasia* and *stile* "to always wander (*vagare*) at his will in his pictures"); Paleotti, 1582, 440 (painters enjoy grotesques because they allow their imagination to wander, "andare vagando a capriccio").

64 Bellori, 1672, 632 (reporting Maratta's views on art): "[M]a perché la consuetudine dell'occhio continua, non è considerata qual'è veramente in se stessa, confondendosi la sua bellezza dalla quasi comune ignoranza, ch'ingannata dalla vaghezza d'un bel dipinto, non attende alla sua vera forma." For similar condemnations of *vaghezza* by reference to its audience, see above, note 57.

65 Some writers who praised *vaghezza* were indeed middle-brow popularizers, for instance Orlandi, whose primer *Abecedario* is littered with such references (1704, 75–76, 80, 92, 96, 107, 121, 202, 239, 243; and 1733, 146–47, 157, 198, 258). Guidebook authors enjoyed using *vaghezza* indiscriminately: Titti, 1721, 121, 125, 183, 185, 301, and 399; and Panni, 1762, 10, 13, 72, 78, 100, 130, 143, 145, and 155. However, it was used in a positive sense, without a hint of condescension by writers with higher aspirations: Borghini, 1584, 53, 140, 188, 197, 205, 564, 614–15 and 645; Faberio, 1609, 40; F. Zuccaro, marginalia in his copy of Vasari's *Vite* published by Hochmann, 1988, 70; Tassoni, 1627, 634; Ridolfi, 1648, 2: 93, 129, 131, and 141; Scaramuccia, 1674, 8 and 48–49; Zanelli, 1722, 7; and Ciocchi, 1725, 44.

66 Vasari, letter of 12 February 1547 to Varchi, published in Varchi, 1549, 61.

67 Franchini, 1716, 34: "La vera vaghezza diceva egli [Viani] non consistere in un certo sfavillar di colore, e molto meno nel colorire aperto, cioè con ombre languide, e smorte. Che però aveva quasi bandita [abandoned] dalla sua tavolozza la biacca." Dolce tried to separate unnatural *vaghezza* from the lovely Petrarchan variety by labeling it *vana vaghezza* (Dolce, 1557, 1:200): "Non ha dimostro Tiziano nelle sue opere vaghezza vana, ma proprietà convenevole di colori, non ornamenti affettati, ma sodezza da maestro, non crudezza, ma il pastoso e tenero della natura: e nelle cose sue combat-

tono e scherzano sempre i lumi con l'ombre, e perdono e diminuiscono con quell'istesso modo, che fa la medesima Natura."

68 Bellori, 1672, 229.

69 Marcus Aurelius, 1992, 8.

70 James and Webb, 1991, 8.

71 Le Brun (lecture of 5 November 1667), in Félibien, ed., 1668, 101–8.

72 Félibien, 1725, 4:143.

73 Poussin, letter to Chantelou (28 April 1639); in Jouanny, 1911, 21. The review of Bellori's *Vite* appeared in *Il Giornale de' letterati di Francesco Nazari per tutto l'anno 1673* (Rome, 1673), 77; quoted by Previtali, 1976, li.

74 For a left-to-right, top-to-bottom reading, see Bellori (1672, 187–88) on Barocci's *Perdono di Assisi*. For a pictorial framing use of center/margins and symmetry, see Bellori (195) on Barocci's *Presentation of the Virgin* (Rome, Chiesa Nuova). For Bellori's debt to Agucchi, see Bätschmann, 1995; Hausmann, forthcoming. For the effect of describing prints instead of the original paintings (re left–right relations), see Perini, 1996, 297–98.

75 For related observations on Agucchi's ekphrases, see Perini, 1989, 184. Hochmann (1994, 61 and 65) makes this point about ekphrasis in general.

76 Bellori, 1672, 254.

77 Turner, 1971, 297–325. Perini (1989, 187–90) questions the extent of Bellori's indebtedness to Carli.

78 Lacombe, 1758, 392: "*Vaghezza*. Ampio significato ha questa voce nella Pittura; conciossiachè s'appplichi al Colorito, al Disegno, al composto, al tutto, ed alle sue parti. Denota alcuna fiata certi toni brillanti, e luminosi, tocchi larghi, gran gusto di Disegno, strisciate di chiari, e d'ombre; finalmente vapori, che pare che inviluppino gli oggetti tutti del Quadro."

79 Lacombe, 1758, 44: "*Bellezze fuggitive, o passeggiere*. Hanno i Pittori alcuna fiata, così chiamati alcuni tratti fuggitivi, i quali non sono sostanzialmente uniti ai loro soggetti, e che bisogna afferrare in quell'istante, in che vengono dalla Natura presentati. Tali appunto sono le Passioni dell'animo: l'impressione cagionata sul volto dal vedere un qualche singolare spettacolo, e simiglianti. Possonsi pure appellare *Bellezze passeggiere* cotali effetti vivaci della luce prodotti dall'accozzamento casuale delle nuvole; da quei fuochi celesti; da cotali tuoni straordinarj, in una parola da un'infinita spezie

di varietadi, cui sogliono osservare nella Natura gli attenti occhi de' riguardanti."

80 For more on these different compositional types, particularly the former, see Sohm, 2000b.

81 Magalotti, 1721, 32–33.

82 Milizia, 1797, s.v. *vaghezza*: "Vaghezza esprime una certa leggerezza o finezza di tinte provenienti da un felice misto. L'armonia del colorito esige un misto di nuvole, di tinte, di lumi, di riflessi, di ombre, che non vi si discernono i legami, si chiama vaghezza. Il Cielo è il più vago." See also Watelet and Lévesque, 1792, 5: 797: "Vague se dit en peinture de la couleur, & plus particuliérement de celle du ciel.... On dit quelquefois vaguesse, qui est imité de l'italien vaghezza, pour exprimer ce ton aerien une certaine légéreté ou finesse de teintes."

83 Lomazzo, 1590, 329–30 (on how painters working *di prattica*, "born like mushrooms," delight the eyes with *vaghezza*); and 331–32: "Ma se si rivolgiamo alle composizioni di questi ripieni di furore, ancora che nella prima vista porgano non so che di vaghezza, per la virtù del colore et anco per il chiaro et iscuro che averà ben inteso, non essendo per il resto introdotte con considerazione opportuna, come prima vi affissiamo addosso gli occhi della ragione, subito giudichiamo che sono scatenate e prive affatto di tutto quello che si li doverà di ragione. . . ." For other condescending remarks about people who absorb and judge paintings "at a glance," see Vasari, 1568, 4:247; Dolce, 1557, 181; Bellori, 1672, 358 (Domenichino "ricordava che nel considerar le cose non ci fidassimo di una prima vista, e che l'intelletto e non l'occhio è giudice del colore") and 56 ("[D]obbiamo avvertire che la loro forma richiede spettatore attento ed ingenoso, il cui giudizio non risieda nella vista ma nell'intelletto. Questo al certo non resterà sodisfatto di comprendere in una occhiata tutto quello che vede. . . ."); Malvasia, 1678, 2:67–68 (the furtive – *furbesco* – Donducci hid difficulties in deep shadows "su que' scuri poi maravigliosamente spiccando le prime piazze de' chiari, che alla prima ferivano la vista, e con estrema vaghezza appagavano il gusto"); Scaramuccia, 1674, 174.

84 Scannelli, 1657, 110–11.

85 Malvasia, 1678, 2:67–68: "Ed ascondendo in tal guisa le scorrezioni e gli errori quando ve ne potessero esser stati, e su que' scuri poi

maravigliosamente spiccando le prime piazze de' chiari, che alla prima ferivano la vista, e con estrema vaghezza appagavano il gusto."

86 For a discussion of *macchia*, see above Chapter 6. For *vaghezza* as bold or sketchy brushwork, see Baldinucci, 1681–1728, 3:76–77 and Passeri, 1673, 79, 21.

87 Calvi, 1655, 9 ("un chaos di vaghezza"); Castellamonte, 1674, 75 ("La prego Signor Conte à svelarmi questa sì nobile confusione, & à rischiarirmi questo sì vago, e dilettevole Caos"). For *vaghezza* signaling an absence of *disegno*, see Aretino, letter to L. Dolce: "Che onor si fanno i colori vaghi che si consumano in dipingere frascariuole senza disegno?" And Vasari (1568, 6:156): Titian and other Venetian painters chose to "nascere sotto la vaghezza de' colori lo stento del non sapere disegnare." For *vaghezza* as a capricious and strange style, see Vasari (1568, 6:69): "[Michelangelo] ha lassato da parte le vaghezze de' colori, i capricci e le nuove fantasie di certe minuzie e dilicatezze. . . ." And Lomazzo, 1590, 286; Pascoli, 1736, 517 ("nel bizzarro, capriccioso, e vago modo che si vede").

88 Franchini (1716, 34) in denying that *vaghezza* consists of "un certo sfavillar di colore," tells us what the common view was.

89 For the most complete Renaissance discussion of the technique and effects, see Lomazzo, 1584, 173–75; and Boschini, 1673, 733–36. For a discussion of the technique from a modern point of view, see Hall, 1992, 20–22, 108–9, 106–9, 113–15 and 123–29.

90 Ripa, 1603, 118: "Vestesi di cangiante, che mostri diversi colori, come diverse apparenze delle cose, che fanno gli huomini irresoluti."

91 Pliny, *Historia naturale*, trans. Domenichi, 1561, 1105: "Non è da passare anchora Ludio, che fu al tempo d'Augusto; e fu il primo, che trovò la vaghissima pittura delle mura, ville, portichi, luoghi ornati d'arbuscelli, selve, colli, vivai, canali, fiumi, riviere, secondo gli appetiti delle persone. . . ." Vasari (letter of 12 February 1547; published in Varchi, 1549, 1:61); Gelli, 1556, 682–83 ("per la vaghezza de' colori e per la varietà de' paesi"); Rinaldi, 1593; Boschini, 1660, 428 ("Paesi singulari, oh come beli, / Vaghezze maestose e naturale"); Soprani, 1674, 23 ("la vaghezza d'un bel Paese, che riesce di gran ricreatione a gl'occhi de' riguardanti"); Borboni, 1661, 55; Passeri, 1673–79, 31 ("un vago paese"); Cambiagi, 1757 1 (de-

scribing the Boboli gardens as a delightful place "sì per il vago e ben composto salvatico che . . . per la vaghezza del colle").

92 Vasari, 1568, 4:92. Pino (1548, 97–98) has the Florentine "Fabio" criticize the Venetian painter's love of nature by identifying it with his indiscriminate love of women. When the Venetian "Lauro" exalts the beauty of twenty-five women, "Fabio" reprimands him for speaking "as a Venetian, not as a painter." A painter would see the women (as Zeuxis viewed the women of Crotona) as material to be refined into a higher beauty, not as beauty itself.

93 Giovio, *Dialogus de viris litteris illustribus cui in calce sunt additae vincii, michaelis angeli, raphaelis urbinatis vitae*; cited in Pedretti, 1977, 1:11.

94 Domenici, 1742, 3:613.

95 Domenici (1742, 3:3) has Ribera fall in love (*invaghi*) with Correggio's colors.

96 Mancini, 1956, 1:303. See also 1:109: "E se bene non va [Giuseppe Cesare d'Arpino] osservando tanto essattamente il naturale come quella del Caravaggio nè quella gravità e sodezza di quella delli Caracci, nondimeno ha in sè quella vaghezza che in un tratto rapisce l'occhio e diletta. . . ."

97 Boschini, 1660, 367.

98 Paleotti (1582, 2:432): ". . . dove i pittori con la vaghezza dei colori e ornamenti che vi aggiongono cercano supplire al difetto dell'arte e del disegno." Later (2:441) he lumped "la vaghezza de' colori" together with "i ornamenti attrattivi" as qualities of the grotesque. See also Agucchi, in Masini, xlviii: "E sorgevano nuove, e diverse maniere lontane dal vero, e dal verisimile, e più appoggiate all'apparenza, che alla sostanza, contentandosi gli artefici di pascer gli occhi del popolo con la vaghezza de' colori, e con gli addobbi delle vestimenti. . . ." C. A. Bellini, 1664, 95; in Della Valle, 1990, 107: "[N]on avendo le figure [painting in Vercelli before 1500] alcuna proporzione né simetria senza il vago dell'ombre, senza vivacità di colori; e finalmente che piuttosto sembravano fatte con un pennello da Mastro da muro che un pennello da Pittore." Pascoli, 1736, 2:317–18: Modern paintings, like rooms decorated with precious drapings, "fanno la vaghezza, e forza de' colori, che eleganza, e la correzion delle forme. Imperocchè il colorito dà subito nell'occhio, ed è da ognun conosciuto, laddove il disegno resta

addietro, ed è da' soli maestri osservato. . . ." He used this observation to explain the popularity of Seiter: "Fu il nostro Daniello [Seiter] un ferace, e vago coloritore; e benchè alla feracità, ed alla vaghezza del colorito non corrispondesse l'esattezza del disegno." See also Zanotti, 1739, 2:349 (the drapery folds of Titian and Veronese have "più al fastoso . . . e al vago, che al verisimile o al vero"). Gherardi, 1744, 47: "[Paolo Veronese] abbellì nell'esterno i corpi con vaghezza di vestimenta e con piegature bellissime di panni." This should be read in the context of Gherardi's statement that Veronese was not "esatto né corretto nel disegno" but achieved fame by "un prodigioso colorito." For *vaghezza* as an illusion and accident, see Varchi, in Barocchi, ed., *Trattati*, 1:38 and 52.

99 Frugoni, 1666, 167: "È questa una Pittura [portrait of *il Modista*], che vuol'esser illuminata colla punta del pennello più acuto, che impugni la Belgia ingegnosa. Bisognerebbe miniarla col sudore dell'arte. . . . Perrin del Vago, sarebbe il proprio per esprimerlo dal naturale, poiche il Modista si preggia tanto di parer vago. Un Pittor vi vorrebbe, come il Greghetto Genovese, che pingea per eccellenza, tra l'altre bestie, i Papagalli. . . . È d'huopo qui l'hipocrisia di un pennello lussureggiante per effigiare la vanità hipocrita di un volto; tutto rivolto a parer dissimile da sè stesso." For the threatened effects of *vaghezza* blinding prudent judgment, see Gualdo-Priorato, 1677, 2:8: "Eran vaghe queste considerazioni e'l colore che le miniava aveva gran forza d'ingannar l'occhio della prudenza."

100 Baldinucci did not give *vaghezza* any sense of mannerism in his definition, but in practice he did (1681–1728, 3:76–77; quoted in Chapter 6, note 115). The phrase "discostandosi alquanto dal naturale e dal modo di co-lorire degli altri pittori" recalls his definition of mannered art (*ammanierato: Vocabolario*, 88) as "discostandosi molto dal vero." More to the point, mannered art is where paintings "potranno bene appair facilmente, e francamente fatte," which moves it into the orbit of *vaghezza*. For *vaghezza* as facility, see Borghini, 1584, 614–15 and 619; Armenini, 1587, 84–85; Lomazzo, 1590, 272 and 300–301; Faberio, 1603, 40; Scannelli, 1657, 349, 352–53; and Passeri, 1673–79, 16. For *vaghezza* as an unnatural appearance, see Dolce, 1557, 1:200; Mancini, 1956, 1:109 (Cesare d'Arpino did not observe nature as precisely as Caravaggio, but he did have "quella vaghezza che in un tratto rapisce l'occhio"). Malvasia, 1678, 2:115: "[Le] cose moderne . . . hanno maggior vaghezza e brio; ma forse mancano di tanto fondamento e naturalezza."

101 Calvi, 1655, 54. Boschini, *Carta*, 493: "Oh zogie oriental de gran decoro! / Oh piere preciose in squisitezza! / Esempio de purissima vaghezza, / Degne de star aponto in fondi d'oro!" Martinioni, 1663, 123: the altarpiece in San Salvatore by Alessandro Vittoria "è bellissimo per dissegno, ricchissimo per i marmi de quali è composto, e vaghissimo per gli ornamenti." Passeri (1673–79, 382–83) described Cortona's Barberini ceiling as: "copiosa nel componimento, studiosa, e in tutto mirabile, abondante e vaga nell'ornamento."

102 Gilio, 1564, 48 and 80. Michelangelo painted his figures in the *Last Judgment* in forced and unnatural poses – painted "*di maniera*" – whereas, instead of violently distorted, they should have been "vago e naturale." Elsewhere, but still within the theme of the didactic function of art, Gilio wrote that artists should try to attain honesty and decorum (codes for the natural) instead of "la vaghezza de l'arte."

BIBLIOGRAPHY

PRIMARY SOURCES

ANONYMOUS OR MULTIAUTHORED WORKS WITHOUT AN EDITOR

Le Belle Arti pittura, sculturae architettura, compimento e perfezione delle bellezze dell'universo. Mostrate nel Campidoglio dall'Accademia del Disegno. Rome, 1711.

Le Buone Arti sempre più gloriose nel Campidoglio per la solenne Accademia del Disegno. Rome, 1704.

Componimenti in lode del signor Leopoldo del Pozzo Romano celebre dipintore di musaico. Venice, 1729.

Descrizione della Galleria Gabinetto dell'Ill.mo Sig.re Cav.re Gabburri. Florence, Biblioteca Nazionale MSS II. iv 240.

Dichiarazione della regole per restituire alla pristina solidità, o sia per modellar di rilievo quel disegno di nuova invenzione, che cavato del solido; contained in *Varii scritture apparenti alla pittura e suoi professori.* Florence, Biblioteca Nazionale MSS II. iv. 239.

Gli Eccelsi pregi delle belle arti e la scambievole lor Congiunzione con le Mattematiche Scienze mostrata nel Campidoglio dall'Accademia del Disegno. Rome, 1733.

Il Funerale d'Agostino Carraccio fatto in Bologna sua patria da gl'Incaminati Academici del Disegno. Bologna, 1603.

Lettere scritte al Signor Pietro Aretino da molti Signori, Comunità, Donne di valore, Poeti, & altri Eccellentissimi Spiriti. Venice, 1552.

Delle Lodi delle belle arti. Orazioni e componimenti poetici detti in Campidoglio. Rome, 1739.

Il Merito delle belle arti. Pittura, scultura e architettura, riconosciuto nel Campidoglio per l'Accademia del Disegno. Rome, 1709.

Nota delli musei, librerie, galerie, et ornamenti di statue e pitture ne' palazzi, nelle case, e ne' giardini di Roma. Rome, 1664. Edition cited: E. Zocca, ed. Rome, 1976.

Le Pompe dell'Accademia del Disegno. Solennemente celebrate nel Campidoglio. Rome, 1702.

Roma tutrice delle belle arti pittura, scultura e architettura, mostrata nel Campidoglio dall'Accademia del Disegno. Rome, 1710.

Le Scienze illustrate dalle belle arti nel Campidoglio per l'Accademia del Disegno. Rome, 1708.

Le Tre Belle Arti, pittura, scultura e architettura, in Lega coll'Armi per difesa della Religione: Mostrate nel Campidoglio dall'Accademia del Disegno. Rome, 1716.

Il Trionfo della Fede solennizzato nel Campidoglio dall'Accademia del Disegno. Rome, 1713.

L'Utile nelle belle arti riconosciuto nel Campidoglio per l'Accademia del Disegno. Rome, 1707.

Vocabolario degli Accademici della Crusca. Florence, 1612. Revised editions: Florence, 1623; Florence, 1691; Florence, 1729–1738.

AUTHORED WORKS

Accolti, P. 1625. *Lo inganno degl'occhi.* Florence.

Aglionby, W. 1685. *Painting Illustrated in Three Dialogues . . . Together with the Lives of the Most Eminent Painters.* London.

Alberti, L. B. 1547. *Pittura.* Trans. L. Domenichi. Venice.

Alberti, R. 1599. *Origine e progresso dell'Accademia del disegno.* Rome.

Albertini, A. 1510. *Memoriale di molte statue et picture sono nella inclyta Cipta di Florentia per mano di sculptori & pictori excellenti moderni & antiqui.* Rome.

Algarotti, F. 1754. *Saggio sopra quella quistione perché i grandi ingegni a certi tempi sorgano tutti a un*

tratto e fioriscano insieme. Venice. Edition cited: *Saggi,* ed. G. Da Pozzo. Bari, 1961.

1756. *Trattato della pittura.* Venice. Revised edition: Bologna, 1762. Edition cited: *Saggi,* ed. G. Da Pozzo. Bari, 1961.

1763. *Saggio sopra l'Accademia di Francia chè in Roma.* Livorno. Edition cited: *Saggi,* ed. G. Da Pozzo. Bari, 1961.

1791. *Opere.* 10 vols. Venice.

Allegri, A. 1605. *Rime e prose.* Siena. Edition cited: Amsterdam, 1754.

Alunno, F. 1557. *La fabrica del mondo nella quale si contengono le voci di Dante, del Petrarca, del Boccaccio, e d'altri buoni autori, mediante le quali si possono scrivendo isprimere tutti i concetti dell'huomo di qualunque cosa creata. Di nuovo ristampata, ricorretta, et ampliata.* Venice.

Ammanati, B. 1582. *Lettera agli Academici del Disegno.* Florence. Edition cited: *Trattati,* ed. Barocchi. Vol. 8.

Aretino, P. 1957. *Lettere sull'arte.* Ed. E. Camesasca and F. Pertile. 3 vols. Milan.

Aristotle. 1544. *Rhetoricorum Aristotelis Libri tres, interprete Hermolao Barbaro P.V. Commentaria in eosdem Danielis Barbari.* Venice.

1549. *Rettorica et Poetica.* Trans. Bernardo Segni. Florence.

1572. *I Tre libri della Retorica d'Aristotele e Theodette.* Trans. Alessandro Piccolomini. Venice.

1591. *De Arte Rhetorica.* Ed. and trans. A. Maioragi. Venice.

Rhetoric. 1926. Trans. J. H. Freese. London and Cambridge, MA.

1960. *Posterior Analytics.* Ed. and trans. H. Tredennick. Cambridge, MA and London.

Armenini, G. B. 1587. *De' Veri precetti della pittura.* Ravenna. Edition cited: ed. M. Gorreri. Turin, 1988.

Aromatari, G. degli, ed. 1644. *Degli autori del ben parlare.* Venice.

Averoldo, G. A. 1700. *Le Scelte pitture di Brescia.* Brescia.

Baglione, G. 1639. *Le nove chiese di Roma.* Rome. Edition cited: ed. Liliana Barroero. Rome, 1990.

1642. *Vite de' pittori, scultori, et architetti.* Rome.

Baldi, C. 1621. *In Physiognomica Aristotelis Commentarii.* Bologna.

1622. *Trattato come da una lettera missiva si conoscano la natura e qualità dello scrivere.* Carpi.

Baldinucci, F. 1681. *Vocabolario Toscano dell'arte del disegno.* Florence.

1681–1728. *Notizie de' professori del disegno dal Cimabue in qua.* Florence. Edition cited: ed., Barocchi. 7 vols. Florence, 1975.

1687. *Lettera all'Ill. e Clariss. Sig. Senatore e Marchese Vincenzo Capponi.* Rome. Published in *Notizie,* ed. Barocchi, 7, 461–85. Florence, 1975.

1768–1817. *Notizie de' professori del disegno dal Cimabue in qua.* Ed. G. Piacenza, 5 vols. Turin.

Baldinucci, F. S. 1981. "Notizie della vita di Filippo Baldinucci." In *Zibaldone baldinucciano,* ed. B. Santi, 2, 3–35. Florence.

Bandello, M. 1952. *Opere.* Ed. F. Flora. Rome.

Barbaro, D. 1557. *Della Eloquenza.* Venice. Edition cited: *Trattati,* ed. Weinberg Vol. 2.

, ed. 1567. Vitruvius, *I dieci libri dell'architettura.* Trans. and commentary by D. Barbaro. Venice.

Barocchi, P., ed. 1960. *Trattati d'arte del cinquecento fra manierismo e controriforma.* 3 vols. Bari.

, ed. 1971. *Scritti d'arte del cinquecento.* 3 vols. Milan and Naples.

Bartoli, D. 1646. *Dell'huomo di lettere difeso & emendato.* 6th ed. Bologna.

1659. *La Ricreatione del savio in discorso con la Natura e con Dio.* Rome.

Bartolozzi, S. 1753. *Vita di Jacopo Vignali pittore Fiorentino.* Florence.

Baruffaldi, G. 1714. *La Tabaccheide.* Ferrara.

1758. *I baccanali.* Bologna.

1844–46. *Vite de' pittori e scultori ferraresi.* Ed. G. P. Zanotti et al. 2 vols. Ferrara.

Bellini, C. A. 1664. *Serie degli Uomini e donne illustri della città di Vercelli col compendio delle Vite dei medesimi.* Part 3 dates from 1664 and includes "Persone eccellenti in diverse altre Virtù, cioè Pittura, Scultura e Musica." Manuscript in Turin, Biblioteca Reale. Published in G. Della Valle, *Notizie degli artefici piemontesi,* ed. G. C. Sciolla, 104–110. Turin, 1990.

Bellori, G. P. 1645. *Icones et segmenta illustrium e marmore tabularum quae Romae adhuc extant a Francisco Perrier delineata incisa et . . . restituta. (Figuris his omnibus suppositas notas ad explicationem adjunxit Jo). Petrus Bellorius.* Rome.

1657. *Argomento della Galeria Farnese dipinta da Annibale Carracci, disegnata e intagliata da Carlo Cesio. Nel quale spiegansi e riduconsi allegoricamente alla moralità le Favole Poetiche in essa rappresentate.* Rome.

1672. *Le Vite de' pittori, scultori e architetti moderni.* Rome. Edition cited: ed. E. Borea. Turin, 1976.

1677. *Indice delle stampe intagliate in rame al bulino e all'acquaforte* (verses by Bellori). Rome.

1679. *Columna Antoniniana Marci Aureli Antonini Augusti rebus gestis insignis Germanis simul et Sarmatis gemino bello devictus ex S.C. Romae in Antonini Foro ad viam Flaminiam erecta ac utriusque belli imaginibus anaglyphice insculpta nunc primum a Petro Sancte Bartolo iuxta delineationes in Bibliotheca Barberini adservatas a se cum antiquis ipsius columnae signis collatas, aere incisa et in lucem edita cum notis excerptis et declarationibus Io: Petri Bellorii.* Rome.

1680a. *Le Pitture antiche del sepolcro de Nasonii nella via Flaminia.* Rome. 2 ed. with 35 new plates. Rome, 1691.

1680b. *Sigismundi Augusti Mantuam adeuntis profectio ac triumphus . . . anno MCCCCXXXII, opus ex archetypo Julii Romani a Francisco Primaticcio Mantuae in Ducali Palatio quod del T noncupatur, platica atque anaglyphica sculptura mire elaboratum . . . cum notis Jo: Petri Bellori a Petro Sancti Bartoli ex veteri exemplari traductum aerique incisum.* Rome.

1685. *L'Historia Augusta da Giulio Cesare a Costantino il Magno, illustrata con la verità dell'antiche medaglie da Francesco Angeloni. Seconda impressione con le emendazioni postume del medesimo Autore e col supplemento de' rovesci che mancavano nelle loro tavole tratti dal tesoro delle medaglie della Regina Christina Augusta e descritti da Gio. Pietro Bellori, Bibliotecario e Antiquario di Sua Maestà.* Rome.

1691. *Le antiche lucerne sepolcrali figurate raccolte dalle cave sotterranee e grotte di Roma, Nelle quali si contengono molte erudite memorie, Disegnate ed intagliate nelle loro forme da Pietro Santi Bartoli, divise in tre parti con l'osservationi di Gio: Pietro Bellori.* Rome.

1693. *Admiranda romanorum antiquitatum ac veteris sculpturae vestigia anagliphico opere elaborata ex marmoribus quae Romae adhuc extant . . . a Pietro Sancti Bartolo delineata incisa . . . notis Jo: Petri Bellorii illustrata.* Rome.

1695. *Descrizzione delle imagini dipinti da Rafaelle d'Urbino nelle Camere del Palazzo Apostolico Vaticano.* Rome.

1697. *Gli antichi sepolcri, overo mausolei romani et etruschi, trovati in Roma et altri luoghi celebri, nelli quali si contengono molte erudite memorie, raccolti, disegnati et intagliati da Pietro Santi Bartoli.* Rome.

1728. *Le vite de' pittori, scultori ed architetti moderni . . . in questa seconda edizione accresciute colla vita e ritratto del cavaliere D. Luca Giordano.* Rome.

Bembo, P. 1505. *Gli Asolani.* Venice. Edition cited: ed. C. Dionisotti. Turin, 1932.

Beni, P. 1614. *Il Cavalcanti overo la difesa dell'Anticrusca di Michelangelo Fonte.* Padua.

Bernini, P. 1713. *Vita del Cavalier Gio. Lorenzo Bernino.* Rome.

Bianconi, G. L. 1776. "Lettera scritta da Perugia al sig. abate Carlo Bianconi in Roma nella quale si danno notizie intorno alla vita di Raffaello da Urbino (28 ag. 1776)." In *Opere.* Milan, 1802.

Billi, A. 1991. *Il Libro di Antonio Billi.* Ed. Fabio Benedettucci. Anzio.

Biondo, M. 1544. *Angoscia, Doglia e Pena. Le tre furie del mondo.* Venice. Edition cited: *Trattato del cinquecento sulla donna,* ed. G. Zonta. Bari, 1913.

Bisagno, F. 1642. *Trattato della pittura fondato nell'auttorità di molti eccellenti in questa professione.* Venice.

Boccaccio, G. 1956. *Decameron.* Ed. N. Sapegno. Turin.

Boccalini, T. 1612. *Ragguagli di Parnasso.* Venice. Expanded and definitive edition: Venice, 1613; edition cited: ed. G. Rua. Bari, 1910–12.

Bocchi, F. 1591. *Le Bellezze di Firenze.* Florence.

Bonifacio, G. 1616. *L'Arte dei cenni.* Vicenza.

Borboni, G. A. 1661. *Delle statue.* Rome.

Borghini, R. 1584. *Il Riposo in cui della pittura e della scultura si favella.* Florence.

1730. *Il Riposo.* Ed. Giovanni Gaetano Bottari. Florence.

Borghini, V. 1855. "Comparazione fra Dante e 'l Petrarca." In *Studi sulla Divina Commedia di G. Gallilei, V. Borghini ed altri,* ed. O. Gigli, 306–13. Florence.

1898. "Difesa speciale [di Dante] contro a quello di che l'incolpa il Bembo." In *Ruscelleide ovvero Dante difeso dalle accuse di G. Ruscelli,* ed. C. Arlia, 1: 79ff. Città di Castello.

1912. *Carteggio artistico inedito.* Ed. A. Lorenzoni. Florence.

1971. "Lingue perché si variino o mutino." In *Scritti inediti o rari sulla lingua,* ed. J. R. Woodhouse. Bologna.

1988. "Modo di Salvare il Bembo." In *Discussioni linguistiche del Cinquecento,* ed. M. Pozzi, 742–45. Turin.

Borromeo, F. 1624. *De pictura sacra.* Milan. Edition

cited: *Della pittura sacra.* ed. B. Agosti. Pisa, 1994.

1625. *Musaeum.* Milan.

Boschini, M. 1660. *La Carta del navegar pitoresco.* Venice. Edition cited: ed. A. Pallucchini. Venice and Rome, 1966.

———. 1673. "Breve instruzione." In *Le Ricche minere della pittura veneziana.* Venice. Edition cited: ed. A. Pallucchini, 703–56. Venice and Rome, 1966.

Boselli, O. 1978. *Osservazioni della scoltura antica dai manoscritti Corsini e Doria e altri scritti.* Ed. P. D. Weil. Florence.

———. 1994. *Osservazioni sulla scultura antica. I manoscritti di Firenze e di Ferrara.* Ed. A. Torresi. Ferrara.

Bosse, A. 1649. *Sentiments sur la distinction des diverses manières de peinture, dessin et gravure, et des originaux d'avec leur copies.* Paris.

Bottari, G. G. 1754. *Dialoghi sopra le tre arti del disegno.* Milan.

Bottari, G. G., and Ticozzi, S. eds. 1822–25. *Raccolta di lettere sulla pittura, scultura ed architettura.* Milan.

Bouhours, D. 1671. *Entretiens d'Ariste et d'Eugène.* Paris.

———. 1687. *Le Manière de bien penser dans les ouvrages d'esprit.* Paris.

Brosse, C. de. 1931. *Lettres familières sur l'Italie.* Ed. Y. Bezard. 2 vols. Paris.

Buffon. 1967. *Discours sur le style.* Ed. P. Battista. Rome.

Buonarroti, M. 1965. *Il Carteggio di Michelangelo. Edizione postuma di Giovanni Poggi.* Ed. P. Barocchi and R. Ristori. 5 vols. Florence.

Buoninsegni, F. 1644. *Contro 'l lusso donesco. Satira menippea . . . con Antisatira D.A.T. in risposta.* Venice.

Calvi, D. 1655. *Le misteriose pitture del Palazzo Moroni.* Bergamo.

Cambiagi, G. 1757. *Descrizione dell'Imperiale Giardino di Boboli.* Florence.

Canal, V. da. 1804. *Vita di Gregorio Lazzarini.* Ed. G. A. Moschini. Venice.

———. 1810. "Della maniera del dipingere moderno." *Mercurio filosofico letterario e poetico,* March 1810, 3–20. Venice.

Caporali, C. 1912. *Rime.* Ed. G. Monti. 2 vols. Lanciano.

Capra, G. F. 1525. *Della Eccellenza e dignità delle done.* Rome. Edition cited; ed. M. L. Doglio. Rome, 1988.

Cardano, G. 1643. *De propria vita liber.* Paris. Edition cited: *Autobiografia,* ed. and trans. P. Franchetti. Turin, 1945.

Cardi, G. B. 1628. *Vita di Ludovico Cigoli.* Ed. G. Battelli and K. Busse. Florence, 1913.

Carducho, V. 1633. *Los Dialogos de la pintura.* Madrid.

Caro, A. 1558. *Apologia de gli Academici di Banchi di Roma contra M. Lodovico Castelvetro da Modena in forma d'uno Spaccio di Maestro Pasquino. . . . In difesa de la seguente Canzone del Commendatore Annibal Caro.* Parma. In *Opere,* ed. V. Turri, vol. 1. Bari, 1912.

———. 1570. *La Rhetorica di Aristotile.* Venice.

———. 1957–61. *Lettere.* Ed. A. Greco. 3 vols. Florence.

Castellamonte, A. di. 1674. *Venaria Reale. Palazzo di piacere, e di caccia ideata dall'Altezza Reale di Carlo Emanuel II Duca di Savoia, Re di Cipro.* Turin.

Castiglione, B. 1528. *Il Cortegiano.* Venice. Edition cited: ed. E. Bonora. Milan, 1972.

Ceci, G. B. 1618. *Compendio d'avvertimenti di ben parlare volgare, correttamente scrivere e comporre lettere di Negocio e complimenti.* Venice.

Celano, C. 1681. *Degli avanzi delle poste.* 2 vols. Naples.

Celio, G. 1638. *Memoria fatta dal Signor Gaspare Celio . . . Delli nomi dell'artefici delle pitture che sono in alcune chiese, facciate, e palazzi di Roma.* Naples.

Cellini, B. 1958. *Vita.* Milan.

Cennini, C. 1971. *Il Libro dell'arte.* Ed. F. Brunello. Vicenza.

Celano, C. 1676–81. *Degli avanzi delle poste.* Naples.

Certaldo, P. da. 1945. *Libro di buoni costumi.* Ed. A. Schiaffini. Florence.

Chantelou, P. Fréart de. 1985. *Diary of the Cavaliere Bernini's Visit to France.* Ed. A. Blunt and G. Bauer, trans. M. Corbett. Princeton, NJ.

Ciampoli, G. 1649. *Prose.* Rome.

Ciapetti, G. F. 1678. *La sacra magnificenza descritta per la famosa, e venerabile Scuola del Gloriosiss.o Prencipe San Rocco.* Venice.

Cinelli Calvoli, G. 1677. In F. Bocchi, *Le Bellezze della Città di Firenze . . . Scritte già da Francesco Bocchi, ed ora da Giovanni Cinelli ampliate, ed accresciute.* Florence.

———. 1716. *Della Biblioteca Volante.* Ferrara.

Ciocchi, G. M. 1725. *La Pittura in Parnaso.* Florence.

Cocchi, A. 1791. *Consulti medici.* Bergamo.

Colaccio, M. 1486. *De fine oratoris.* Venice.

Colombina, G. 1623. *Discorso distinto in quattro capitoli*. Padua.

Condivi, A. 1553. *Vita di Michel Angelo Buonarroti*. Rome.

Cortesi, P. 1977. *De hominibus doctis*. Ed. G. Ferraù. Messina.

Costa, G. B. 1752. "Lettere varie e documenti autenici intorno le opere e vero nome, cognome, e patria di Guido Cagnacci pittore." *Raccolta d'opuscoli scientifici e filologici* 47:117–61.

Cotta, L. A. 1701. *Museo Novarese*. Milan.

Cozzando, L. 1694. *Vago, e curioso ristretto profano, e sacro dell'historia Bresciana*. Brescia.

Cresci, G. F. 1579. *Il perfetto cancelleresco corsivo . . . con un'breve discorso circa l'honore, & utile, che apporta al Secretario lo scriver'bene*. Rome.

Danti, E. 1577. *Le scienze matematiche ridotte in tavole*. Bologna.

Danti, V. 1567. *Il primo libro del Trattato delle perfette proporzioni*. Florence. In *Trattati*, ed. Barocchi, vol. 1.

Dati, C. 1657. *Discorso dell'obbligo di ben parlare la propria lingua*. Florence.

——— 1663. "Editto dell'Accademia della Crusca." In *Scritti vari*, ed. L. Panciatichi. Florence, 1856.

——— 1664. *Delle lodi del Commendatore Cassiano dal Pozzo*. Florence.

——— 1667. *Vite de' pittori antichi*, Florence. Edition cited: ed. Gugliemo Dalla Valle. 2 vols. Milan, 1823–30.

——— 1825. *Lettere*. Ed. D. Moreni. Florence.

David, L. n.d. *Dissertazione*. Modena, Biblioteca Estense, MSS Campori, 1071.

——— 1695. *Dichiarazione della pittura della Capela del Collegio Clementino di Roma*. Rome.

Della Porta, G. B. 1644. *Della Fisionomia dell'huomo*. Venice.

Della Valle, G. 1990. *Notizie degli artefici piemontesi*. Ed. G. C. Sciolla. Turin.

Delminio, G. C. 1544. *Due trattati. L'uno delle materie che possono venir sotto lo stile dell'eloquente. L'altro della imitazione*. Venice. Edition cited: *Trattati*, ed. Weinberg, vol. 1.

——— 1593. *Le Idee, overo forme della oratione da Hermogene considerate & ridotte in questa lingua*. Udine.

Demetrius. 1594. *Commentarii in librum Demetrii Phalerei de elocutione*. Ed. P. Vettori. Florence.

——— 1603. *Della locuzione*. Trans. Pier Segni. Florence.

Diderot, D. 1965. "Essais sur la peinture." In *Oeuvres esthétiques*, ed. P. Vernière. Paris.

Dionysius of Halicarnassus. 1615. *Scripta quae extant omnia; historica et rhetorica*. Ed. and trans. F. Sylburgium. Hannover.

——— 1702. *De structura orationis*. Ed. J. Upton and trans. Sylburgii and Poleni. London.

Dolce, L. 1545. *Dialogo della institution delle donne*. Venice.

——— 1557. *Dialogo della pittura*, Venice. Edition cited: *Trattai*, ed. Barocchi, vol. 1.

——— 1564. *Modi affigurati e voci scelte et eleganti della volgar lingua*. Venice.

De' Dominici, B. 1742. *Vite de' pittori, scultori, ed architetti napoletani*. Naples.

Doni, A. F. 1549. *Disegno*. Venice.

[Faberio, L.]. 1603. "Oratione in morte d'Agostino Carraccio." In *Il Funerale d'Agostino Carraccio fatto in Bologna sua patria da gl'Incaminati Academici del Disegno*, 29–43. Bologna.

Félibien, A. 1676. *Des principes de l'Architecture, de la Sculpture et de la Peinture*. Paris.

——— 1725. *Entretiens sur les vies et sur les ouvrages des plus excellens peintres anciens et modernes*. Vol. 4. Trevoux.

Félibien, A., ed. 1668. *Conférences de l'Academie Royale de Peinture et de Sculpture pendant l'année 1667*. Paris. Edition cited: *Les Conférences de l'Académie royale de peinture et de sculpture au XVIIe siècle*, ed. A. Mérot. Paris, 1996.

Ferrari, G. B. 1638. *Flora ovvero cultura dei fiori*. Rome.

Ficino, M. 1989. *Three Books on Life*. Ed. C. V. Kaske and J. R. Clark. Binghamton, NY.

Ficoroni, F. de. 1744. *Le Vestigie e rarità di Roma antica ricercate e spiegate*. Rome.

Filarete, A. 1972. *Trattato di architettura*. Ed. A. M. Finoli and L. Grassi. Milan.

Fileti Mazza, M., and Gaeta Bertelà, G., eds. 1987. *Archivio del Collezionismo Mediceo. Il Cardinal Leopoldo. I: Rapporti con il mercato veneto*. Milan and Naples.

Firenzuola, A. 1548. *Prose*. Ed. L. Scala and L. Domenichi. Florence. Edition cited: *Opere*, ed. D. Maestri. Turin, 1977.

Franchi, A. 1739. *La Teorica della pittura*. Lucca.

Franchini, G. G. 1716. *Vita di Domenico Maria Viani. Pittore bolognese*. Bologna.

Fréart de Chambray, R. 1662. *Idée de la perfection de la peinture*. Mans.

Du Fresnoy, C. A. 1684. *L'Art de peinture. Traduit en françois. Enrichy de remarques, reveu, corrigé, & augmenté*. Paris.

Frugoni, F. F. 1687–89. *Del cane di Diogene*, 6 vols. Venice.

Gabburri, F. N. M. n.d. *Vite di pittori*. Firenze, Bib. Naz. Centrale, MSS Palatini E. B. 9. 5.

Galilei, G. 1890. *Opere*. Ed. A. Favaro and I. Del Lungo. Florence.

 1953. *Opere scelte*. Ed. F. Flora. Milan and Naples.

Gelli, G. B. 1549. *Sopra que' due sonetti del Petrarcha che lodano il ritratto della sua M. Laura*. Florence.

 1551. *Ragionamento sopra le difficoltà di mettere in regole la nostra lingua*. Florence. Edition cited: *Opere*, ed. I. Sanesi. Turin, 1952.

 1556. *Lettura terza sopra lo Inferno di Dante*. Florence. Edition cited: *Opere*, ed. D. Maestri. Turin, 1976.

Gellius, Aulus 1982. *Attic Nights*. Trans. J. Rolfe. Cambridge, MA, and London.

Gherardi, F. 1690. *La Nuova pittura. Opera . . . su la volta, e tribuna della Chiesa di San Pantaleo . . . di Roma. Scoperta l'Anno MDCXC*. Rome.

Gherardi, P. E. 1744. *Descrizione delle pitture esistenti in Modena nell'Estense Ducal Galleria*. Modena. Edition cited: ed. G. Bonsanti. Modena, 1986.

 1749. *Descrizione de' cartoni disegnati da Carlo Cignani e de' quadri dipinti da Sebastiano Ricci posseduti dal Signor Giuseppe Smith Console della Gran Bretagna*. Venice.

Ghiberti, L. 1998. *Commentarii*. Ed. L. Bartoli. Florence.

Ghiradelli, C. 1630. *Cefalogia fisonomica*. Bologna.

Giambullari, P. F. 1551. *Lezzioni*. Florence.

Gigli, G. 1722. *Diario Sanese in cui si veggono alla giornata tutte le cose importanti*. Siena.

Gigli, G. C. 1615. *La Pittura trionfante*. Venice. Reprint edition with introduction and notes by B. Agosti and S. Ginzburg. Porretta Terme, 1996.

Gilio, G. A. 1564. *Due dialoghi, nel primo de' quali si ragiona de le parti morali e civili appartenenti a' letterati cortigiani . . . nel secondo si ragiona degli errori de' pittori circa l'historie*. Camerino. Edition cited: *Trattati*, ed. Barocchi, vol. 2.

Giovio, P. 1956. *Lettere*. Ed. G. G. Ferrero, 2 vols. Rome.

Giraldi Cinzio, G. B. 1554. *Discorso intorno al comporre dei romanzi*. Venice. Edition cited: *Scritti critici*, ed. C. Guerrieri Crocetti. Milan, 1973.

 1982. *Scritti contro lo Canace. Giudizio ed Epistola latina*. Ed. C. Roaf. Bologna.

Giustiniani, V. 1981. *Discorsi sulle arti e sui mestieri*. Ed. A. Banti. Florence.

Gualandi, M., ed. 1845. *Nuova raccolta di lettere sulla pittura, scultura ed architettura*. Bologna.

Gualdo-Priorato, Galeazzo. 1650. *1650. Giardino di Chà Gualdo*. Ed. L. Puppi. Florence, 1972.

 1677. *Storia del ministero del cardinale Giulio Mazarini*. Bologna.

Hermogenes. 1986. *On Types of Style*. Ed. and trans. C. W. Wooten. Chapel Hill, NC.

Horace. 1573. *Opere*. Trans. Giovanni Fabrini. 2d ed. Venice.

 1926. *Satires, Epistles and Ars Poetica*. Trans. H. R. Fairclough. London and Cambridge, MA.

Ingegneri, G. 1607. *Fisionomia naturale . . . nella quale con ragioni tolte della Filosofia, dalla medicina, & dall'anatomia si dimostra, come dalle parti del corpo humano, per la sua naturale complessione, si possa agevolmente conietturare quali siano l'inclinatione de gl'Huomini*. Milan, 1607, and Vicenza, 1615.

Jouanny, C. 1911. *Correspondence de Nicolas Poussin*. Archives de l'art français, n.p., vol. 5.

Jouin, H., ed. 1883. *Conférences de l'Académie Royale de Peinture et de Sculpture*. Paris.

Junius, F. 1637. *De pictura veterum*. Amsterdam. Translated as *The Painting of the Ancients*. London, 1638. Edition cited: *The Literature of Classical Art: The Painting of the Ancients and a Lexicon of Artists and the Works*, ed. K. Aldrich, P. Fehl, and R. Fehl. 2 vols. Berkeley and Los Angeles, 1991.

Lacombe de Prezel, H. 1758. *Dizionario portatile delle belli arti; ovvero Ristretto di ciò, che spetta all'Architettura, alla Scultura, alla Pittura, all'Intaglio, alla Poesia, ed alla Musica*. Venice.

Lana, F. 1584. *Prodromo overo saggio di alcune inventioni nuove premesso all'arte maestra. Opera . . . per mostrare diversi prencipi, & personaggi fatte dall'Ecc. & Nobile, M. Bernardino Campi pittore cremonese*. Cremona.

Lancellotti, S. 1623. *L'oggidì overo il mondo non peggiore né più calamitoso del passato*. Venice (with many subsequent editions: Pavia, 1626; Ascoli, 1627; etc.).

 1636. *L'oggidì overo gl'ingegni non inferiori a' passati*. Venice.

Landino, C. 1974. *Scritti critici e teorici*. Ed. R. Cardini. Rome.

Lante, A. 1786. "Orazione." In *In Lode delle belle arti. Orazione e componimento poetici. Relazione nel concorso e de' premj distribuiti in Campidoglio dall'insigne Accademia del Disegno in S. Luca*, xiii–xxxv. Rome.

Lanzi, L. 1789. *Storia pittorica dell'Italia dal risorgimento delle belle arti fin presso la fine del XVIII*

secolo. Bassano. Edition cited: *Storia pittorica*, ed. M. Capucci. Florence, 1968.

Leonardo da Vinci. 1890. *Trattato della pittura*. Ed. G. Milanesi. Rome.

 1956. *Treatise on Painting*. Ed. P. McMahon. Princeton, NJ.

 1959. *The Literary Works*. Ed. J. Richter. 2 vols. London.

 1977. *The Literary Works*. Ed. C. Pedretti. 2 vols. Oxford.

Lomazzo, G. P. 1584. *Trattato dell'arte della pittura*. Milan. Edition cited: *Scritti sulle arti*, ed. R. Ciardi, vol. 2. Florence, 1973.

 1590. *Idea del tempio della pittura*. Milan. Edition cited: *Scritti sulle arti*, ed. R. Ciardi, vol. 1 Florence, 1973.

Lucian, 1913. *Works*. Trans. A. M. Harmon. Vol. 1. London and New York.

 1959. *Works*. Trans. K. Kilburn. Vol. 6. London and Cambridge, MA.

Machiavelli, N. 1961. *Lettere*. Ed. F. Gaeta. Milan.

Maffei, S. 1955. *Epistolario*. Ed. C. Garibotto. Milan.

Magalotti, L. 1721. *Lettere scientifiche ed erudite*. Florence.

 1769. *Delle lettere familiari*. Florence.

Malvasia, C. C. 1678. *Felsina pittrice. Vite de' pittori bolognesi divise in duoi tomi*. Bologna. Edition cited: ed. G. P. Zanotti et al., 2 vols. Bologna, 1841.

 1686. *Le Pitture di Bologna*. Bologna. Ed. G. P. Zanotti. Bologna, 1706 and 1732.

 1961. *Vite de' pittori bolognese. Appunti inediti*. ed. A. Arfelli. Bologna.

 1980. *Le Carte di Carlo Cesare Malvasia: Le "Vite" di Guido Reni e di Simone Cantarini dal manoscritto B. 16–17 della Biblioteca Comunale dell'Archiginnasio di Bologna*. Ed. L. Marzocchi, Bologna.

 n.d. *Scritti originali del Conte Carlo Cesare Malvasia spettanti alla sua Felsina pittrice*. Ed. L. Marzocchi. Bologna.

Malvezzi, V. 1648. *Consideratoni con occasione d'alcuni luoghi delle vite d'Alcibiade e di Coriolano*. Bologna.

Mancini, G. 1956. *Considerazioni sulla pittura*. Ed. A. Marucchi and L. Salerno. 2 vols. Rome.

Maratta, C. 1696. "Orazione accademica." In *Il Centesimo dell'anno MDCXCV celebrato in Roma dall'Accademia del Disegno*, 23–36. Rome.

Marino, G. B. 1615. *Dicerie sacre*. Venice. Edition cited: *Dicerie sacre e La strage de gl'innocenti*, ed. G. Pozzi. Turin, 1960.

 1911–12. *Epistolario*. Ed. A. Borzetti and F. Nicolini. Bari.

 1966. *Lettere*, ed. M. Guglielminetti. Turin.

Martello, P. J. 1710. *Commentario*. Rome.

Mascardi, A. 1627. *I Discorsi morali su la Tavola di Cebete*. Venice.

 1630. *Prose vulgari*. Venice.

 1636. *Dell'Arte istorica*. Rome. Revised edition, Venice, 1655. Edition cited: ed. A. Bartoli. Florence, 1859 (anastatic reprint: Modena, 1994).

Masini, A. 1646. *Diverse figure al numero di ottanta, disegnata di penna nell'hore di ricreatione da Annibale Carracci intagliatore in rame*. Rome. Published in *Le arti di Bologna di Annibale Carracci*, ed. A. Marabottini. Rome, 1976.

 1650. *Bologna perlustrata*. Bologna.

Maximus of Tyre. 1997. *The Philosophical Orations*, trans. and ed. M. B. Trapp. Oxford.

Mazzoni, S. 1661. *Il Tempo perduto. Scherzi sconcertanti*. Venice.

Medici, L. de'. 1914. *Opere*. Ed. A. Simioni. 2 vols. Bari.

Mengs, A. R. 1787. *Opere pubblicate da Giuseppe Niccolo D'Azara*. 2 vols. Rome.

Migliore, F. L. del. 1684. *Firenze città nobilissima illustrata*. Florence.

 n.d. *Riflessioni e aggiunte alle 'Vite de' pittori' di Vasari*. Florence, Biblioteca Nazionale, MSS II. IV. 218.

Milizia, F. 1781. *Dell'Arte di vedere nelle belle arti*. Venice.

 1797. *Dizionario delle belle arti del disegno*. Bassano.

Monaldini, V. 1755. *Risposta alle Riflessioni critiche sopra le differenti pitture del Sig. Marchese d'Argens*. Lucca.

Montaiglon, A. de, ed. 1887. *Correspondance des Directeurs de l'Académie de France à Rome avec les Surintendants des Bâtiments*. Paris.

Morello, B. 1603. *Il Funerale d'Agostino Carraccio fatto in Bologna sua patria da gl'Incaminati Academici del Disegno*, 1–28 (preface). Bologna.

Moücke, F. 1754. *Serie di ritratti degli eccellenti pittori dipinti di propria mano che esistono nell'Imperial Galleria di Firenze. Colle vite in compendio de' medesimi*. Florence. Vol. 1 (1752); vol. 2 (1754); vol. 3 (1756); vol. 4 (1762). Florence.

Muratori, L. A. 1735. *La filosofia morale*. Milan. Edition cited: Bassano, 1774.

Nicolini, G. G. 1659. *Le ombre del pennello glorioso del molt'illustre Signore Pietro Bellotti, Eccellentissimo Pittore, Abbozzate da Gio. Giorgio Nicolini*. Venice.

Orlandi, P. A. 1704. *Abecedario pittorico*. Bologna.

 1733. *Abecedario pittorico dall'autore ristampata, corretto ed accresciuto*. Naples.

 1753. *Abecedario pittorico*. Ed. P. Guarienti. Venice.

Orsi, G. G., ed. 1735. *Considerazioni sopra la Maniera di ben pensare ne' componimenti, già pubblicata da Padre Domenico Bouhours*. Modena.

Ottonelli, G. D., and Berrettini, P. 1652. *Trattato della pittura e scultura, uso ed abuso loro, composto da un Theologo e da un Pittore, per offerirlo al Sigg. Accademici del Disegno di Firenze*. Florence.

Paglia, F. 1713. *Il Giardino della pittura*. Brescia. Edition cited: ed. C. Boselli, 2 vols. Brescia, 1967. Includes sections not in original edition.

Paleotti, G. 1582. *Discorso intorno le immagini sacre e profane*. Bologna. Edition cited: *Trattati*, ed. Barocchi, vol. 2.

Pallavicino, S. 1662. *Trattato dello stile e del dialogo*. Rome. Edition cited: ed. E. Mattioli. Modena, 1994.

Panigarola, F. 1609. *Il predicatore overo Demetrio Falereo dell'elocutione*. Venice. Edition cited: in *Degli autori del ben parlare*, vol. 1. Venice, 1642.

Panni, A. M. 1762. *Distinto rapporto delle dipinture che trovansi nelle Chiese della Città, e Sobborghi di Cremona*. Cremona.

Pascoli, L. 1730–36. *Vite de' pittori, scultori, ed architetti moderni*. 2 vols. Rome. Edition cited: ed. V. Martinelli. Perugia, 1992.

 1732. *Vite de' pittori, scultori, ed architetti perugini*. Rome.

 1981. *Vite de' pittori, scultori, ed architetti viventi*. Ed. F. F. Mancini. Treviso.

Passeri, G. B. 1670. *Il Silenzio. Discorso sopra la Pittura*. Rome, Biblioteca Corsiniana, MSS 29 A 21, n. 1.

 n.d. "La Fisonomia overo del aria naturale delle teste. Discorso per l'Accademia Romana nella chiesa di San Luca." Rome, Biblioteca Casantense, MSS 1482, cc. 61r–67v.

 n.d. "La Mensogna Veridica. Discorso per la Accademia de Pittori, Scultori et Architetti." Rome, Biblioteca Casantense, MSS. 1482, cc. 86r–87v.

 1673. *La Fantasia. Discorso accademico recitato nell'Accademia di Roma de signori pittori, scultori, & architetti*. Rome, Biblioteca Corsiniana, MSS 29 A 21, n. 2.

 1673–79. *Die Künstlerbiographien von Giovanni Battista Passeri*. Ed. J. Hess. Leipzig and Vienna, 1934.

1772. *Vite de' pittori, scultori ed architetti che hanno lavorato in Roma, morti dal 1641 fino al 1673*. Ed. G. Bianconi and G. G. Bottari. Rome.

Patina, C. C. 1691. *Pitture scelte e dichiarate*. Cologne.

Piero della Francesca. 1942. *De Prospectiva pingendi*. Ed. G. Nicco Fasola. Florence.

Piles, R. de. 1684. "Termes de peinture." In Du Fresnoy's *De arte graphica* (Paris, 1667). Edition cited: *L'Art de peinture. Traduit en françois. Enrichy de remarques, reveu, corrigé, & augmenté*. Paris.

 1699. *Abrégé de la vie des peintres*. Paris. Edition cited: Paris, 1715.

 1708. *Cours de peinture par principes*. Paris.

Pindemonte, G. 1674. *Discorsi accademici*. Verona, n.d. [1674].

Pino, P. 1548. *Dialogo di pittura*. Venice. Edition cited: ed. Barocchi, *Trattati*, vol. 1.

Pio, N. 1977. *Vite di pittori, scultori et architetti (Cod. Mss. Capponi 257)*. Ed. C. Enggass and R. Enggass. Vatican City, 1977.

Pirani, P. 1646. *Dodici capi pertinenti all'Arte Historica del Mascardi*. Venice.

Plato. 1961. *Collected Dialogues*. Ed. E. Hamilton and H. Cairns. Princeton, NJ.

Pliny. 1476. *Historia naturale di C. Plinio Secondo Tradocta di lingua Latina in Fiorentina per Christophoro Landino Fiorentino al Serenissimo Ferdinando Re di Napoli*. Venice: Nicolai Iansonis, 1476. Edition cited: Venice: Philippi, 1481.

 1561. *Historia naturale di G. Plinio Secondo, tradotta per M. Lodovico Domenichi, con le postile in margine. . . .* Venice: Giolito de' Ferrari, 1561.

 1952. *Natural History*. Trans. H. Rackham. Cambridge, MA, and London.

Plutarch. 1560. *Vite*. Trans. Lodovico Domenichi. Venice.

Poussin, N. 1989. *Lettres et propos sur l'art*. Ed. A. Blunt. Paris.

Pozzo, A. 1693–1792. "Breve istruzione per dipingere a fresco." In *Perspectiva pictorum et architectorum*. Rome.

Dal. Pozzo, B. 1749. "Serie de' pittori veronesi." In P. Zagata, *Cronaca veronese*, vol. 3. Verona.

Quartremère de Quincy, A.-C. 1788–1825. *Encyclopédie méthodique*. 3 vols. Paris.

Quintilian. 1584. *L'Institutioni oratorie*. Trans. Oratio Toscanella. Venice.

Raimondi, E. 1677. *Il novissimo passatempo politico, istorico & economico*. Venice.

Ratti, R. 1768. *Delle Vite de' pittori, scultori, ed architetti genovesi*. Genoa.

Resta, S. 1707a. *Indice del Tomo de' disegni raccolti da S. Resta. Intitolato l'Arte in Tre' Stati, cioè in istato di perfezione nell'epoca di Raffaele, di sostegno nella declinazione nell'epoca de' Zuccari, di trionfo nella totale reparazione nell'epoca de' Caracci, e della loro insigne scuola.* Perugia.

——— 1707b. *Indice del libro intitolato Parnaso de' Pittori in cui si contengono vari disegni originali raccolti in Roma.* Perugia.

——— 1958. *Correggio in Roma.* Ed. A. E. Popham. Parma.

——— 1976. "La Galleria portatile." In *I disegni del Codice Resta,* ed. G. Bora. Bologna.

Reynolds, J. 1992. *Discourses.* Ed. P. Rogers. Harmondsworth.

Richardson, J. 1719. *Two Discourses. I. An Essay on the whole Art of Criticism as it relates to Painting. Shewing how to judge I. Of the Goodness of a Picture; II. Of the Hand of the Master; and III. Whether 'tis an Original, or a Copy. II. An Argument in behalf of the Science of a Connoisseur.* London.

Ridolfi, C. 1648. *Le Maraviglie dell'arte, overo le vite de gl'illustri pittori veneti.* Venice. Edition cited: ed. D. von Hadeln. 2 vols. Rome, 1956.

Rinaldi, G. 1593. *Il vago, et dilettevole, giardino di Giovanni Rinaldi diviso in due trattati. Nel primo de' quali si ragione del significato de' colori; nel secondo si tratta dell'herbe, et fiori.* Pavia.

Ripa, C. 1603. *Iconologia.* Rome.

Roberti, G. B. 1758. *Orazione agli studiosi di pittura, scultura, ed architettura dell'Accademia Clementina.* Bologna, n.d.

Romei, A. 1586. *Discorsi . . . divisi in sette giornate nelle quali tra dame e cavaglieri ragionando, nella prima si tratta della bellezza.* Florence.

Rucellai, O. 1826. *Saggio di lettere.* Ed. D. Moreni. Florence.

Ruscelli, G. 1581. *Commentari della lingua italiana.* Venice.

Ruspoli, F. 1777. "Orazione." In *In Lode delle belle arti. Orazione e componimenti poetici. Relazione del concorso e de' premi distribuiti in Campidoglio dall'insigne Accademia del Disegno in San Luca,* 13–35. Rome.

Ruspoli, L. 1779. "Orazione." In *I Pregi delle belle arti celebrati in Campidoglio pel solenne concorso tenuto dall'insigne Accademia del Disegno in San Luca,* xix–xxxiv. Rome.

Salviati, L. 1584. *Avvertimenti della lingua sopra il Decamerone.* Florence.

——— 1827. "Degli Accademici della Crusca difesa dell'Orlando furioso dell'Ariosto contra 'l Dialogo dell'epica poesia di Cammillo Pellegrino. Stacciata prima." In *Opere di Torquato Tasso colle controversie sulla Gerusalemme,* ed. G. Rosini, vol. 18. Pisa.

Sandrart, J. von. 1675. *Teutsche Academie der Edlen Bau-, und Mahlerey-Künste.* Nuremberg. Edition cited: ed. A. R. Peltzer. Munich, 1925.

Savonarola, G. 1962. *Prediche sopra Ruth e Michea.* Ed. V. Romano. Rome.

Scannelli, F. 1657. *Il Microcosmo della pittura.* Cesena.

Scaramuccia, L. 1674. *Le Finezze de' pennelli italiani.* Pavia.

Scilla, A. 1688. "Discorso per l'Academia del disegno in Roma in occasione del concorso dell'anno 1688." Rome, Biblioteca Casantense, MSS 1482, cc. 105r–115).

Seneca the Elder. 1974. *Controversiae 1. 8–10.* Trans. M. Winterbottom. Cambridge, MA, and London.

Seneca the Younger. 1972. *Epistulae.* Trans. D. A. Russell and M. Winterbottom. In *Ancient Literary Criticism: The Principal Texts in New Translations.* Oxford.

Sigonio, V. 1978. *La difesa per le donne.* Ed. F. Marri, Bologna.

Silos, G. M. 1670. *Conferenze accademiche.* Rome.

Soderini, T. 1766. "Orazione." In *Orazione e componimenti poetici in lode delle belle arti. Relazione del solenne concorso e della distribuzione de' premi. Celebrata sul Campidoglio dall'Insigne Accademia del Disegno,* 23–36. Rome.

Soprani, R. 1674. *Vite de' pittori, scoltori, et architetti genovesi.* Genoa.

Sorte, C. 1580. *Osservazioni nella pittura.* Venice. Edition cited: ed. Barocchi, *Trattati,* vol. 1.

Speroni, S. 1542. *Dialoghi,* Venice. Edition cited: Venice, 1596.

——— 1978. *Dialogo d'amore.* In *Trattatisti del Cinquecento,* ed. M. Pozzi. Milan and Naples, 1978.

Spini, G. 1569. *I primi tre libri sopra l'instruzioni de' Greci et Latini Architettori intorno agl'ornamenti che convengono a tutte le fabbriche che l'architettura compone.* Manuscript of 1569 in Venice, Biblioteca Marciana, MS ital. IV, 38. Published in *Il Disegno interroto. Trattati medicei d'architettura,* ed. F. Borsi et al. Florence, 1980.

Spontoni, C. 1626. *La Metoposcopia overo commensuratione delle linee della fronte.* Venice.

Stigliani, T. 1627. *Dello occhiale. Opera difensiva in risposta al Cavalier Gio. Battista Marini.* Venice.

——— 1664. *Lettere.* Rome.

Superbi, A. 1620. *Apparato degli huomini illustri della città di Ferrara.* Ferrara.

Taja, A. M. 1705. *Lettera e poetici componimenti. In ragguaglio, e in encomio della nuova Ripa presso al Sepolcro de' Cesari in Roma.* Rome.

1750. *Descrizione del Palazzo Apostolico Vaticano. Opera postuma.* Rome.

Tasso, T. 1564. *Discorsi dell'arte poetica.* Venice. Edition cited: *Prose,* ed. E. Mazzali. Milan and Naples, 1959.

1982. *Dialogues.* Trans. C. Lord and D. Trafton. Berkeley.

Tassoni, A. 1627. *Dieci libri di pensieri diversi.* Milan.

Terzago, P. M. 1666. *Museo ò Galeria adunata dal sapere, e dallo studio del Sig. Canonico Manfredo Settala nobile Milanese.* Trans. P. F. Scarabelli. Tortona.

Tesauro, E. 1654. *Il Cannocchiale aristotelico.* Turin. Revised and much expanded. Venice, 1665. Edition cited: Turin: Zavatta, 1670.

Testelin, H. 1675. "Sur l'expression générale et particulière." Published in *Les Conférences de l'Académie royale de peinture et de sculpture au XVIIe siècle,* ed. A. Mérot, 314–25. Paris, 1996.

1696. *Sentiments des plus habiles peintres sur la pratique de la peinture et sculpture.* Paris.

Tiraboschi, G. 1712. *Storia della letteratura italiana.* 9 vols. Florence.

Titi, P. 1751. *Guida per il passeggiere dilettante di pittura, scultura, ed architettura nella città di Pisa.* Lucca.

Titti, F. 1721. *Nuovo studio di pittura, scoltura, ed, architettura nelle chiese di Roma, Palazzo Vaticano, di Monte Cavaloo, ed altri.* Rome.

Valla, L. 1962. *Opera omnia.* Ed. E. Garin. Turin.

Varchi, B. 1549. *Due lezioni di M. Benedetto Varchi, nella prima delle quali si dichiara un Sonetto di M. Michelagnolo Buonarroti, nella seconda si disputa quale sia piu nobile arte, la scultura o la pittura, con una lettera d'esso Michelagnolo & piu altri eccellentissimi pittori, et scultori, sopra la quistione sopradetta.* Florence. Editions cited: ed. Barocchi, vol. 1, 1960, and B. Varchi, *Opere,* vol. 2. Florence, 1590.

c.1550. *Il Libro della beltà e della grazia.* Published in Barocchi, ed., 1960, vol. 1.

Vasari, G. 1568. *Le Vite de' più eccellenti pittori scultori e architettori nelle redazioni del 1550 e 1568.* Ed. P. Barocchi and R. Bettarini, 6 vols. Florence, 1966–76.

1647. *Le vite dei pittori, scultori ed architetti.* Ed. Carlo Manolessi. Bologna.

1759–60. *Le vite de' pittori, scultori ed architetti.* Ed. G. G. Bottari. Rome.

1930. *Der literarische Nachlass Giorgio Vasari, herausgegeben und mit kritischen Apparate versehen von K. Frey.* 2 vols. (1, 1923; 2, 1930). Munich.

Verdizotti, G. M. 1622. *Breve compendio della Vita del famoso Tiziano Vecelli, Cav. et Pittore.* Venice.

Vitruvius. 1567. *I dieci libri dell'architettura.* Trans. and commentary by D. Barbaro. Venice.

De architectura. 1945. Ed. and trans. F. Granger, Cambridge, MA, and London.

Vittoria, V. 1703. *Osservazioni sopra il libro della Felsina pittrice per difesa di Raffaello da Urbino, dei Carracci e della loro scuola.* Rome. Edition cited: *Felsina pittrice,* ed. G. P. Zanotti, (as appendix to vol. 2). Bologna, 1841.

n.d. *Academia de pintura del Senor Carlos Maratti.* Rome, Biblioteca Corsiniana, Cod. 660, 44 A 5.

Volpato, G. B. 1685. *La Verità pittoresca Ritamente svelata a giovani filosografi.* Vicenza.

n.d. *La Verità pittoresca svelata à dilettanti. Ove con peregrine ragioni scolasticamente spiegata si fa chiaramente vedere che cosa sia pittura come possa un huomo da per se steso acquistarla praticarla e intenderla.* Bassano, Biblioteca Comunale MSS 31 A 25.

1849. "Modo da tener nel dipinger." MSS. Bassano, Biblioteca Comunale, n.d.; published in Mary Merrifield, *Original Treatises on the Arts of Painting,* 721–755. New York.

Watelet, C. H. and P. C. Lévesque. 1792. *Dictionnaire des Arts de peintre, sculpture et gravure.* Paris.

Weinberg, B., ed. 1970. *Trattati di poetica e retorica del cinquecento.* 3 vols. Bari.

Winckelmann, J. J. 1972. *Geschichte der Kunst des Altertums.* Darmstadt.

Zanelli, I. 1722. *Vita del gran pittore Carlo Cignani.* Bologna.

Zanetti, A. M. 1733. *Descrizione di tutte le pubbliche pitture della città di Venezia.* Venice.

Zanotti, G. P. 1703. *Nuovo fregio di gloria a Felsina sempre pittrice nella vita di Lorenzo Pasinelli, pittor bolognese.* Bologna.

1705. *Lettere familiari scritte ad un amico in difesa del Conte Carlo Cesare Malvasia.* Bologna. Edition cited: appendix of the 1841 edition of C. C. Malvasia, *Felsina pittrice,* vol. 2.

1739. *Storia dell'Accademia Clementina di Bologna.* Bologna.

1756. *Le Pitture di Pellegrino Tibaldi e di Niccolo Abbati esistenti nell'Istituto di Bologna.* Venice.

1776. *Il Claustro di San Michele in Bosco di Bologna de' Monaci Olivetani dipinto dal Famoso Lodovico Carracci e da altri eccellenti maestri.* Bologna.

Zuccaro, F. 1605. "Il Lamento della pittura su l'onde venete." In *Lettera a prencipi e signori amatori del dissegno, pittura, scultura et architettura.* Mantua. Published in *Scritti d'arte di Federico Zuccaro,* ed. D. Heikamp. Florence, 1961.

—— 1607. *L'Idea de' scultori, pittori e architetti.* Turin. Edition cited: *Scritti d'arte,* ed. D. Heikamp. Florence, 1961.

∾

SECONDARY SOURCES

Accetto, T. 1984. *Della dissimulazione onesta.* Ed. S. S. Nigro, Genoa.

Ackerman, J. S. 1962. "A Theory of Style." *Journal of Aesthetics and Art Criticism* 20 227–37; revised as "Style," in *Art and Archaeology,* ed. J. S. Ackerman and R. Carpenter. 164–86. Englewood Cliffs, NJ, 1963.

Adorno, T. 1984. *Aesthetic Theory.* Trans. C. Lenhardt. London.

Aikema, B. 1990. *Pietro della Vecchia and the Heritage of the Renaissance in Venice.* Florence.

—— 1995. "Tiziano, la Maniera e il Pubblico." *Mitteilungen des kunsthistorischen Institutes in Florenz* 39:167–84.

Alfassa, P. 1933. "L'origine de la lettre de Poussin sur les modes d'après un travail récent." *Bulletin de la Société de l'histoire de l'art français,* 125–43.

Alpers, P. and Alpers, S. 1972. "*Ut Pictura Noesis?* Criticism in Literary Studies and Art History." *New Literary History* 3:437–58.

Alpers, S. 1987. "Style Is What You Make It: The Visual Arts Once Again." In *The Concept of Style,* ed. B. Lang, 137–62. 2d rev. ed. (first published 1979). Ithaca, NY.

Altieri, C. 1987. "Style as the Man: What Wittgenstein Offers for Speculating on Expressive Activity." *Journal of Aesthetics and Art Criticism,* 177–92. Revised as "Style as the Man: From Aesthetics to Speculative Philosophy," in *Analytic Aesthetics,* ed. R. Shusterman, 59–84. New York, 1989.

—— 1995. "Personal Style as Articulate Intentionality." In *The Question of Style in Philosophy and the Arts,* ed. C. van Eck, J. McAllister and R. van de Vall, 201–19. Cambridge.

Ames-Lewis, F. 1992. "Introduction." In *Decorum in Renaissance Narrative Art,* ed. F. Ames-Lewis and A. Bednarek, 1–14. London.

—— 2000. *The intellectual life of the early Renaissance artist.* New Haven.

Anceschi, L. 1989. *Gli specchi della poesia. Riflessione, poesia, critica.* Turin.

Ankersmit, F. 1995. "Metaphor and Paradox in Toqueville's Analysis of Democracy." In *The Question of Style in Philosophy and the Arts,* ed. C. van Eck, J. McAllister, and R. van de Vall, 141–56. Cambridge.

Aquilecchia, G. 1976. "Pietro Aretino e la lingua 'zerga.'" In *Scheda di italianistica,* 153–69. Turin.

Argan, G. C. 1980. "Ideology and Iconology." In *The Language of Images,* ed. W. J. T. Mitchell, 15–24. Chicago.

Arikha, A. 1989. "Réflexion sur Poussin." In N. Poussin, *Lettres et propos sur l'art,* ed. A. Blunt, 203–42. Paris.

Badt, B. 1969. *Die Kunst des Nicolas Poussin.* Cologne.

Bal, M., and Bryson, N. 1991. "Semiotics and Art History." *Art Bulletin* 73:174–208.

Baldassarri, G. 1983. "*Acutezza* e *Ingegno*: Teoria e pratica del gusto Barocco." In *Storia della cultura veneta* (Vicenza) 4/1: 223–47.

Bandera, S. 1979. "Lettere di Giov. Battista Natali a Leopoldo de' Medici." *Paragone* 347:93–113.

Bann, S. 1989. *The True Vine: On Visual Representation and the Western Tradition.* Cambridge.

Barilli, R. 1989. *Rhetoric.* Trans. G. Menozzi. Minneapolis, MN.

Barkan, L. 1995. "Making Pictures Speak." *Renaissance Quarterly* 48:326–51.

—— 2000. "The Heritage of Zeuxis: Painting, Rhetoric, and History." In *Antiquity and Its Interpreters,* ed. A. Kuttner, A. Payne, and R. Smick, 99–109. Cambridge.

Barocchi, P. 1975. "Nota critica." In F. S. Baldinucci, *Notizie.* 6:9–67.

—— 1976. "Il collezionismo del Cardinale Leopoldo e la storiografia del Baldinucci." In *Omaggio a Leopoldo de' Medici. Parte I: Disegni,* ed. A. Forlani Tempesti and A. M. Petrioli Tofani, 14–25. Florence.

—— 1979. "Storiografia dal Vasari al Lanzi." In *Storia dell'arte italiana,* ed. G. Previtali, pt. 1, 2:5–82. Turin.

—— 1981. "Storiografia artistica: Lessico tecnico e lessico letterario." *Studi di lessicografia italiana,* 3:5–27. Reprinted in *Studi Vasariani,* 135–156. Turin, 1984.

—— 1984. "Premessa al commento secolare alle *Vite* di Giorgio Vasari," and "Le postille di Del Migliore alle *Vite* vasariane." Both in *Studi vasariani,* 75–82. Turin.

Barocchi, P., ed. 1994. *Giorgio Vasari. Le Vite de' più eccellenti pittori scultori e architettori nelle redazioni del 1550 e 1568. Indice di frequenza.* Pisa.

Barolsky, P. 1990. *Michelangelo's Nose.* University Park, PA.

1991. *Why Mona Lisa Smiles and Other Tales By Vasari.* University Park, PA.

Barthes, R. 1970. *Writing Degree Zero.* Boston.

1971. "Style and Its Image." In *Literary Style: A Symposium,* ed. S. Chatman. Oxford.

Barzman, K.-E. 1992. "Perception, Knowledge, and the Theory of *Disegno* in Sixteenth-Century Florence." In Larry Feinberg, *From Studio to Studiolo. Florentine Draftsmanship under the First Medici Grand Dukes.* Exh. cat., Allen Memorial Art Museum, Oberlin College, 37–48. Seattle, WA.

Bassi, E. 1946. *La R. Accademia di Belle Arti di Venezia.* Florence.

Bätschmann, O. 1990. *Nicolas Poussin. Dialectics of Painting.* London.

1995. "Giovan Pietro Belloris Bildbeschreibungen." In *Beschreibungskunst–Kunstbeschreibung: Ekphrasis von der Antike bis zur Gegenwart,* ed. G. Böhm and H. Pfotenhauser, 279–313. Munich.

Battisti, E. 1954. "Alcune vite inedite di Leone Pascoli: Antonio Balestra." *Commentari* 5:26–39.

1956. "Il Concetto d'imitazione nel Cinquecento." *Commentari* 7:86–104 and 249–62.

1960. *Rinascimento e Barocco.* Turin.

Baxandall, M. 1963. "A Dialogue on Art from the Court of Lionello d'Este: Angelo Decembrio's 'De politia litteraria' Pars LXVIII." *Journal of the Warburg and Courtauld Institutes* 26:304–27.

1971. *Giotto and the Orators. Humanist Observers of Painting in Italy and the Discovery of Pictorial Composition 1350–1450.* Oxford.

1985. *Patterns of Intention: On the Historical Explanation of Pictures.* New Haven, CT.

1991. "The Language of Art Criticism." In *The Language of Art History,* ed. S. Kemal and I. Gaskell, 67–75. Cambridge.

Beal, M. 1984. *A Study of Richard Symonds. His Italian Notebooks and Their Relevance to Seventeenth-Century Painting Techniques.* New York and London.

Beardsley, M. 1962. "The Metaphorical Twist." *Philosophy and Phenomenological Research* 22:293–307.

1987. "Verbal Style and Illocutionary Action."

In *The Concept of Style,* ed. B. Lang (rev. ed.), 205–29. Ithaca, NY.

Becatti, G. 1971. "Plinio e Vasari." *Studi di storia dell'arte in onore di Valerio Mariani,* 173–82. Naples.

Becq, A. 1984. *Genese de l'esthetique française moderne. De la raison classique à l'imagination créatrice 1680–1814.* 2 vols. Pisa.

Bell, J. 1988. "Cassiano dal Pozzo's Copy of the Zaccolini Manuscripts." *Journal of the Warburg and Courtauld Institutes* 51:103–25.

1993. "Zaccolini's Theory of Color Perspective." *Art Bulletin* 75:91–112.

1995. "Re-visioning Raphael as a 'Scientific Painter.' " In *Reframing the Renaissance: Visual Culture in Europe and Latin America,* ed. C. Farago, 91–111. New Haven and London.

Forthcoming. "Introduction." In *Art History in the Age of Bellori,* ed. J. Bell and T. Willette. Cambridge.

Bellini, E. 1991. "Agostino Mascardi fra 'Ars poetica' e 'Ars historica.' " *Studi secenteschi* 32:65–136.

1994. "Linguistica barberiniana. Lingue e linguaggi nel 'Trattato dello Stile e del Dialogo' di Sforza Pallavicino." *Studi seicenteschi* 35:57–104.

Beltramme, M. 1990. "Le teoriche del Paleotti e il riformismo dell'Accademia di San Luca nella politica artistica di Clemente VIII (1592–1605)." *Storia dell'arte* 69:201–33.

Benardete, J. 1993. "Real Definitions: Quine and Aristotle." *Philosophical Studies. An International Journal for Philosophy in the Analytic Tradition.* 72:265–82.

Benassi, S. 1991. "Definizione di gusto: La polemica Orsi-Bouhours." *Estetica e Arte. Le concezioni dei "moderni,"* 107–126. Bologna.

Besomi, O. 1969. *Ricerche intorno alla "Lira" di G. B. Marino.* Padua.

1972. "Tommaso Stigliani: Tra parodia e critica." *Studi secenteschi* 13:5–118.

1975. *Esplorazioni secenteschi.* Padua.

Bettarini, R. 1974. "Vasari scrittore: Come la Torrentiniana diventò Giuntina." In *Il Vasari storiografo e artista. Atti del congresso internazionale nel IV centenario della morte,* 485–500. Florence.

Bialostocki, J. 1961. "Das Modusproblem in den bildenden Künsten. Zur Vorgeschichte und zum Nachleben des 'Modusbriefes' von Nicolas Poussin." *Zeitschrift für Kunstgeschichte* 24:128–41.

Black, M. 1954–55. "Metaphor." *Proceedings of the Aristotelian Society* 55:273–94.

Black, R. 1982. "Ancients and Moderns in the Reniassance: Rhetoric and History in Accolti's *Dialogue on the Preeminence of Men of His Own Time*." *Journal of the History of Ideas* 43:3–32.

1987. "The New Laws of History." *Renaissance Studies* 1:126–56.

Blunt, A. 1937–38. "Poussin's Notes on Painting." *Journal of the Warburg and Courtauld Institutes* 1: 344–51.

1967. *Nicolas Poussin*. (The A. W. Mellon Lectures in the Fine Arts). 2 vols. New York.

1973. *Artistic Theory in Italy 1450–1600*. Oxford.

Bolinger, D. 1985. "Defining the Indefinable." In *Dictionaries, Lexicography and Language Learning*, ed. R. Ilson, 69–73. Oxford.

Bologna, F. 1982. *La coscienza storica dell'arte d'Italia*. Turin.

Bolzoni, L. 1995. *La stanza della memoria. Modelli letterari e iconograpfici nell'età della stampa*. Turin.

Bonelli, R. 1985. "Nota introduttiva." In Pietro Cataneo and Giacomo Barozzi da Vignola, *Trattati con l'aggiunta degli scritti di architettura di Alvise Cornaro, Francesco Giorgi, Claudio Tolomei, Giangiorgio Trissino, Giorgio Vasari*, ed. E. Bassi et al., 117–23. Milan.

Bonfait, O. 1996. " 'Ut pingerem perpetuas virgilias . . .' Un éloge de Poussin adressé à Camillo Massimi." In *Poussin et Rome. Actes du colloque de l'Académie de France à Rome*, ed. O. Bonfait et al., 47–65. Paris.

1994a. *Roma 1630. Il trionfo del pennello*. Exh. cat., Rome, Académie de France à Rome. Milan.

Bonfait, O., ed. 1994b. *Peinture et rhétorique: Actes du colloque de l'Académie de France à Rome*. Paris.

Bora, G., ed. 1976. *I disegni del Codice Resta*. Bologna (Fontes Ambrosiani, LVI).

Bordignon Favero, E. 1994. *Giovanni Battista Volpato critico e pittore*. Treviso.

Borea, E. 1992. "Giovan Pietro Bellori e la 'commodità delle stampe.' " In *Documentary Culture: Florence and Rome from Grand Duke Ferdinand I to Pope Alexander VII*, ed. E. Cropper et al., 263–81. Bologna.

Borzelli, A. 1898. *Il Cavalier Giovan Battista Marino (1569–1625)*. Naples.

Boschloo, A. 1988. "La fortuna degli affreschi bolognesi dei carracci nella letteratura artistica." In *Les Carrache et les Décors Profanes* (Actes du Colloque organisé par l'École française de Rome), 457–76. Rome.

Boselli, C. 1971. *Nuove fonti per la storia dell'arte. L'Archivio dei Conti Gambara presso la Civica Biblioteca Queriniana di Brescia: I. Il Carteggio*. Istituto Veneto di Scienze, Lettere ed Arti, Memorie classe di scienze morali, lettere ed arti, vol. XXV, fasc. 1. Venice.

Bouwsma, W. 1968. *Venice and the Defense of Republican Liberty. Renaissance Values in the Age of the Counter Reformation*. Berkeley.

Brink, C. O. 1971. *Horace on Poetry. The 'Ars Poetica.'* Cambridge.

Bryce, J. 1995. "The Oral World of the Early Accademia Fiorentina." *Renaissance Studies* 9:77–103.

Bryson, N. 1983. *Vision and Painting: The Logic of the Gaze*. New Haven, CT.

Buck, A. 1973. *Di "Querelle des anciens et des modernes" im italienischen Selbstverstaendnis der Renaissance und des Barocks*. Wiesbaden.

Buddensieg, T. 1965. "Gregory the Great, The Destroyer of Pagan Idols. The History of a Medieval Legend concerning the Decline of Ancient Art and Literature." *Journal of the Warburg and Courtauld Institutes.* 28:44–65.

Bulletta, S. 1995. *Virgilio Malvezzi e la storiografia classica*. Milan.

Burrow, J. A. 1986. *The Ages of Man: A Study of Medieval Writing and Thought*. Oxford.

Campbell, S. J. 1996. "*Pictura* and *Scriptura*: Cosmè Tura and Style as Courtly Performance." *Art History* 19:267–95.

Campori, G. 1855. *Gli artisti italiani e stranieri negli stati Estensi*. Modena.

Canuti, F. 1931. *Il Perugino*. Siena.

Caramel, L. 1966. "Arte e artisti nell'epistolario di Girolamo Borsieri," *Contributi dell'Istituto di Storia dell'Arte Medievale e Moderna*, 1:173–75.

Caroli, F. 1995. *Storia della fisiognomica. Arte e psicologia da Leonardo a Freud*. Milan.

Casale, V. 1997. "Poetica di Pietro da Cortona e teoria del Barocco nel 'Trattato della pittura e scultura.' " in *Pietro da Cortona 1597–1669*, ed. A. Lo Bianco, 107–16. Milan.

Casella, P. 1993. "Un dotto e curioso trattato del primo Seicento: 'L'arte de' cenni' di Giovanni Bonifacio." *Studi secenteschi* 34:331–403.

Cast, D. 1998. "Vasari on the Practical." In *Vasari's Florence. Artists and Literati at the Medicean Court*, ed. P. Jacks, 70–80. Cambridge.

Castellano, A. 1963. "Storia di una parola letteraria: It. *Vago*." *Archivio Glottologico Italiano*, 48:126–69.

Cave, T. 1979. *The Cornucopian Text*. Oxford.

Chatman, S. 1987. "The Styles of Narrative Codes." In *The Concept of Style*, ed. B. Lang, 230–44. Ithaca, NY.

Cheney, L. 1998. "Vasari's Interpretation of Female Beauty." In *Concepts of Beauty in Renaissance Art*, ed. F. Ames-Lewis and M. Rogers, 179–90. Aldershot.

——— ed. 1997. *Readings in Italian Mannerism*. American University Studies, series 20, Fine Arts, vol. 24. New York.

Chiesa, M. 1980. "Appunti sul 'rozzo parlar.' " *Giornale storico della letteratura italiana* 97:282–92.

Cinotti, M. 1971. "Appendice." In G. A. Dell'Acqua and M. Cinotti, *Il Caravaggio e le sue grandi opere da San Luigi dei Francesi*. Milan. 1973. *Immagine del Caravaggio*. Milan.

Cipriani, A., ed. 1989. *I premiati dell'Accademia: 1682–1754*. Rome.

Cipriani, A., and Valeriani, E., eds. 1989. *I disegni di figura nell'Archivio Storico dell'Accademia di San Luca*. 3 vols. Rome.

Cohen, T. 1978. "Metaphor and the Cultivation of Intimacy." In *On Metaphor*, ed. S. Sacks, 1–10. Chicago.

Colantuono, A. 1996. "Interpreter Poussin. Métaphore, similarité et 'maniera magnifica.' " In *Nicolas Poussin (1594–1665). Actes du colloque organisé au musée du Louvre par le Service culturel du 19 au 21 octobre 1994*, ed. A. Mérot, 2:647–65. Paris.

——— 1997. *Guido Reni's Abduction of Helen. The Politics and Rhetoric of Painting in Seventeenth-Century Europe*. Cambridge.

——— Forthcoming. "*Scherzo*: Hidden Meaning, Genre, and Generic Criticism in Bellori's *Vite*." In *Art History in the Age of Bellori*, ed. J. Bell and T. Willette. Cambridge.

Colomer, J. L. 1996. "Peinture, histoire antique et *scienza nuova* entre Rome et Bologne: Virgilio Malvezzi et Guido Reni." In *Poussin et Rome. Actes du colloque de l'Académie de France à Rome*, ed. O. Bonfait et al., 201–14. Paris.

Conte, G. G. 1986. *The Rhetoric of Imitation. Genre and Poetic Memory in Virgil and Other Latin Poets*. Ithaca, NY.

Corti, L., Daly Davis, M., Davis, C., and Kliemann J., eds., 1981. *Principi, letterati e artisti nelle carte di Giorgio Vasari. Lo Storiografo dell'arte nella Toscana dei Medici*. Exh. cat., Casa Vasari and Sottochiesa di S. Francesco. Arezzo.

Costa, G. 1968. "G. B. Vico e lo pseudo-Longino." *Giornale critico della filosofia italiana* 48:502–28.

——— 1981. "Longinus' Treatise *On the Sublime* in the Age of Arcadia." *Nouvelles de la Republique des Lettres*, 1:65–86.

Costanzo, M. 1983. *I segni del silenzio e altri studi sulle poetiche e l'iconografia letteraria del Manierismo e del Barocco*, 47–54. Rome.

Cotroneo, G. 1971. *I Trattatisti dell'Ars historica*. Naples.

Croce, F. 1955. "I critici moderato-barocchi: La discussione sull'Adone." *Rassegna della letteratura italiana* 59:414–39.

Cropper, E. 1976. "On Beautiful Women, Parmigianino, *Petrarchismo* and the Vernacular Style." *Art Bulletin* 58:374–94.

——— 1984. *The Ideal of Painting. Pietro Testa's Düsseldorf Notebook*. Princeton, NJ.

——— 1986. "The Beauty of Woman: Problems in the Rhetoric of Renaissance Portraiture." In *Rewriting the Renaissance. The Discourses of Sexual Difference in Early Modern Europe*, ed. M. Ferguson et al., 175–90. Chicago.

——— 1987. "Tuscan History and Emilian Style." In *Emilian Painting of the 16th and 17th Centuries: A Symposium*, 49–62. Center for the Advanced Study of the Visual Arts, National Gallery of Art, Washington, DC, Bologna.

——— 1988. "Pietro Testa, 1612–1650: The Exquisite Draughtsman from Lucca." In Elizabeth Cropper, *Pietro Testa 1612–1650. Prints and Drawings*. Exh. cat., Philadelphia Museum of Art, xi–xxxvi.

——— 1991a. "The Petrifying Art: Marino's Poetry and Caravaggio." *The Metropolitan Museum Journal* 26:193–212.

——— 1991b. " 'La più bella antichità che sappiate desiderare': History and Style in Giovanni Pietro Bellori's 'Lives' ." In *Der Künstler über sich in seinem Werk* (Wolfenbütteler Forschungen. Kunst und Kunsttheorie 1400–1900), ed. M. Winner, 145–73. Wolfenbüttel.

——— 1992a. "Marino's *Strage degli Innocenti*: Poussin, Rubens, and Guido Reni." *Studi seicenteschi* 33:137–66.

——— 1992b. "Vincenzo Giustiniani's 'Galleria.' The Pygmalion Effect." *Cassiano Dal Pozzo's Paper Museum. Volume II*, 101–26. n.p.

——— 1992c. "Introduction." In Craig Hugh Smyth, *Mannerism and Maniera*, 12–21. Vienna.

——— 1995. "The Place of Beauty in the High Renaissance and Its Displacement in the History of Art." In *Place and Displacement in the Renais-*

sance, ed. A. Vos, 159–205. Medieval and Renaissance Texts and Studies, 132. Binghamton, NY.

Cropper, E., and Dempsey, C. 1987. "The State of Research in Italian Painting of the Seventeenth Century." *Art Bulletin* 49:498–502.

———. 1996. *Nicolas Poussin. Friendship and the Love of Painting.* Princeton, NJ.

Culler, J. 1975. *Structuralist Poetics: Structuralism, Linguistics, and the Study of Literature.* Ithaca, NY.

———. 1988. "De Man's Rhetoric." In *Framing the Sign: Criticism and Its Institutions*, 107–35. Oxford.

Curtius, E. 1953. *European Literature and the Latin Middle Ages.* Princeton, NJ.

Danto, A. 1981. *The Transfiguration of the Commonplace.* Cambridge, MA.

Davey, N. 1995. "Beyond the Mannered: The Question of Style in Philosophy or Questionable Styles in Philosophy." In *The Question of Style in Philosophy and the Arts*, ed. C. Van Eck, J. McAllister, and R. Van De Vall, 177–200. Cambridge.

Davis, M. Daly. 1982. "Beyond the 'Primo Libro' of Vincenzo Danti's 'Trattato delle Perfette Proporzioni.'" *Mitteilungen des Kunsthistorischen Institutes in Florenz* 26:63–84.

Davis, C. 1981. "L'origine delle *Vite*." In *Giorgio Vasari. Principi, letterati e artisti nelle carte di Giorgio Vasari*, 213–15. Arezzo.

DeGrazia, D. 1979. *Prints and Related Drawings by the Carracci Family. A Catalogue Raisonné.* Washington, DC: National Gallery of Art.

De Marchi, F. 1987. "Introduzione." In *Mostre di quadri a S. Salvatore in Lauro, 1682–1725. Stime di collezione romane, note e appunti di Giuseppe Ghezzi.* Rome.

Dempsey, C. 1977. *Annibale Carracci and the Beginnings of Baroque Style.* Glückstadt.

———. 1982. "Mythic Inventions in Counter-Reformation Painting." *Rome in the Renaissance. The City and the Myth*, ed. P. A. Ramsey, 55–75. Binghamton, NY.

———. 1986. "Malvasia and the Problem of the Early Raphael and Bologna." In *Raphael before Rome*, ed. J. Beck, 57–70. *Studies in the History of Art*, vol. 17. Washington, DC.

———. 1987. "The Carracci and the Devout Style in Emilia." In *Emilian Painting of the 16th and 17th Centuries: A Symposium.* Center for the Advanced Study of the Visual Arts, National Gallery of Art, Washington, DC. Bologna.

———. 1988. "The Greek Style and the Prehistory of Neoclassicism." In Elizabeth Cropper, *Pietro Testa 1612–1650. Prints and Drawings*, xxxvii–lxv. Philadelphia Museum of Art.

———. 1990. "Introduzione." In G. Perini, *Gli scritti dei Carracci*, 9–31. Bologna.

Dens, J.-P. 1981. *L'Honnête Homme et la critique du goût.* Lexington, KY.

Didi-Hubermann, G. 1993. "L'imitation comme mythe à la Renaissance." In *Künstlerischer Austausch. Artistic Exchange (Akten des XXVIII. Internationalen Kongresses für Kunstgeschichte)*, ed. T. W. Gaehtgens, 493–502. Berlin.

Diffley, P. B. 1988. *Paolo Beni. A Biographical and Critical Study.* Oxford.

Di Teodoro, F. 1994. *Raffaello, Baldassar Castiglione e la Lettera a Leone X.* Bologna.

Dittmann, L. 1967. *Stil, Symbol, Struktur: Studien zu Kategorien der Kunstgeschichte.* Munich.

Eck, C. van. 1995. "*Par le style on atteint au sublime*: The Meaning of the Term 'Style' in French Architectural Theory of the Late Eighteenth Century." In *The Question of Style in Philosophy and the Arts*, ed. C. van Eck, J. McAllister, and R. van de Vall, 89–107. Cambridge.

Eco, U. 1993. "Introduzione." In J. K. Lavater, *Della Fisiognomica.* Milan.

Elkins, J. 1998. *On Pictures and the Words That Fail Them.* Cambridge.

Ellis, J. M. 1974. *The Theory of Literary Criticism: A Logical Analysis.* Berkeley.

Emison, P. 1991. "Grazia." *Renaissance Studies* 5: 427–60.

Enggass, R., and Brown, J. 1970. *Italy and Spain 1600–1750. Sources and Documents.* Englewood Cliffs, NJ.

Enkvist, N. E. 1964. "On Defining Style." In *Linguistics and Style*, ed. N. E. Enkvist, J. Spencer, and M. J. Gregory. London.

Evans, E. 1969. *Physiognomics in the Ancient World.* (Transactions of the American Philosophical Society, 59/5.) Philadelphia.

Fabriczy, C. de. 1893. "Il Codice dell'Anonimo Gaddiano (Cod. magliabechiano XVII, 17) nella Biblioteca Nazionale di Firenze." *Archivio Storico Italiano*, ser. 5, vol. 12, nos.3–4, 15–94 and 275–334.

Fagiolo dell'Arco, M. 1994. "La nobiltà della scultura. Orfeo Boselli e la cultura degli 'antiquari.'" In O. Boselli, *Osservazioni sulla scultura antica. I manoscritti di Firenze e di Ferrara*, ed. A. Torresi. Ferrara.

Fantham, E. 1988. "*Varietas* and *Satietas; De oratore*

3.96–103 and the limits of *ornatus*." *Rhetorica* 6:275–90.

1995. "The Concept of Nature and Human Nature in Quintilian's Psychology and Theory of Instruction." *Rhetorica* 13:125–36.

Fanti, M. 1979. "Le postille carraccesche alle 'Vite' del Vasari: Il testo originale." *Il Carrobbio* 5: 147–64.

1991. "Annibale Carracci e Zeusi." *Il Carrobbio* 17 (1991):119–23.

Farago, C. 1992. *Leonardo da Vinci's Paragone*. Leiden.

Feigenbaum, G. 1990. "Drawing and Collaboration in the Carracci Academy." In *IL 60: Essays Honoring Irving Lavin on His Sixtieth Birthday*, ed. M. Aronberg Lavin, 145–65. New York.

1993. *Ludovico Carracci*. Ed. A. Emiliani. Bologna. Exh. cat., Pinacoteca Nazionale and Fort Worth, Kimball Art Museum.

1993. "Practice in the Carracci Academy." In *The Artist's Workshop*, ed. P. Lukehart. *Studies in the History of Art* 38:59–76.

Fermor, S. 1993. "Movement and Gender in Sixteenth-century Italian Painting." In *The Body Imaged: The Human Form and Visual Culture since the Renaissance*, ed. K. Adler and M. Pointon, 129–45. Cambridge.

Ferrarino, L. 1975. *Tiziano e la Corte di Spagna*. Madrid.

Ferretti, M. 1981. "Falsi e tradizione artistica." In *Storia dell'arte italiana*, pt. 3, 3:113–95. Turin.

Findlen, P. 1990. "Jokes of Nature and Jokes of Knowledge: The Playfulness of Scientific Discourse in Early Modern Europe." *Renaissance Quarterly* 43:292–331.

Fish, S. 1976. "Interpreting the *Variorum*." *Critical Inquiry* 2:465–85.

1980. "Literature in the Reader: Affective Stylistics." In *Reader-Response Criticism from Formalism to Post-Structuralism*, ed. J. Tompkins, 70–100. Baltimore.

Franck, D. 1995. "Style and Innocence – Lost, Regained – and Lost Again?" In *The Question of Style in Philosophy and the Arts*, ed. C. van Eck, J. McAllister, and R. van de Vall, 220–41. Cambridge.

Frangenberg, T. 1990. *Der Betrachter: Studien zur florentinischen Kunstliteratur des 16ten Jahrhunderts*. Cologne.

1994. "The Geometry of a Dome: Ludovico David's *Dichiarazione della Pittura della Capella del Collegio Clementino di Roma*." *Journal of the Warburg and Courtauld Institutes* 57:191–208.

1995. "The Art of Talking about Sculpture: Vasari, Borghini and Bocchi." *Journal of the Warburg and Courtauld Institutes* 58:115–131.

Frare, P. 1991. "Il *Cannocchiale aristotelico*: Da retorica della letteratura a letteratura della retorica." *Studi secenteschi* 32:33–63.

Frati, L. 1907. "Lettere autogiografiche di pittori al P. Pellegrino Antonio Orlandi." *Rivista d'Arte* 5/5–6: 65–67.

Freedberg, D. 1993. "Imitation and Its Discontents." In *Künstlerischer Austausch. Artistic Exchange (Akten des XXVIII. Internationalen Kongresses für Kunstgeschichte)*, ed. T. W. Gaehtgens, 483–92. Berlin.

Freedberg, S. 1965. "Observations on the Painting of the *Maniera*." *Art Bulletin* 47:187–97.

Frey, D. 1964. *Manierismus als europaisches Stilerscheinung. Studien zur Kunst des 16. und 17. Jahrhunderts*. Ed. G. Frey. Stuttgart.

Friedländer, W. 1925. "Die Entstehung des antiklassischen Stiles in der italienischen Malerei um 1520." *Repertorium für Kunstwissenschaft* 46: 49–86.

Fumaroli, M. 1980. *L'Âge de l'éloquence. Rhétorique et 'res literaria' de la Renaissance au seuil de l'époque classique*. Geneva.

1989. *L'inspiration du poète de Poussin. Essai sur l'allégorie du Parnasse*. Paris: Louvre.

1994. *L'École du silence. Le sentiment des images au XVIIe siècle*. Paris.

Gaeta, F. 1961. "Alcune considerazioni sul mito di Venezia." *Bibliothèque d'Humanisme et Renaissance* 23:58–71.

Gaye, G. 1840. *Carteggio inedito d'artisti*. Florence.

Geisenheimer, H. 1909. *Pietro da Cortona e gli affreschi nel Palazzo Pitti. Notizie documentate*. Florence.

Getrevi, P. 1991. *Scritture del volto: Fisiognomia dal medioevo*. Milan.

Getto, G., ed. 1954. *Marinisti*. Turin.

Gibson-Wood, C. 1988. *Studies in the Theory of Connoisseurship from Vasari to Morelli*. New York and London.

Gilbert, C. 1993. "Grapes, Curtains, Human Beings: The Theory of Missed Mimesis." In *Künstlerischer Austausch. Artistic Exchange (Akten des XXVIII. Internationalen Kongresses für Kunstgeschichte)*, ed. T. W. Gaehtgens, 413–22. Berlin.

Gill, M. 1989. *Aristotle on Substance. The Paradox of Unity*. Princeton, NJ.

Ginzburg, C. 1983. "Clues: Morelli, Freud, and Sherlock Holmes." In *The Sign of Three*, ed.

U. Eco and T. Sebeok, 81–118. Bloomington, IN.

——. 1998. "Style as Inclusion, Style as Exclusion." In *Picturing Science, Producing Art*, ed. C. A. Jones and P. Galison, 27–54. New York and London.

Ginzburg, S. 1996. "Giovanni Battista Agucchi e la sua cerchia." In *Poussin et Rome. Actes du colloque de l'Académie de France à Rome*, ed. O. Bonfait et al., 273–91. Paris.

Goldberg, E. 1983. *Patterns in Late Medici Art Patronage*. Princeton, NJ.

——. 1988. *After Vasari. History, Art, and Patronage in Late Medici Florence*. Princeton, NJ.

Goldstein, C. 1994. "L'Académie de Poussin." In *Nicolas Poussin. 1594–1665*, ed. P. Rosenberg and L.-A. Prat, 74–78. Paris: Galeries nationales du Grand Palais.

Golzio, V. 1971. *Raffaello nei documenti: Nelle testimonianze dei contemporanei e nella letteratura del suo secolo*. Farnborough: Gregg International.

Gombrich, E. H. 1960a. *Art and Illusion*. Princeton, NJ.

——. 1960b. "Vasari's *Lives* and Cicero's *Brutus*." *Journal of the Warburg and Courtauld Institutes* 23: 309–11.

——. 1962. "Blurred Images and the Unvarnished Truth." *British Journal of Aesthetics* 2:170–79.

——. 1966. *Norm and Form: Studies in the Art of the Renaissance*. London.

——. 1968. "Style." In *International Encyclopedia of the Social Sciences*, 15:352–61. New York.

Goodman, N. 1968. *Languages of Art: An Approach to a Theory of Symbols*. Indianapolis.

——. 1972. "On Likeness of Meaning." *Analysis* 10/1 (1949): 1–7. Reprinted in N. Goodman, *Problems and Projects*, 231–38. Indianapolis.

——. 1975. "The Status of Style." *Critical Inquiry* 1: 799–811.

——. 1978. *Ways of Worldmaking*. Indianapolis.

Greenblatt, S. 1980. *Renaissance Self-Fashioning: From More to Shakespeare*. Chicago.

Greene, T. 1982. *The Light in Troy: Imitation and Discovery in Renaissance Poetry*. New Haven, CT.

Greenstein, J. 1997. "On Alberti's 'Sign': Vision and Composition in Quattrocento Painting." *Art Bulletin* 79:669–98.

Gregori, M. 1964. "Una notizia del Peruzzini fornita dal Magalotti." *Paragone*, 169:24–28.

Grosser, H. 1992. *La sottigliezza del disputare. Teorie degli stili e teorie dei generi in età rinascimentale e nel Tasso*. Florence.

Guiraud, P. 1954. *La Stylistique*. Paris.

Hall, M. 1992. *Color and Meaning. Practice and Theory in Renaissance Painting*. Cambridge.

Hammond, F. 1996. "Poussin et les modes: Le point de vue d'un musicien." In *Poussin et Rome. Actes du colloque de l'Académie de France à Rome*, ed. O. Bonfait et al., 75–91. Paris.

Hansmann, M. Forthcoming. "*Con modo nuovo li descrive*: Bellori's Method of Describing." In *Art History in the Age of Bellori*, ed. J. Bell and T. Willette. Cambridge.

Harries, K. 1978. "Metaphor and Transcendence." In *On Metaphor*, ed. S. Sacks, 71–88. Chicago. First published in *Critical Inquiry* 5 (1978).

Hasan, R. 1971. "Rime and Reason in Literature." In *Literary Style: A Symposium*, ed. S. Chatman, 299–326. Oxford.

Haskell, F. 1985. *History and Its Images*. New Haven, CT.

Hauser, A. 1958. *Philosophie der Kunstgeschichte*. Munich. Edition and translation cited: *The Philosophy of Art History*. Evanston, IL, 1985.

Hausman, C. 1989. *Metaphor and Art: Interactionism and Reference in the Verbal and Nonverbal Arts*. Cambridge.

——. 1991. "Figurative Language in Art History." In *The Language of Art History*, ed. S. Kemal and I. Gaskell, 101–28. Cambridge.

Hawkins, P. 1984. "Dante's *Paradiso* and the Dialectic of Ineffability." In *Ineffability: Naming the Unnamable from Dante to Beckett*, ed. P. Hawkins and A. Howland Schotter, 5–22. New York.

Herklotz, I. Forthcoming. "Bellori, Raffele Fabretti, and Trajan's Column." In *Art History in the Age of Bellori*, ed. J. Bell and T. Willette. Cambridge.

Hess, J. 1968. "Note manciane." *Münchner Jahrbuch der Bildende Kunst* 19:103–20.

Hirsch, E. D. 1975. "Stylistics and Synonymity." *Critical Inquiry* 1:559–69.

Hirst, M. 1988. *Michelangelo and His Drawings*. New Haven and London.

Hochmann, M. 1988. "Les annotations marginales de Federico Zuccaro à un exemplaire des *Vies* de Vasari. La réaction anti-vasarienne à la fin du XVIe siècle." *Revue de l'Art* 80:64–71.

——. 1994. "L'ekphrasis efficace. L'influence des programmes iconographiques sur les peintures et les décors italiens au XVIe siècle." *Peinture et rhétorique. Actes du colloque de l'Académie de France à Rome*, ed. O. Bonfait, 43–76. Paris.

Hohendahl, P. U. 1995. *Prismatic Thought. Theodor W. Adorno.* Lincoln, NE.

Holenstein, E. 1976. *Roman Jakobson's Approach to Language: Phenomenological Structuralism.* Trans. C. Schelbert and T. Schelbert. Bloomington, IN.

Holly, M. A. 1984. *Panofsky and the Foundations of Art History.* Ithaca, NY.

Hope, C. 1988. "Aspects of Criticism in Art and Literature." *Word & Image* 4:1–16.

——— 1995. "Can You Trust Vasari?" *New York Review of Books*, 42/15, 10–13.

Ivanoff, N. 1955. "Le ignote considerazioni di G. B. Volpato sulla 'maniera.' " In *Retorica e Barocco. Atti del III Congresso Internationale di Studi Umanisitici*, 99–109. Rome.

——— 1957. "Stile e maniera." *Saggio e memorie di storia dell'arte* 1:109–63.

Iversen, M. 1979. "Style as Structure: Alois Riegl's Historiography." *Art History* 2:62–71.

——— 1993. *Alois Riegl. Art History and Theory.* Cambridge, MA.

Jacobs, F. 1994. "Woman's Capacity to Create: The Unusual Case of Sofonisba Anguissola." *Renaissance Quarterly* 47:74–101.

——— 1997. *Defining the Renaissance Virtuosa. Women Artists and the Language of Art History and Criticism.* Cambridge.

——— 2000. "Aretino and Michelangelo, Dolce and Titian: *Femmina, Masculo, Grazia.*" *Art Bulletin* 82:51–67.

James, L., and Webb, R. 1991. " 'To Understand Ultimate Things and Enter Secret Places': Ekphrasis and Art in Byzantium." *Art History* 14:1–17.

Jameson, F. 1972. *The Prison-House of Language: A Critical Account of Structuralism and Russian Formalism.* Princeton, NJ.

Jankelevitch, V. 1980. *Le je-ne-sais-quoi et la presque-rien.* Paris.

Janson, T. 1964. *Latin Prose Prefaces.* Stockholm.

Jauss, H. 1982. *Toward an Aesthetic of Reception.* Theory and History of Literature, 2. Minneapolis, MN.

Jones, P. M. 1989. "Federico Borromeo's Ambrosian Collection as a Teaching Facility for the Academy of Design." In *Academies of Art between Renaissance and Romanticism*, ed. A. Boschloo et al., 44–60. The Hague. (*Leids Kunsthistorisch Jaarboek* 5–6 [1986–87].)

——— 1993. *Federico Borromeo and the Ambrosiana. Art Patronage and Reform in Seventeenth-Century Milan.* Cambridge.

Jordan, C. 1990. *Renaissance Feminism: Literary Texts and Political Models.* Ithaca and London.

Kallab, W. 1908. *Vasaristudien.* Ed. J. von Schlosser et al. Vienna and Leipzig.

Kaufmann, T. 1975. "The Perspective of Shadows: The History of the Theory of Shadow Projection." *Journal of the Warburg and Courtauld Institutes* 38:258–87.

Kemp, M. 1976. " 'Ogni dipintore dipinge se': A Neoplatonic Echo in Leonardo's Art Theory?" In *Cultural Aspects of the Italian Renaissance. Essays in Honour of Paul Oskar Kristeller*, ed. C. Clough, 311–23. New York.

——— 1977. "From 'Mimesis to Fantasia': The Quattrocento Vocabulary of Creation, Inspiration and Genius in the Visual Arts." *Viator* 8:347–98.

——— 1987. " 'Equal excellences': Lomazzo and the Explanation of Individual Style in the Visual Arts." *Renaissance Studies* 1:1–26.

——— 1989. "The 'Super-Artist' as Genius: The Sixteenth-Century View." In *Genius. The History of an Idea*, ed. P. Murray, 32–53. Oxford.

——— 1991. " 'Intellectual Ornaments': Style, Function and Society in Some Instruments of Art." In *Interpretation and Cultural History*, ed. J. Pittock and A. Wear, 135–52. Basingstoke and London.

——— 1994. "Coming into Line: Graphic Demonstrations of Skill in Renaissance and Baroque Engravings." In *Sight and Insight. Essays on Art and Culture in Honour of E. H. Gombrich at 85*, ed. J. Onians, 221–44. London.

Kemp, W. 1974. "Disegno. Beitrage zur Geschichte des Begriffs zwischen 1547 und 1607." *Marburger Jahrbuch für Kunstwissenschaft* 19:219–40.

Kessler, M. 1976. *Aristoteles' Lehre von der Einheit der Definition.* Munich.

Klein, R. 1959. "Le Sept Gouverneurs de l'art selon Lomazzo." *Arte Lombarda* 4:277–87.

Klein, R., and Zerner, H. 1989. *Italian Art, 1500–1600. Sources and Documents.* Evanston, IL.

Koerner, J. 1993. *The Moment of Self-Portraiture in German Renaissance Art.* Chicago.

Köhler, E. 1966. " 'Je ne sais quoy.' Ein Beitrag zur Begriffsgeschichte des Unbegreiflichen." In *Esprit und arkadische Freiheit.* Frankfurt.

Kristeva, J. 1969. *Semiotikè: Recherches pour une sémanalyse.* Paris.

Kubler, G. 1987 [1979]. "Toward a Reductive Theory of Visual Style." In *The Concept of Style*, ed. B. Lang, 163–73. 2d rev. ed. Ithaca, NY.

Land, N. 1986. "Ekphrasis and Imagination: Some Observations on Pietro Aretino's Art Criticism." *Art Bulletin* 68:207–12.

——— 1994. *The Viewer as Poet. The Renaissance Response to Art.* University Park, PA.

Lang, B. 1987. "Postface." *The Concept of Style*, 13–17. Ithaca, NY.

——— 1995. "The Style of Method: Repression and Representation in the Genealogy of Philosophy." In *The Question of Style in Philosophy and the Arts*, ed. C. Van Eck, J. McAllister, and R. Van De Vall, 18–36. Cambridge.

——— ed. 1987. *The Concept of Style.* Ithaca, NY.

Lange, H.-J. 1974. *Aemulatio Veterum sive de optime genere dicendi: Die Entstehung des Barockstils im XVI Jahrhundert durch eine Geschmackverschiebung in Richtung der Stile des manieristischen Types.* Bern-Frankfurt.

Lecercle, F. 1987. *La Chimère de Zeuxis. Portrait poétique et portrait peint en France et en Italie à la Renaissance.* Tübingen.

Leeman, A. D. 1963. *Orationis Ratio: The Stylistic Theories and Practice of the Roman Orators, Historians and Philosophers.* 2 vols. Amsterdam.

Le Mollé, R. 1988. *Georges Vasari et le vocabulaire de la critique d'art dans les "Vite."* Grenoble.

Levin, S. 1965. "Internal and External Deviation in Poetry." *Word* 21:225–37.

Lewis, C. S. 1990. *Studies in Words.* 2d ed. Cambridge.

Lichtenstein, J. 1993. *The Eloquence of Color. Rhetoric and Painting in the French Classical Age.* Trans. E. McVarish. Berkeley and Los Angeles.

Lloyd, G. E. R. 1966. *Polarity and Analogy: Two Types of Argumentation in Early Greek Thought.* Cambridge.

Longhi, R. 1951. "Alcuni pezzi rari nell'antologia della critica caravaggesca." *Paragone* 2/17:44–62.

Lucas, C. 1989. "L'artiste et l'écriture: *Il dire* et *il fare* dans les écrits de Cellini." In *Culture et professions en Italie (XV–XVII siècles)*, ed. A. C. Fiorato, 67–97. Paris.

Lukehart, P. 1987. "Contending Ideals: The Nobility of Painting and the Nobility of G. B. Paggi." Ph.D. diss., The Johns Hopkins University.

——— 1993. "Delineating the Genoese Studio: *Giovani accartati* or *sotto padre*?" In *The Artist's Workshop*, ed. P. Lukehart, 37–57. Studies in the History of Art, 38. Washington, DC.

Luzio, A. 1913. *La Galleria dei Gonzaga venduta all'Inghilterra nel 1627–28.* Milan.

Maguire, P. 1995. "Poussin's *Israelites Gathering Manna in the Wilderness* (1638–1639): A Painting for Chantelou." Ph.D. diss., Columbia University.

Mahon, D. 1947. *Studies in Seicento Art and Theory.* London.

——— 1962. "Poussiniana. Afterthoughts Arising from the Exhibition." *Gazette des Beaux Arts* 104 (July/August): 1–138.

Mamoojee, A. H. 1981. "*Suavis* and *Dulcis*. A Study of Ciceronian Usage." *Phoenix* 35:220–236.

Mancini, G. 1896. "Vite d'artisti di Giovanni Battista Gelli." *Archivio storico italiano* 17:32–62.

Manucci, F. L. 1908. "La vita e le opere di Agostino Mascardi." *Atti della società ligure di storia patria*, vol. 5.

Marchesano, L. Forthcoming. "Antiquarian Modes and Methods: Bellori and Filippo Buonaroti the Younger." In *Art History in the Age of Bellori*, ed. J. Bell and T. Willette. Cambridge.

Martin, J. 1997. "Inventing Sincerity, Refashioning Prudence: The Discovery of the Individual in Renaissance Europe." *The American Historical Review* 102:1309–42.

Massey, L. 1997. "Anamorphosis through Descartes or Perspective Gone Awry." *Renaissance Quarterly* 50:1148–89.

McGrath, E. 1994. "From Parnassus to Careggi: A Seventeenth-Century Celebration of Plato and Renaissance Florence." In *Sight and Insight. Essays on Art and Culture in Honour of E. H. Gombrich at 85*, ed. J. Onians, 191–220. London.

McLauglin, M. 1995. *Literary Imitation in the Italian Renaissance: The Theory and Practice of Literary Imitation.* Oxford.

McTighe, S. 1993. "Perfect Deformity, Ideal Beauty, and the *Imaginaire* of Work: The Reception of Annibale Carracci's *Arti di Bologna* in 1646." *Oxford Art Journal* 16:75–91.

Mendelsohn, L. 1980. *Paragoni: Benedetto Varchi's Due Lezzioni and Cinquecento Art Theory.* Ann Arbor, MI.

Menghini, M. 1890. *Tommaso Stigliani.* Gênes.

Merling, M. 1992. "Marco Boschini's *La Carta del Navegar Pitoresco*: Art Theory and Virtuosa Culture in Seventeenth-Century Venice." Ph.D. diss., Brown University.

Mérot, A. 1994. "Les modes, ou le paradoxe du peintre." In *Nicolas Poussin, 1594–1665*, ed. P. Rosenberg and L.-A. Prat, 80–86. Paris: Galeries nationales du Grand Palais.

Messerer, W. 1972. "Die *Modi* im Werk von Poussin." *Festschrift Luitpold Dussler*, 335–56. Munich-Berlin.

Meyer, L. 1987. "Toward a Theory of Style." In *The Concept of Style*, ed. B. Lang, 21–71. Ithaca, NY.

Miedema, H. 1978–79. "On Mannerism and *maniera*." *Simiolus* 10:19–45.

Milic, L. 1971. "Rhetorical Choice and Stylistic Option: The Conscious and Unconscious Poles." In *Literary Style: A Symposium*, ed. S. Chatman, 77–88. Oxford.

Mirollo, J. 1984. *Mannerism and Renaissance Poetry. Concept, Mode, Inner Design*, New Haven, CT.

Missirini, M. 1823. *Memorie per servire alla storia della romana Accademia di S. Luca fino alla morte di Antonio Canova.* Rome.

Montagu, J. 1989. *Roman Baroque Sculpture.* New Haven, CT.

——— 1992. "The Theory of the Musical Modes in the Académie royale de peinture et de sculpture." *Journal of the Warburg and Courtauld Institutes* 55:233–48.

——— 1994. *The Expression of the Passions: The Origin and Influence of Charles Le Brun's Conférence sur l'expression générale et particulière.* New Haven, CT.

Morford, M. 1991. *Stoics and Neostoics: Rubens and the Circle of Lipsius.* Princeton, NJ.

Moxey, K. 1994. *The Practice of Theory: Poststructuralism, Cultural Politics, and Art History.* Ithaca, NY.

Muller, J. 1985. " 'Con diligenza, con studio e con amore': Terms of Quality in the Seventeenth Century." In *Rubens and His World*, ed. R.-A. d'Hulst, 273–78. Antwerp.

Müller, W. G. 1977. "Der Topos 'Le style est l'homme même.' " *Neophilologus* 61:481–94.

Natali, G. 1951. "Storia del 'non so che.' " *Lingua nostra* 12:45–49.

Nodelman, S. 1970. "Structuralist Analysis in Art and Anthropology." In *Structuralism*, ed. J. Ehrmann, 79–93. New York.

Nyholm, E. 1977. *Arte e teoria del Manierismo.* 2 vols. Odense.

Ohmann, R. 1969. "Generative Grammars and the Concept of Literary Style." In *Contemporary Essays on Style*, ed. G. A. Love and M. Payne. Glenview, IL.

Ong, W. 1958. *Ramus, Method, and the Decay of Dialogue from the Art of Discourse to the Art of Reason.* Cambridge, MA.

Onians, J. 1988. *Bearers of Meaning: The Classical Orders in Antiquity, the Middle Ages, and the Renaissance.* Princeton, NJ.

——— 1998. "The Biological Basis of Renaissance Aesthetics." In *Concepts of Beauty in Renaissance Art*, ed. F. Ames-Lewis and M. Rogers, 12–27. Aldershot.

O'Rourke Boyle, M. 1998. *Senses of Touch. Human Dignity and Deformity from Michelangelo to Calvin.* Leiden.

Pagano, E. 1989. "L'eredità di Paolo Giovio nella storiografia artistica vasariana." *Atti della Accademia Pontaniana*, n.s. 38:211–17.

Pallucchini, A. 1966. "Introduzione." In M. Boschini, *La Carta del navegar pitoresco* (1660), ix–lxxxi. Venice and Rome.

Panichi, R. 1991. *La tecnica dell'arte negli scritti di Giorgio Vasari.* Florence.

Panofsky, E. 1955. "The First Page of Giorgio Vasari's '*Libro.*' " In *Meaning in the Visual Arts.* New York. Edition cited: 2d ed. Middlesex, 1970.

——— 1960. *Idea: Ein Beitrag zur Begriffsgeschichte der alteren Kunsttheorie.* Berlin. English edition: *Idea. A Concept in Art Theory*, trans. J. Peake. New York, 1968.

——— 1964. *Galileo as a Critic of the Arts.* The Hague.

Paoli, E. 1990. "Le biografie manoscritte di Andrea Polinori." In *Pittura del Seicento in Umbria. Ferraù Fenzoni, Andrea Polinori, Bartolomeo Barbiani*, ed. F. Todini, 341–51. Todi.

Pardo, M. 1993. "Artifice as Seduction in Titian." In *Sexuality and Gender in Early Modern Europe. Institutions, Texts, Images*, ed. J. G. Turner, 55–89. Cambridge.

Parshall, P. 1978. "Camerarius on Dürer – Humanist Biography as Art Criticism." In *Joachim Camerarius (1500–1574). Beiträge zur Geschichte des Humanismus im Zeitalter der Reformation*, ed. F. Baron, 11–29. Munich.

Payne, A. 1999. *The Architectural Treatise in the Italian Renaissance: Architectural Invention, Ornament, and Literary Culture.* New York and Cambridge.

Pepper, D. S. 1984. *Guido Reni: A Complete Catalogue of His Works.* Oxford.

Perini, G. 1980. "Il lessico tecnico del Malvasia." In *Convegno nazionale sui lessici tecnici del sei e settecento*, 1:221–53. Pisa.

——— 1981. "La Storiografia artistica a Bologna e il collezionismo privato." *Annali della Scuola Normale Superiore di Pisa* (Classe di Lettere e Filosofia), ser. 3, vol. 11, 181–243.

1984. "L'epistolario del Malvasia. Primi frammenti: Le lettere all'Aprosio." *Studi secenteschi* 25:183–230.

1988. "Carlo Cesare Malvasia's Florentine Letters: Insight into Conflicting Trends in Seventeenth-Century Italian Art Historiography." *Art Bulletin* 70 (1988): 273–99.

1989a. "Disegno romano dall'antico, amplificazioni fiorentine, e modello artistico bolognese." In *Cassiano dal Pozzo. Atti del Seminario Internazionale di Studi*, ed. F. Solinas, 203–19. Rome.

1989b. "L'arte di descrivere. La tecnica dell'ecfrasi in Malvasia e Bellori." *I Tatti Studies. Essays in the Renaissance*, 3:175–206.

1989c. "Central Issues and Peripheral Debates in Seventeenth-Century Art and Literature: Carlo Cesare Malvasia's *Felsina pittrice*." In *World Art: Themes of Unity in Diversity*, 139–43. University Park, PA.

1990a. "Biographical Anecdotes and Historical Truth: An Example from Malvasia's 'Life of Guido Reni.' " *Studi secenteschi* 25:149–60.

1990b. "Nota critica." In *Gli scritti dei Carracci*, 33–99. Bologna.

1991. "Copie ed originali nelle collezioni settecentesche italiane: Il 'Parere' di Giacomo Carrara e la progressiva definizione della figura del conoscitore in Italia." *Accademia Clementina. Atti e memorie*, 28–29:169–208.

1992. "Le lettere degli artisti da strumento di comunicazione, a documento, a cimelio." In *Documentary Culture: Florence and Rome from Grand Duke Ferdinand I to Pope Alexander VII*, ed. E. Cropper et al., 165–83. Bologna.

1994. "Raccolta di testi inediti o rari su Ludovico Carracci." *Accademia Clementina. Atti e Memorie*, 33–34:85–104.

1995. "Un breve trattato inedito per il conoscitore di stampe compilato da Carlo Bianconi." In *Artisti lombardi e centri di produzione italiani nel Settecento. Interscambi, modelli, techniche, committenti, cantieri. Studi in onore di Rossana Bossaglia*, ed. G. C. Sciolla and V. Terraroli, 229–235. Bergamo.

1996. "Il Poussin di Bellori." In *Poussin et Rome. Actes du colloque de l'Académie de France à Rome*, ed. O. Bonfait et al., 293–308. Paris.

Forthcoming. "*Belloriana methodus*: A Scholar's *Bildungsgeschichte* in Seventeenth-Century Rome." In *Art History in the Age of Bellori*, ed. J. Bell and T. Willette. Cambridge.

Perini, G., ed. 1990. *Gli scritti dei Carracci*. Bologna.

Pesenti, F. R. 1986. "La disputa a Genova del 1590 sull'Arte della Pittura e Giovan Battista Paggi." In *La Pittura in Ligura. Artisti del primo seicento*, 9–22. Genoa.

Pevsner, N. 1925. "The Counter-Reformation and Mannerism." In *Studies in Art, Architecture and Design. I: From Mannerism to Romanticism*, 10–33 London, 1968. Originally published in *Repertorium für Kunstwissenschaft*, vol. 46: (1925).

Pigman, G. W. 1980. "Versions of Imitation in the Renaissance." *Renaissance Quarterly* 33:1–32.

Pinelli, A. 1981. "La maniera: Definizione di campo e modelli di lettura." *Storia dell'arte italiana. Pt. 2: Dal Medioevo al Novecento*, 2/1 (Turin): 89–184. Republished, with slight modifications, as *La Bella maniera: Artisti del Cinquecento tra regola e licenza*. Turin, 1993.

Pinto, V. 1997. *Racconti di opere e racconti di uomini. La storiografia artistica a Napoli tra periegesi e biografia. 1685–1700*, 61–126. Naples.

Plett, H. 1983. "The Place and Function of Style in Renaissance Poetics." In *Renaissance Eloquence*, ed. J. J. Murphy, 356–73. Berkeley and Los Angeles.

Podro, M. 1982. *The Critical Historians of Art*. New Haven and London.

Pollitt, J. J. 1974. *The Ancient View of Greek Art: Criticism, History and Terminology*. New Haven, CT.

Pomeroy, S. 1975. *Goddesses, Whores, Wives and Slaves: Women in Classical Antiquity*. New York.

Pomponi, M. 1992. "Alcune precisazioni sulla vita e la produzione artistica di Pietro Santi Bartoli." *Storia dell'arte* 75:195–225.

Popescu, G. A. 1990. "Raffaello e la teoria artistica del settecento." In *Raffaello e l'Europa*, ed. M. Fagiolo, 589–603. Rome.

Pozzi, M. 1975. "Il Pensiero linguistico di Vincenzio Borghini." In *Lingua e cultura del cinquecento*, Bologna.

1980. "Teoria e fenomenologia della 'Descriptio' nel cinquecento italiano." *Giornale storico della letteratura italiana* 97:161–79.

Prandi, A. 1941. "Contributi alla storia della critica. Un'*Academia de Pintura* delle fine del Seicento." *Rivista del R. Istituto d'Archeologia e Storia dell'arte*, 8:201–16.

Previtali, G. 1964. *La fortuna dei primitivi dal Vasari ai neoclassici*. Turin.

1976. "Introduzione." In G. P. Bellori, *Le Vite de' pittori, scultori e architetti moderni*, ed. E. Borea. Turin.

Preziosi, D. 1989. *Rethinking Art History: Meditations on a Coy Science*. New Haven, CT.

Prodi, S. n.d. "Nota critica." In reprint of Filippo Baldinucci, *Vocabolario Toscano dell'arte del disegno*, iii–xxxiii. Florence, 1681.

Puglisi, C. 1999. *Francesco Albani*. New Haven and London.

Pullan, B. 1964. "Service to the Venetian State: Aspects of Myth and Reality in the Early Seventeenth Century." *Studi secenteschi* 5:95–148.

Puttfarken, T. 1985. *Roger de Piles' Theory of Art*. New Haven, CT.

——— 1999. "Poussin's Thoughts on Painting." In K. Scott and G. Warwick, eds., *Commemorating Poussin. Reception and Interpretation of the Artist*, 53–75. Cambridge.

Quednau, R. 1984. " 'Imitatione d'altrui.' Anmerkungen zu Raphaels Verarbeitung entlehnter Motive." In *De Arte et Libris. Festschrift Erasmus. 1934–1984*, 349–67. Amsterdam.

Quint, D. 1983. *Origin and Originality in Renaissance Literature: Versions of the Source*. New Haven, CT.

Quiviger, F. 1995. "The Presence of Artists in Literary Academies." In *Italian Academies of the Sixteenth Century*, ed. D. S. Chambers and F. Quiviger, 105–12. London.

Raimondi, E. 1961. "Grammatica e retorica nel pensiero del Tesauro" and "Polemica intorno alla prosa barocca." In *Letteratura barocca. Studi sul seicento italiano*. Florence.

——— 1966. "Alla Ricerca del Classicismo." In *Anatomie secentesche*. Pisa.

——— 1988. "Literature in Bologna in the Time of Guido Reni." In *Guido Reni, 1575–1642*, 119–41. Exh. cat., Bologna, Pinacoteca Nazionale; Los Angeles County Museum of Art; Fort Worth, TX, Kimbell Art Museum, 1988–89.

Raimondi, E., ed. 1960. *Trattatisti e narratori del seicento*. Milan and Naples.

Reinhardt, V. 1998. "The Roman Art Market in the Sixteenth and Seventeenth Centuries." In *Art Markets in Europe 1400–1800*, ed. M. North and D. Ormrod, 81–92. Aldershot.

Ricoeur, P. 1978. "The Metaphorical Process as Cognition, Imagination, and Feeling." In *On Metaphor*, ed. S. Sacks, 141–57. Chicago. First published in *Critical Inquiry*, vol. 5 (1978).

——— 1981. *The Rule of Metaphor. Multi-disciplinary Studies of the Creation of Meaning in Language*. Toronto.

Ricuperati, G. 1982. "Periodici eruditi, riviste e giornali di varia umanità dalle Origini a metà Ottocento." In *Letteratura italiana. 1. Il letterato e le istituzioni*, 921–43. Turin.

Riffaterre, M. 1959. "Criteria for Style Analysis." *Word* 15:154–74.

——— 1960. "Stylistic Context." *Word* 16:207–18.

——— 1966. "Describing Poetic Structures: Two Approaches to Baudelaire's 'Les chats.' " *Yale French Studies* 36–37:200–242.

Robinson, J. 1984. "Style and Personality in the Literary Work." *The Philosophical Review* 94: 227–47.

Rosenberg, M. 1995. *Raphael and France: The Artist as Paradigm and Symbol*. University Park, PA.

Rosenberg, R. 1995. "Zur Frage der wissenschaftlichen Bildbeschreibung. Vasari, Agucchi, Félibien, Burkhardt." *Zeitschrift für Kunstgeschichte* 58:297–318.

Roskill, M. 1968. *Dolce's "Aretino" and Venetian Art Theory of the Cinquecento*. New York.

Rossi, P. 1998. "*Sprezzatura*, Patronage, and Fate: Benvenuto Cellini and the World of Words." In *Vasari's Florence. Artists and Literati at the Medicean Court*, ed. P. Jacks, 55–69. Cambridge.

Rossi, S. 1980. "Il 'Trattato delle perfette proporzioni' di V. Danti e l'incidenza della 'Poetica' sulle teorie artistiche del secondo Cinquecento." In *Dalle botteghe alle accademie. Realtà sociale e teorie artistiche a Firenze dal XIV al XVI secolo*, 123–145. Milan.

Rothstein, M. 1990. "Etymology, Genealogy, and the Immutability of Origins." *Renaissance Quarterly* 43:332–47.

Rowland, I. 1994. "Raphael, Angelo Colocci and the Genesis of the Architectural Orders." *Art Bulletin* 76:81–104.

——— 1998. *The Culture of the High Renaissance. Ancients and Moderns in Sixteenth-Century Rome*. Cambridge.

Rubin, P. 1994. "Raphael and the Rhetoric of Art." In *Renaissance Rhetoric*, ed. P. Mack, 165–82. New York.

——— 1995. *Giorgio Vasari. Art and History*. New Haven and London.

Rudolph, S. 1988–89. "Vincenzo Vittoria fra pitture, poesie e polemiche." *Labyrinthos* 13/16: 223–66.

Ruffo, V. 1916. "La Galleria Ruffo nel secolo XVII in Messina." *Bolletino d'arte*, 10:284–320.

Saccone, E. 1979. "*Grazia, Sprezzatura*, and *Affettazione* in Castiglione's *Book of the Courtier*." *Glyph. Johns Hopkins Textual Studies*, 5:34–54.

Sacks, O. 1990. *The Man Who Mistook His Wife for a Hat and Other Clinical Tales*. New York.

Salerno, L. 1951. "Sul Trattato di Giulio Mancini." *Commentari*, 2/1: 26–39.

——— 1956. "Giulio Mancini e le cose di Siena." In *Scritti di storia dell'arte in onore di Lionello Venturi*, 2:9–17. Rome.

Sauerländer, W. 1983. "From Stilus to Style: Reflections on the Fate of a Notion." *Art History*, 6:253–70.

Scapini, A. 1970. *Dalla Fisiognomica di G. B. della Porta alla morfologia costituzionalistica*. Pisa.

Scavizzi, G. 1992. *The Controversy on Images from Calvin to Baronius*. New York, Bern, and Frankfurt.

Schapiro, M. 1953. "Style." In *Anthropology Today*, ed. A. L. Kroeber, 287–312. Chicago.

——— 1969. "On Some Problems in the Semiotics of Visual Art: Field and Vehicle in Image-Signs." *Semiotica*, 1:223–42.

Schlosser, J. von. 1912. *Lorenzo Ghibertis Denkwürdigkeiten (I Commentari)*. Berlin.

Scorza, R. 1995. "Borghini and the Florentine Academies." In *Italian Academies of the Sixteenth Century*, ed. D. S. Chambers and F. Quiviger, 137–63. London.

Segal, C. P. 1959. "The Problem of Cultural Decline in the *De Sublimitate*." *Harvard Studies in Classical Philology* 64:121–46.

Seymour, C. 1968. " 'Fatto di sua mano': Another Look at the Fonte Gaia Drawing Fragments in London and New York." In *Festschrift Ulrich Middeldorf*, 1:93–105. Berlin.

Sharples, R. W. 1985. "Species, Form, and Inheritance: Aristotle and After." In *Aristotle on Nature and Living Things. Philosophical and Historical Studies Presented to David M. Balme on his Seventieth Birthday*, ed. A. Gotthelf, 117–28. Pittsburgh and Bristol.

Shearman, J. 1963. "Maniera as an Aesthetic Ideal." In *Renaissance and Mannerism. Acts of the 20th International Congress of the History of Art*, 2: 200–221. Princeton, NJ.

——— 1967. *Mannerism*. Harmondsworth.

——— 1992. *Only Connect . . . Art and the Spectator in the Italian Renaissance*. Princeton, NJ.

Silverman, K. 1983. *The Subject of Semiotics*. Oxford.

Smyth, C. H. 1962. *Mannerism and Maniera*. New York.

Snyder, J. 1989. *Writing the Scene of Speaking. Theories of Dialogue in the Late Italian Renaissance*. Stanford, CA.

Sohm, P. 1991. *Pittoresco. Marco Boschini, His Critics and Their Critiques of Painterly Brushwork in Seventeenth- and Eighteenth-Century Italy*. Cambridge.

——— 1995a. "Gendered Style in Italian Art Criticism from Michelangelo to Malvasia." *Renaissance Quarterly* 48:759–808.

——— 1995b. "Seicento Mannerism: Eighteenth-Century Definitions of a Venetian Style." In *Treasures of Venice. Paintings from the Museum of Fine Arts Budapest*, ed. G. Keyes, I. Barkóczi, and J. Satkowski. Exh. cat., 51–66. Minneapolis Institute of Arts.

——— 1999. "*Maniera* and the Absent Hand: Avoiding the Etymology of Style." *RES: Anthropology and Aesthetics* 36:100–124.

——— 2000a. "Ordering History with Style: Giorgio Vasari on the Art of History." In *Antiquity and Its Interpreters*, ed. A. Kuttner, A. Payne, and R. Smick, 40–55. Cambridge.

——— 2000b. "Baroque Piles and Other Decompositions." In *Pictorial Composition from Medieval to Modern Art*, ed. F. Quiviger and P. Taylor, 58–90. London: Warburg Institute Colloquia, 6.

Sparshott, F. 1982. *The Theory of the Arts*. Princeton, NJ.

Spear, R. 1982. *Domenichino*. 2 vols. New Haven and London.

——— 1997. *The "Divine" Guido: Religion, Sex, Money, and Art in the World of Guido Reni*. New Haven and London.

Spini, G. 1970. "Historiography: The Art of History in the Italian Counter Reformation." In *The Late Italian Renaissance, 1525–1630*, ed. E. Cochrane, 91–133. London.

Spitzer, L. 1962. *Linguistics and Literary History*. New York.

Stanton, D. 1980. *The Aristocrat as Art*. New York.

Steinmann, E. 1930. *Michelangelo im Spiegel seiner Zeit*. Leipzig.

Stone, D. 1989. "Theory and Practice in Seicento Art: The Example of Guercino." Ph.D. diss., Harvard University.

Storr, R. 1995. "At Last Light." In *Willem de Kooning: The Late Paintings, the 1980s* (Exh. cat., San Francisco Museum of Modern Art), 50–53.

Strinati, C. M. 1972. "Studio sulla teorica d'arte primoseicentesca tra Manierismo e Barocco." *Storia dell'arte*, 13:80–81.

Strunk, W. Jr., and White, E. B. 1979. *The Elements of Style*. 3d ed. New York.

Stumpel, J. 1988. "Speaking of Manner." *Word & Image* 4:247–64.

Summers, D. 1981. *Michelangelo and the Language of Art*. Princeton, NJ.

 1987. *The Judgment of Sense. Renaissance Naturalism and the Rise of Aesthetics*. Cambridge.

 1989a. " 'Form,' Nineteenth-Century Metaphysics, and the Problem of Art Historical Description." *Critical Inquiry* 15:372–406.

 1989b. "ARIA II: The Union of Image and Artist as an Aesthetic Ideal in Renaissance Art." *Artibus et Historiae* 20:15–32.

 1991. "Conditions and Conventions: On the Disanalogy of Art and Language." In *The Language of Art History*, ed. S. Kemal and I. Gaskell, 181–212. Cambridge.

 1994. "Form and Gender." In *Visual Culture*, ed. N. Bryson, M. A. Holly, and K. Moxey, 384–411. Hanover, NH.

Thuillier, J. 1957. "Polémiques autour de Michel-Ange au XVIIe siècle." *XVIIe siècle. Bulletin de la Société d'Etude du XVIIe siècle*, 353–91.

Todorov, T. 1971. "The Place of Style in the Structure of the Text." In *Literary Style: A Symposium*, ed. S. Chatman, 29–41. Oxford.

Tonelli, L. 1934. *Dante e la poesia dell'ineffabile*. Florence.

Torrini, M., ed. 1990. *Giovan Battista Della Porta nell'Europa del suo tempo*. Naples.

Treves, M. 1941. "*Maniera*: The History of a Word." *Marsyas*, 1:69–88.

Trimpi, W. 1973. "The Meaning of Horace's *Ut Pictura Poesis*." *Journal of the Warburg and Courtauld Institutes*, 36:1–31.

Turner, N. 1971. "Ferrante Carlo's 'Descrittione della Cupola di S. Andrea della Valle, dipinta dal Lanfranchi,' a Source for Bellori's Descriptive Method." *Storia dell'arte* 12:297–325.

 1973. "Four Academic Discourses by G. B. Passeri." *Storia dell'arte* 19:231–47.

Ullmann, S. 1964. *Language and Style*. Oxford.

Vannugli, A. 1987. "Ludovico Carracci: Un'Erminia ritrovata e un riesame delle committenze romane." *Storia dell'arte* 59:47–69.

Venturi, L. 1952. "La critica di Giorgio Vasari." In *Studi Vasariani. Atti del Convegno Internazionale per il IV Centenario della Prima Edizione della "Vite" del Vasari*, 29–46. Florence.

Vickers, B. 1988. *In Defense of Rhetoric*. Oxford.

Villari, R. 1987. *Elogio della dissimulazione. La lotta politica nel Seicento*. Bari.

Vitale, M. 1966. "La III Edizione del 'Vocabolario della Crusca.' Tradizione e innovazione nella cultura linguistica fiorentina secentesca." *Acme* 19:109–53.

Vliegenthart, A. 1976. *La Galleria Buonarroti. Michelangelo e Michelangelo il Giovane*. Florence.

Waal, H. van de. 1967. "The *Linea summae tenuitatis* of Apelles; Pliny's Phrase and Its Interpreters." *Zeitschrift für Aesthetik und Allgemeine Kunstwissenshaft* 12/1: 5–32.

Waetzoldt, W. 1965. *Deutsche Kunsthistoriker. I, Von Sandrart bis Rumohr*. 2d ed. Berlin.

Warnke, M. 1977. "Die erste Seite aus den 'Viten' Giorgio Vasaris: Der politische Gehalt seiner Renaissancevorstellung." *Kritische Berichte 5*, 5–28.

 1982. "Praxisfelder der Kunsttheorie: Uber die Geburtswehen des Individualstils." *Idea. Jahrbuch der Hamburger Kunsthalle*, 1:54–71.

 1987. "Der Kopf in der Hand." In W. Hofmann, *Zauber der Medusa. Europäische Manierismen*, 55–61. Vienna.

Warwick, G. 1996. "Poussin and the Arts of History." *Word & Image* 12:333–48.

 2000. *The Arts of Collecting: Padre Sebastiano Resta and the Market for Drawings in Early Modern Europe*. New York and Cambridge.

Watson, R., and Olson, D. 1987. "From Meaning to Definition: A Literate Bias on the Structure of Word Meaning." In *Comprehending Oral and Written Language*, ed. R. Horowitz and I. Samuels, 329–53. San Diego, CA.

Waźmbiński, Z. 1987. *L'Accademia Medicea del Disegno a Firenze nel Cinquecento. Idea e istituzione*. 2 vols. Florence.

Weise, G. 1952. "La doppia origine del concetto di Manierismo." In *Studi Vasariani* (Atti del Convegno internazionale per il IV Centenario della prima Edizione delle 'Vite' del Vasari), 181–85. Florence.

 1962. "Le Maniérisme: Histoire d'une terme." In *L'information d'histoire de l'art*, 7:113–25.

 1971. *Il Manierismo. Bilancio critico del problema stilistico e culturale*. Florence.

Wellek, R. 1969. *The Literary Theory and Aesthetics of the Prague School*. Ann Arbor, MI.

Whitfield, C. 1973. "Programme for Erminia by Agucchi." *Storia dell'arte* 19:217–29.

Wiesing, L. 1995. "Aesthetic Forms of Philosophising." In *Questions of Style in Philosophy and the Arts*, ed. C. van Eck, J. McAllister, and R. van de Vall, 108–23. Cambridge.

Wildenstein, G. 1957. *Les graveurs de Poussin au XVIIe siècle*. Paris.

Willette, T. 1986. "Bernardo De Dominici e le Vite

de' pittori, scultori ed architetti napoletani. Contributo alla riabilitazione di una fonte." *Ricerche sul' 600 napoletano*, 255–73. Milan.

——— 1994. "Biography, Historiography, and the Image of Francesco Solimena." In *Angelo e Francesco Solimena due culture a confronto*, ed. V. de Martini and A. Braca, 201–07. Naples.

Williams, R. 1988. "Vincenzo Borghini and Vasari's 'Lives.'" Ph.D. diss., Princeton University.

——— 1989. "A Treatise by Francesco Bocchi in Praise of Andrea del Sarto," *JWCI* 52:111–139.

——— 1995. "The Vocation of the Artist as Seen by Giovanni Battista Armenini." *Art History* 18: 518–36.

——— 1997. *Art, Theory, and Culture in Sixteenth-Century Italy from Techne to Metatechne.* Cambridge.

Wohl, H. 1999. *The Aesthetics of Italian Renaissance Art. A Reconsideration of Style.* Cambridge.

Wolf, G. 1993. "*Toccar con gli occhi*: Zu Konstellationen und Konzeptionen von Bild und Wirklichkeit im späten Quattrocento." In *Künstlerischer Austausch. Artistic Exchange (Akten des XXVIII. Internationalen Kongresses für Kunstgeschichte)*, ed. T. W. Gaehtgens, 437–52. Berlin.

Wölfflin, H. 1912. "Das Problem des Stils in der bildenden Kunst." In *Sitzungsberichte der Königlich Preussischen Akademie der Wissenschaften*, 572–78.

——— 1915. *Kunstgeschichtliche Grundbegriffe: Das Problem der Stilentwickelung in der neueren Kunst.* Munich. Edition and translation cited: *Principles of Art History*, trans. M. D. Hottinger. New York, 1950.

Wollheim, R. 1987a. "Pictorial Style: Two Views." In *The Concept of Style*, ed. B. Lang, 183–202. rev. ed., Ithaca, NY.

——— 1987b. *Painting as an Art.* Princeton, NJ.

——— 1995. "Style in Painting." In *The Question of Style in Philosophy and the Arts*, ed. C. van Eck, J. McAllister, and R. van de Vall, 37–49. Cambridge.

Woods-Marsden, J. 1987. "Pictorial Style and Ideology: Pisanello's Arthurian Cycle in Mantua." *Art Lombarda* 80–82:132–37.

Zagorin, P. 1990. *Ways of Lying: Dissimulation, Persecution, and Conformity in Early Modern Europe.* Cambridge, MA.

Zamarra, E. 1985. "*Dolce, soave, vago* nella lirica italiana tra XIII e XVI secolo." *Critica letteraria* 13:71–118.

Zeitler, R. 1965. "Il problema dei *modi* e la consapevolezza di Poussin." *Critica d'arte* 12/69: 26–35.

Zerner, H. 1972. "Observations on the Use of the Concept of Mannerism." In *The Meaning of Mannerism*, ed. F. W. Robinson and S. G. Nichols, 105–21. Hanover, NH.

Zimmerman, C. P. 1976. "Paolo Giovio and the Evolution of Renaissance Art Criticism." In *Cultural Aspects of the Italian Renaissance. Essays in Honor of Paul Oskar Kristeller*, 418–24. Manchester.

INDEX

NAMES

Académie Royale de Peinture et de Sculpture, 52, 137–38, 251n88
Accademia degli Arcadi, 60
Accademia del Disegno, 59, 169–70
Accademia del Disegno (Ambrosiana), 224n33
Accademia della Crusca, 33, 74, 82, 84, 102, 110, 117, 139, 148–49, 163–64, 166–68, 175–76, 179, 245n12
Accademia di Belle Arti, 169
Accademia di San Luca, 45–46, 59, 60–61, 192
Ackerman, James, 70–72
Adorno, Theodor, 22
Adriani, Giovanni Battista, 263n95
Agnelli, Jacopo, 276n45
Agucchi, Giovanni Battista, 21–23, 24, 51–52, 141–43, 174, 197, 219n86, 226n58, 249n49, 271n55, 277n57, 280n98
Aikema, Bernard, 8–9
Albani, Francesco, 31, 125, 137, 140, 206n14, 209n9, 240n31, 247n35, 248n40, 248n42, 249n55, 250n62, 272n70, 276n45
Alberti, Leon Battista, 100, 108, 112, 140, 195, 259n26, 277n57, 278n58
Alberti, Romano, 228n88
Albertini, Francesco, 239n20
Algarotti, Francesco, 60, 131, 183, 192, 210n27, 216n69, 218n75, 221n99, 227n68, 243n70, 249n50, 263n87, 268n33, 274n31, 276n45
Aliense, Antonio, 253n106
Allegri, Alessandro, 42, 171
Alpers, Svetlana, 2–4
Altieri, Charles, 186
Alveraldo, G.A., 213n49
Apelles, 53–54, 57, 75
Aprosio, Angelico, 223n23
Arese, Paolo, 116, 119
Aretino, Pietro, 52, 95–96, 122, 280n87
Aristotle, 4–5, 30, 62, 66, 76, 77, 81–82, 84, 100, 101, 103, 108, 110–12, 160, 187, 193, 247n34, 264n98, 266n2
Armenini, Giovanni Battista, 44, 68, 82, 100, 113, 150, 160–61, 181, 206n14, 215n61, 219n83, 233n139, 235n165, 249n49, 249n57–58, 271n55, 272n57, 272n63, 276n47, 277n57, 281n100
Arpino, Cesare d', 140, 280n96, 281n100
Averoldo, G.A., 248n42

Baglione, Giovanni, 28, 249n49, 275n42
Baldi, Camillo, 66, 232n130, 235n178, 273n6
Baldinucci, Filippo, 11, 55, 57, 62, 63, 77, 82–84, 122, 132, 148–50, 158, 164, 165–84, 188, 190, 195, 199, 208n50, 215n61, 218n80, 219n84, 221n3, 226n64, 248n40, 248n42, 249n49, 254n120, 261n62, 262n78, 263n95–96, 272n64, 273n16–17, 274n32, 275n38, 281n100
Baldinucci, Francesco Saverio, 212n39, 266n9, 268n35, 275n42
Balestra, Antonio, 230n103, 248n42
Bandello, Matteo, 228n77
Bandinelli, Baccio, 33
Barbaro, Daniele, 101–2, 241n45, 266n3
Barkan, Leonard, 13
Barocci, Federico, 125, 133, 275n38, 279n74
Barthes, Roland, 7, 70–72, 73
Bartoli, Cosimo, 100, 264n99
Bartoli, Daniele, 232n126, 235n179, 266n3
Baruffaldi, Giorlamo, 191, 194, 221n96, 249n50, 272n63, 275n38, 276n43–44
Bassano, Jacopo, 37, 139, 146, 152–53, 156, 183, 221n96
Bassano, Francesco, 163
Baxandall, Michael, 44
Becelli, G.C., 273n8
Bellini, C.A., 280n98
Bellini, Gentile, 20
Bellini, Giovanni, 31, 95–96, 139, 140, 183, 214n53, 216n66, 278n63
Bellori, Giovan Pietro, 5, 28, 31, 45–50, 52, 60, 61–62, 75, 116, 121–22, 130, 131–32, 133, 143, 144, 160, 161, 162, 174, 175, 196, 197, 200, 206n15, 212n46, 221n99, 224n31, 244n2–3, 246n28, 247n33, 247n40, 249n49, 252n96, 255n138, 261n70, 263n92, 266n3, 268n25, 271n55, 272n70, 278n64, 279n83
Bellotti, Pietro, 46–47, 125
Bembo, Pietro, 104, 111, 122, 217n72, 258n22, 278n63
Beni, Paolo, 224n33
Bernini, Gianlorenzo, 25, 37, 51, 61, 181
Bevilacqua, Marco, 227n68
Bianconi, Carlo, 268n28
Bianconi, Giovanni Ludovico, 48, 272n64
Billi, Antonio, 249n57, 263n91
Biondo, Michelangelo, 110, 243n73
Bisagno, Francesco, 59, 219n84, 249n49, 272n57
Blunt, Anthony, 88, 116, 119
Boccaccio, Giovanni, 258n20

Zaccolini, Matteo, 212n45
Zagata, P., 255n135, 271n55, 274n31, 275n42, 276n44, 276n47
Zanelli, Ippolito, 278n65
Zanetti, Anton Maria, 259n47, 266n3, 272n70, 274n31, 276n47
Zanotti, Giovanni Pietro, 31–32, 52, 181, 191, 194, 215n57, 218n76, 224n27, 226n61–62, 251n81, 262n78, 266n3, 271n55, 272n70, 275n38, 276n46, 276n49, 278n57, 281n98
Zarlino, Giuseppe, 135–37, 142
Zeno, Apostolo, 191
Zeuxis, 37, 38–39, 54
Zuccaro, Federico, 7, 59, 63–64, 82, 157, 162, 211n29, 258n20, 260n53
Zuccaro, Taddeo, 125, 129, 251n79

❧

SUBJECTS AND TERMS

accent, 130–31, 187
accordamento, 180, 182, 258n22, 270n50
accurato, 263n95, 263n97
acuto, 281n99
alla prima, 36, 276n43
ammaccatura, 188–89, 257n8
ammanierato, 122, 165, 174–75, 182, 200, 230n98, 230n103, 265n113, 272n62, 272n64
aporia, 45–46, 186, 188, 191–92
architectural orders, 97–98, 137–38
aria, 12–13, 68, 74, 89, 94, 185, 188, 276n43
ars/ingenium, 62–70, 89, 108–14, 115–17, 120–22, 129–30, 132–33, 136, 181
artifice, 147, 159–64, 221n99, 225n43, 239n27, 245n7, 255n138, 257n5, 259n36, 270n50, 271n51, 275n35, 277n57
aspro, 125, 131–32, 213n50, 215n63, 217n71, 251n92
atticciato, 271n50

beauty, 89, 108–14, 192–200
binarism, 62–74, 181–83
byzantine style, 93–95, 214n53

cangiante, 188, 199
canons, 140
carattere, 10, 89, 119–20, 137, 159, 220n92, 233n145, 267n15, 269n39, 275n38
caricato, 224n27, 248n43
character and identity, 12–15, 23–26, 28, 64–70, 73, 124–25, 129–43, 171
classification, 119–20, 134–43
clothing, 7, 22, 65, 73, 77, 128
coloring, 5, 22, 118, 180, 192, 198–200
colpo, 146–47, 152–53
composizione, 117, 175–76, 279n83
connoisseurship, 26–27, 41–42, 55–57, 74–75, 136, 158–59, 169–73, 181
content/style, 24, 65, 72–74, 115–17, 120, 123–34
crudo, 93, 107, 109, 125, 132, 176–84, 212n45, 213n49, 214n53–54, 215n61, 215n63, 265n113, 270n49–50, 272n63, 278n67

decorum, see content/style
definition, 10, 81–85, 100, 148–49, 153, 175–76, 178, 185–86

delicato, 120, 125–26, 130, 134, 162, 184, 213n49, 249n57–58, 251n84, 252n104, 253n107, 263n88, 263n90, 263n95, 280n87
deviation, 71–72, 76–77, 120, 173–76, 181, 187
dilavato, 176–84
diligence, 30–31, 54, 115, 140, 141, 161, 178, 213n49, 216n65, 224n33, 252n99, 256n138, 263n95, 263n97, 264n108, 265n114, 269n40, 272n57, 274n32
disegno, 11, 63–64, 74, 82–83, 92, 98–101, 107, 117–18, 151, 180
dolce, 124–26, 133, 134, 135, 195, 213n49, 215n63, 244n80, 249n49–52, 249n57–58, 257n13, 270n49, 272n57, 272n66, 273n17–18, 275n38, 278n61
duro, 30, 125, 132, 213n53, 215n61, 216n66, 216n68–69, 217n72, 247n34, 252n97, 270n50, 274n32

ekphrasis, 35–36, 45, 47–48, 50, 51–53, 76, 196–98
eroico, 122, 137, 217n70, 223n23, 245n7, 246n27, 247n36, 248n41–42, 248n45, 254n118
esatto, 226n50, 280n98
esprit, 159, 235n173
esquisito, 257n13, 263n95, 275n33, 281n101
evolution of style, 29–33
expression, 43–44, 118, 136–38, 235n178, 237n3

facile, 221n98, 225n37, 255n138, 265n1
family resemblances, 12
fiero, 125, 152, 182, 211n30, 251n79, 221n98, 252n103–4, 257n5, 264n108, 272n66
fighting, 19–33, 123
first impressions, 198
foreign/foreigners, 30, 49, 92, 146, 187
form, 63–64, 145
formula, 90–97, 103–5
forte, 129, 134, 140, 176–84
franco, 140, 178, 243n70, 257n8, 263n97, 265n113, 265n1, 270n50
freddo, 216n66, 216n69, 270n50
fuggitivo, 198
furbesco, 279n83

gagliardo, 134, 176–84, 216n66, 253n108–9
gender, 5–6, 23–24, 53–54, 102–3, 108–14, 120, 124–26, 129–30, 180, 190, 193–95
genere, 137
gesture, 13, 66–67, 69–70, 139, 154–55, 157–58
grace, 109–11, 190–92, 194
grand style, 116–26, 130, 137, 142, 176–77
grave, 122, 137, 219n83, 232n130, 247n34, 254n110, 280n96
gretto, 176–84
gusto, 10–11, 117, 171, 209n1, 217n71, 217n75, 220n91–2, 229n92, 230n98, 253n107, 262n78, 268n34, 269n39

habit, 91, 94–97, 154–55, 159, 168, 181
hand, 74, 152–59
hard/soft, 28–33, 36–37
heresy, 21–23, 174

ideale, 177–84, 217n75, 262n85
imitation, 11, 28–29, 32–33, 35–42, 68, 72, 92–93, 96–97, 98, 103–5, 141–43, 181
impasto, 146–47